LOUIS VUITTON

CATWALK

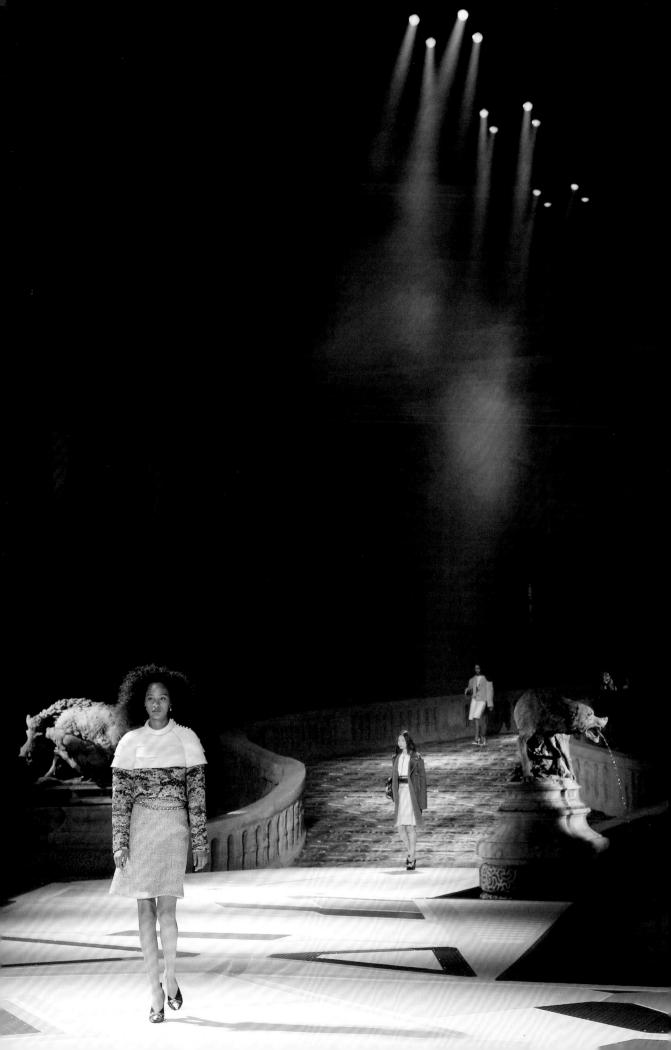

LOUIS VUITTON

CATWALK

The Complete Fashion Collections

Introduction by Jo Ellison

Collection texts and designer biographies by Louise Rytter

Yale University Press

Contents

The Collections

Louis Vuitton
by Marc Jacobs

Louis Vuitton
by Nicolas Ghesquière

Introduction

In the beginning was a trunk.

A large, flat-topped travelling case, innocuous enough to look at, with a pale grey cotton canvas exterior. The only clue to its manufacturer in the early days was the name of Louis Vuitton printed on the lining inside. The famous Damier check followed not long thereafter, a broadside to the counterfeit copies that followed in its wake. After the death of Louis Vuitton in 1892 his son Georges created and patented the monogram canvas we still know today.

Launched in 1858, the trunk was a product of its age, a treasure chest designed for an era of global exploration, long sea voyages and transcontinental train journeys. It quickly became one of the world's most decadent and coveted accessories. The cases, with their distinctive shape and graphic proportions, are still today the *sine qua non* of the elite, an emblem of extraordinary privilege designed for those who can command a retinue of porters and bell-boys to ferry them around.

As the starting point for a womenswear collection, however, the trunk's qualities are more opaque: it's bulky and heavy. It's solid and architectural. Its silhouette is, shall we say, unyielding. But it's the first thing with which a Louis Vuitton designer must grapple when they start working with the house. 'You feel its presence,' said the current creative director of womenswear, Nicolas Ghesquière, shortly after his arrival at Vuitton in 2013. 'And it's very big.'

Even worse, it's an anomaly: these days luxury travel is as often defined by how little, rather than how much, we carry with us. Which perhaps explains why, in a curious psychological play, Ghesquière's first response to the trunk was to miniaturize it. For his debut collection, he shrank it to tiny proportions, and made it an evening clutch called the Petite Malle. It was Ghesquière's attempt to 'project the trunk into modern life'; to 'take the history of the house, and remake it my way'.

Y

But Ghesquière's challenge was perhaps not as great as that which faced Marc Jacobs, the US-born designer who arrived in Paris as the house's first creative director in 1997, tasked with building a ready-to-wear fashion line from scratch. Ghesquière, at least, inherited a working studio of nearly 20 years' standing and an atelier of staff. 'I had nothing,' recalls Jacobs of his first days on rue du Bac, the small office space from which he started assembling the design team who would define the Vuitton 'look'.

'There was nothing there,' he continues. 'No archive. No archive of shoes. No archive of jewelry. Only bags. And mostly suitcases. And they weren't

fashion bags. They weren't "city" bags, as my grandmother would call them. They were bags for travel. And so the idea of building everything around this idea of the trunk seemed logical.' Jacobs's debut collection, which he showed in Paris in March 1998, was based on the grey trunk. It featured the same stone-pale palette: softly tailored jackets, coats made in collaboration with Mackintosh, a down jacket and double-faced cashmere knits. It suggested gentle luxury and discreet wealth. 'We called it collection zero,' he says of the show, which featured only a single bag, a simple messenger, in which the house's monogram was embossed on white lambskin, scarcely visible to the eye. The collection was almost minimal in execution. And, with very few exceptions, it was seen as a failure.

Jacobs's critical mistake, he says now, had been to hold back. 'I was trying to be cerebral,' he says. 'It wasn't a celebration of the logo, or the monogram. There was no visible status to it. And, of course, nobody liked it.'

As Jacobs, and any subsequent designer who enters the house of Vuitton soon understands, subtlety isn't going to work. To be successful, you have to embrace the monogram. And you have to hold it close. The Vuitton client is an extroverted soul, little interested in stealth. They like their bags – and, by that token, their scarves, their coats, their hats and their key fobs – to announce themselves.

'The thing that everybody loves about Louis Vuitton,' says Jacobs, 'is that everybody knows it. Everyone knows what the bag is. And it's a sign. It says "I have money". The Louis Vuitton woman is not a Céline lady. Or a Hermès woman. She's not interested in understatement (even though I don't happen to think there's anything very understated about Hermès; everybody knows what that is, too). But people always know the monogram. And they want the monogram, because owning a bit of it gives you membership of that club.'

Jacobs's first collection was a lightbulb moment. 'After that first show, I realized that the reason people love Vuitton is not because it's practical. That trunk is not the most functional. It's not the most easy to pack. But it's luxurious. And it's highly identifiable. So, instead of hiding the branding, I said let's celebrate it. And from that point on, I started each season with the idea of the bags as star of the show.' And hence he came up with the philosophy – bold design, brave choices, clubbable accessibility, a dash of anarchy – that has infused the Louis Vuitton ateliers ever since.

✦

Louis Vuitton is a vastly changed house from the family business first founded nearly 150 years ago on rue Neuve-des-Capucines, Paris. One of the 70 brands that sit within the LVMH conglomerate group controlled by Bernard Arnault, Louis Vuitton now accounts for 25 per cent of all LVMH group sales and an

estimated 50 per cent of its profits. It makes billions of dollars in
sales each year. Much of its success can be credited to Jacobs, whose arrival
in 1997 coincided with an era of unprecedented corporate expansion and
massive revenue growth. The late 1990s were a heady time in luxury: new
markets in Asia promised untold riches; an acquisitional spending spree found
the fashion industry dominated by a few conglomerate corporations; and the
consumer appetite was insatiable. Arnault, aware of the opportunities abroad,
was impatient for growth. Keen to emulate the success of labels like Prada,
the leather goods company that had by 1997 established an authoritative and
highly desirable ready-to-wear line under Miuccia Prada, or Tom Ford's
Gucci, with which the fashion world was then enthralled, he enlisted Jacobs,
an outspoken young New York-based designer famed for introducing the
grunge aesthetic to high fashion, to stir things up.

Jacobs was quick to respond to the market's demand for big, strong
statements. After that first rather muted debut he quickly began to push
the rather uptight, bourgeois French house to the very reaches of its
comfort zone. With the second Autumn/Winter collection, he introduced
the Monogram Vernis, a patent, glossed leather branded bag, near lacquered
in scarlet red. The bag had been an early prototype at the house, now
he pushed it centre stage, and used the same scarlet accents and graphic
branding on the clothes.

The bags drove the design: 'Clothes became the vehicle to show the bags,'
he says. 'They set up my mind for who the Vuitton woman should be. And
I realized she could be any woman, young or old, but that woman would
always have a handbag. She wasn't a pockets girl. And so we always started
with the idea of the bags as star of the show.'

The idea of coordinating different categories – shoes, jewels, clothes, bags –
under the umbrella of a single theme may seem quite obvious today, but
Jacobs's elevation of the handbag on the catwalk, taking what had once only
been an accessory to fashion rather than the thing from which the look was
built, did much to change the language of fashion design. It introduced a
dialogue between the different ateliers, which has become more commonplace
today. Rare are the shows on today's schedule that don't feature handbags,
and the accessories are often conceived alongside the collection. Jacobs insists
he had no choice but to make the bags the star, but in doing so he helped
develop the concept of the luxury brand as a multi-category enterprise.

Subsequent shows became bombastic as Jacobs unleashed his inner showman.
He harnessed pop iconography, street influences and art to inform his vision
for the brand. In 2001, he enlisted the punk artist and fashion designer
Stephen Sprouse to deface the sacred monogram. Sprouse used marker pens
to scrawl a graffiti print on bags and scarves and clothes. For a house that had
copyrighted and protected its monogram with a tenacious grip for more than
a century, the act was both anarchic and a piece of marketing genius.

'I'd been to see Charlotte Gainsbourg's apartment,' recalls Jacobs of the collaboration's genesis. 'And by her bed was a Vuitton trunk that had been given to her by her father, the singer, Serge. It was painted black.' The trunk made him think. As with Marcel Duchamp, who defaced the Mona Lisa by drawing a moustache on it in his work *L.H.O.O.Q.*, the gesture inspired Jacobs to do something similarly bold. 'I wanted to take something revered and loved and deface it. To turn it into this punky, cool thing. That would appeal to a younger customer. And so we started with the classic bags, the Keepall and the Speedy, and then introduced it on different shapes within the LV vocabulary.'

Not everyone was happy with the brand's new direction. 'At first they refused to produce the Sprouse collection,' Jacobs recalls. 'The bag was on every cover of every magazine, the counterfeiters were selling Sprouse copies on Canal Street, but there was a huge resistance to put it on the market.'

Jacobs persisted. 'I remembered a quote from Karl Lagerfeld, who said that you should always be respectful, but have a healthy amount of disrespect. And I decided that I wasn't there to win a popularity contest.'

He won, largely supported by Arnault, who was keen to try new things. 'Mr Arnault gave me the job to shake things up,' says Jacobs. 'He wanted Vuitton to be interesting to a youth – not just mothers, grandmothers and secretaries.' The collaboration went on to become one of the most successful collections in Vuitton's history and set a precedent for artistic collaborations that continues to this day. In 2003, Jacobs enlisted the Japanese anime artist Takashi Murakami, who again worked with the monogram, this time creating a comic rendering of its distinctive trefoils that resulted in a whole new set of characters.

Looking back, the Murakami prints, like the Sprouse graffiti, have now become so familiar to us that they seem somehow inevitable. It's easy to forget, when a garment or accessory becomes so emblematic of an era, that the evolution of each idea was actually a combination of happenstance, accident and plain good fortune.

'It was really a random thing,' says Jacobs of the Multicolor Monogram. 'At the time, I lived near the Cartier Foundation and I went to see the Murakami exhibition, and was really taken by the colours and scale – I just thought it was trippy and cool. And then I remembered I had read an article about him. And then I happened to see his sculpture "Hiropon" on the back cover of the Christie's catalogue, because I collect contemporary art. And I wondered if he'd be interested in collaborating. It was totally instinctive, as was the Sprouse thing. And although, looking back, I have all the logic, and the rationale, it was all born of chance things. Just like I happened to see a black trunk.'

The Murakami association lasted thirteen years. Other art collaborators have included the American artist Richard Prince, who in 2008 emblazoned bags with his Joke works, while Jacobs dressed models in nurses' uniforms and embroidered hats. In 2012, the Japanese artist Yayoi Kusama covered the monogram in spots (these designs were not shown on the catwalk but went straight to select stores). For his Cruise collection, in May 2017, Nicolas Ghesquière worked with the Japanese designer and artist Kansai Yamamoto to create a collection decorated in avant-garde kabuki prints and manga illustrations.

Perhaps the freedom of having very little DNA or archive to work with allows for new ideas and collaborations to flourish. Designers aren't shackled to older notions of what a luxury fashion line should be. Louis Vuitton had no silhouette and no signature fabrics, save for a coated canvas. And despite the house's rigorous testing procedure – a process that Jacobs describes as driving him 'batshit crazy' – the role of the designer at Louis Vuitton has been circumscribed only by their own imagination.

<div align="center">⊗</div>

Certainly, when Nicolas Ghesquière took over after Jacobs's departure in 2013, he was ready to carve his own signature above the door and introduce a new language at the house. Where Jacobs's shows were dramatic, often featuring vast set pieces (one will surely never forget the sight of a steam train pulling into the showspace at the Louvre for A/W 2012–2013, or the giant merry-go-round that delivered models onto the catwalk for S/S 2012), Ghesquière's sensibilities have shifted the brand's direction once more.

Ghesquière arrived at a house transformed by huge profits and years of success, but in a world disrupted by new technologies. The internet, the mobile phone, a new dialogue with consumers, and a reinterpretation of what constitutes a luxury item had possessed the industry. Ghesquière's arrival coincided with the advent of the Cruise show, a huge annual spectacle staged in international venues to showcase the winter collections that once crept into stores unnoticed. The front-row audience is now joined by millions of online viewers, who watch the shows on their screens. Clothes are no longer delivered according to seasonal drops; the purchase of new clothes has become an act of 24/7 gratification. Once suspended between the spring and autumn seasons, like two giant tent poles, the fashion calendar is now a mutable thing.

In this environment, the designer is less governed by trends. More and more they are given to broader creative visions. When Ghesquière arrived in 2013, he was already talking about the 'wardrobe'; the idea that a woman might add pieces to an existing collection of clothes rather than re-invent herself anew each season. But he understood that within that wardrobe he must find the key creative pieces that excite.

Ghesquière's trademark signatures – sci-fi silhouettes, the mix of sporty accents, a narrow lean line, and a passion for working with new technical fabrications – have been the underlying themes in collections that offer a sense of evolution from one to the next instead of an abrupt U-turn.

'The most defining feature of the female silhouette in the 21st century so far has been in the way a woman wears sports clothes and mixes them with much more elaborate designer pieces,' he says of the things that drive his creative process. 'And fashion will be remembered in our time for that collage. But this shift in the way women dress was driven by women themselves. Not by designers. What's most interesting to me is how we [as designers] react to that. It's about movement also; there's a new body consciousness about the way women dress. One of the great evolutions is how technology has been incorporated into fabric development. I'm fascinated by the way artificial fibres, like polyester, have become ennobled. Today, textile development has become so strong and inventive that the integration of those fibres mixed with natural materials makes intelligent fabrics.'

Ghesquière's Vuitton is one of futuristic landscapes in which his women appear as global nomads, warrior-like and strong. He, too, has embraced the monogram and made the bag a star: the trunk, at first miniaturized, was then blown up and turned into a travelling case, coated in aluminium and complete with iPhone chargers and a docking station. In s/s 2016, it found perhaps its most inevitable expression – as a phone case cover.

Sporty elements are also key. Early collections featured moto-cross sweaters, yoga leggings and athleisure-wear sweats. In October 2017, Ghesquière introduced his first sneaker for the house: a big rubber-soled statement running shoe that was worn with an 18th-century-style frock coat and track shorts. His aesthetic is perhaps more rooted in the everyday than his predecessor, but his ambitions are anything but pedestrian.

'We are designers. We don't want to do things that exist already,' he says of his constant drive to create something new. 'Today, at Louis Vuitton, the resources, the possibilities, the perspectives are so large, it has given me complete freedom to express what I want at one of the ultimate luxury brands in the world, if not *the* one. But, at the same time, the brand needs innovation; it needs new, it needs fresh ideas. And while it's very comfortable to have this patrimony and this history, at the same time there is a big risk because everything you do is multiplied by a thousand.'

Ⱡ

Despite its comparatively short history as a fashion house, Jacobs and Ghesquière have both carved an extraordinary narrative in luxury for Louis Vuitton. Nearly 20 years after 'collection zero', the lv show towers over the schedule as the landmark event of the season – a destination event

that everyone attends. For Jacobs, the designer who was so instrumental in building the ready-to-wear line, there must be no small amount of pride in what he achieved.

'It's bittersweet to look back,' he admits. 'But I'm proud that we, as a team, created this thing. That no one did it before us. That we were the first. But, additionally, I will say – and it's not me being humble at all; it's true of all of us who have worked as Louis Vuitton designers – working with a name that's so revered and respected, and with a team of artisans with such know-how, I could achieve extraordinary things. But what I could achieve was only possible because it was Vuitton. I'm not downplaying or downsizing the contribution, but without that iconic name and that iconic monogram I'm not sure it could have reached those proportions, that scope, or that reach or desire. You can't simulate that without the monogram.'

It always comes back to the trunk.

Jo Ellison

The Collections

Marc Jacobs

Marc Jacobs was born in New York on 9 April 1963. Both of his parents worked at the William Morris talent agency, but, due to family circumstances, he spent his teenage years living with his grandmother at the Majestic Apartments on the Upper West Side. He credits his grandmother with encouraging him to pursue a career in fashion. She bought him copies of *Vogue* magazine and taught him how to knit, which later became a signature trait.

Jacobs learned about the history of costume and took life-drawing classes while at the High School of Art and Design in Manhattan. At the age of 15, he started as a part-time assistant at the fashionable boutique Charivari; he also became a regular at Studio 54. Encouraged by fashion designer and Charivari customer Perry Ellis, Jacobs enrolled at Parsons School of Design in 1981. Of his time there, he once said: 'Every day was like a fashion parade... We would do five times what was required just because we really enjoyed it.' He benefited from a summer course in Paris offered by Parsons, during which he visited Yves Saint Laurent's atelier and attended a talk by Sonia Rykiel. Aged 17, he also did work experience with Kansai Yamamoto.

Jacobs's graduation collection of 1984 won him the Design Student of the Year award, the Chester Weinberg Gold Thimble award, and the Perry Ellis Gold Thimble award. The collection's distinctive oversized sweaters, inspired by the British Op art painter Bridget Riley, were handknitted by his grandmother, and a limited-edition version was sold exclusively at Charivari. Legendary street-style photographer Bill Cunningham soon picked up the trend for *The New York Times*: 'That's when people started to say, "Who's this kid?"' Jacobs recalled.

Meeting businessman Robert Duffy at the graduation show resulted in a lifelong partnership and the beginning of Jacobs's namesake label. Duffy oversaw Jacobs's hiring for brands including Reuben Thomas (Duffy worked for the company and persuaded them to launch a sportswear collection, called Sketchbook), Jack Atkins, Epoch-3 and Kashiyama USA (the latter went on to back Jacobs's first own-label collection in 1986). Then, on 23 November 1988, Jacobs was appointed vice-president of design at Perry Ellis, responsible for womenswear and accessories (Duffy was appointed president). In 1992, taking inspiration from Seattle street style and music by Sonic Youth and Nirvana, Jacobs presented a now-infamous 'grunge' collection. This was widely admired and led to Jacobs winning the Council of Fashion Designers of America (CFDA) Womenswear Designer of the Year award (*Women's Wear Daily* hailed him 'the guru of grunge'). However, the Perry Ellis executives – unhappy with the direction the brand had taken – dismissed Jacobs and Duffy.

Part of the severance package included the purchase of a one-third stake in Jacobs's own brand. This continued to flourish, and new lines were

introduced, including the diffusion line Marc by Marc Jacobs, menswear, childrenswear, fragrances, cosmetics and stationery; even a bookstore ('Bookmarc').

During the 1990s, however, the French luxury goods company LVMH was looking to revitalize its brands, and designer Tom Ford (who had previously been hired by Jacobs to work on the Perry Ellis jeans line) encouraged LVMH CEO Bernard Arnault and Louis Vuitton CEO Yves Carcelle to meet with Jacobs. The conglomerate was considering designers for the houses of Dior, Givenchy and Louis Vuitton. On 7 January 1997 – having impressed with a portfolio of sketches, fronted by a photograph of a brooding Mick Jagger – Jacobs was named artistic director of Louis Vuitton's new ready-to-wear and accessory lines for women and men; Duffy became studio director. Coinciding with the appointments, LVMH bought out Perry Ellis's stake in Marc Jacobs Trademarks and also acquired a majority interest in Marc Jacobs International.

Jacobs was empowered to take risks at Louis Vuitton, resulting in the iconic LV logo and Monogram pattern being reimagined. Bold and commercially successful designs were created, often in collaboration with artists (Jacobs had himself become an avid collector of contemporary art). Drawing on the history of the house and its skilled artisans, the Louis Vuitton look merged Parisian chic and American sportswear, with Jacobs's playfulness and showmanship attracting a cult following. In 2012, in celebration of over 150 years of creative excellence, an exhibition at the Musée des Arts Décoratifs in Paris paid tribute to Jacobs and to founder Louis Vuitton.

Jacobs was at the helm of Louis Vuitton for 16 years, helping to turn the company into a brand worth more than 7 billion euros, with over 400 stores worldwide. Since his departure in 2013, he has devoted his time to his eponymous company, which has been involved with over 60 charities. He has become part of popular culture (a documentary on him, by Loïc Prigent, was released in 2007; and he famously appeared, in cartoon form, in the television show *South Park*), but he is also one of the most decorated designers in the business. He has been awarded the prestigious CFDA award eleven times; he was honoured in France, as a Chevalier des Arts et des Lettres, in 2010; that same year, he was the only fashion designer to be included in *Time* magazine's register of the '100 most influential people in the world'; in 2013, he and Duffy were presented with the Fashion Group International's prized Superstar award, for their 'extraordinary body of work and a partnership that changed the course of fashion design'.

Louise Rytter

'Hidden Luxury'

Louis Vuitton's inaugural catwalk show was presented on 9 March 1998. Creative director Marc Jacobs said, 'I made a conscious decision not to do what the fashion community expected', electing to show a single handbag and to hide the house's emblematic Monogram motif almost entirely. 'We couldn't make it look like old Vuitton, because there was no tradition, and if we put logos on it we'd be accused of looking like Gucci or Prada. So I started from zero, without putting any insignia on the outside of things.'

The sportswear-inspired collection, styled by Joe McKenna, included wardrobe basics influenced by the zeitgeist of the 1990s and concept of understated luxury. Jacobs chose the first trunk designed by Louis Vuitton – the Trianon, its revolutionary flat top and bottom making it easy to transport – as the collection's key source of inspiration, echoing its distinct (grey) colour, craftsmanship and pared-back aesthetic on both the outside and inside of garments. Of the 50 looks, the house stated: 'Refinement and elegance blend with simplicity and modernity.'

Revealing the details and tailoring, Jacobs explained his vision: 'The buttons had Louis Vuitton on underneath so they were not visible; the tapes on the inside of the raincoats had the Monogram.' He continued: 'I remember thinking that the luxury was all hidden. We did skirts that had huge hems that were wrapped twice and these cashmere sweaters that were endlessly long but they were folded up twice and they had these bulky hems. So there was a lot of extra luxury, but it wasn't what you saw.'

Model Kirsten Owen (right) opened the show wearing a white rubberized cotton coat with a white monogram-embossed messenger bag – the only accessory in the show, to the bemusement of some of the press. Describing the new Monogram Vernis bag line, Jacobs explained, 'We came up with this idea of creating a surface that was very visible and striking through the colour, and the fact that it was shiny and patent leather, but the Monogram had become just embossed, so it kind of disappeared... [I]t was about making something more visible, but downplaying something of what it had always been before, or changing what it had always been.'

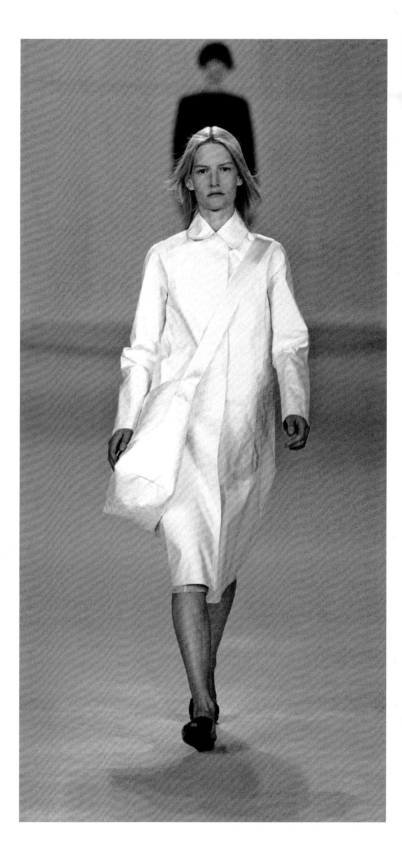

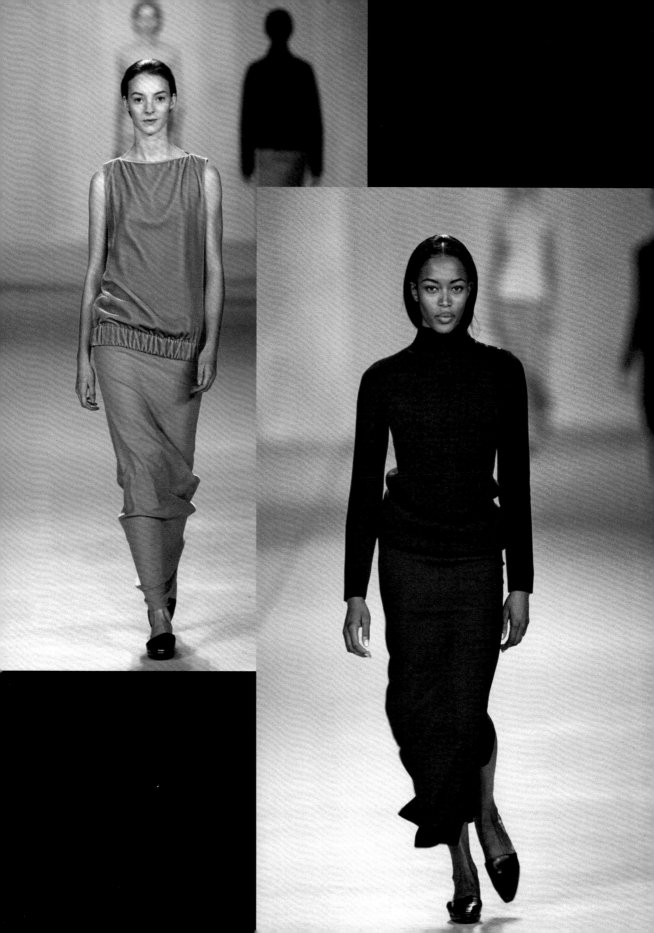

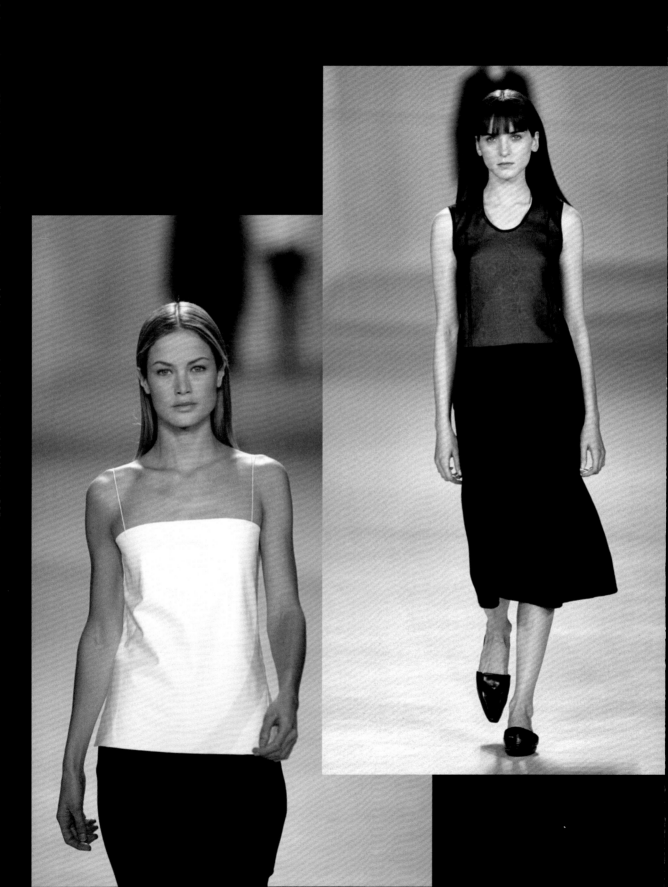

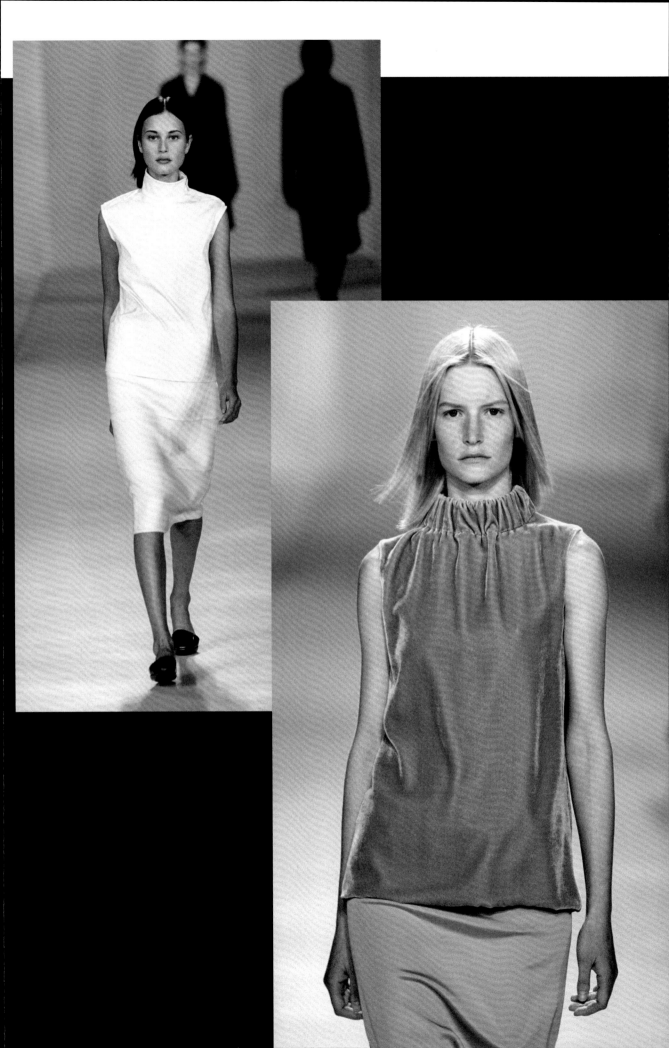

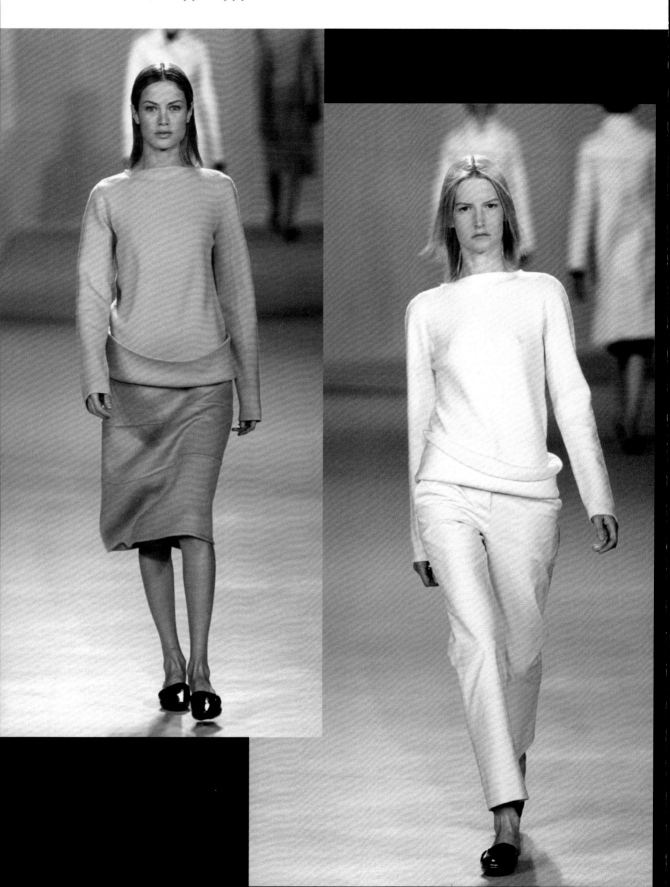

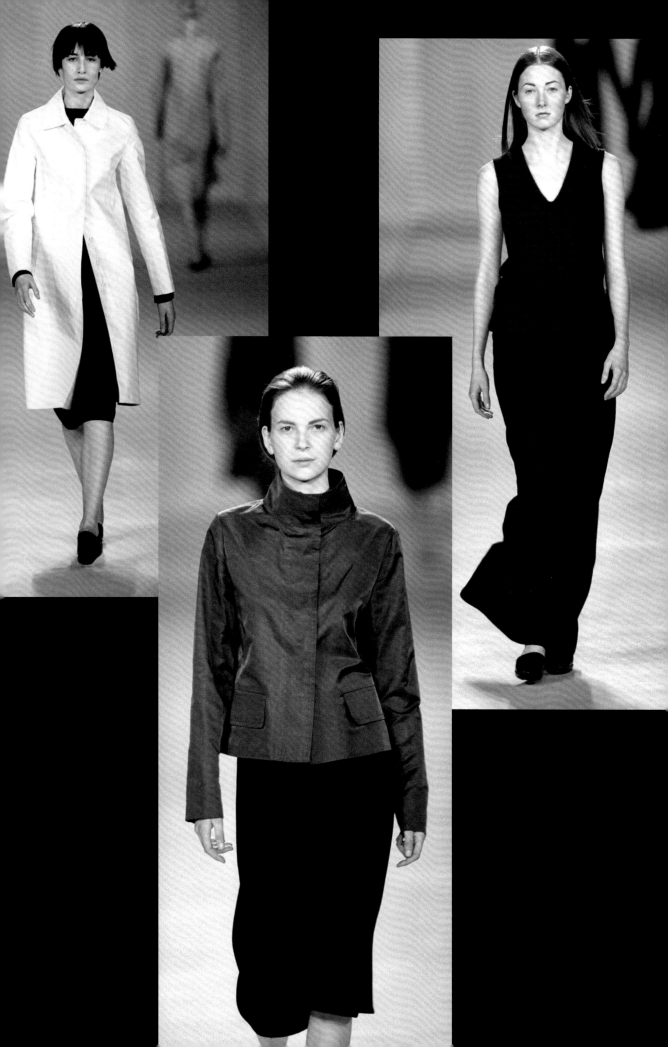

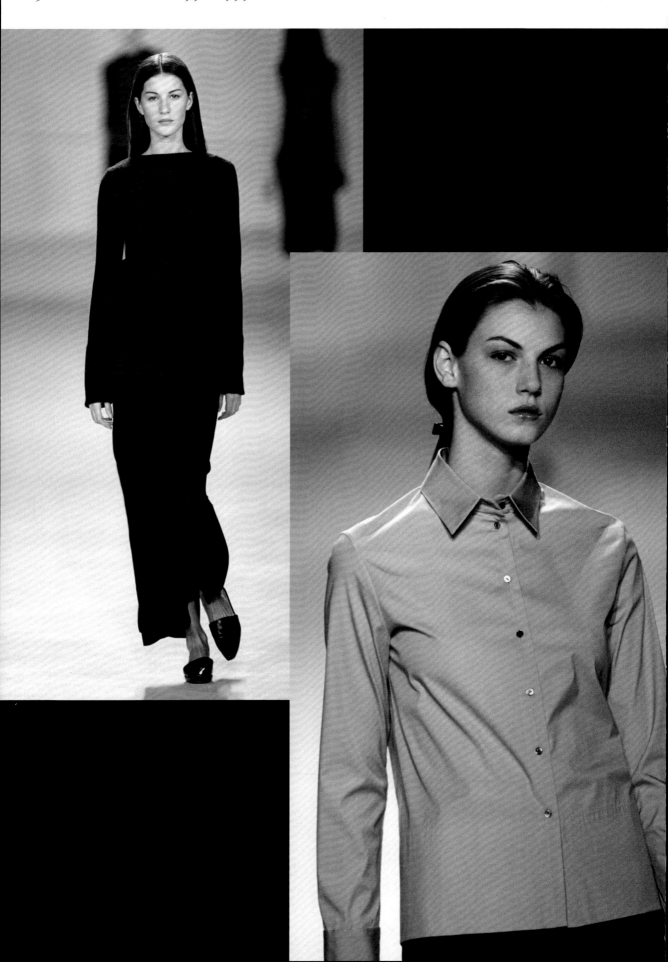

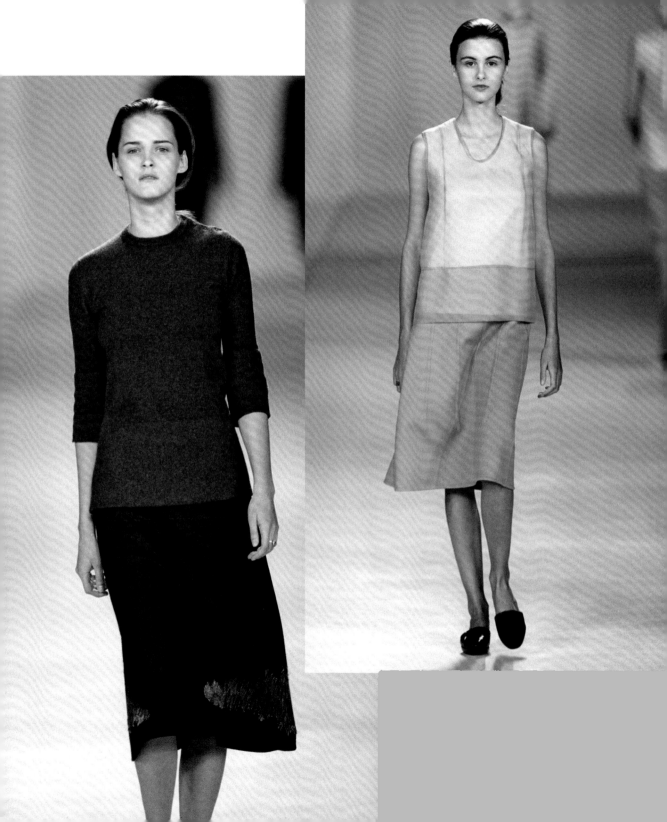

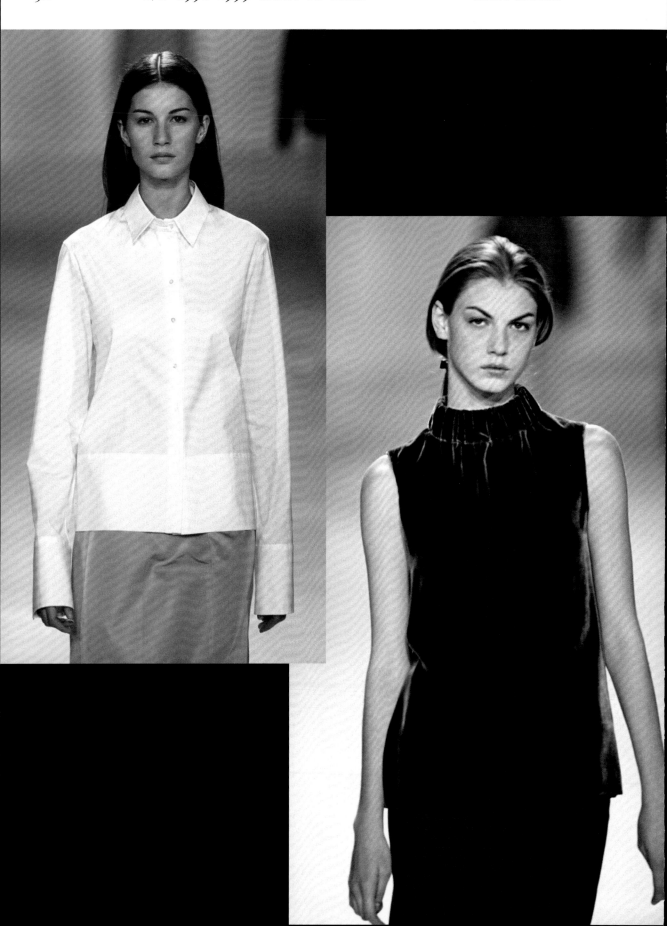

'Jet-Wear Fashion Without Jet-Lag'

Marc Jacobs's second ready-to-wear collection
for Louis Vuitton was presented in a greenhouse
pavilion at Parc André-Citroën on 12 October 1998.
The collection featured 61 looks, 21 bags and one
motorcycle helmet with two antennas, proposing,
as the show notes stated, 'chic and practical clothes
for the modern-day trunk'. Designed for the ultimate
luxury – the art of travelling – these were 'sleek,
modern and relaxed clothes for an international
woman who no longer counts the seasons as she
takes flight by jet-setting from country to country.
Here there's a marriage between French refinement
and American sportswear for a collection that
is "Jet-wear fashion without Jet-lag".

Jade Parfitt (right) opened the show wearing
mini-shorts with a slimline belt, sandals, and what
Vogue described as 'a new millennium must-have:
the silk poncho', referencing multifunctional military
raincoats and voluminous tailoring mastered by
Cristóbal Balenciaga. Parfitt also wore another
signature look of the season: a khaki-green two-piece
motorcycle suit, white boots, helmet and a pearl
white Monogram Vernis waist-belt fanny pack (p. 40).
Predominantly white, the collection included military
jackets, a balloon-shaped raincoat, cashmere sweaters
with kangaroo pockets, safari shirts, V-neck tops,
hooded neckline blouses, capri pants, bermuda shorts,
velvet and plastic swimwear, and apron-like skirts
over cigarette pants.

Prints and patterns took inspiration from Louis
Vuitton's Damier canvas trunk, patented in 1888 and
presented the following year at the Paris World Fair,
alongside the Eiffel Tower. The geometric chequerboard
pattern and inscription 'marque L. Vuitton déposée'
inside each trunk made the Damier hard to imitate
compared to earlier models. Jacobs chose to use
the iconic design on handbags, and reinterpreted
the pattern on tops and dresses, using transparent
cubes, square embroideries, mirrored sequins and
'LV'-embossed hooks. Jacobs also introduced a
striking print with 'invisible' tears and polka dots
(p. 37), referencing M90 camouflage used by the
Swedish army.

Inspired by straps on trunks, the leather and canvas
belts were wrapped around the waist, becoming what
the show notes called 'the inescapable accessory'
of the season. The Monogram Vernis collection was
expanded to include backpacks, money bags, bumbags
and waist-packs in shiny silver grey, lime and rose pink.
The house called it a 'resolutely feminine line that
accessorizes the Louis Vuitton ready-to-wear with a
bit of impertinence'. The styles and colours of the bags
matched the collection, and were designed to elegantly
slip in 'your cigarettes or cell phone ... Discman
and CD holder'.

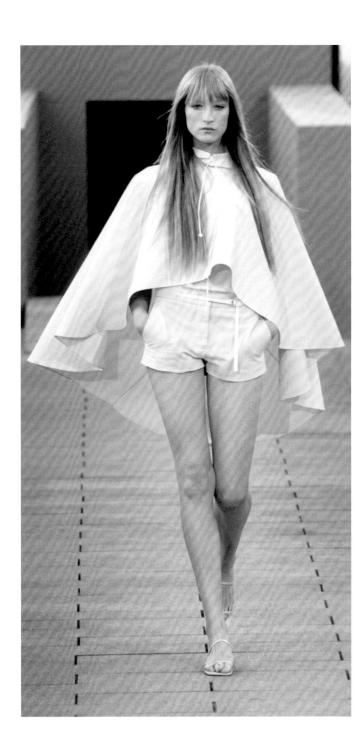

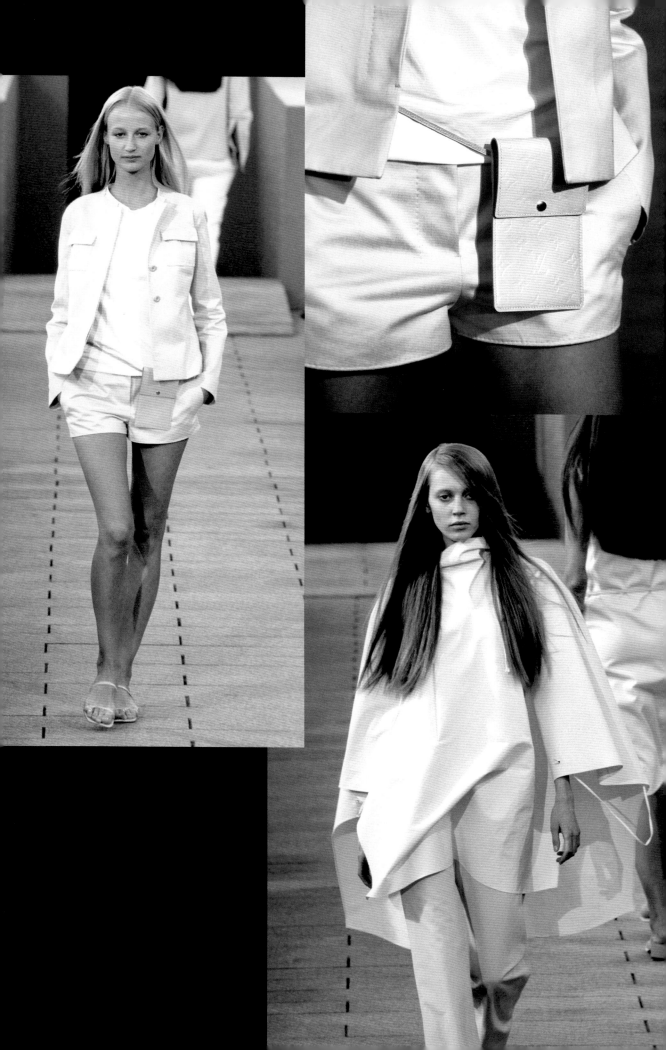

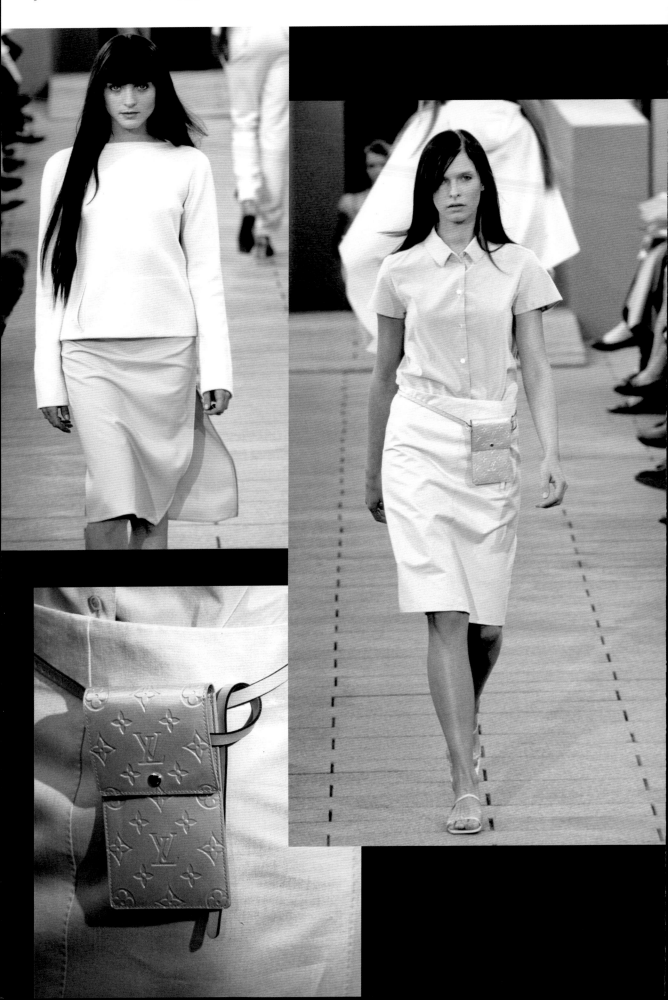

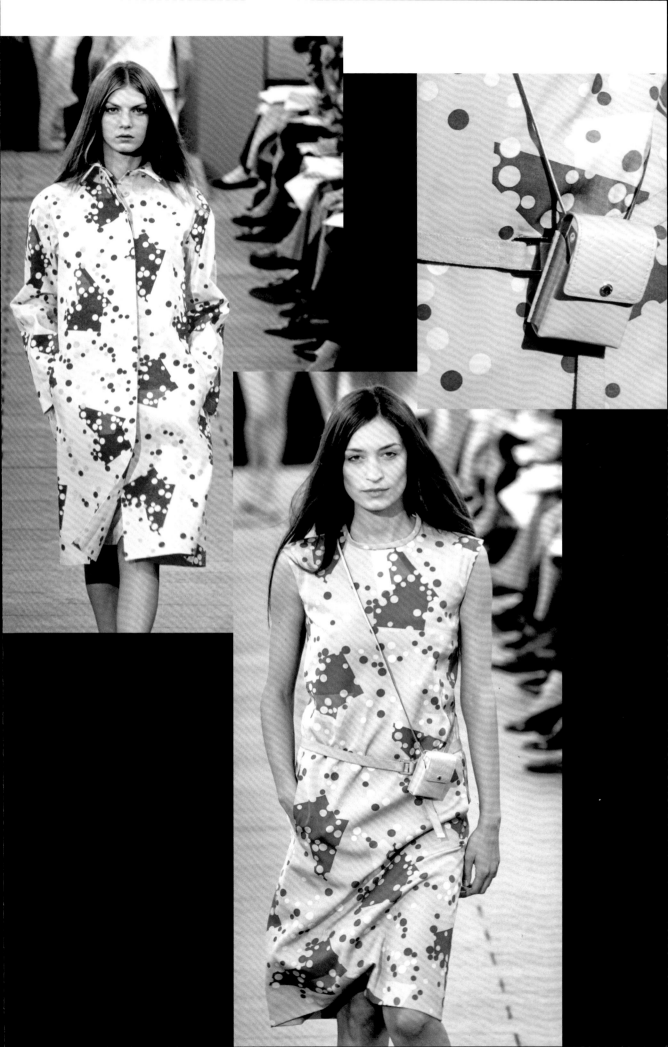

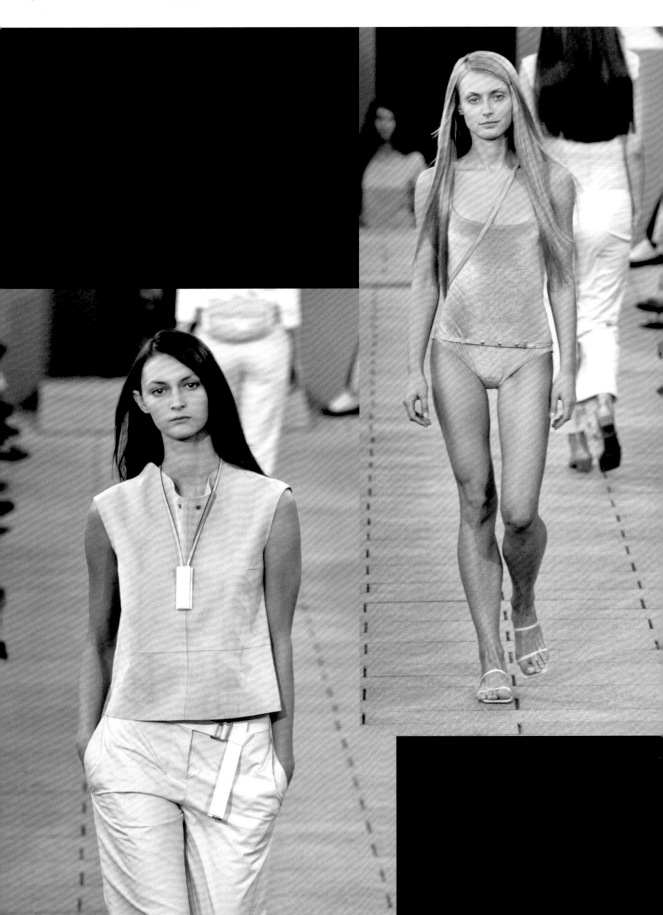

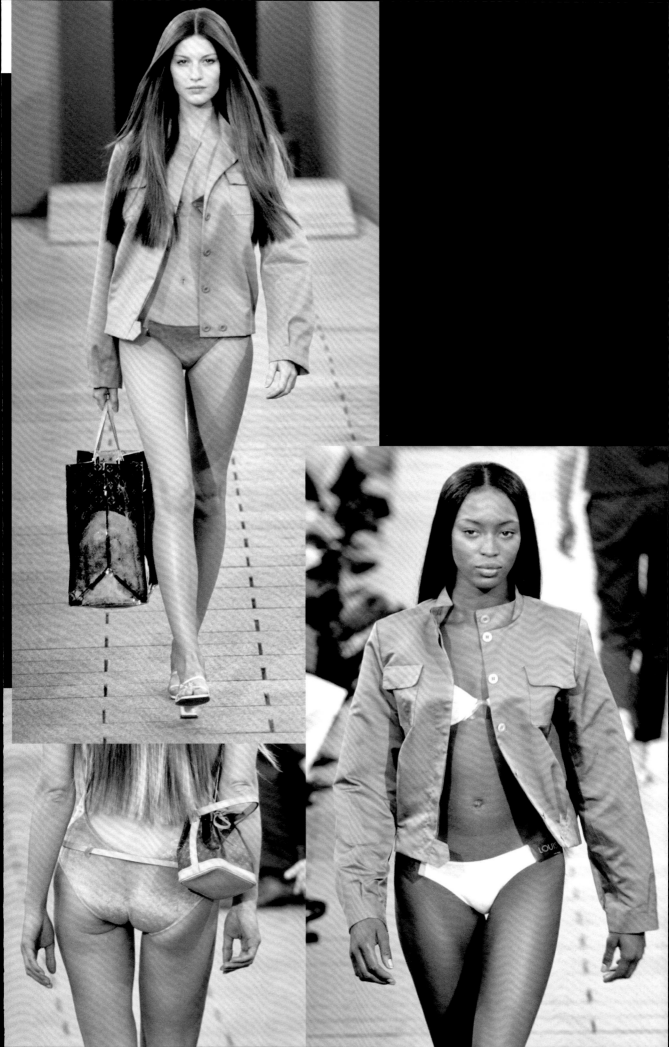

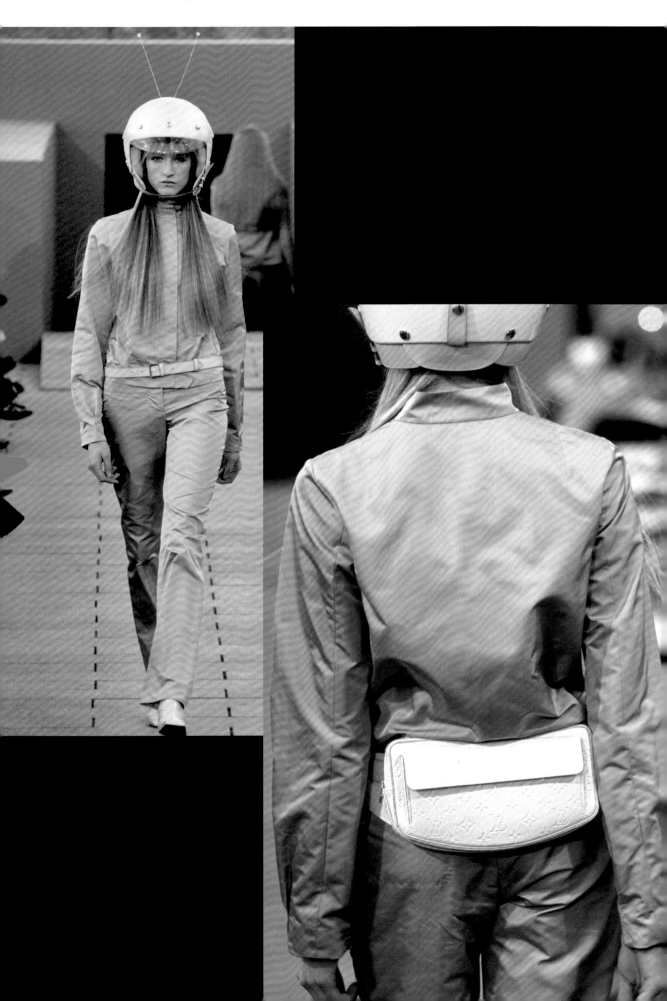

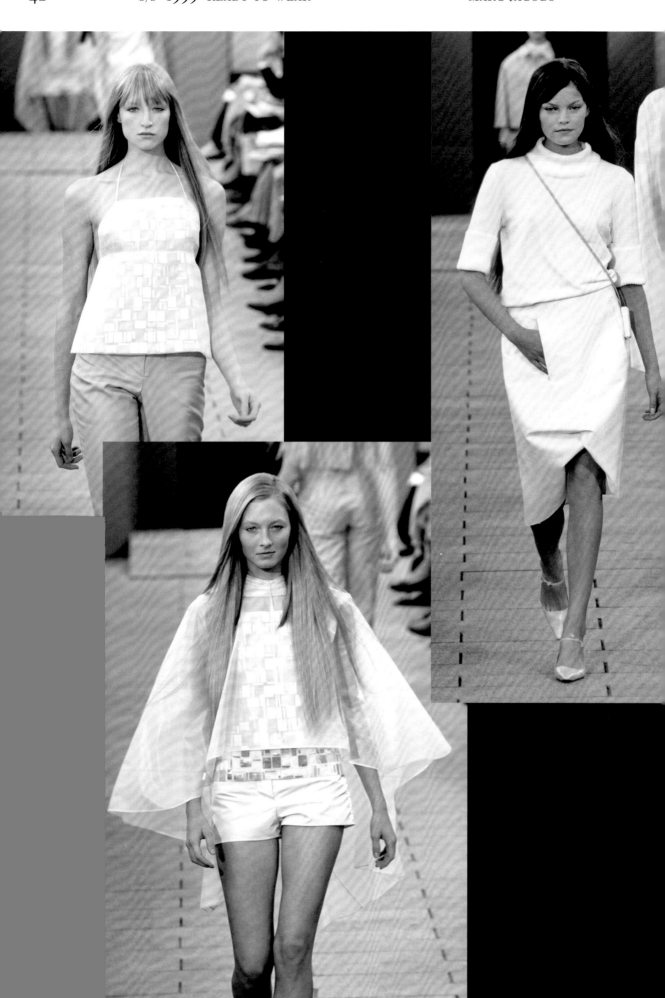

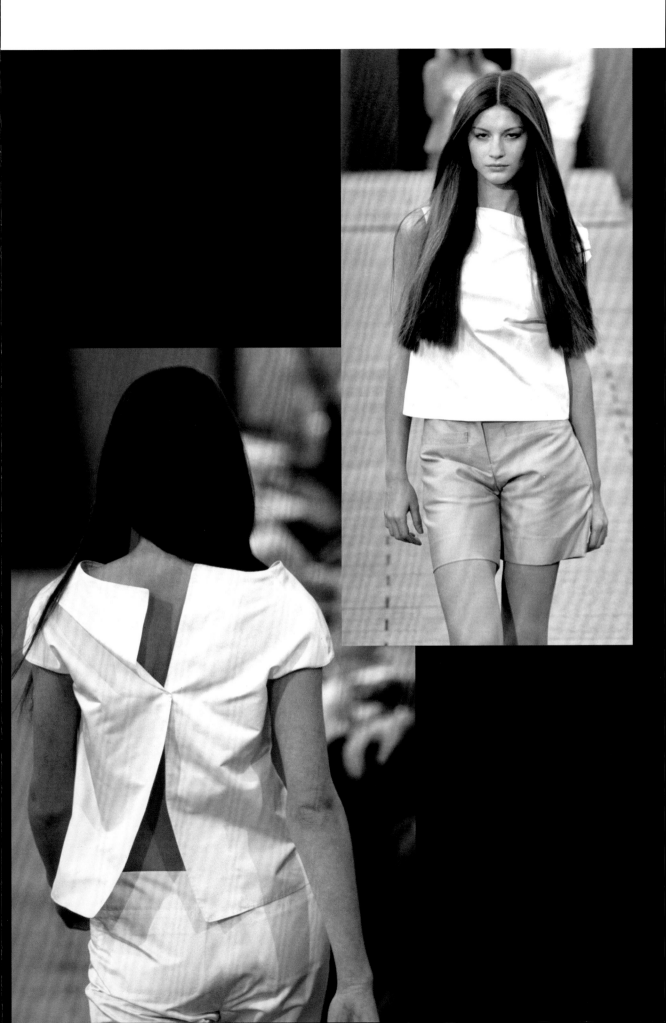

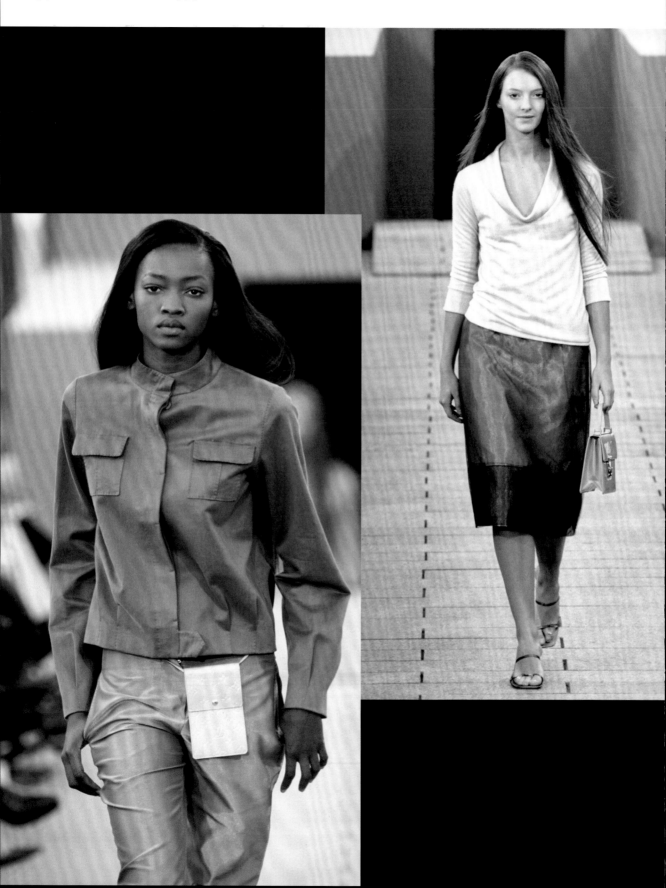

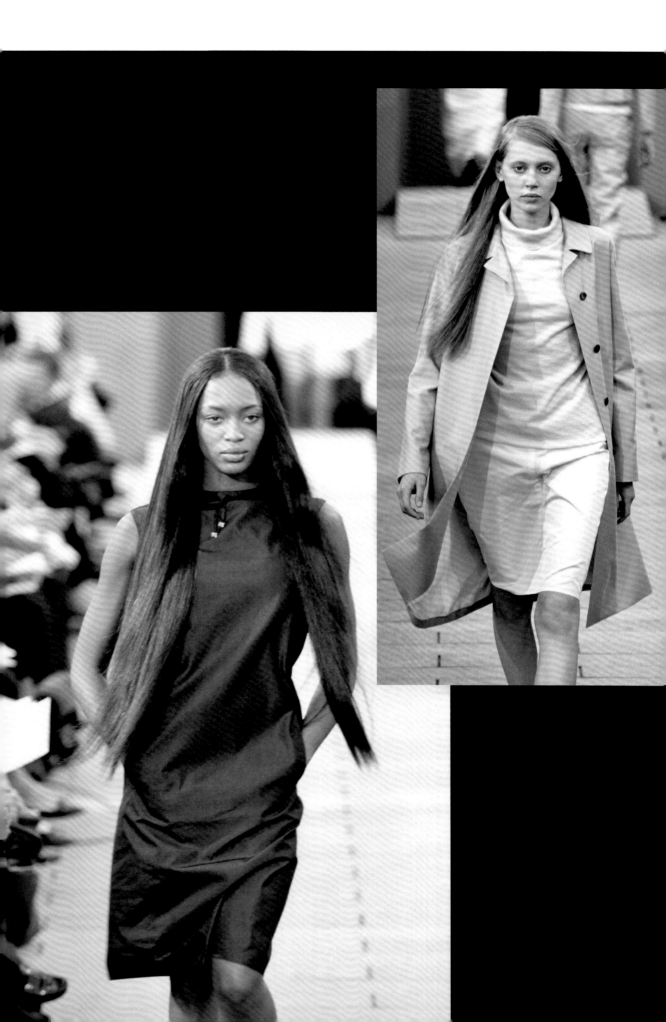

Louis Vuitton Goes Camping

Marc Jacobs had, for his Louis Vuitton autumn/winter 1999 collection, gone 'camping, in more ways than one', reported Susannah Frankel of *The Independent*. She elaborated: 'Take the world's largest (and most expensive) rucksack in tomato-red, patent, monogrammed leather and complete with rolled-up sleeping bag – cashmere of course – and there you have it.' Jacobs's bold statement of 90 looks for men and women celebrated the spirit of travel and millennial glamour, making a clear diversion from his previous collections dominated by minimalism and understated luxury. The combination of bright colours, playful travel accessories and luxurious materials made it an exuberant collection, confirming what the show notes called the 'true Louis Vuitton style'.

The show invitation came with a leather wristband in purple, which was the dominant colour of the season alongside black, beige, anise green and bright red. Fur opened and closed the show. The silhouette was slender, with long A-line skirts, cashmere turtlenecks with removable sleeves, tubular knitted sweaters, cigarette pants, form-fitting tuxedo jackets, goose-down kimono coats, long coats nipped in at the waist, and knee-high leather boots. A feminine silhouette was emphasized with trousers cut high and loose above the navel, as well as braided leather and trunk-nail-inspired belts tied around the waist. Taking inspiration from men's tailoring, Jacobs used Prince of Wales stripes and white thread AMF overstitching to attract 'the attention of lovers of modern luxury where elegance rhymes with subtlety'.

Inspired by scarves worn by football fans, Jacobs played with the graphic universe of Louis Vuitton, making the LV logo visible on prints and patterns. He draped traditional woollen Louis Vuitton blankets into coats, ponchos, scarves and stoles, echoing the design of the Rayée trunk canvas from 1872. The Damier canvas was printed on the lining of raincoats and the turn-ups of fishing hats. It was less traditionally interpreted in a Pop Art-inspired black and white jacquard pattern and glam rock-inspired eveningwear made of metallic padded fabric. The iconic chequerboard pattern was also transformed into chunky 1970s metallic square bangles.

Karen Elson wore red from top to toe, with matching Monogram Vernis trolley and bag (p. 49), embodying the elegance and cheerful spirit of the season. Frankel reported on the bags: 'the biggest and most brash of the season: a tote that would house a family of four; a shopping trolley in which to wheel about an entire year's provisions. Once these have been scaled down for public consumption, they will no doubt sell and sell.'

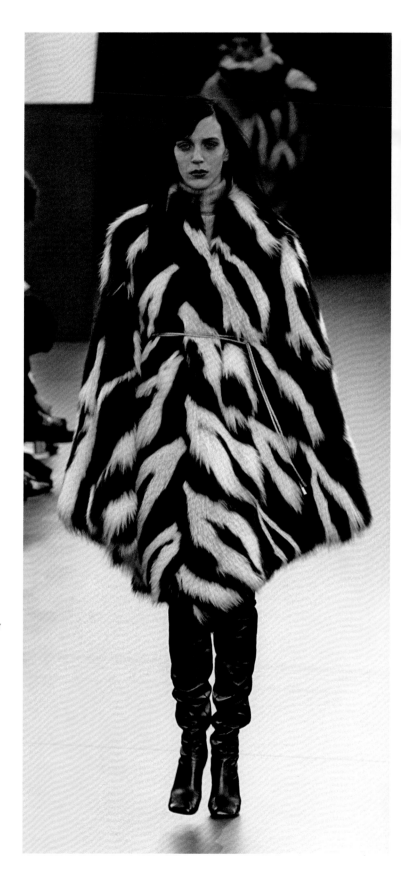

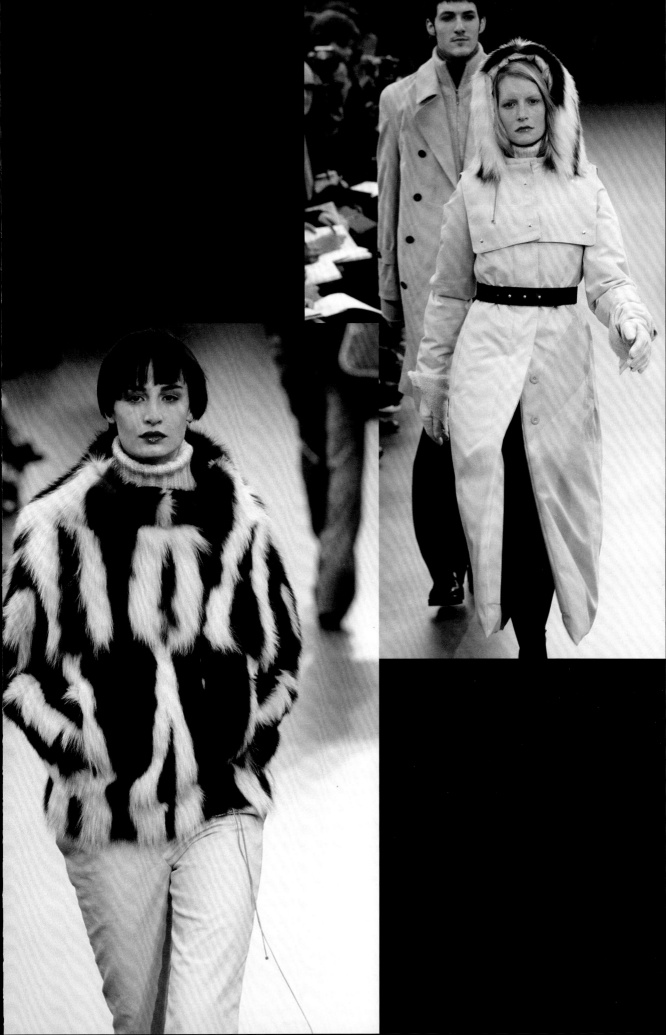

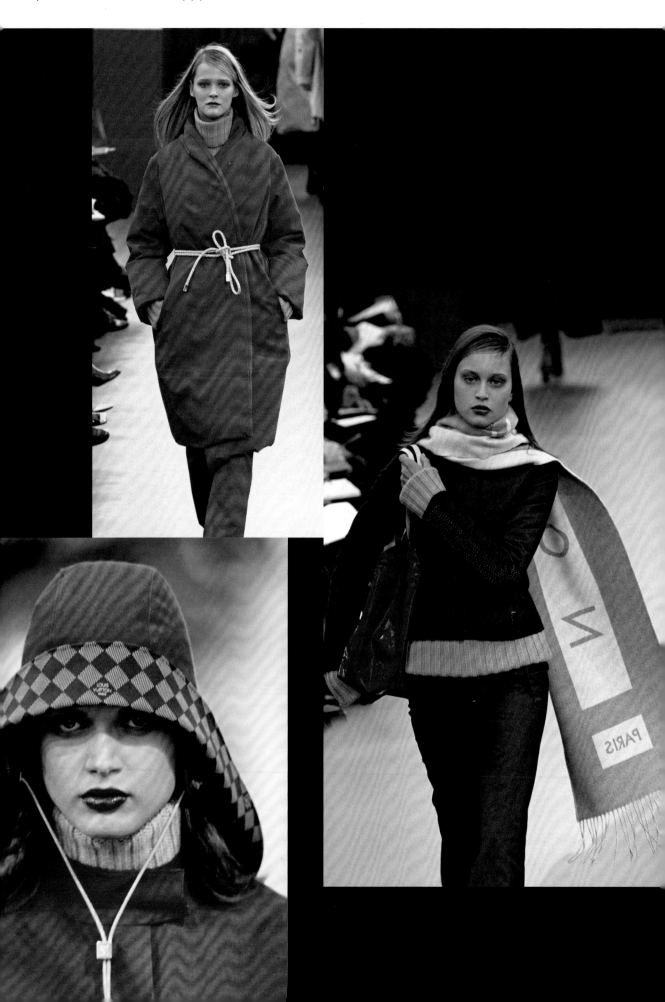

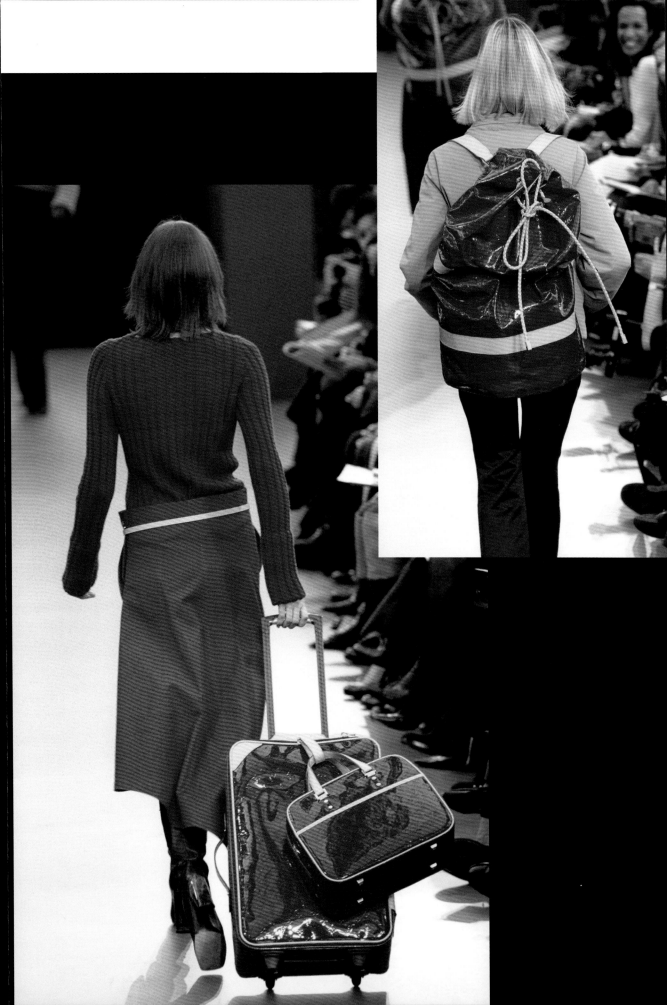

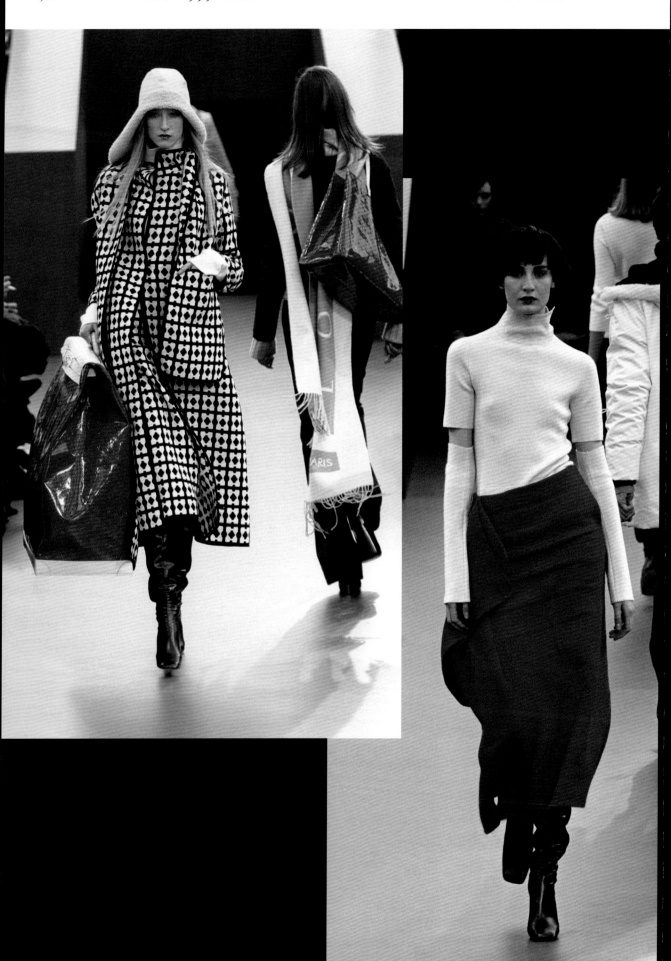

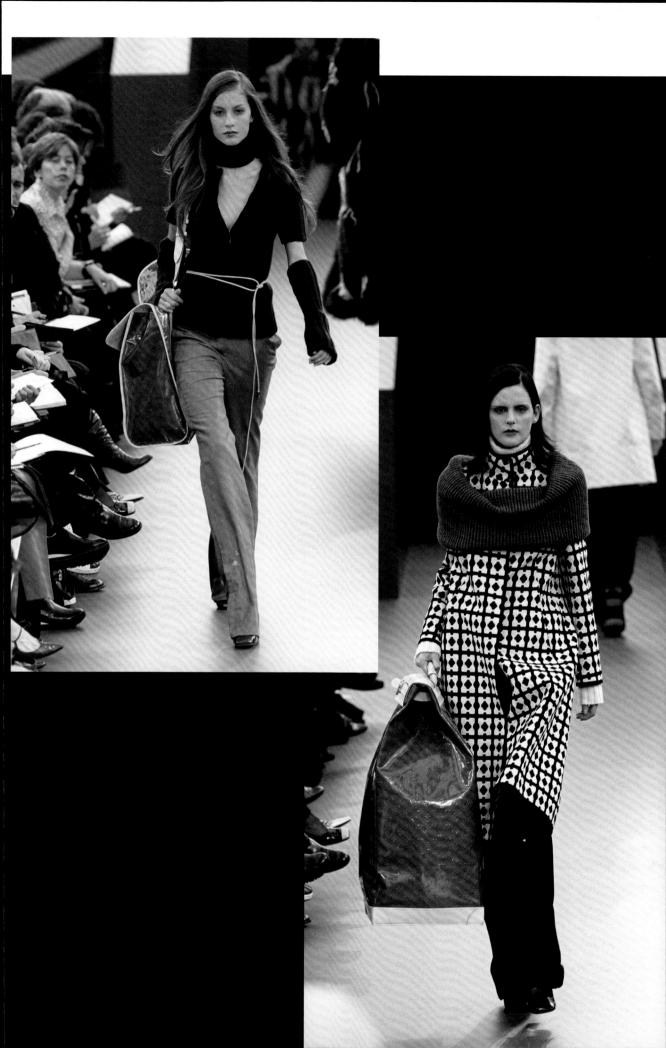

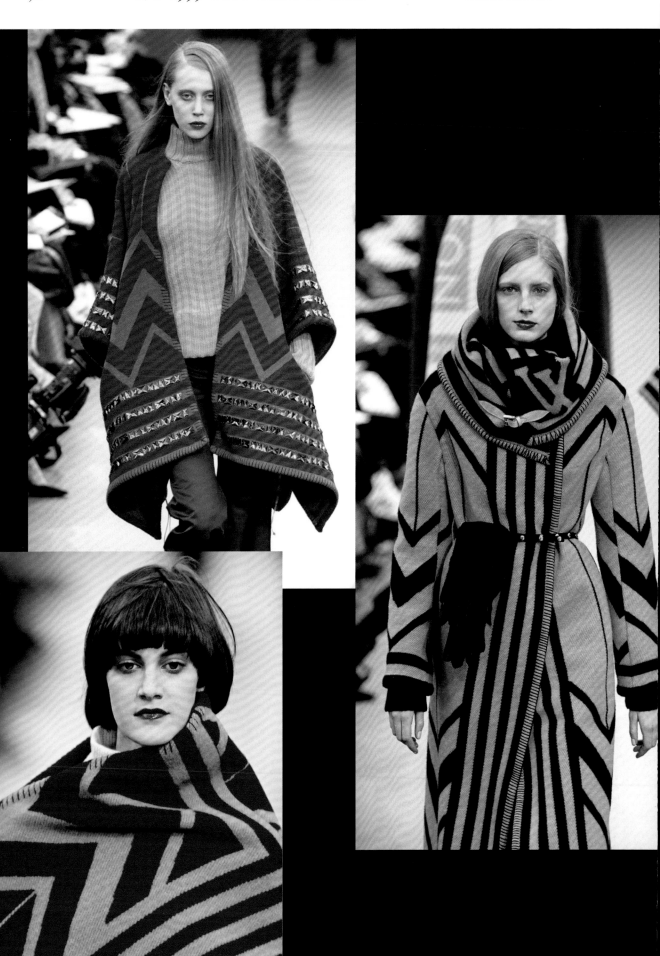

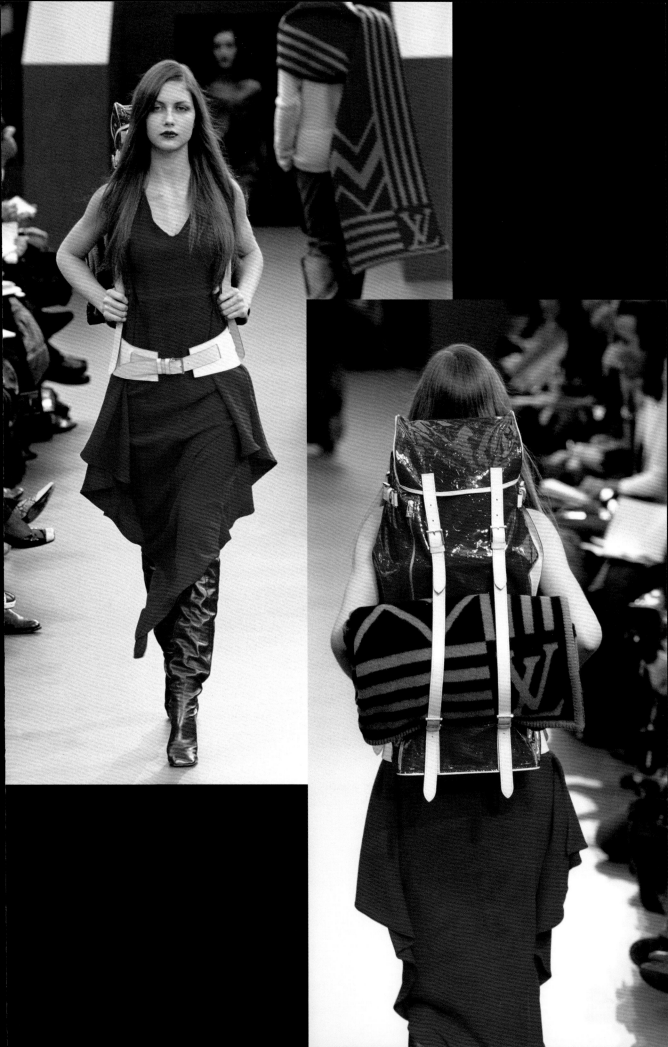

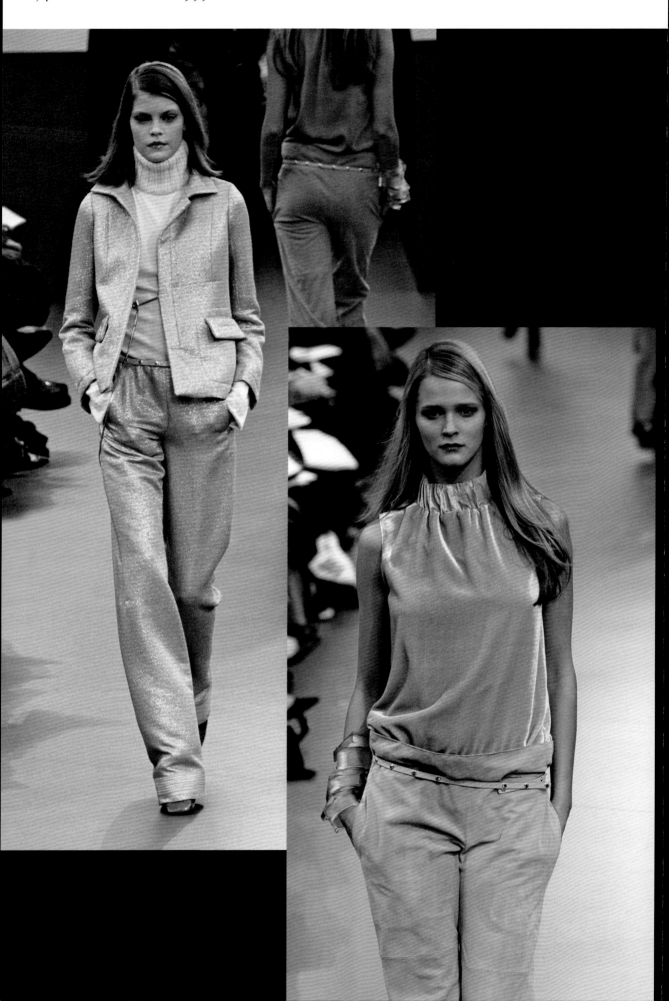

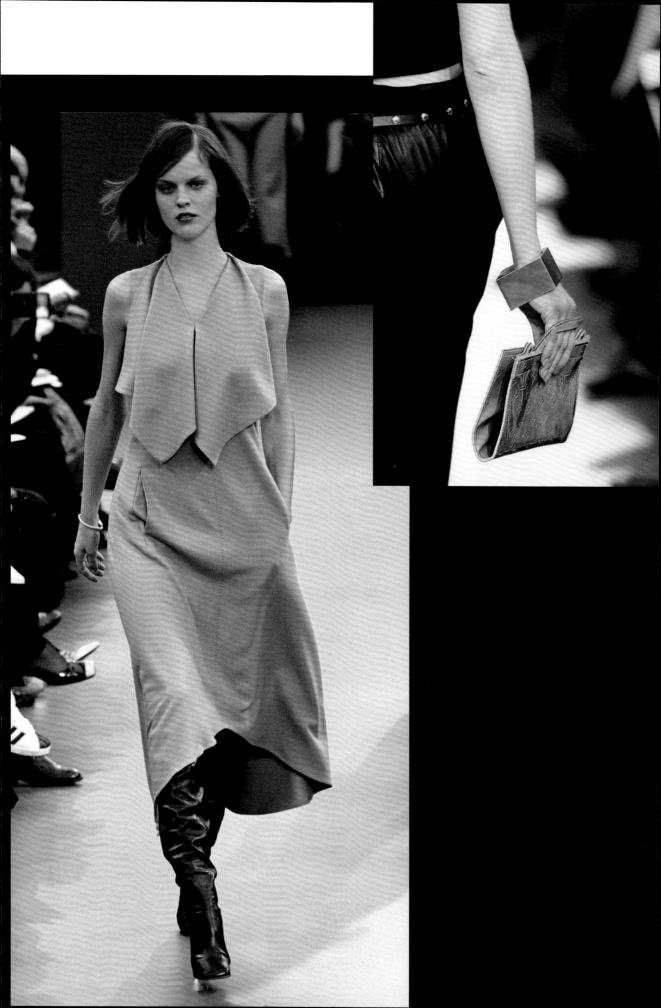

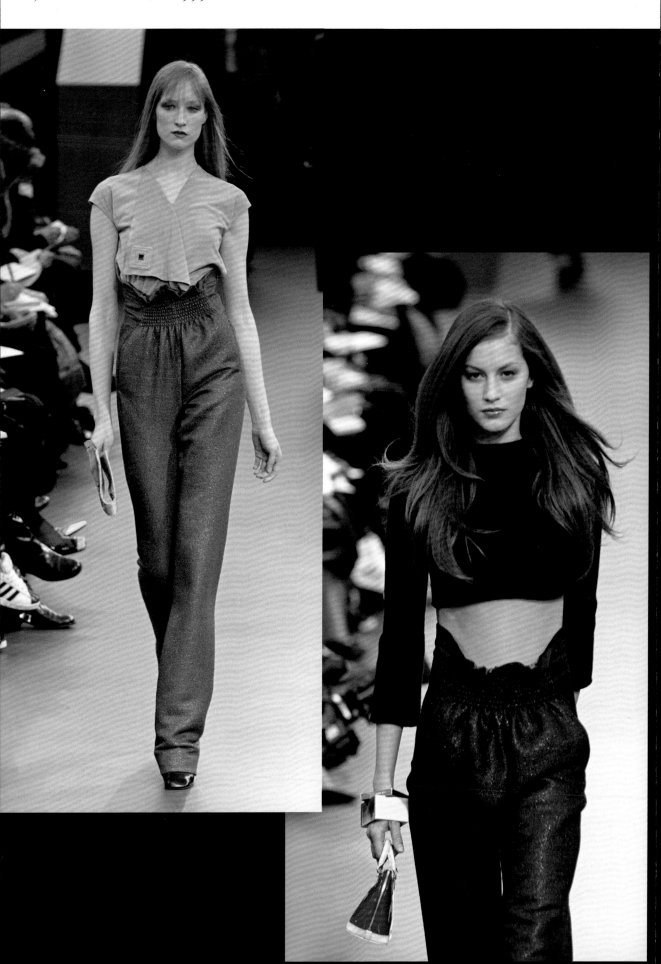

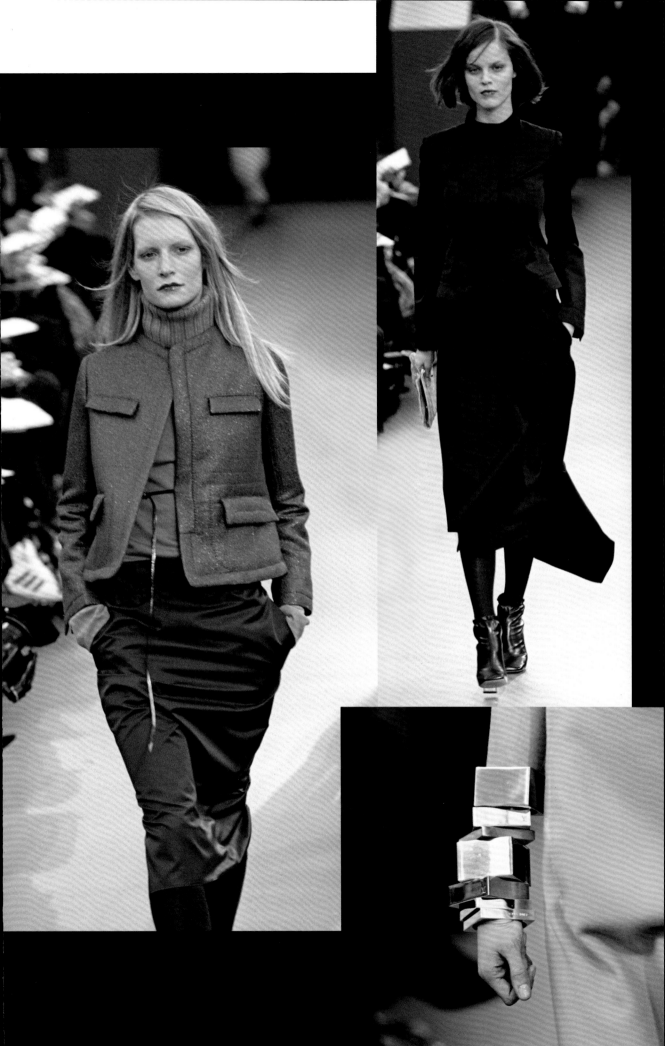

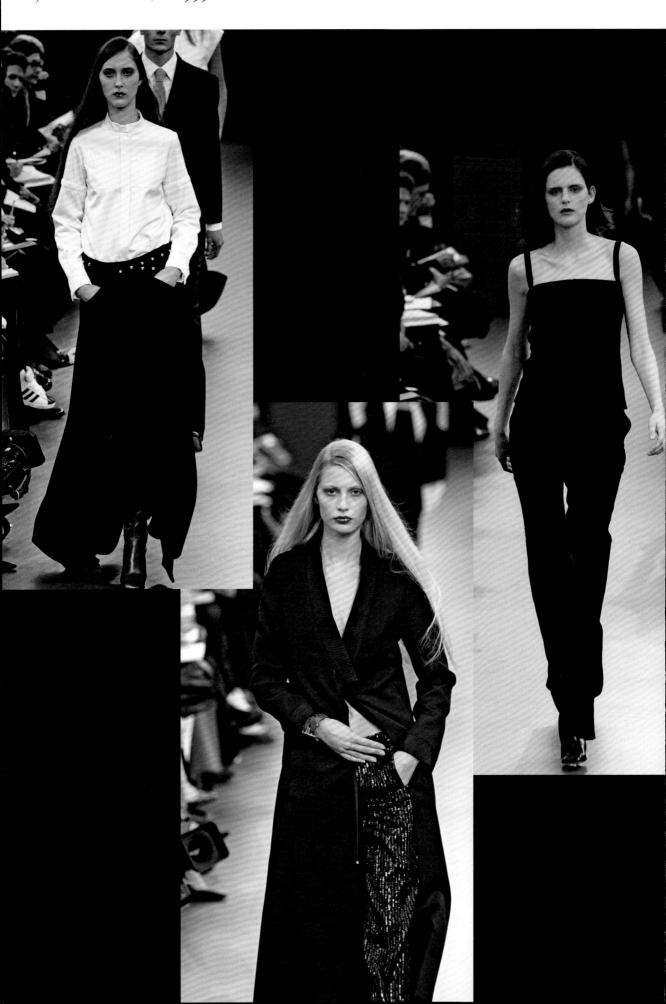

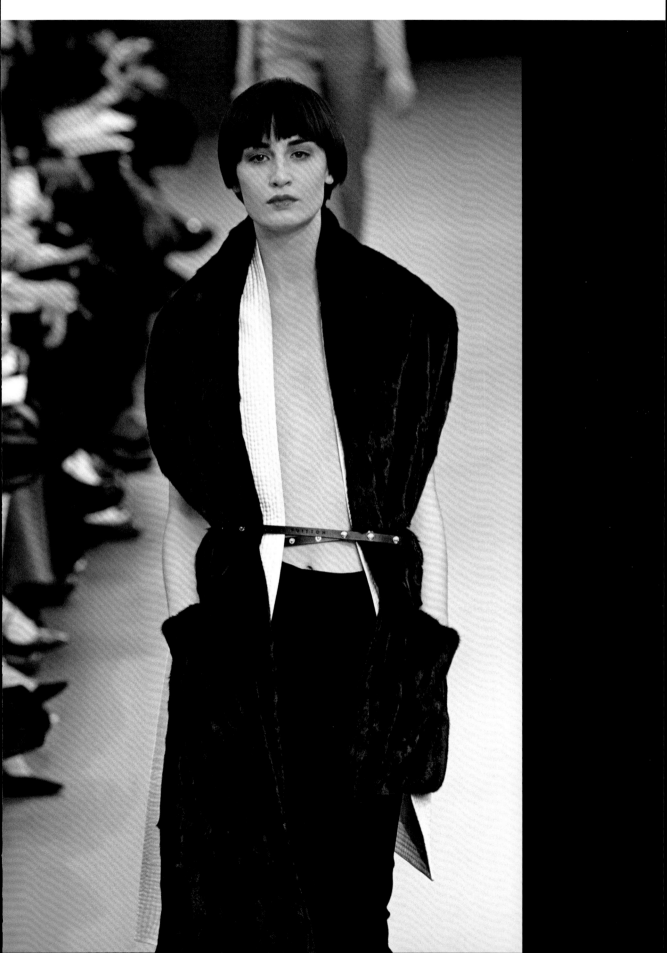

Bourgeois Sportswear & Explorers' Uniforms

The summer wardrobe of the globetrotting Louis Vuitton woman was lauded the 'sporty "Girls Just Want to Have Fun"' collection by *The New York Times*. The 83 monogram-emblazoned looks were shown in khaki, beige, brown, grey, sunflower yellow and sky blue, and echoed rare Vuittonite trunks. Jacobs said, 'Logos are something to celebrate. They're not something we have to apologize for any more.'

The collection was inspired by 1970s bourgeois elegance, explorers' uniforms and urban sportswear. *Vogue* reported: 'Travel and luxury have always been essential components of the Vuitton allure, and this season it looks like jet-setters will feel equally at home on their way to a safari in Africa or hopping on the Concorde between New York and Paris.'

Claudia Schiffer opened the show wearing the signature look of the season: a mini LV-monogrammed belted trenchcoat, baseball cap, platform sandals and tube shoulder bag (right). *The New York Times* described it as a 'jaunty style outrageously embellished with logos'. The show notes stated: 'In order to adapt the Monogram to ready-to-wear, Marc Jacobs has changed the scale. A micro monogram khaki print on beige canvas cloth has been cut into skirts, jackets, raincoats, sandals, coats and bags. Leather bands outline the hems.' The monogram was also visible as large rainbow-coloured swirling geometric prints on silk dresses and sequin halterneck tops.

Elements of Monogram Vernis motifs were transformed into playful bag shapes, including a cylindrical 'can bag', trapezium 'triangle bag' and mini triangle bag. Other bags were inspired by the lens boxes, portfolios and safari bags carried by photographers, architects and explorers.

The collection introduced AMF overstitching outlined with pearl embroidery, Prince of Wales wool bias-cut skirts and leather baseball jackets, backless jogging tops and V-neck cashmere sweaters wrapped around the waist. *The Independent* reported: 'There were skin-tight dark denim jeans with monogrammed pockets, micro hot-pants, super-skinny power trench coats and draped jersey... The accessories in particular – wrap-around sunglasses, baseball caps, visors and even Louis Vuitton umbrella shields – screamed ladies who lunch at the tennis club from the rooftops. No sporting activities necessary.'

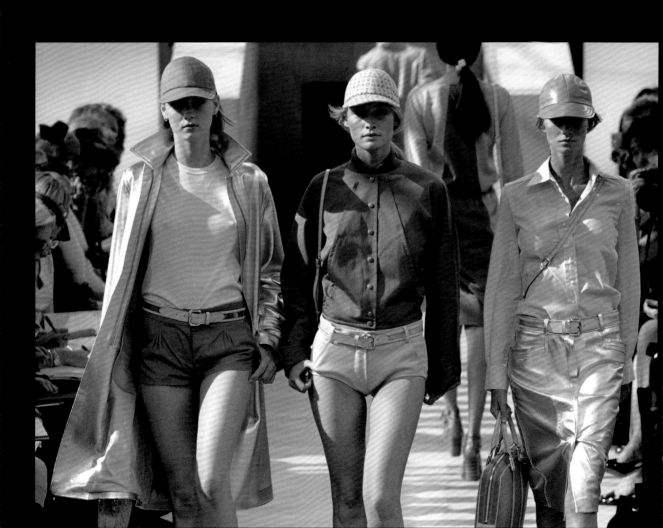

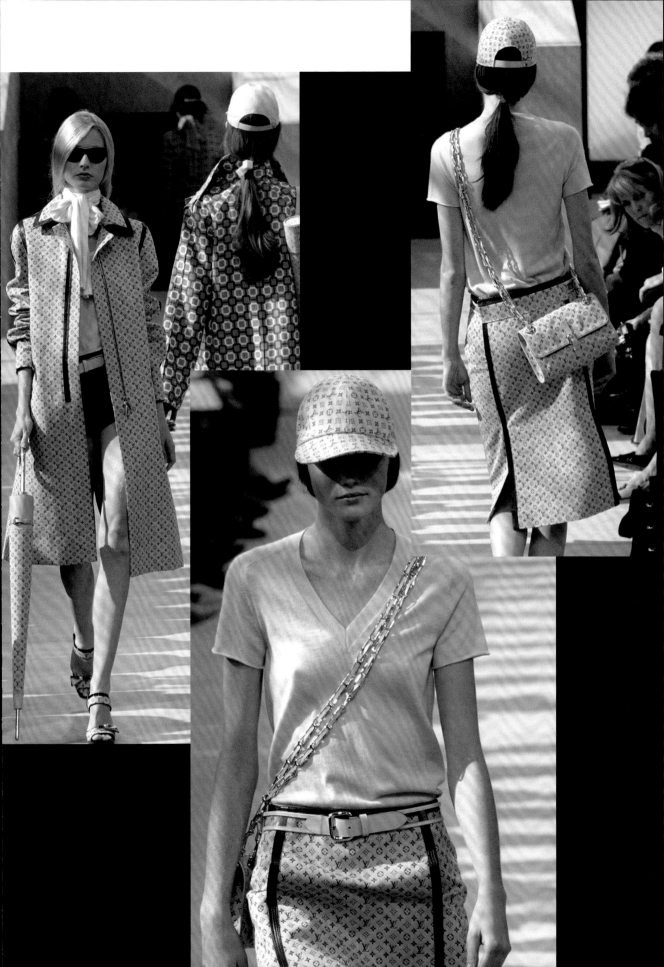

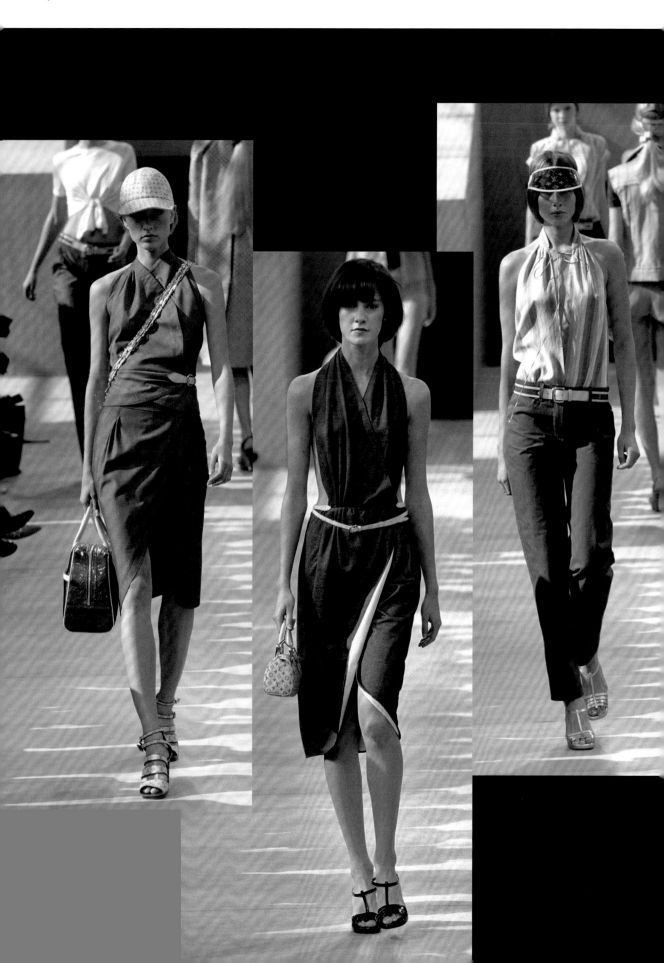

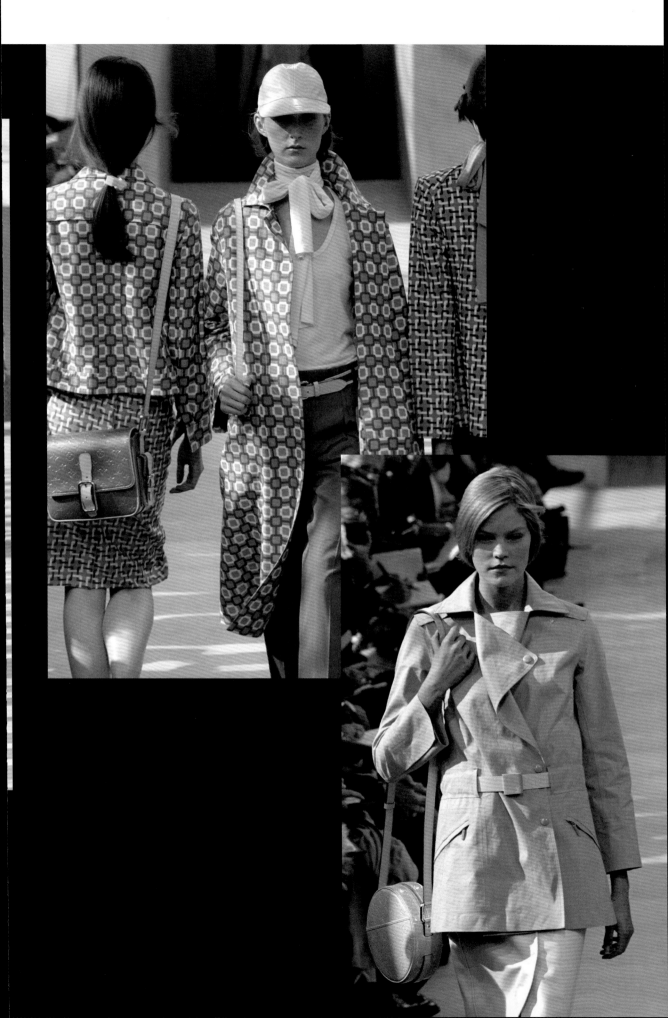

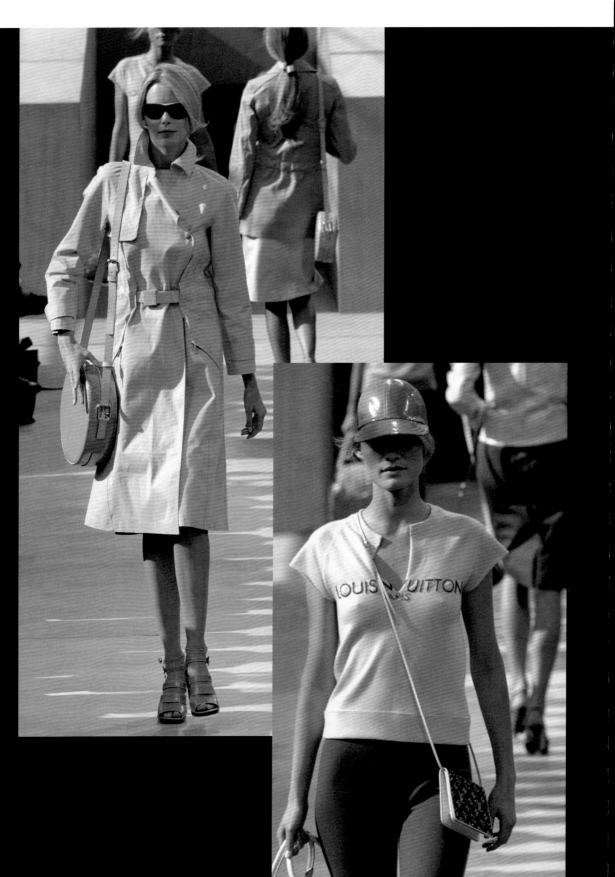

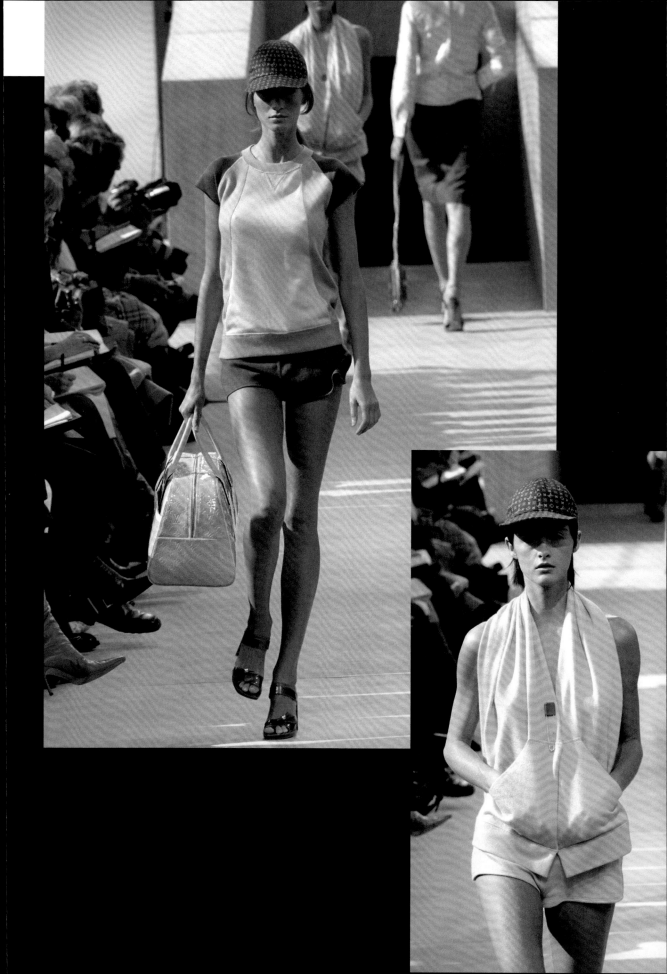

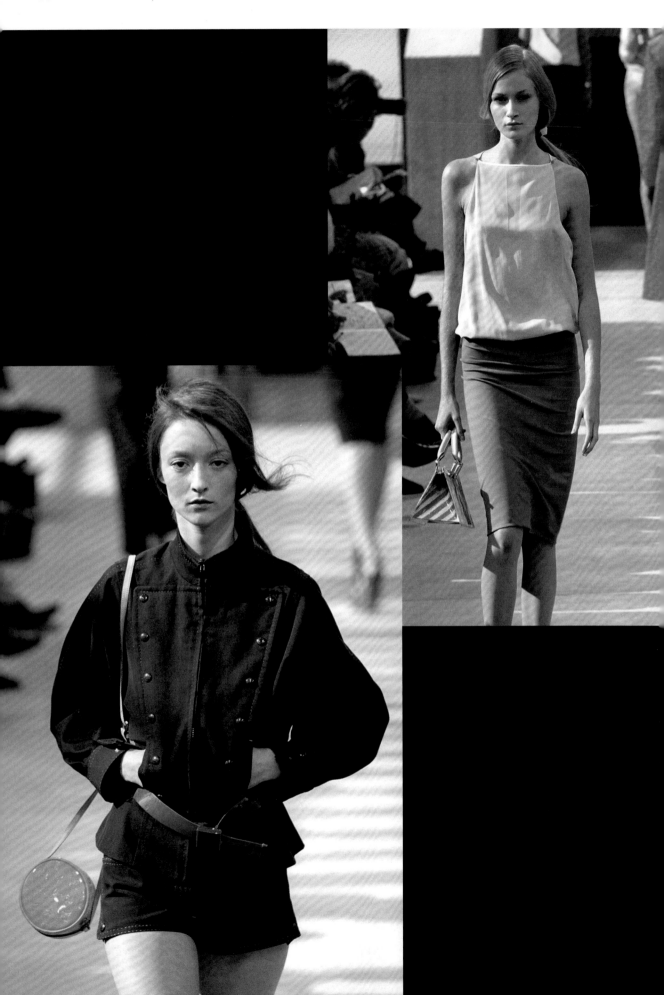

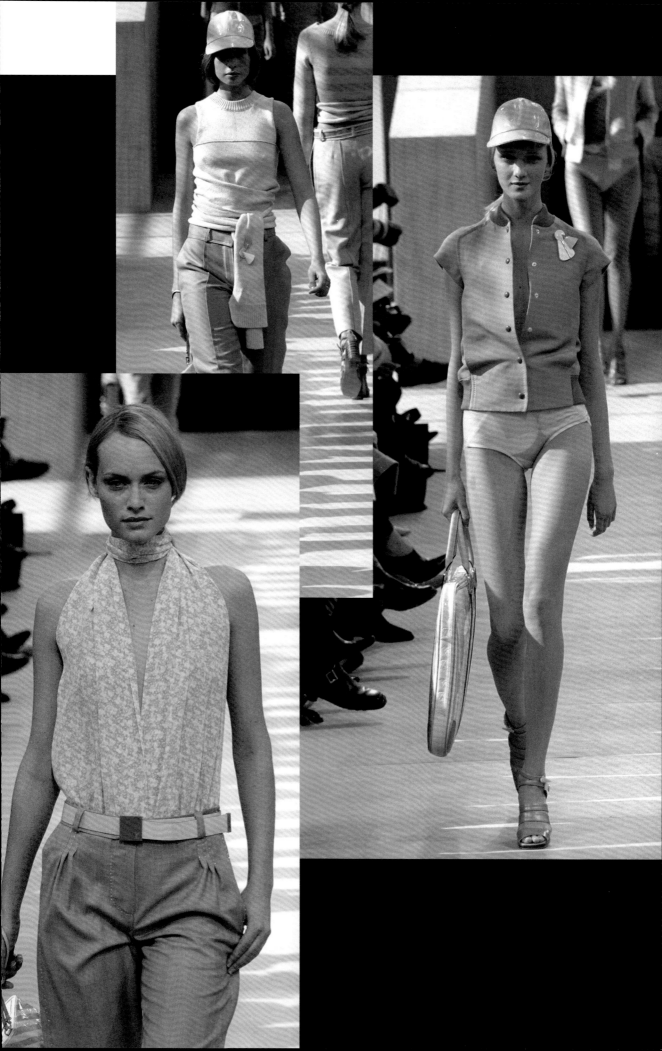

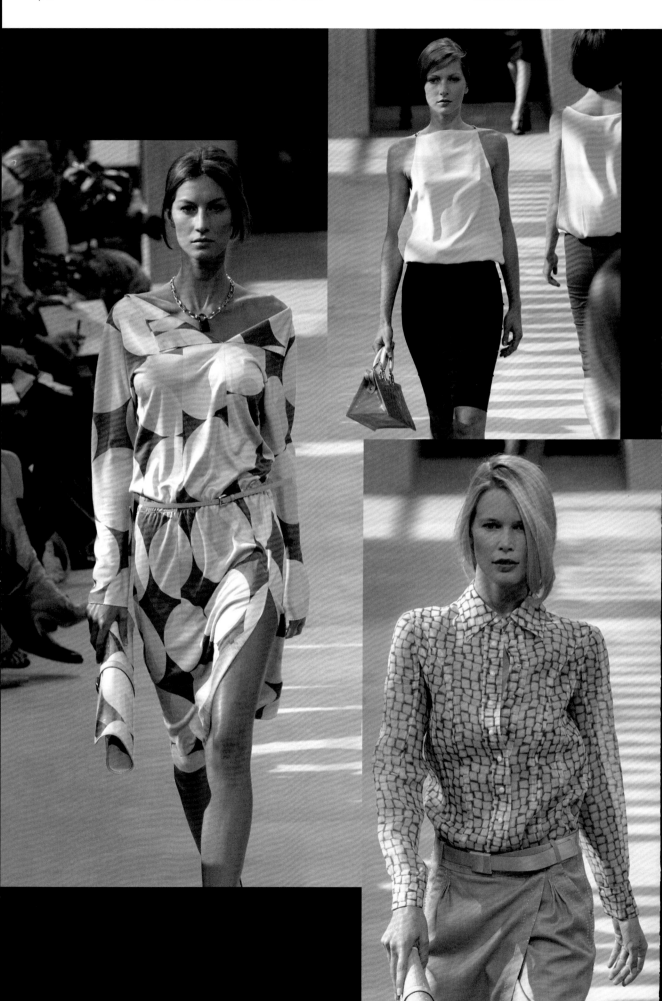

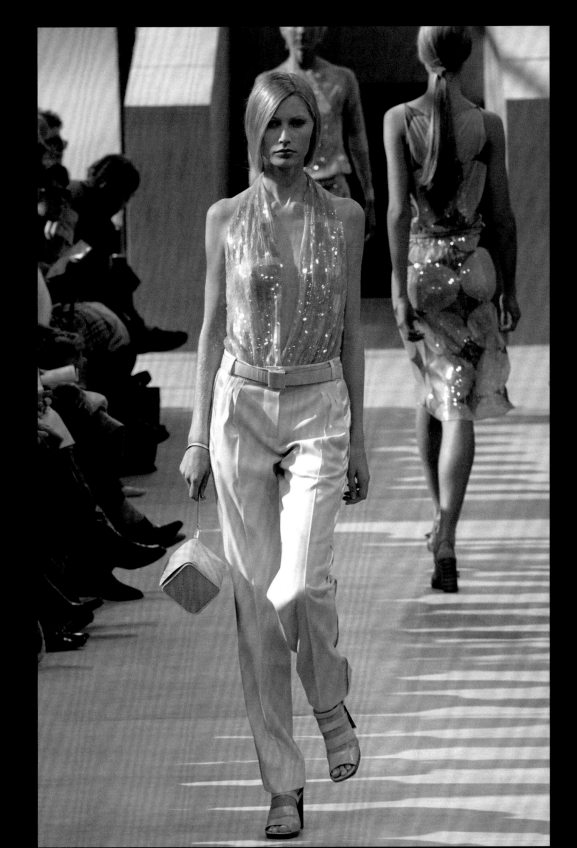

New Wave Nights

Marc Jacobs presented his black-infused autumn/winter
collection to an eclectic soundtrack by Les Rita
Mitsouko and the Mathématiques Modernes, making
the latter's founder, 'queen of punk' Edwige Belmore,
his heroine of the season. The collection was infused
with the vibrant energy and rebellious spirit of Paris
during the punk/new wave era. The show notes stated
that Jacobs 'amuses himself by infusing this chic DIY
with irony and glamour, making it as beige and glossy
as possible – and proposing a perfectly reasonable
version for the luxury set'.

Models with flushed pink cheeks first appeared
as if travelling into the dark Parisian night wearing
biker jackets belted at the hip, motorcycle gloves and
berets, eventually arriving stylishly as if for clubbing
in shimmering metallic dresses. Hamish Bowles reported
for *Vogue* that the collection referenced Madonna's early
style, designs by Claude Montana and Thierry Mugler,
and 'looks featured in publications like the so-hip-it-
hurts style manual JILL'.

The silhouette was androgynous yet also feminine,
with its emphasis on the hip. Metal zips on leather
pencil skirts, batwing dresses and tweed coats created
a graphic and playful look. Sleeves were pushed up
to the elbow, and sweaters were presented with a deep
V-neck or off the shoulder. Luxurious materials included
sheared mink, crocodile and lizard leather. Bowles
highlighted that Jacobs's 'twisted palette ... brought
[the 1980s] flooding back – endless existentialist
black of course, spiked with café au lait, chocolate,
peppermint and teal (dazzling for a crocodile
trouser suit)'.

Jacobs's interpretation was not literal, however. After
the show, he commented: 'It's not the Eighties. We did
it all from our imagination.' Yet, while cementing his
own artistic vocabulary, he took inspiration from the
house archives. Illustrations of Louis Vuitton trunks
were printed on silk handkerchiefs and elegantly tucked
in the breast pockets of oversized men's outerwear.
The Damier chequerboard pattern was revised on black
silk satin trenchcoats, skirts and handbags, while the
trademark inscription was visible on metal pins, and
enlarged to decorate clasps on bags. The glittering
finale pieces were made up of floral Monogram motifs
printed and cut into shiny sequins, in the signature
brown of the Monogram canvas.

Bowles reported that the 'tortoise-shell, sequinned
mini dresses closing the whirlwind show were suspended
from – or trimmed with – the fine gold chain that was
also used for the adorable midget disco purse – just big
enough to hold that members' pass for disco hotspot
Le Palace.'

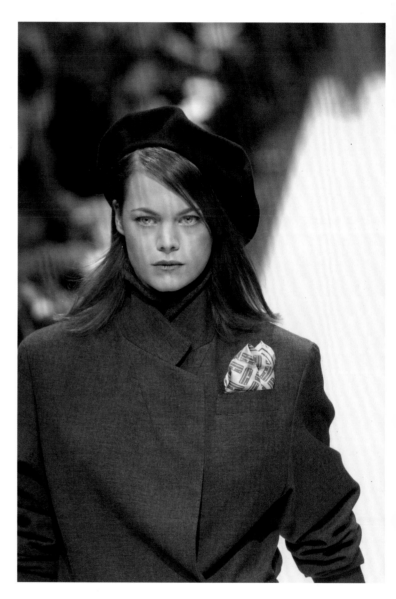

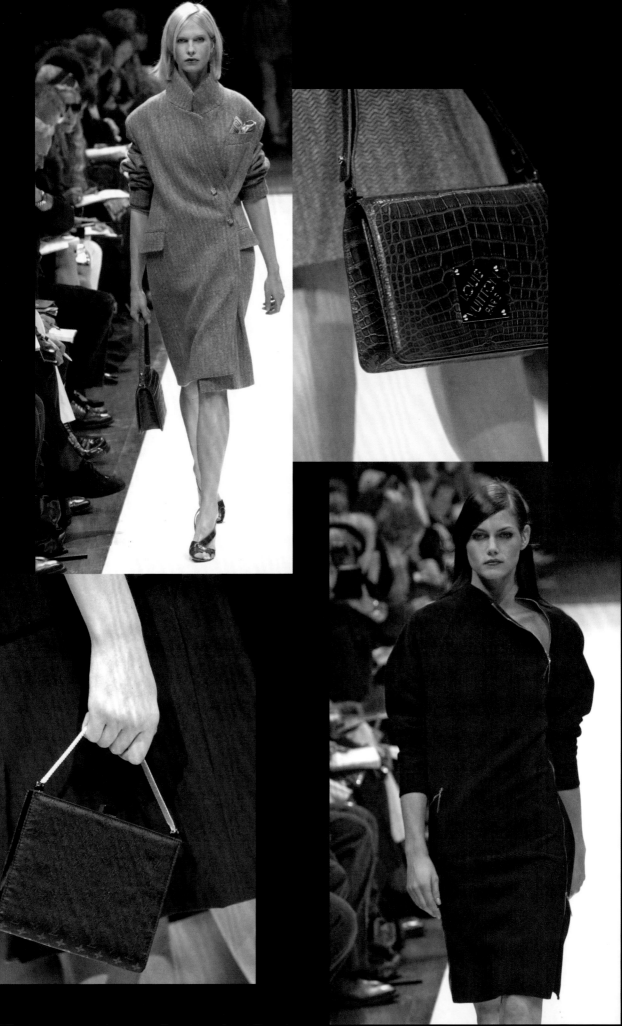

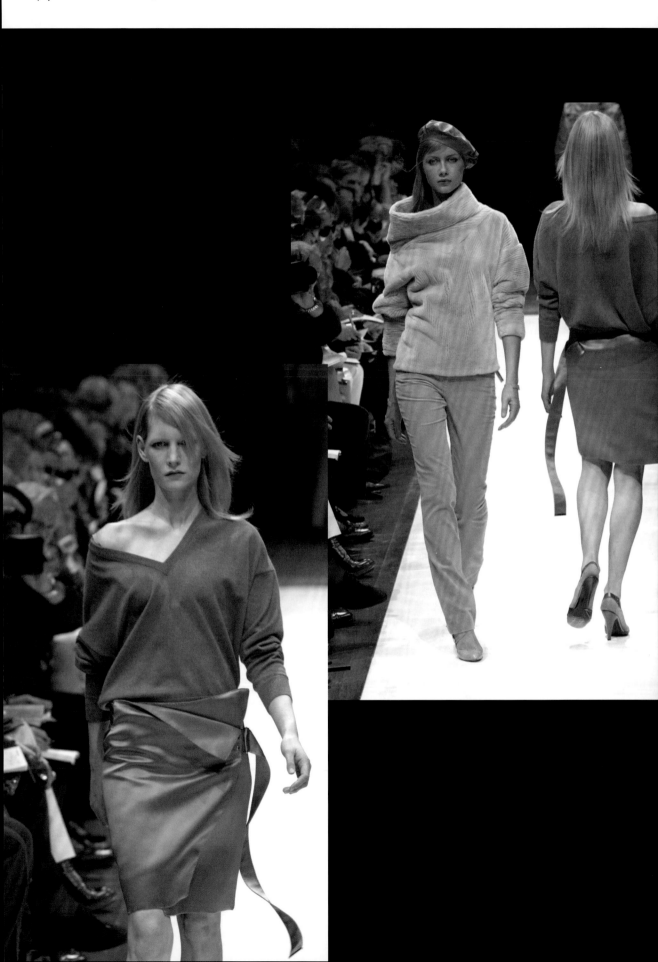

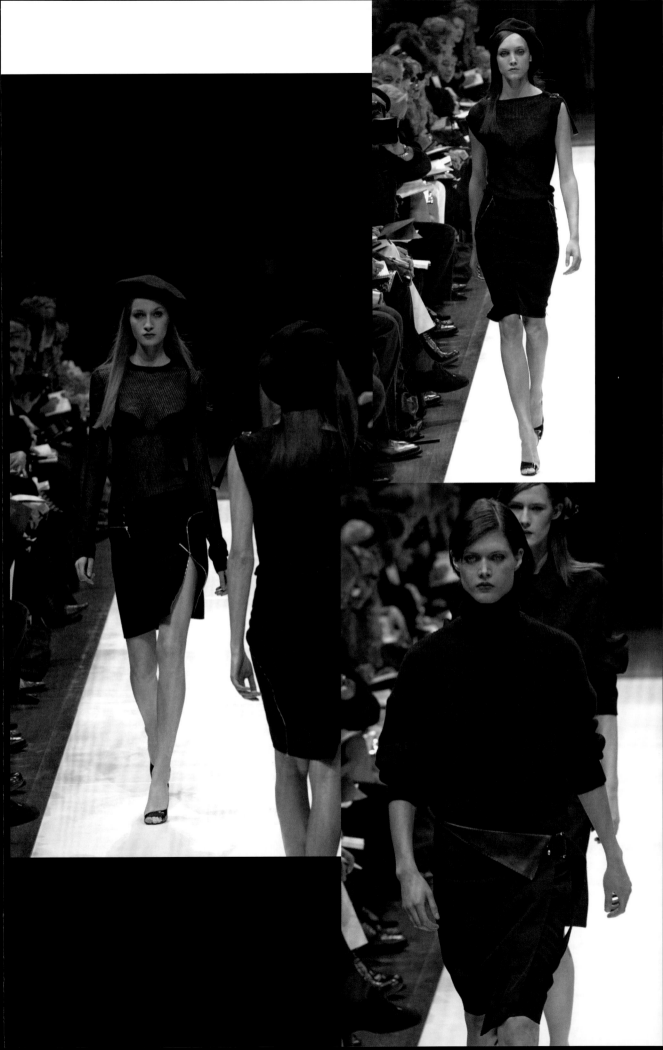

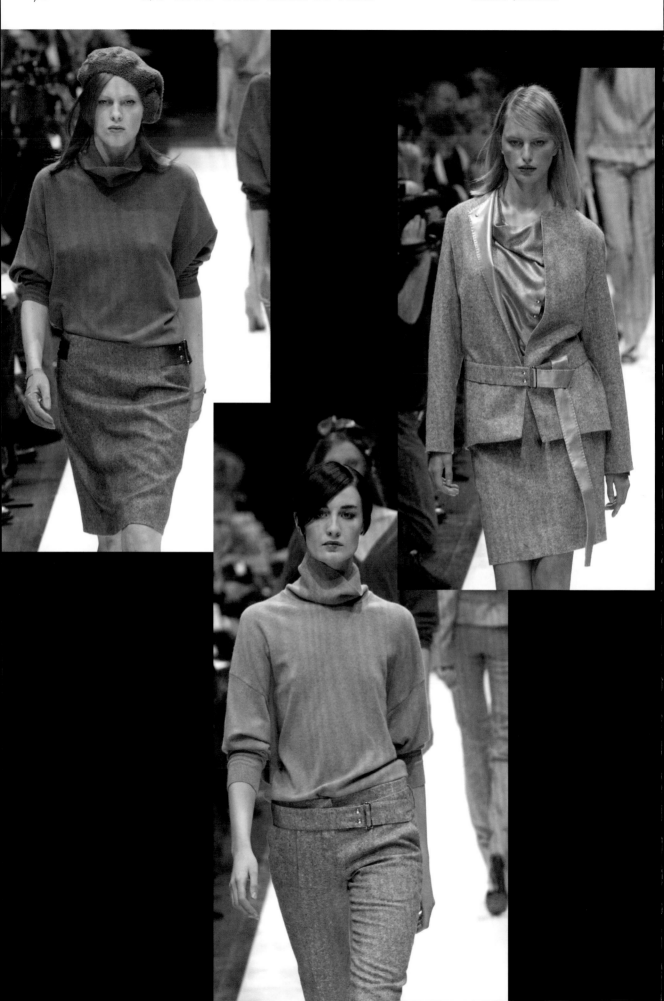

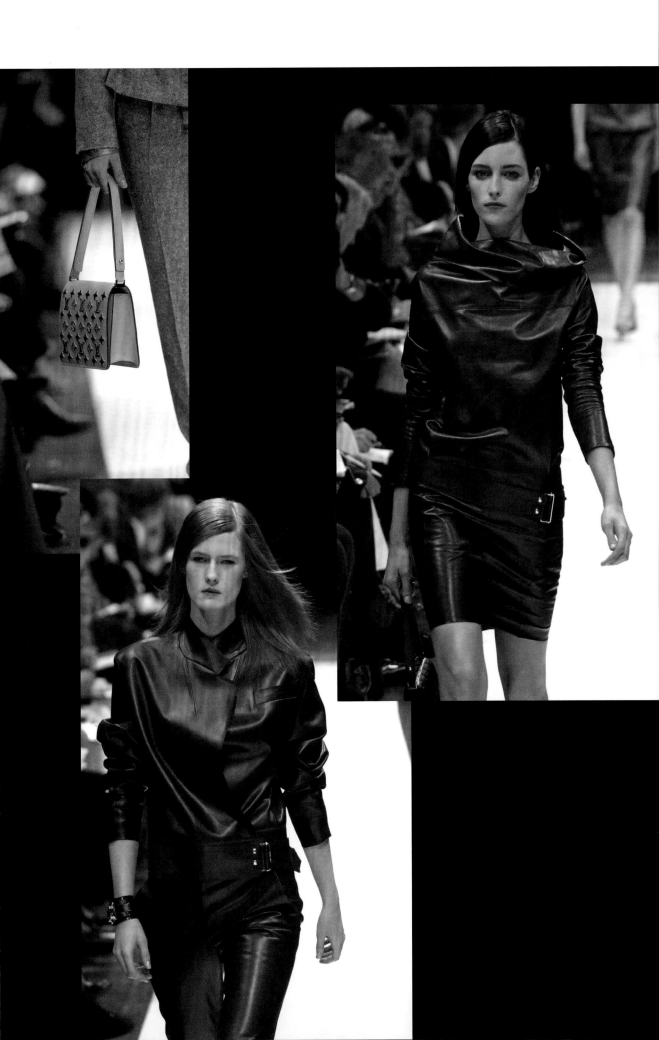

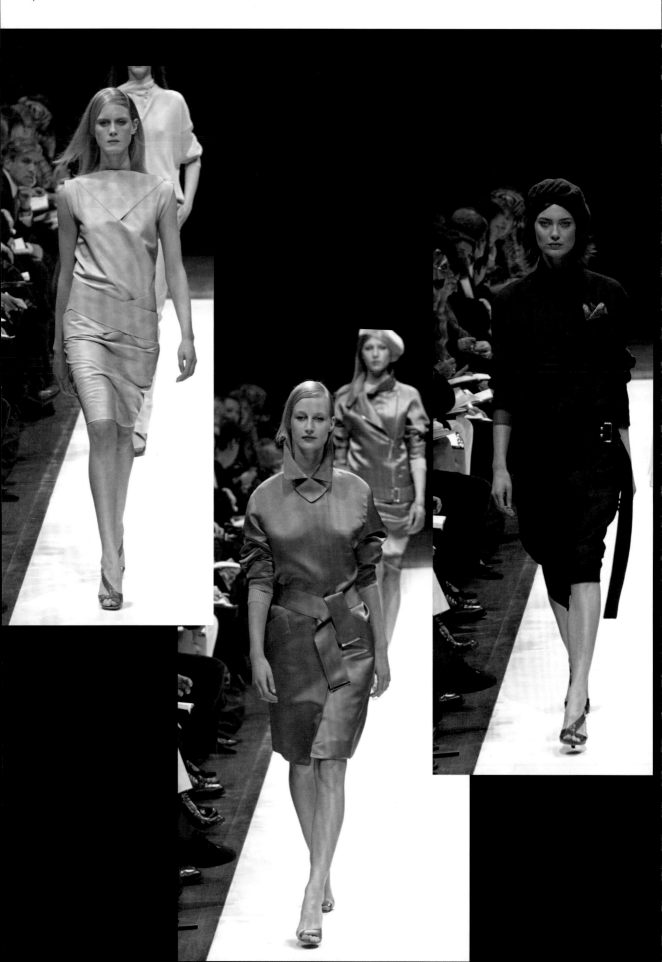

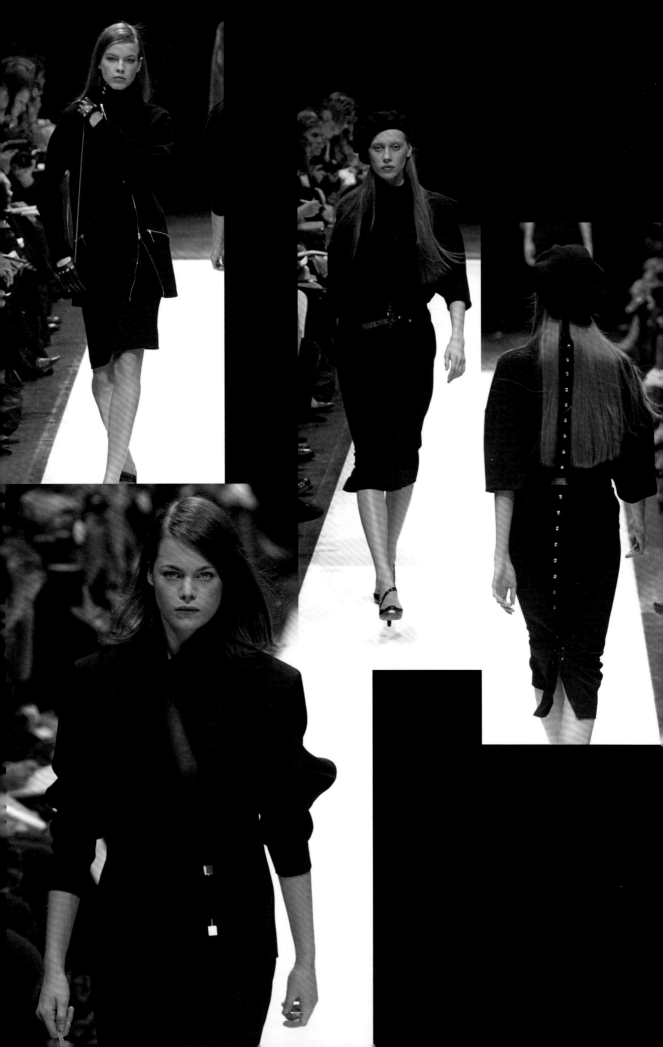

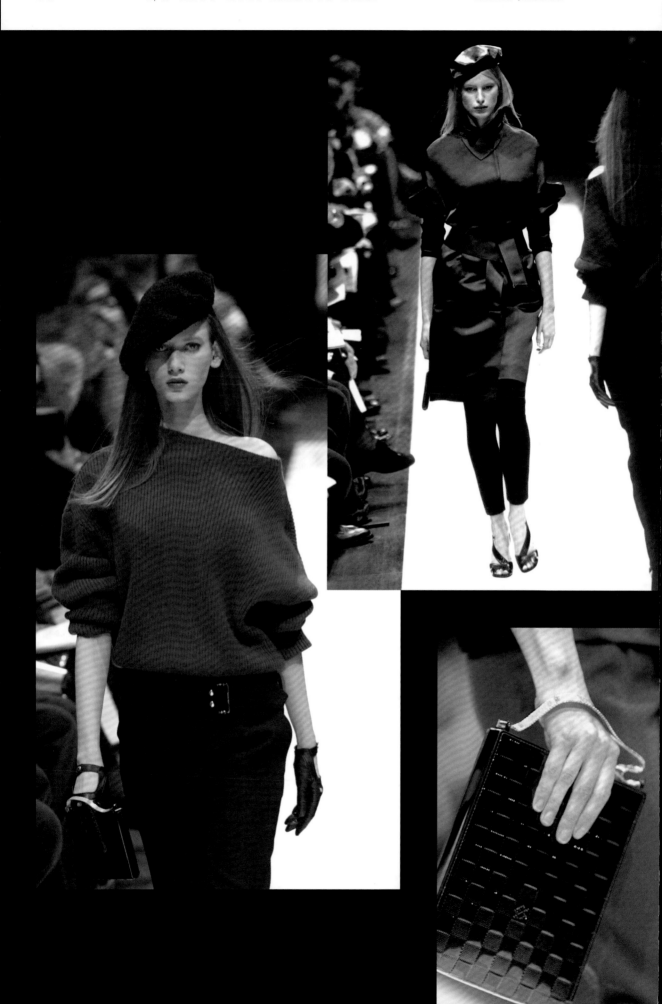

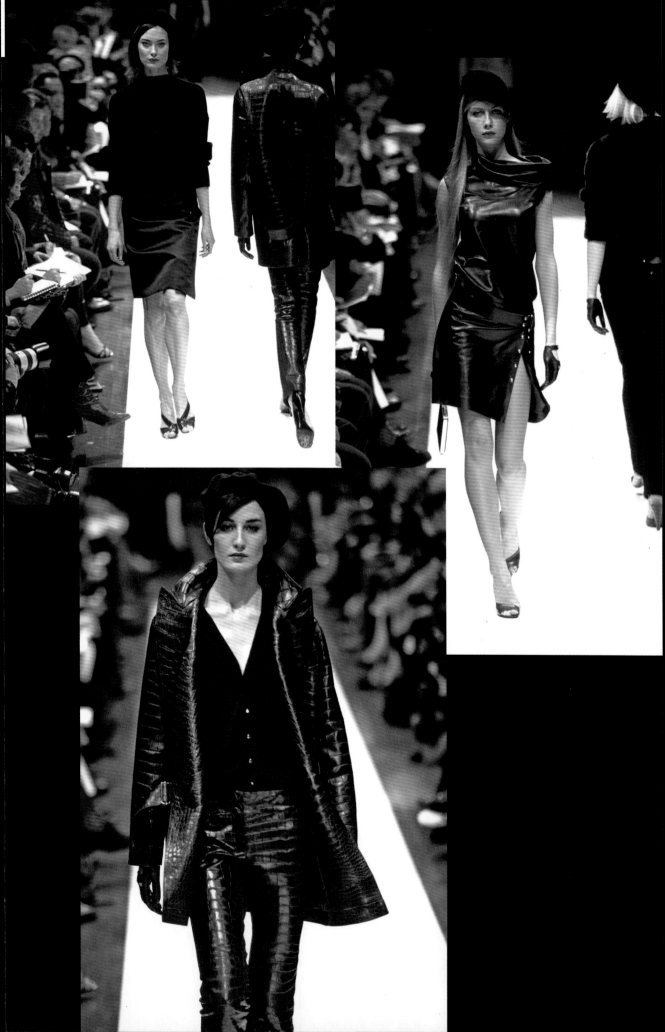

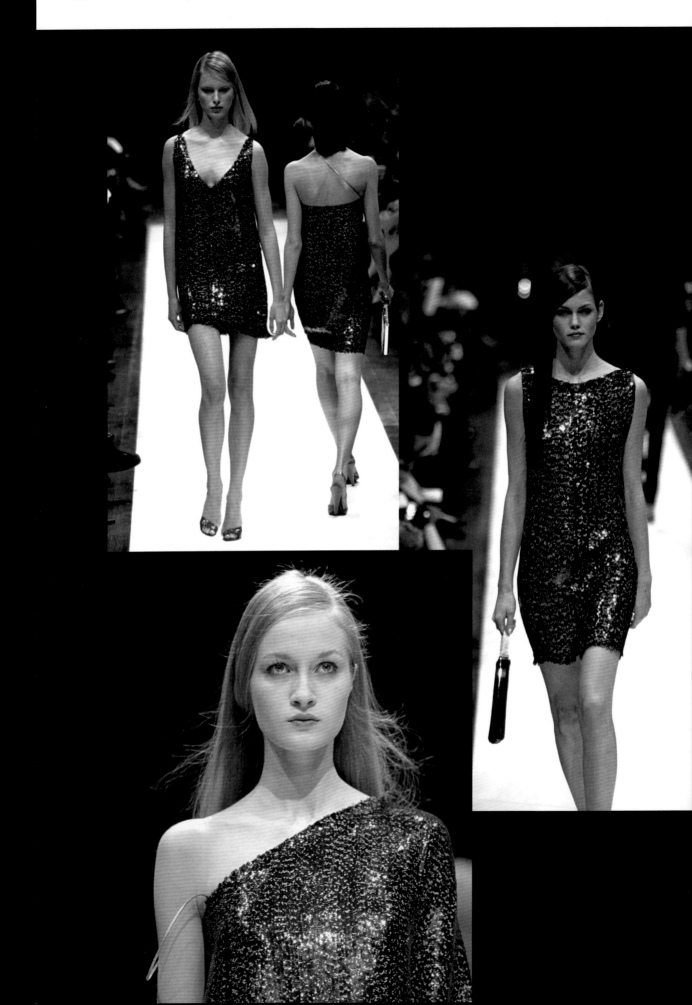

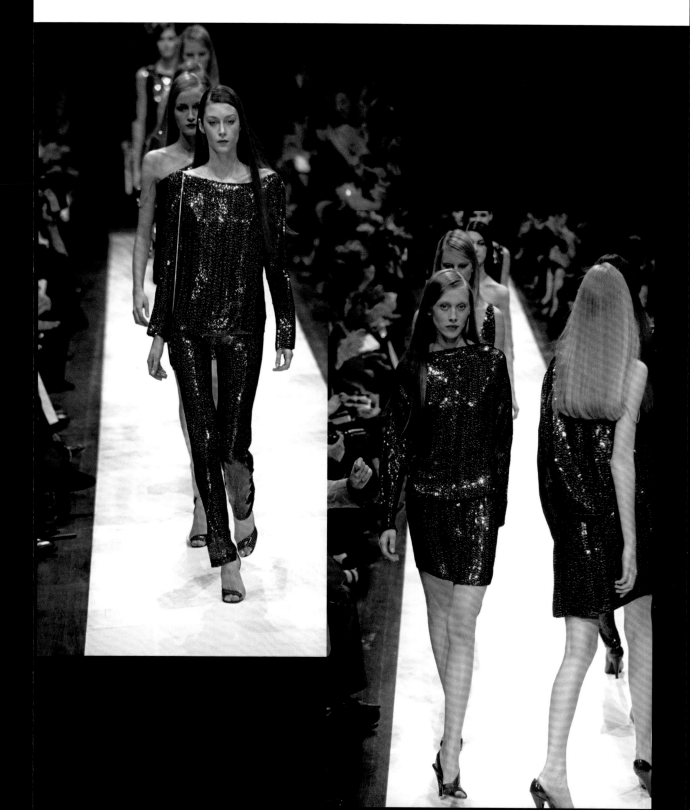

Graffiti by Stephen Sprouse

For his spring/summer 2001 collection, Marc Jacobs
put Louis Vuitton on fashion's centre stage by
collaborating with Stephen Sprouse, legendary stylist
of New York's underground in the 1980s. Jacobs,
having been inspired by seeing a Louis Vuitton trunk
customized in black paint by Serge Gainsbourg, asked
Sprouse to use his signature graffiti on the house's iconic
bags, gloves and shoes. The collection paid homage to
Sprouse's work with Andy Warhol, and was, according
to *Vogue*, 'the perfect compromise between art and
commerce'. Jacobs said, 'It's like Duchamp's moustache
on the Mona Lisa.'

The New York Times reported: 'So here's the legendary
badboy designer who gave street credibility to the staid
Louis Vuitton collection ... audaciously trashing it with
his trademark graffiti. Every defiled LV-monogrammed
bag, in every size, is now either sold or spoken for. Even
fake ones are hard to come by from knock-off vendors
on Canal Street.'

Four male porters dressed in black opened the show
carrying dozens of the must-have graffiti-painted
Monogram suitcases and bags, including the Keepall,
Speedy, Pochette and Alma. Jacobs said about the
design: 'I had all [these] feelings about taking the
venerable Monogram and sort of defacing it, but it also
made it entirely visible for a younger group of people.
It was disrespectful and respectful at the same time, and
I think that is why it worked.' (Each Graffiti Monogram
bag was precision-printed, the compositions custom-
aligned to the specific design of each bag model.)

The collection also presented a love affair with roses,
which Sprouse created in an array of colours and styles.
He painted pink, red, beige, green and blue roses in oil
and watercolour, and these were printed on white funnel
skirts, dresses and tops. A black and white rose print
echoed Man Ray's photograms. A striking camouflage
rose print in khaki, black and beige tones was shown
on tank tops, tulip skirts and underwear.

Jacobs's clothes juxtaposed a feminine 1950s figure-
hugging silhouette with military-inspired jackets and
tailored coats. Colours matched the army theme through
khaki and olive green, while day-glo paint was splashed
on V-neck sweaters and shoes. The 63 looks were
accessorized with long graffiti gloves, logo-embossed
metal belts and naval officer hats created by British
milliner Philip Treacy.

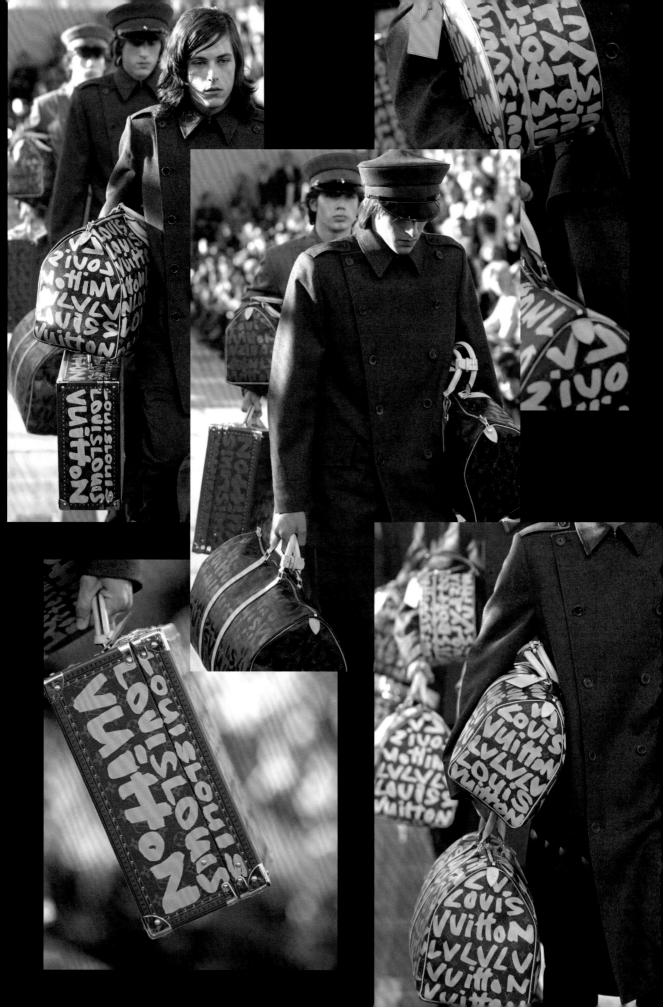

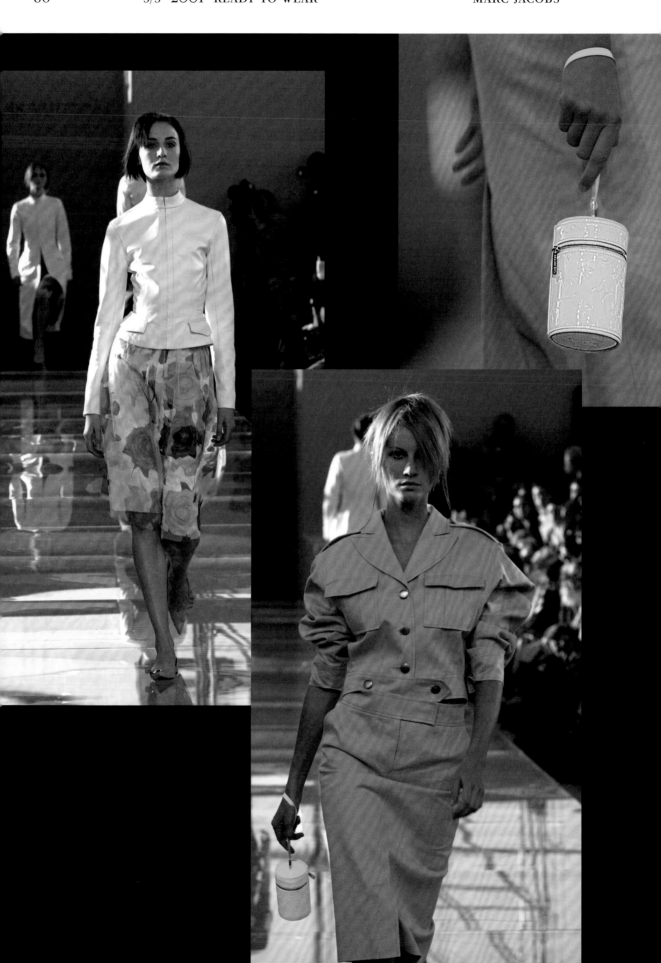

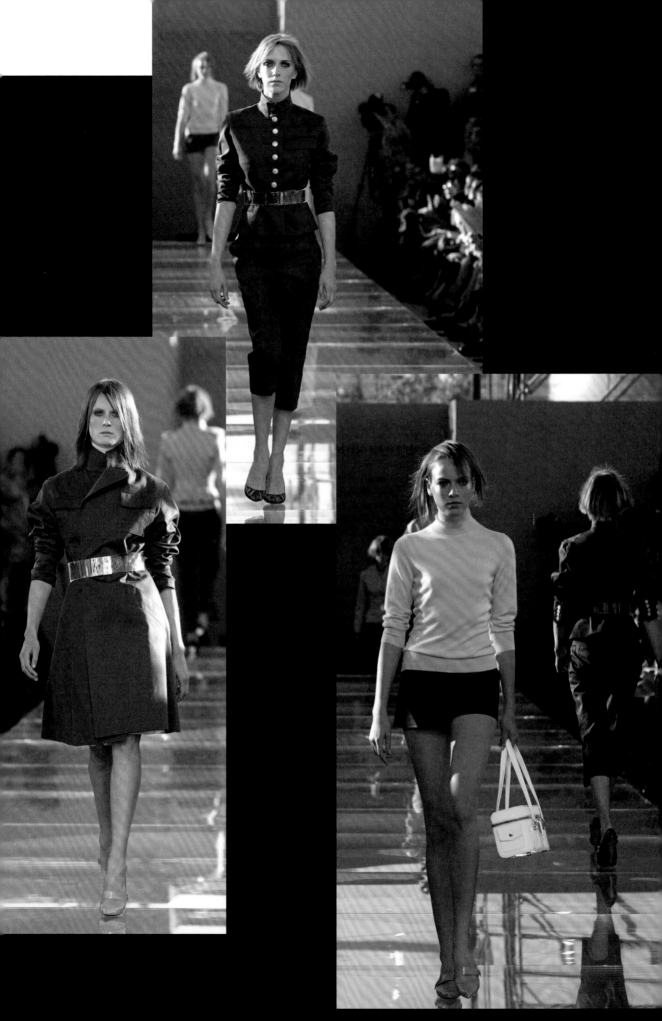

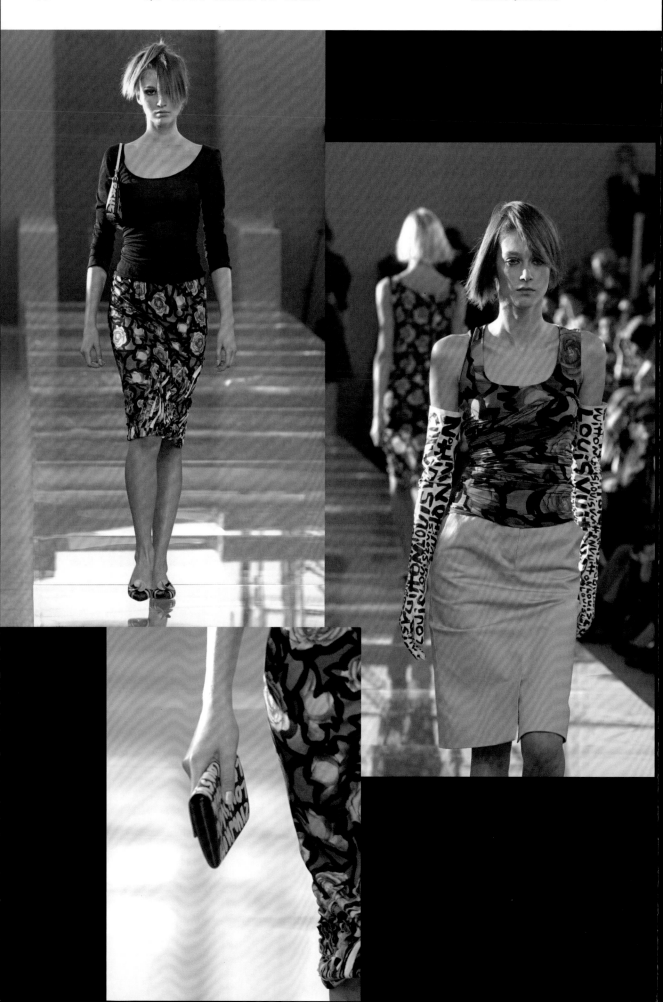

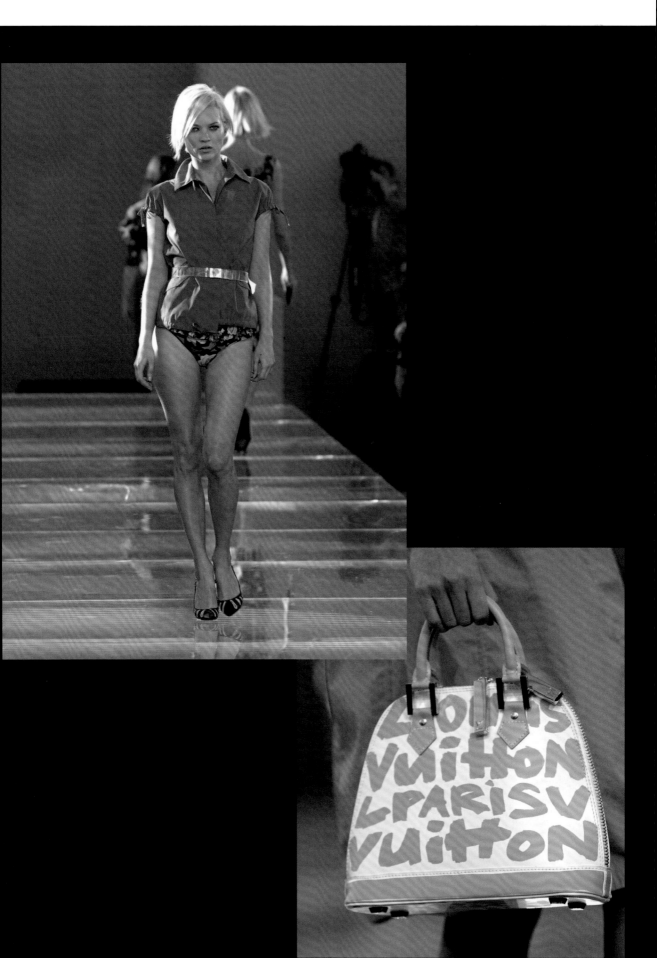

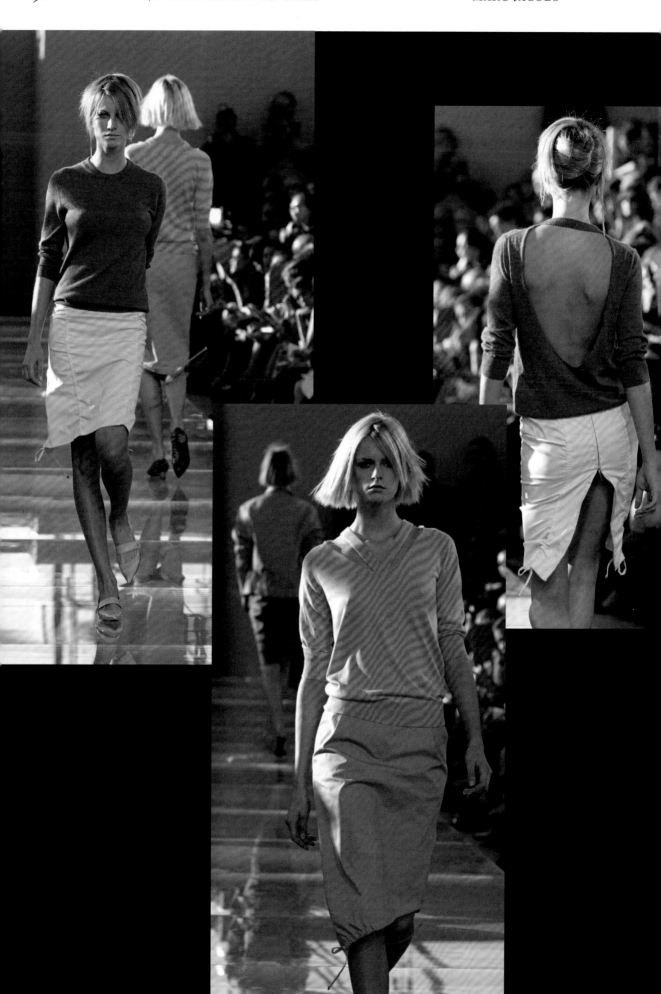

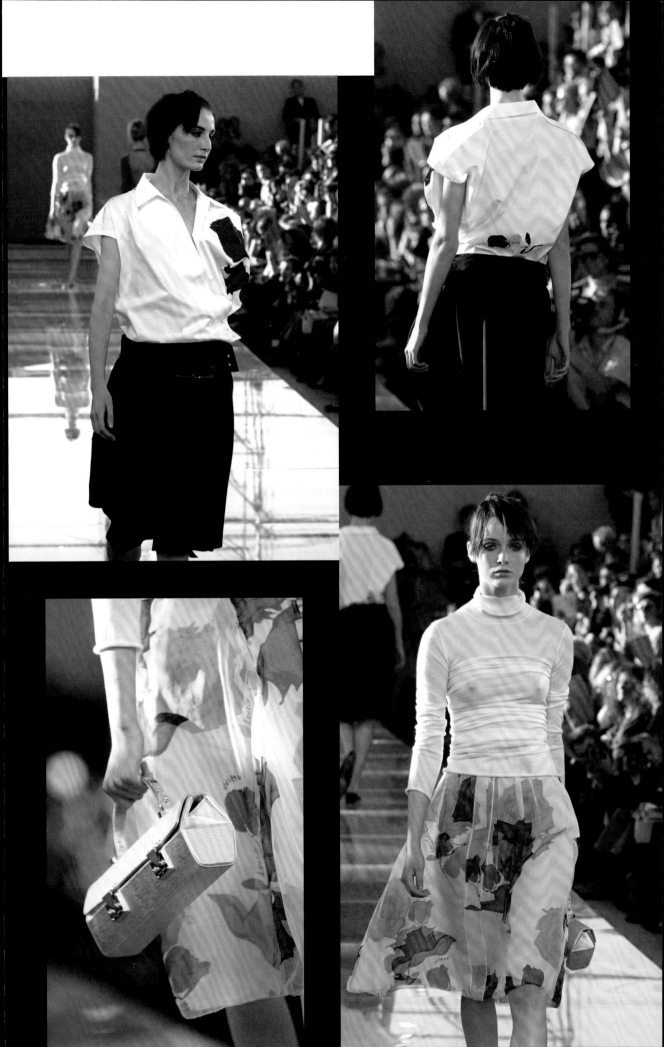

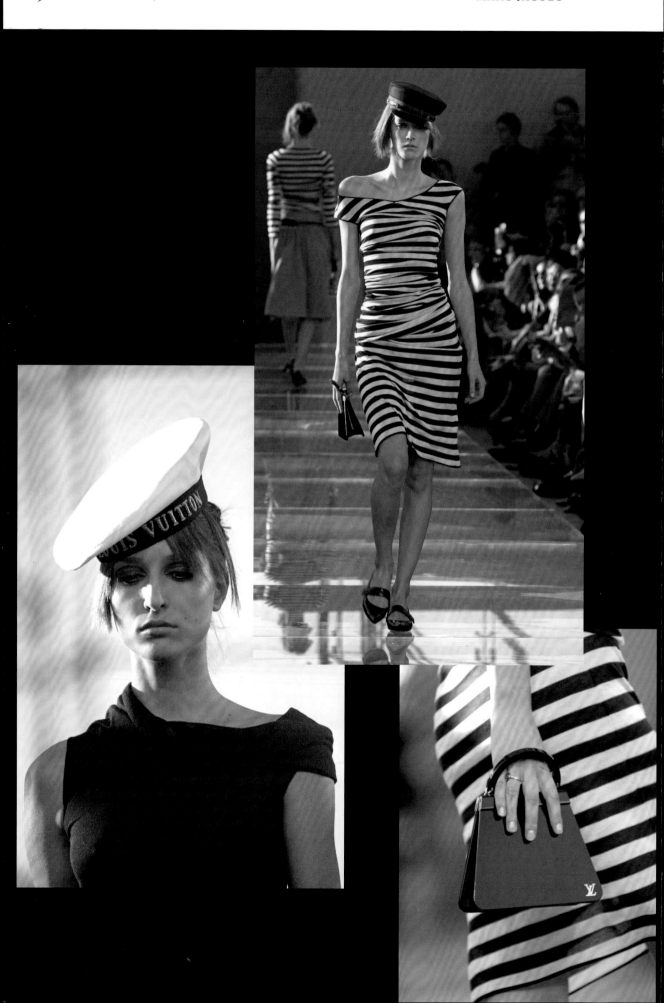

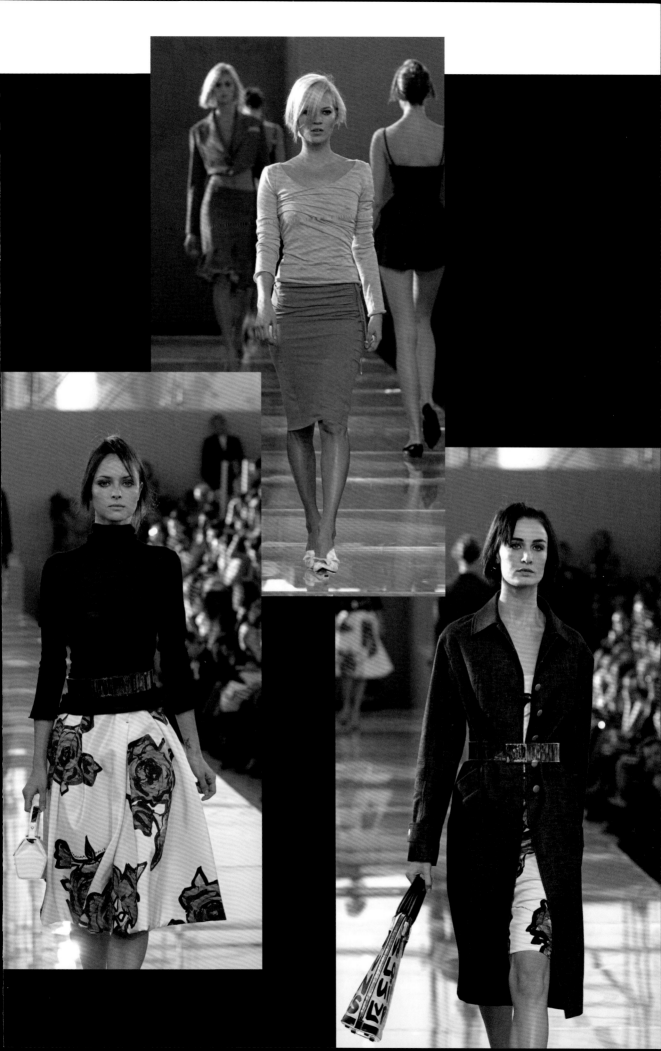

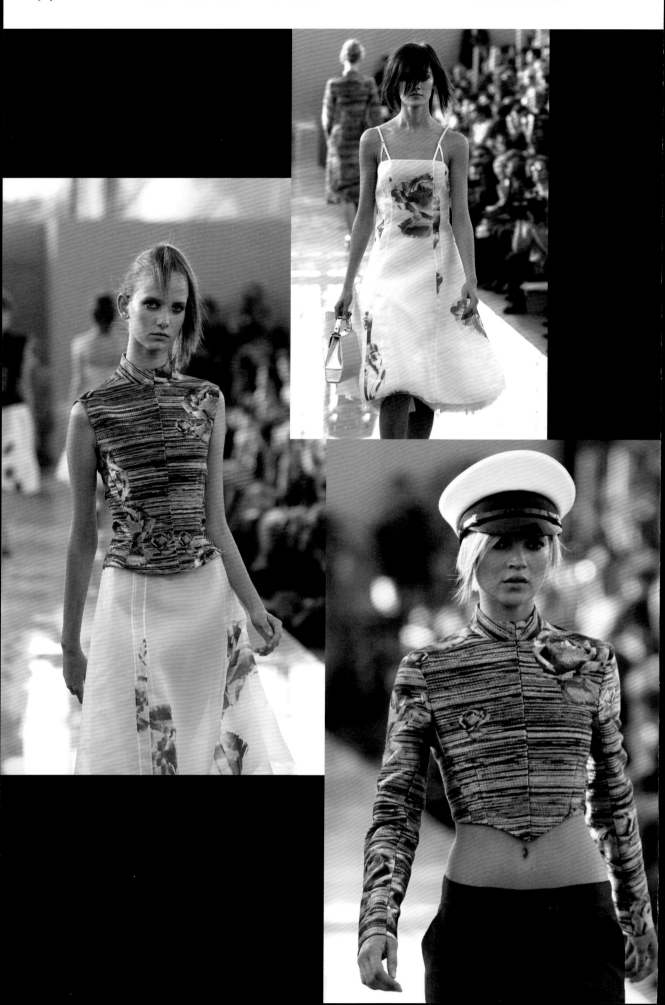

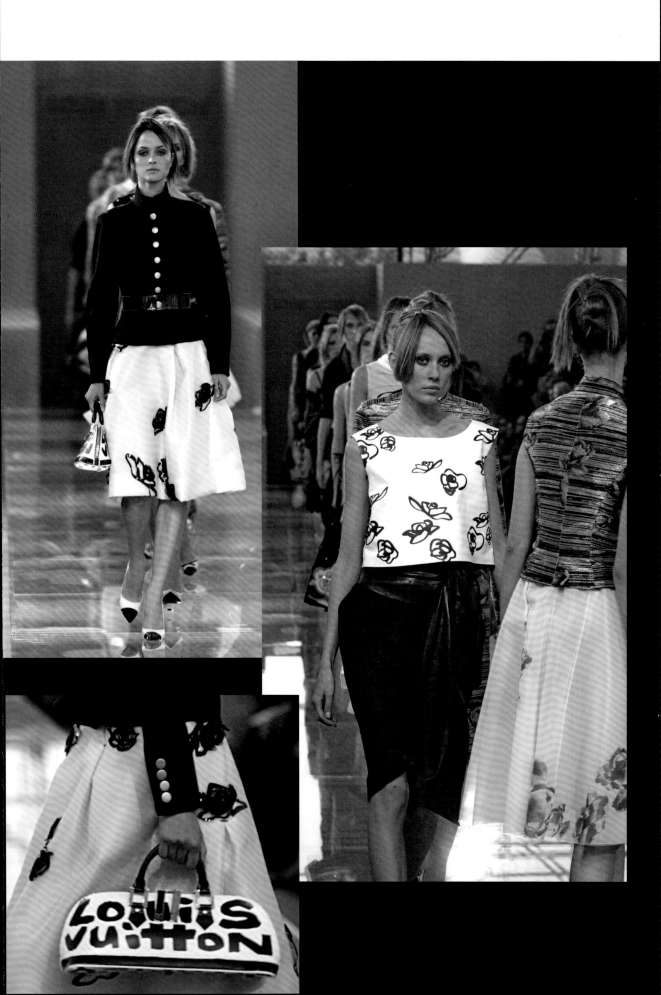

Doctor Zhivago in Paris

'Marc Jacobs delivered yet another impeccable collection
for Louis Vuitton today, once again raising the ante for
designers in Paris,' wrote *Vogue*. Inspired by the dark
romanticism of *Doctor Zhivago*, Jacobs envisioned a
'mysterious woman' dressed in black for autumn/winter
2001. Redefining chic for the 21st century, the 53 elegant
looks evoked a Russian and French love story. Worthy
of a modern-day Lara Antipova, the Cossack-inspired
collection included warm brimless fur hats, a long
babushka-doll-shaped cloak (p. 101, left), knee-high
leather boots and mink fur collars. A seductive
silhouette was emphasized by 1960s-inspired denim
miniskirts and skirt suits, 1970s-style plunge necklines,
and wide high-waisted belts inspired by the Parisian
coquette of Saint-Germain-des-Prés.

A felted cavalry twill coat with mink buttons, silk
twill dotted skirt and cordovan side-laced boots
opened the show (right). At first glance the collection
seemed demure and classic, with its use of military
and menswear tailoring. However, the details revealed
a more playful approach, with mink trimmings, shiny
sequins, and splashes of pastel blue and lilac jazzing
up the black. Pockets, collars, lapels and cuffs were
decorated with fur, making it the fabric of the season.
Shiny black-dyed seal fur was made into belted coats,
jackets, empire dresses and A-line skirts with brims
and belts. Raccoon and fox were used on hats, ponyskin
on boots, and joyful black and white pompoms were
made of mink.

'Jacobs is a cultural and visual magpie,' declared
Lisa Armstrong of *The Times*, highlighting the way
in which the designer was reinventing classics such
as Jean Muir's 'calf-length jersey dress' and an array
of designs by Geoffrey Beene. 'The references included
Beene's blouson skirts and cropped jacket, the use of
trapunto detailing on the jacket and the juxtaposition
of three differently sized sets of polka dots in one
outfit, including those on the tights.'

Heralding Jacobs for his 'impeccable sense of taste',
Armstrong concluded: 'In the time that he has been
in charge at Louis Vuitton, that famous monogram
has been rescued from duty-free hell and risen to the
heights of fashion again.' Accompanying the clothes
were two new, discreet leather bag lines in matte and
glossy 'LV'-embossed leather, with the classic S-lock.
The envelope-sized Mini Monogram Glacé line had
a thin handle and included a pocket mirror. The
Monogram Black suitcase line with rounded corners
– taking inspiration from the 1950s Alzer suitcase
and traditional babushka dolls – came in three
sizes and was lined with silk.

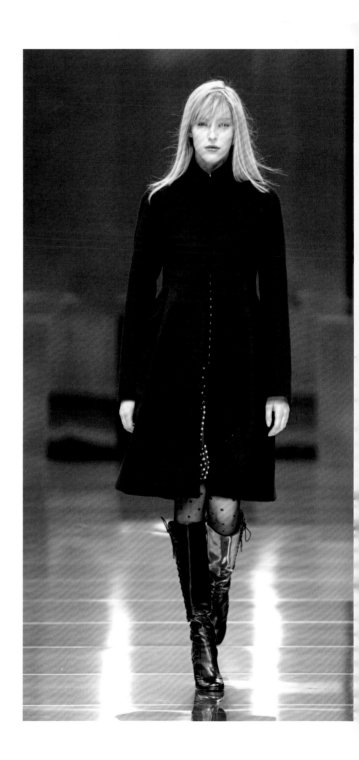

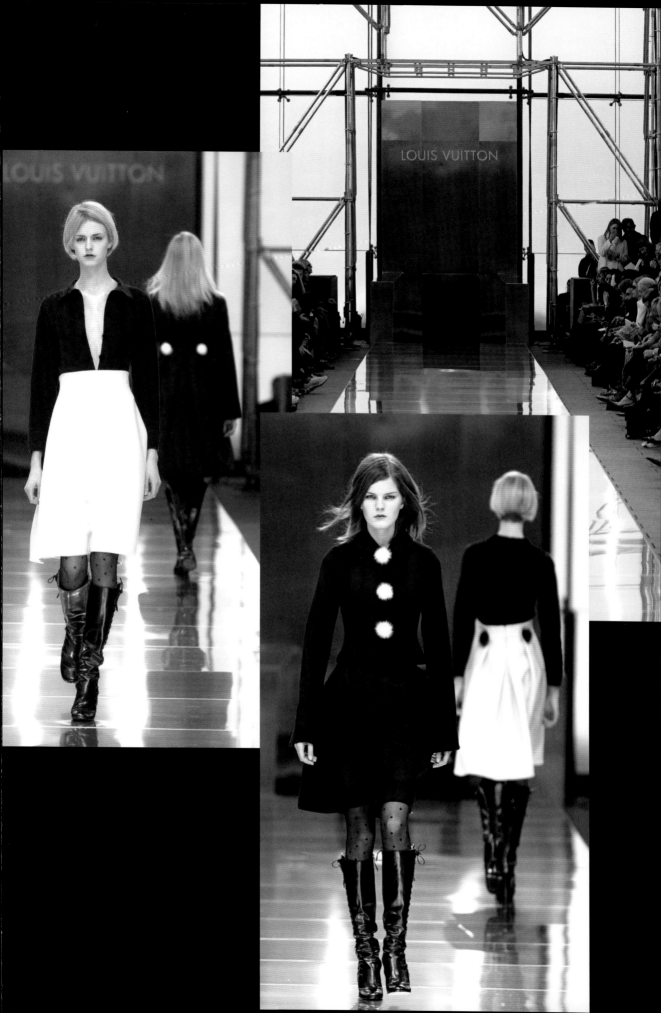

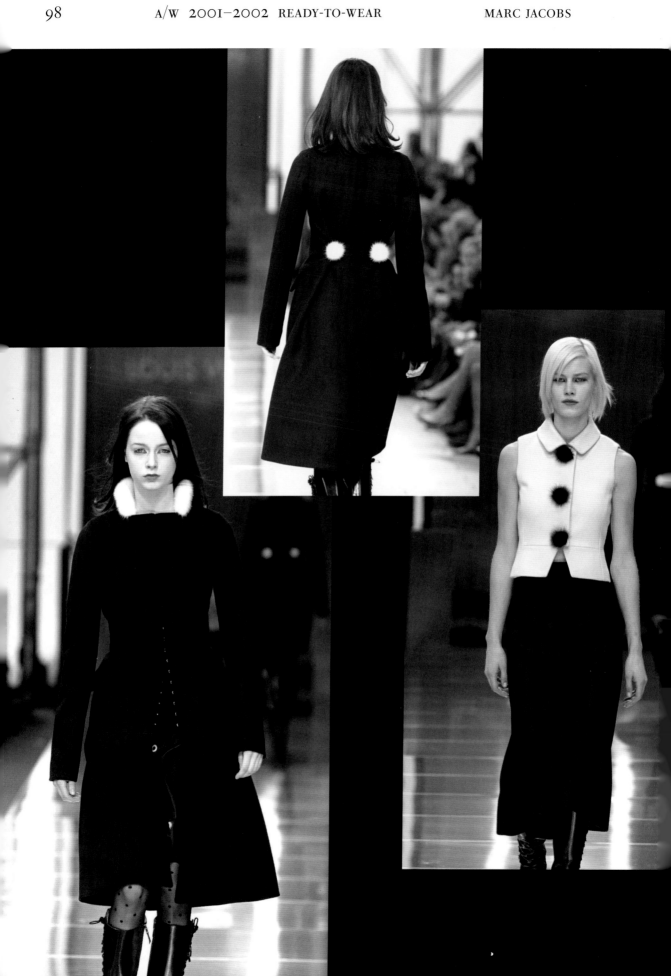

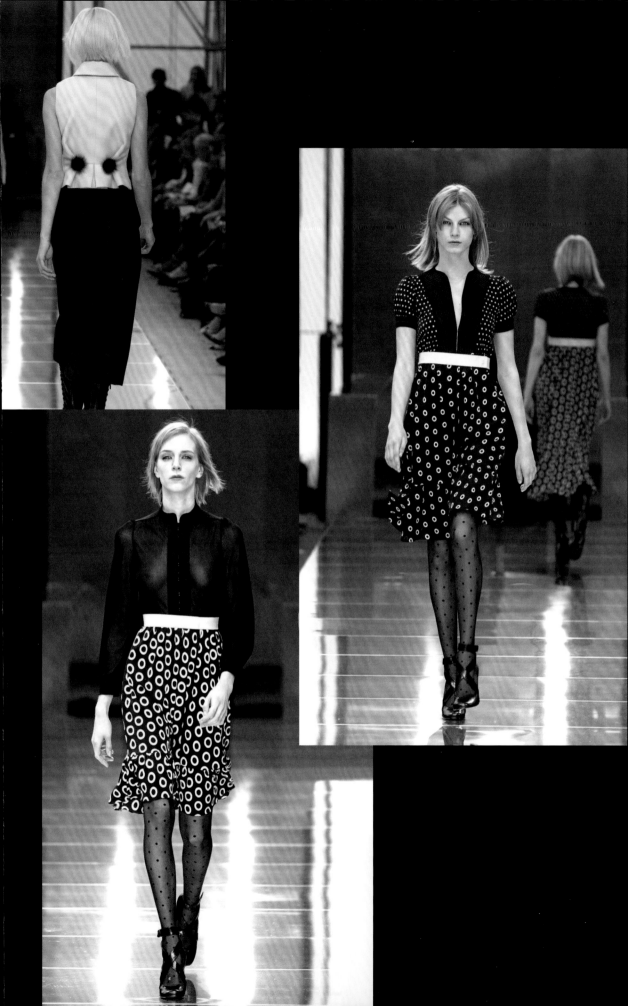

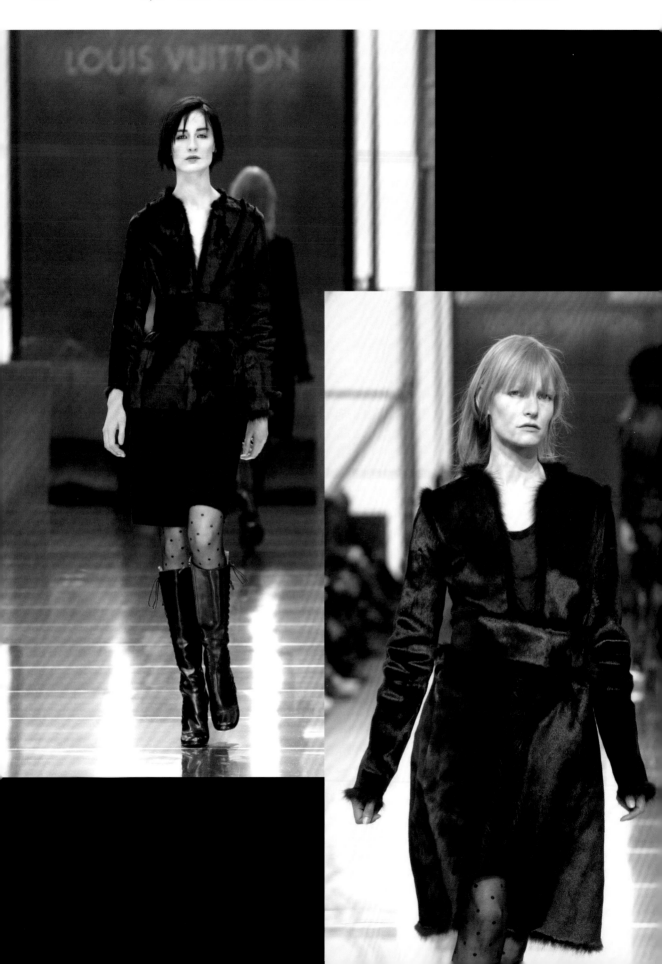

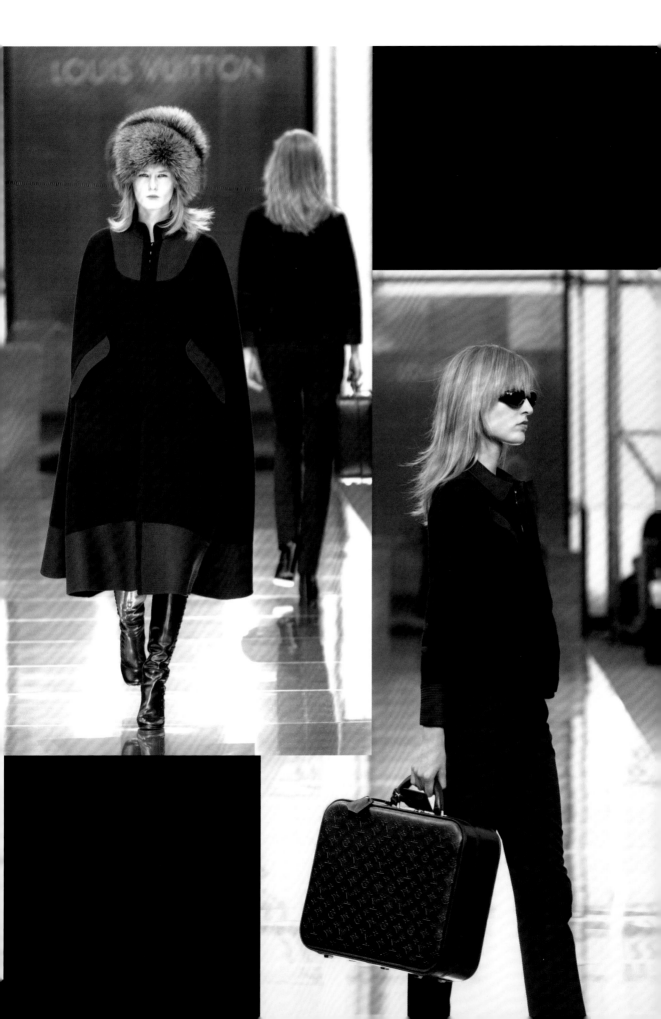

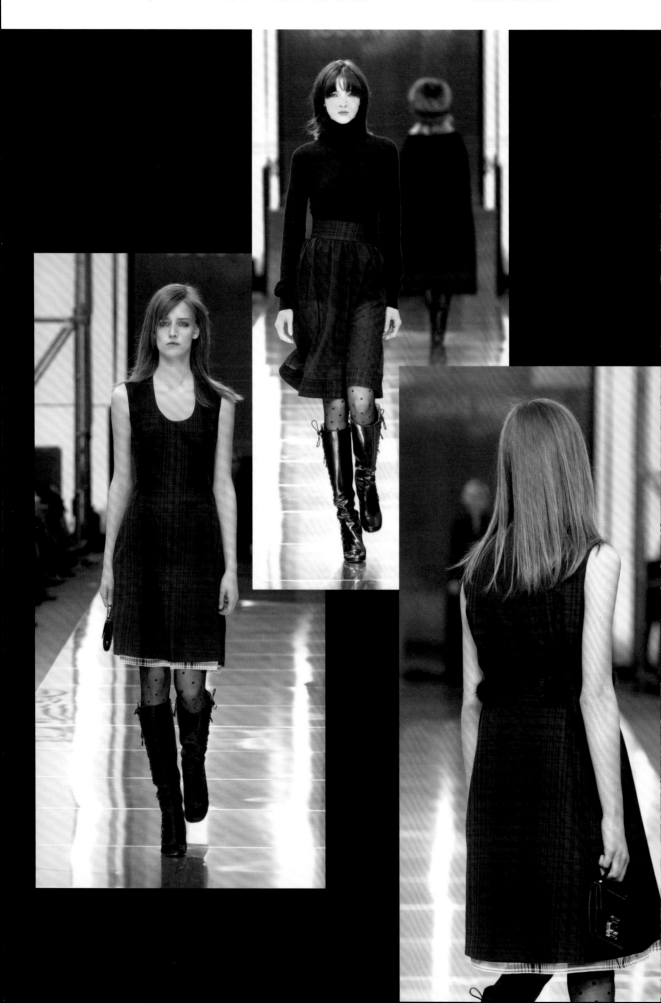

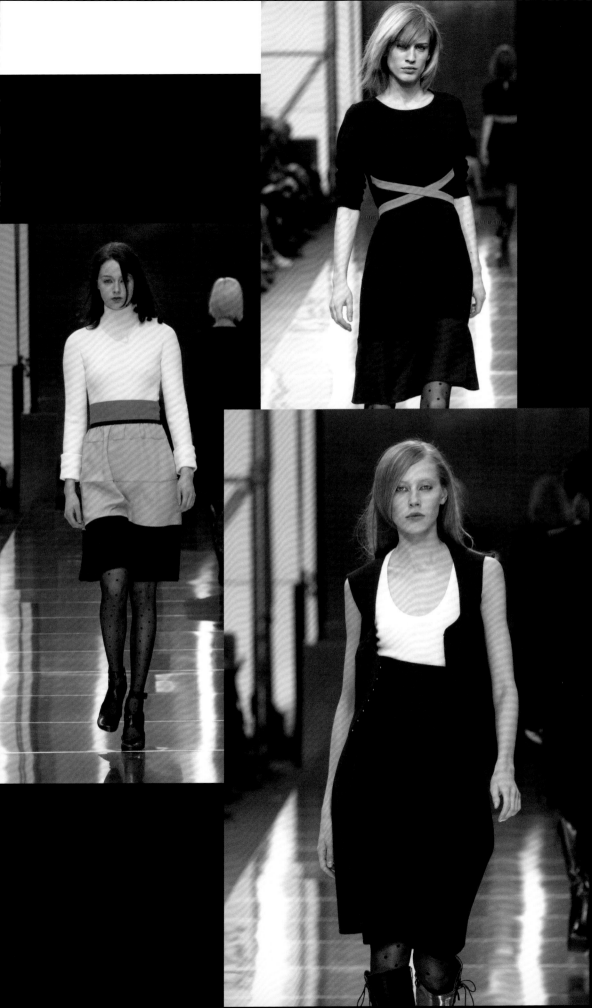

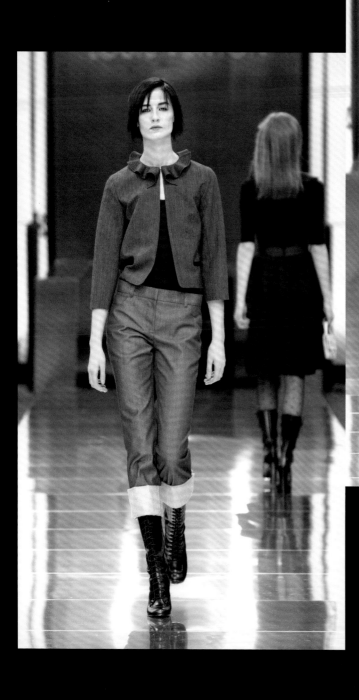

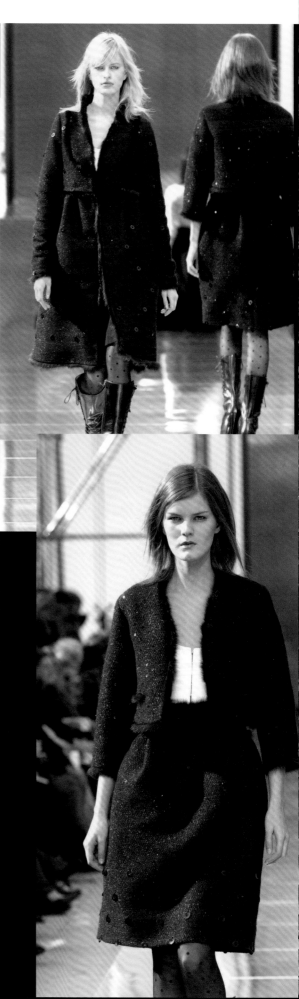

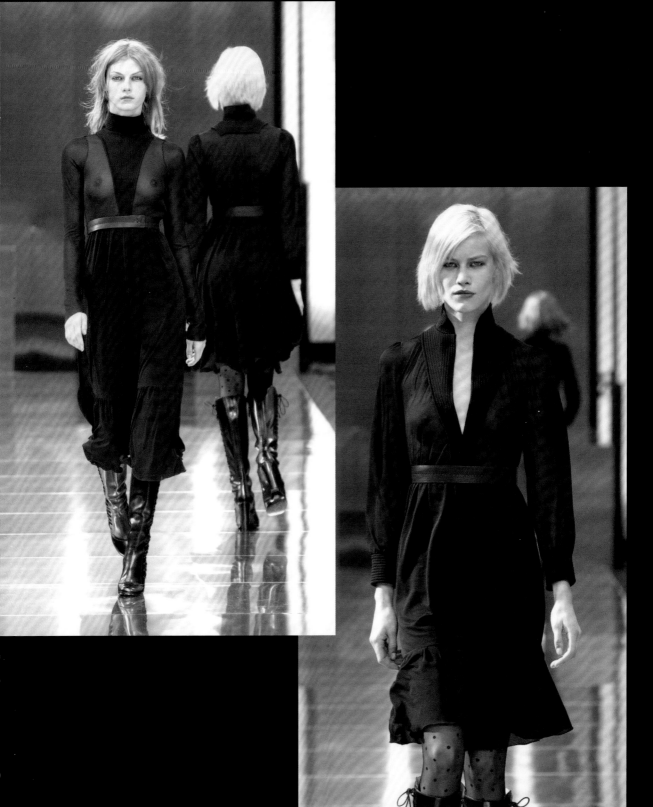

Fairy Tales with Julie Verhoeven

The spring/summer 2002 Louis Vuitton show took
place a month after 9/11, and offered an opportunity
to escape reality by indulging in the ultimate world of
luxury. Marc Jacobs presented an optimistic, creative
and joyful wardrobe. The combination of bright natural
sunlight in Parc André-Citroën's greenhouse and
shimmering metallic python leather garments made
press and buyers squint at the opening of the show.
Indeed, the entire collection was dazzling, highlighting
the unique combination of Jacobs's creative vision
and the atelier's unrivalled craftsmanship.

'Marc Jacobs has chosen dream and innocence,
transporting each of his designs into a fairy-tale
universe,' stated the show notes. Romanticism was
the key concept for the season, demonstrated in
the 1970s-inspired boho collection. Colin McDowell
reported for *The Sunday Times*: 'The 1970s London
of Bill Gibb and Ossie Clark was the inspiration for
a collection that could have been called Ossie Goes
to Marrakesh. Berber tent dresses, Persian miniature
flower embroidery, punched suede and top stitching
made this collection high on wearable charm.'

Key styles included high-waisted trousers, hot-pants,
culottes, V-neck tunics, denim Mao jackets and jersey
tiered dresses. A hippie-ish colour palette for daywear
included white, pale yellow, sky blue, lilac, beige and
water green. Burgundy, brown and black were more
dominant for the eveningwear.

Embellished by Parisian haute couture embroidery
specialist Atelier Montex, white leather jackets, coats
and boots came arrayed with enchanting botanical
gardens of meadow flowers with the LV logo, referencing
Mexican peasant dresses. Similarly decorated was a
white lambskin coat (p. 117). Striking iris appliqués were
sewn onto a gold kimono coat and a jacket, complete
with obi sashes (pp. 113 and 114). 'Flying straight on
to most-wanted lists around the world were butterfly-
shaped hair accessories in turquoise and coral
monogrammed patent leather,' added *The Guardian*.

The magical botanical theme was translated by
British artist Julie Verhoeven into quirky collage
designs, with the different Louis Vuitton leathers
(Damier Canvas, Damier Sauvage, Monogram Vernis,
Epi and exotic leathers) topstitched and embroidered
over monogrammed materials. Verhoeven's 'Fairy Tale'
series included the Landscape (p. 109, top right), Garden
(p. 109, bottom left) and Twilight (p. 111, top left). *The
Guardian* commented: 'Pick of the bunch were handbags
in the traditional Vuitton monogrammed designs,
appliquéd with cartoon scenes of rainbows, gardens,
tortoises and flowers.' Presented in 'the same childlike,
tongue-in-cheek vein, tiny flat handbags of glossy,
monogrammed patent leather came in the shape
of mice, owls, butterflies and even toads'.

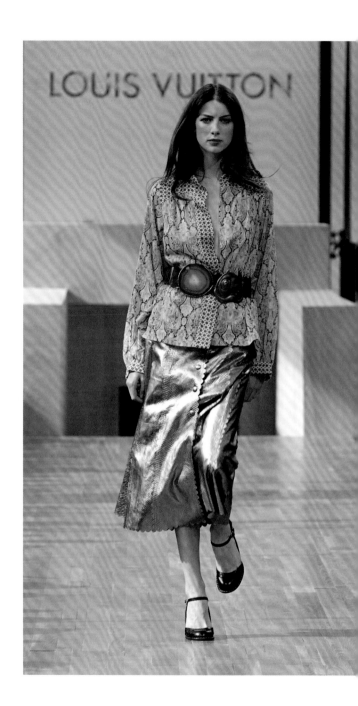

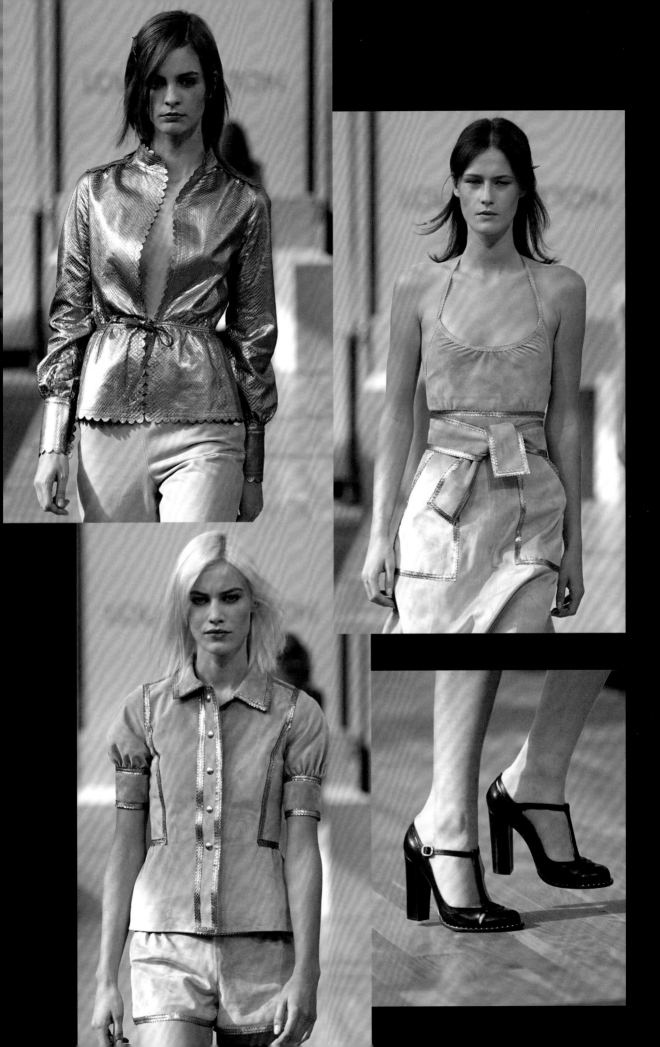

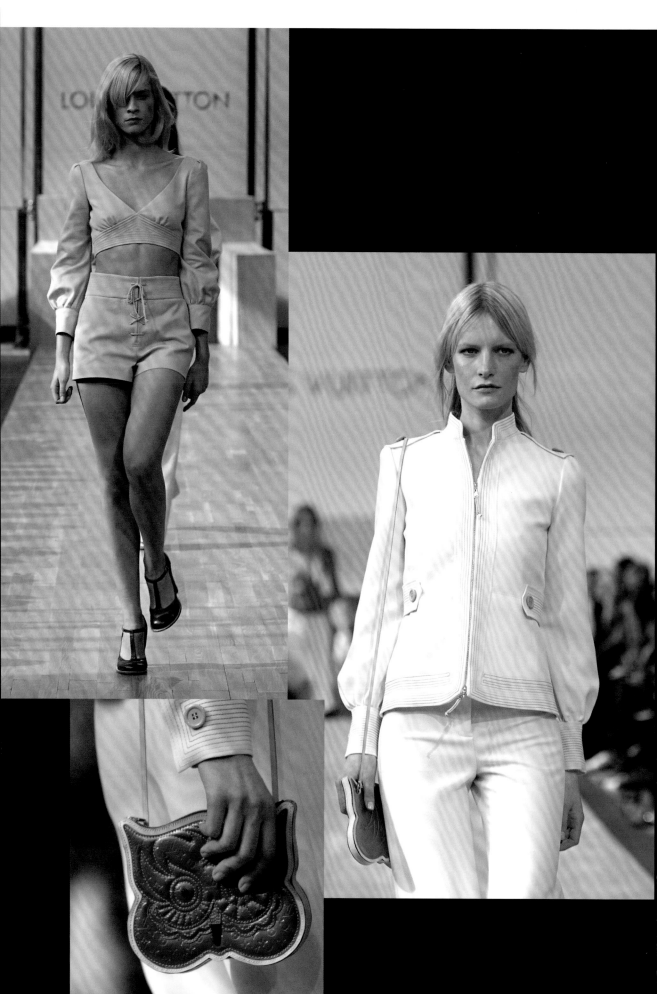

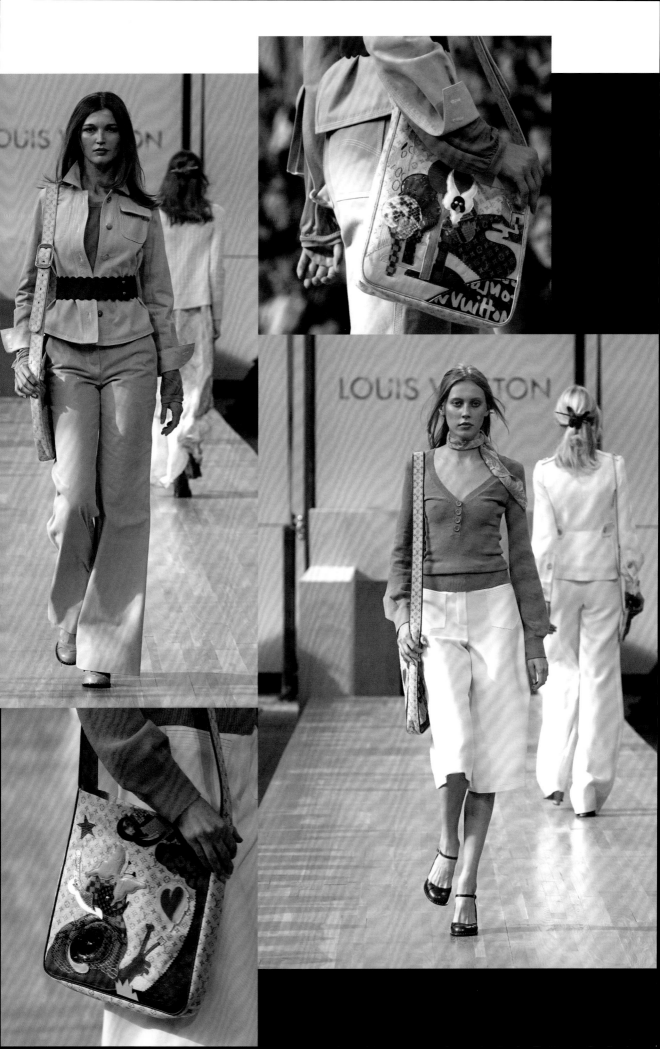

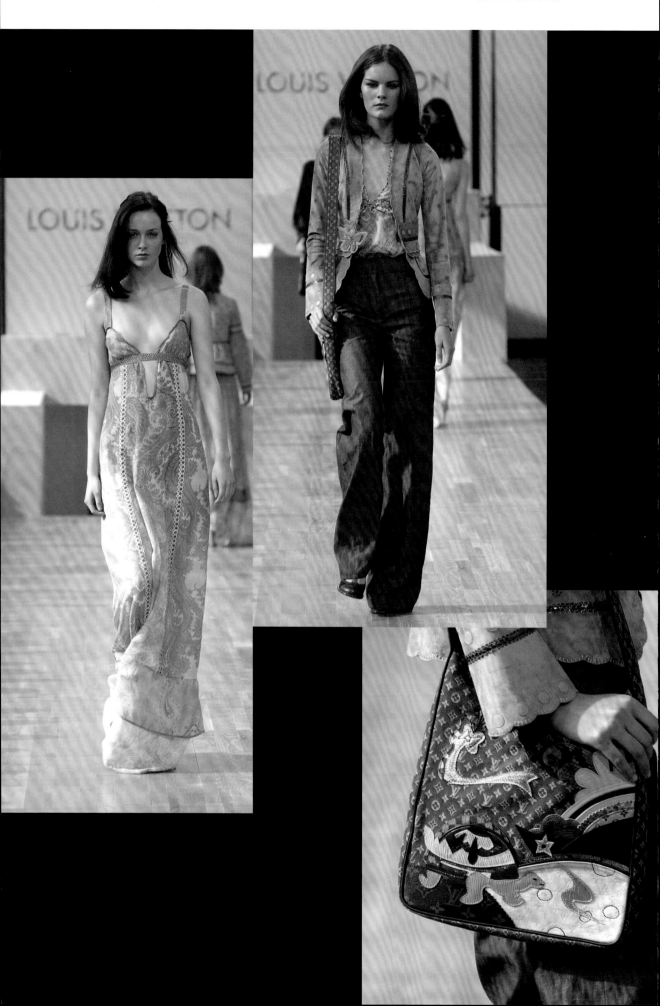

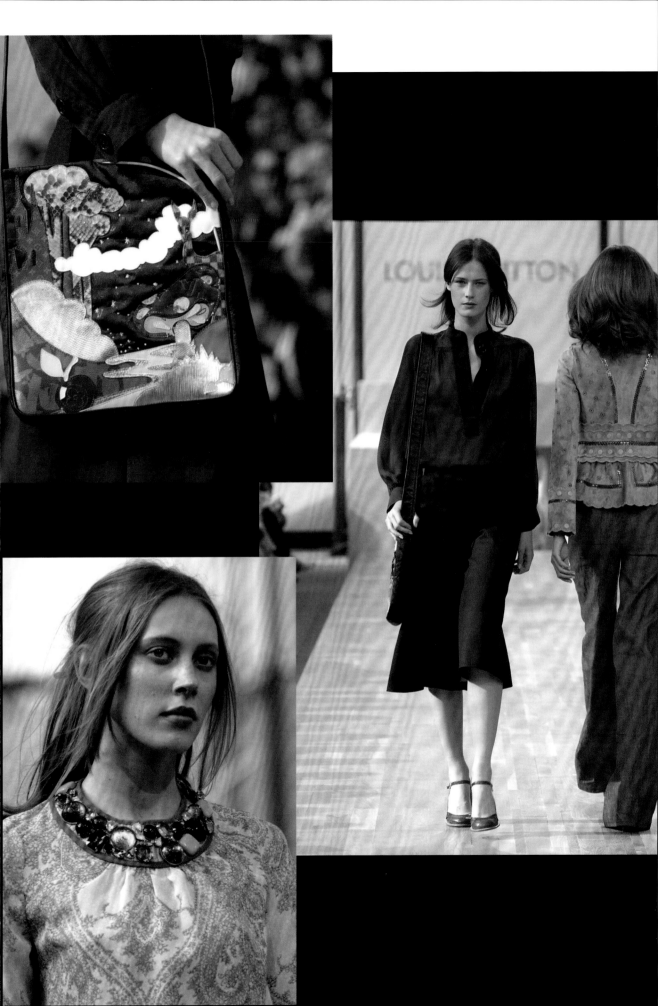

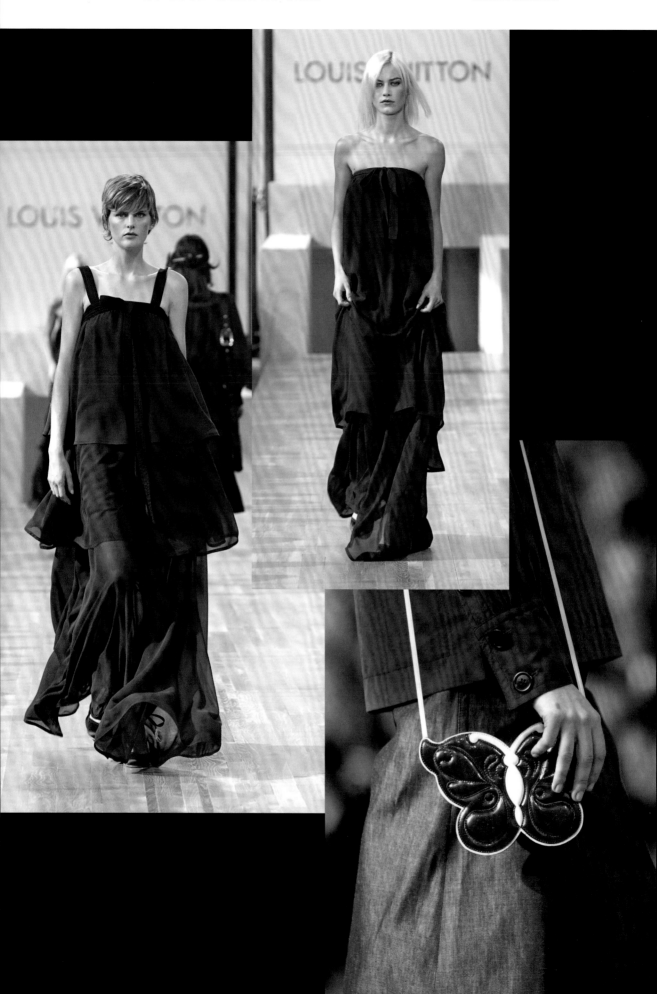

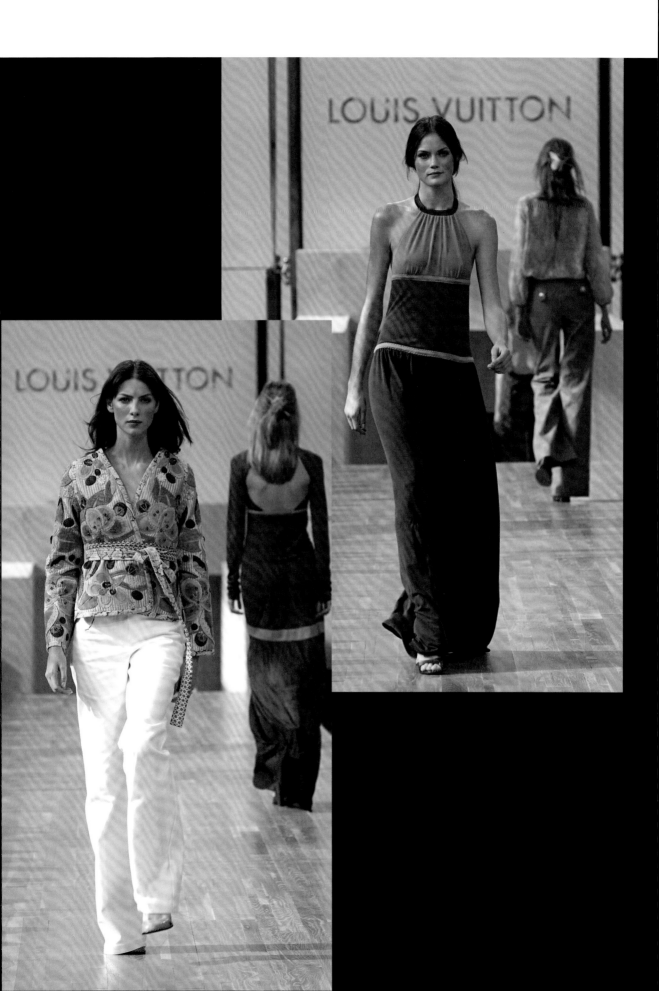

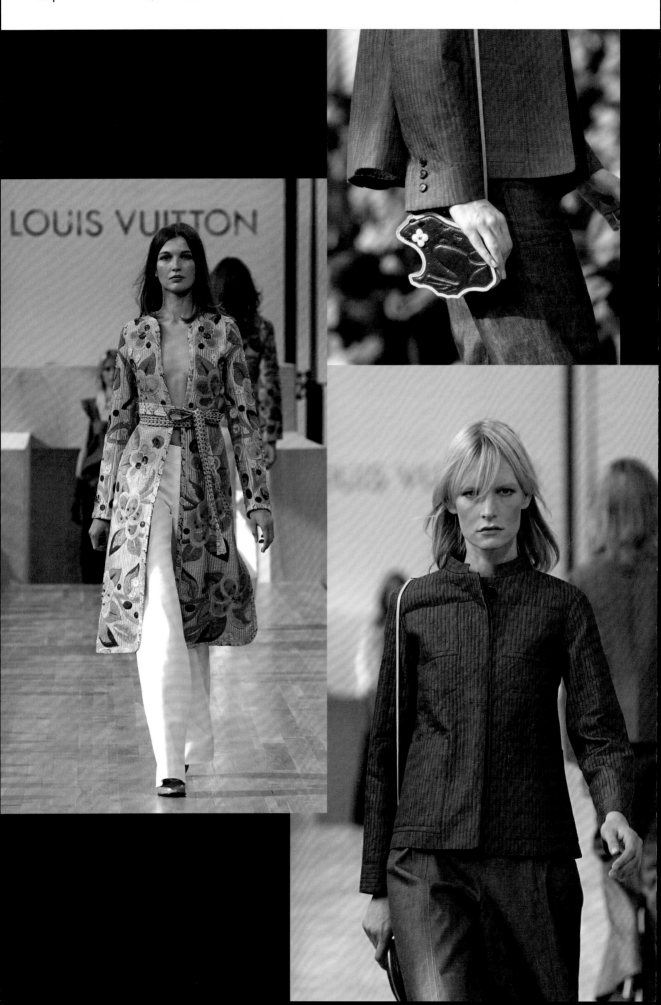

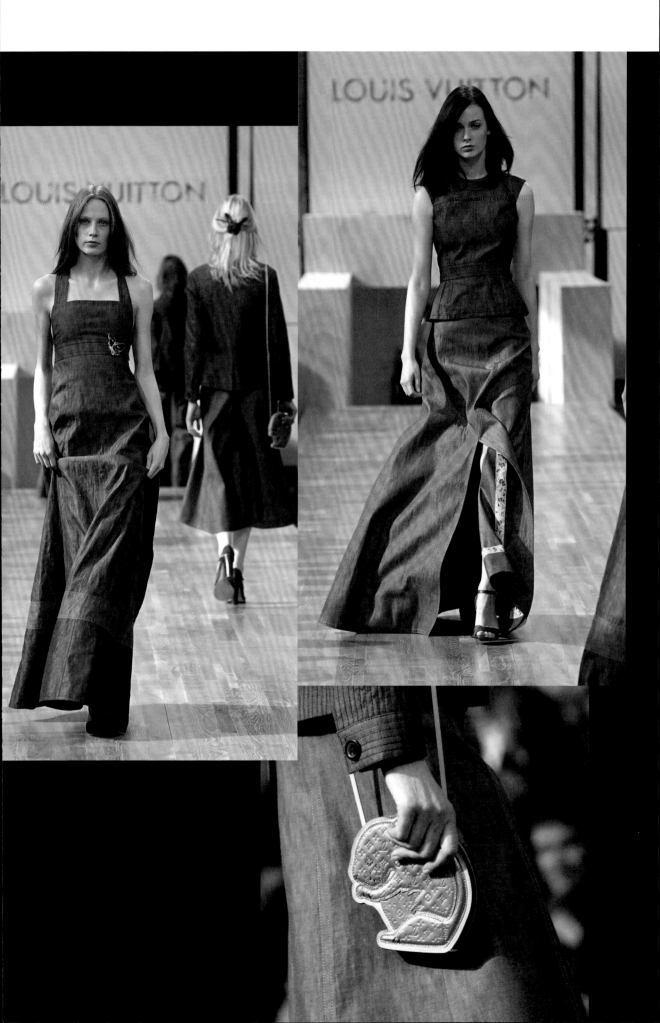

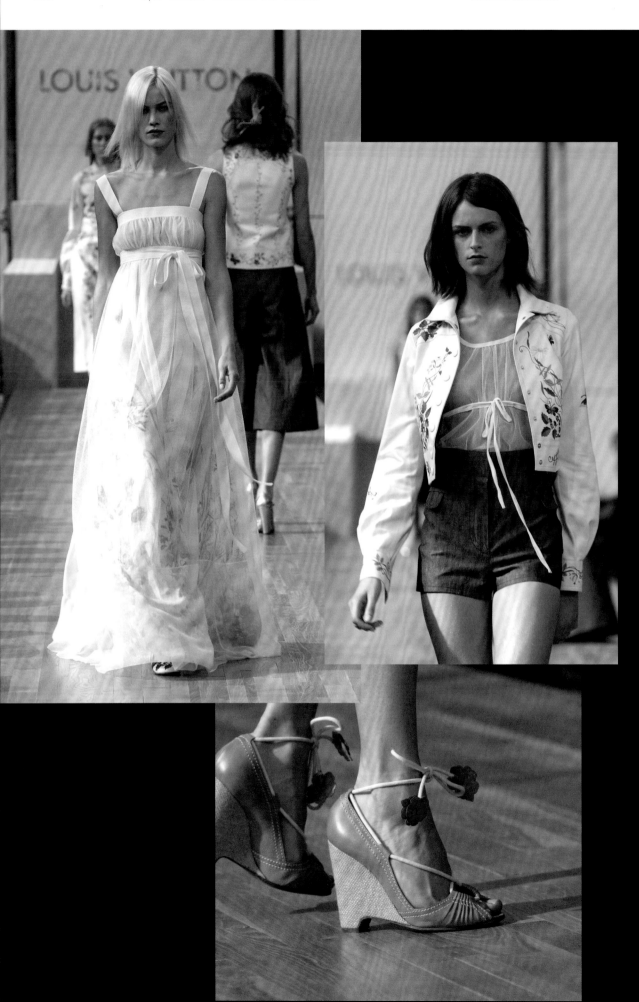

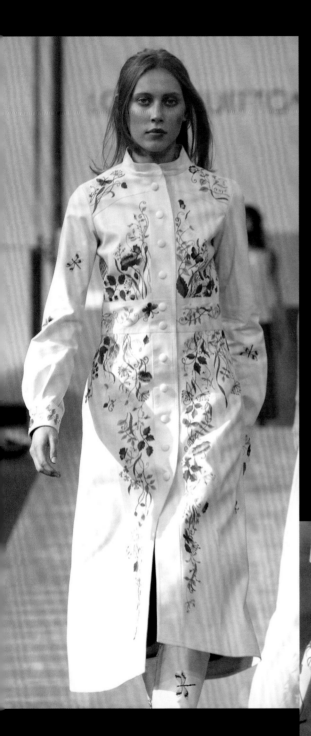
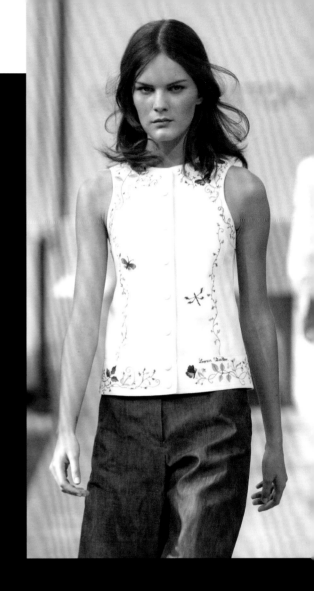
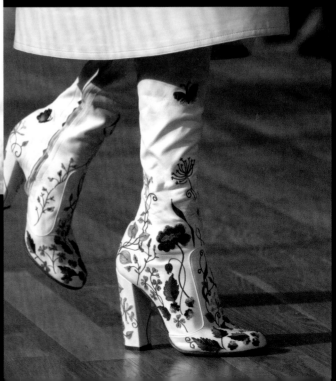

The 'Hitchcock' Collection

'Trust Marc Jacobs, the quiet American at Louis Vuitton, to come up with the perfect synthesis of dazzle and reality,' wrote *The Times* about his autumn/winter 2002 collection, the first to be styled by Katie Grand. Inspired by heroines in Alfred Hitchcock's Hollywood-era movies, the collection evoked glamour and mystery. Jacobs offered the femme fatale of the season unlimited styling options by presenting 49 looks broken down into an array of separates accessorized with charm bracelets and two new versions of the Monogram bag, including the multi-pocket McKenna. The collection was 'for women who like their glamour to become part of their aura rather than a mission statement,' reported *The Times*.

A chic feminine silhouette was shown in tones of sand, ivory and white juxtaposed with darker hues of grey, brown, burgundy and black. 'There was an element of the sinister to the collection, with a glimpse of blood-red cashmere showing from underneath a slender dove grey or cream skirt suit, while Jacobs' sexy, purple satin, kitten-heeled slingbacks added to the drama,' reported *Vogue*. The colour combinations and garment construction referenced the silk linings of the house's iconic trunks. The LV logo and monogram flower were imprinted on buttons, and a black fur skirt referenced the Monogram pattern (p. 126, bottom right).

'The elegant and the rumpled were literally fused in the designer's first two outfits [right, and opposite, left], trompe l'œil dresses that joined silky tops to knee-length alpaca skirts,' wrote *Vogue*'s Sarah Mower. She continued: 'A throw-it-on attitude toward the ultra-luxe was cultivated throughout, especially via herringbone tweed pencil skirts with washed silk camisoles and casual white rabbit bombers.'

The collection mixed lingerie, 1940s tailoring and 1950s Hollywood glamour with Eskimo clothing and a cool biker attitude. There were silk blouses with Peter Pan collars, biker leather trousers, jackets with multiple zipped pockets, lady-like coats with hoods and half-belts, jacquard cashmere dresses, ostrich feather skirts and jackets with aviator straps. Mink, coyote, raccoon and rabbit fur were made into trims on skirts, jackets, parkas and boots.

Vogue reported: 'The prerequisite red-hot LV accessories for winter include slim, monogrammed metallic mesh shoulder bags with gilt chains and sweet charm pendants hanging with mini suitcases or bottles of Champagne (with Jacobs, it's always in the detail) – expect to see them everywhere' (see the Maille on p. 123). Also launching that season was the brand's first watch collection, evoking 'timeless elegance'.

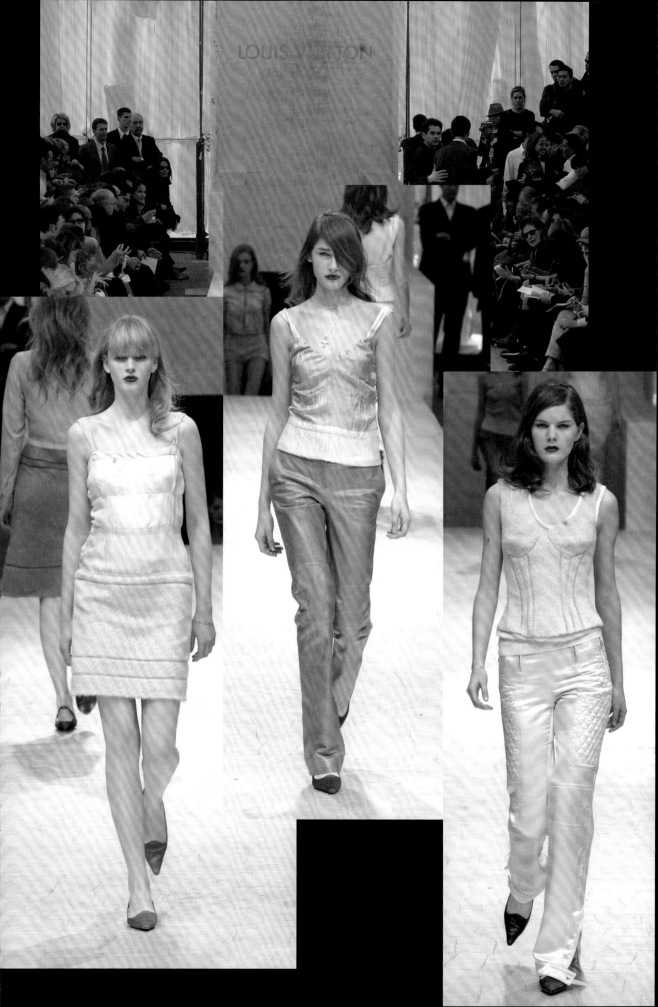

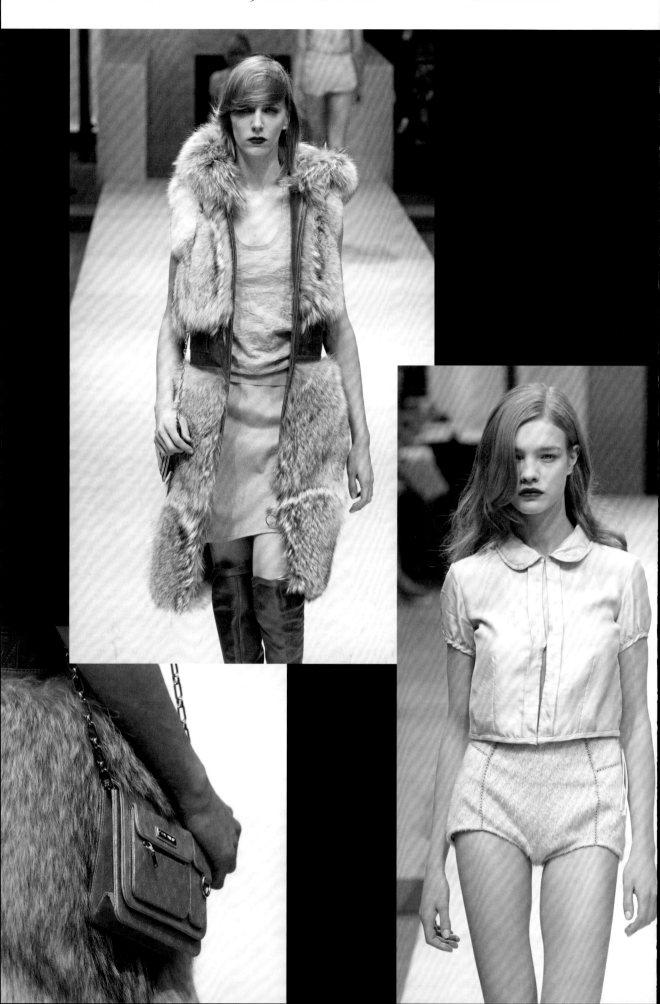

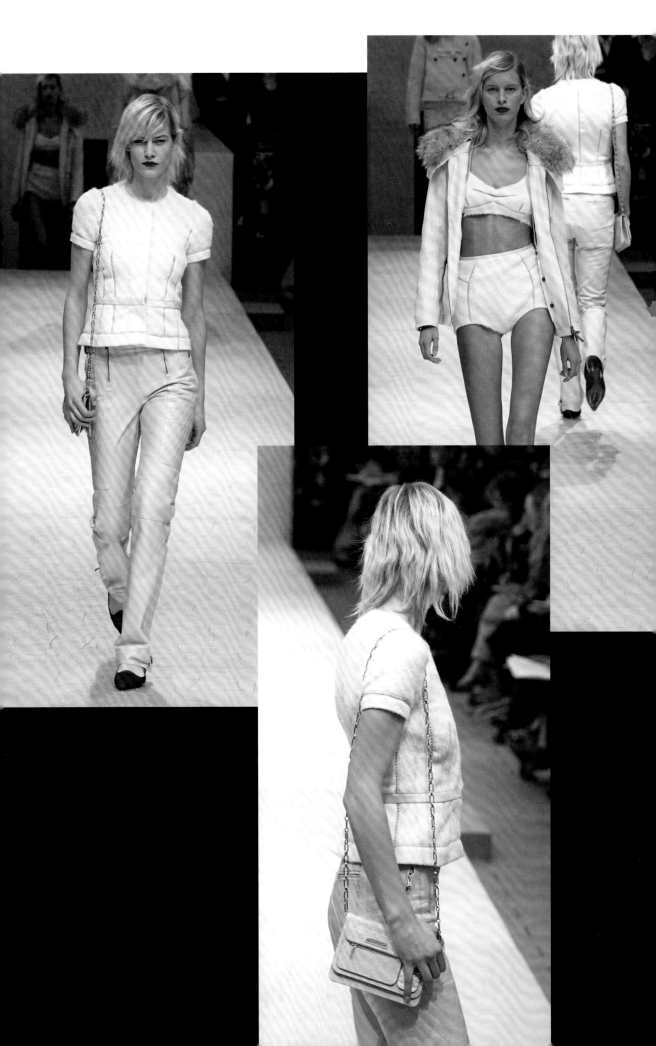

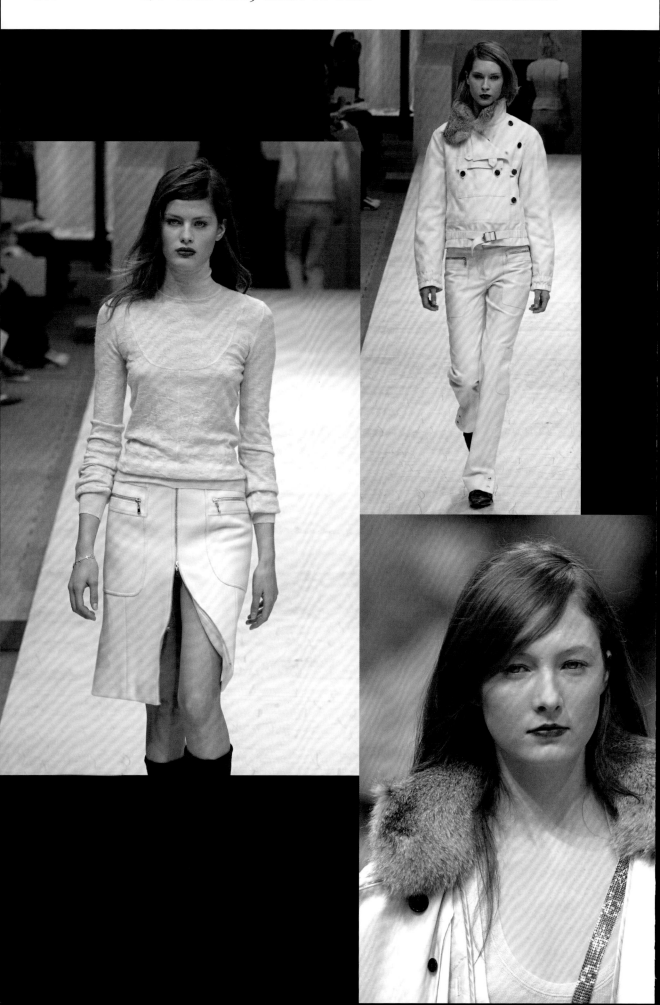

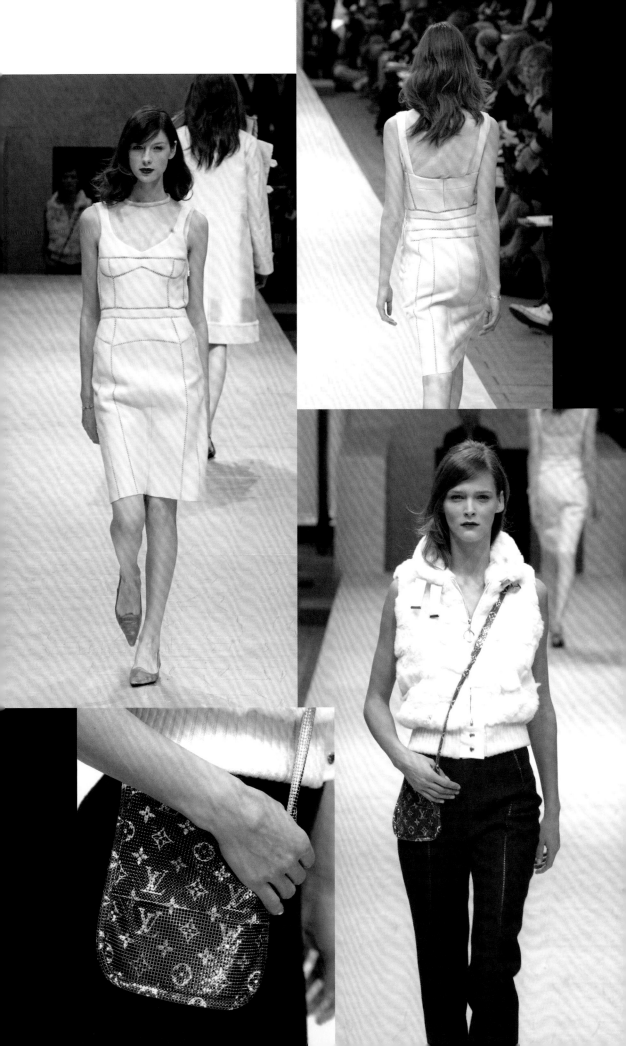

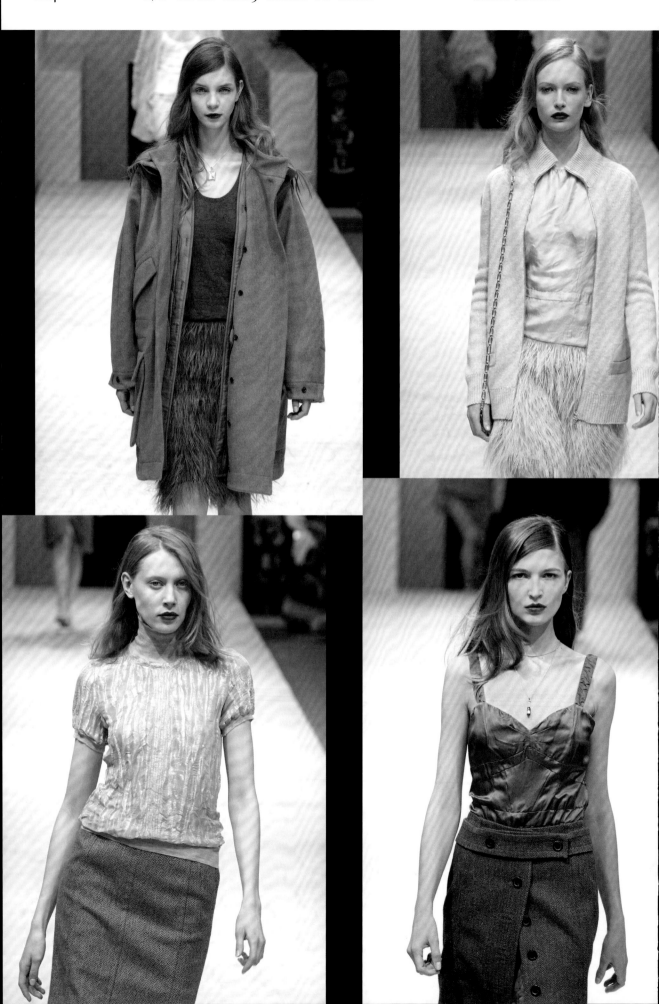

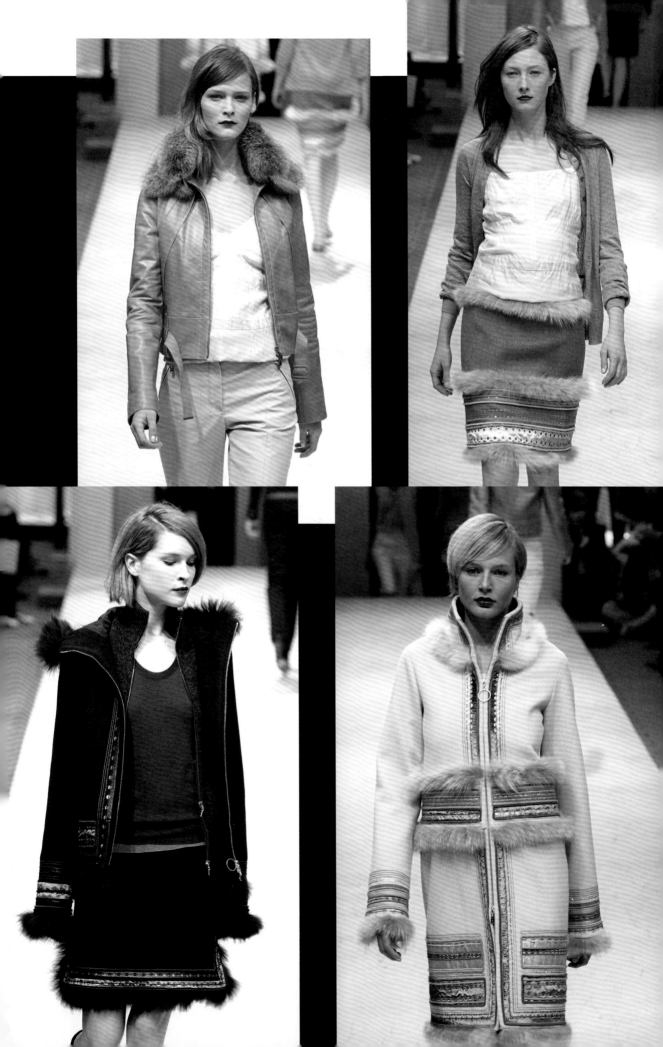

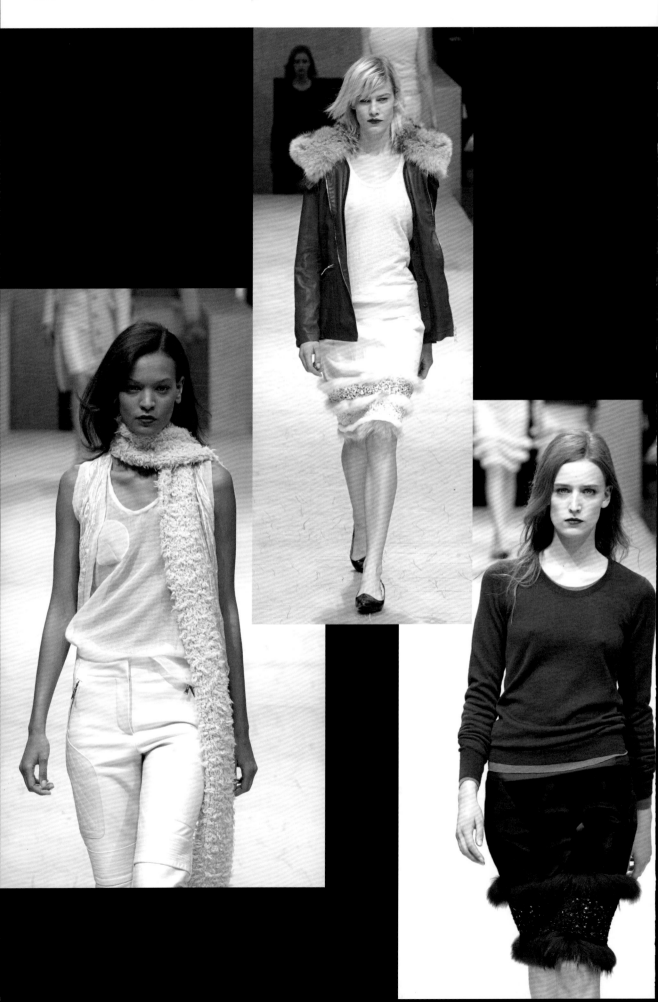

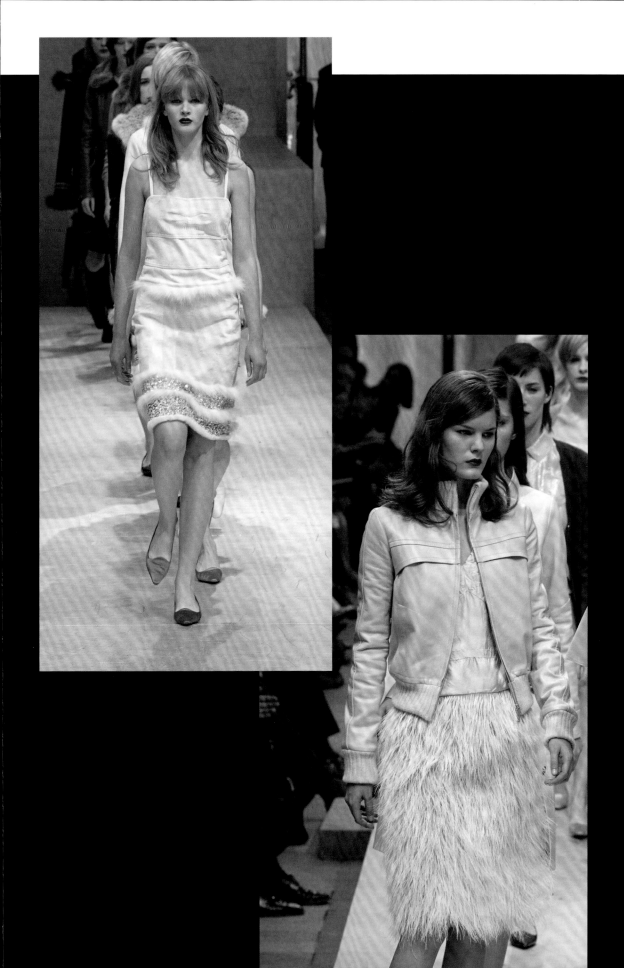

'Multicolor' Fantasy
with Takashi Murakami

Louis Vuitton's spring/summer 2003 show presented
exactly what the fashion industry was desiring at the
time: 'fun', as Cathy Horyn wrote in *The New York
Times*. Jacobs had chosen the Japanese artist Takashi
Murakami to reinterpret the Monogram canvas, and
the result 'yielded not only a hot new accessory but also
a collection that, in its sweet colors and ruffle-kissed
shifts, offered something better than newness: a sense
of optimism'.

Jacobs and Murakami transformed fashion into
fantasy, inspired by Manga cartoons, Pop Art, Alice
in Wonderland, 1950s pin-up style, and the artist's
'superflat' theory. Three new Monogram bag styles
were launched: 'Multicolor' in 33 colours (see, for
example, right); 'Eye Love' in 93 colours, Murakami's
playful 'eye' replacing a traditional LV floral motif
(see opposite); and 'Cherry Blossom' in three colours
(see p.136). Interestingly, the designs echoed Gaston
Louis Vuitton's Japonisme-inspired Art Nouveau
bedroom from 1901.

Jacobs noted: 'We approached the idea of the "icons
of Takashi" and the "icons of Louis Vuitton", being the
Monogram, and we worked on creating a brand-new
canvas.' Murakami added: 'This Western icon brand
was willing to take a risk and if I lived up to the
expectations, I could escape Andy Warhol's phantom
of supposedly not being able to bridge high art with
the commercial.'

The collection presented a wardrobe for 'a very 2-D,
doll-like woman: cheeky, sexy, flirty,' said Jacobs. The
show opened with 'Les Coiffeuses': 12 models with
swinging ponytails, wearing sexy zip-up rainbow-
coloured silk taffeta dresses while carrying versions of
the 'Multicolor'. The next section, 'Initiales LV' (paying
homage to Serge Gainsbourg's song 'Initials BB'), was
full of nods to Brigitte Bardot and 1950s lingerie
style. The third section, 'Paris Mon Amour', evoked
the seductive Parisienne, with striped tops and dresses,
and polka dots on cherry-coloured latex. 'Les Ladurées'
followed, with raffia tweed suits in the pretty colours of
Ladurée macaroons. The show closed with 'Sea, Sex and
Sun' (another Gainsbourg song title), displaying what the
show notes called 'looks for modern sirens', including
neoprene tops and coats adorned with exotic 3-D flowers.

Louis Vuitton had reported $3.26 billion in sales for
2001, with just 3% coming from the womenswear and
menswear collections. At the time one in three women
and one in six men in Japan owned a Louis Vuitton
item. *The Guardian* noted: 'By opening with models
clutching a series of the new-style handbags in every
conceivable shape and size, Jacobs made it abundantly
clear that he understands what Louis Vuitton is
fundamentally about.'

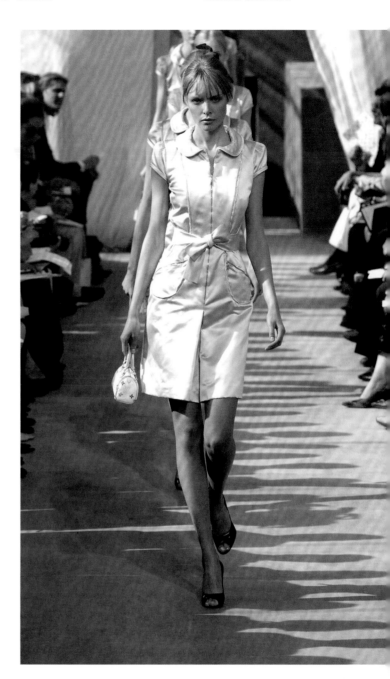

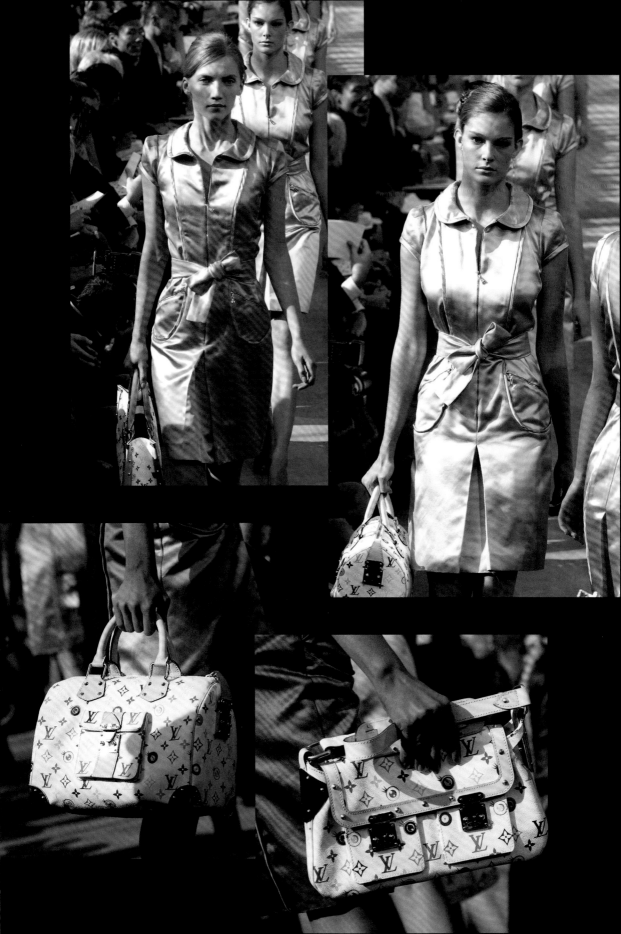

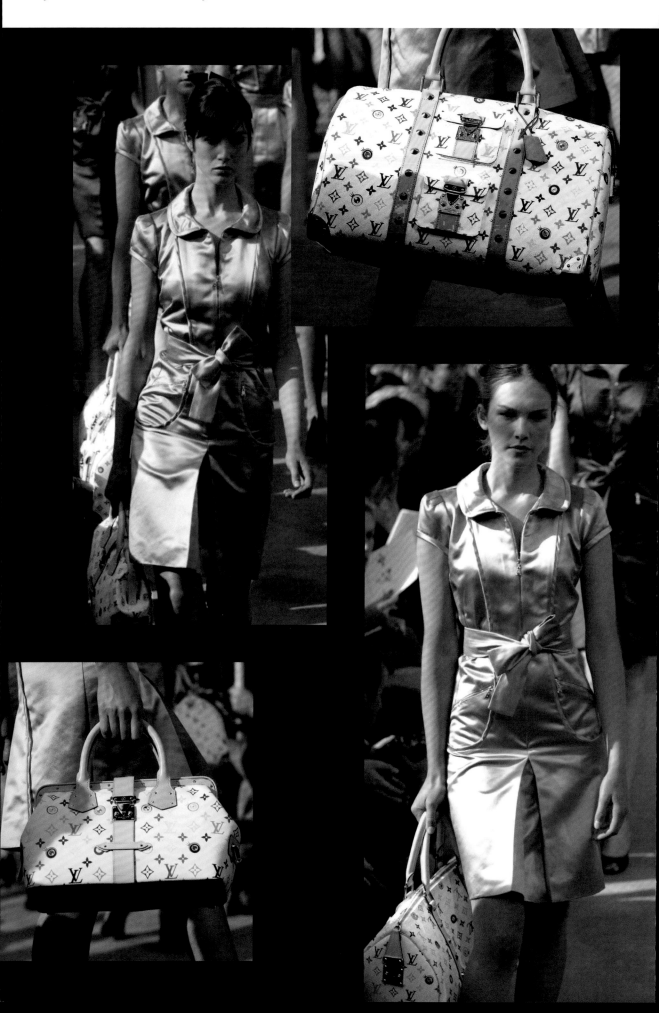

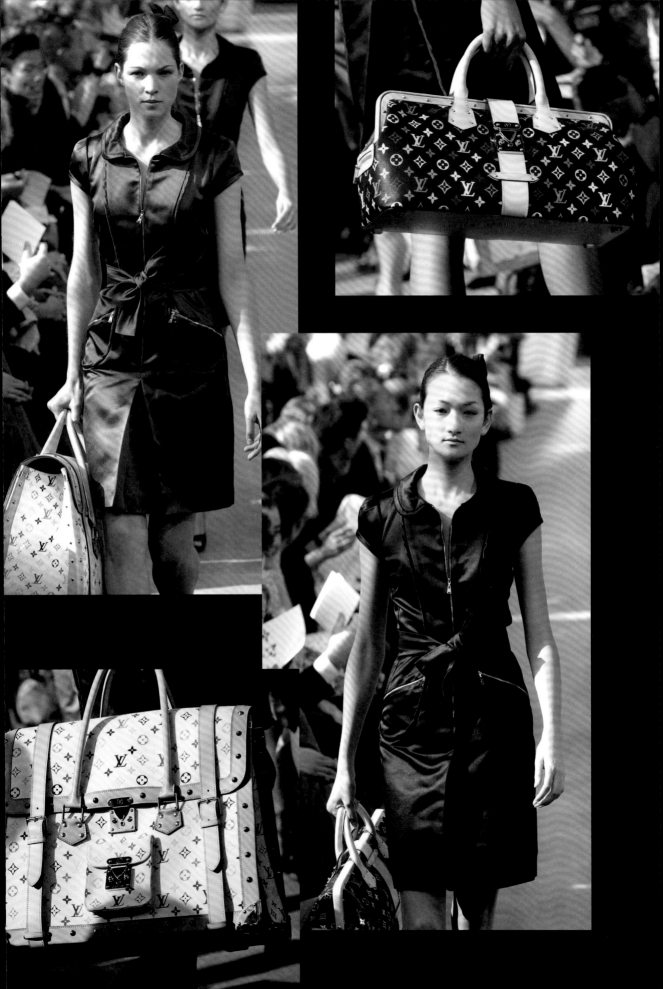

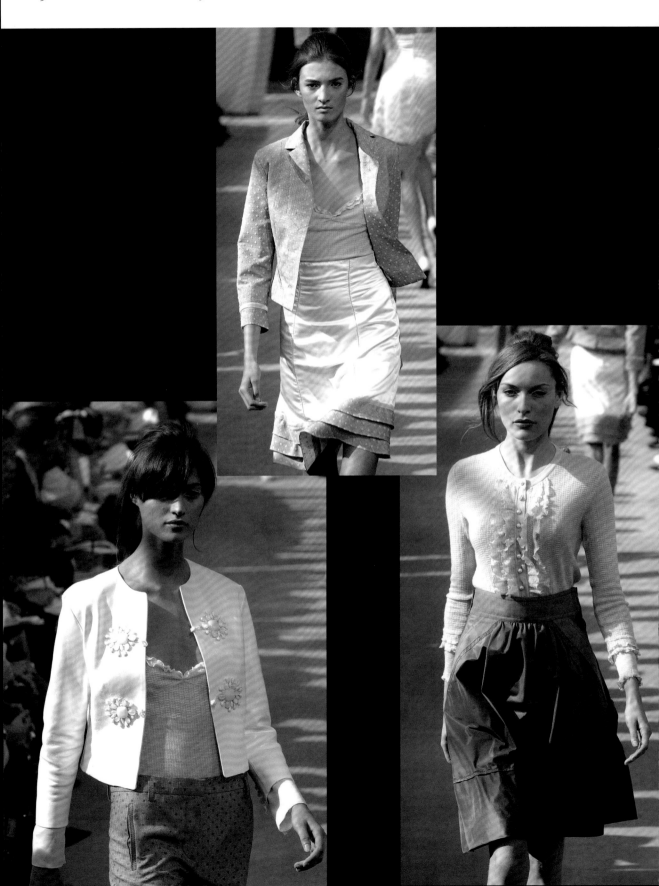

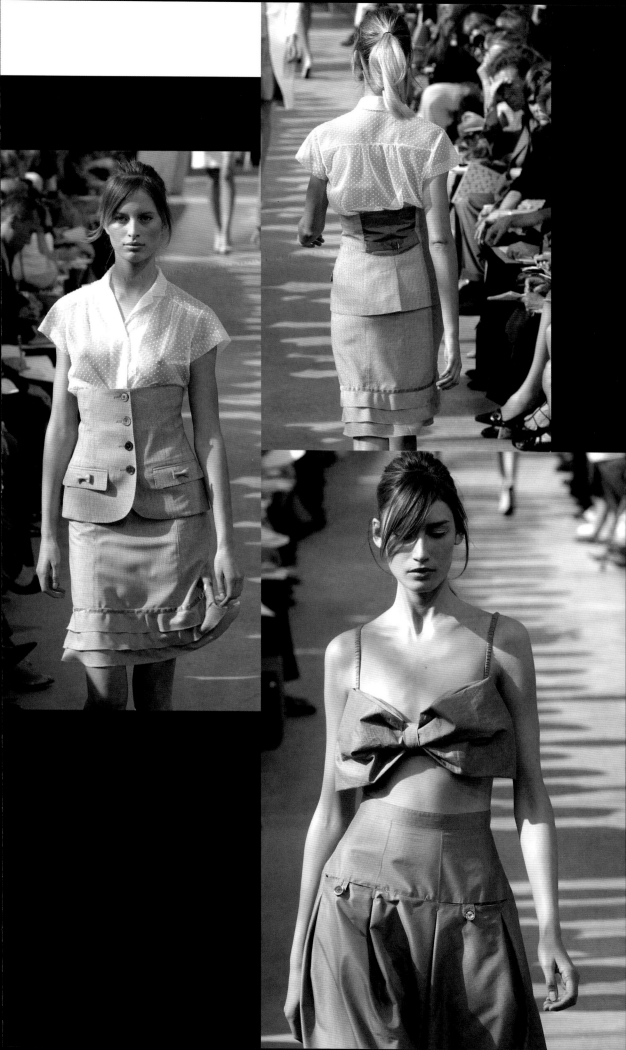

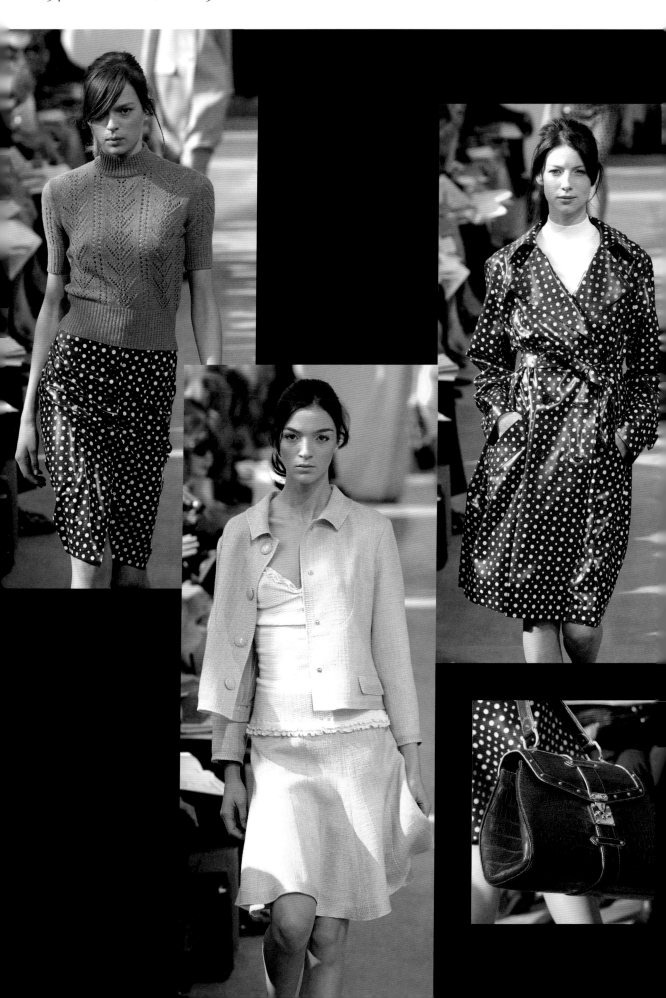

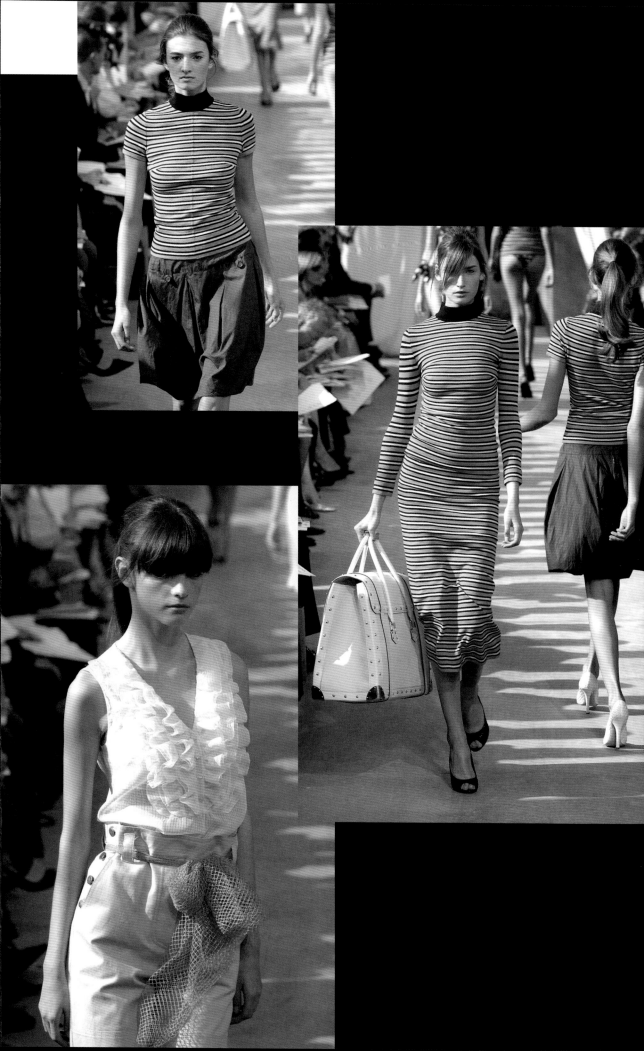

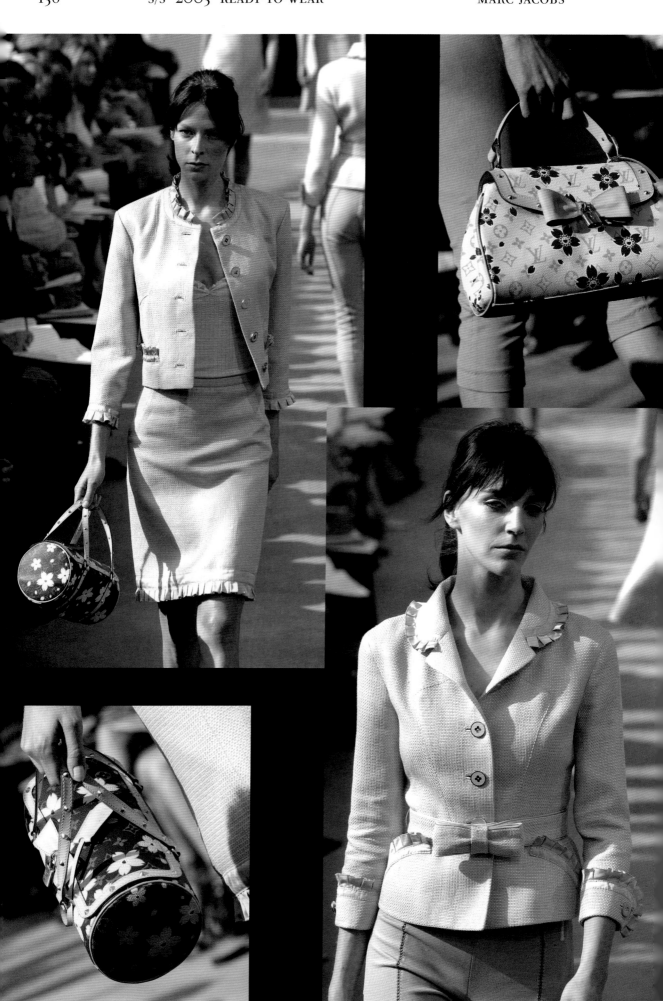

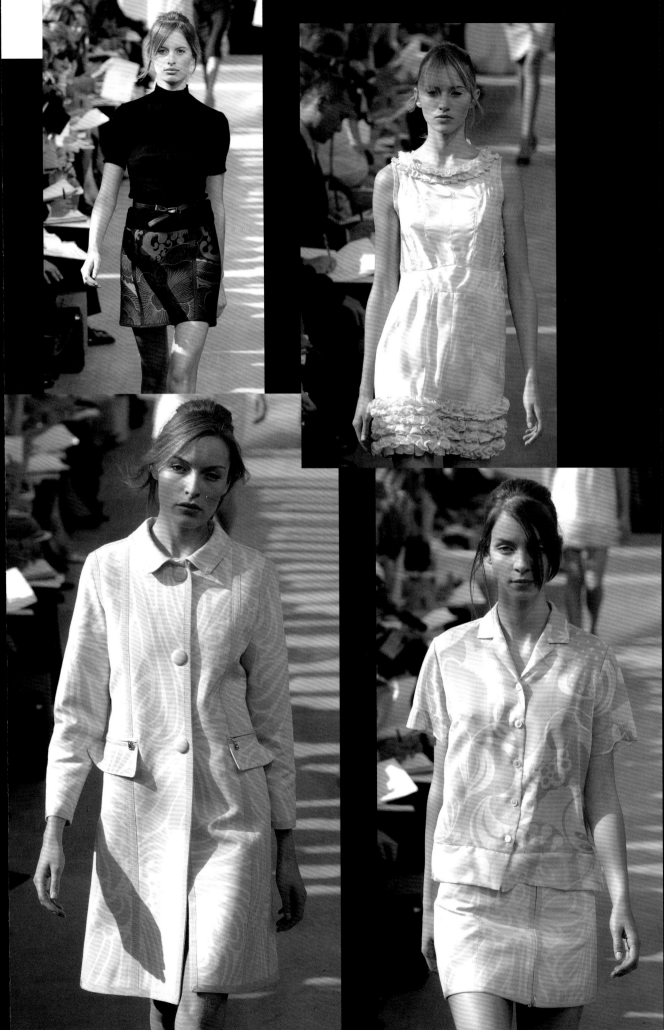

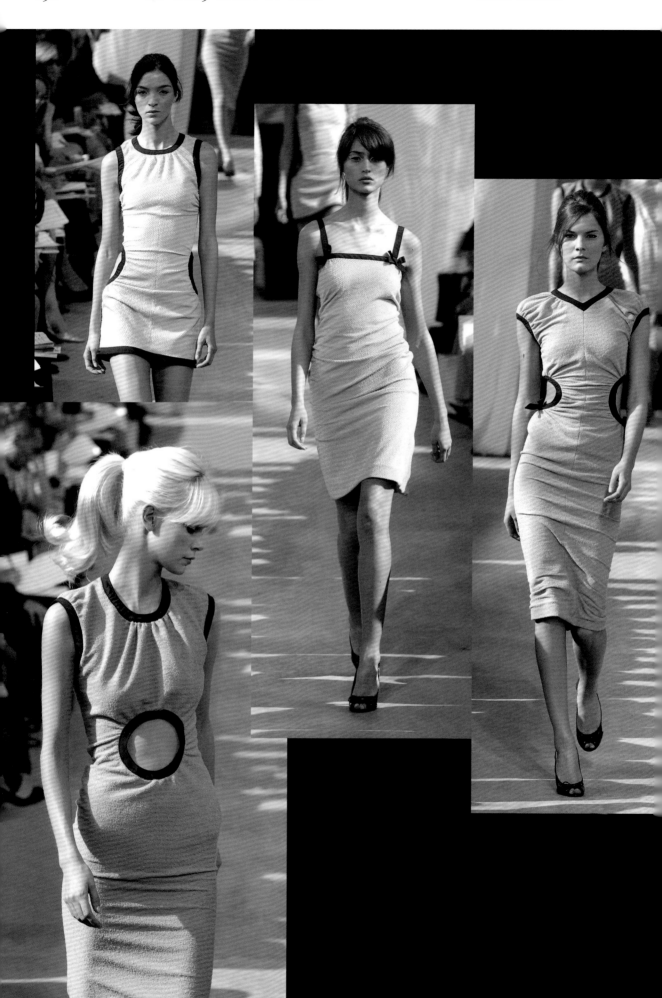

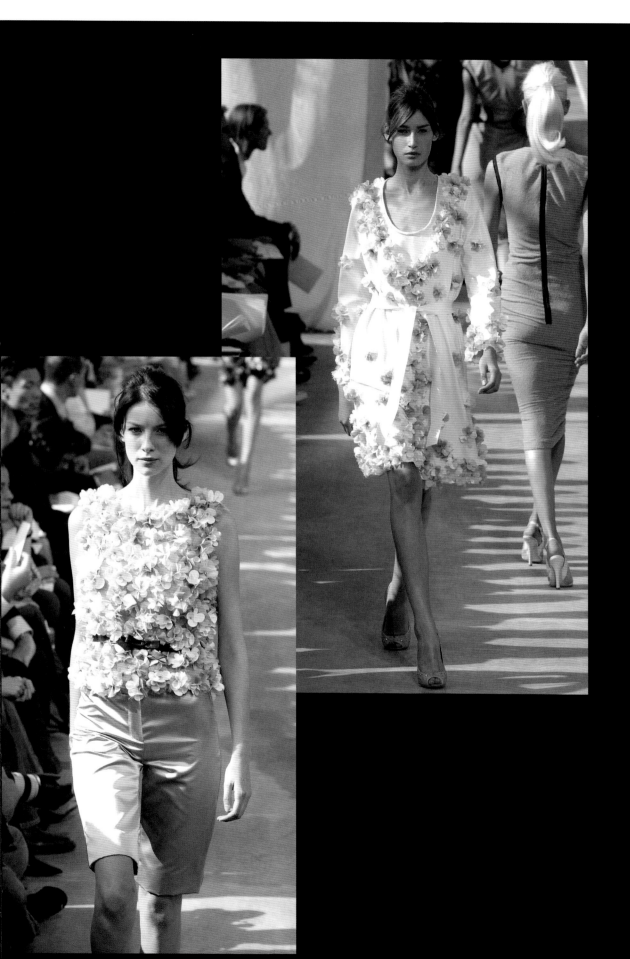

Modern-Day Armour

The Louis Vuitton autumn/winter 2003 collection
was one of Jacobs's best, according to Colin McDowell
in *The Sunday Times*. He elaborated: 'Sculpted,
architectural in cut, his ethos was to revisit medieval
armour, with layered fabrics and studding, while
recalling the 1960s in the way only a good
designer should.'

Taking inspiration from Joan of Arc, Jacobs created
'protective armour for modern times', as the show
notes stated, with knee-length Monogram cashmere
socks, long leather gloves, a flesh-coloured organza
ruffle-sleeved blouse (p. 144), and a dress-cape with
rhinestones and iridescent plastic. *Vogue*'s Sarah
Mower wrote: 'There was a touch of the current feel
for space-age-slash-medieval militarism in the studded
tunics and coats cut to hint at armor-plated layers.
Formfitting ribbed knit dresses with a hint of Claude
Montana about them ended in a flip of gladiator pleats.'
She added: 'But a couple of simply pretty tiered chiffon
dresses, tied with velvet bows – and all those cute
socks – kept the show from stumbling under the
weight of its references.'

Jacobs demonstrated an architectural approach to
fashion in his use of geometric shapes and minimalist
details. The 51 looks evoked the same spirit as the
1960s 'haute athleticism' trend and styles from
André Courrèges' 'space age' collection of 1964.
Courrèges' iconic precision-tailored miniskirts, boxy
jackets, large buttons, white gloves and square-toed
flat shoes were transformed into a lady-like wardrobe
for the 21st-century Louis Vuitton jet-setter. Jacobs was,
like Courrèges, inspired by youth, sportswear and travel.
The *Washington Post* reported: 'The tiers of one mini
seemed to swirl around the model's hips like fashion's
version of the spiraling galleries in Frank Lloyd Wright's
Guggenheim Museum.' The bag collection of the season
was named 'Op Art'.

A sophisticated colour palette was composed of navy
blue, black, purple, grey, white and the same blood-red
colour used in Jacobs's autumn/winter 1999 collection.
Juxtaposing the heavy fabrics and dark colours were
shimmering dresses and embroidery collages presented
'like satellites', according to the show notes.

Jacobs had created a collection for 'modern, strong
and sensual heroines'. It was therefore fitting that the
French actress Catherine Deneuve was seated in the
front row. Paying tribute to her iconic style, Jacobs
presented leopard-printed silk twill dresses and shirts.
Models with long braided ponytails carried disc-shaped
Monogram bags (see p. 149); mink capes, a navy blue
cashmere coat with a beaded collar (right), and a coat
in Monogram vinyl, tweed and mink (p. 146) proved
elegant for this season's heroine.

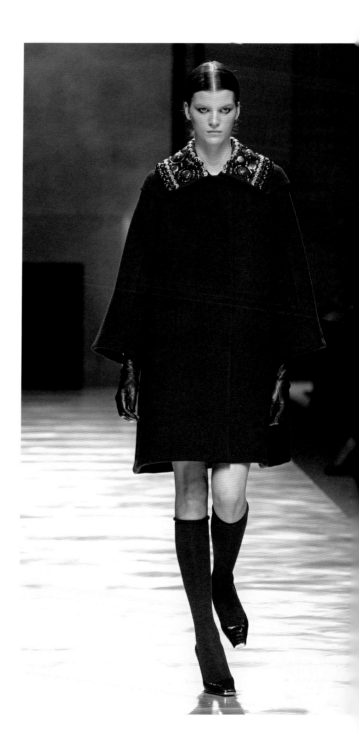

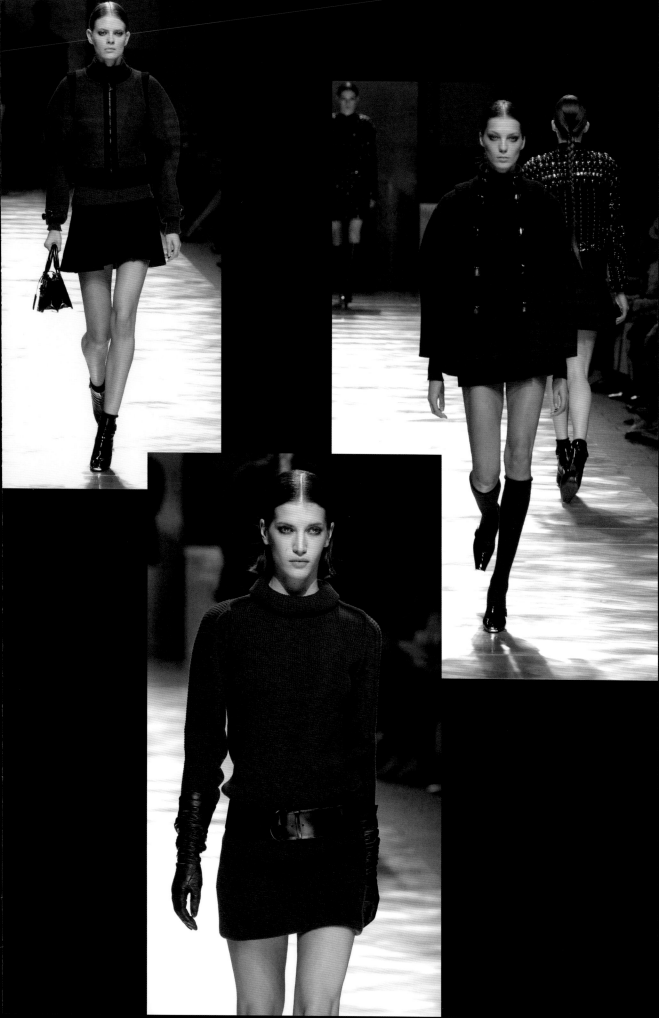

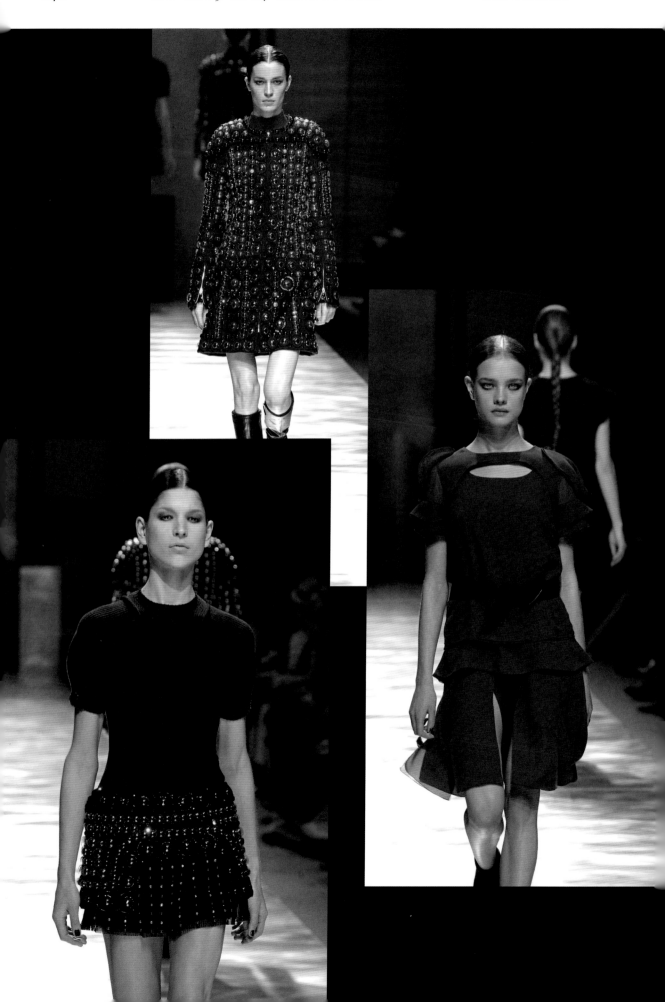

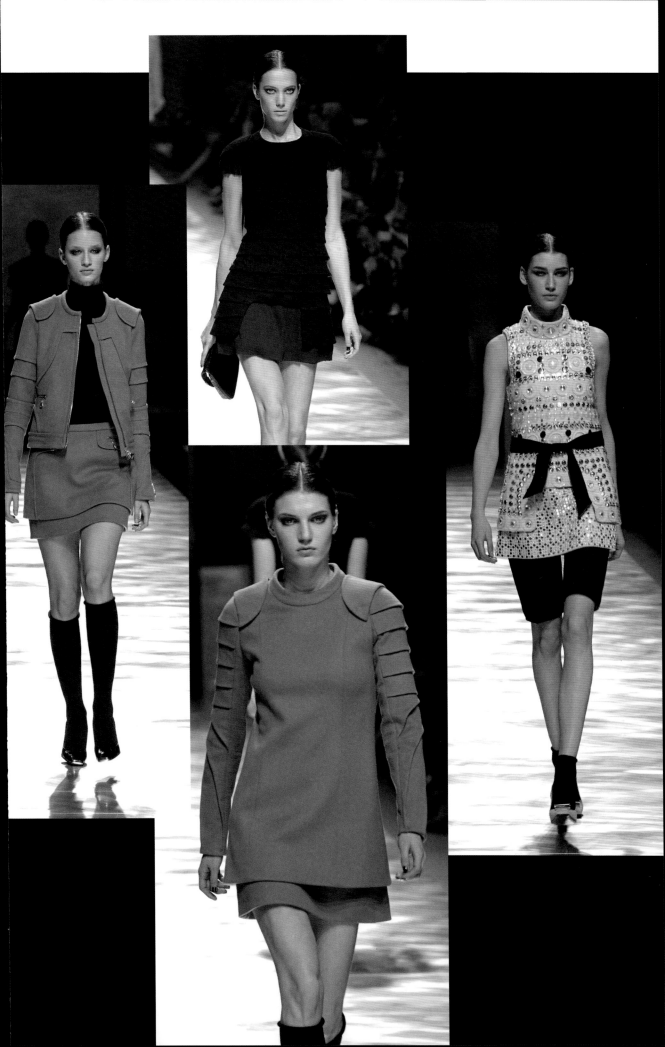

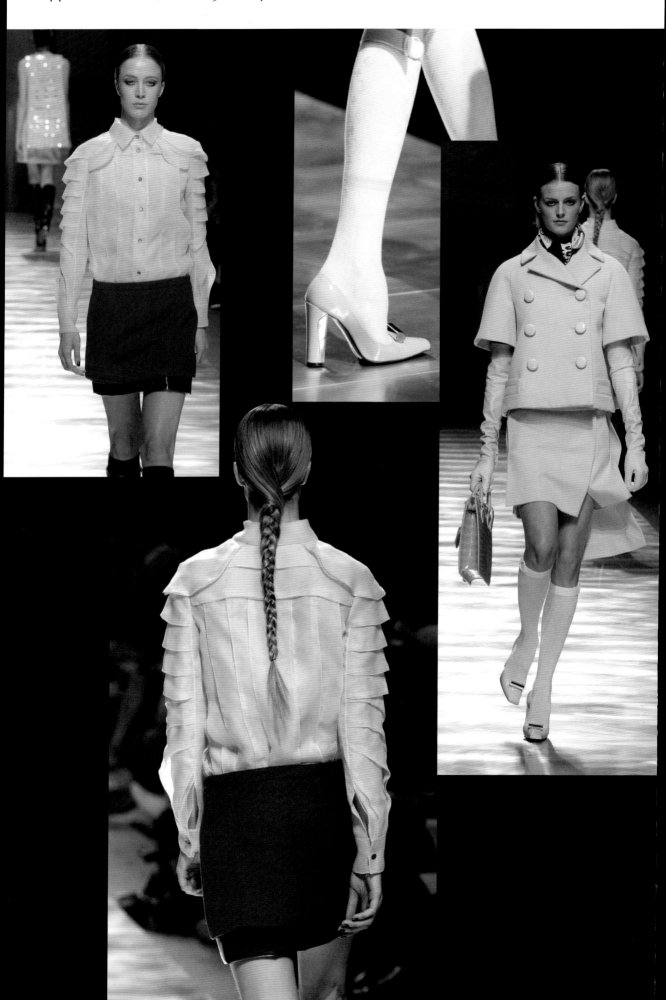

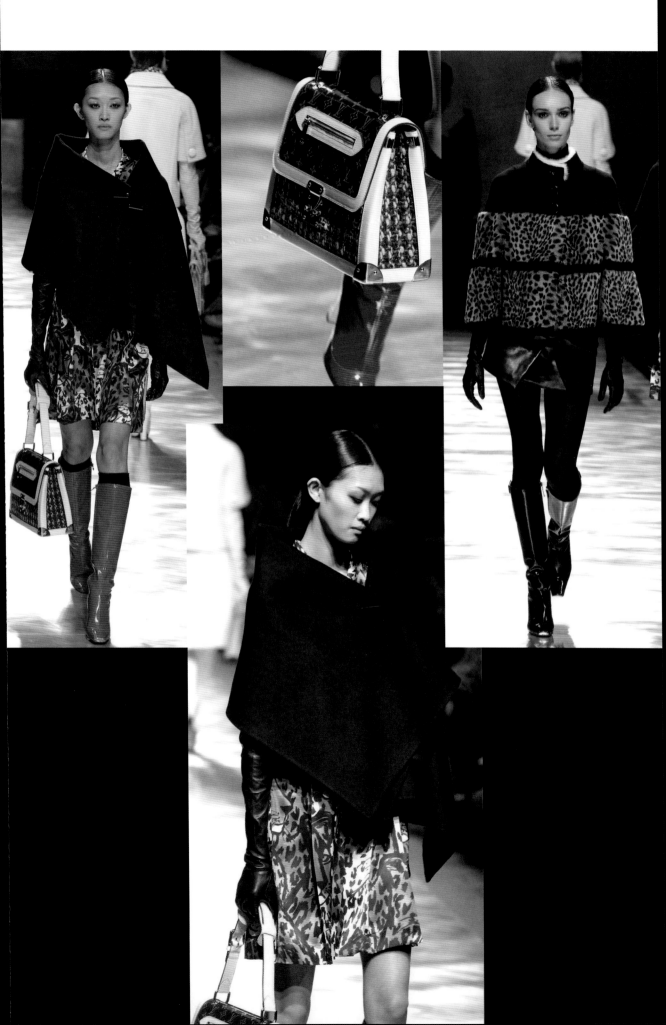

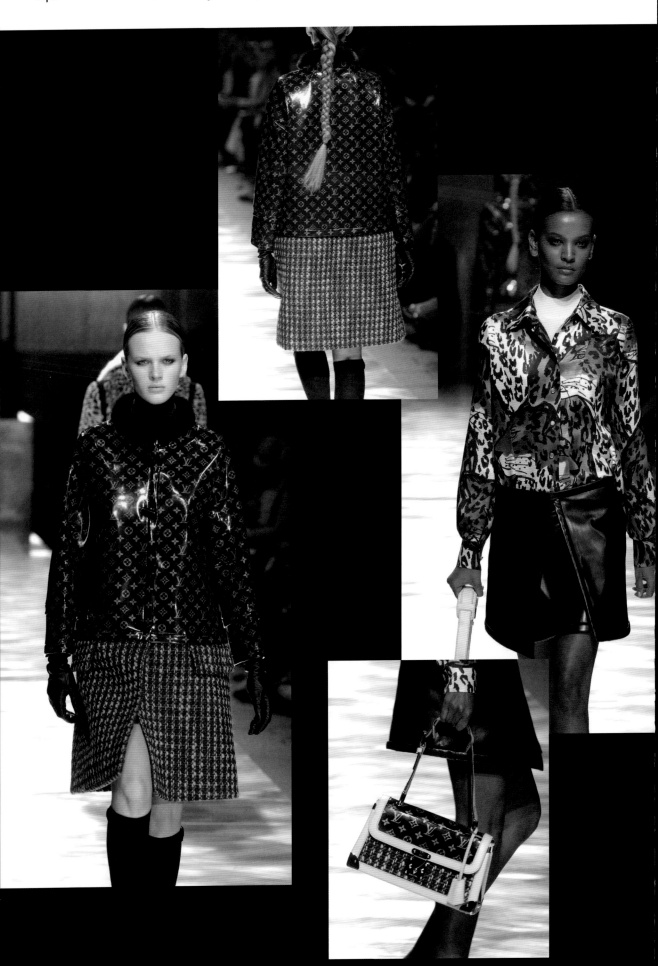

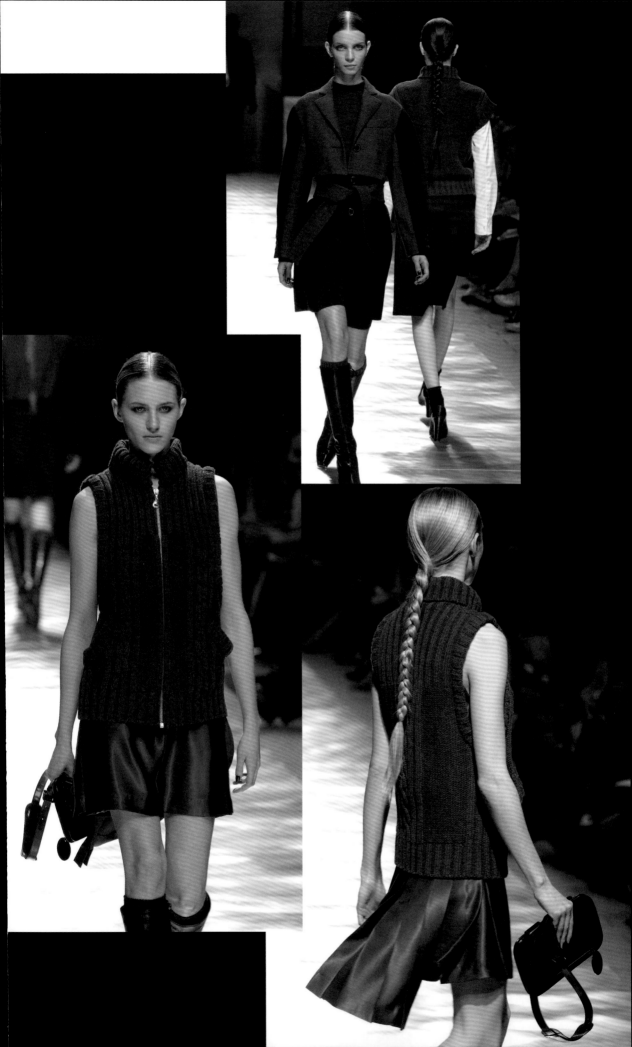

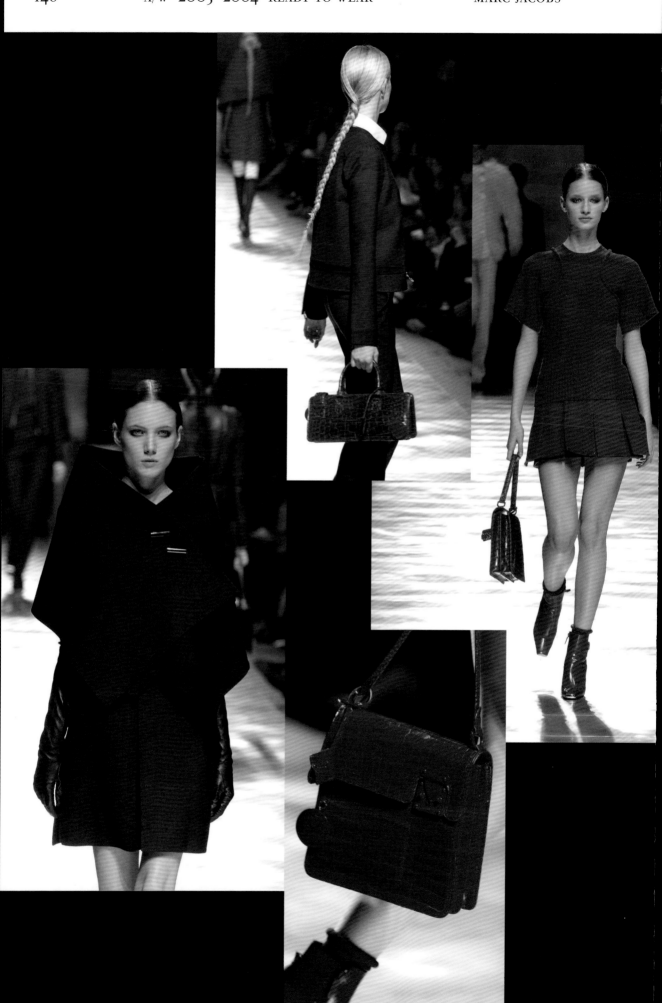

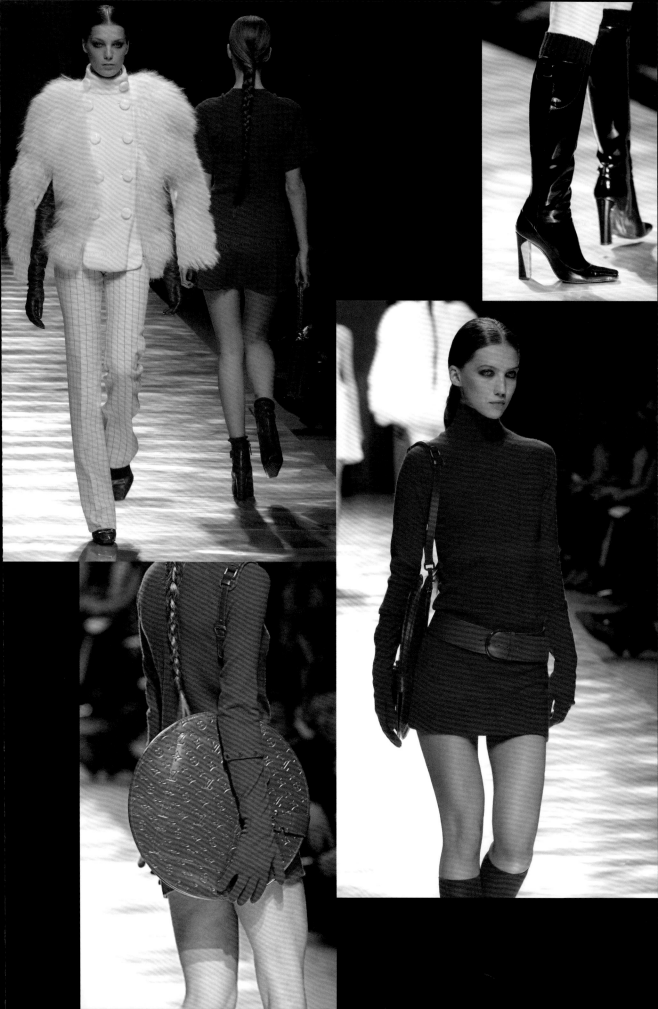

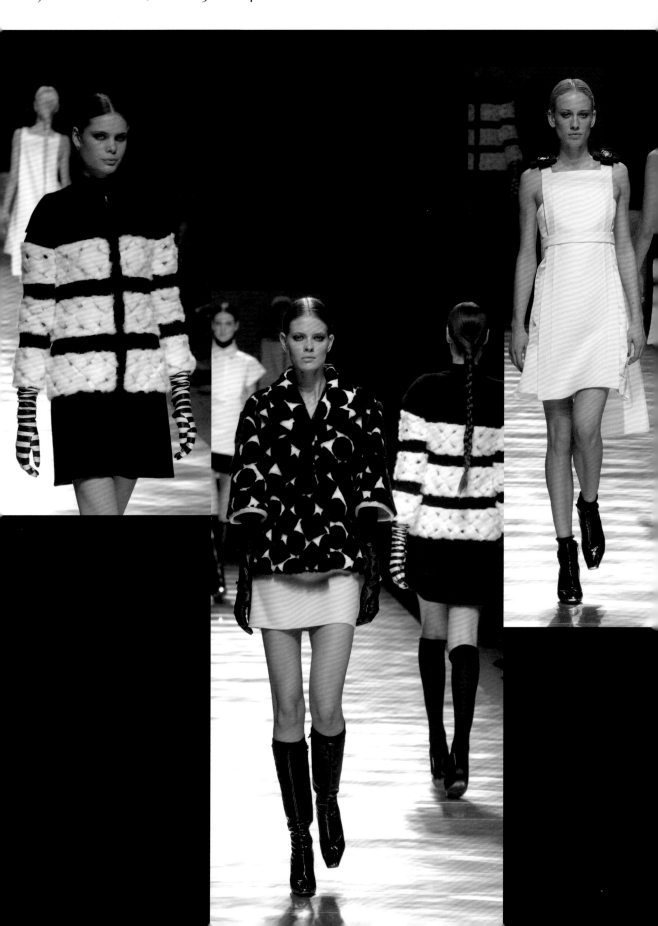

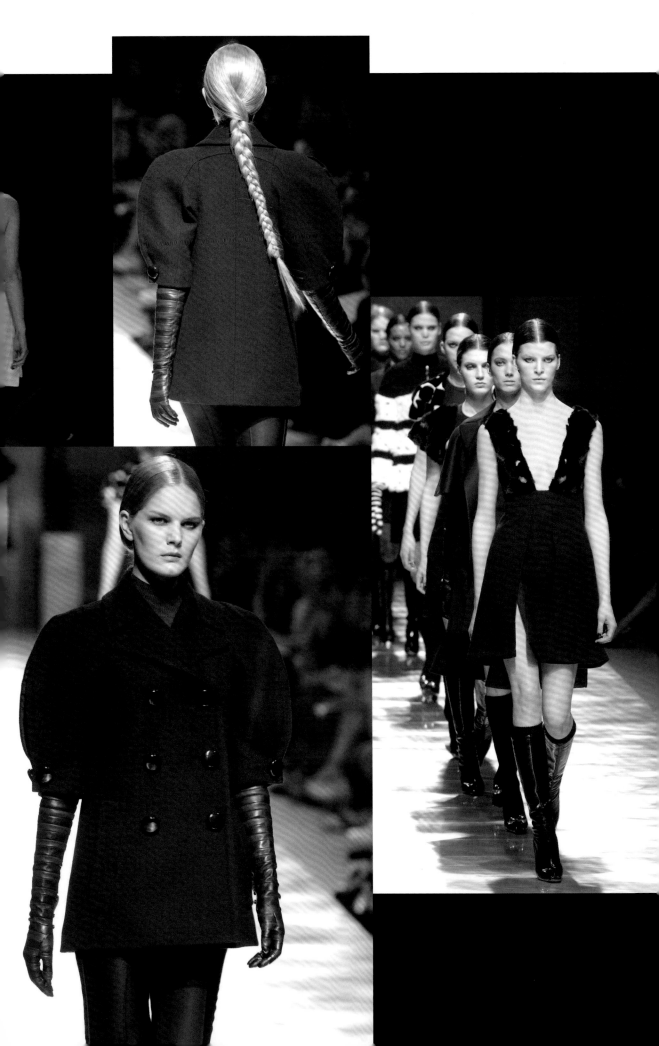

The 'Gold' Collection

Louis Vuitton's 150th anniversary was celebrated with
style in Marc Jacobs's spring/summer 2004 collection,
presented on 12 October 2003. 'The sensation started
the minute the auditorium darkened; music pumped
and a projection of an LV monogram covered the entire
space including the figure of the first advancing model
[right],' wrote *Vogue*'s Sarah Mower. 'She was ... carrying
one of the neat new LV monogrammed bags (this season,
its chunky straps are picked out in juicy colors or gold).'

Gold was the presiding theme of the collection, which,
the show notes stated, was 'a true fireworks display
of wealth, glamour and dreams, presenting a wardrobe
for modern goddesses, inspired by 1950s Hollywood
blockbusters and the ostentation of Cleopatra's court'.
Another key influence was the style of pin-up showgirls,
seen in satin pyjama shorts and bras inspired by
Brazilian carnival ensembles. The theme of travel
was presented in the spirit of 'yachting', with sailor
trousers and sweaters. Adding a youthful attitude to
the looks were bows, draped roses on dresses, and
knitted fingerless gloves with pearls.

Separates in technicolours and Egyptian-fresco-inspired
shades were styled with sparkling accessories from head
to toe. There were gold platform Spartan sandals, hoop
earrings with pearls, 'Louis Vuitton' charm necklaces and
gold leather straps on canvas bags. The closing look was
worn by Jessica Stam, who had been transformed into a
21st-century Cleopatra. Her short black bob juxtaposed
her shiny gold ostrich coat and sparkling 'Ruffled' bag
with padlock and minuscule Vuitton lock chain.

Cathy Horyn of *The New York Times* wrote: 'This
collection worked because the combinations were so
offhand and the details so refined (a pink sweater with
feathery sleeves, cotton shorts striped at the hem in
velvet) that Mr. Jacobs kept you constantly guessing
where he was going.' The message of the show was,
according to Jacobs, simply to 'Dress up!'

Celebrating the DNA of the house, the monogram
appeared throughout the collection: lace chokers,
lace layers over white silk shorts, silk cummerbunds.
The Trianon canvas, originally created in 1854, was
transformed into a chic 'Express' handbag with a
contrast-colour label and straps (see, for example,
p. 156, top). Taking inspiration from 150 years
of meticulous craftsmanship, materials and design,
Jacobs also showed a dazzling collection of hip
monogrammed handbags in an array of colours
and shapes, including the Leonor (p. 157, bottom left)
and the Theda (p. 160, top right).

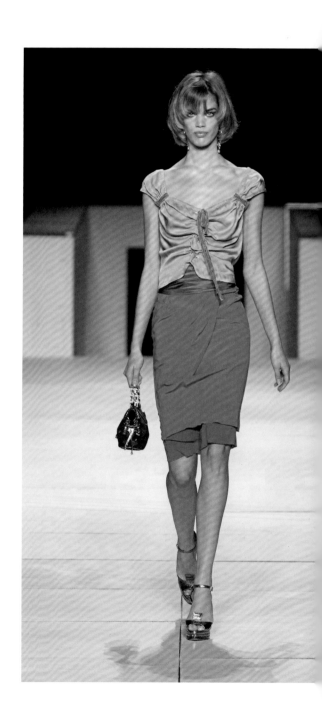

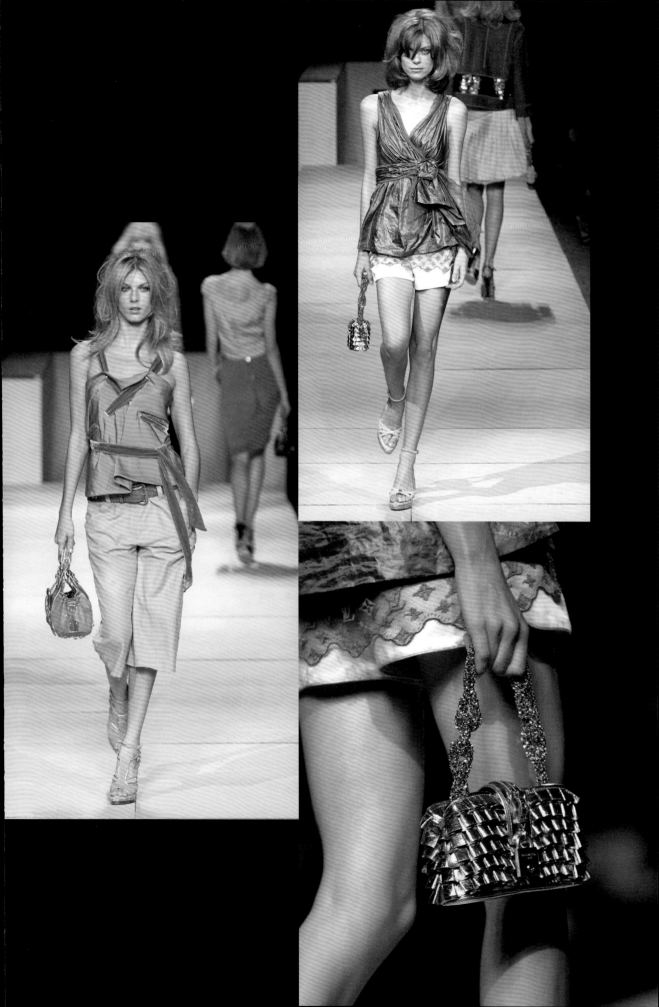

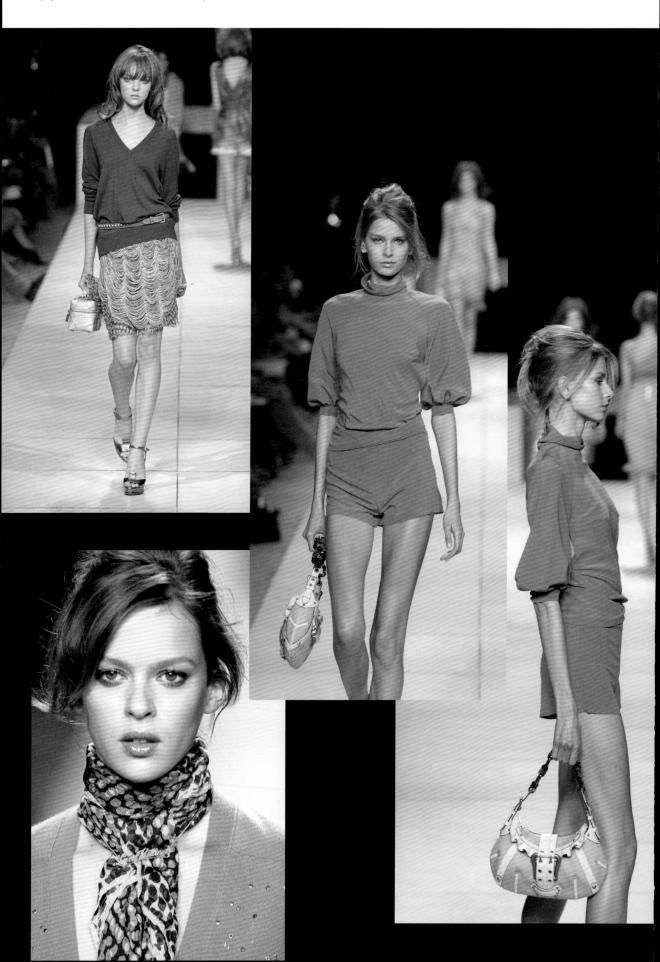

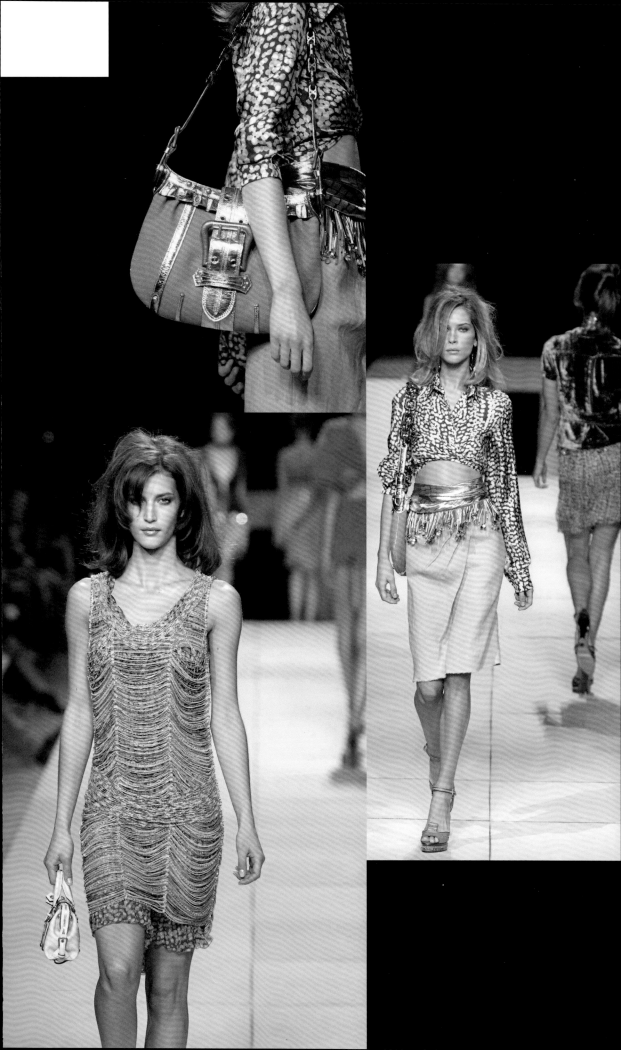

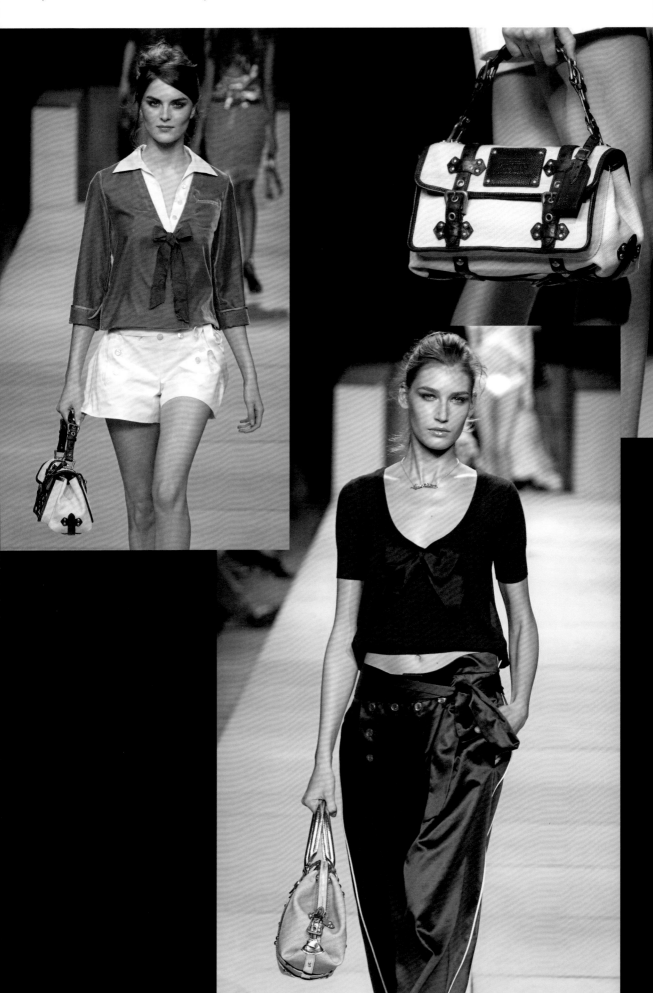

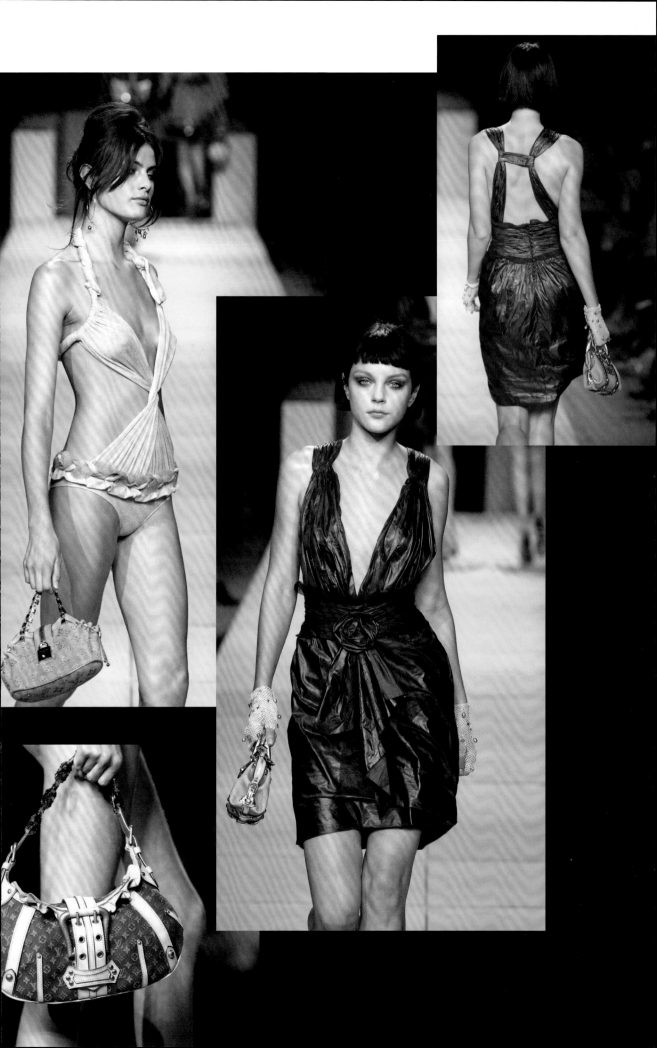

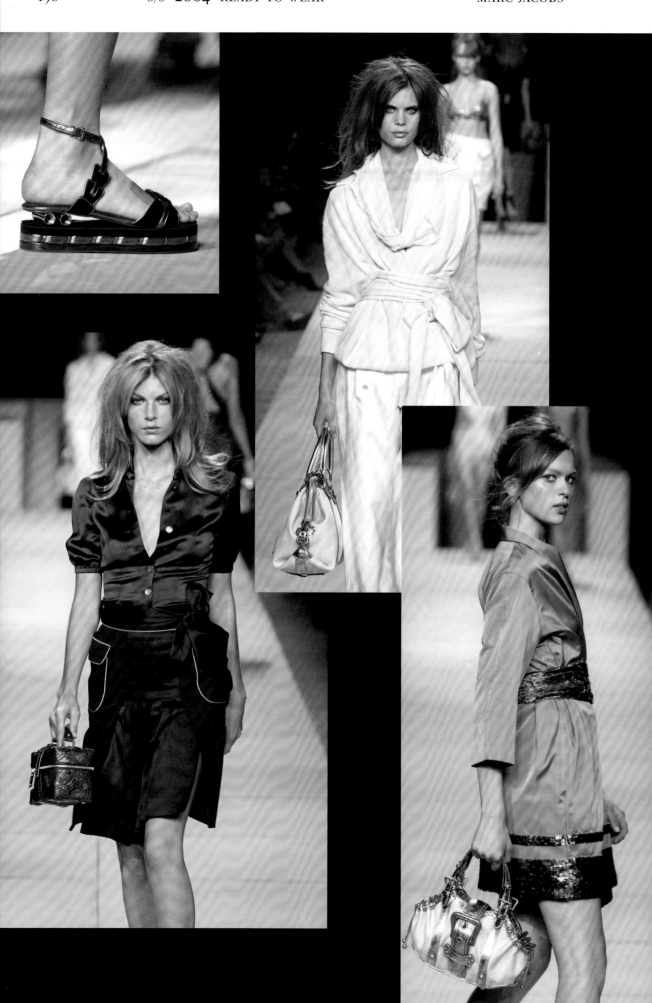

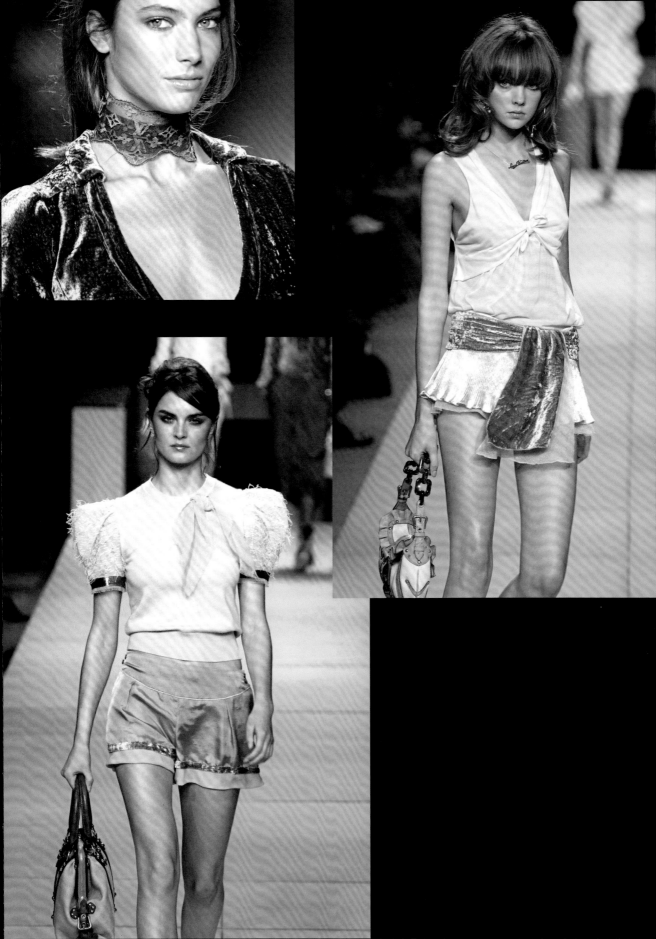

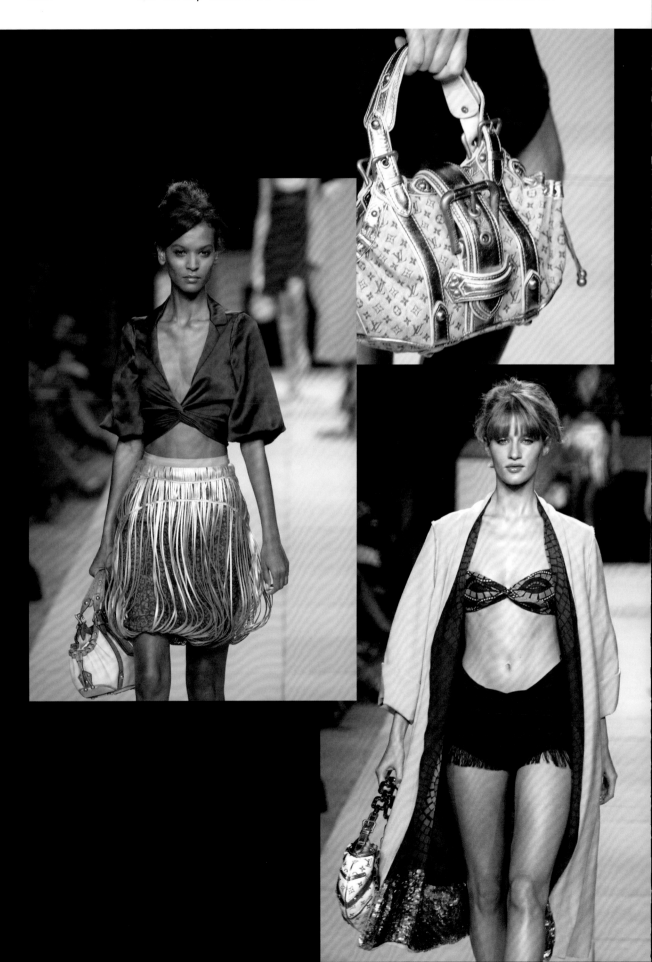

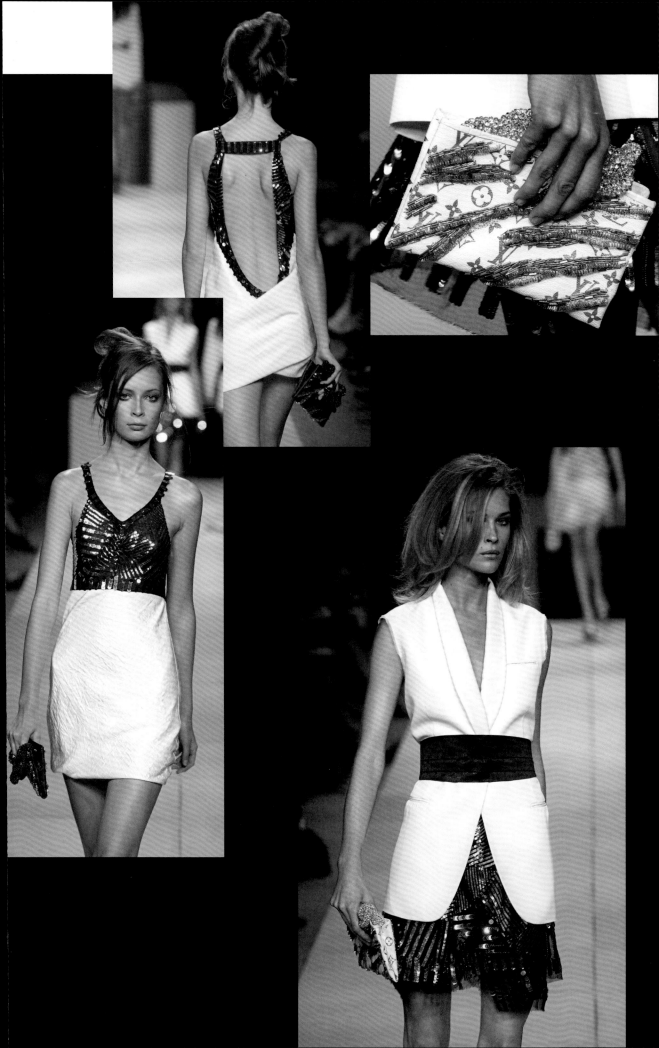

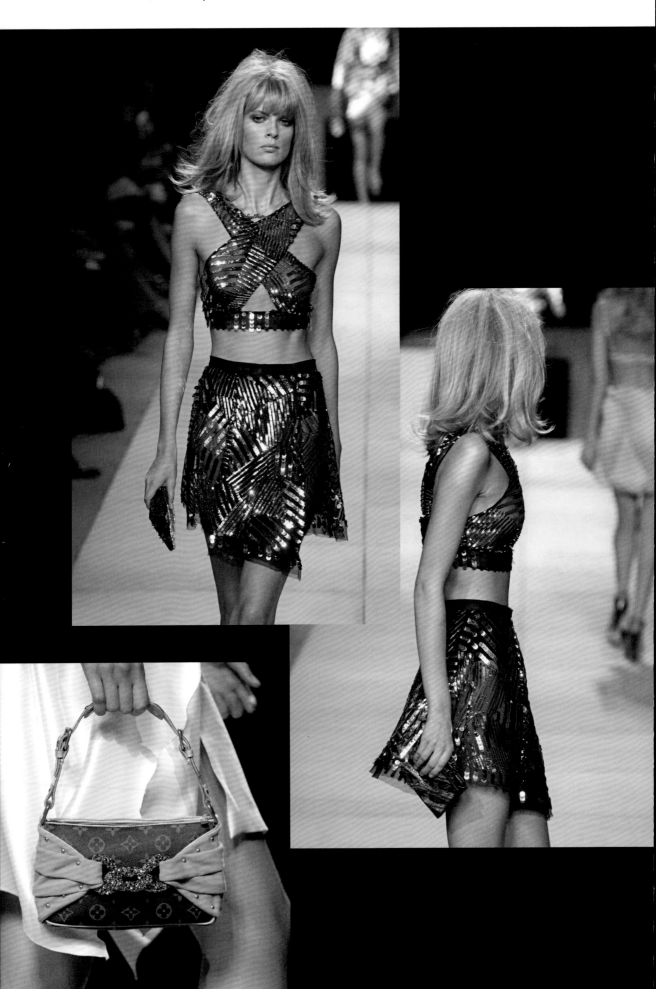

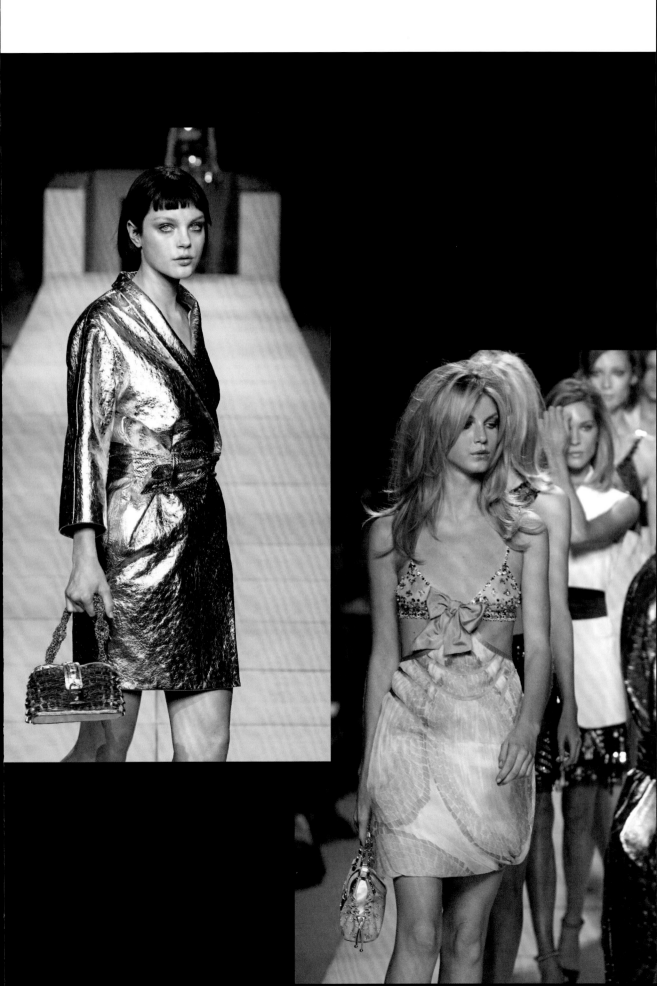

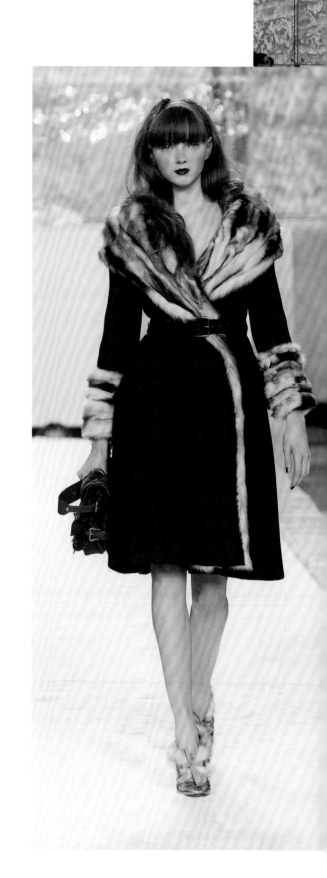

Tweed & Tartan Romance

With its snow-covered catwalk, the Parc André-Citroën greenhouse venue was transformed into what Marc Jacobs called 'something very special and magical and wintry'. 'All this ice and snow and frost on the windows, girls with pale complexions, flushed cheeks and red lips': the Louis Vuitton woman was clearly embarking on a journey to a cold, romantic destination for autumn/winter 2004. Lily Cole opened the show (right), wearing a tartan blanket coat with a fitch collar and cuffs, and carrying a sumptuous Monogram Velours bag (see also p. 167, top right).

Jacobs noted: 'My team ... set off to Scotland, they came back, in love with the staid tweeds and the richness of the tartans, and jewel colours, mixing textures of wools and ... military-type felts, mixed with very opulent piles.' Tartans appeared, reworked and variously treated, in chiffon, taffeta, silk and wool, and Chinoiserie prints were teamed with tweeds. 'We also looked at the work of Schiaparelli,' said Jacobs, 'we looked at '50s couture, we looked at 18th-century bustles and frills.'

The 37 models wore 54 looks that evoked the romanticism of Scotland, Victorian gothic glamour, and paintings of young women by James Tissot and Tsuguharu Foujita. The spirit of the show was presented through Frédéric Sanchez's mix of 'Seven Nation Army' by The White Stripes (drummer Meg White's dark glamour was another of Jacobs's inspirations for the collection), 'Foxy Lady' by Jimi Hendrix and 'Material Girl' by Madonna.

The collection demonstrated Jacobs's flair for mixing style references, fabrics and colours, and his devotion to empowering women through the joy of dressing up. The jewelry updated the concept of family jewels, with cocktail rings, charm bracelets and chokers featuring punk-style safety pins. Striped patterns on blouses evoked the Louis Vuitton Rayée canvas, and the Monogram was shown on a mink scarf (p. 171, bottom left) and an array of bags. Jacobs explained: 'There were some trompe l'œil bags, which was a bit of a wink at Schiaparelli's first trompe l'œil sweater. There were some beautiful rich-coloured, jewel-coloured carpet bags with really heavy heads of brass buckles... There were game bags, needlepoint bags, very grandmotherly with embroidered roses on them and things like that.' The collection also included Monogram Vison in winter mink (p. 166).

This collection was dedicated to the memory of Stephen Sprouse, who had helped redefine Louis Vuitton for the 21st century with his graffiti bags (see p. 84).

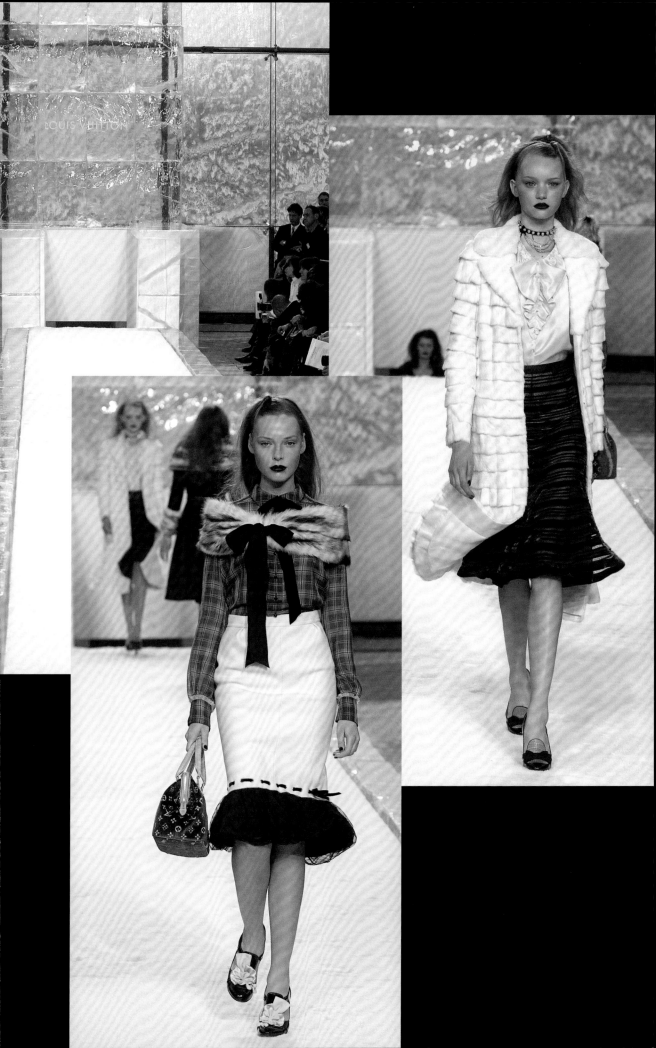

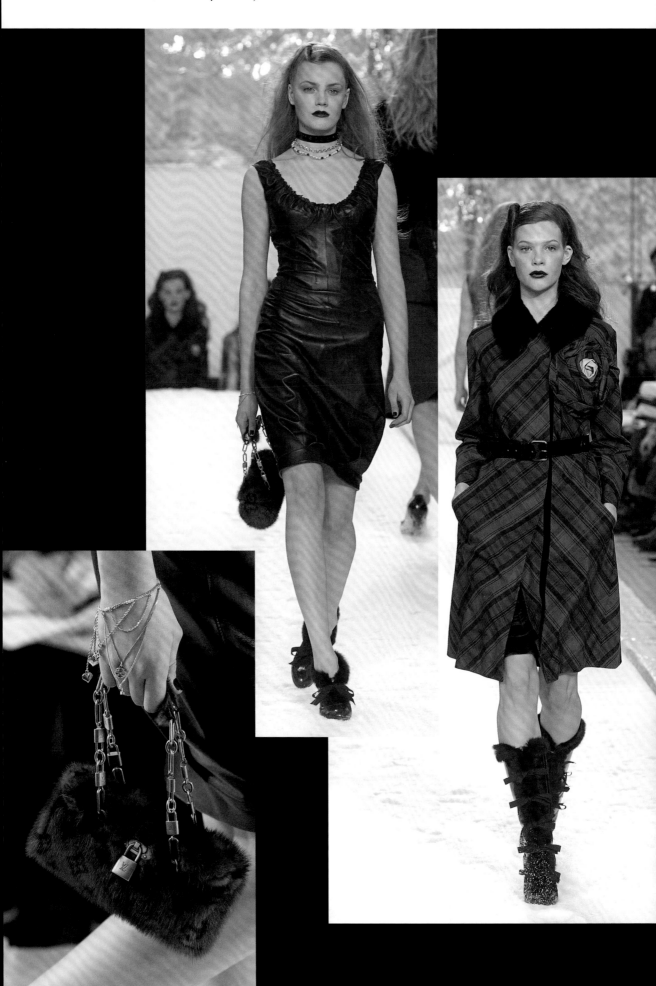

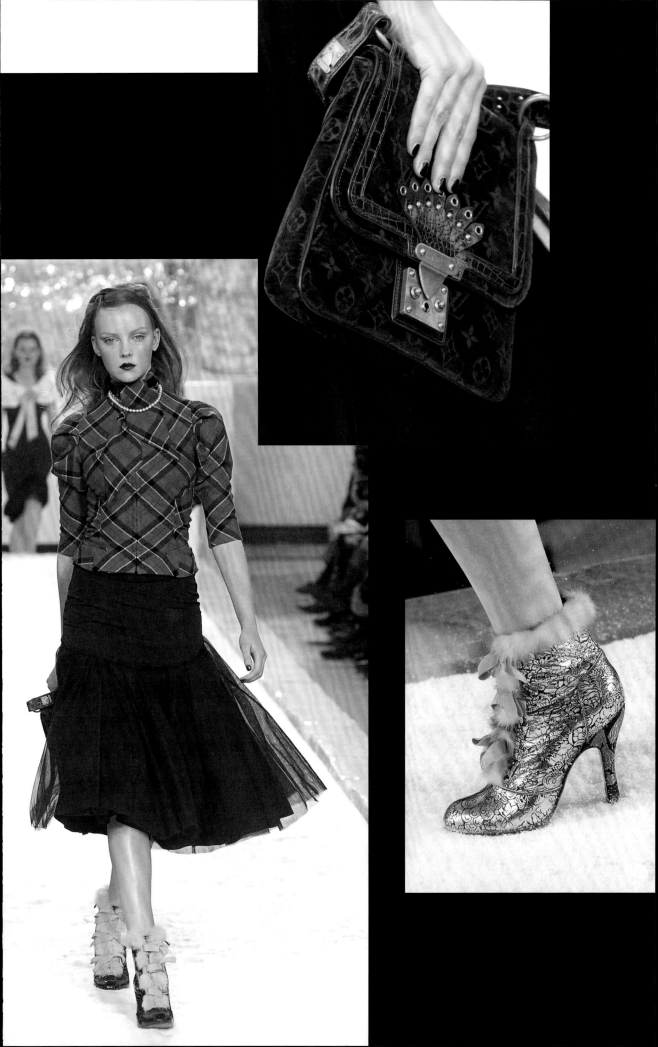

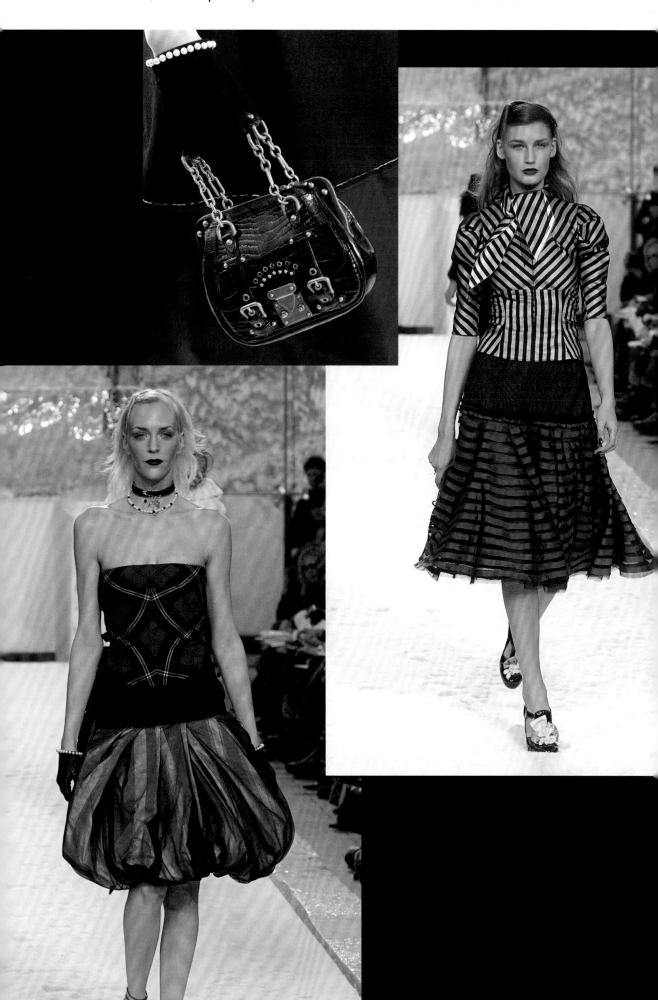

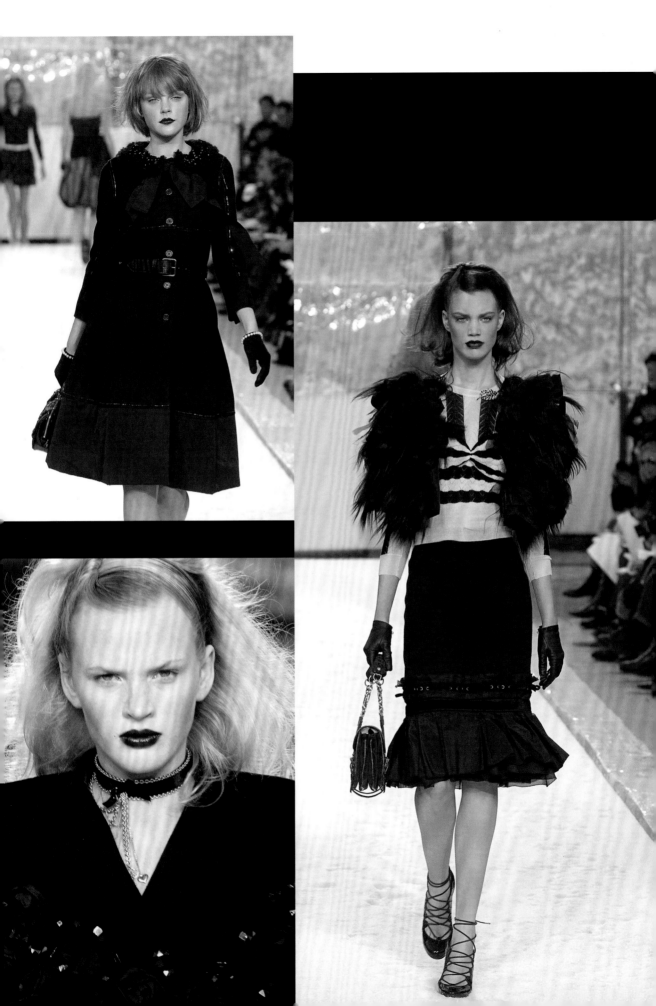

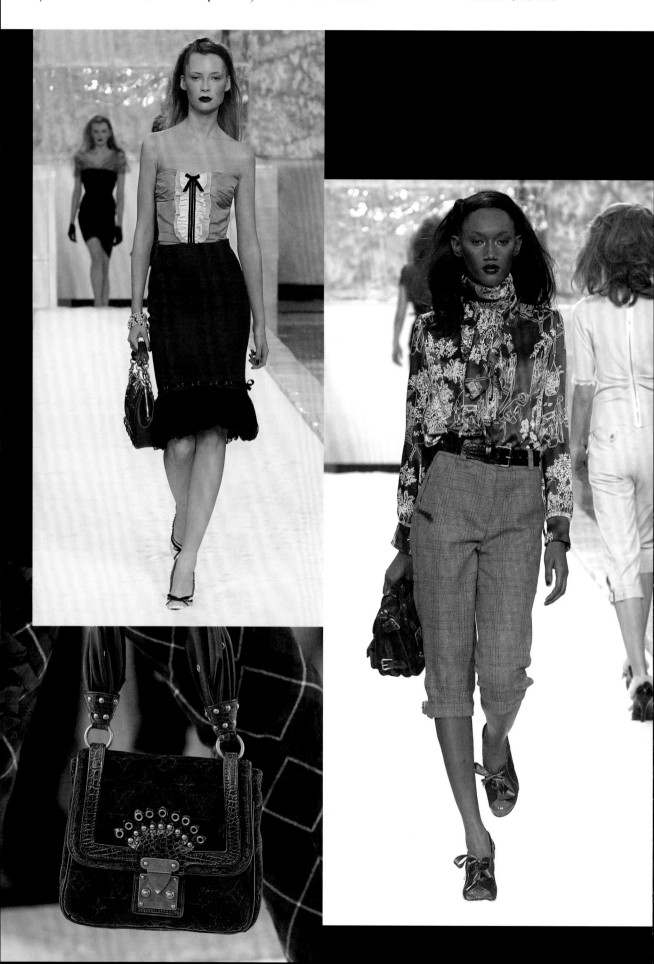

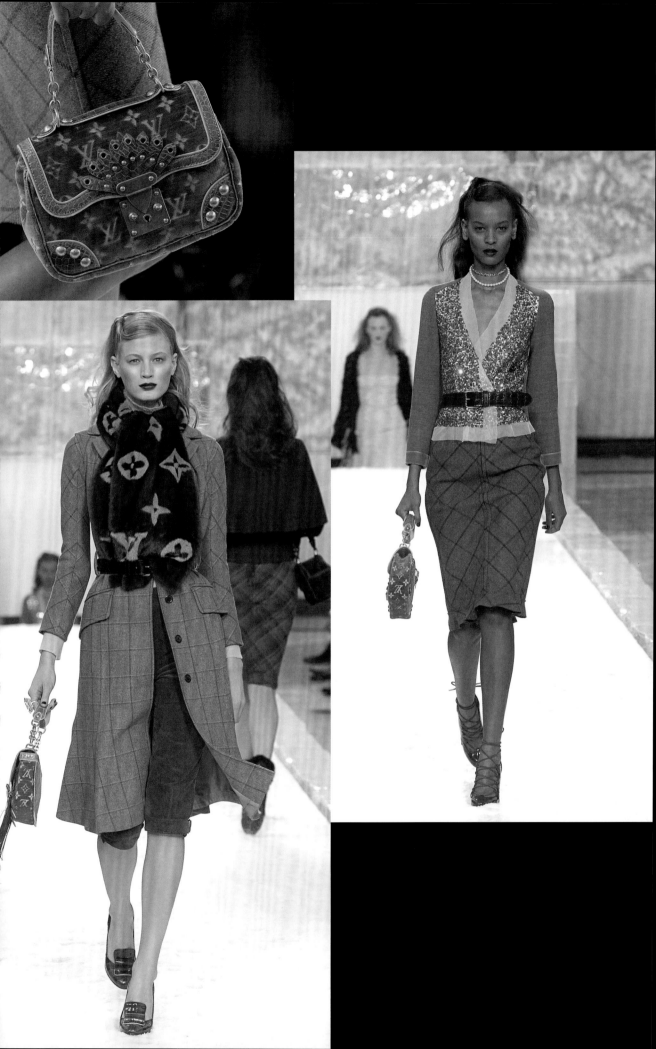

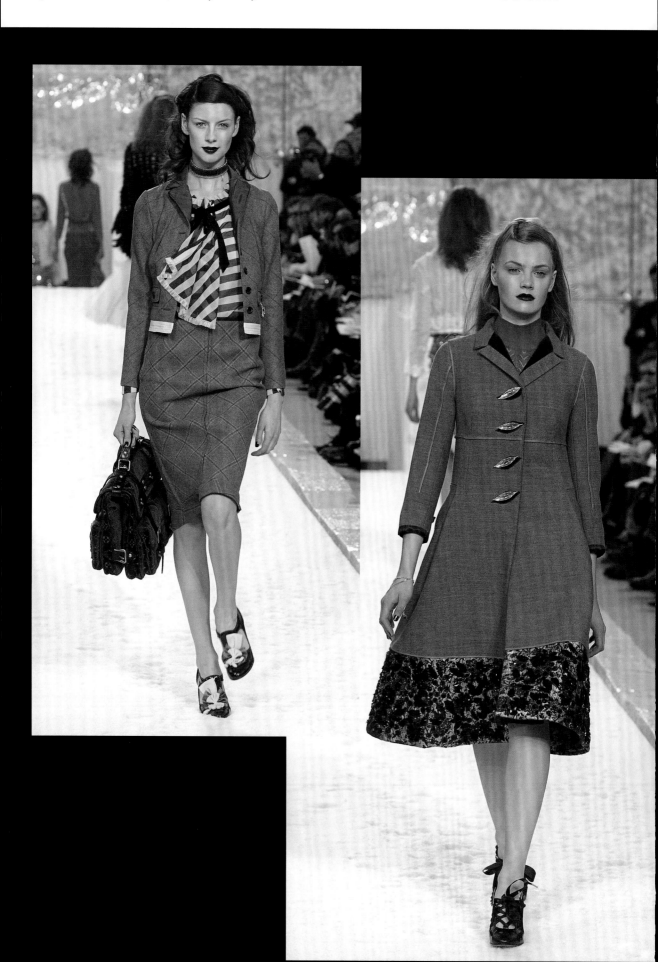

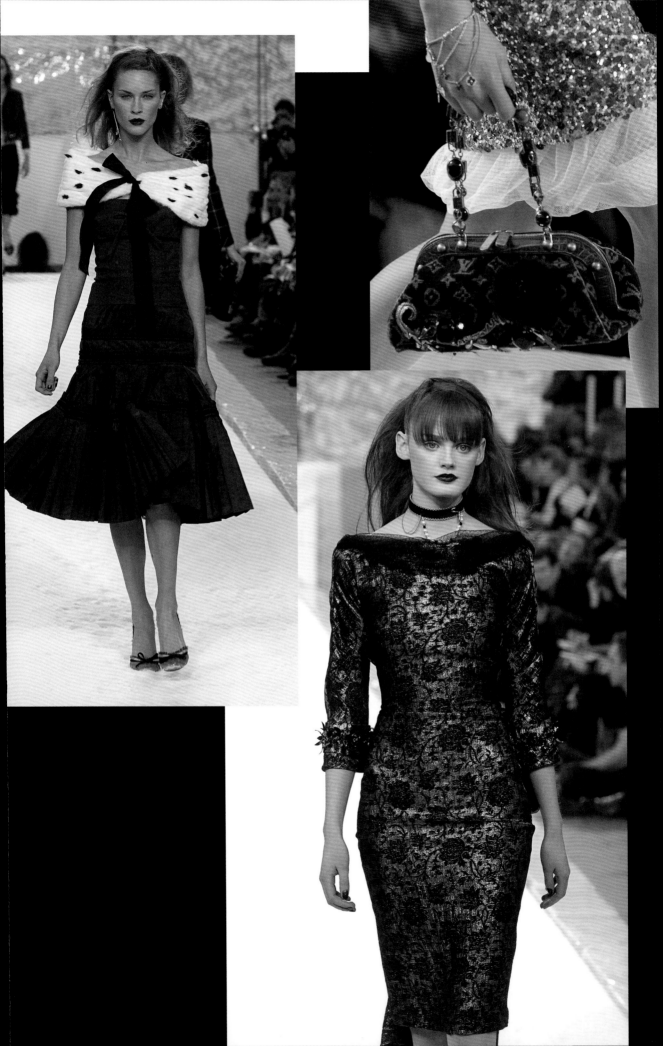

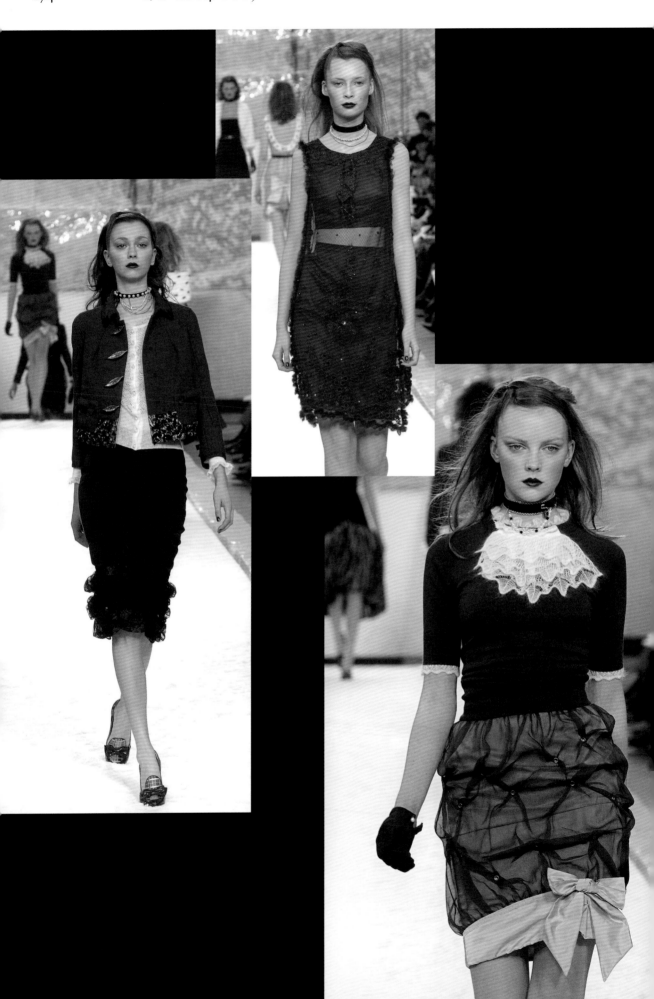

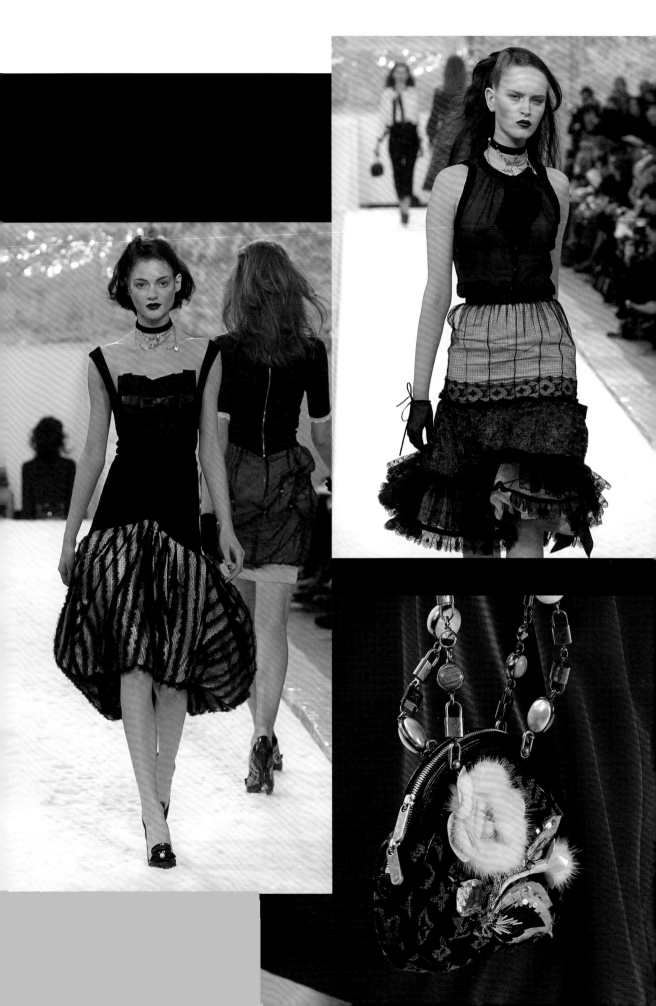

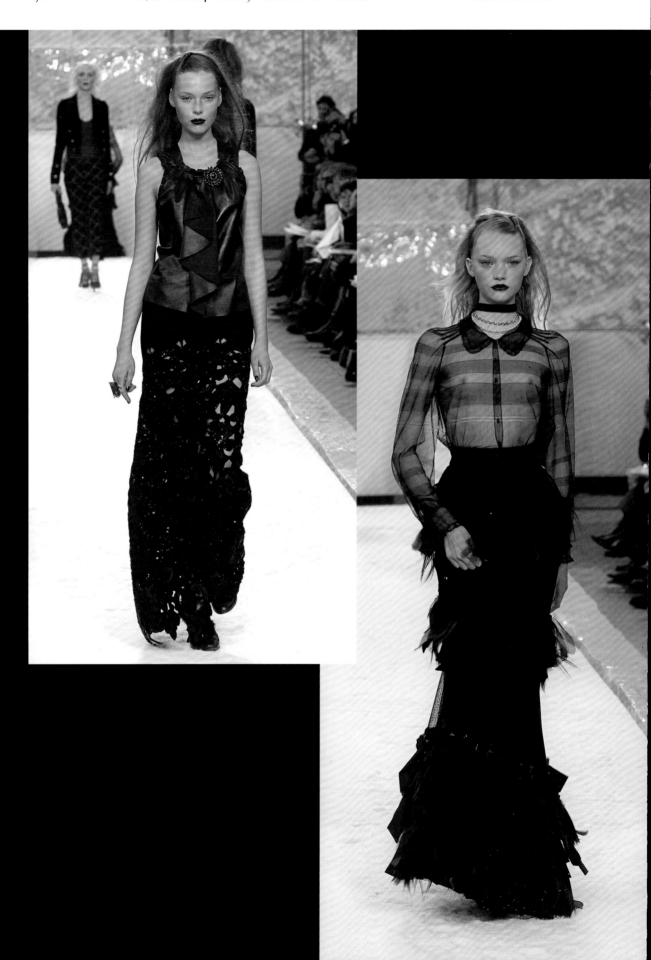

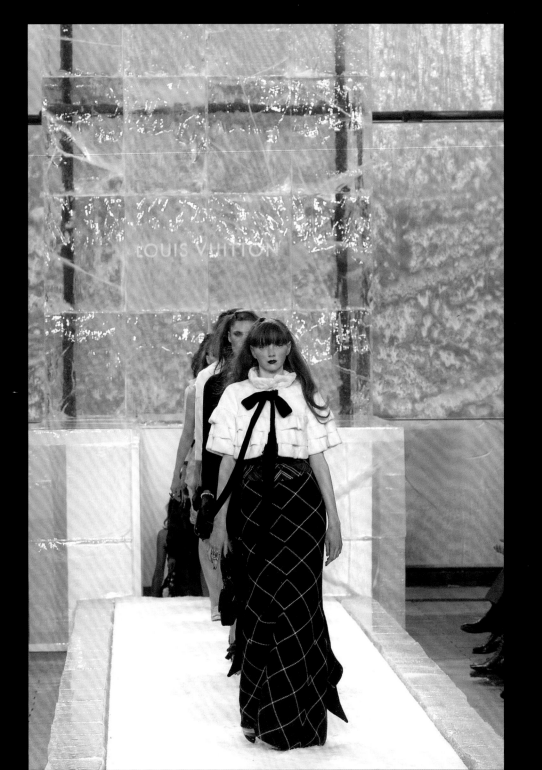

Hollywood Glamour

Revisiting his fascination with Hollywood glamour, Marc Jacobs chose a cinematically lit backdrop for his spring/summer 2005 collection. In perhaps a nod to the house's impressive history of clients and the world's increasing interest in celebrity culture, the show saw famous faces on the front row including Pharrell Williams and Christina Ricci. The American musician had co-designed a range of sunglasses for the house, with a fully integrated hinge system inspired by the S-lock hardware used to secure Louis Vuitton's leather goods. *Vogue* noted that the colourful eyewear collection featured 'plenty of gold detail'. Ricci, before taking her seat in the audience, opened the show wearing a black crepe jacket, stretch skirt and white pumps, and carrying a crocheted white Monogram bag (right).

The show notes stated that the collection offered an 'ultra-feminine, fresh look for the upbeat woman' going on a 'colour-packed, feel-good voyage'. Inspired by the model Querelle Jansen's off-duty vintage style (she also modelled in the show; see p. 180, bottom) and circus images from the 1940s, Jacobs presented 53 vivid looks in a playful glam-rock colour palette. In addition: 'Ballerina skirts make their way into summer, delightfully full and incredibly feminine, teamed up with little tailored tops boasting puff sleeves and Claudine collars. Skirt suits also take the stage... The trouser makes no appearance in the collection whatsoever, moving over to make room for breeches and an ultra-sexy pair of shorts in monogrammed denim.'

Jacobs stated: 'This collection has a lot of references to the Forties, the Fifties, the Seventies, and Eighties.' Emphasizing a rockabilly attitude were headbands, ankle socks, and blouses tucked into swinging circle skirts. Glamour was added with the new retro '70s sunglasses, Art Deco-inspired costume jewelry, and mesmerizing embroideries, sequins, pleats, frills, glitter and patchwork. Putting New York street style in the mix, the striking Louis Vuitton monogrammed denim was made into skirts, jackets and handbags.

The array of new accessories included the cheerful it-bag of the season, the Cherry Monogram by Japanese artist Takashi Murakami (see p. 180, top left and right, and p. 181, left; see also p. 128). For the Monogram Jean bags, with their vintage feel (see, for example, p. 191), the house teamed its denim with vibrant red alligator.

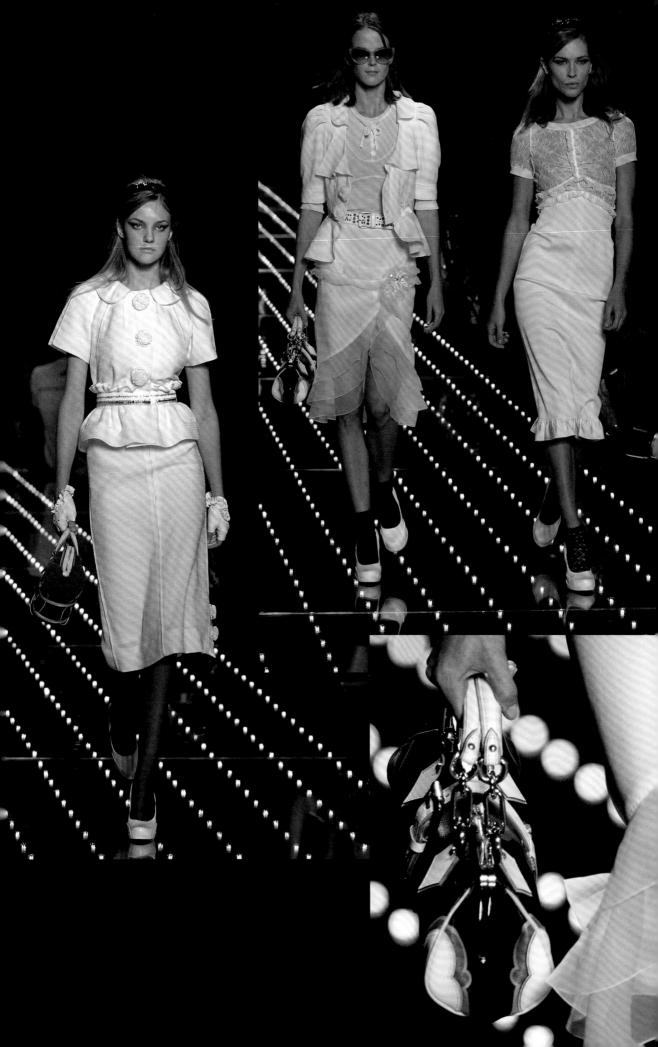

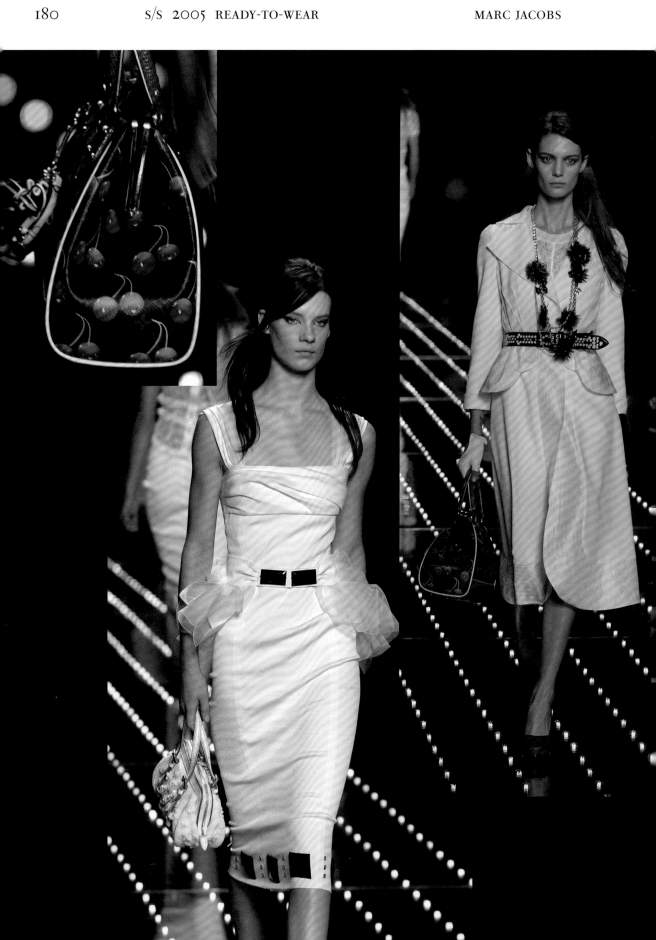

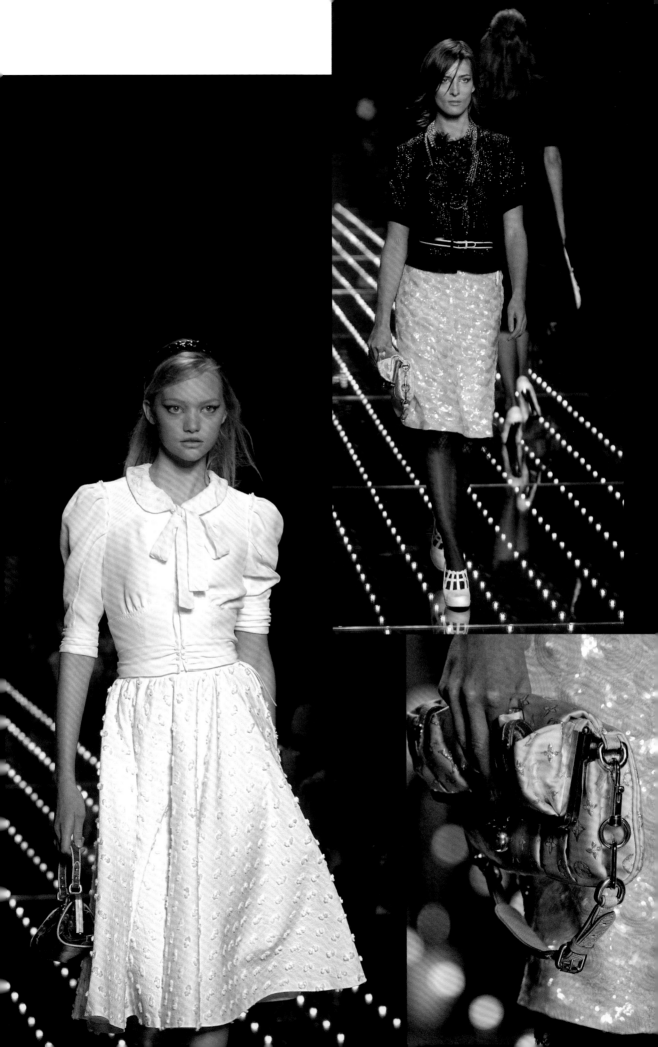

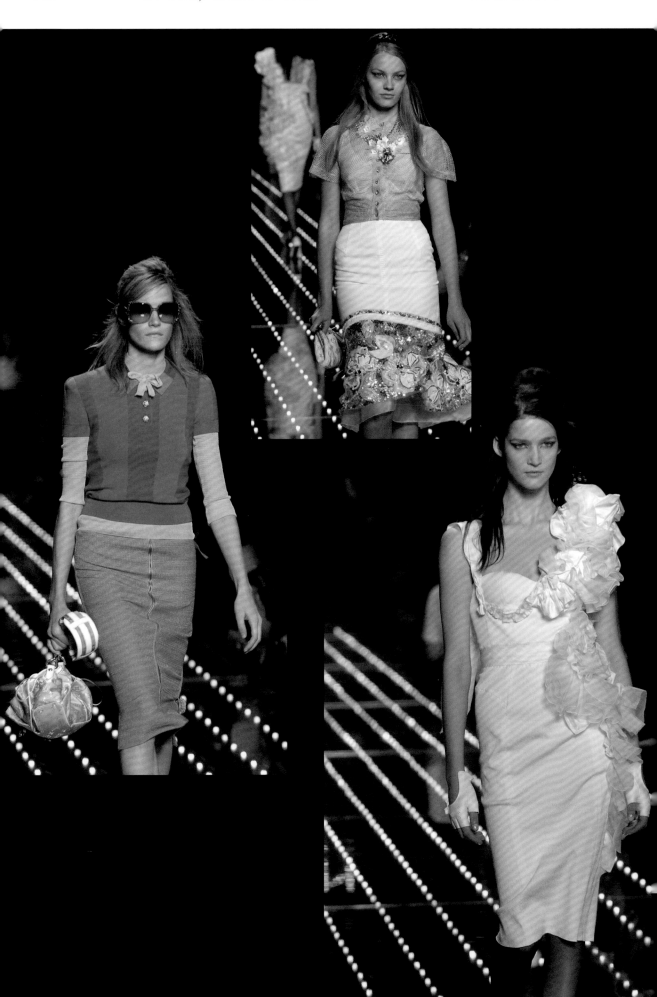

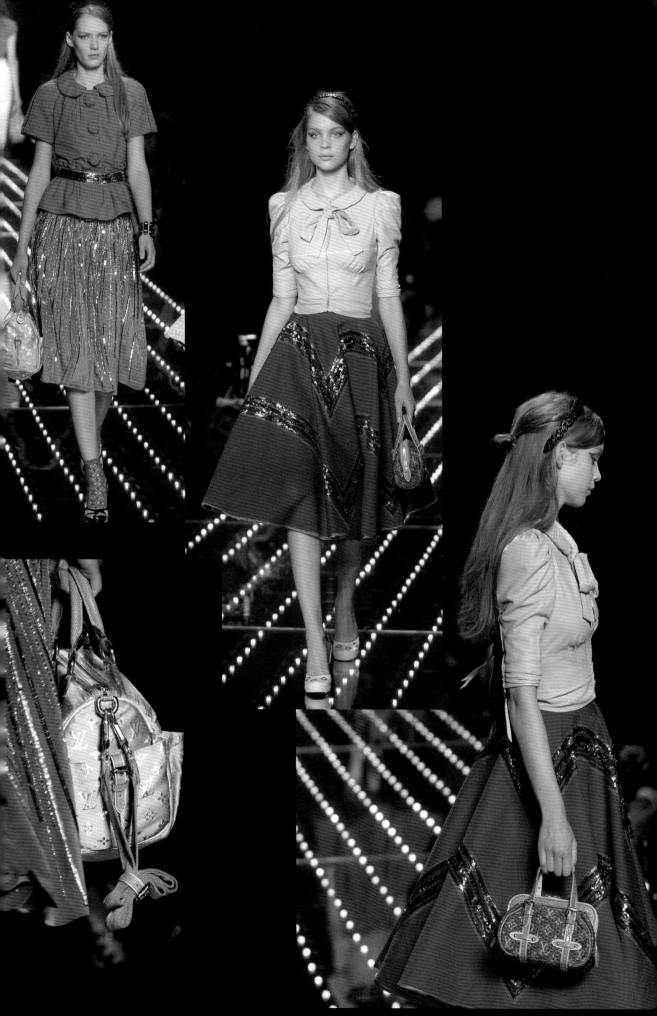

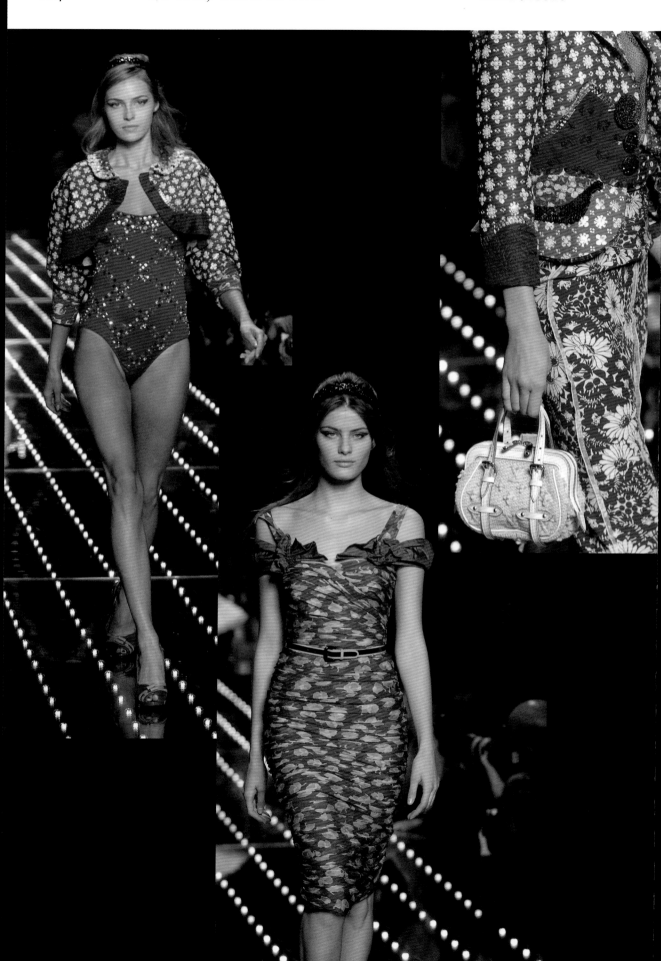

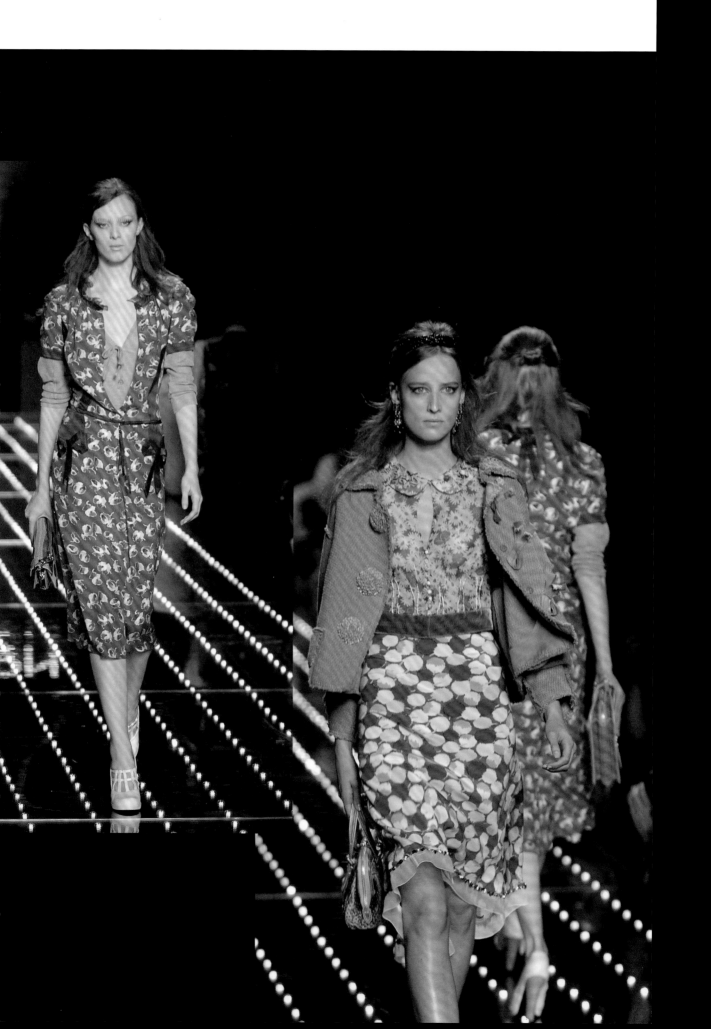

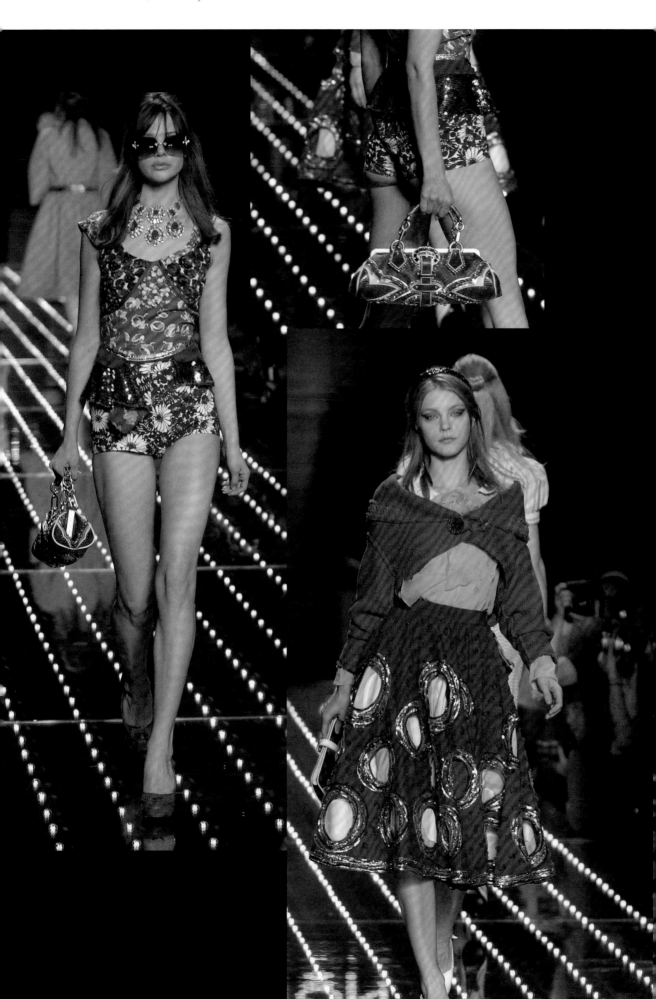

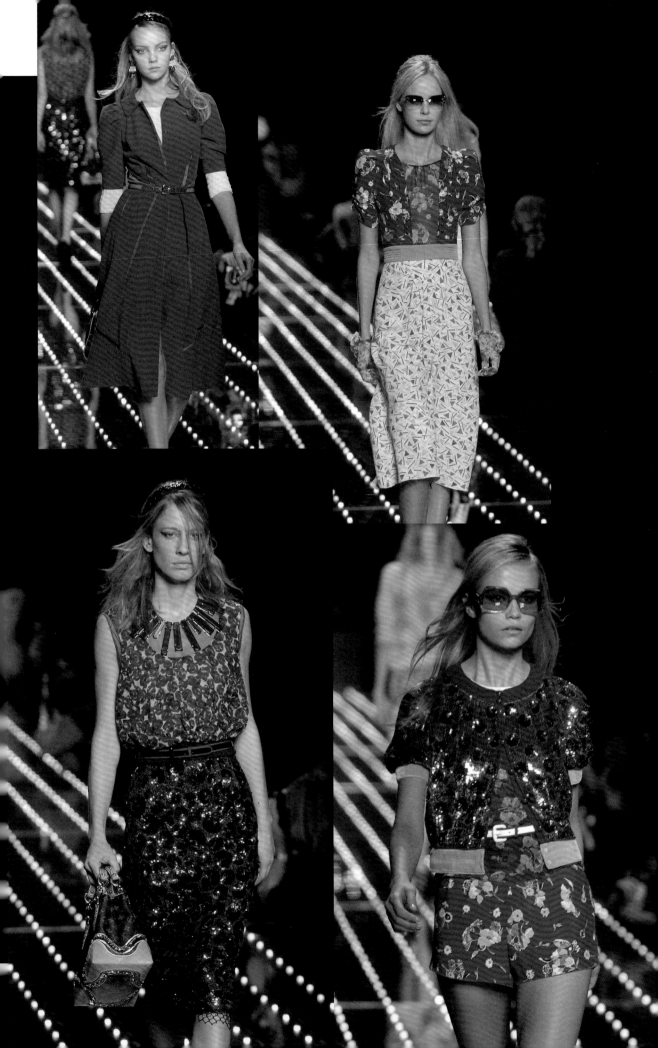

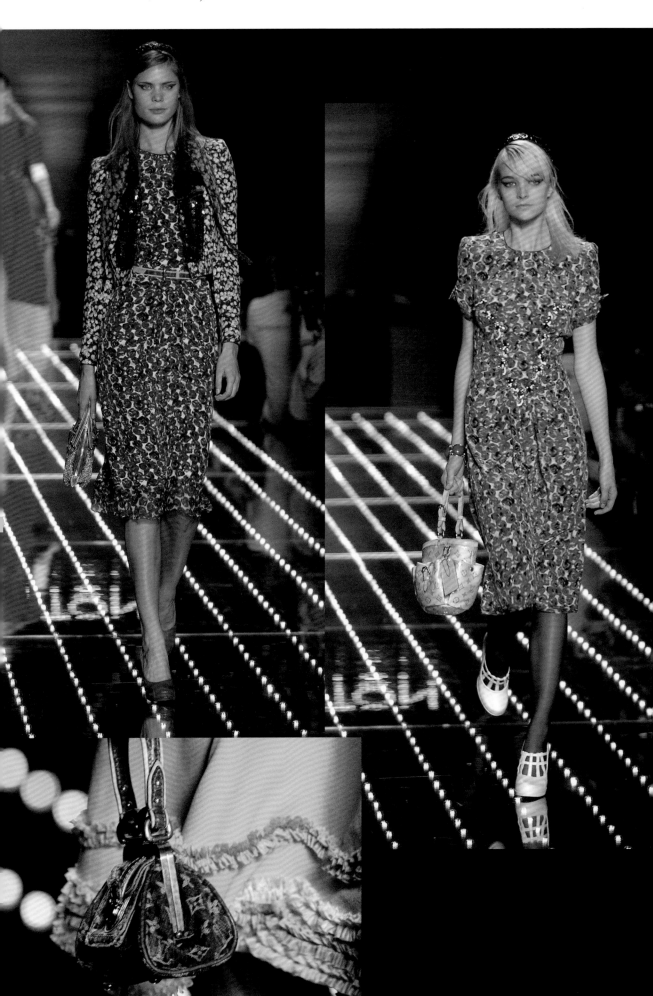

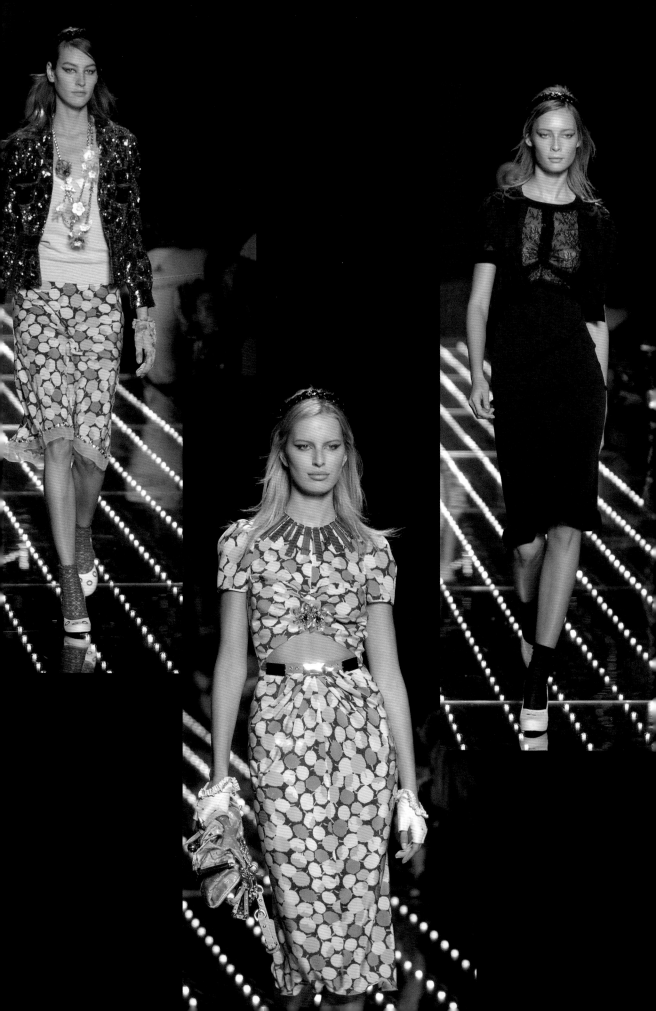

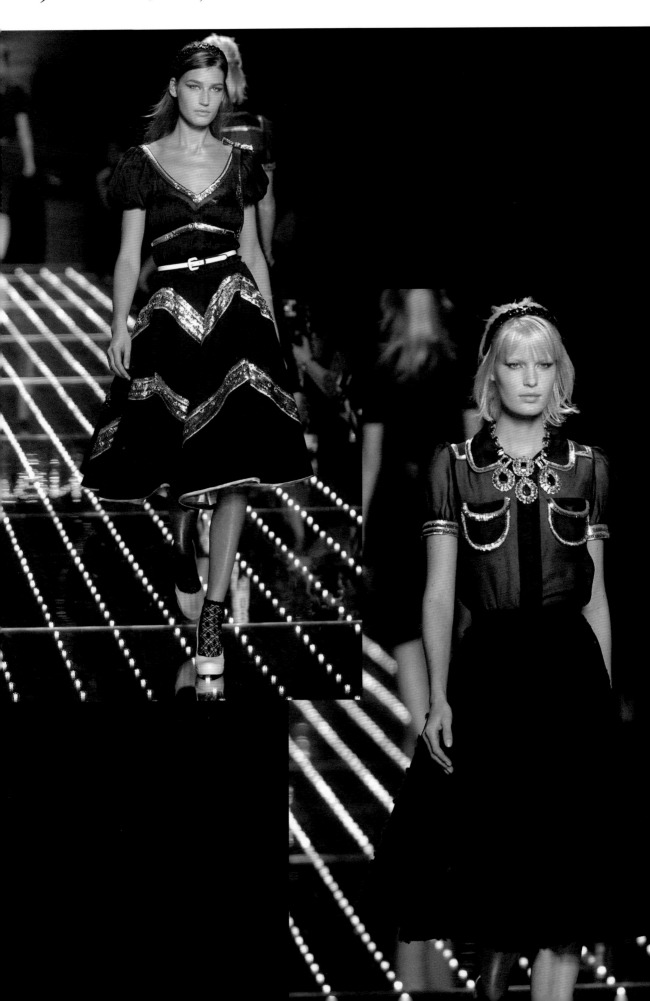

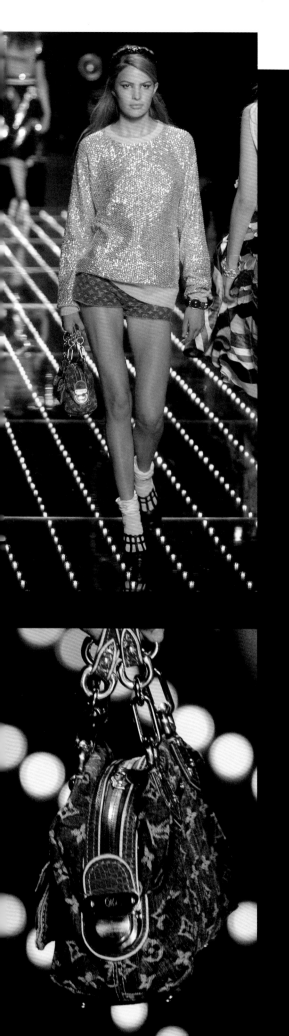
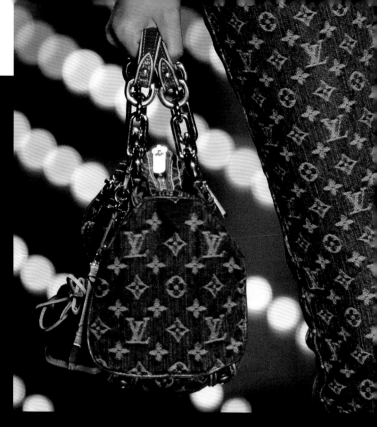
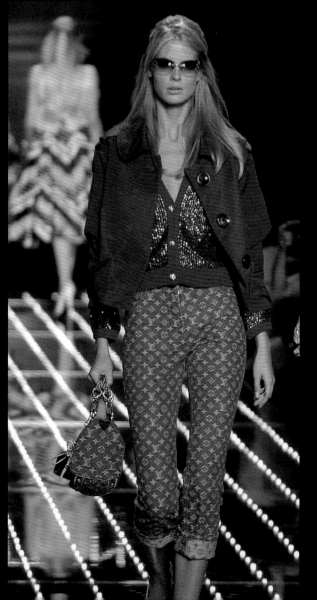

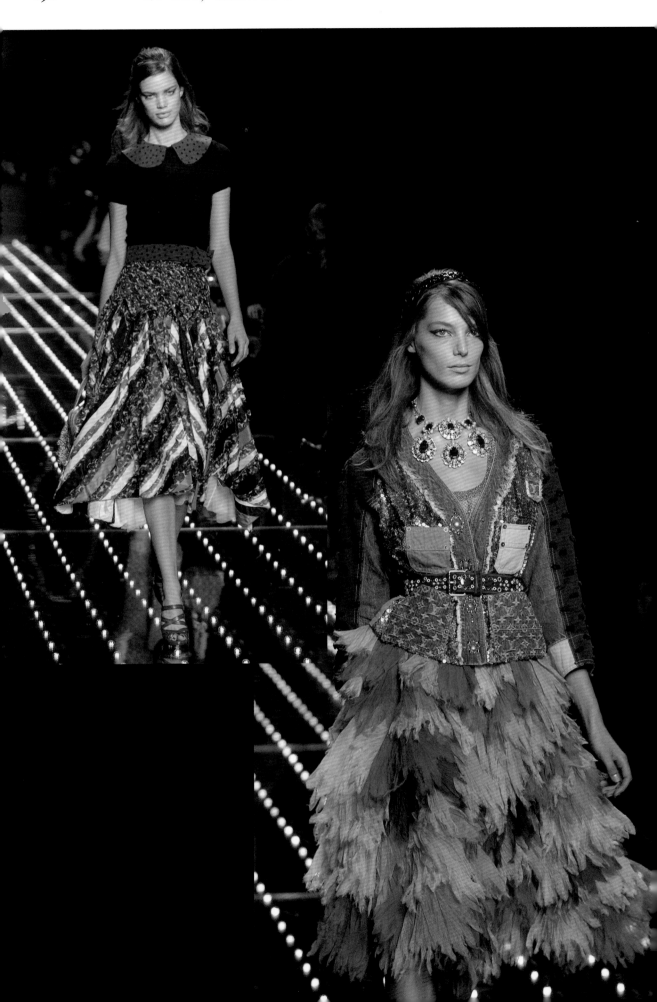

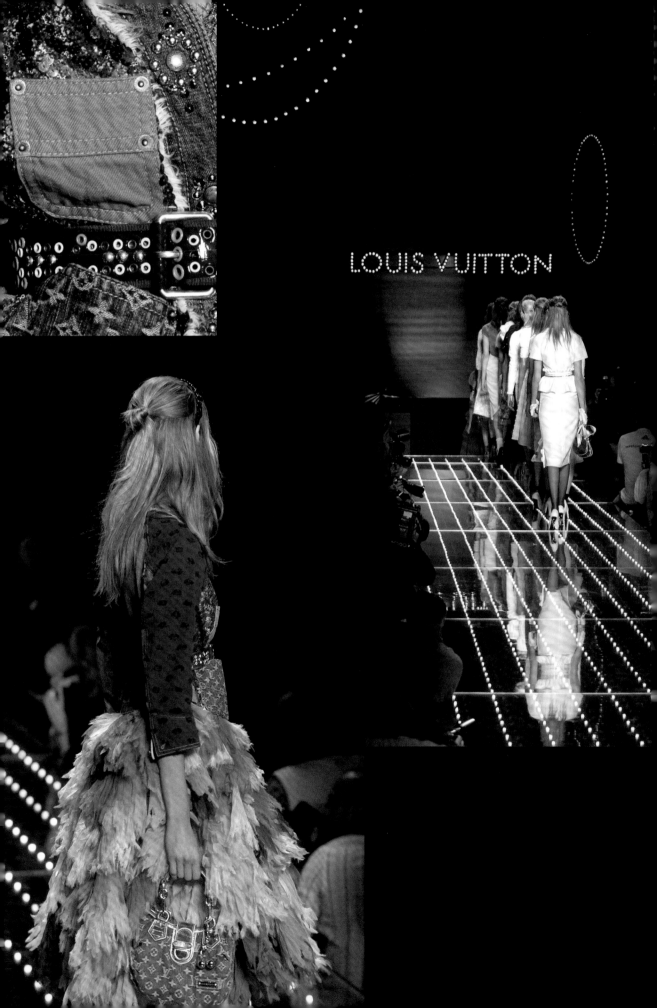

LOUIS VUITTON

Voyage to Vienna

In stark contrast to the previous season, the autumn/
winter 2005 collection presented dark millennium
couture. 'Feminine, but not girlish. Austere but not
plain,' said Marc Jacobs. The glass mosaic backdrop
and grey tiled runway created the perfect setting for a
collection inspired by the graphic universe of the Wiener
Werkstätte and Art Deco. This season's travel destination
was Vienna, where a decadent collection dazzled the
audience with its references to the influential Secession
movement led by architect Josef Hoffmann. The colour
palette was inspired by the work of figurative painter
Egon Schiele, and included black shades juxtaposed
with bronze, emerald and purple tones. Gold seams,
shiny leather patchwork and monogram-embossed bags
referenced the work of symbolist painter Gustav Klimt.
Using painterly techniques, Jacobs created a masterful
collection, with opulent textiles evoking a romantic
aesthetic and subdued luxury.

Wool, cashmere, crocodile, snakeskin and tweed were
used for the belted coats, double-breasted cocoon coats,
patchwork cardigans and pencil skirt suits, while the
turn-of-the-century-inspired dresses and opera coats
were made in velvet, radzimir, taffeta and satin.
Bringing the heritage of the brand to the forefront,
Jacobs transformed the Damier canvas into the most
luxurious and elegant alpaca coat (p. 202, left). Collars
came in a variety of styles and were decorated with
draped roses, velvet trim and mink fur. Skirts and sleeves
were also presented in a variety of shapes and lengths,
emphasizing a sensuous femininity.

'I can't claim to be the first to experiment with volume,
or even the first to revisit those experiments,' remarked
Jacobs, elaborating, 'It's a new thing for me. I think
women will take it in their stride and make it work
for them.' His exercises in proportion evoked the
voluminous silhouettes of Cristóbal Balenciaga.
Vogue's Sarah Mower called the collection an
'uplifting exploration of Parisian chic'.

Makeup artist Pat McGrath created a lady-like look
that recalled the appearance of the house's campaign
model, actress Uma Thurman, who was seated on the
front row (she later described the collection as 'luscious
and structured, with regal sophistication and sexiness').
The models also wore decorous suede gloves, velvet hair
clips, musketeer hats, pumps and black tights. The
Monogram bag was presented in a new range of styles,
including the quilted Matelassé (see, for example,
opposite bottom left), Lamé (p. 198, bottom right),
Passementerie (p. 207, top left) and a chinchilla-
trimmed denim (p. 202, left).

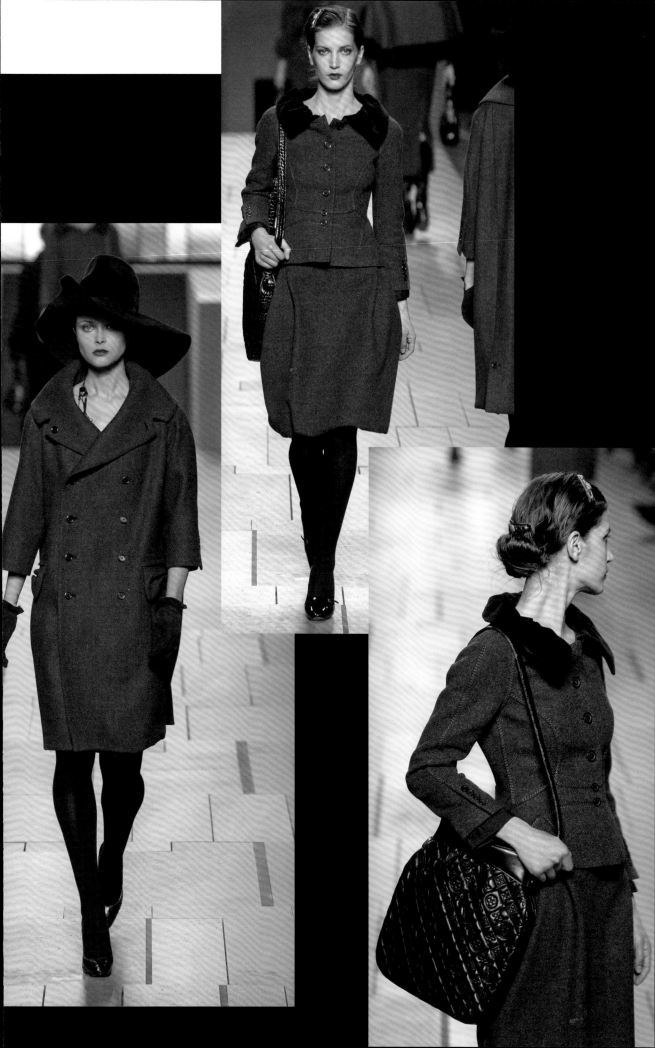

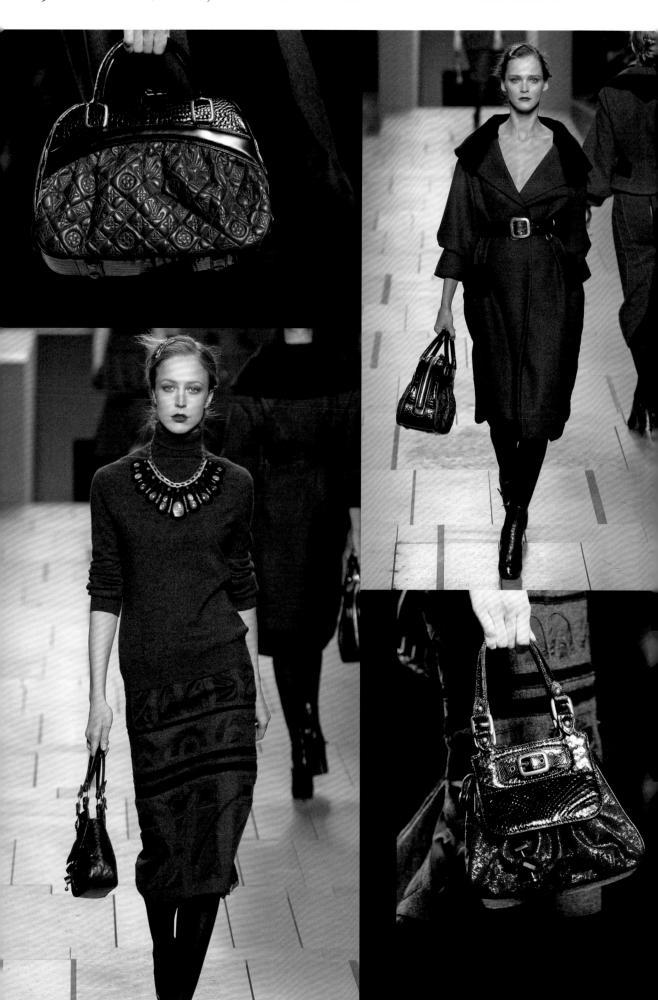

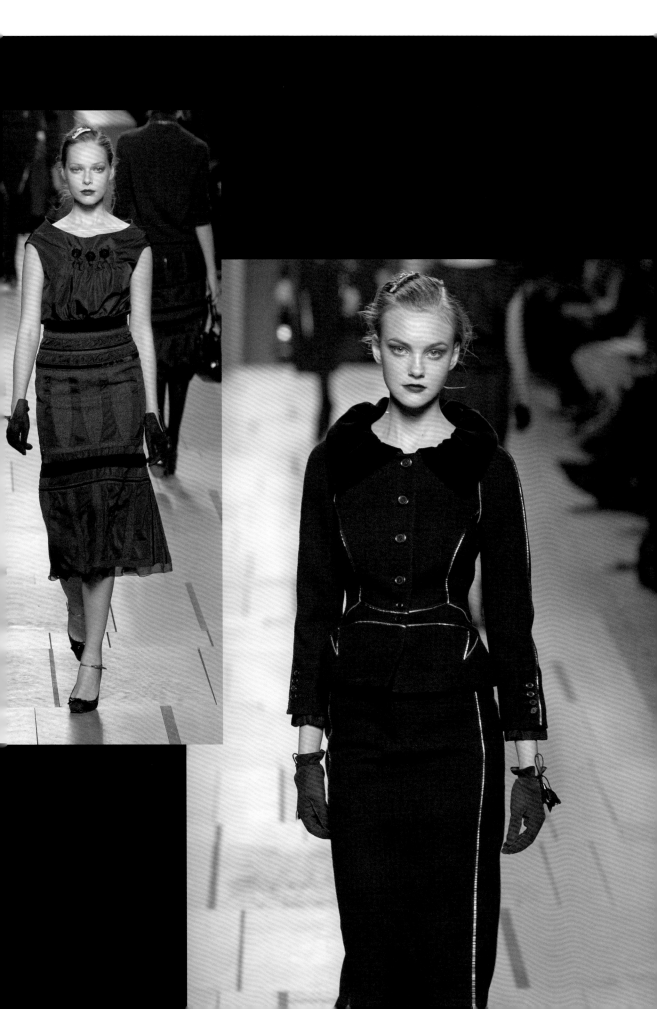

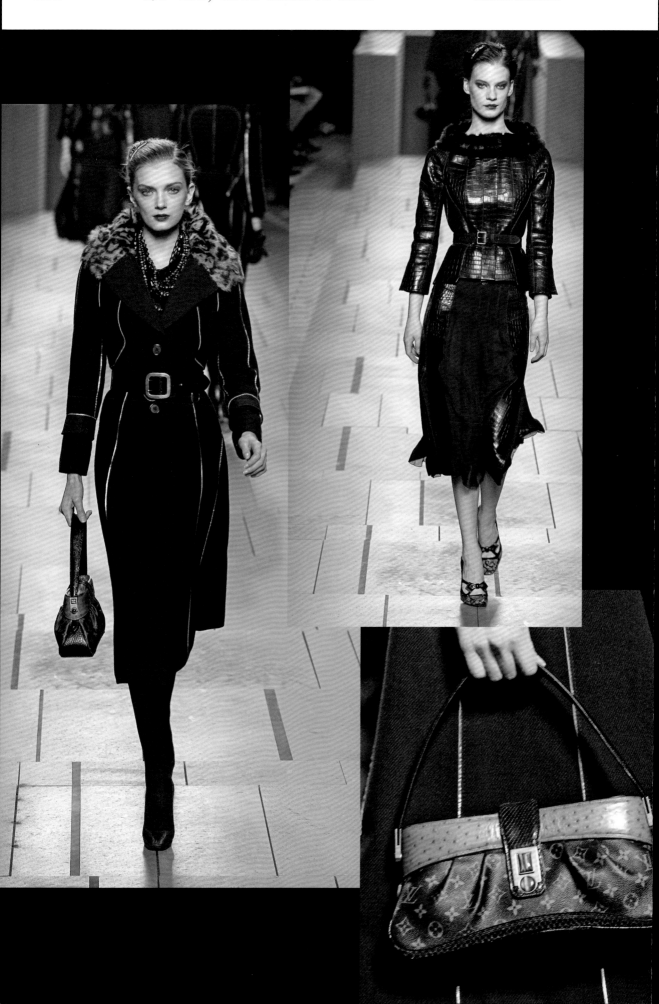

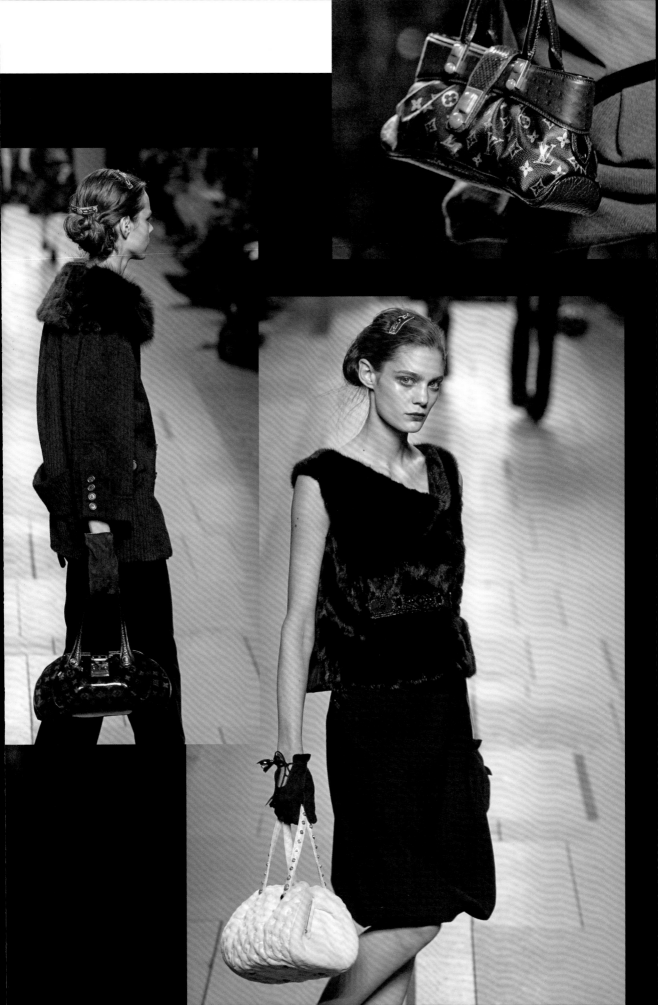

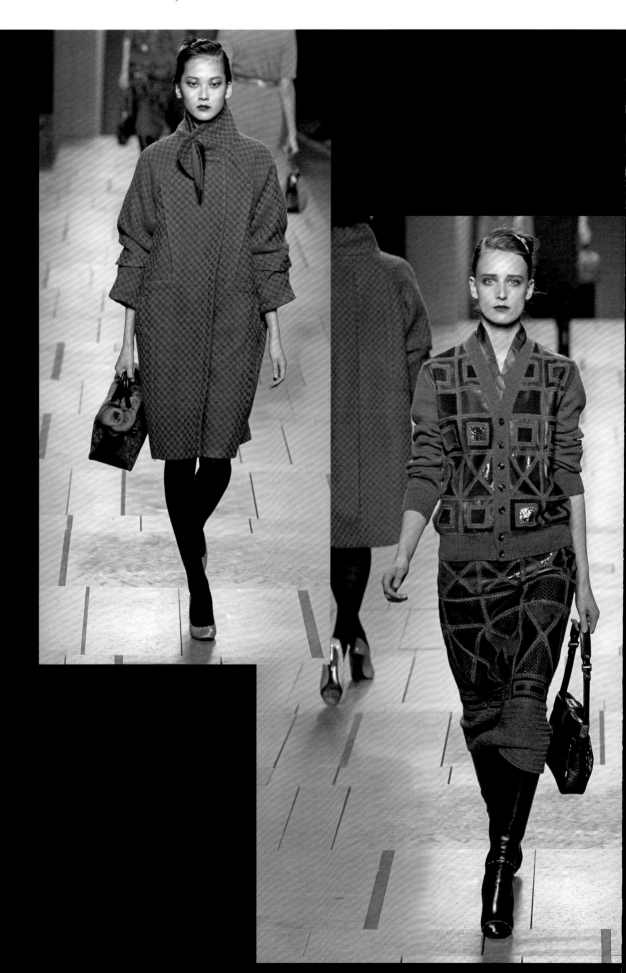

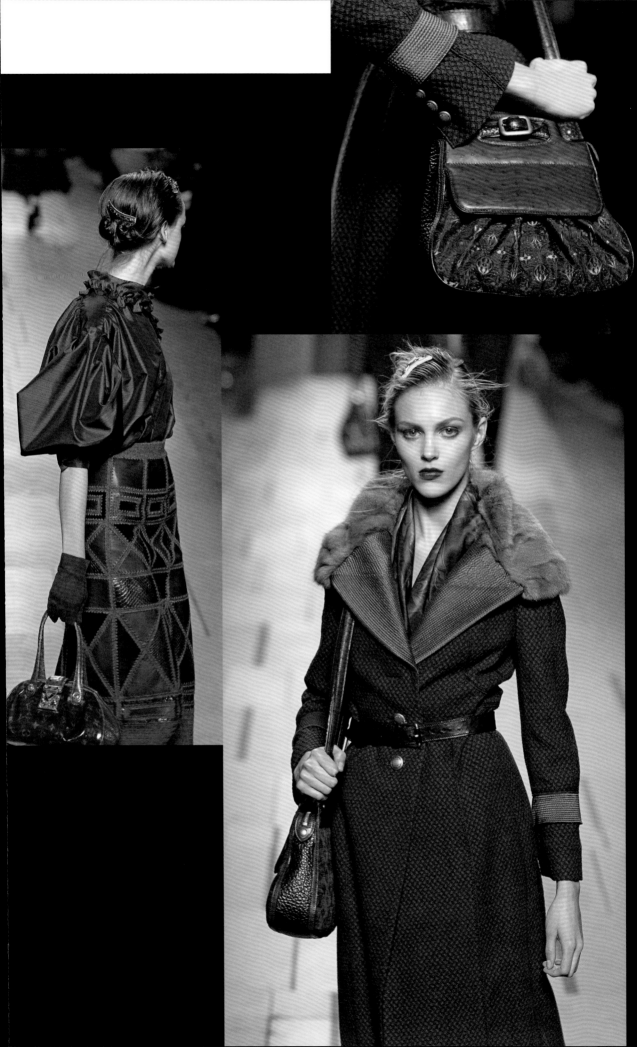

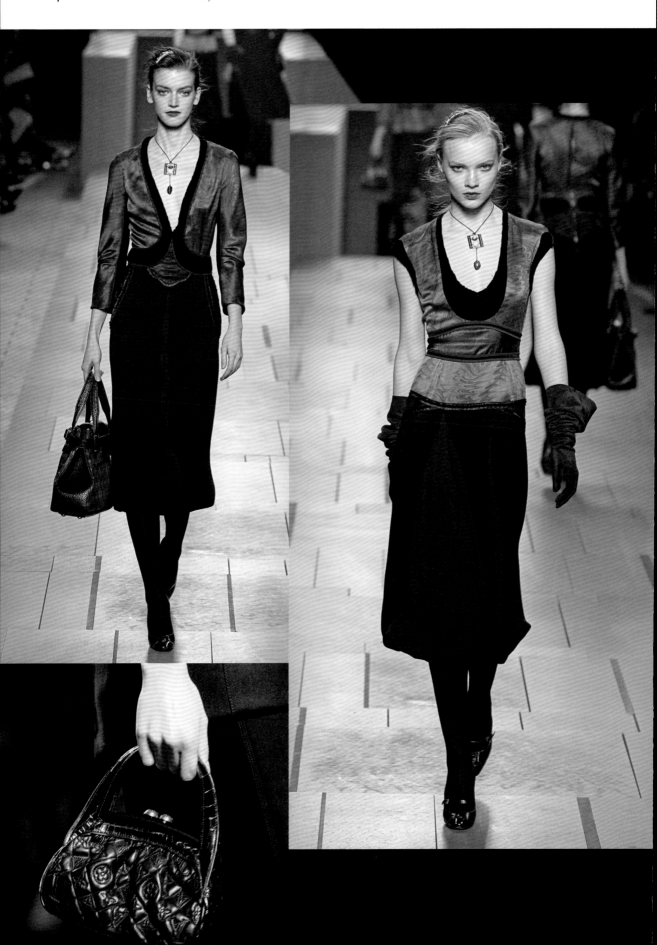

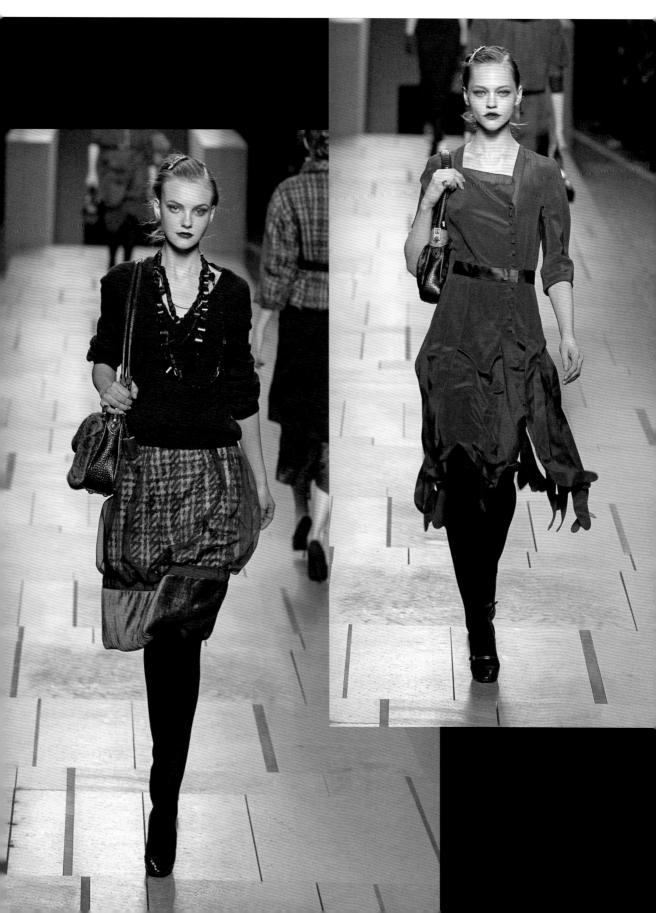

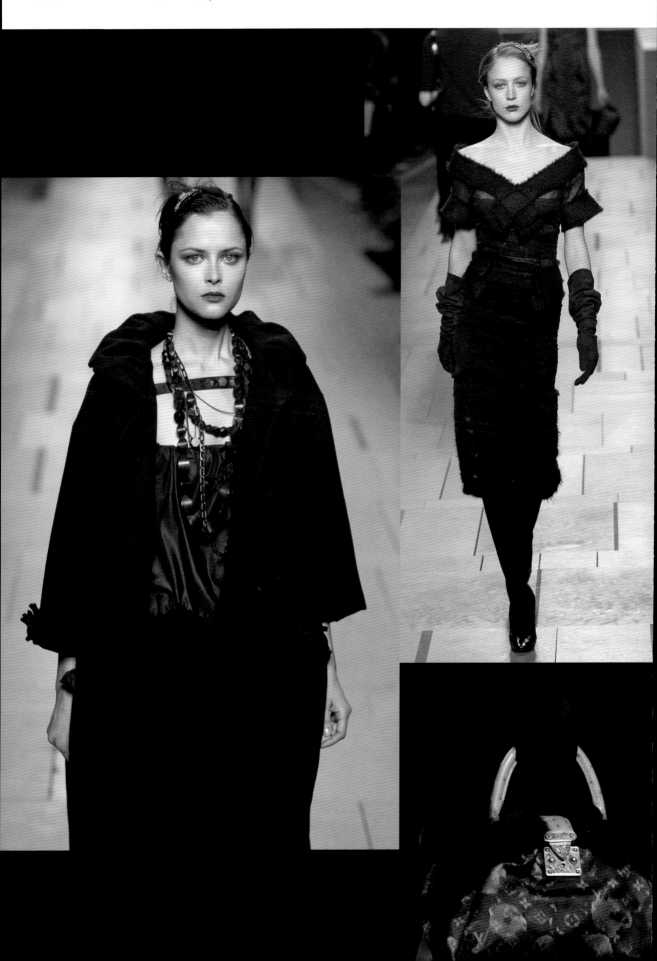

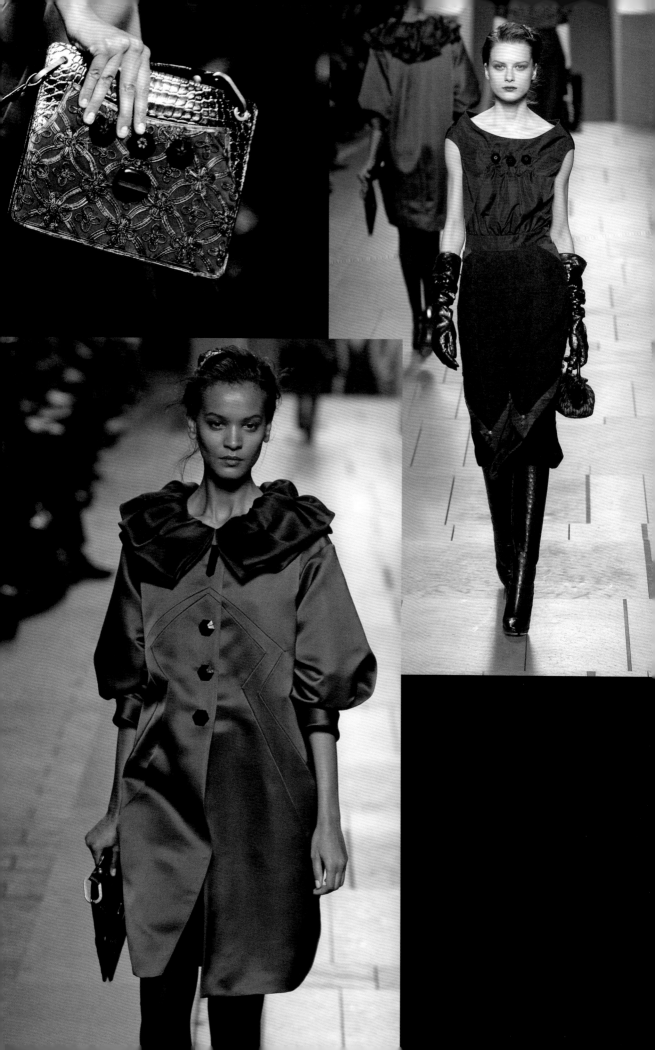

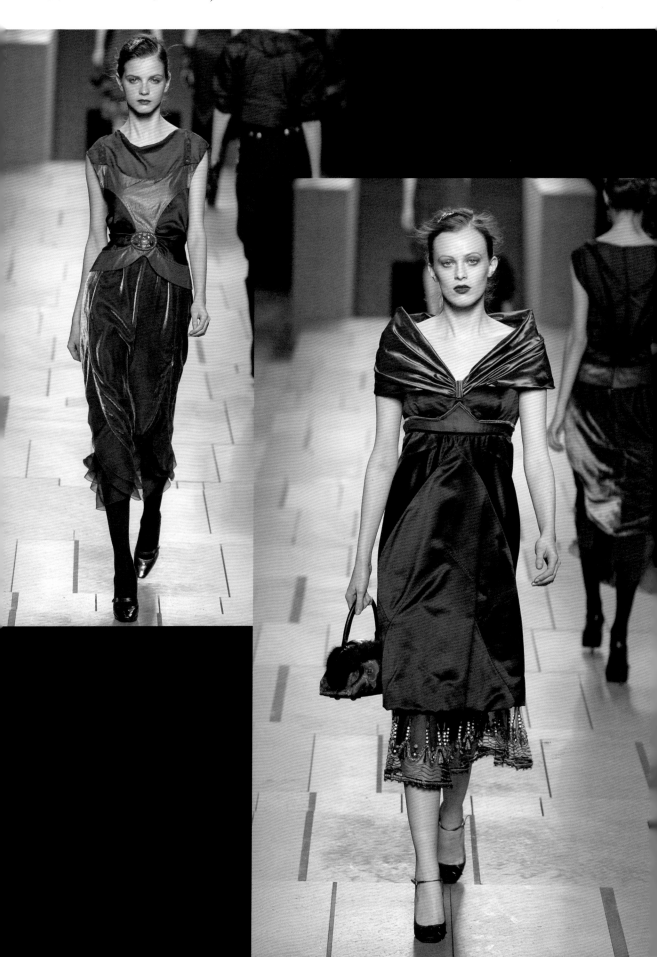

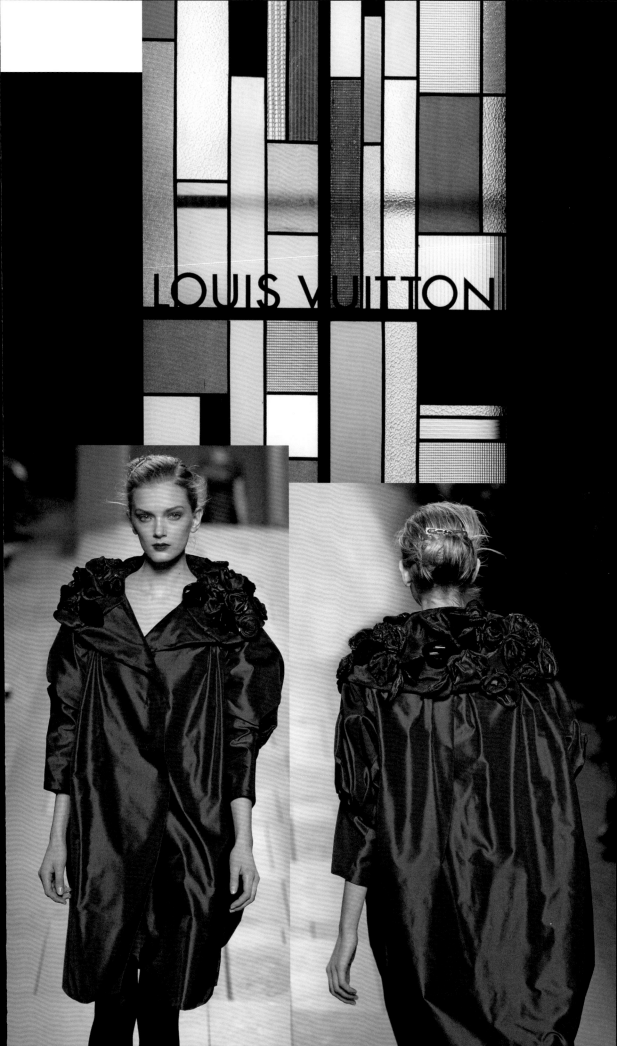

Memphis via New Mexico

Celebrating the recent opening of the world's largest
Louis Vuitton store on the Champs-Élysées, the spring/
summer 2006 collection was presented in a spectacular
show at the Petit Palais. Built for the Universal
Exhibition in 1900, the Beaux-Arts-style building
provided a fitting backdrop, highlighting Louis Vuitton's
connections to Paris and the art world, and helping
to consolidate the company's market share in the
fashion world. The runway was transformed into
a lit-up LV trunk, Pharrell Williams provided the
upbeat soundscape, and front-row celebrities included
Catherine Deneuve, Winona Ryder, Uma Thurman,
Dita Von Teese and Marilyn Manson.

Jacobs's concept for the collection was a sun-drenched
road trip to Memphis, stopping off at Santa Fe and
Las Vegas before touching down at Elvis Presley's
Graceland. The colour palette echoed the road
landscapes: from desert beige miniskirts, a mesa-
khaki trench coat, sunset-red and sparkling gold
leather ensembles to the neon rainbow-coloured
and fringed Murakami Monogram bags. The collection
was inspired by stage costumes worn by 'the King',
and also referenced Navajo textiles and 1980s
flamboyance. The logo-printed bags and scarves,
block colours and sexy silhouette evoked the early
work of Gianni Versace.

It was a collection for a 'strong, vivacious, sparkling
and very sexy' Vuitton woman, according to the show
notes. 'She goes out in the evening, is afraid of nothing.'
Vogue's Sarah Mower reported: 'Out charged the LV
girl army in short, hot-pink, body-conscious, bejeweled
clothes. Clanking with gold medallions, weighed
down with charm bracelets, and toting plastic-covered
scarf-print bags, they looked almost as if they'd walked
straight out of eighties Italian fashion photographs,
by way of Graceland.'

These glamazons wore plunge swimsuits, skin-tight
fuchsia mini-dresses, safari shirts with slim ties,
orange plastic gloves, tops embroidered with mirror
discs, a fringed and laced wool crepe skirt (p. 213, right),
a cashmere poncho dress with lacing at the shoulders
(p. 214, left), and stiletto sandals. Model Freja Beha
Erichsen closed the show wearing a white embroidered
silk radzimir top, wide black organza trousers and
charm bracelets (p. 223).

New bags included the Patent (see, for example, p. 215,
right) and the Perforated Monogram (p. 218, centre
and right). The Monogram pattern and the gigantic
semi-precious gems found in New Mexico provided
inspiration for the dazzling stones, corals and beads
on tops, dresses, earrings, bracelets and bags. As the
show notes stated, this season's woman 'is proud of
her slightly flashy elegance... Summer 2006 will be
hot. And chic.'

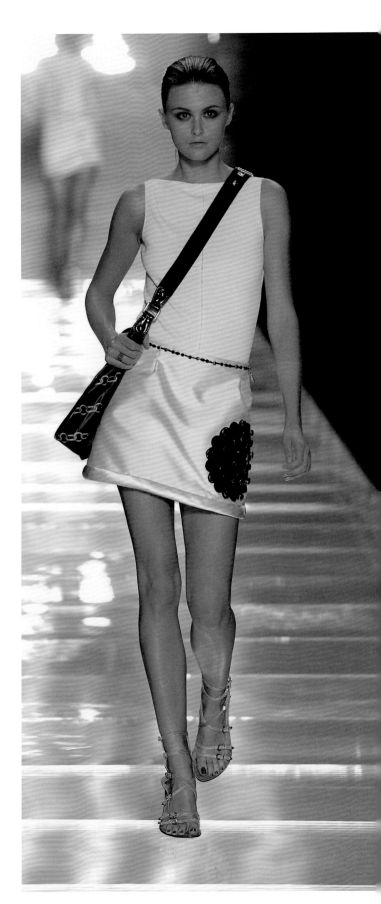

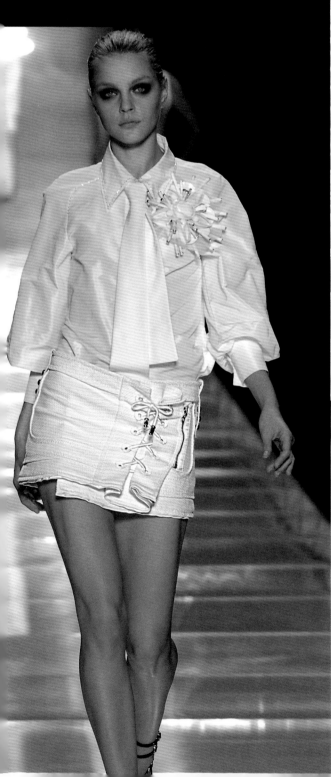

LOUIS VUITTON

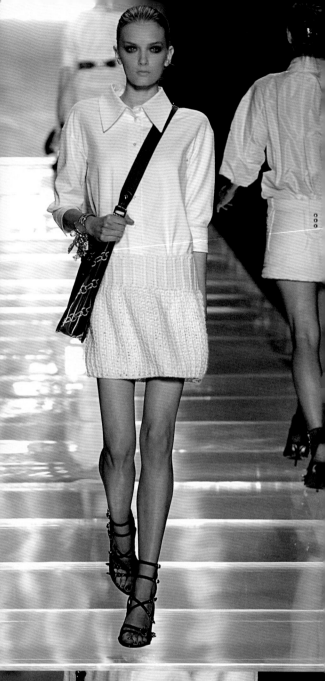

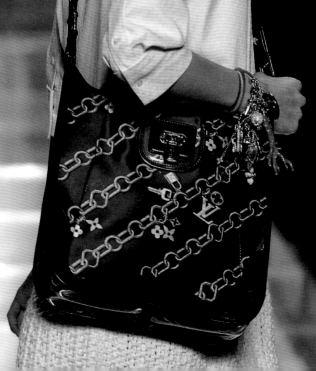

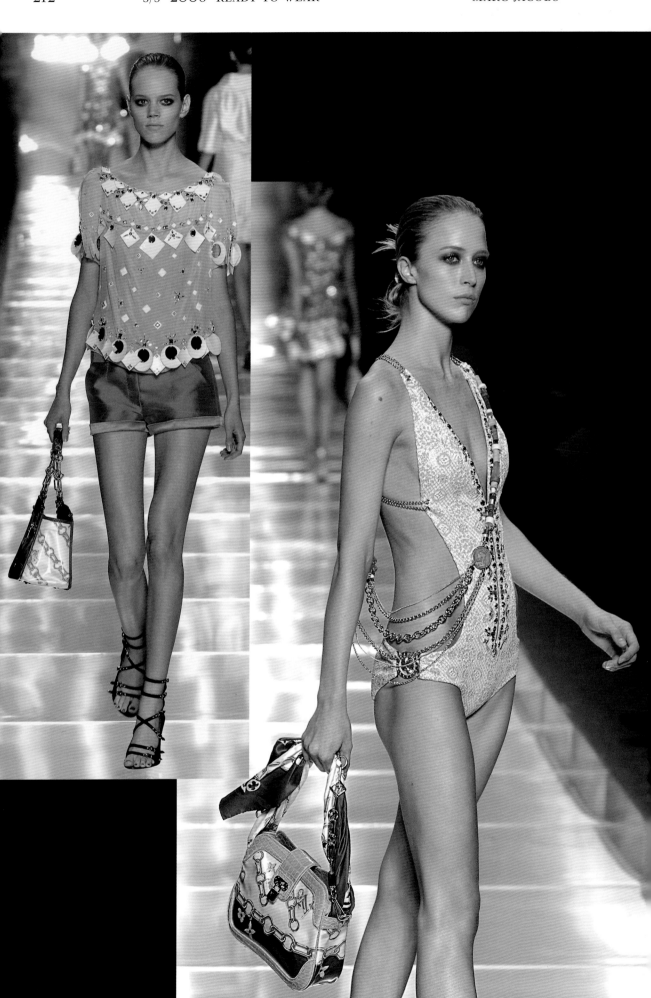

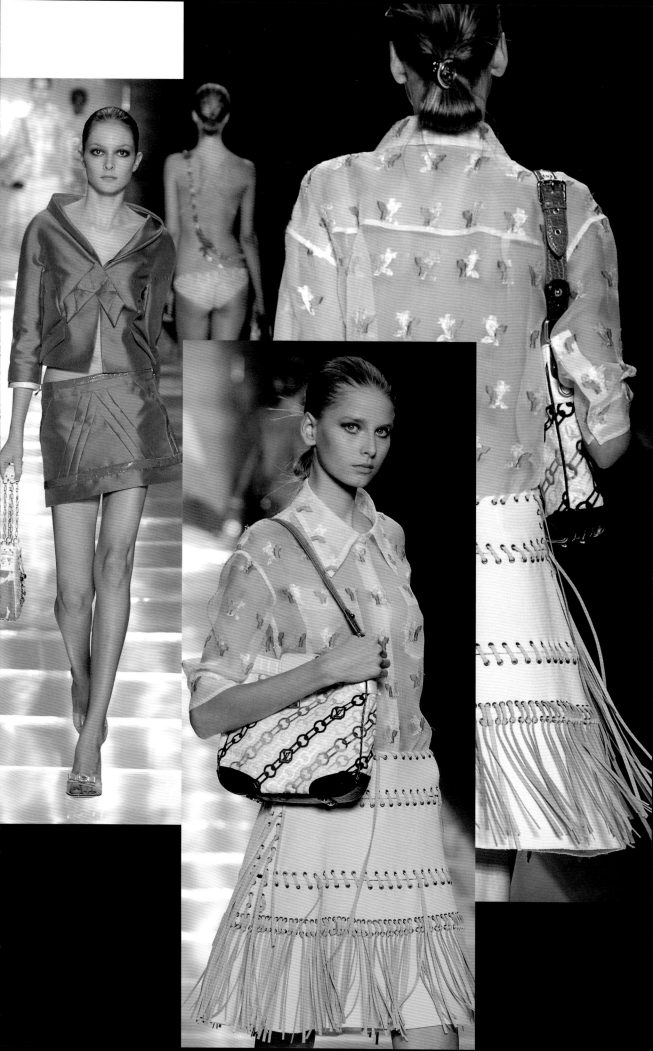

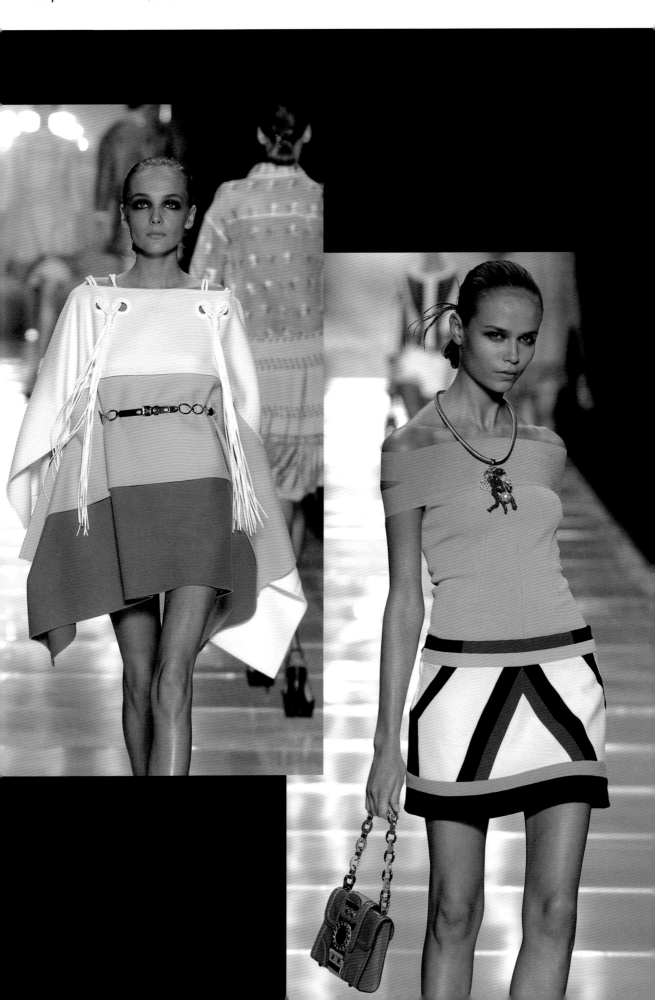

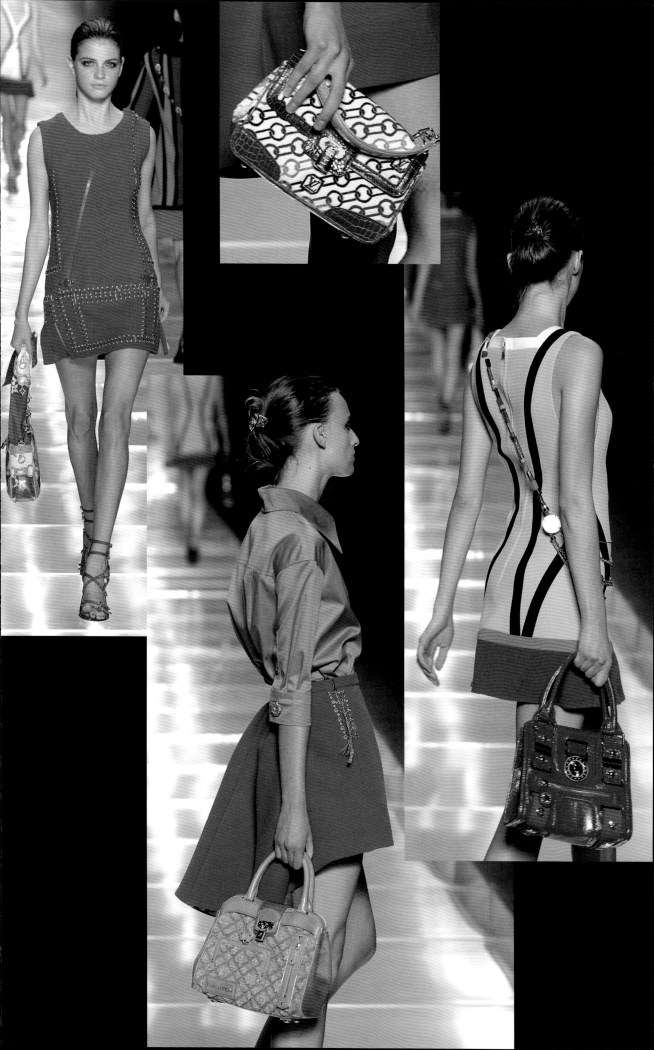

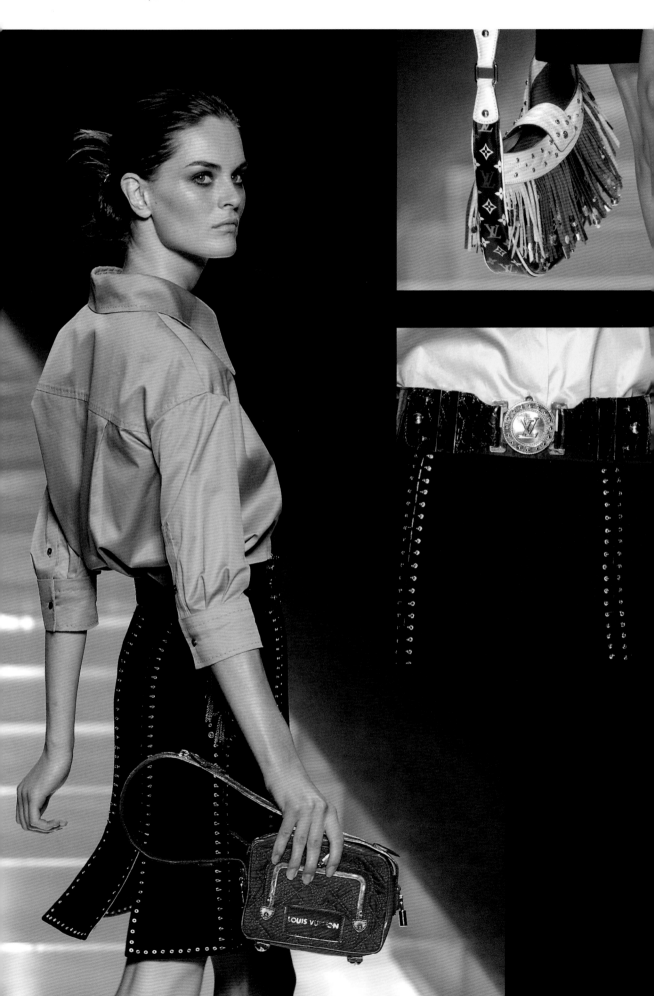

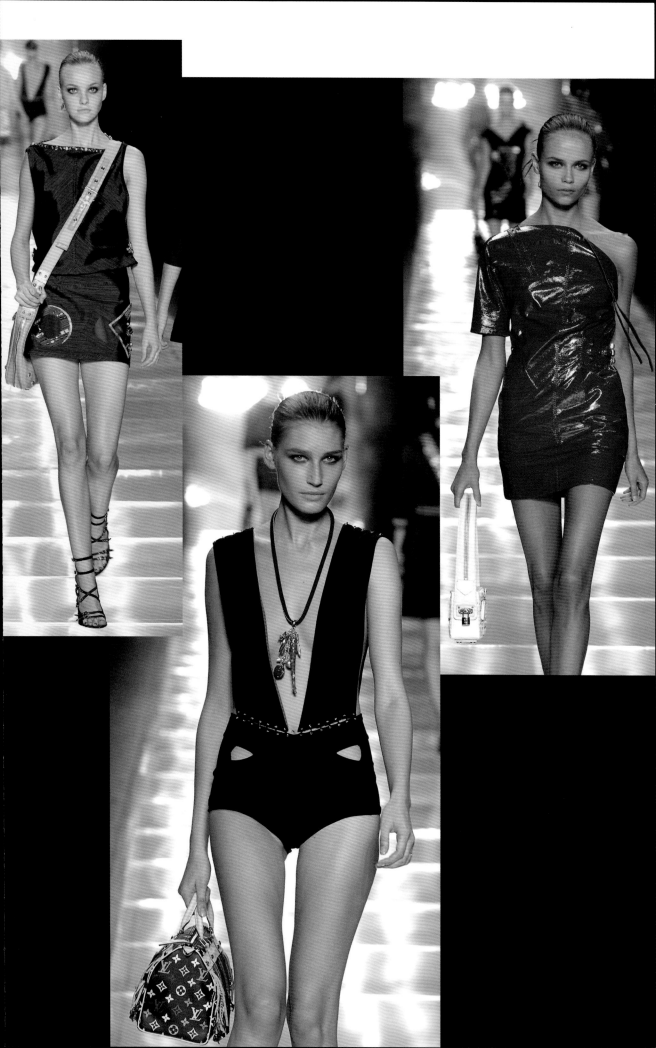

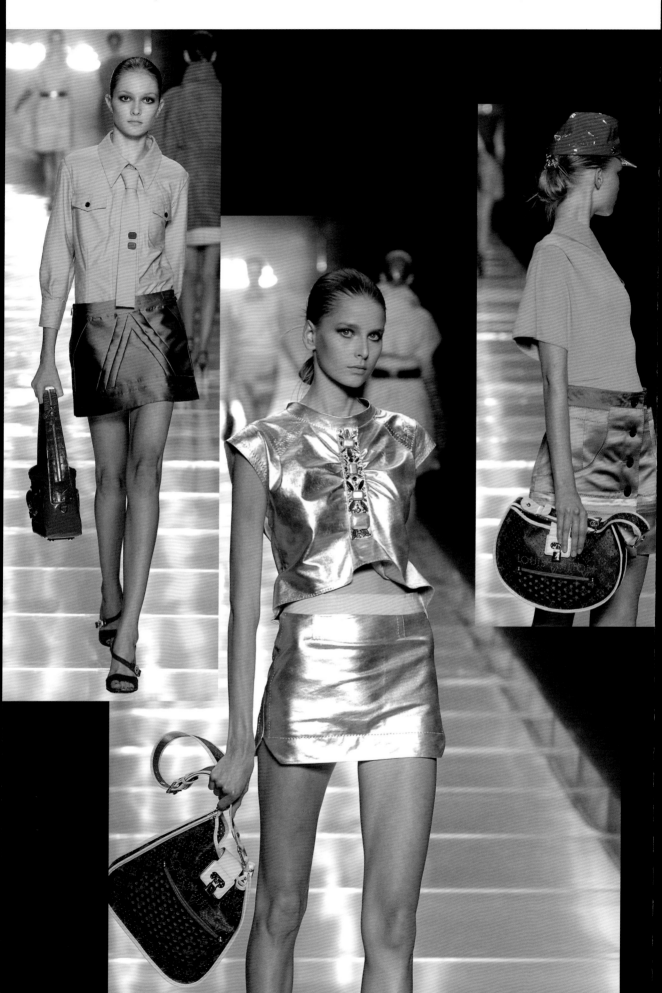

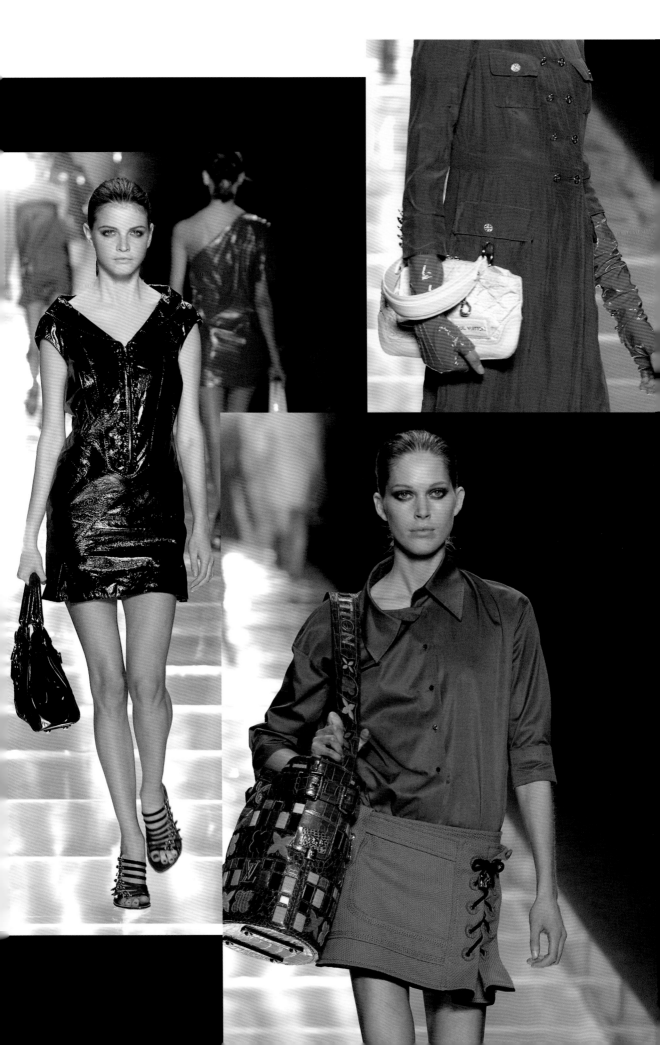

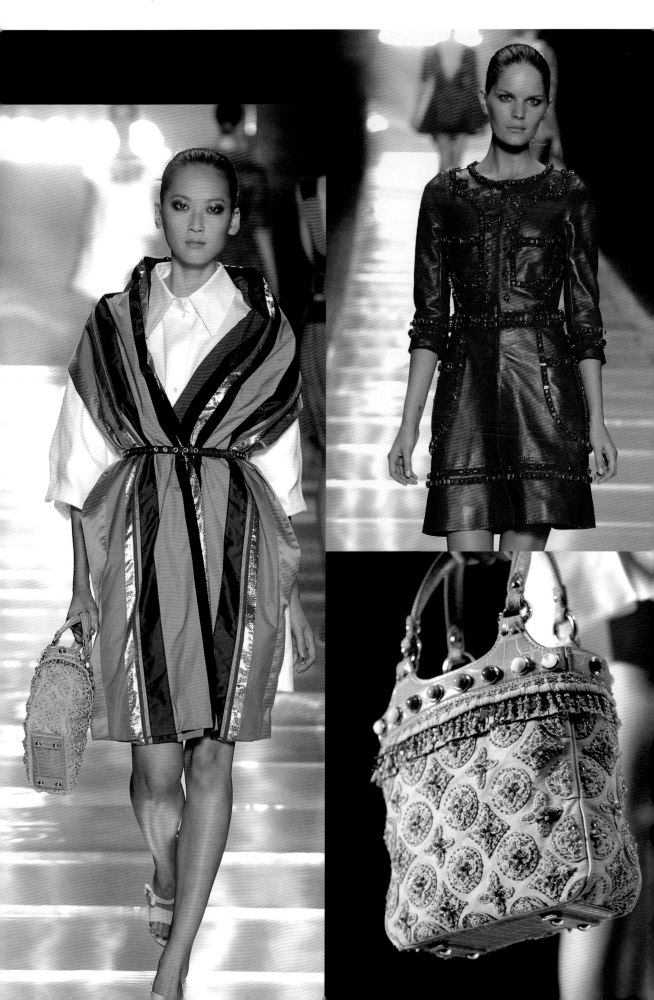

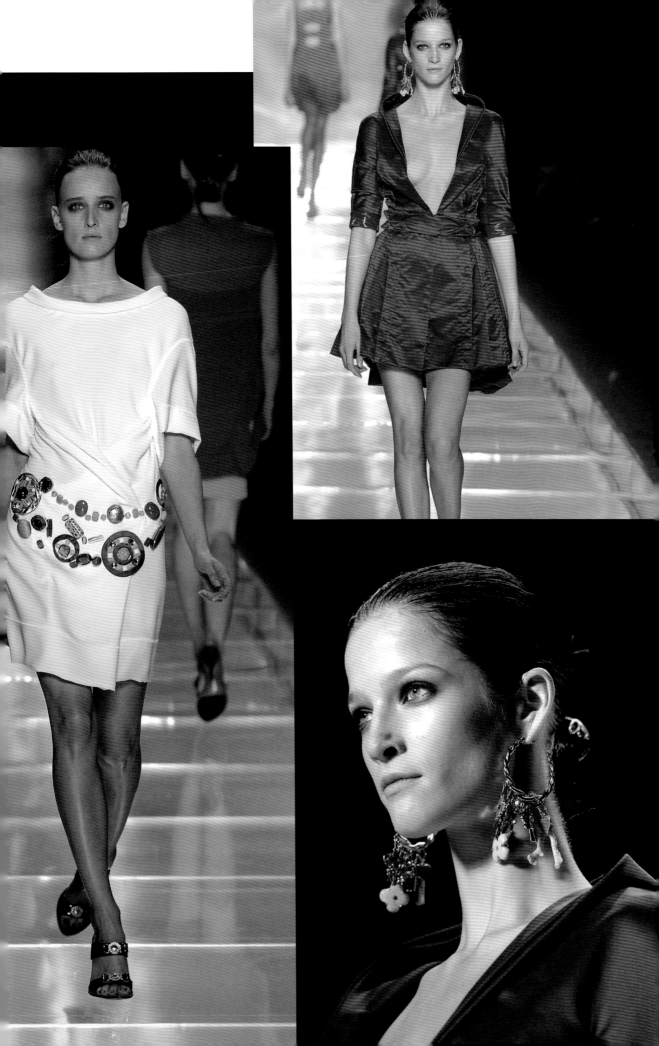

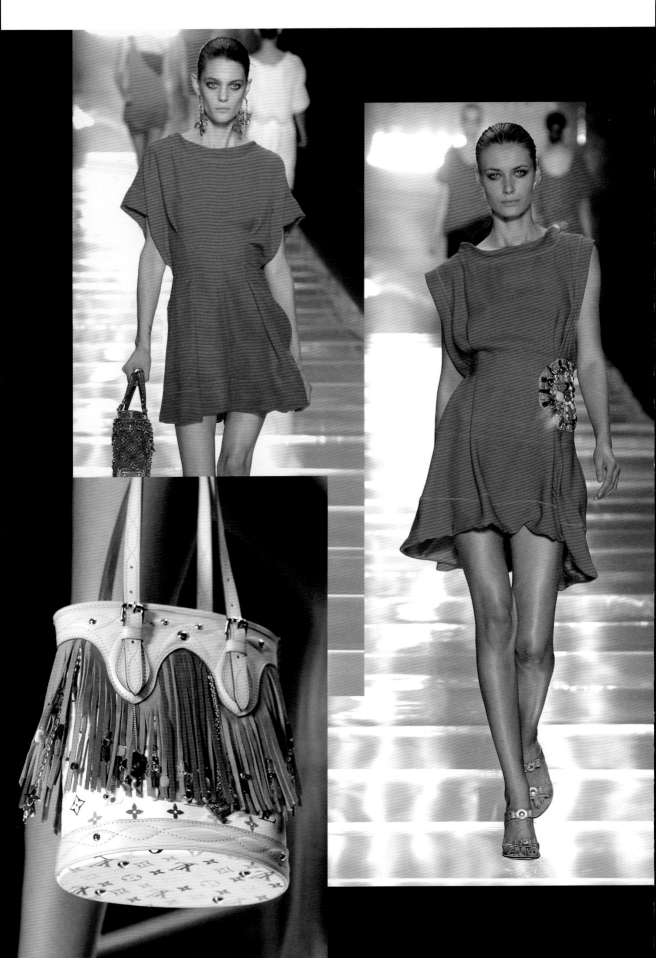

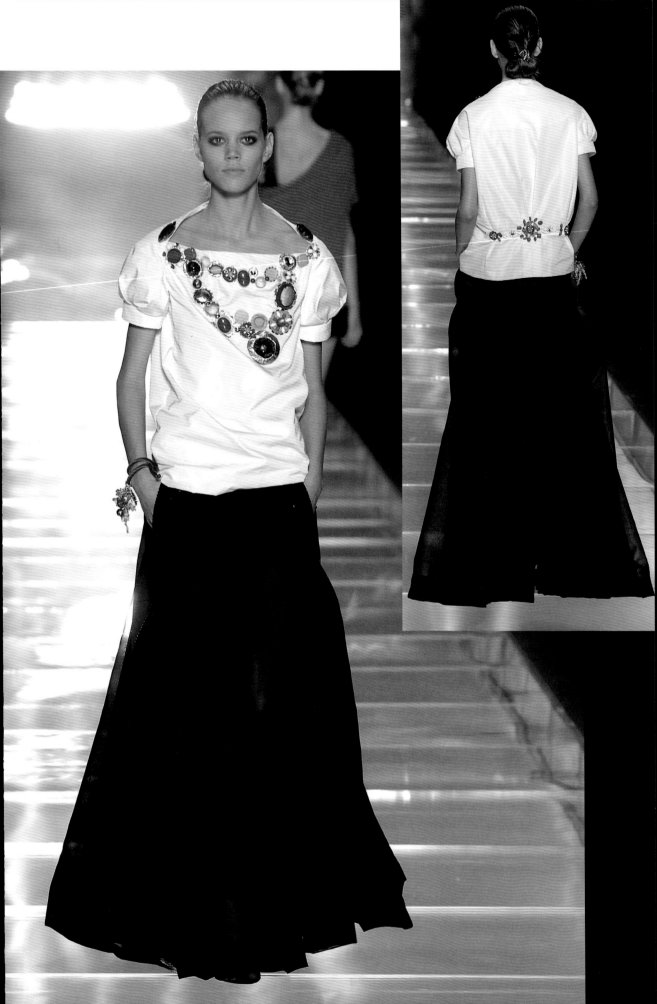

Layered & Oversized

The Louis Vuitton autumn/winter 2006 collection
closed the international fashion schedule with 53
predominantly earthy-coloured looks, implementing
a similar spirit to the show Marc Jacobs had presented
under his eponymous label a month earlier. Coco
Rocha wore the opening look (right): a canvas-coloured
ensemble consisting of a cashmere and latex dress,
silk T-shirt, bucket hat, black velcro ski boots and
white LV-INYL bag.

As the show notes explained, unexpected juxtapositions
were key. Jacobs created layered silhouettes of rich
fabrics playing with outer- and eveningwear, and using
elements from both the women's and men's wardrobe.
There were wool skirts worn with latex and organza
tops (see opposite, right), flannel bustiers and dresses
over knitted turtlenecks (p. 232, left), belted coats with
fur hems and embroidery (p. 235, bottom left), puffa
coats with feather trimmings (p. 237, left), and oversized
wool cardigans wrapped around the waist and hanging
off the shoulder.

Jacobs said the collection was inspired by 'all the
influences of the past'. Prince of Wales tweed suits
and belted coats referenced 1940s military tailoring.
A 1950s trouser look was brought in for autumn, after
skirts had dominated the past few seasons. Sportswear
details included kangaroo pockets, cut-out crochet
gloves and the velcro ski boots inspired by 1940s ski
shoes. Introducing his own version of the 'little black
dress', Jacobs presented a dazzling series of organza
evening dresses at the end of the show (see p. 236, right).

Star accessories included the bucket hat inspired by
Edie Beale of *Grey Gardens* fame, the 'Mademoiselle'
necklace with oversized pearls inspired by Coco Chanel
(see p. 235, top), and the Illusion Wedge d'Orsay pump
(p. 234, bottom right).

The show was again dedicated to Stephen Sprouse
(see p. 164), and used a striking leopard print he had
designed for the house in 2000 (see p. 226, left, p. 235,
bottom left, and p. 237, left). The work of Pop artist
Sylvie Fleury was transformed into shiny Louis Vuitton
classics, including the Monogram Miroir Speedy
(opposite, left) and Super Keepall (p. 232, left).

Also featured were exquisite bags from the limited-
edition 'Les Extraordinaires' collection, including
Headphone (opposite, right), Monogram Mesh
Leopard (p. 230, top left), an all-mink Murakami
Multicolor Monogram doubling up as a muff
(p. 234, left) and a solid silver minaudière (p. 235, right).
Suzy Menkes wrote: 'The knitwear might well have
been made from the finest cashmere, but ... the bag
was the object that caught the eye like a magpie
bringing glitter to a bird's nest.'

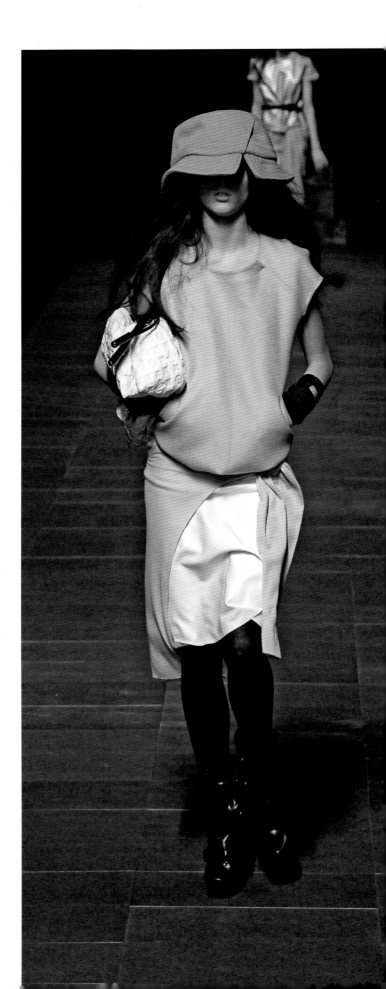

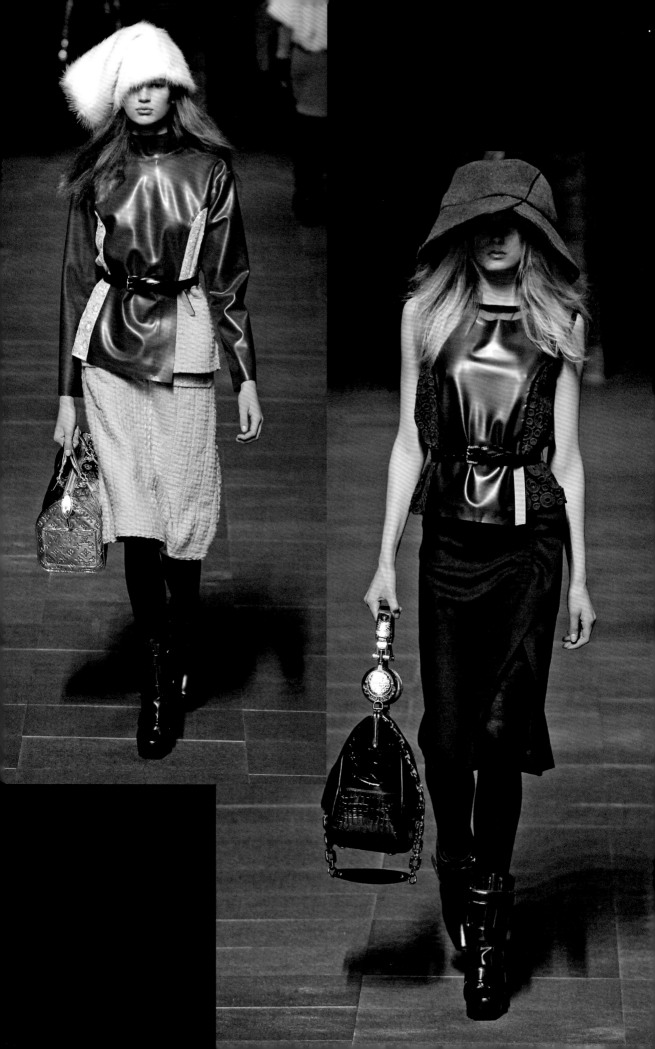

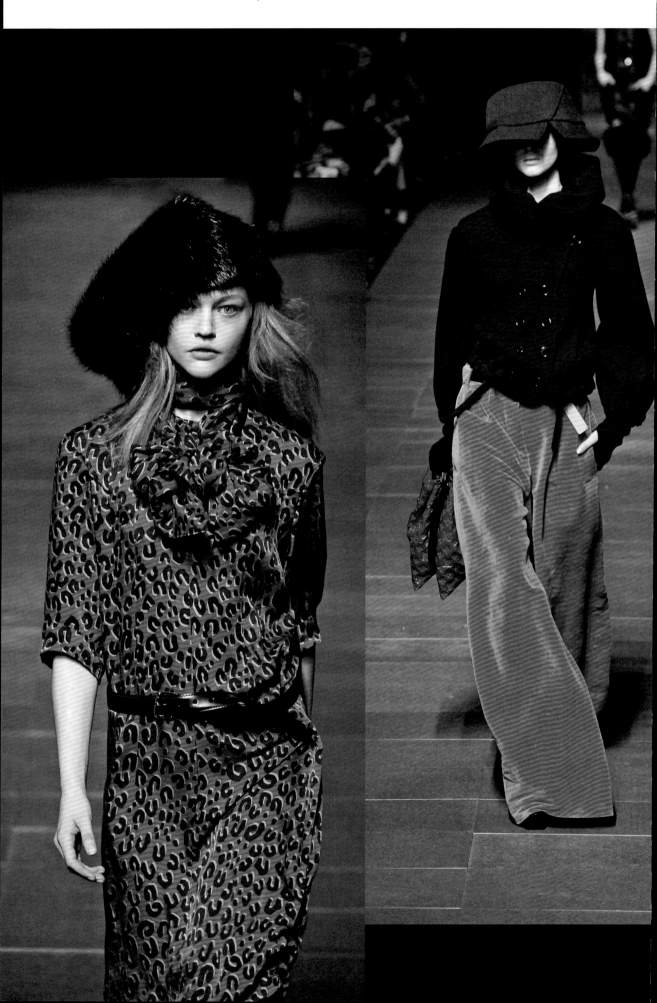

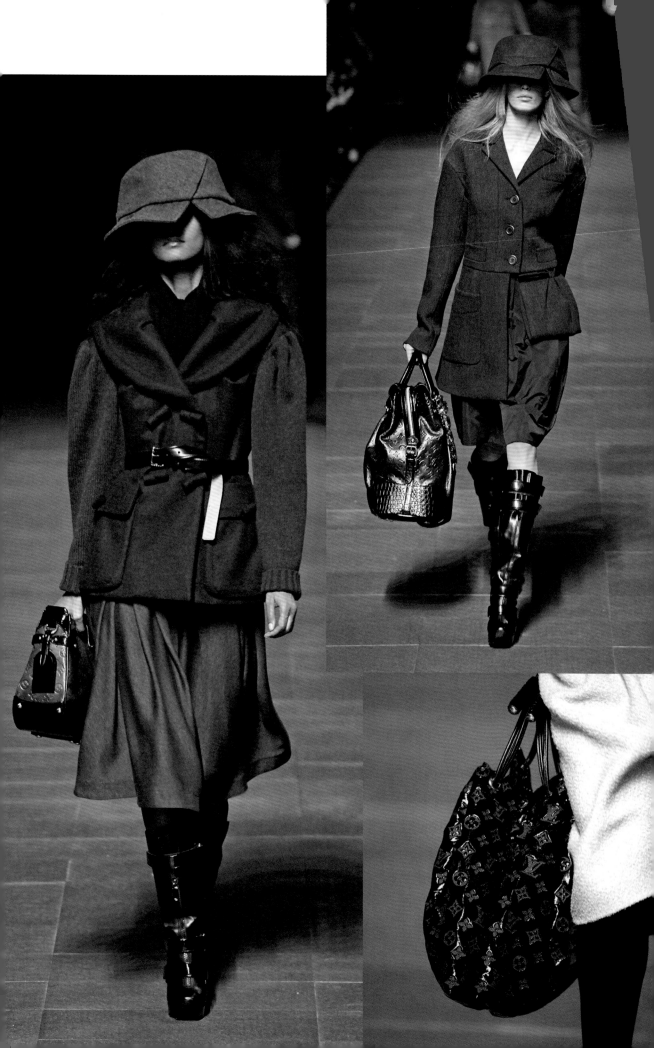

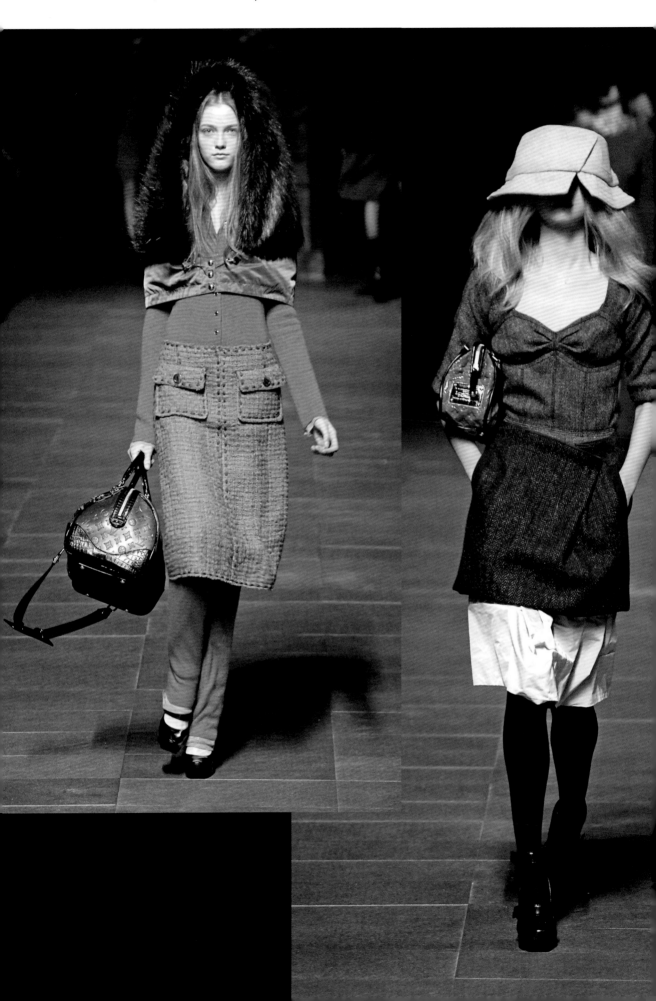

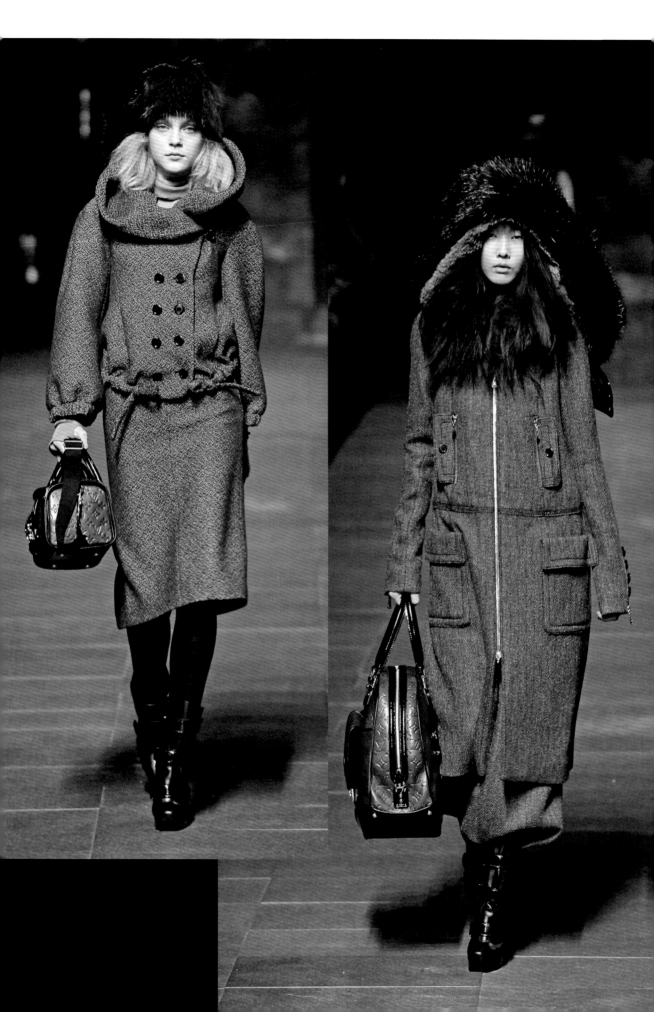

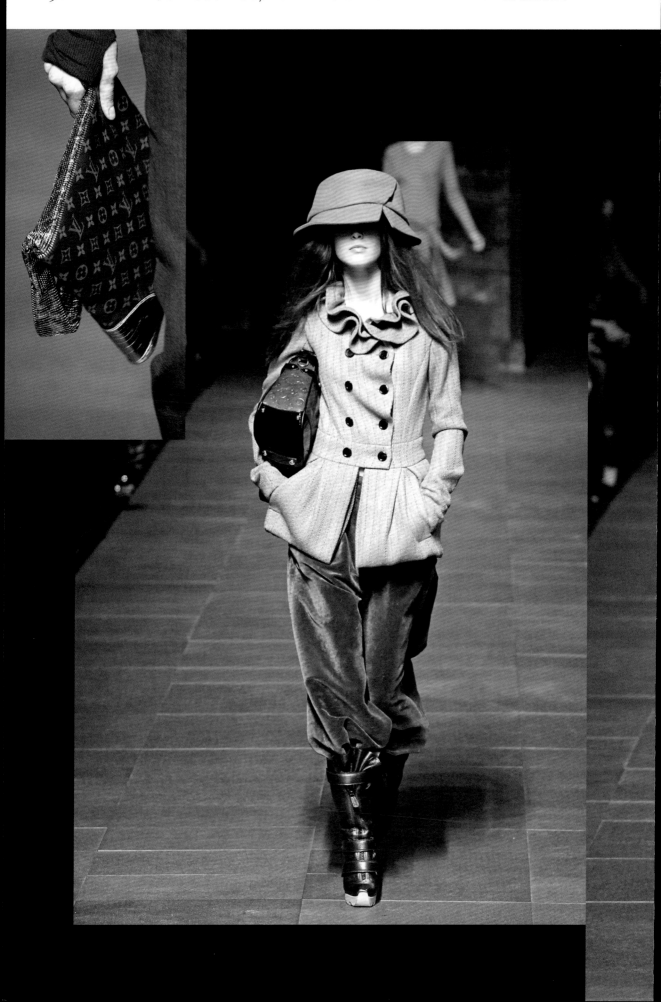

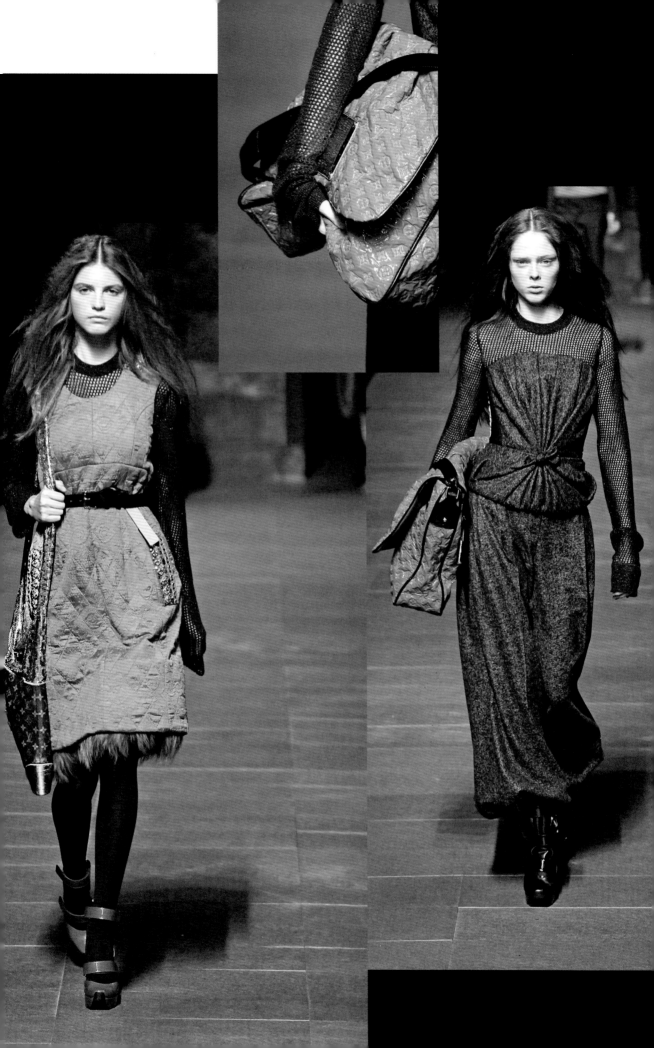

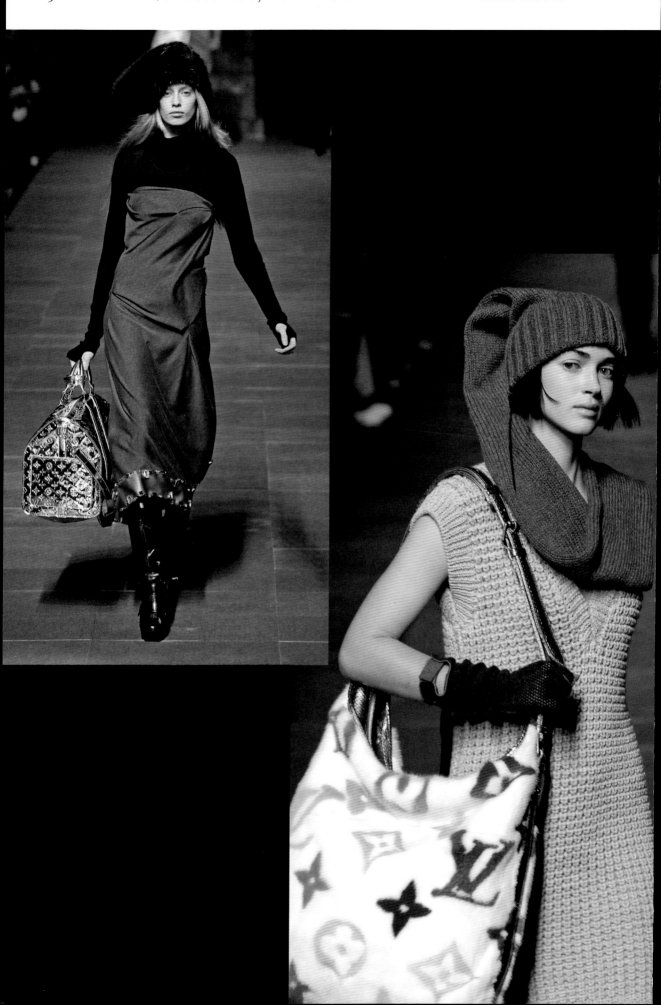

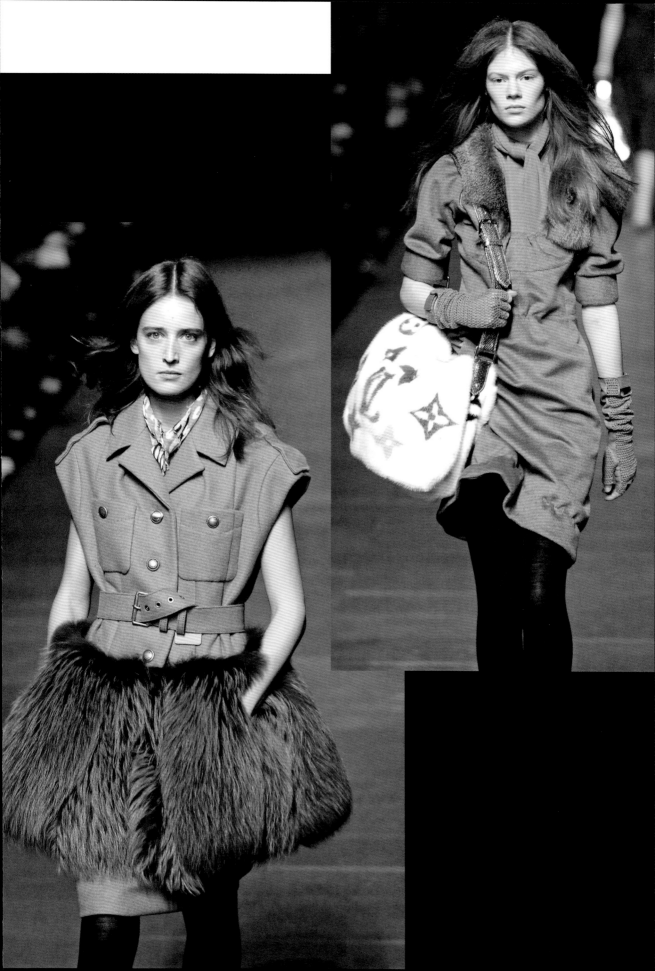

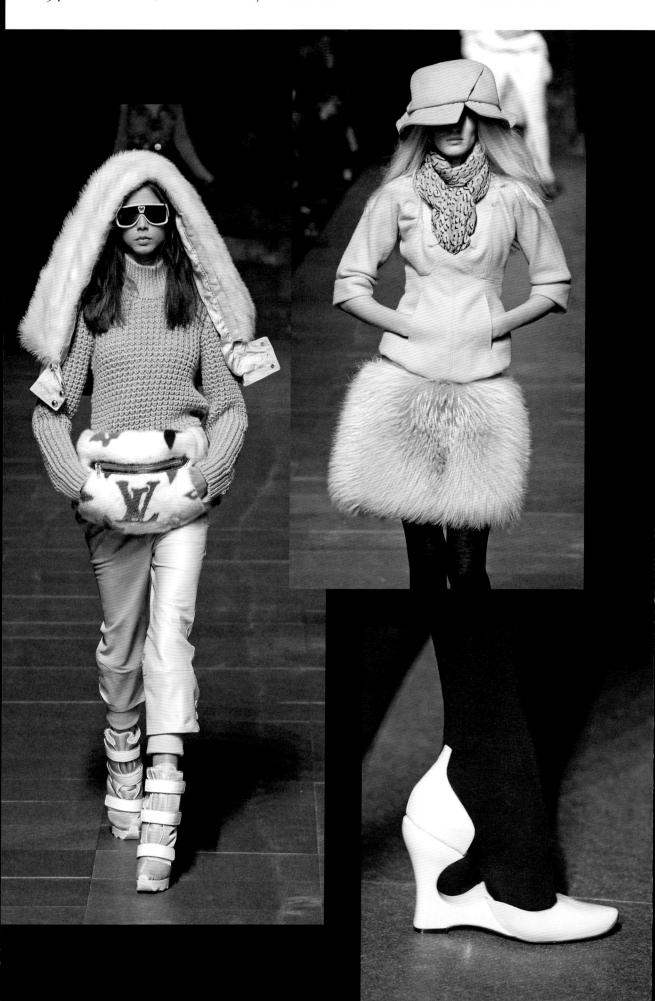

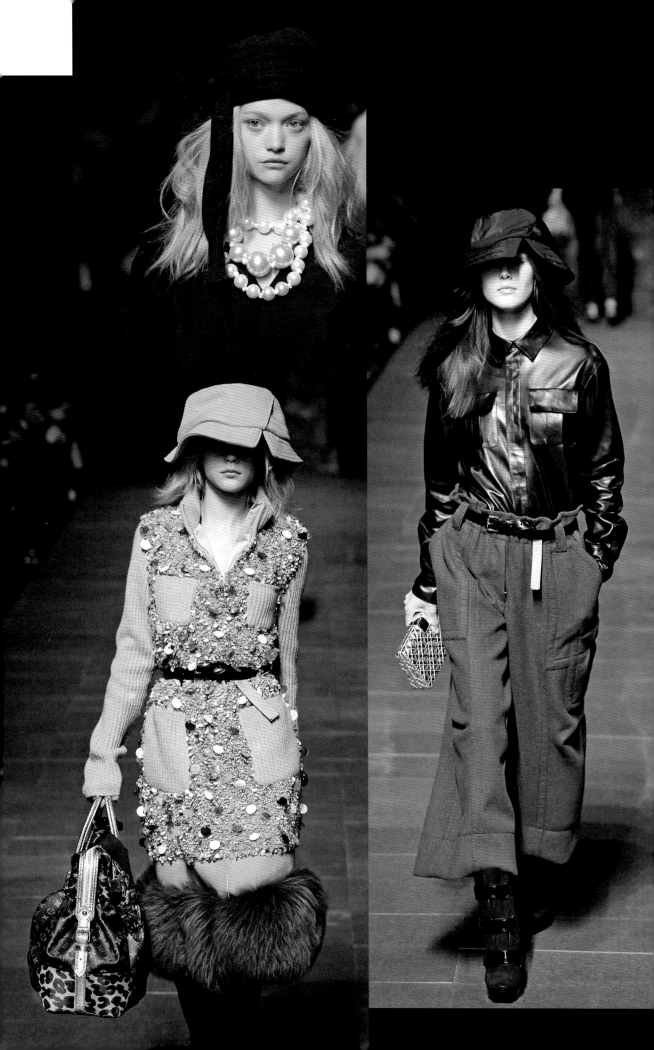

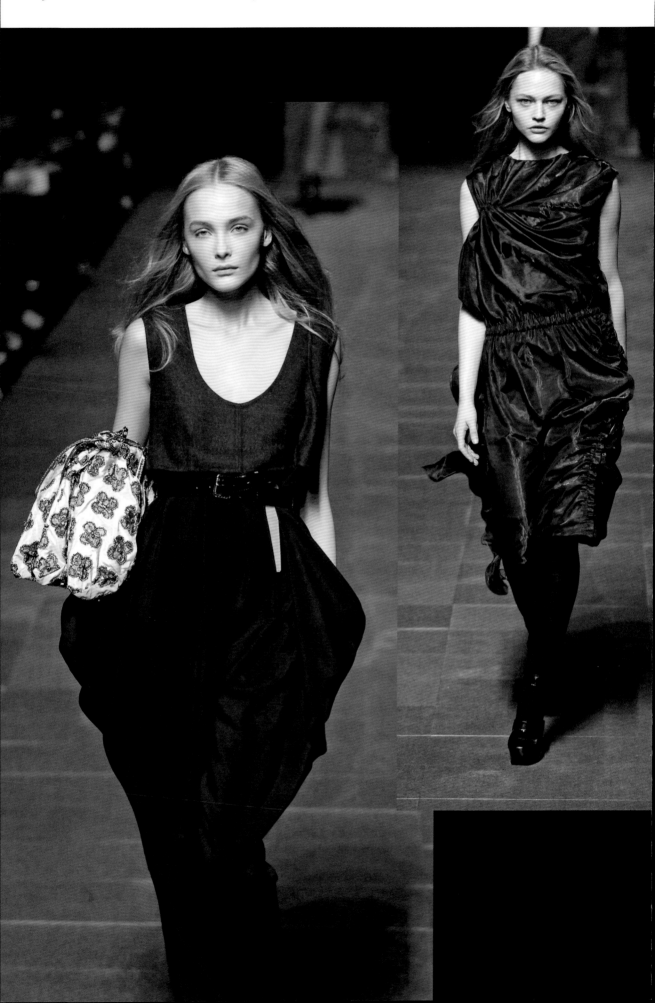

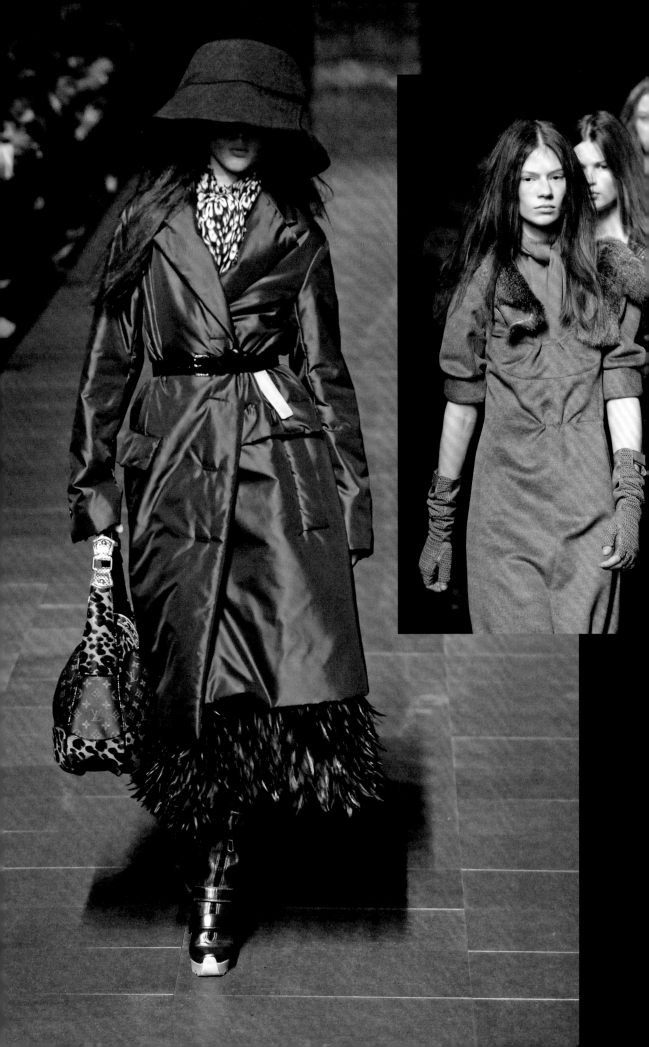

'Pretty in Print'

A video projection of a dark and dramatic storm
opened the spring/summer 2007 collection, only to
set the scene for Marc Jacobs's most romantic show
to date. As the collection notes pointed out, the title
for this 'bouquet of delicate pastel shades and floral
prints with a fabulously feminine charm' might have
been 'Pretty in Print'.

The collection took inspiration from 18th-century
fabrics, Liberty floral prints, Victorian corsetry and
tailoring, Japanese street style and doll costumes
from specialist *figua* stores. The silhouette revisited
elements from last season – playing, as the collection
notes stated, 'with volumes and proportions, layering,
juxtapositions of masculine and feminine, opulence
and poverty' – but the new key theme was patchwork.
Susie Rushton of *The Independent* commented on the
'patching together [of] chalky-coloured pieces of
tulle, organza and Liberty lawn prints, to make
frilly, asymmetric dresses with lingerie details'. Jacobs
confirmed: 'We wanted everything to look as if it had
been taken apart and put back together again.' Jackets,
corsets, petticoats, crinolines and bloomers were mixed
with camisoles, shirt dresses, mattress ticking parkas,
miniskirts with oversized pockets and Jacobs's
signature cashmere sweaters. He noted that his soft
fabrics 'were bleached, washed, sun-faded to look
a little worn and loved'.

Hairstylist Guido Palau created a 'magical' look with
tulle Monogram floral headbands. 'I think the girls look
very very fresh. Girls carrying duchesse satin shopping
bags full of fresh flowers. To me that was [Virginia
Woolf's] Mrs Dalloway,' said Jacobs about the look of the
season. The it-bag was the checked 'Street Shopper' in
woven leather, its passport-style stamp epitomizing the
spirit of travel. Accessories included lace bracelets, a
band-aid ring worn mid-finger (see p. 250, bottom right),
ceramic-soled sandals, oversized Liberty-printed pearl
necklaces, and sequinned Liberty scarves. Bags included
the lacy Monogram Dentelle (p. 243, bottom right), the
Polka Dot Fleurs (p. 248, top left), the Monogram Denim
Patchwork (see pp. 250–51) and the limited-edition
$45,000 Tribute Patchwork crafted from 14 different
models of handbag (see p. 241, left).

The word 'LoVe' was also put on bags and T-shirts,
echoing the iconic image by Pop artist Robert Indiana.
As Style.com's Tim Blanks noted of Jacobs's clever
treatment: 'He is the guy who puts LV in love.'

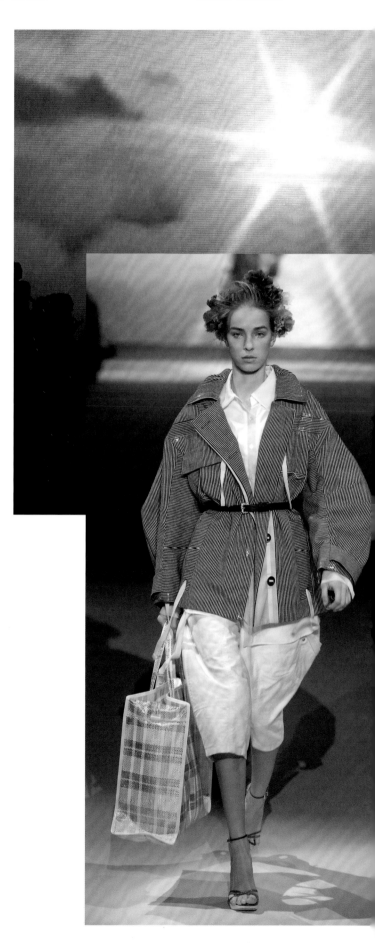

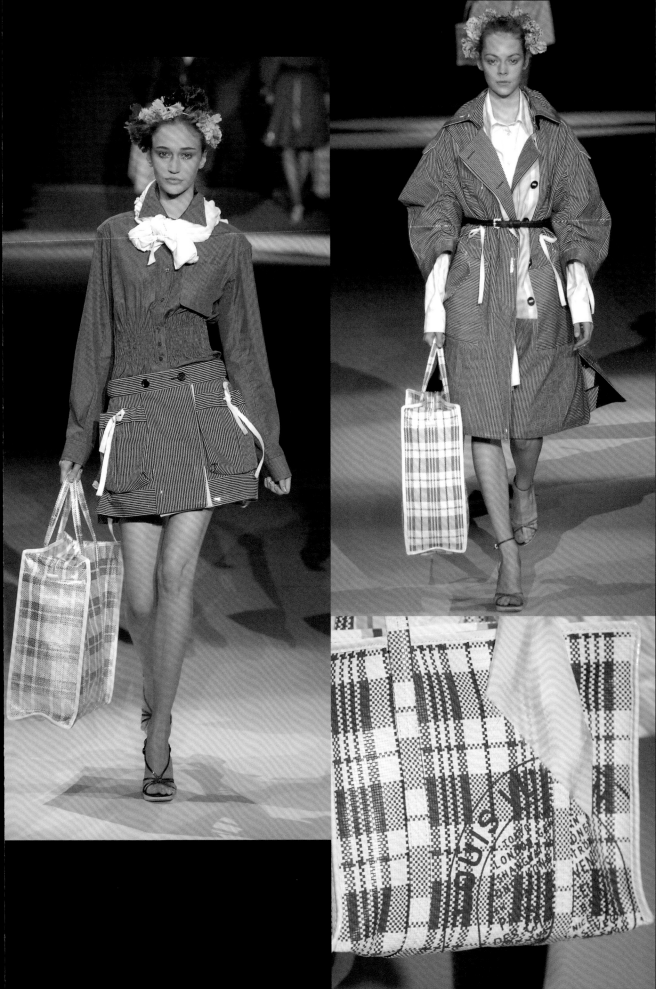

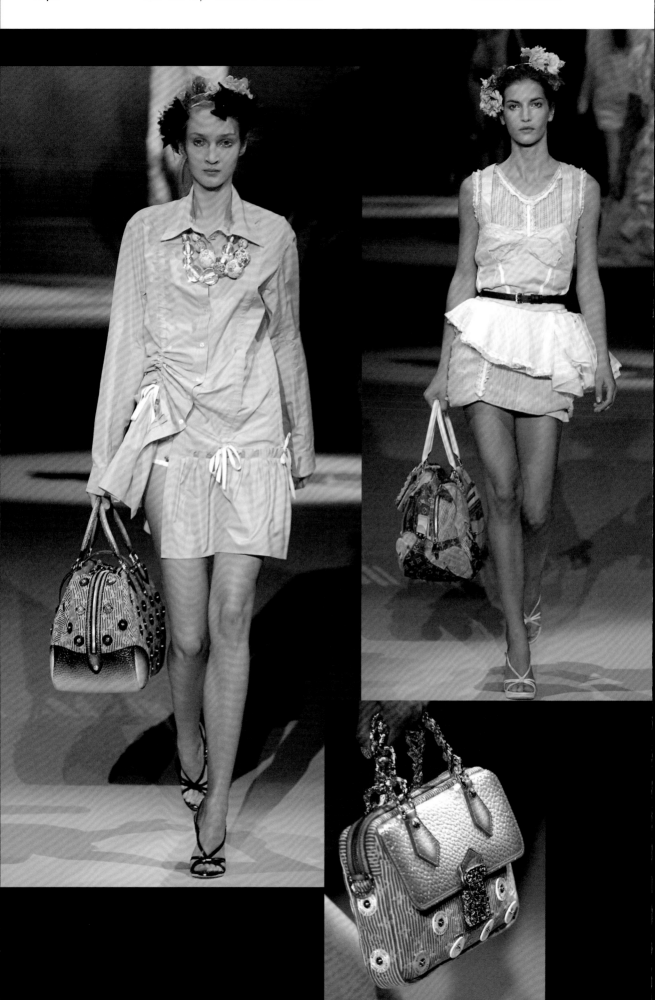

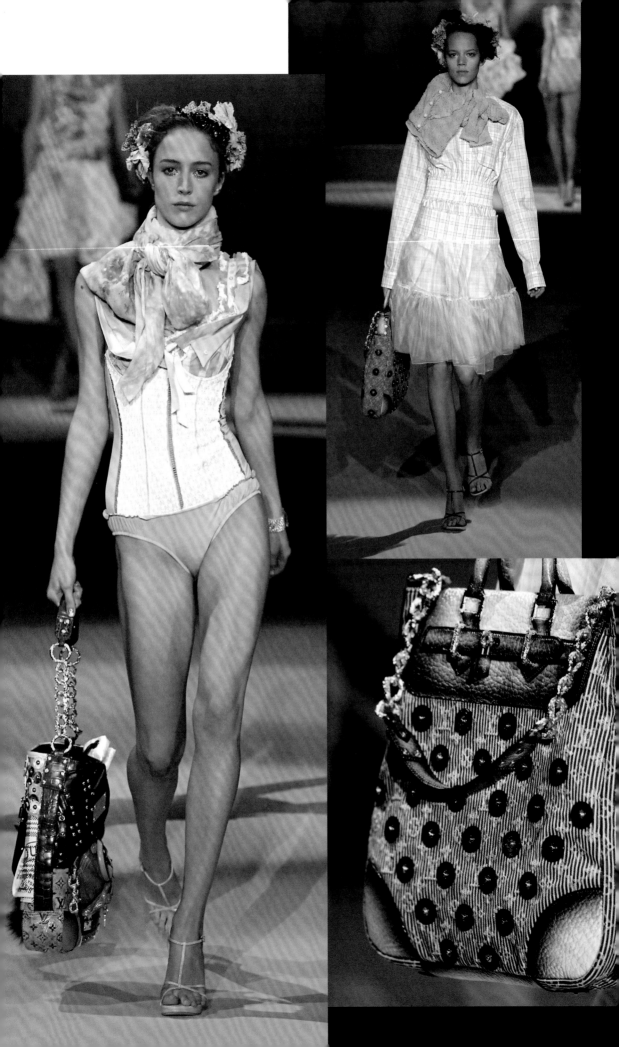

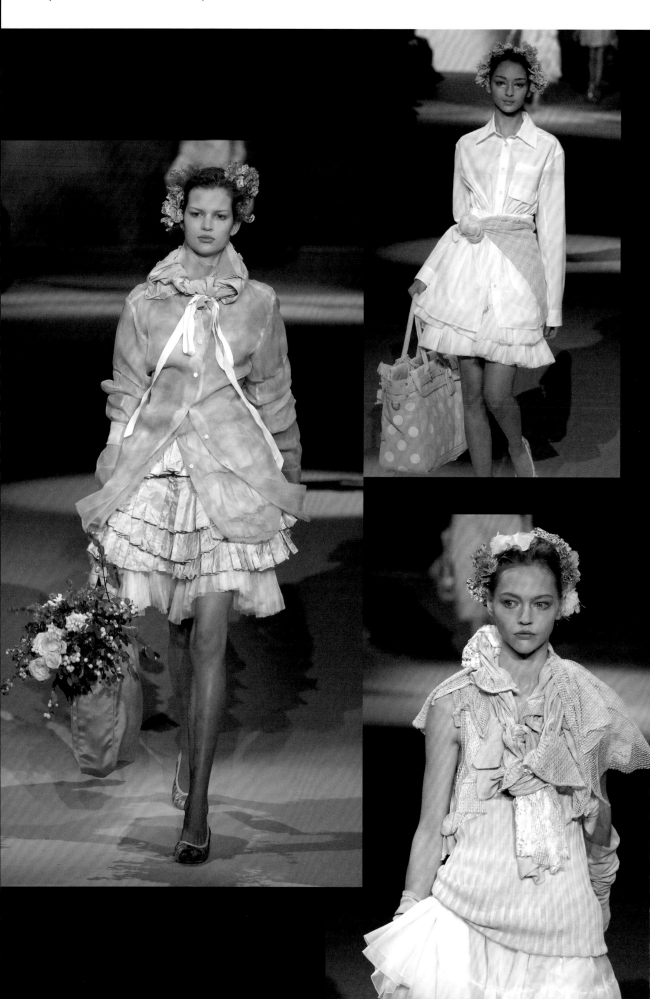

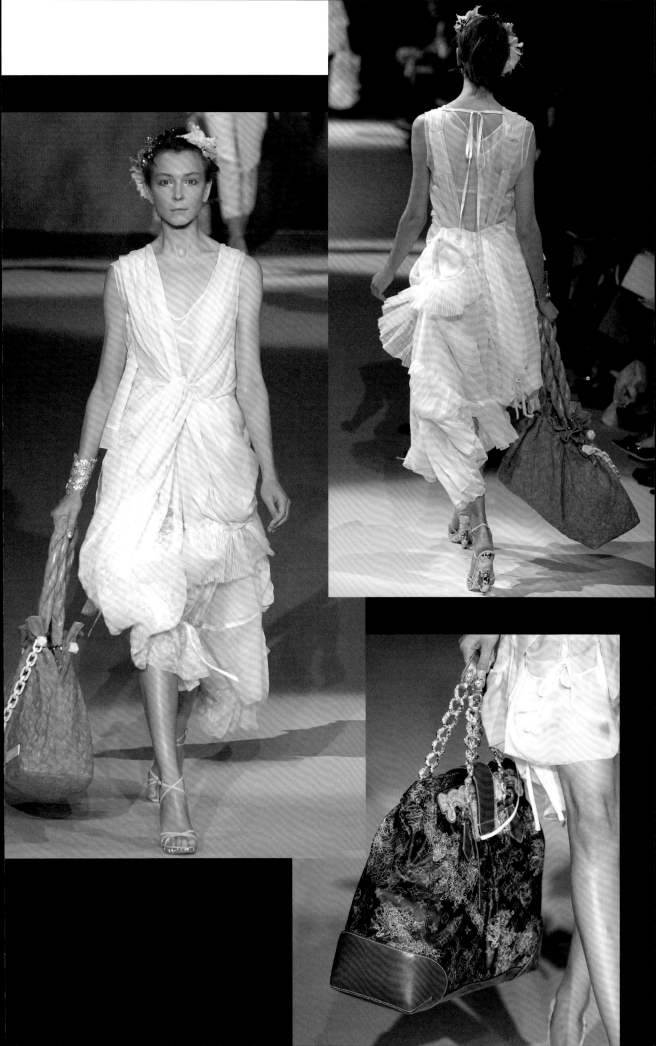

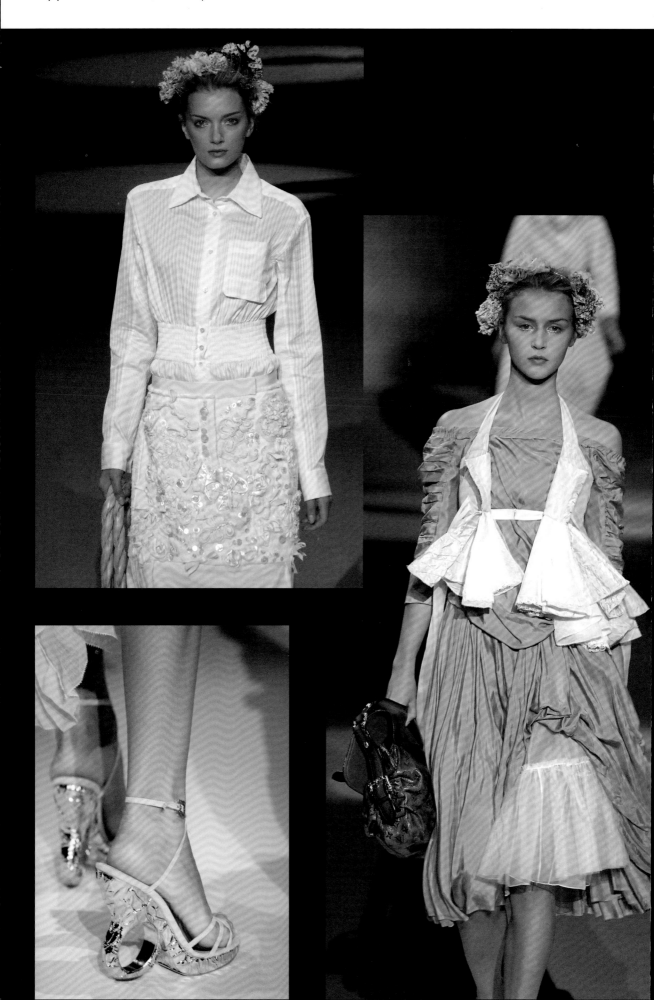

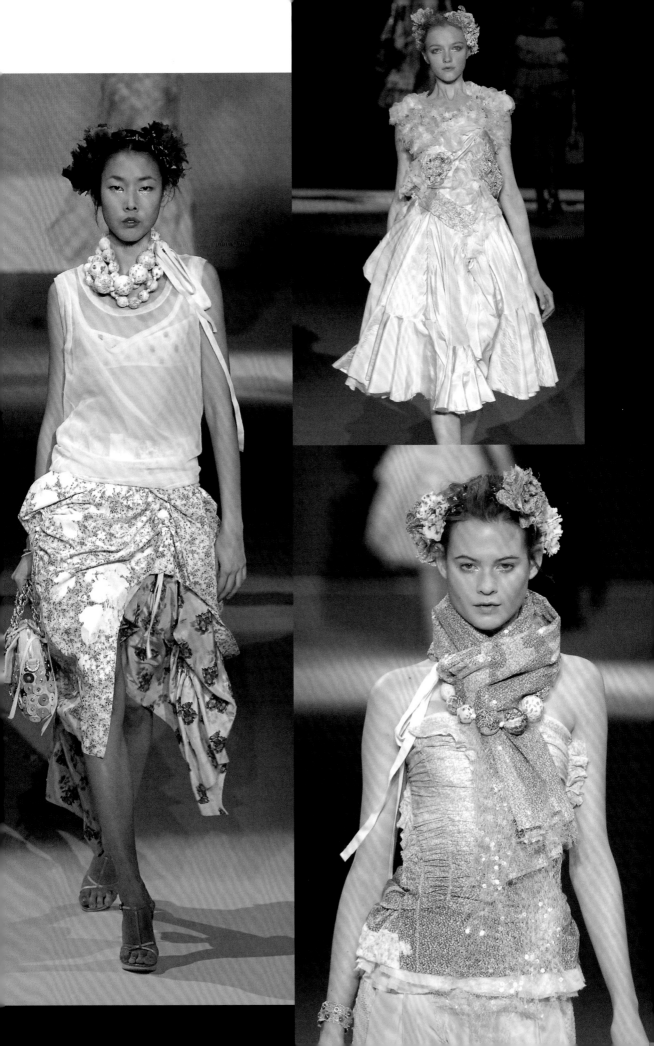

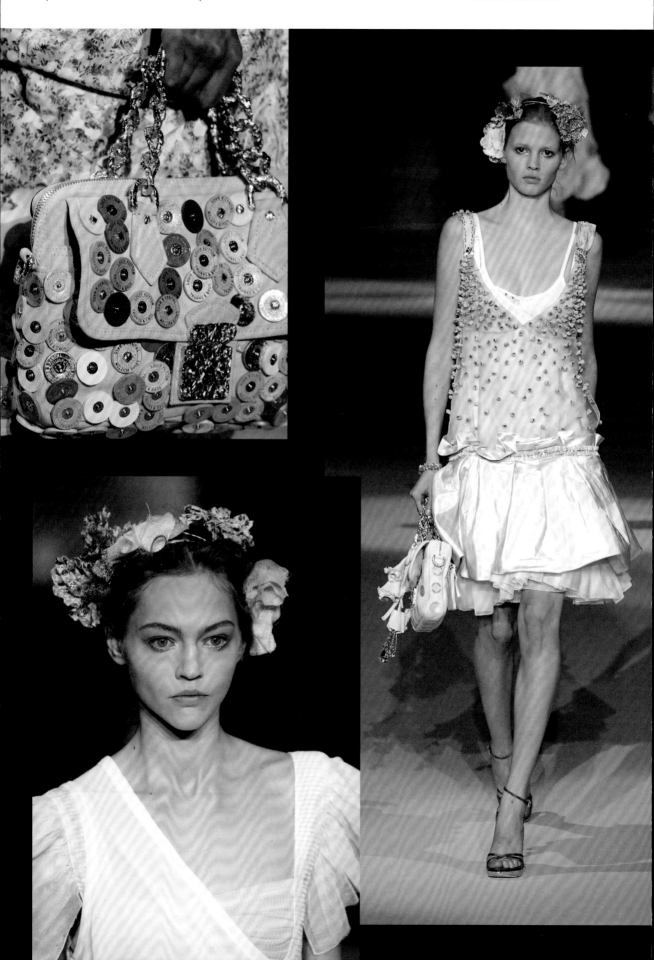

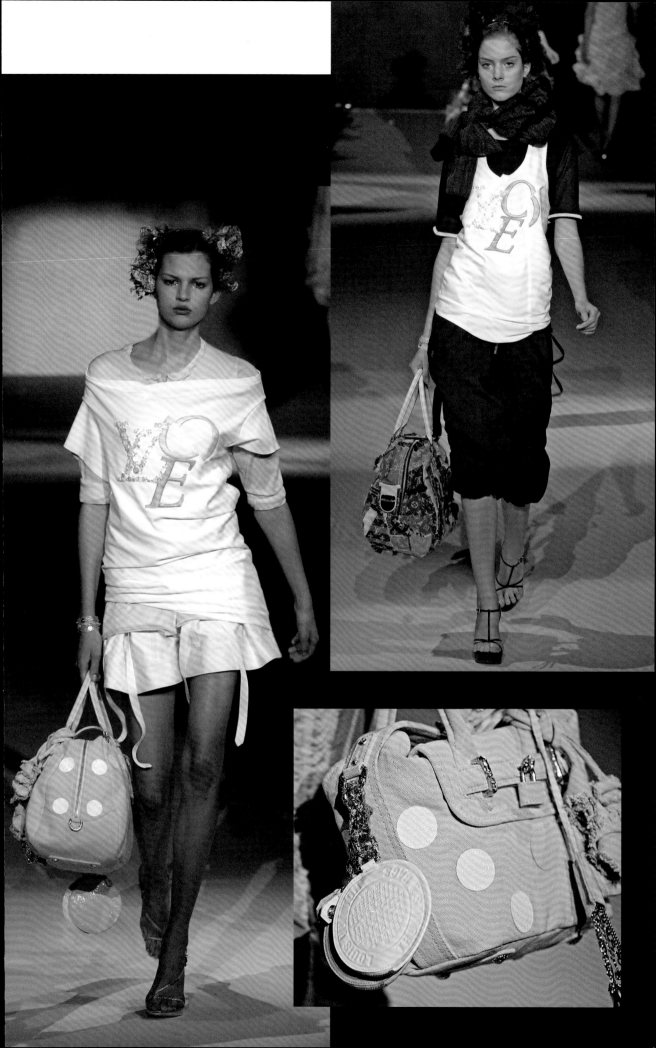

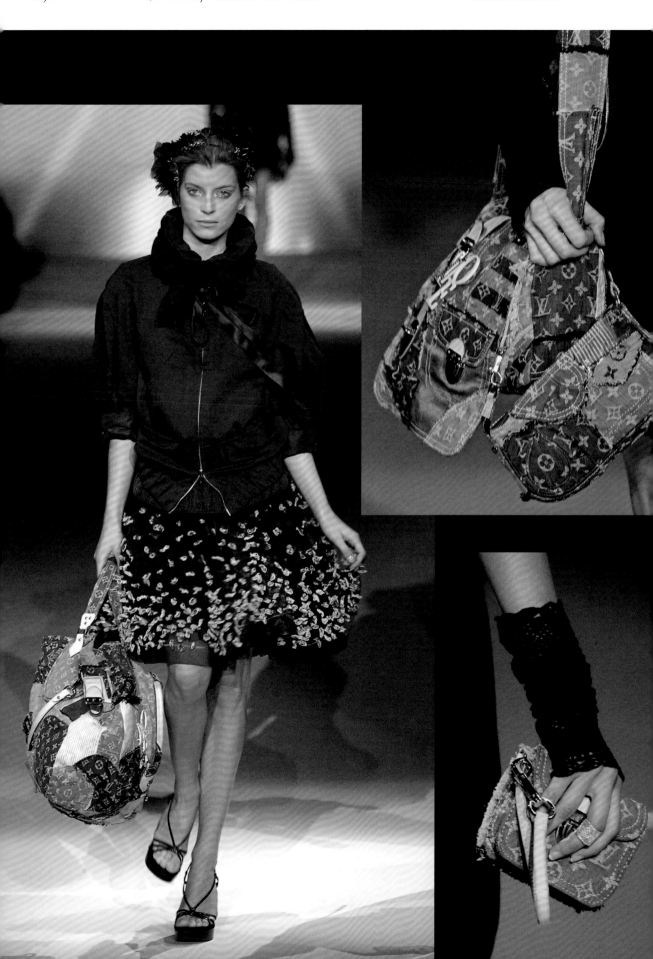

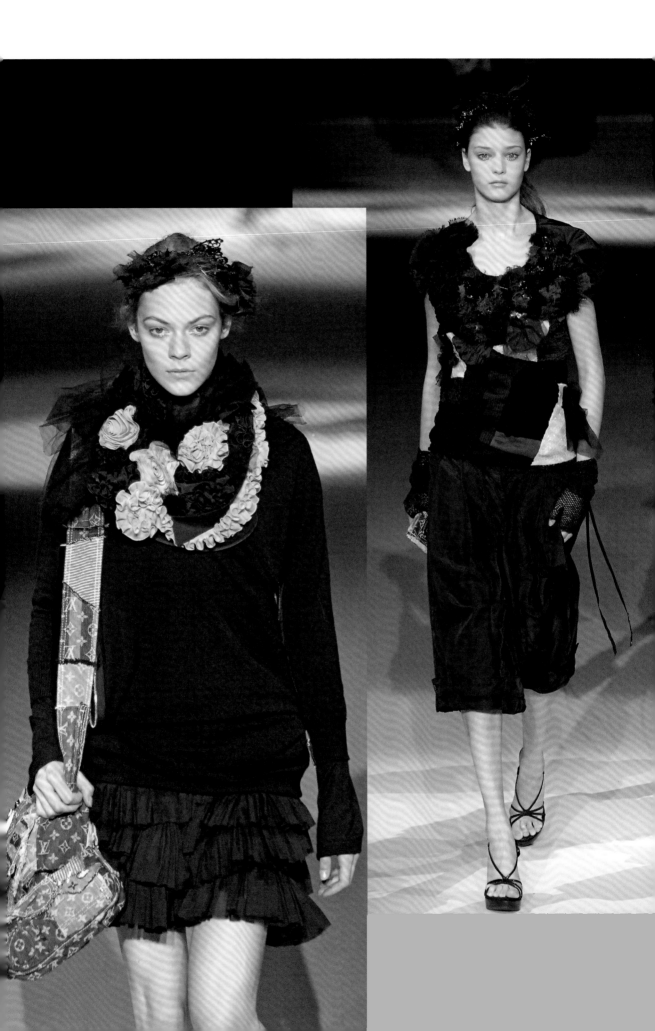

'Girl with a Monogram Handbag – Homage to Vermeer'

Celebrating his tenth year at Louis Vuitton, Marc Jacobs sent a painterly autumn/winter 2007 collection down the catwalk with great energy and panache. Presenting at the Louvre courtyard, he explained: 'It's like in my mind I could reference everything I know about being a painter and an artist – which is not what I see myself as – in putting together the clothes and accessories.'

The arrival of actress Scarlett Johansson on the front row offered a clue. Johansson had recently played the muse of Dutch painter Johannes Vermeer in the movie *Girl with a Pearl Earring*, and would now also be starring in the house's forthcoming campaign styled by Katie Grand. 'A Vermeer palette. Romantic, graphic, painterly, but kind of strong,' said Jacobs about the 52 looks inspired by the master of colouristic effects. Painters' smocks, and oversized berets in wool, alpaca and waxed rabbit, evoked the style of Rembrandt and fellow painters from the Dutch Golden Age. The show notes highlighted the finale's draped dresses 'inspired by portraits by Van Dyck, whose nuances melt into complex colour gradations', from blue to burgundy, beige to blue and blue to grey.

It was at first glance a seemingly minimalist collection, with references to Jacobs's debut for the house. A decade later, however, his concept of modern luxury was now imbued with the chromatic colours, rich textures and sophisticated details found in Dutch *tableaux vivants*. Jacobs also praised the craftsmanship of his collaborators: 'people who do feathers like Lemarié … embroiderers like Montex and Lesage. Those are the things that belong to couture.'

Leather was a major theme. Silver, bronze and gold leather jackets added a youthful spirit to the collection. Models wore plastic-coated crocodile galoshes, spiral-seamed leather boots (see p. 261, left), spectator pumps and 'Sex' boots (p. 265). Susie Rushton reported for *The Independent* on the key accessories: 'As ever at Louis Vuitton, the handbags drew attention, with the house's monogram now given a makeover as a doctor's bag in sheepskin or as a sparkly Lurex clutch bag destined for the disco.' The biker-inspired Motard Monogram was introduced, and the Monogram Mirage line included the 'Griet' (p. 253, top right) and the 'Delft Exotic' (p. 255, top right).

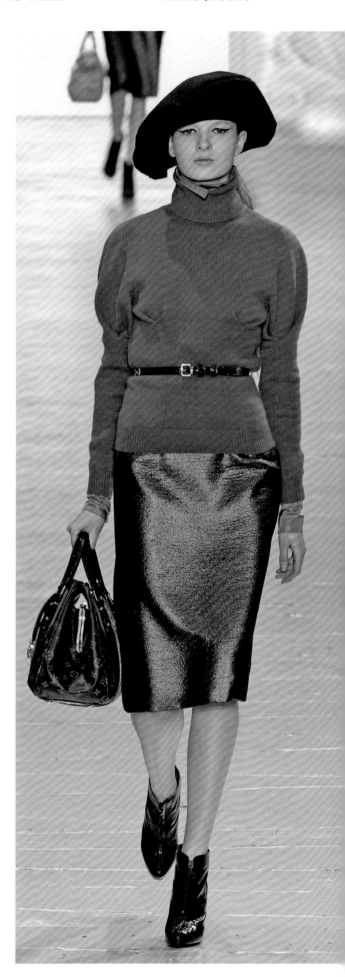

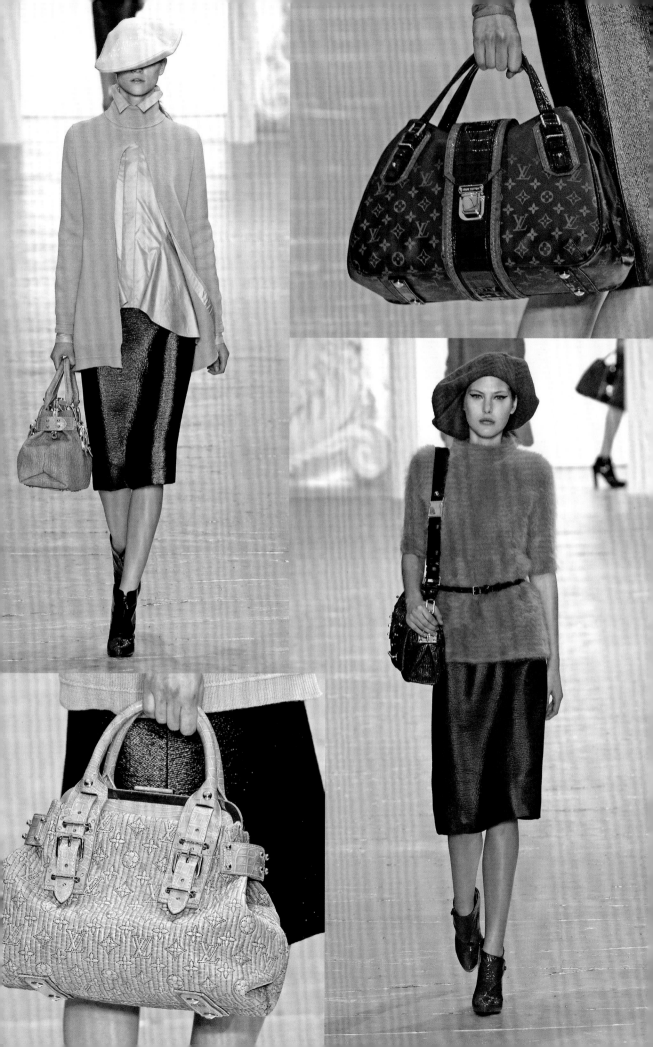

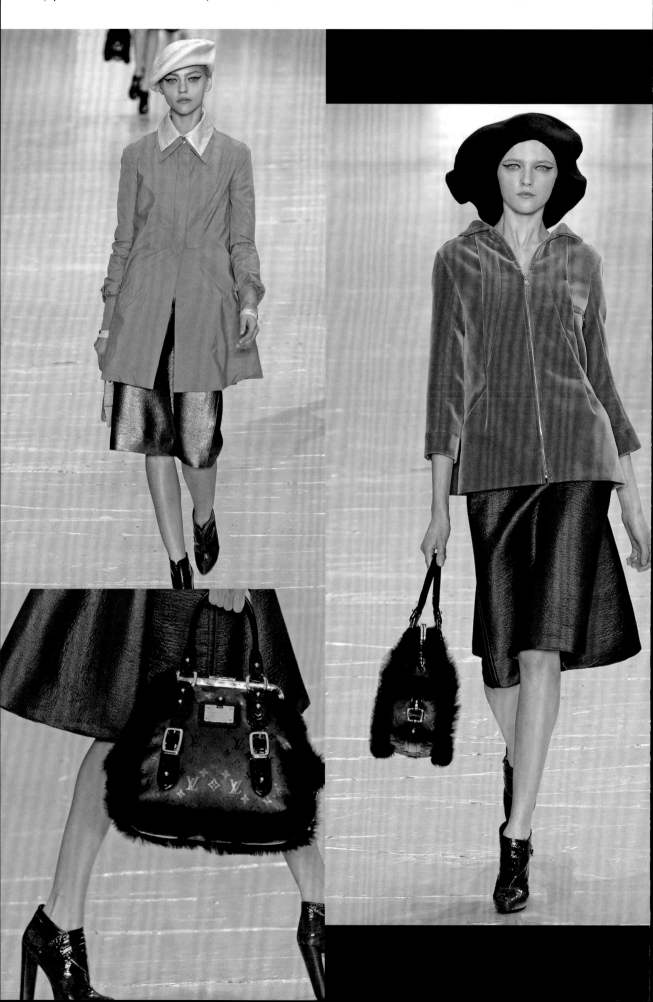

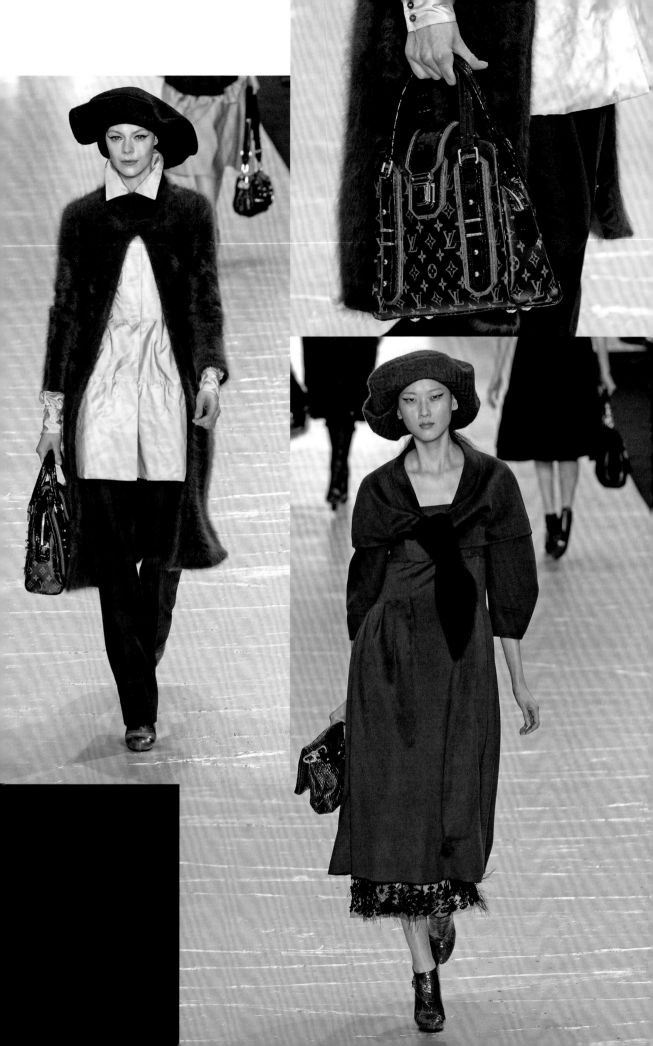

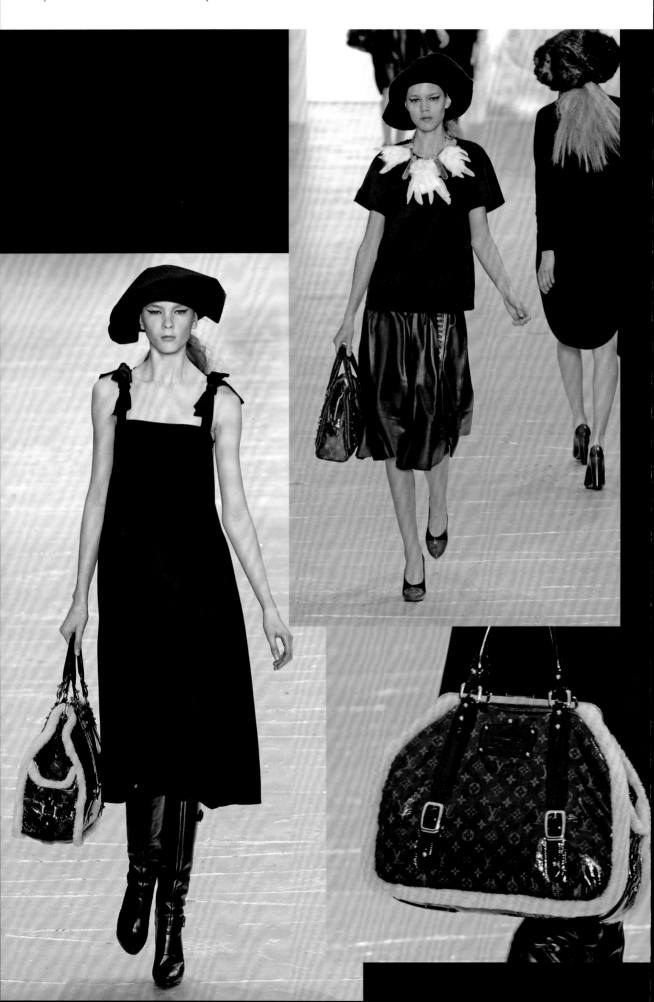

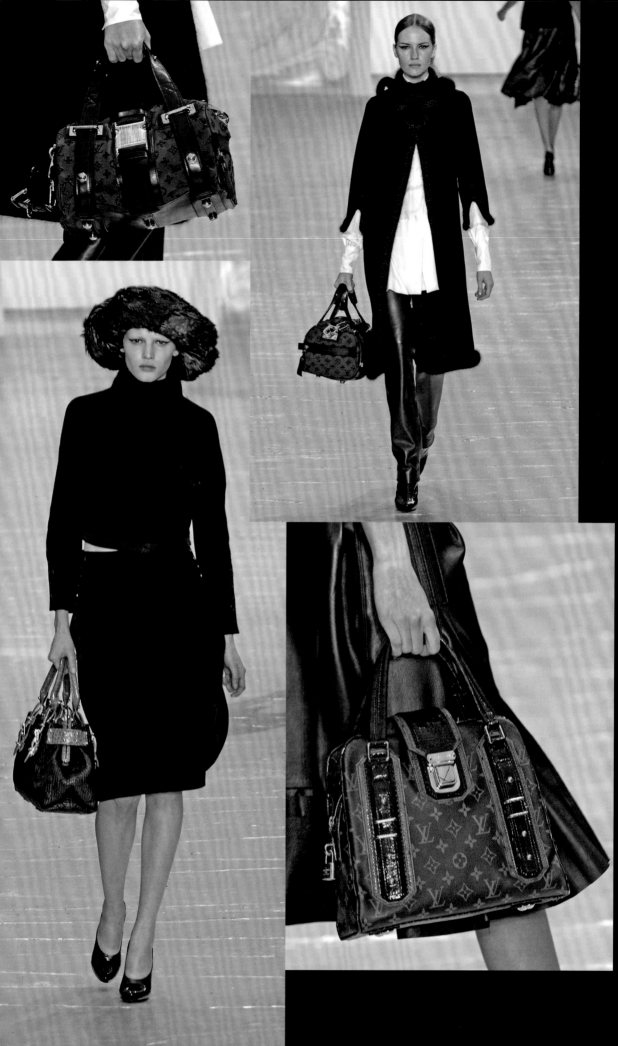

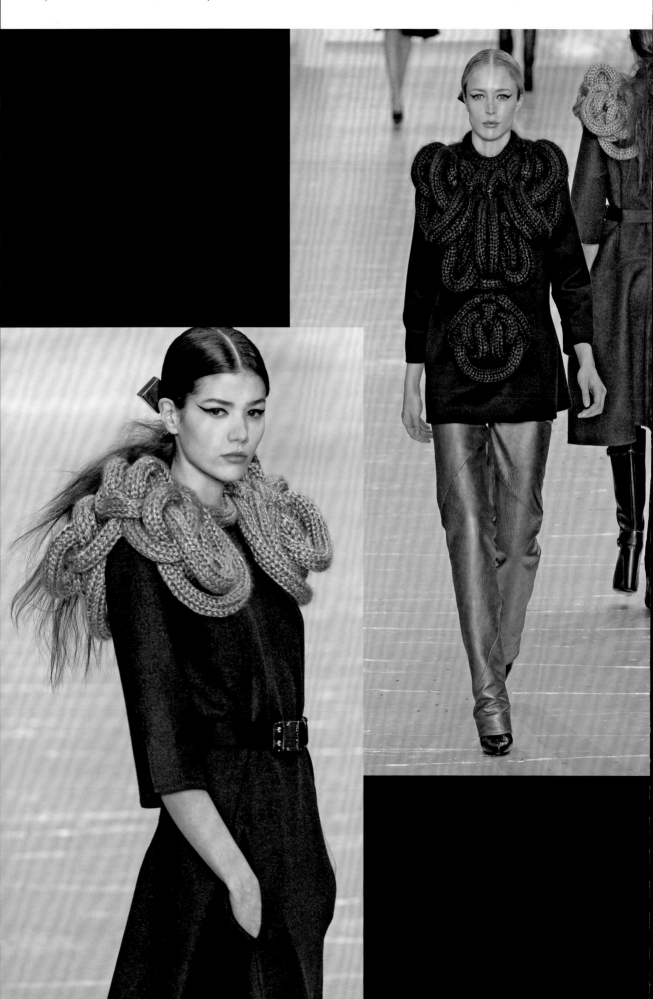

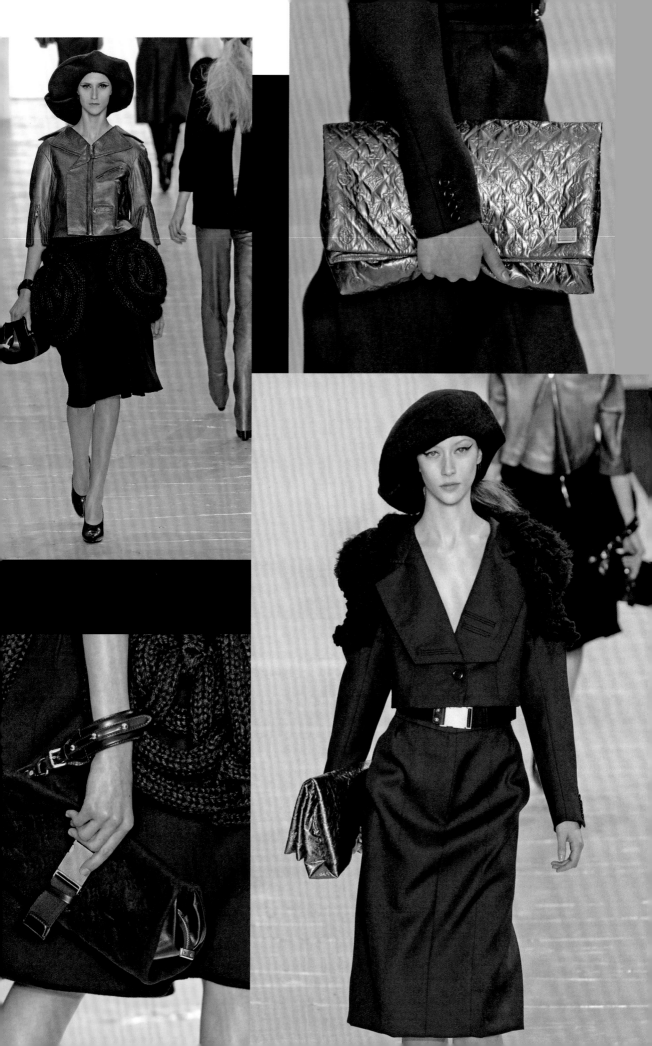

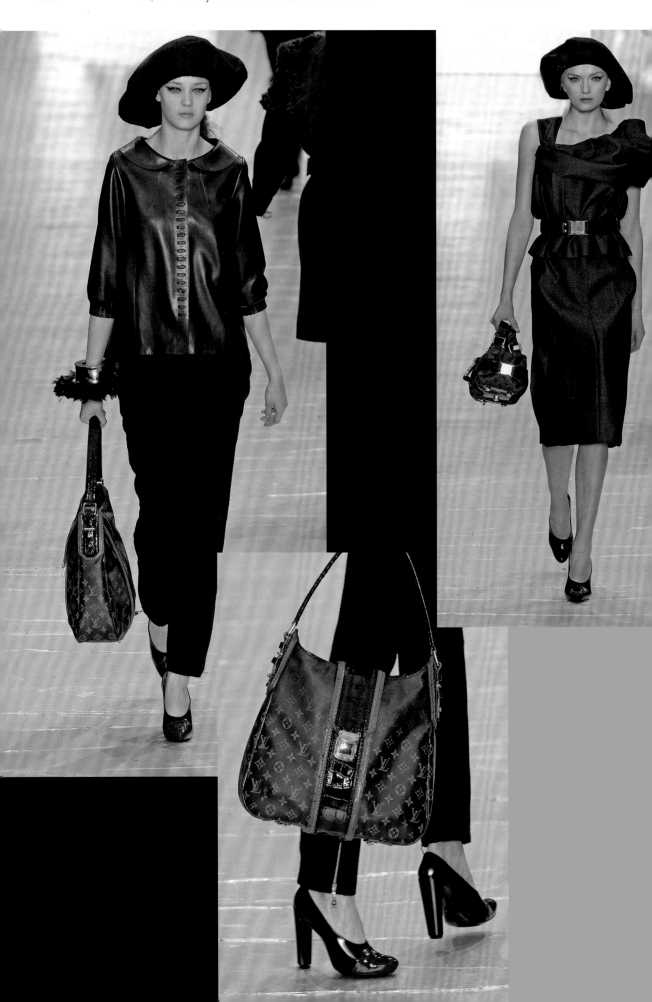

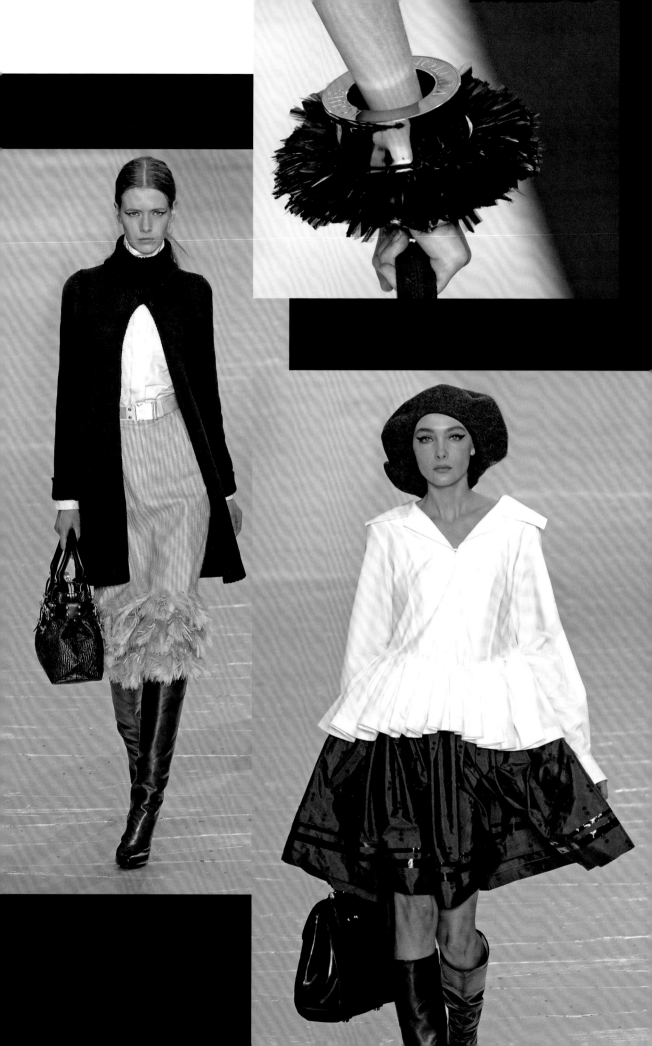

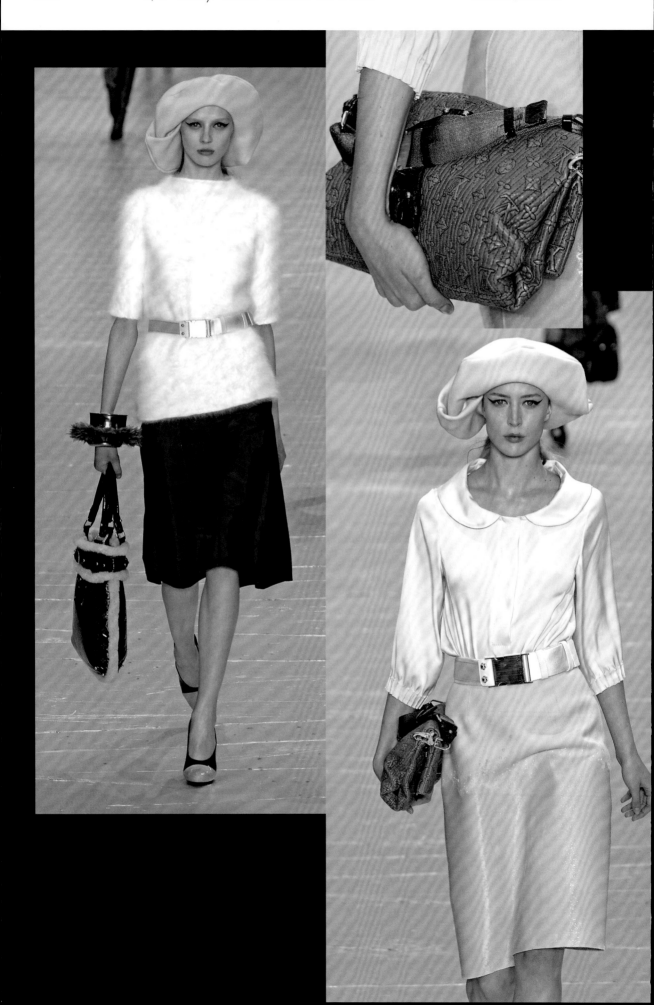

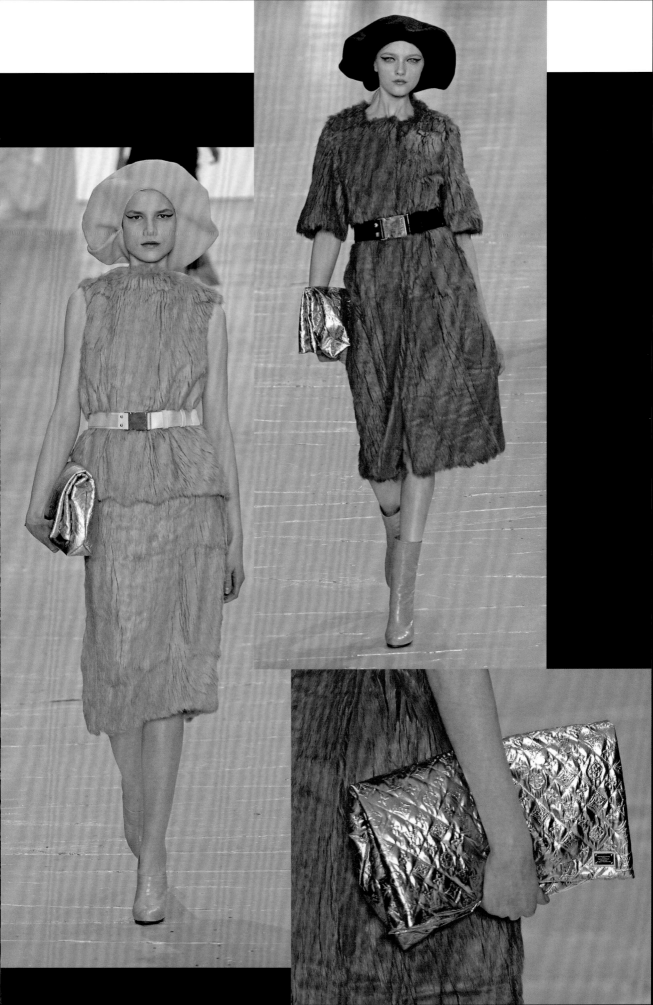

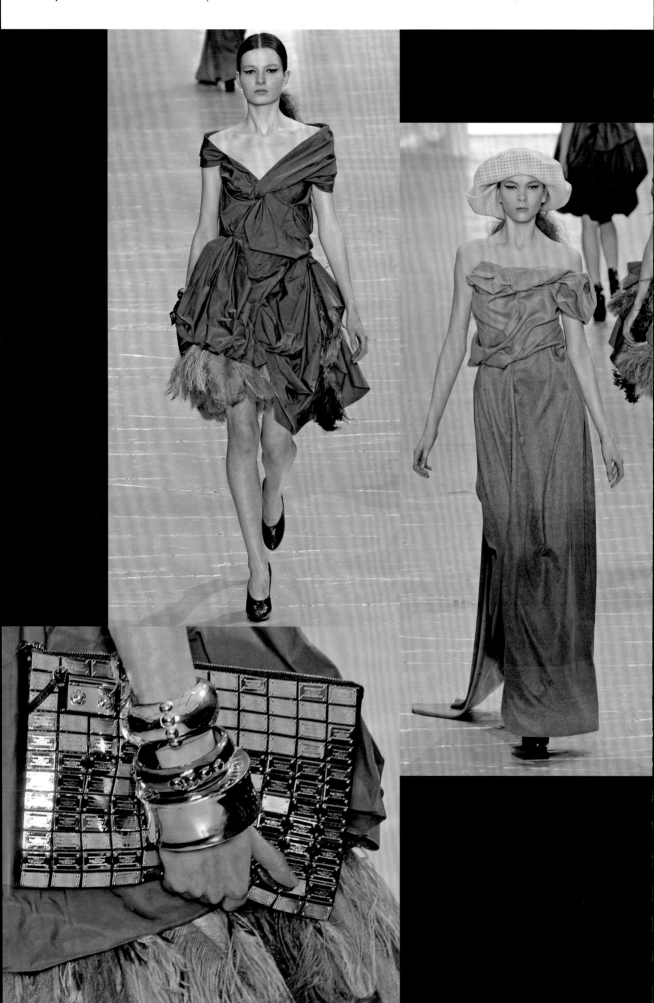

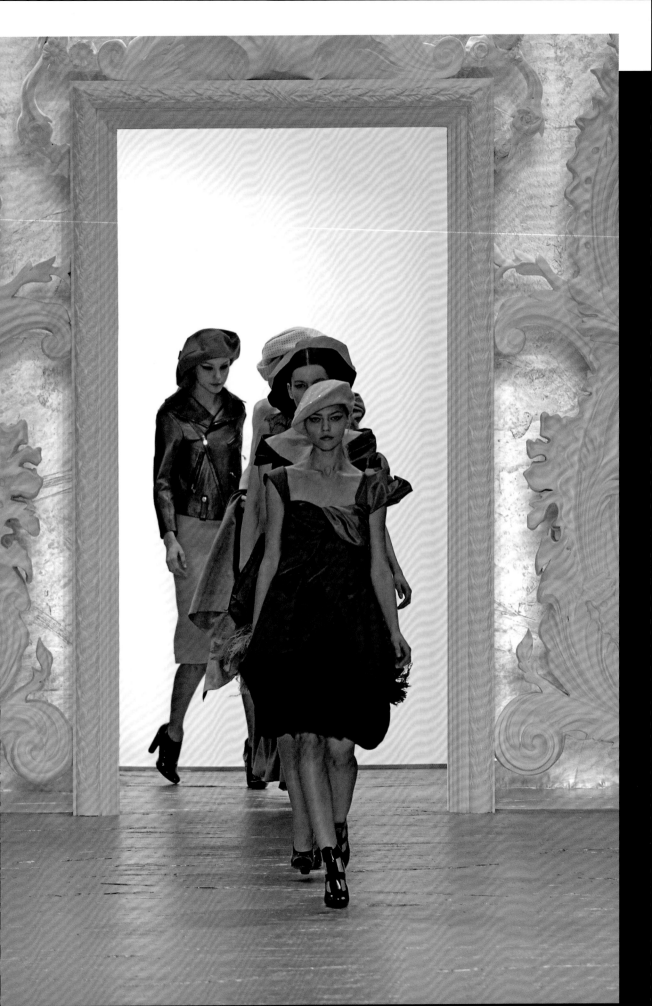

'Louis Vuitton After Dark' with Richard Prince

Following collaborations with Stephen Sprouse and Takashi Murakami, Marc Jacobs turned to artist Richard Prince for this collection. 'I always think Richard represents in the contemporary art world what so many great hip-hop artists do: so much of music is about sampling, appropriation, remixing, remastering... That's an approach I understand very well,' the designer declared. Inspired by Prince's most iconic pieces (his Nurse paintings, for example, and his use of corny jokes and cartoons), the artist and the designer worked together to create 'hybrids of what Vuitton is and what [Prince] is'.

The ceiling and exterior of the huge tent in which the show took place were decorated with enlarged covers of vintage paperback books that the artist collected. 'Their strangely similar titles – *Paris After Dark*, *London After Dark*, *New York After Dark* – evoked the atmosphere of the collection,' the house stated; they also inspired its title.

The handbags of the 'After Dark' collection used four entirely new patterns: Jokes Monogram Canvas (carried by Vuitton's own 'nurses'; see opposite and overleaf), Pulp Monogram Canvas (see p. 272, right), Watercolour Monogram Canvas (see p. 270, top left) and Bonbon Leather Monogram (see p. 275, top left).

Vuitton's familiar Firebird bag was also reinterpreted in Cartoons Monogram (p. 275, bottom left, and p. 278) and Motard Monogram (appliquéd with pink plastic studs that evoked the thick impasto paint which Prince used to transform photographs; see p. 274, bottom right), while for the show's finale (p. 281) Jacobs carried the Video Trunk, with TFT-LCD screens on all sides broadcasting *SpongeBob SquarePants*, a character whose image Prince had earlier appropriated in his work.

The collection was 'full of nutty combinations of fabric and garish SpongeBob pastels', wrote *Vogue*'s Sarah Mower. 'The Lurex knits, pencil skirts, and gazar trenches came in mauve, yellow, pink, and purple, with deconstructed fragments of pinstripe vests, tweed suiting, and goddess-y chiffon fused into the mix.' Citing the abundance of accessories featured, from chunky jewelry to unexpectedly intricate shoes, she added: 'It was crazed, random, playful – yet grounded, as always, in bottom-line business sense.'

Stylist Katie Grand explained: 'Every shoe had a different embroidery on it, and then what made it even more difficult for everyone is we designed the left and the right shoes to be different from one another ... we liked the idea that when you looked at them they weren't identical, they were slightly off.'

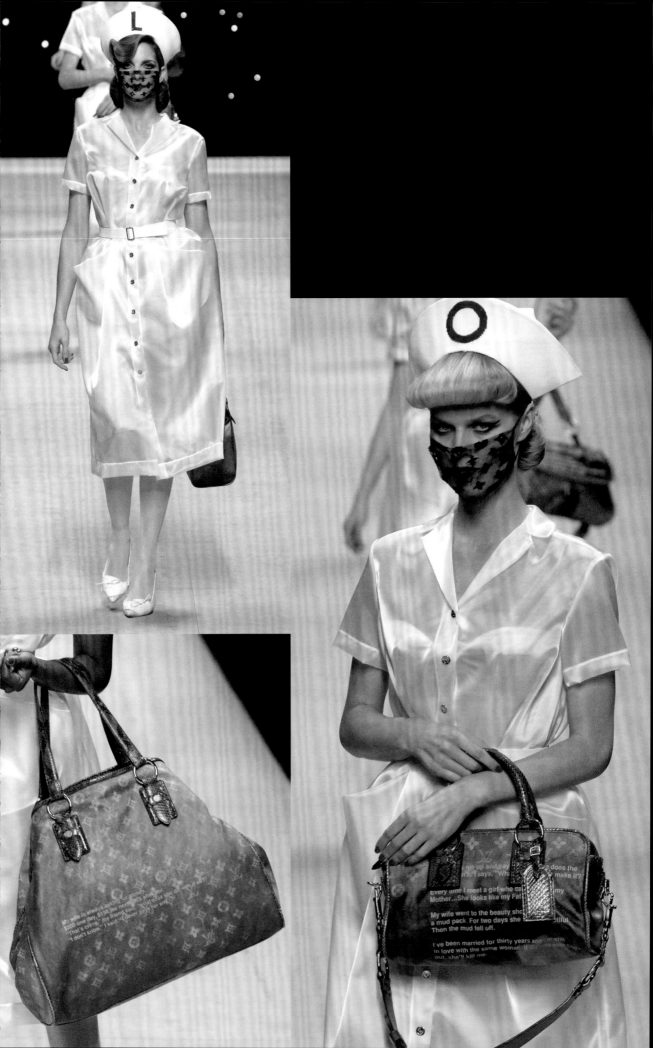

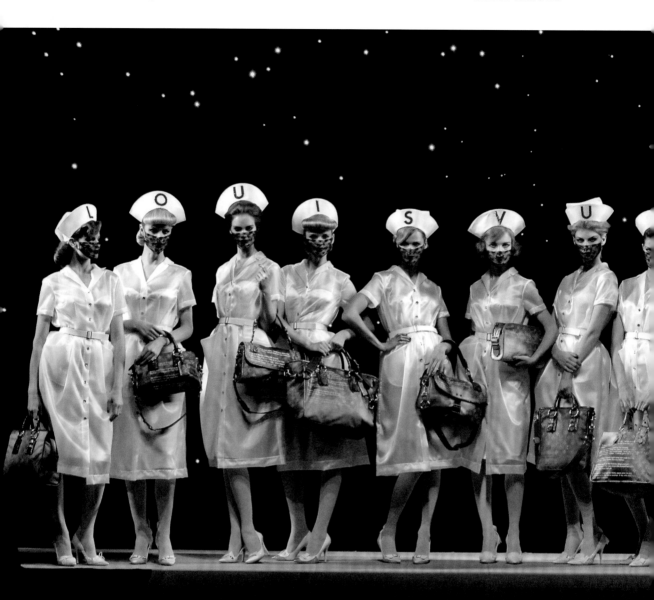

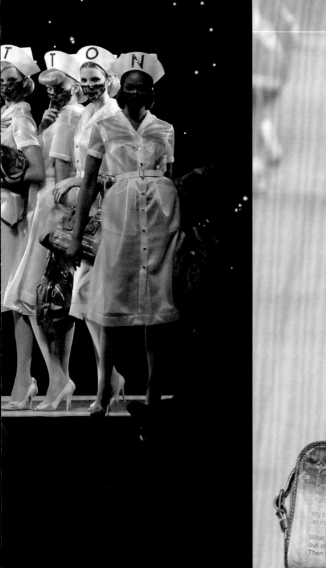
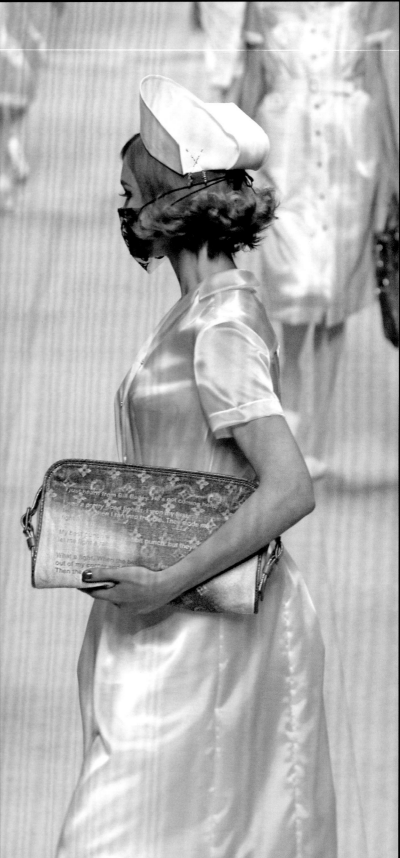

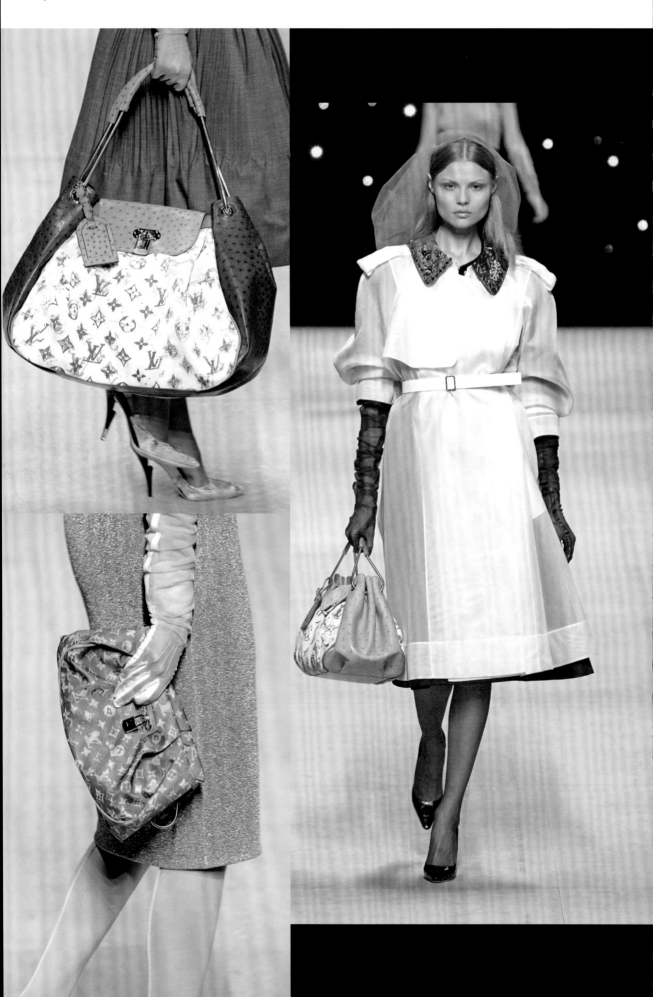

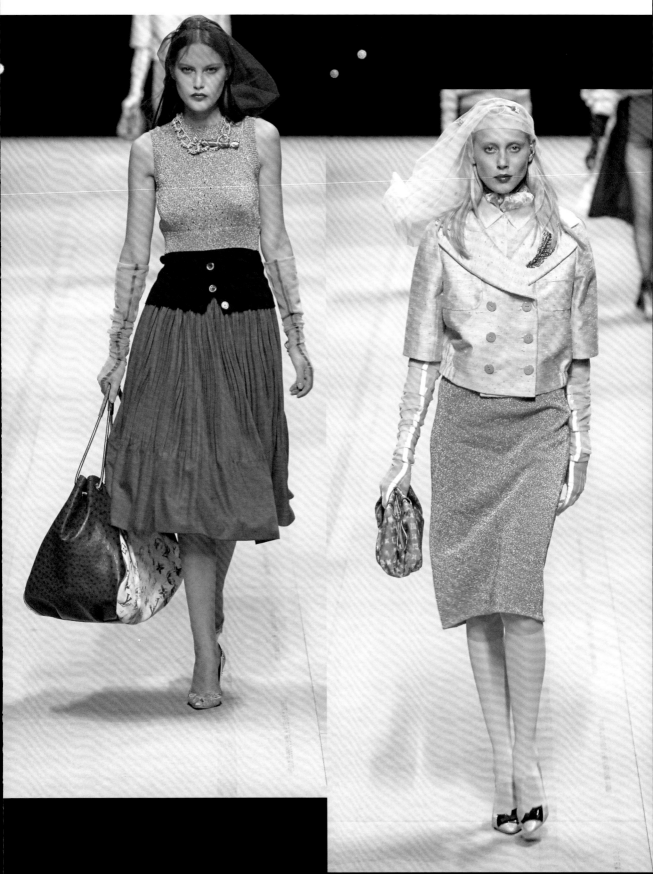

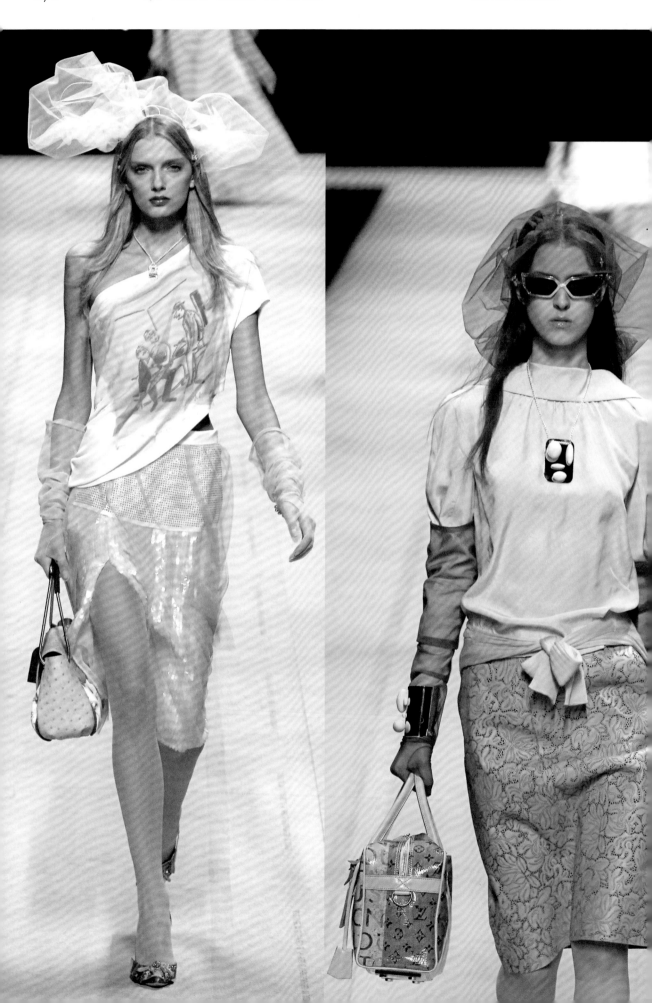

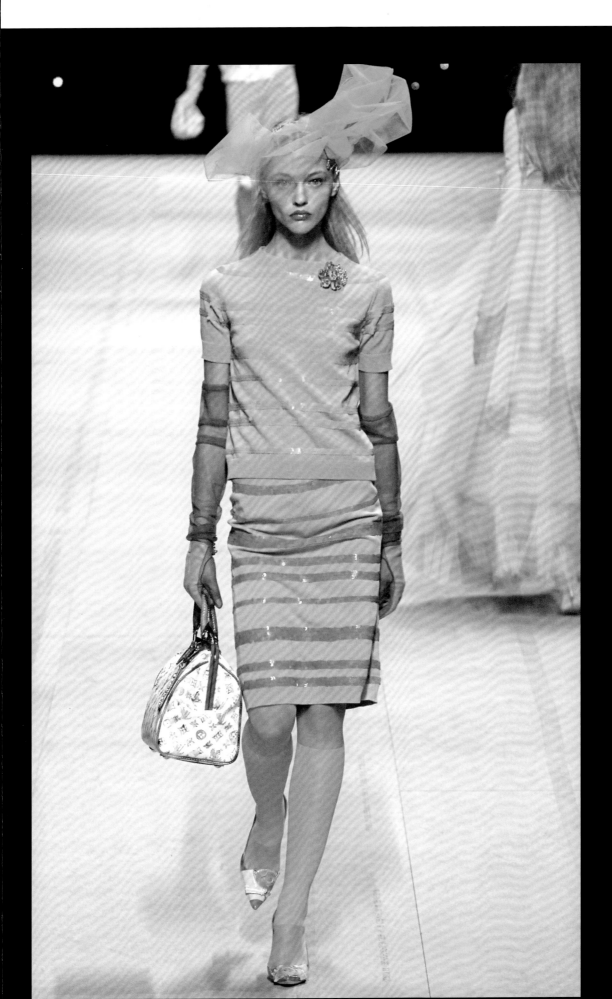

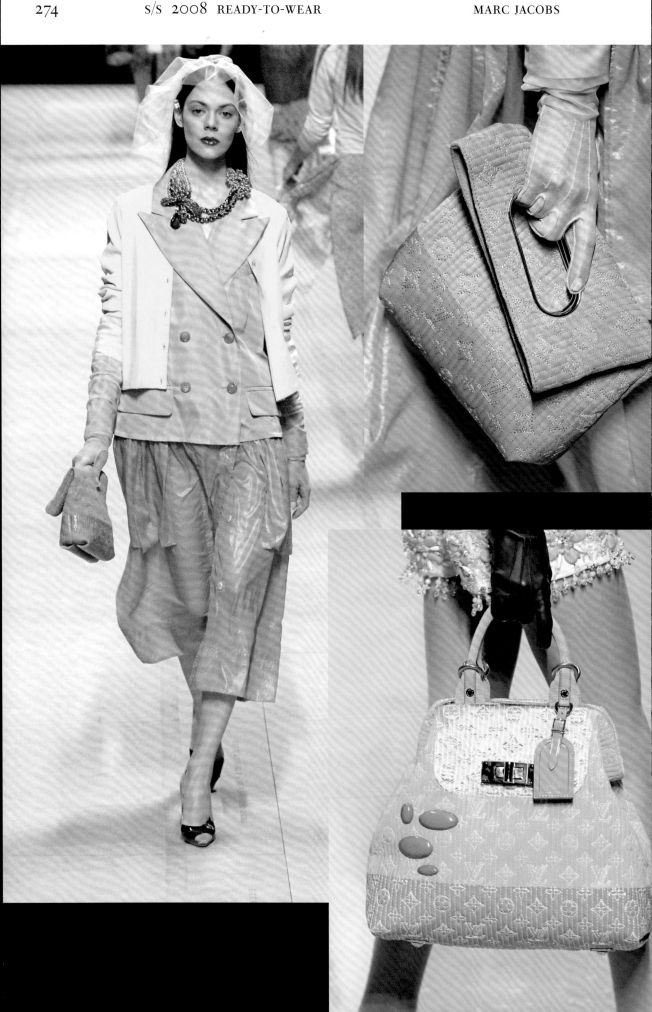

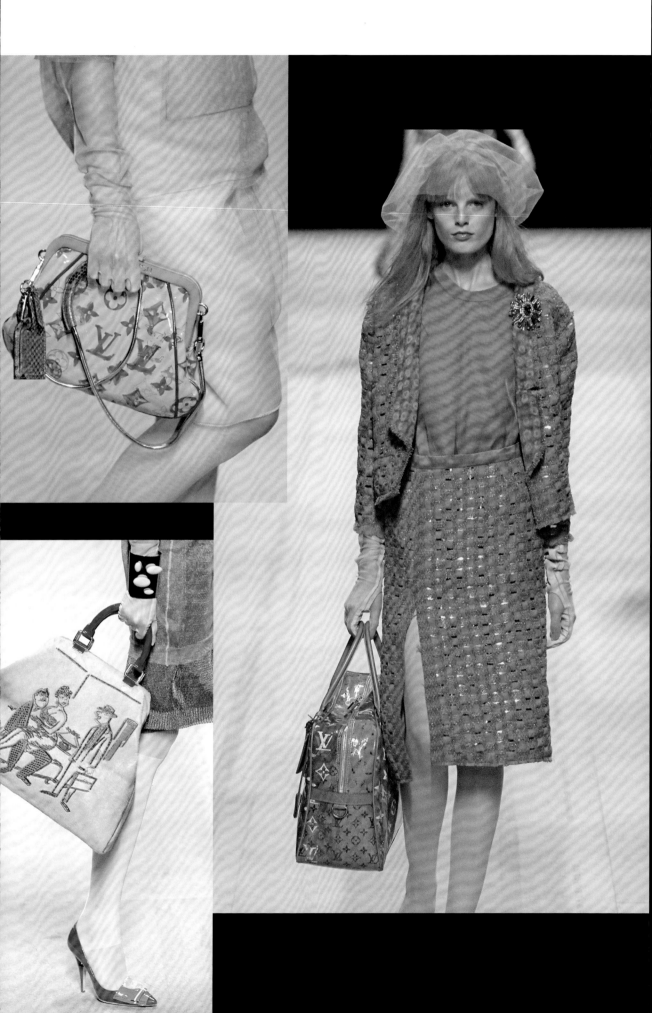

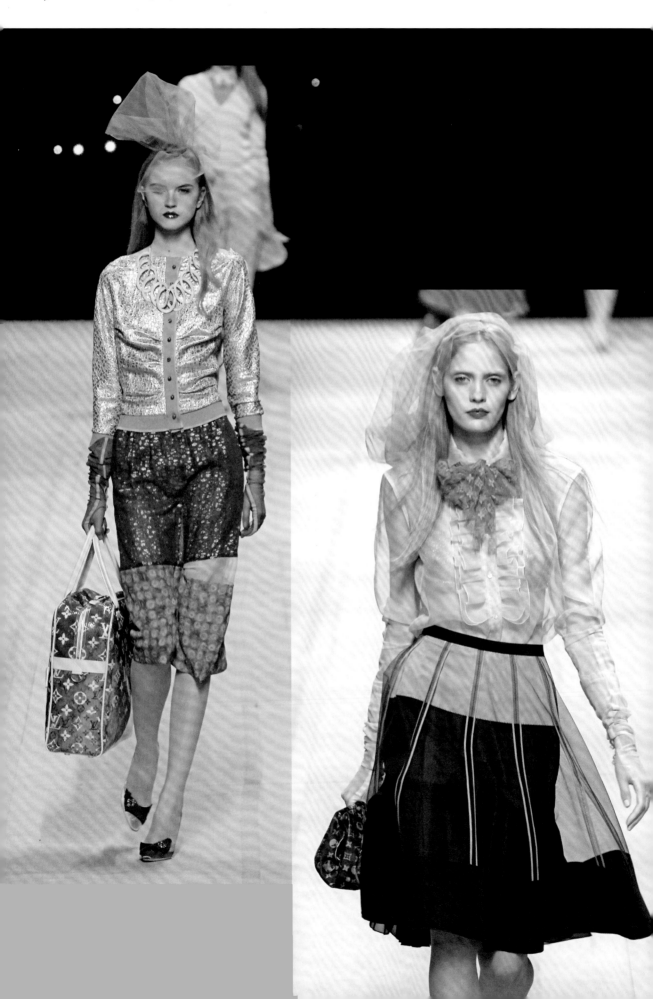

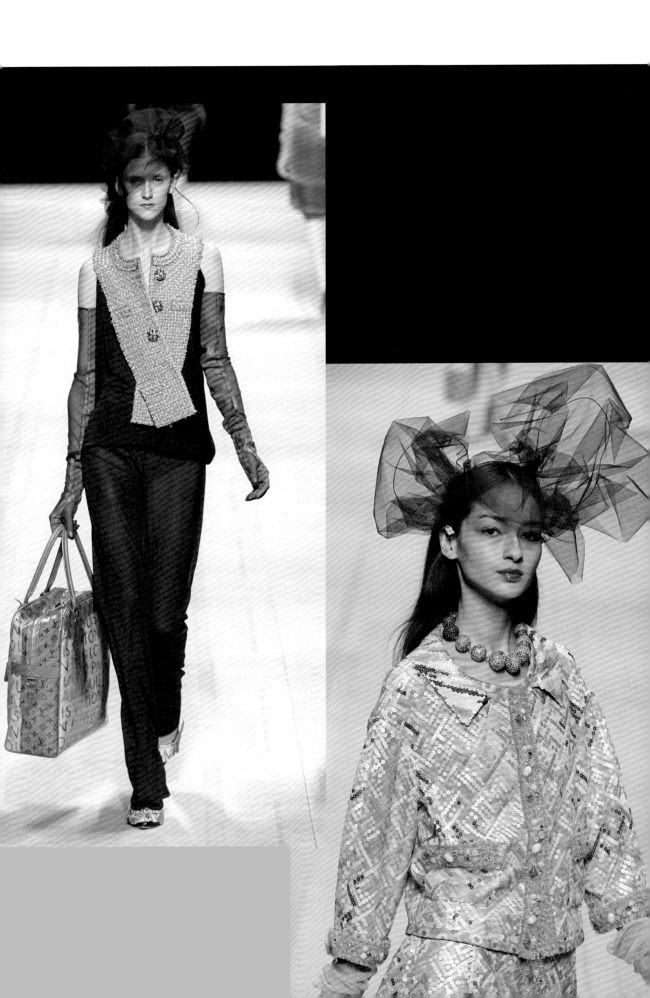

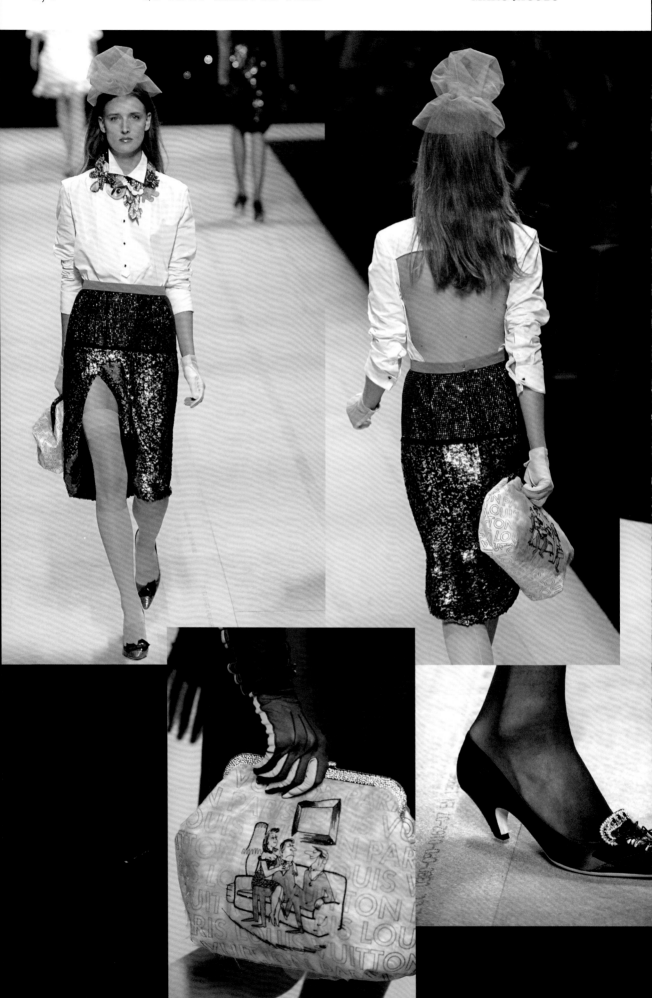

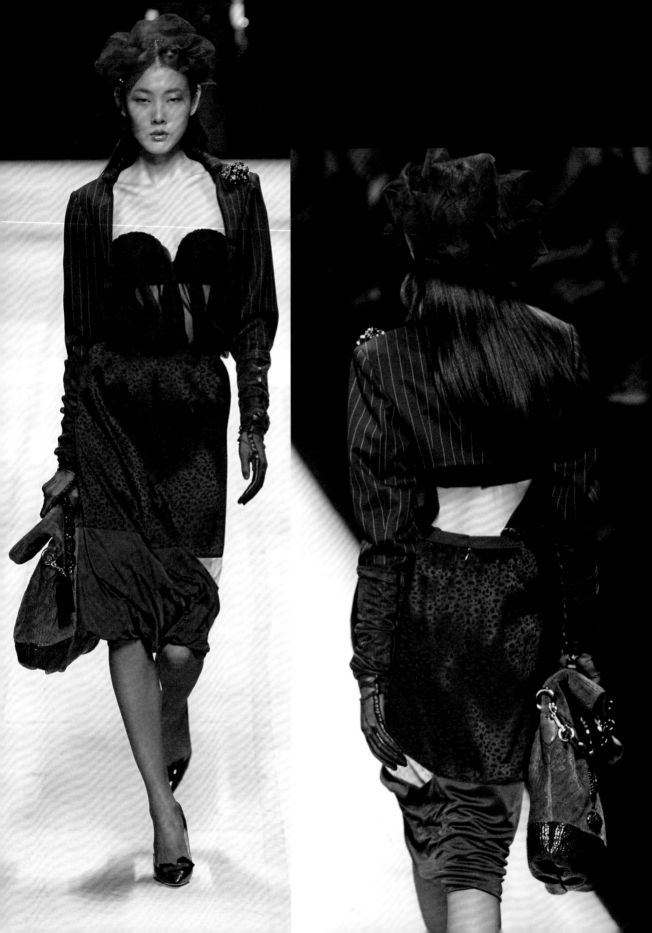

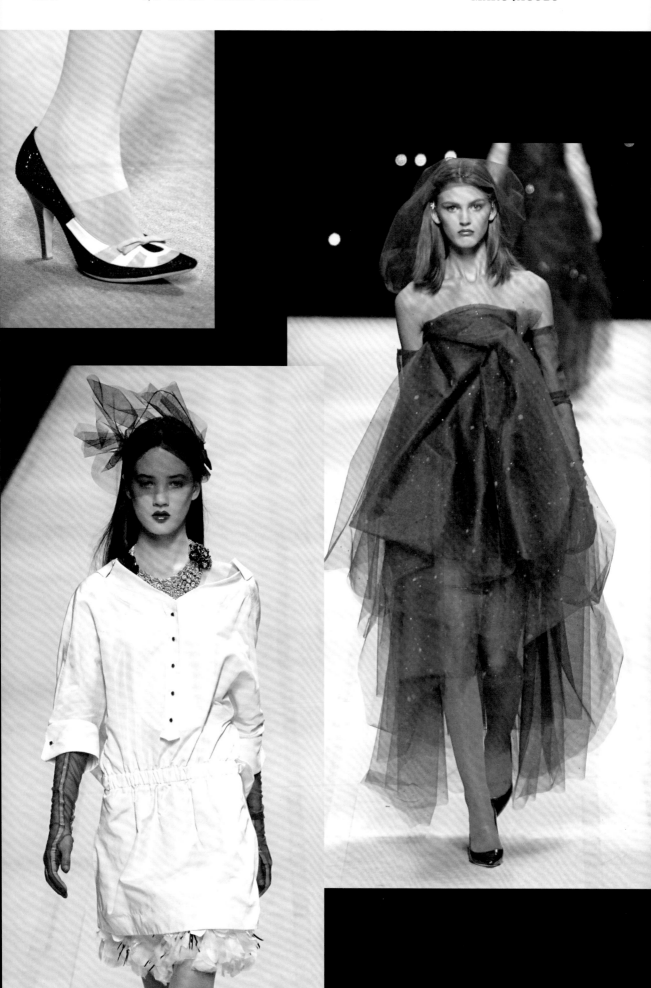

'Modern Sculptures'

Transforming the signature cutting techniques of the masters of haute couture, Jacobs presented a wardrobe for a Louis Vuitton woman, who, 'perched on her vertiginous heels ... dominates her world with elegance, a grandiose silhouette extended with hats, jewelry and gloves'. Inspired by *L'Officiel* and French *Vogue*, Jacobs said he was looking at a time when 'people like Yves [Saint Laurent] and [Hubert de] Givenchy, and Madame Grès ... had shows. And everything was absolutely stunningly perfect. The makeup was perfect. Not a hair out of place.' Style.com's Tim Blanks called it Jacobs's 'fantasy of an ideal French fashion', and dubbed the black- and pastel-toned collection 'twisted bourgeois'.

Where the last season was painterly, this season was sculptural, the show notes referencing 1950s couture ('its sensual curves ... the waist narrow and the hips pronounced') and 1980s glamour ('a determined attitude born from the spirit of a liberated decade'), mixed with Japanese avant-garde. Volume and proportion were created with pegged trousers, panel skirts, twisted collars, draped dresses, long blazers accentuating the hips, and belted vests in the season's all-important fur. For eveningwear, Jacobs introduced black Monogram tights (p. 289, left), long leather gloves, a series of black asymmetric dresses and a fairytale ballgown (p. 295).

The collection was presented against a silver and blue backdrop, surrounding the models with a glowing light to enhance the architectural outline of the looks. Handcrafted accessories – 'modern sculptures', according to the show notes – added a monumental quality. Chunky metal necklaces, brooches and spiral hats 'pushed the limits of body and space'. Each model also wore 16-cm (6⅓ in.) high heels, which *The New York Times*'s Cathy Horyn described as 'monolithic platform shoes that have a crack of air space between the heel and wedge, like two Manhattan skyscrapers'.

Stefano Tonchi, reporting for *The New York Times*, remarked on Jacobs's 'postmodern approach' to the history of fashion. Jacobs also took a modern twist on the original Louis Vuitton trunk and its contents. The metal construction of a crinoline appeared as metallic hoops on petticoats and prints on bustier dresses, which also mimicked the black lining in trunks.

The show notes explained that 'the play of contrasts between suppleness and more structured forms' could also be found in the leather goods. Bags included the Embossed Monogram Suede, with python handle (see opposite, right); Monogram Paris, similarly embossed (p. 284, left); and Python Perforé (p. 290, bottom).

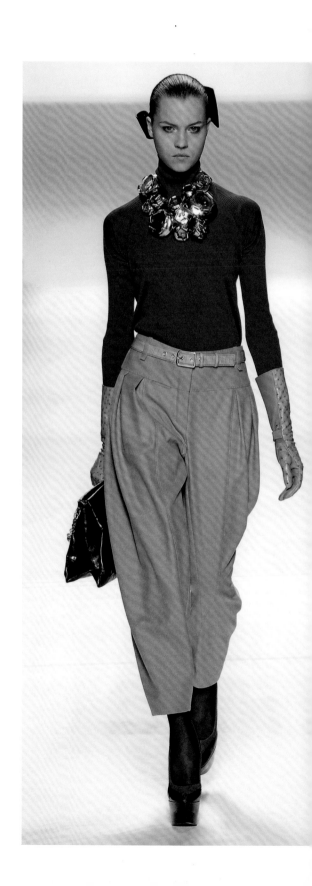

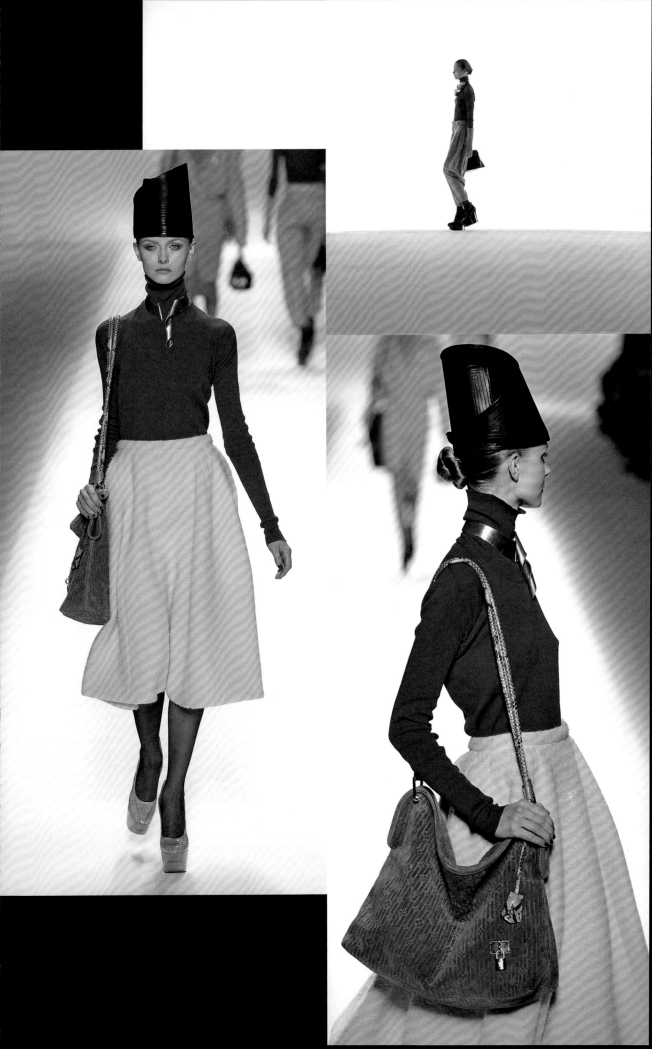

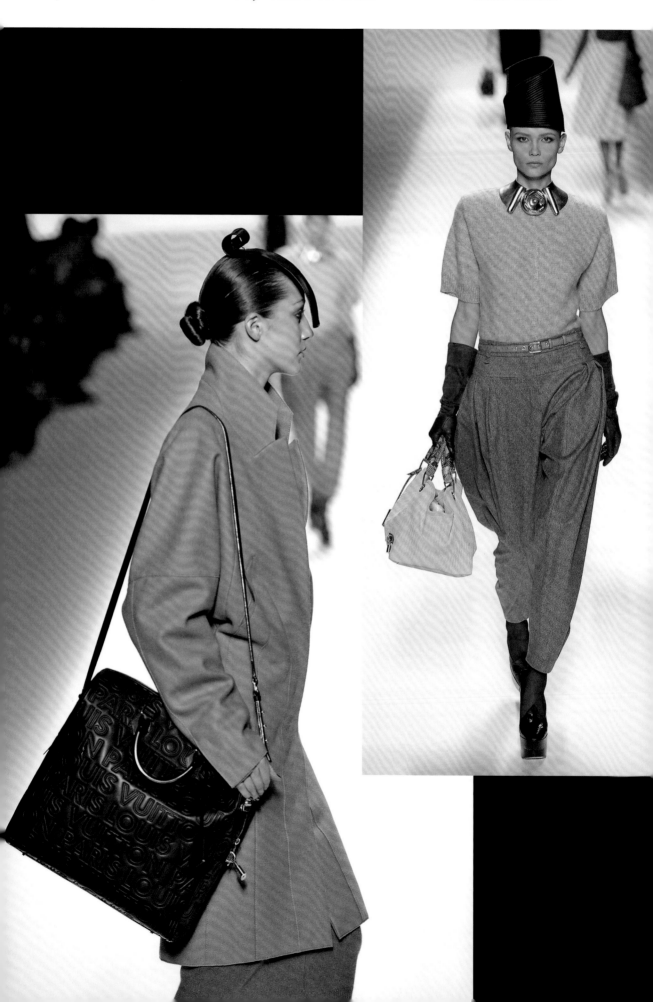

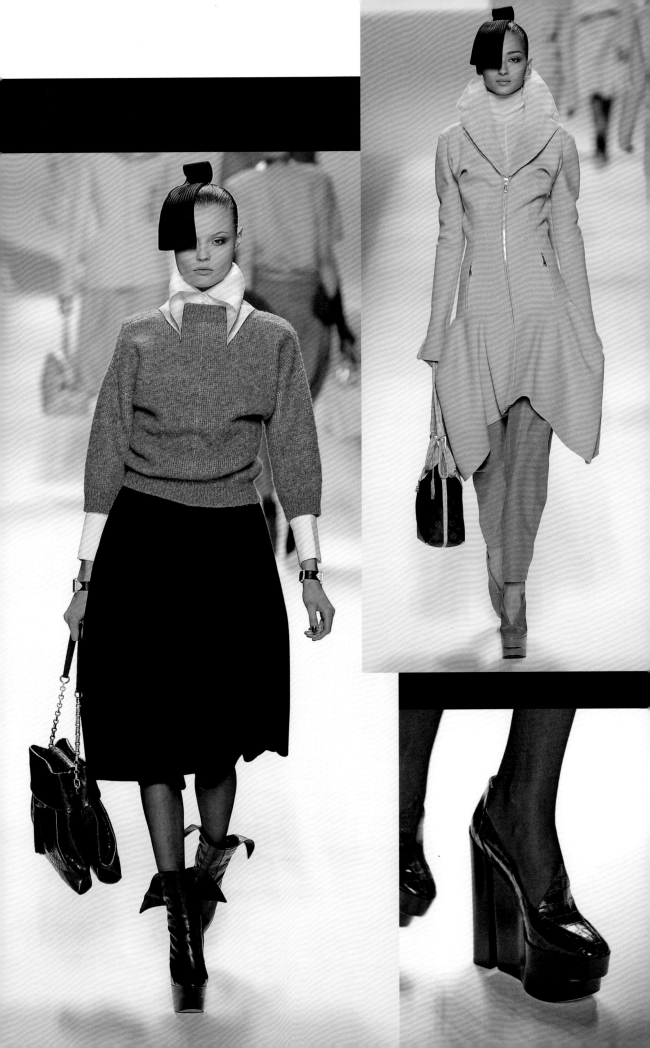

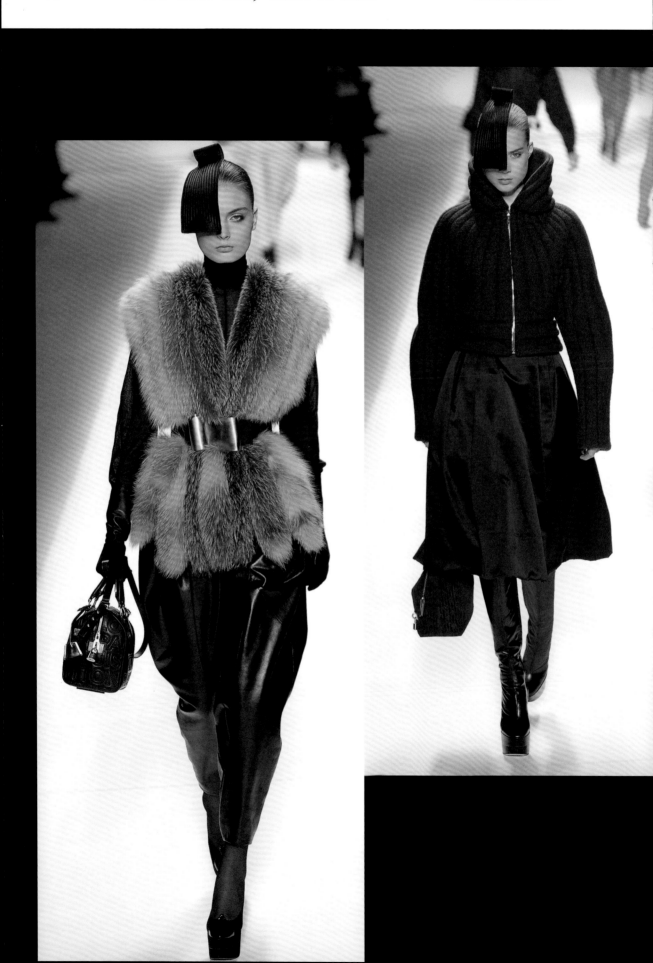

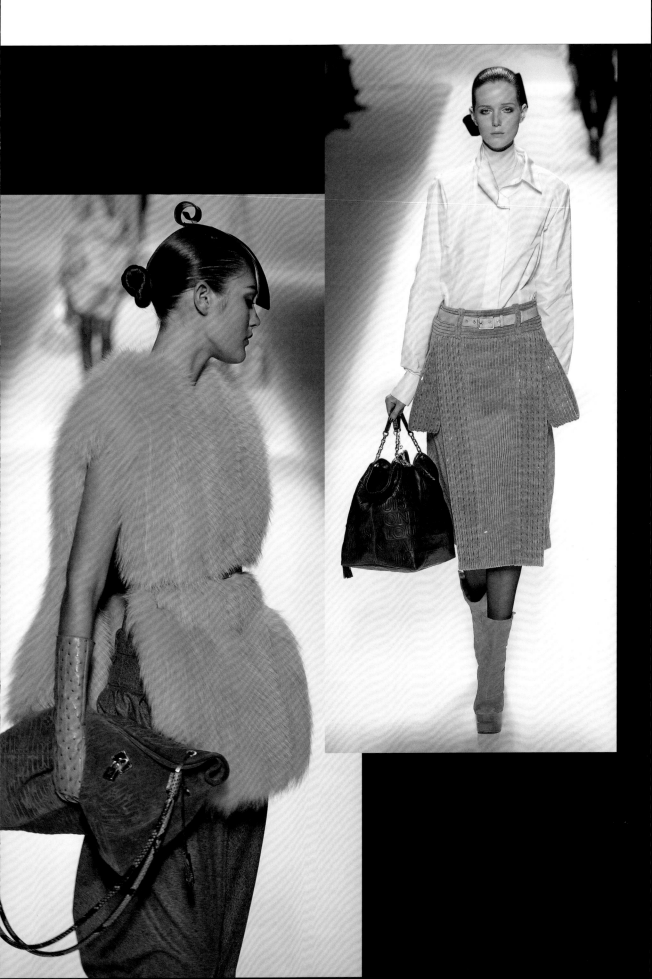

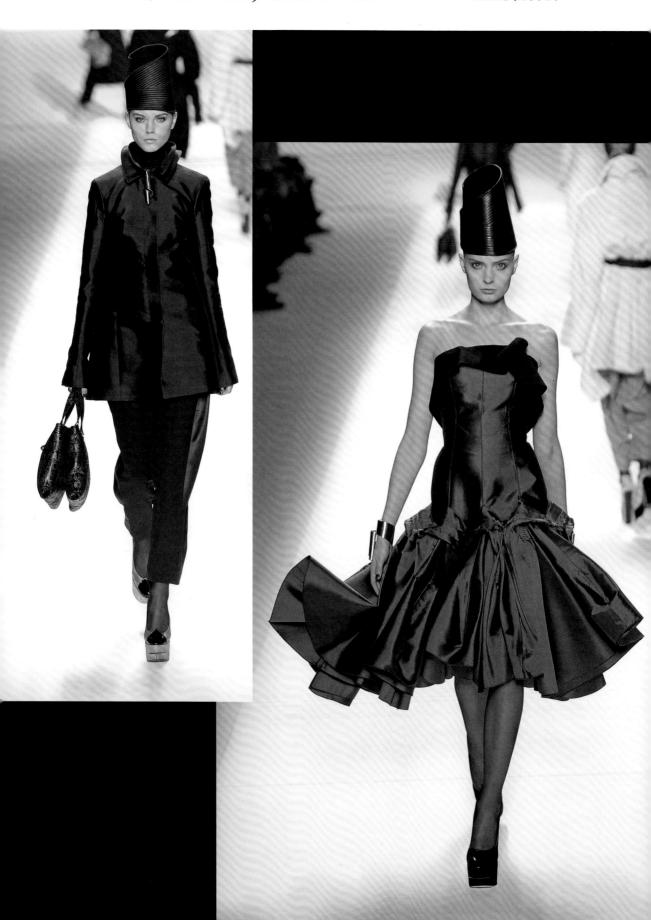

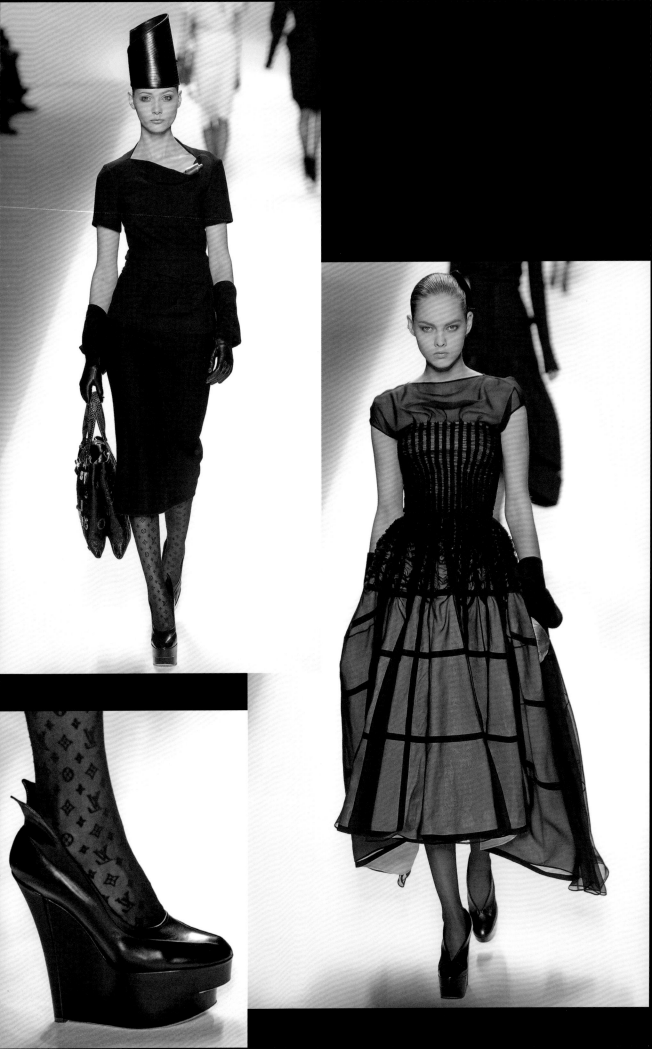

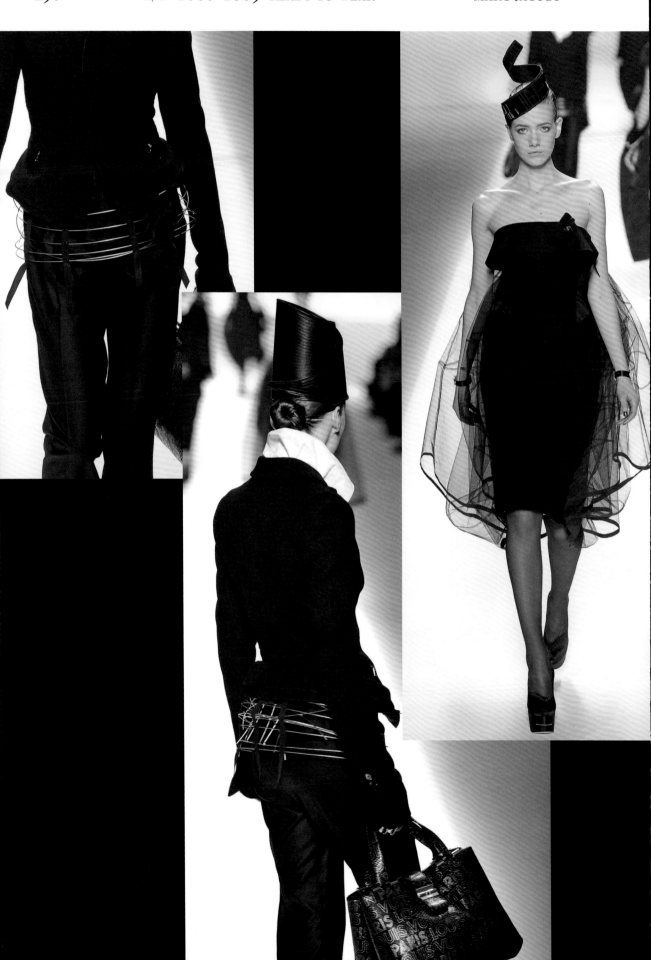

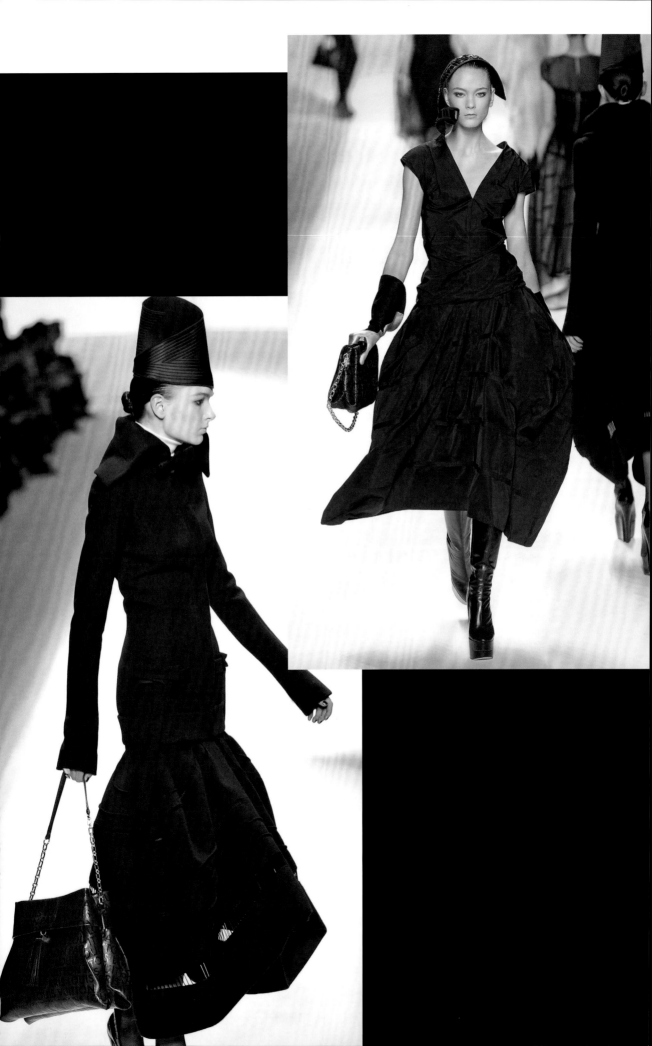

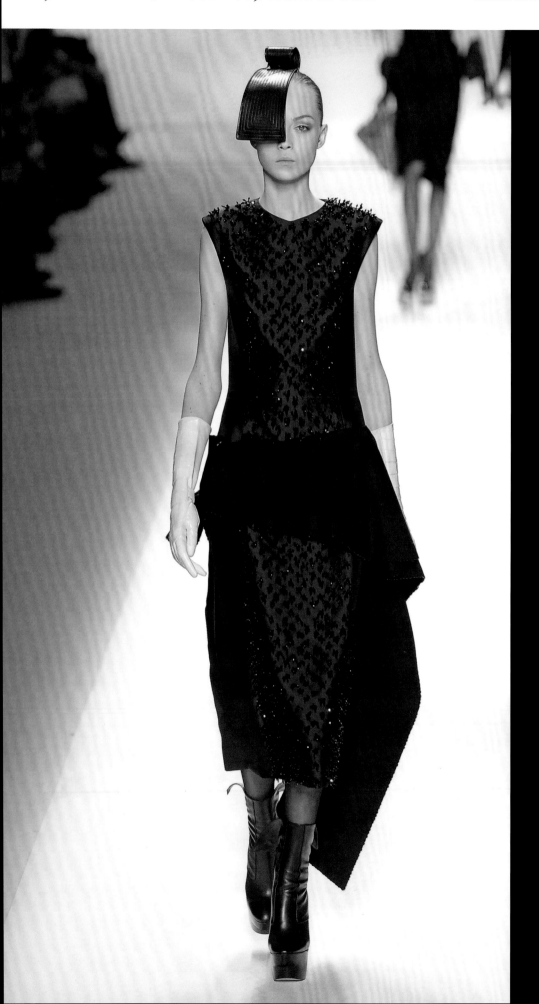

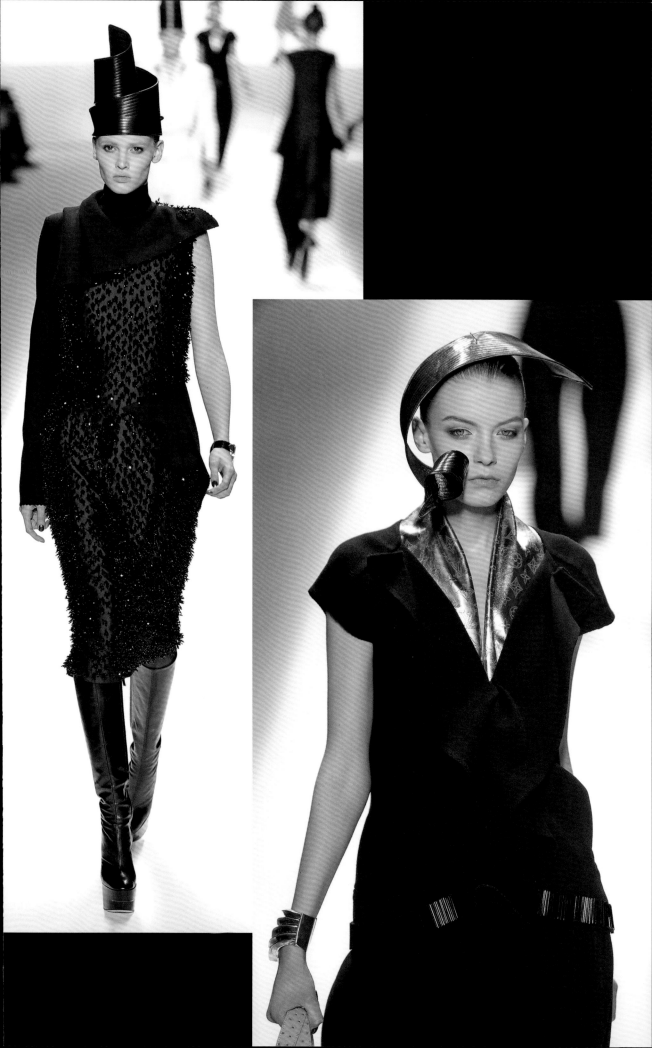

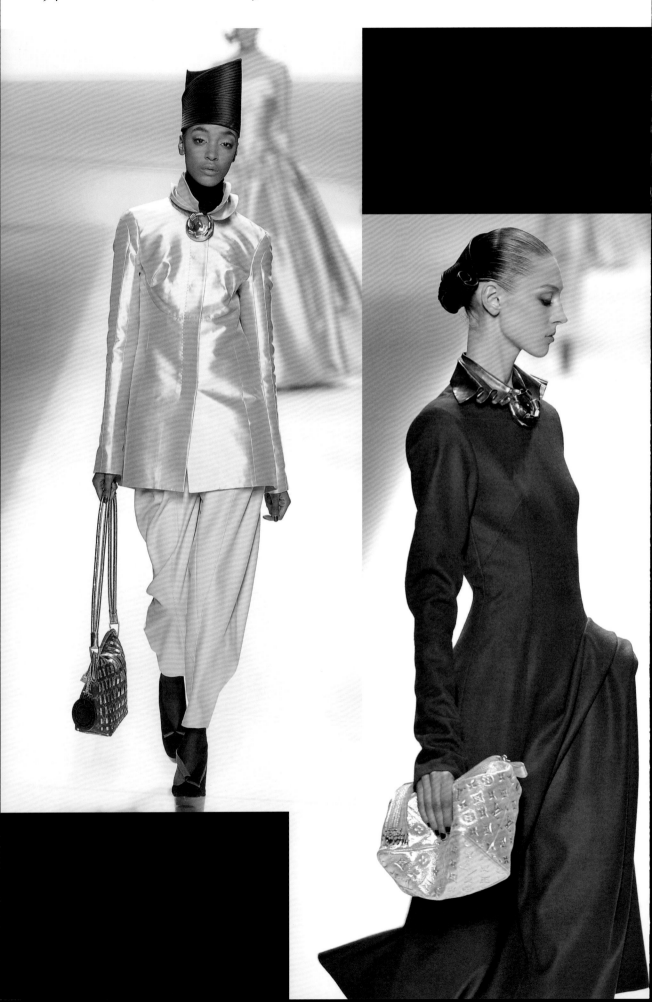

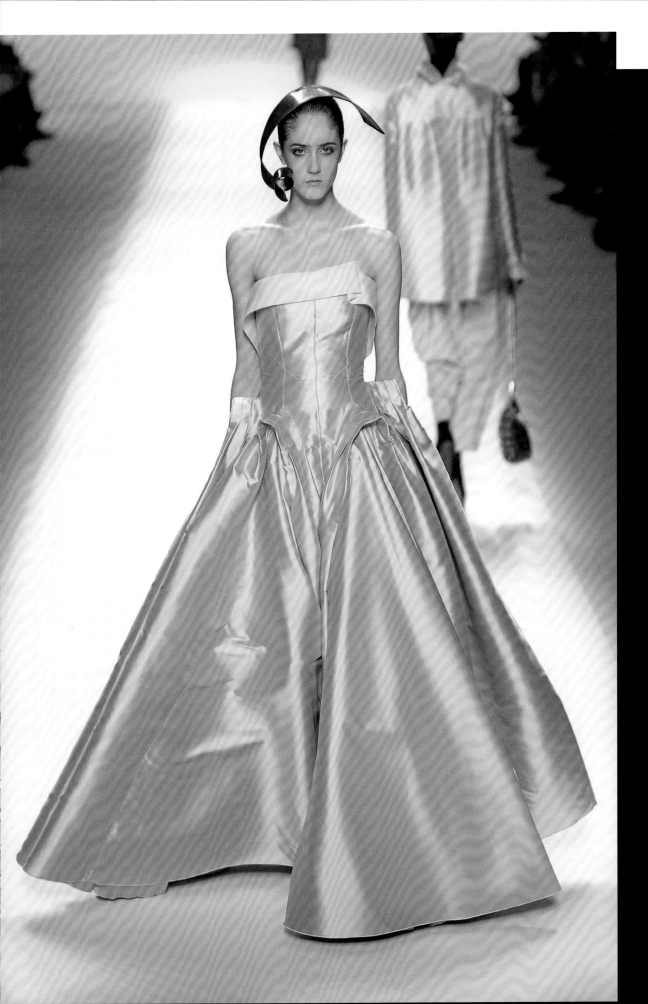

Exotic Parisiennes

Presented to the captivating voice of Édith Piaf,
the spring/summer 2009 collection was an homage
to Marc Jacobs's adoptive city. 'Little Parisienne
princess, no?' said Jacobs about the clothes, which
were infused with references to 1920s showgirls,
Art Deco jewelry, the Orient, African tribal wear
and Yves Saint Laurent. Describing the look of the
season, Jacobs added: 'an exotic, theatrical, trash
and flash, hip-hop version of Josephine Baker
and Catherine Deneuve'.

The models appeared from a forest of bamboo
sticks and showed off the collection on a sand-covered
catwalk. The combination of luxurious fabrics, vibrant
colours and plentiful accessories broke new ground
for Louis Vuitton's concept of the art of travelling,
with Style.com's Tim Blanks calling it 'transportingly
exotic'. There were ostrich feather skirts and belted
dresses, wide obi leather belts, Stephen Sprouse
leopard-printed handbags, 1970s aviator sunglasses,
and safari shirts with leather-decorated cuffs.

The striking ethnic-inspired accessories consisted
of hundreds of bangles, swirling creole earrings
and chunky necklaces in wood, acetate beads, pearls,
feathers, gemstone cabochons and gold. An African
necklace was even printed on a blue cashmere
sweater (p. 301, top left). *Vogue*'s Sally Singer lauded
the collection for being 'street jungle chic', and in
particular called out the narrow-heeled sandals
decorated with pearls, wood, feathers and African
masks (see p. 301, bottom left).

'When the stocks go down, the skirts of Parisian
women go up,' read the show notes, referring to the
financial crisis and the introduction of Jacobs's new
ultra-short miniskirts, short shorts and dresses.
The creative spirit of the collection was visible in
an orange minidress with a tutu skirt, plunge back
and patchwork mirage of fabrics (opposite).

Quintessential French references included polka-dot
prints, black tuxedo suits and 1930s wide-legged
trousers, worn with 1970s makeup and hairstyles.
Reporter Cathy Horyn observed: 'The backbone
of the collection was the structured flirty jacket –
emblematic of Paris fashion.' An Ottoman gold and
black duchesse satin jacket was worn with an eyelet-
pierced suede miniskirt and a Monogram Metisse
African Queen bag (p. 307, bottom left).

Leather and denim handbags were decorated with
tassels, feathers, beads, metal and glitter. Models
clutched small 'Flight' bags inspired by the ones used
by air hostesses in the 1970s, as well as the Monogram
Limelight African Queen (p. 300, top left), Monogram
Lurex (p. 302, top left), Kalahari (p. 304, bottom right),
and an embroidered denim bag with multi-beaded
handle and python interior (opposite).

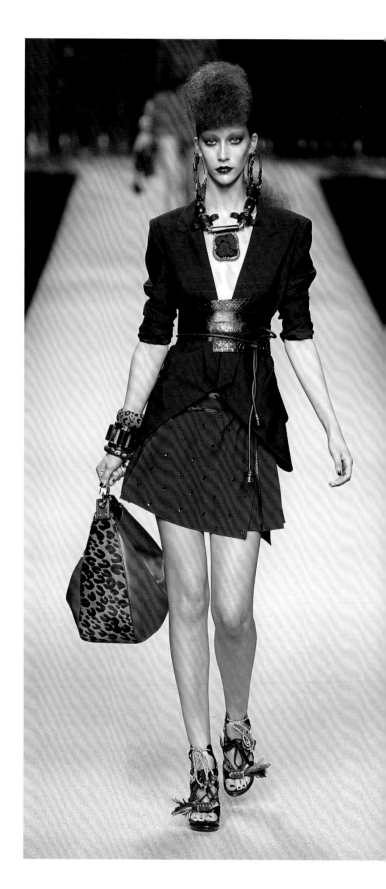

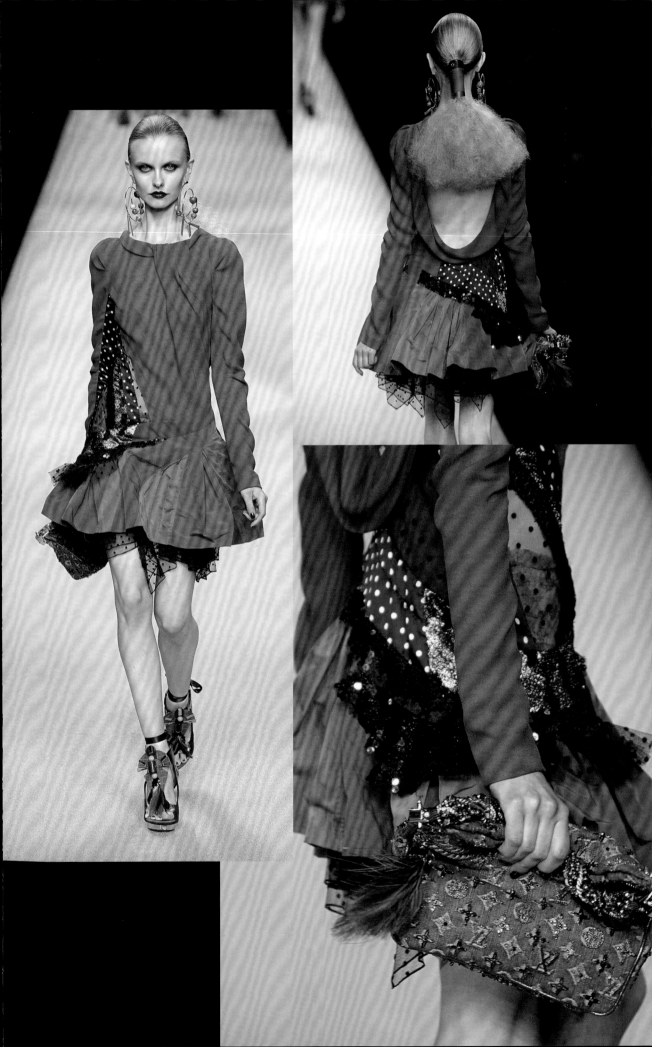

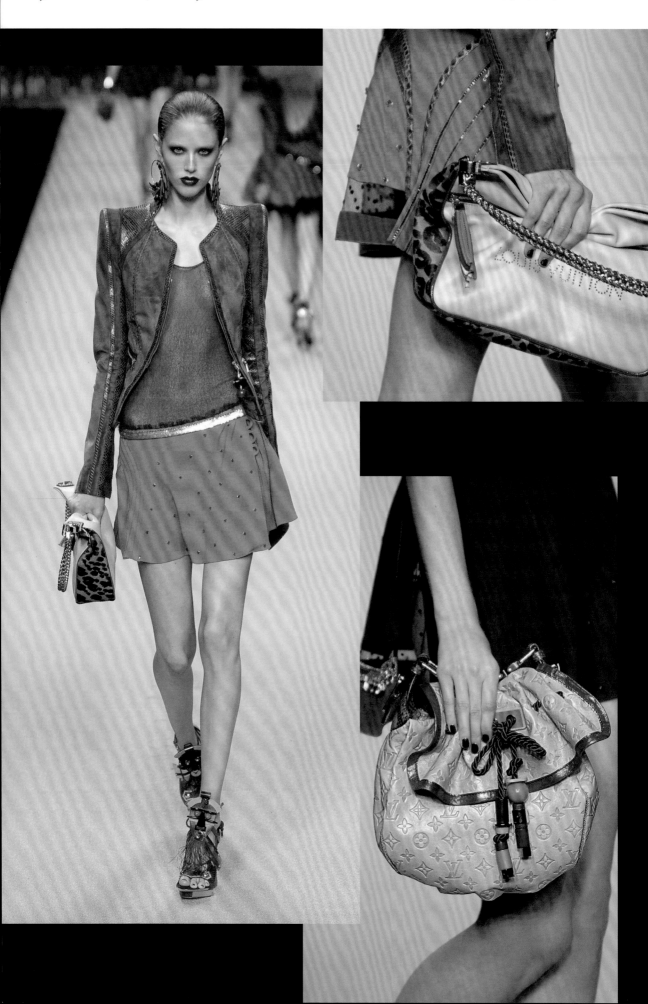

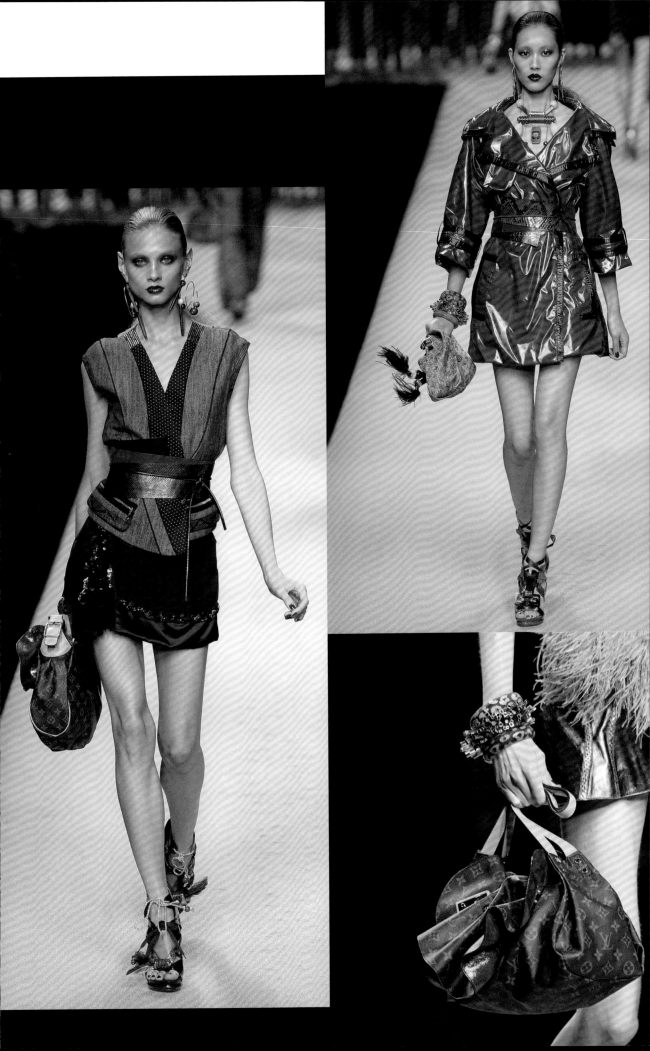

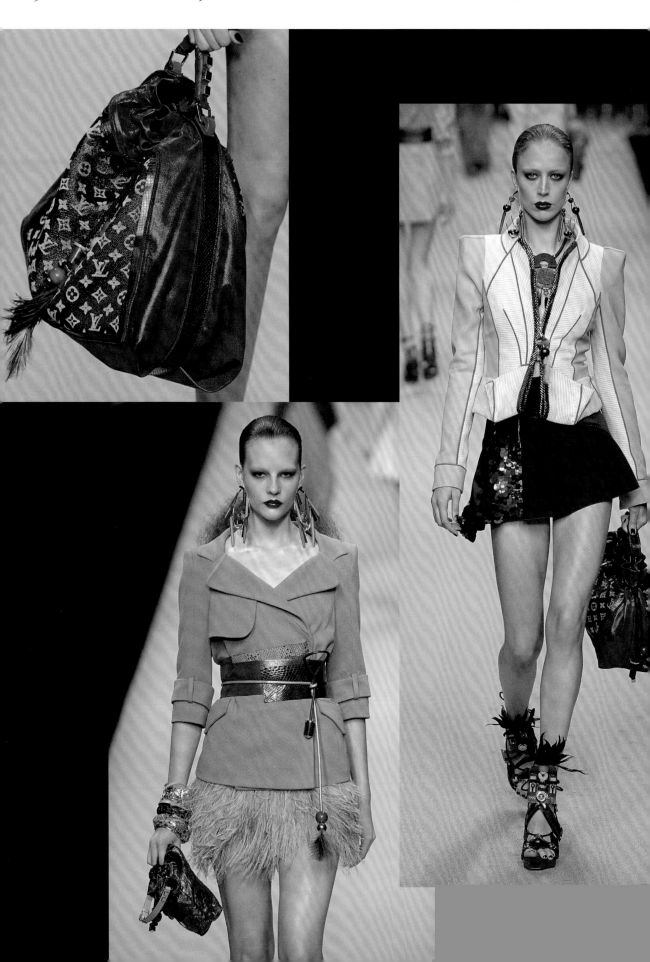

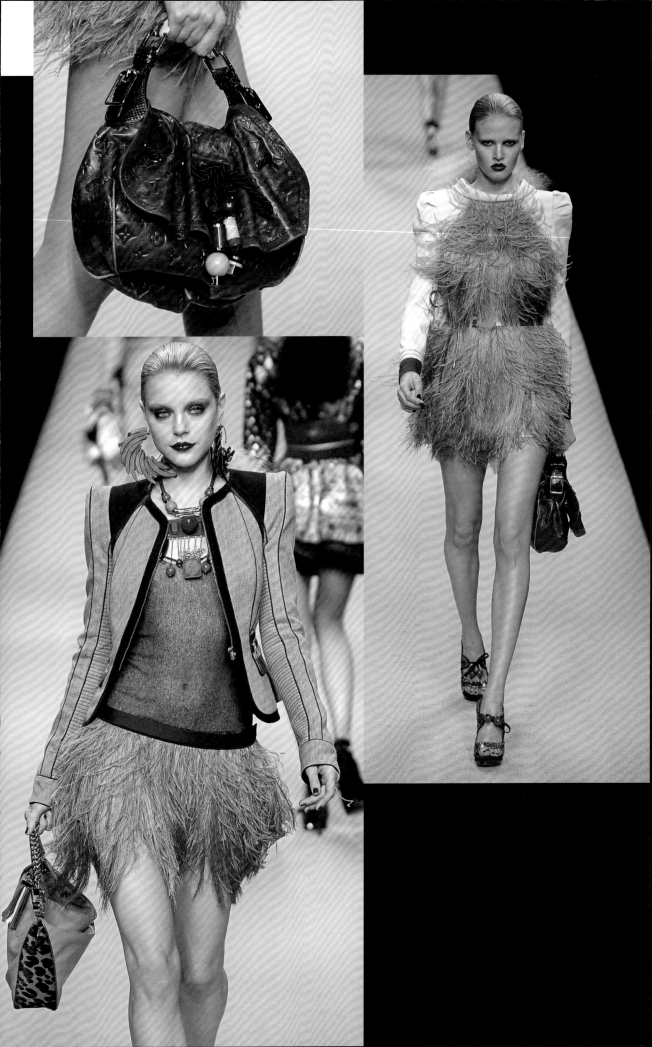

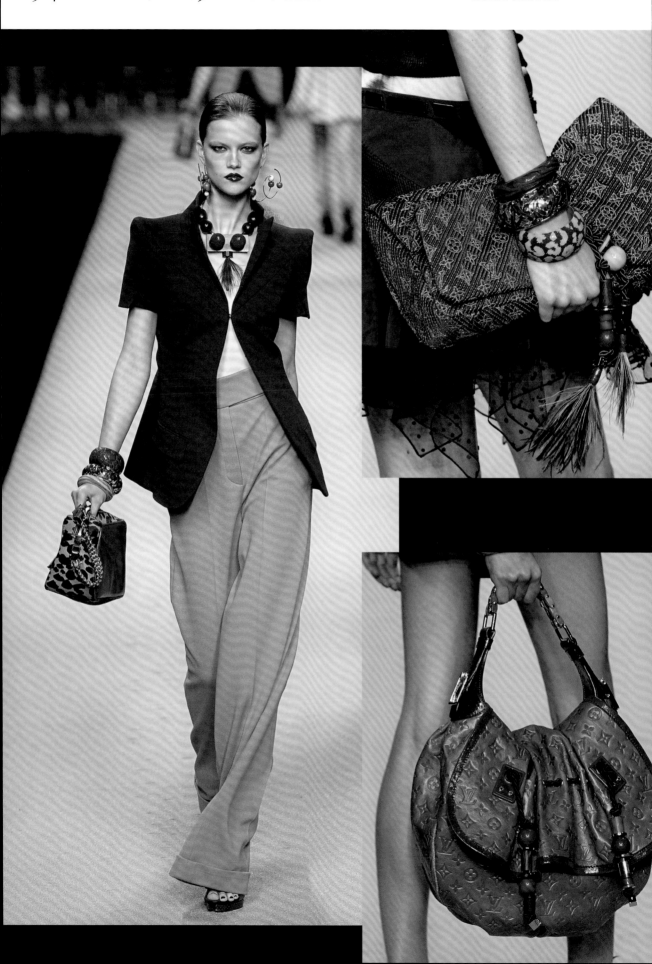

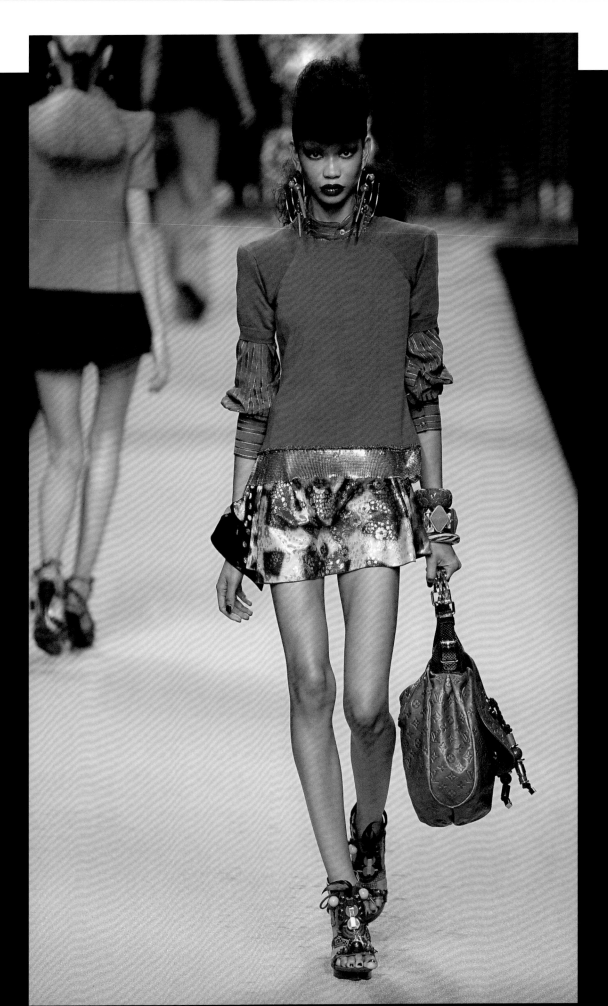

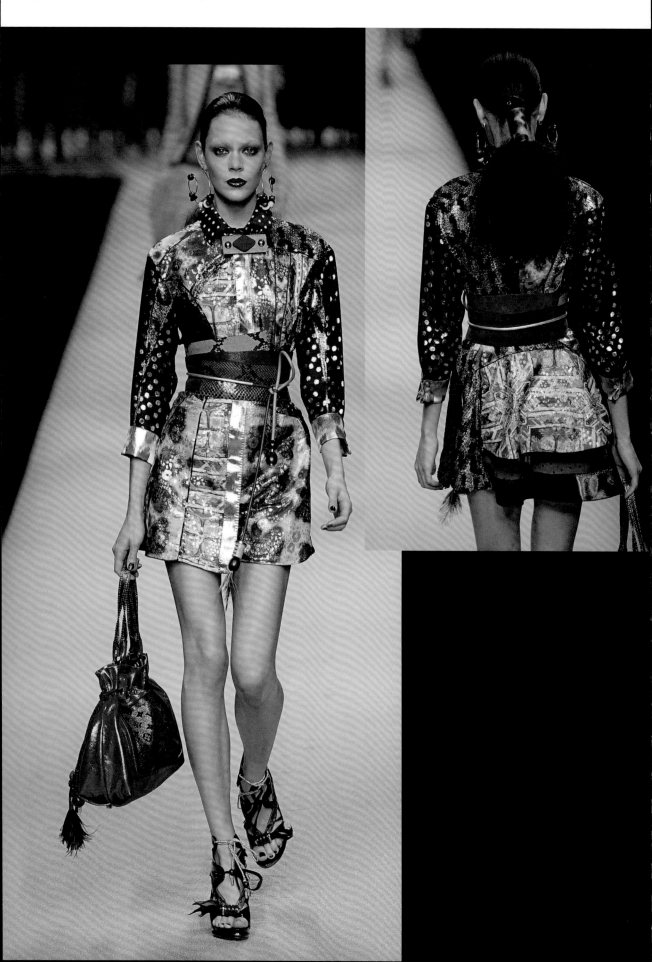

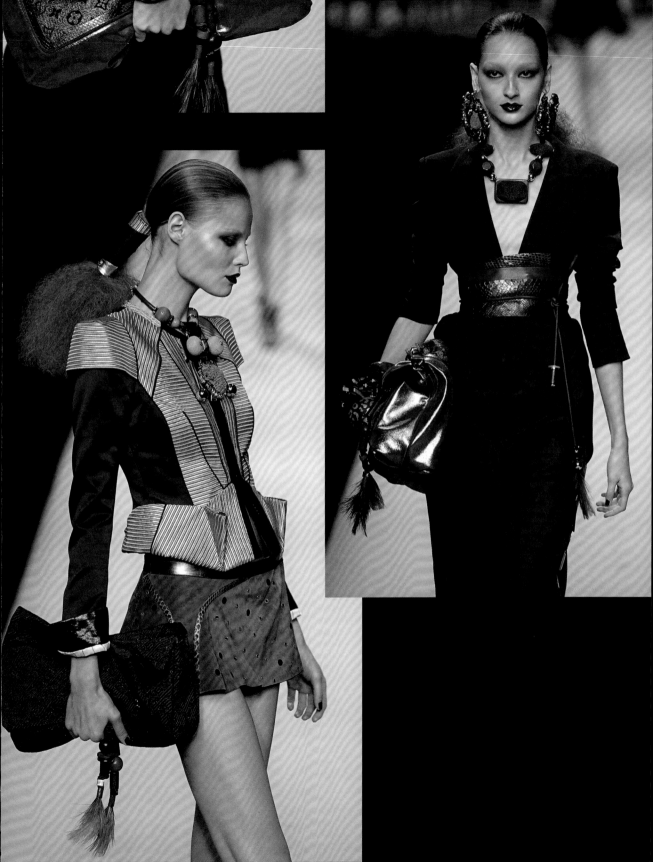

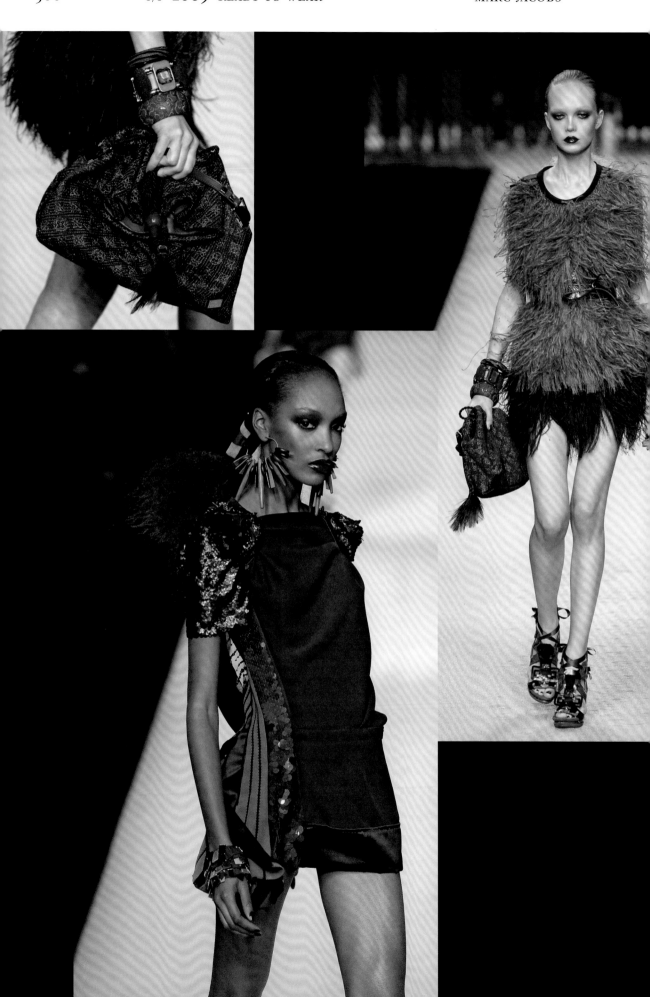

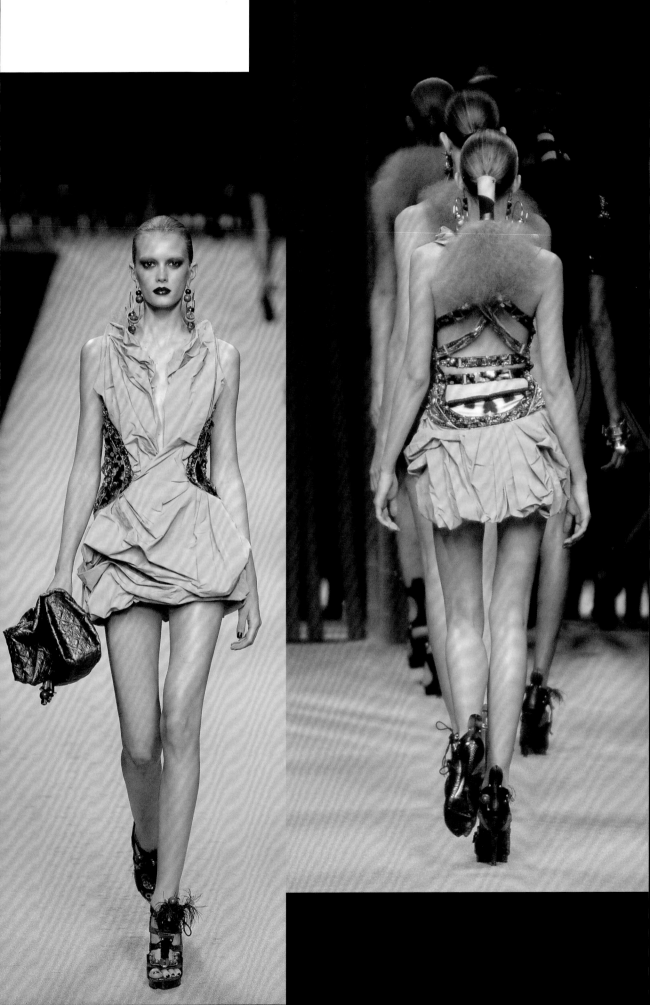

'Homage to 1980s Couture'

'Frivolous, free-spirited and utterly French,' this
collection, the house notes stated, 'took over where
Spring/Summer left off. Once again, the designer's
inspiration was the quintessential *Parisienne*, whom
he dressed this time in a flamboyant homage to 1980s
couture and its memorable muses.' Influenced by the
exhibition 'Model as Muse', and by some of Paris's
most stylish women of the late '80s – Victoire de
Castellane, Inès de la Fressange and Christian Lacroix's
muse Marie Seznec – Jacobs celebrated those who
'embody the joy of being a woman, the joy of dressing,
and asserting with audacity'.

A live brass band provided ambience for the show's
salon-like setting. 'On the runway,' the house stated,
'skirts came short and shoulders big, and everything
came ruched and ruffled, frilled and flounced.'
Magdalena Frackowiak was the first of 62 models
to appear, opening the show in a boudoir-inspired
puffball minidress in electric blue and shocking pink
with black lace, the look styled with a single earring
and bracelet, a black embossed Monogram My Deer
clutch and calfskin 'Cancan' shoes (right).

Vogue's Hamish Bowles praised the collection for
presenting a 'playful upbeat vision' with strong
references to the work of Lacroix and Emanuel Ungaro,
particularly evident in the bows, ruffles, silk blouses
and feminine dresses. Three red coats further enhanced
the '80s vibe, with their broad shoulders, belted waists,
huge pockets and ruffled rose collars (see p. 319, right).

There were ruched skirt suits in green taffeta, indigo
leather and houndstooth check wool. Short balloon
skirts were paired with oversized blazers, wool biker
jackets, a silver trench coat and metallic disco tops.
Jacobs also introduced his 'new twinset': a yellow
cashmere sweater worn with 'a balloon skirt in yellow
paisley print (digitally engineered to look slightly
blurred)' atop extravagantly beaded sportswear-
inspired leggings (p. 320, top left and right).

'Fashion jewelry created ruffles of its own, in the form
of clunky chain necklaces painted with matte lacquer
to look like brightly coloured paper', while huge black
taffeta chignons appeared as bunny-bows, and large
pearl hairpins reappeared on hourglass-shaped heels
(see p. 321, bottom right). Alma and Noé bags were
revisited in a gold-sequinned Monogram canvas
(see p. 318, top right). Also shown were deerskin
clutches with rows of Louis Vuitton padlocks
(see opposite) and a floral pochette with bicycle
chain-style handle (p. 314, top left).

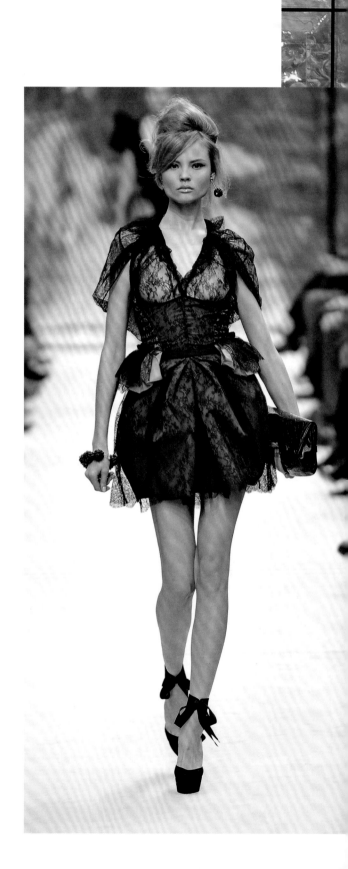

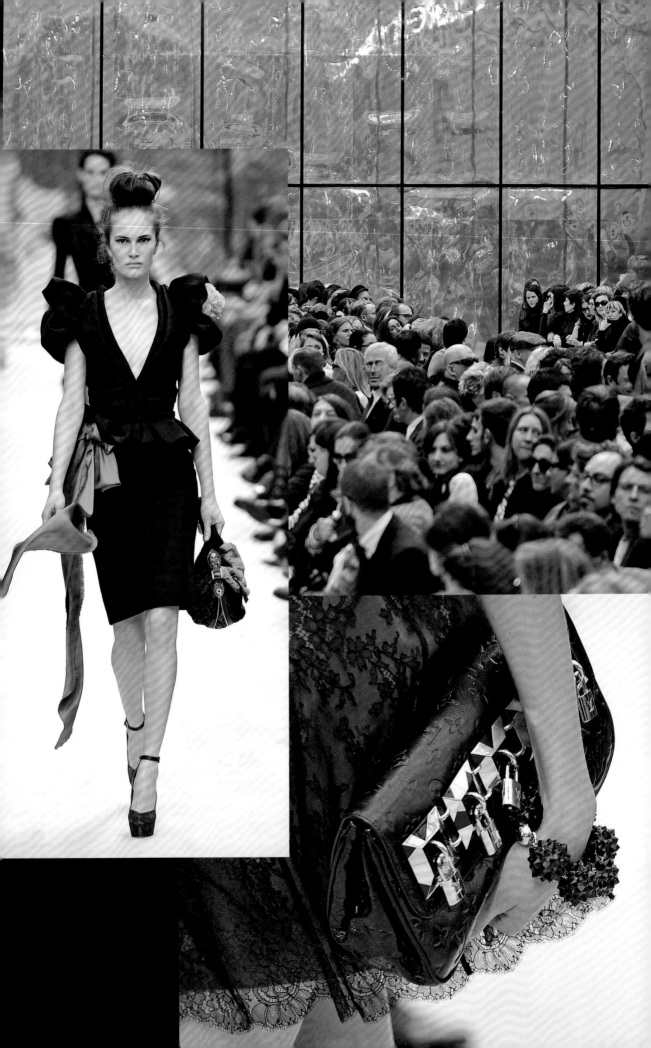

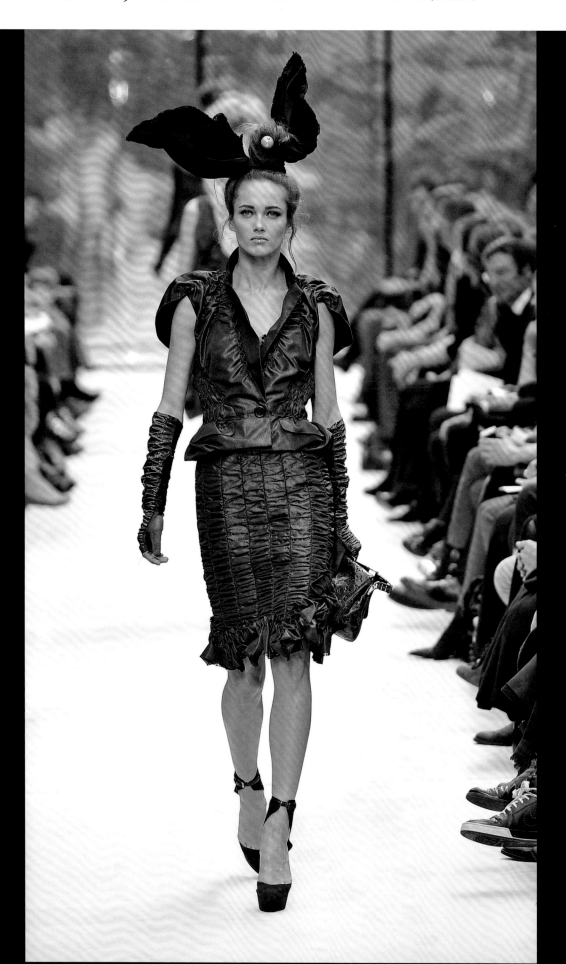

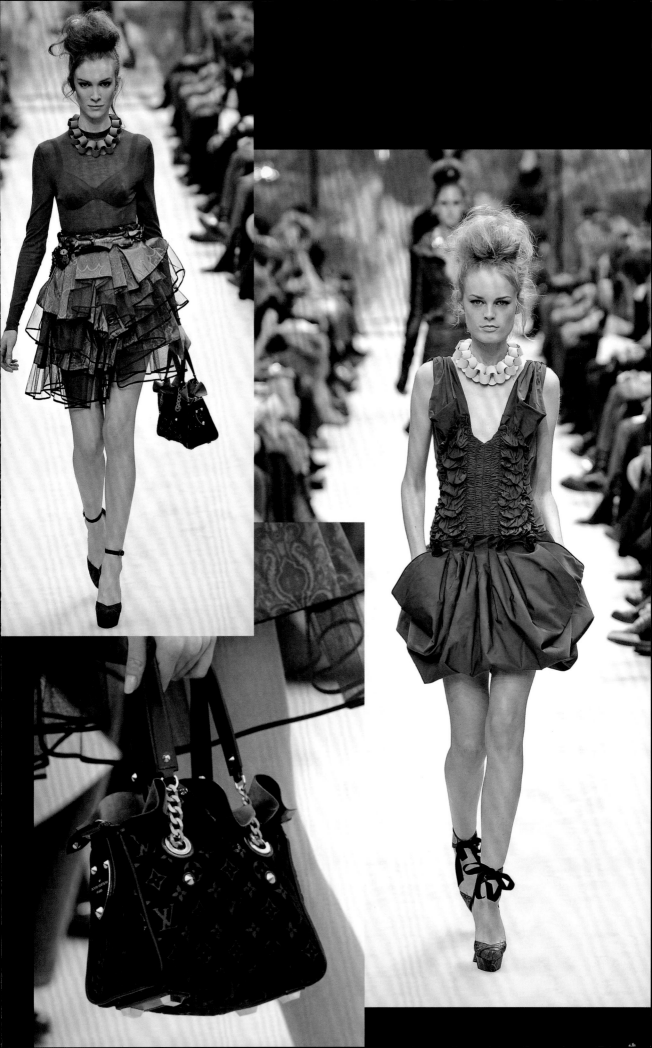

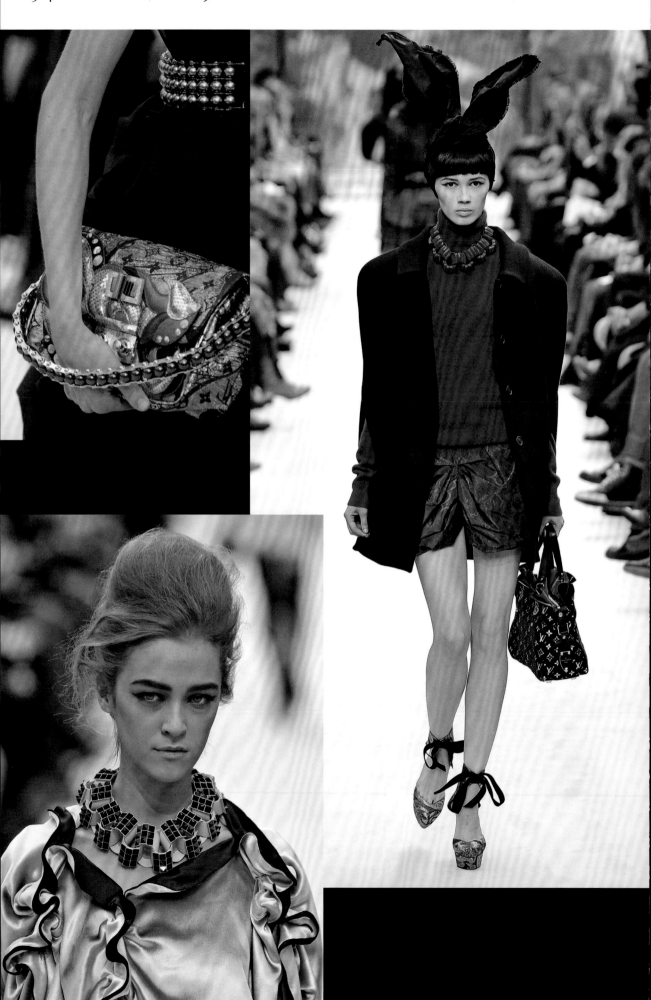

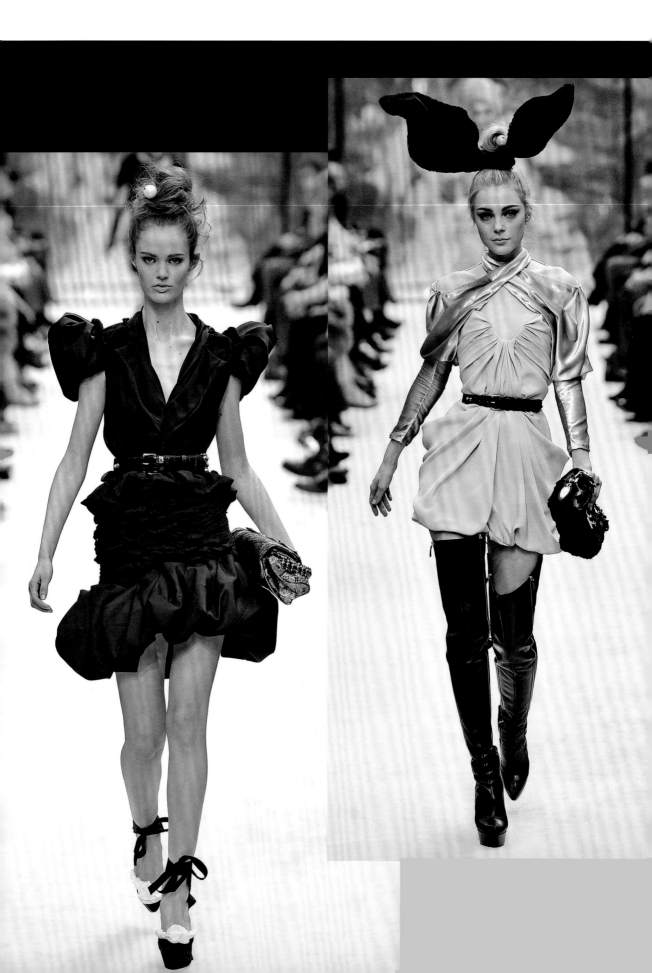

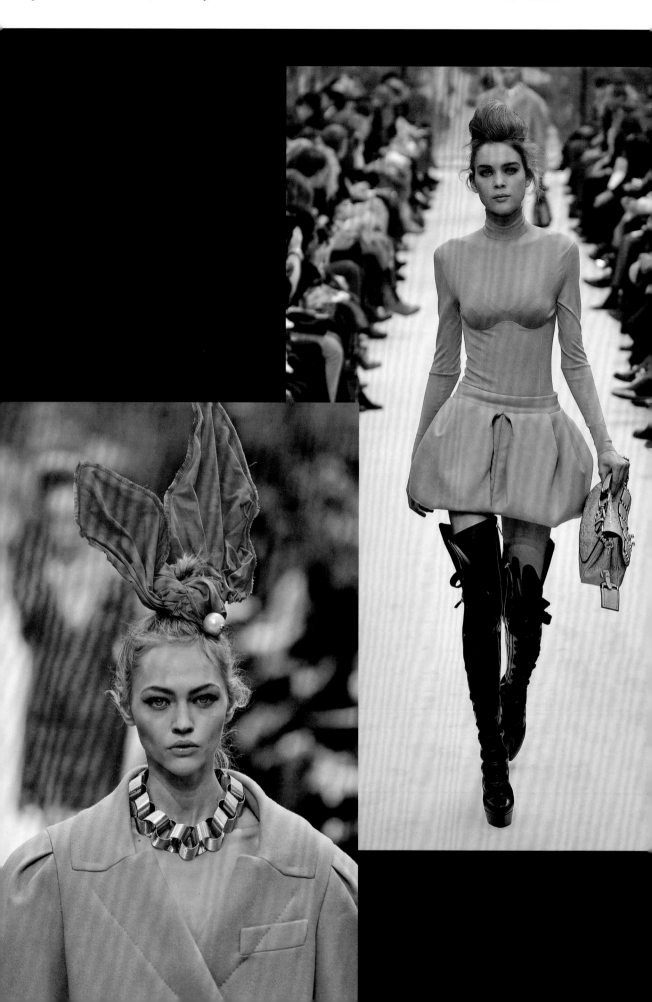

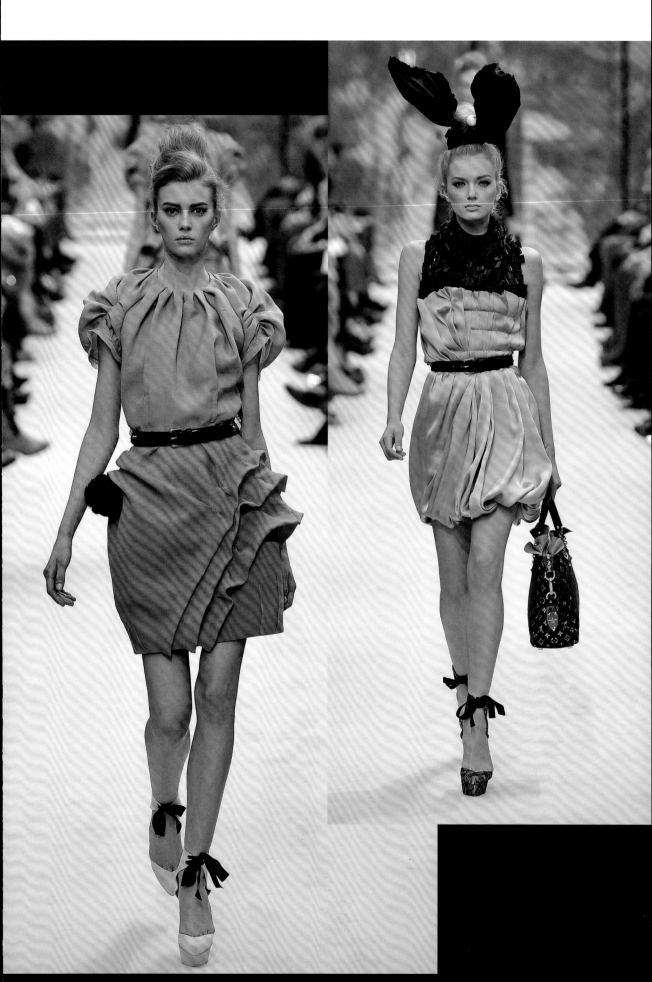

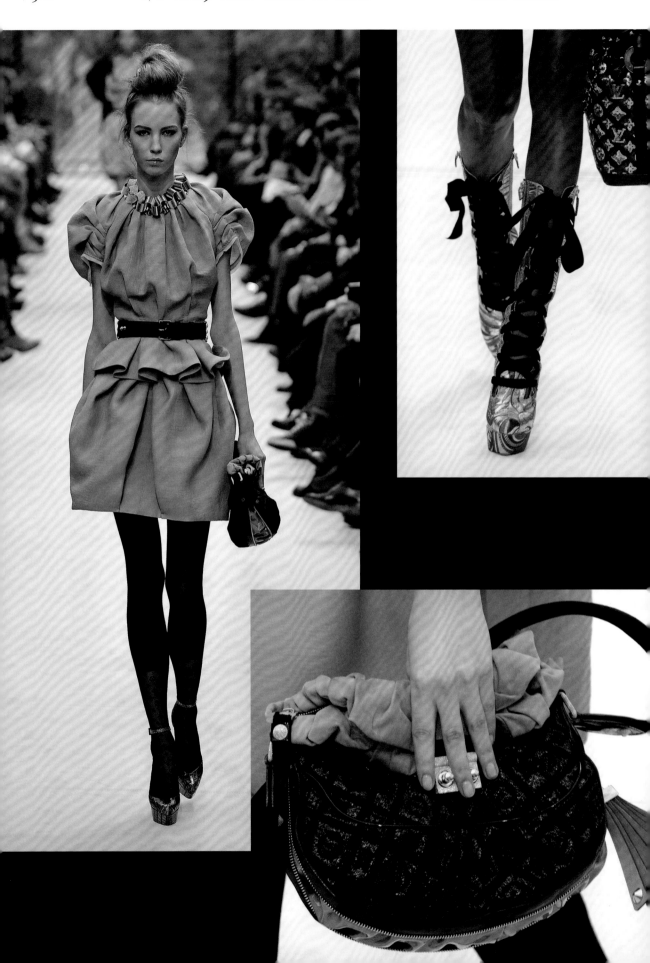

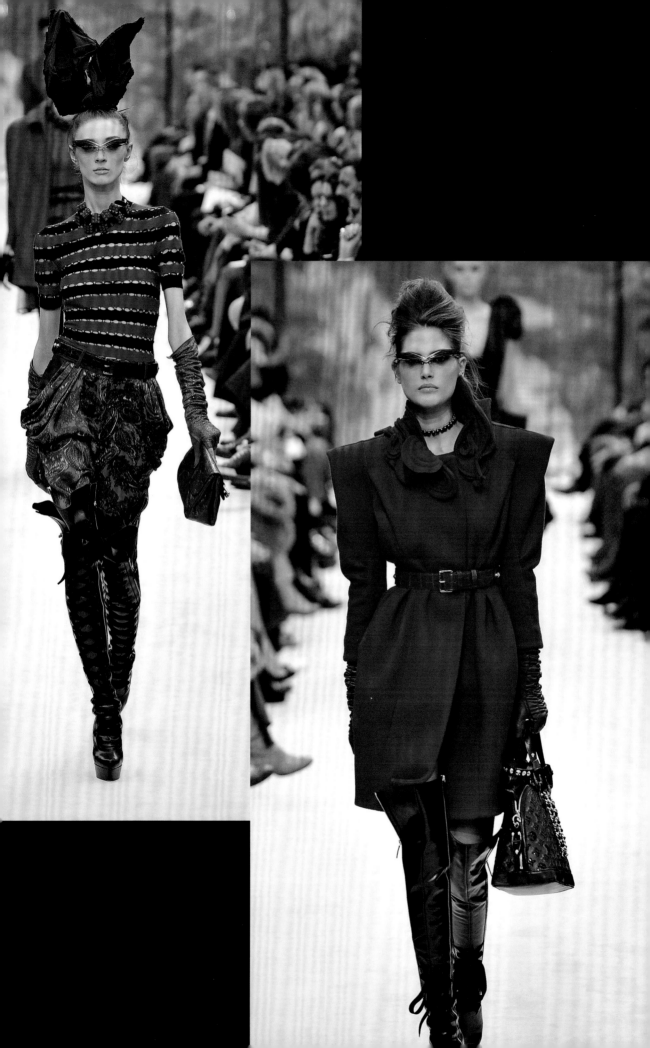

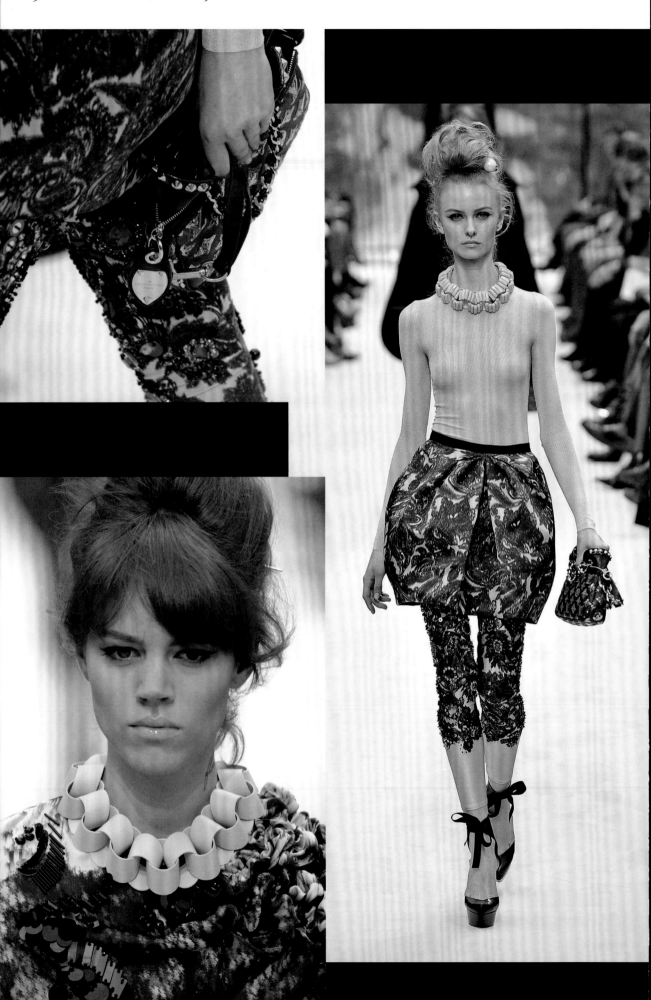

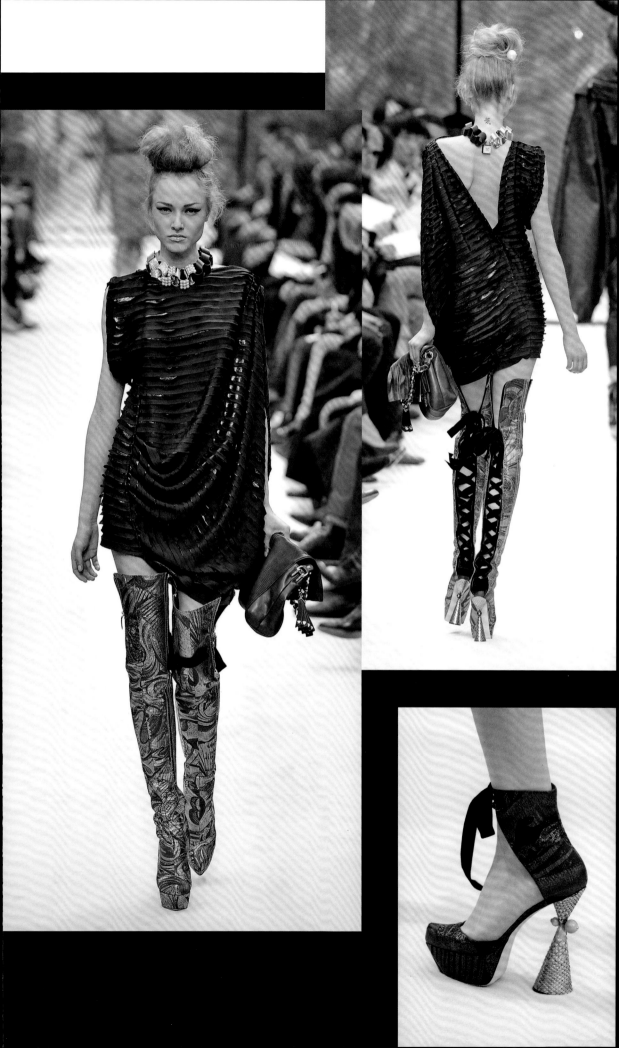

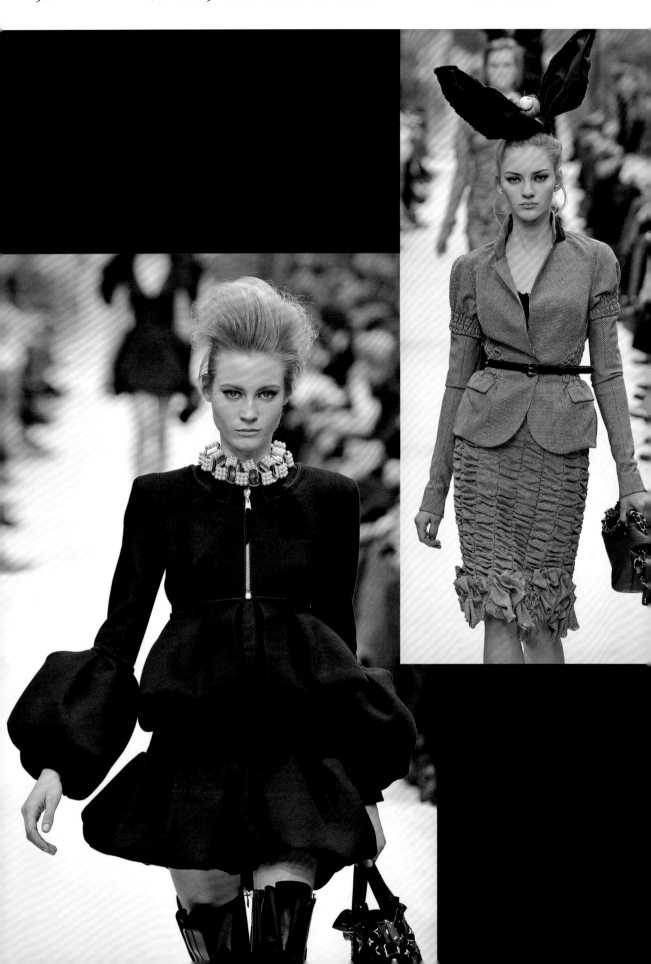

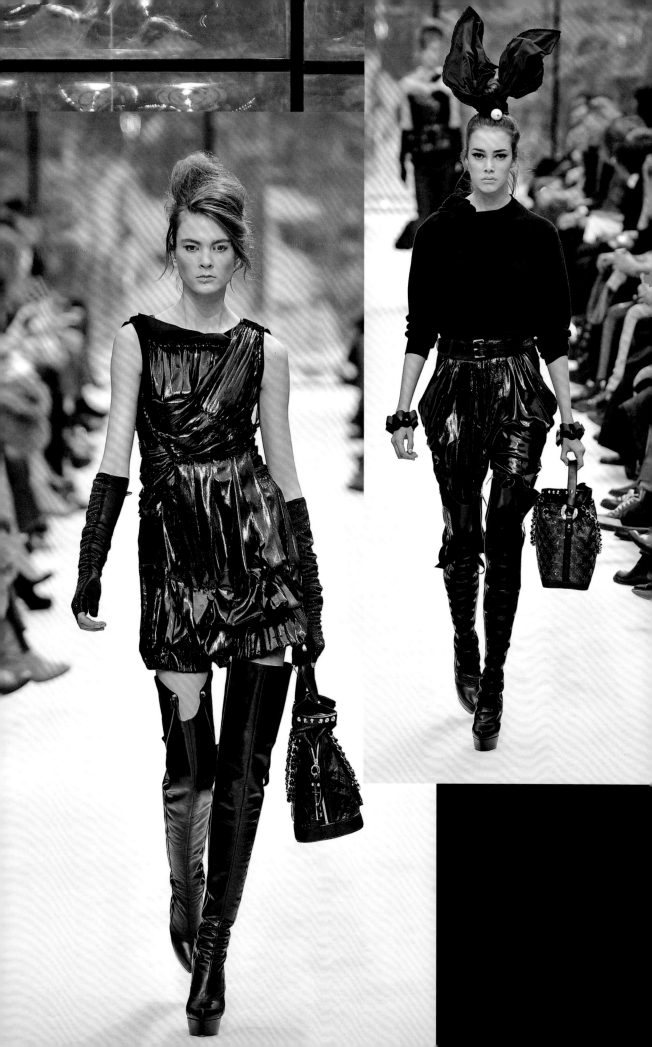

'New Age Travellers'

At 2.30 pm on Wednesday 7 October 2009, more than
700,000 people tuned in to watch the spring/summer
2010 collection livestreamed on Facebook. As the
house stated: 'Marc Jacobs left last season's Parisian
couture salons behind and hit the open road... His
theme – appropriately, given the house's heritage –
was New Age travellers, and his starting point
utilitarian clothes geared to life on the move.' These
travellers, Jacobs explained to his audience, embraced
punk, hippie, cyber – 'a mix of cultures ... which took
on manga-like proportions. We took things that were
kind of ugly and ordinary and made them doll-like,
funny, flirty and silly.'

'It was all about shape,' he continued. 'We thought,
"Let's look at tacky T-shirts. Let's look at parkas, let's
look at skater shorts, let's look at ... all the things that
kids wear." We took things away from couture and then
pumped up the volume. The hair was an important part
of that. I really loved the idea of ... a big round sphere
on top of a tiny little layered silhouette... The makeup
was like a little sunburn across the face and white
around the eyes to give it a healthy doll-like quality.'

Street and sportswear influences combined with
'subtle military influences' and 'a festival of luxe
embellishment'; lingerie and layering were also key
themes. *Vogue*'s Sarah Mower said the collection
was 'at first sight, Japanese by way of early Galliano'.
Jacobs introduced hoods as capes (right and opposite);
a 'rain bag' dress (p. 332) and Raindrop Besace bag in
glossy waxed cotton (p. 333, bottom left); 'classic' tweed
jackets with army pockets and khaki plus-fours; cycling
shorts 'in glittering couture-grade stretch brocade'; and
sporty mesh dresses 'embellished with tie 'n' dye ribbons'.
The DIY aspect was enhanced with steel piping bracelets
and utility drawstrings. Two looks stood out: a silk
tulle baby-doll dress embroidered with fluorescent green
paillettes and hand-cut triangles of print (p. 333, right)
and a Native American geometric-printed skirt suit
(p. 334, left).

'It was really fun to take something as ugly as a clog
and make it as covetable and as fetishistic as a high
heel,' said Jacobs: the season's must-haves came with
low nut-and-bolt heels in fluorescent metallic shades.
Sandals, mules and boots were decorated with fur,
straps and tassels. Totes, rucksacks, gym bags, duffel
bags and satchels mainly came on sturdy cross-body
or shoulder straps, and included the Monogram
Denim Sunburst (p. 327, top right), and the Speedy
and Noé overlaid with metallic strips.

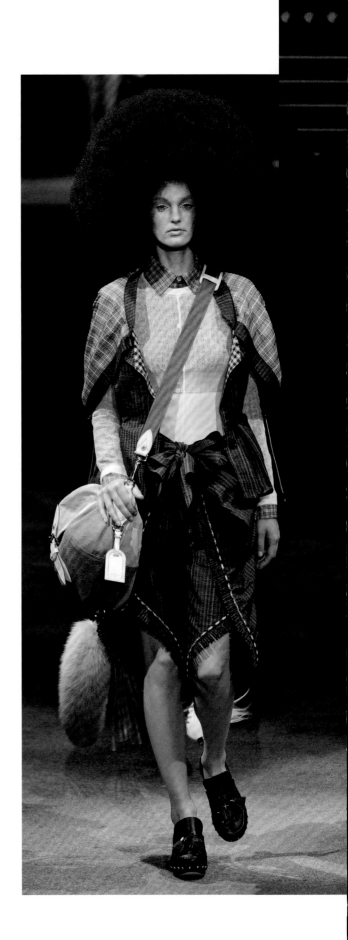

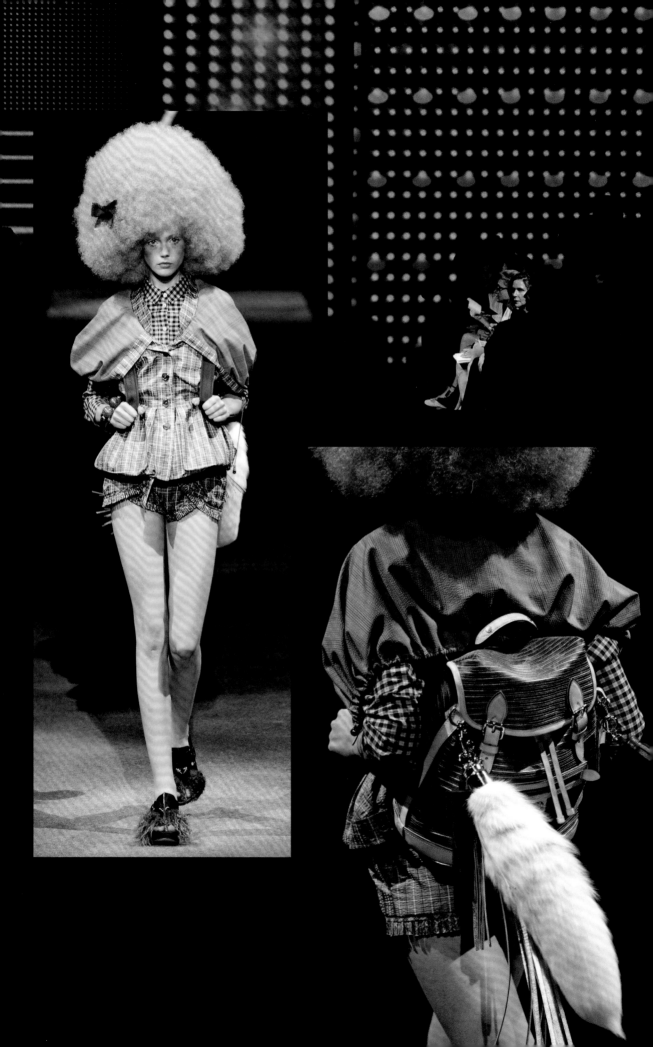

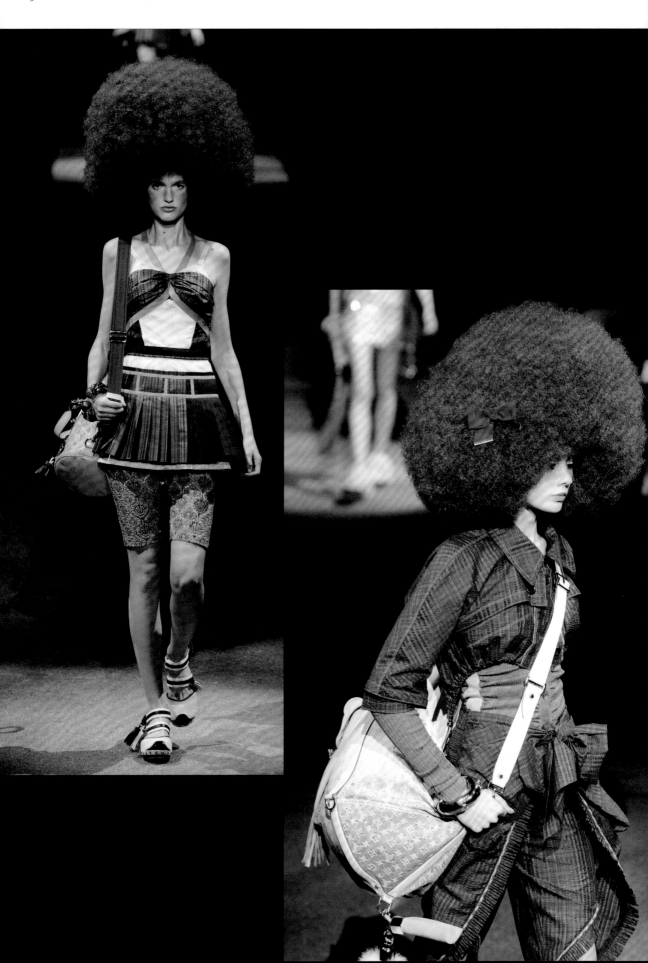

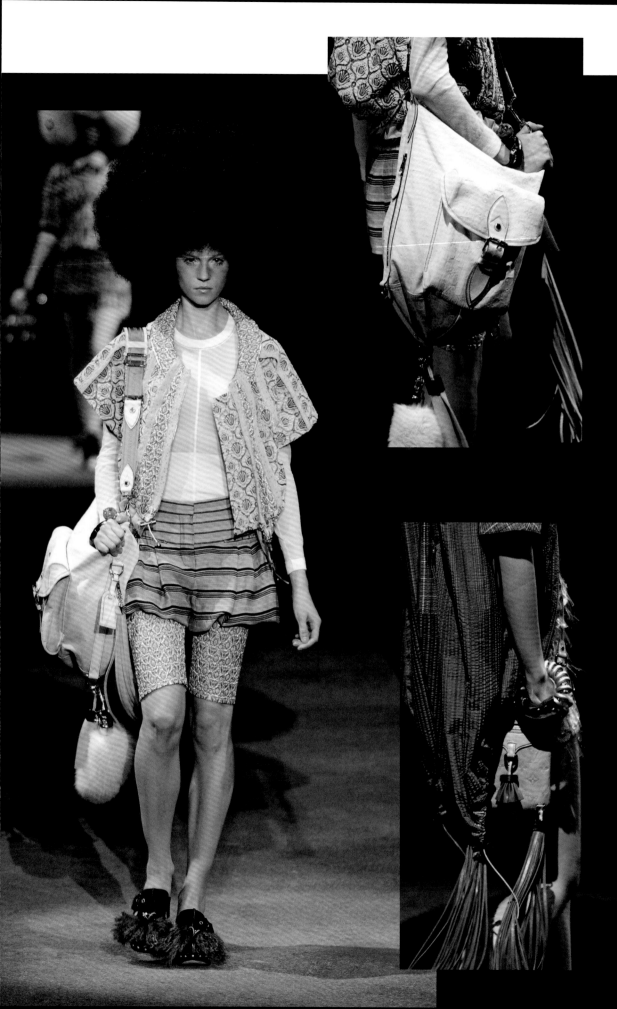

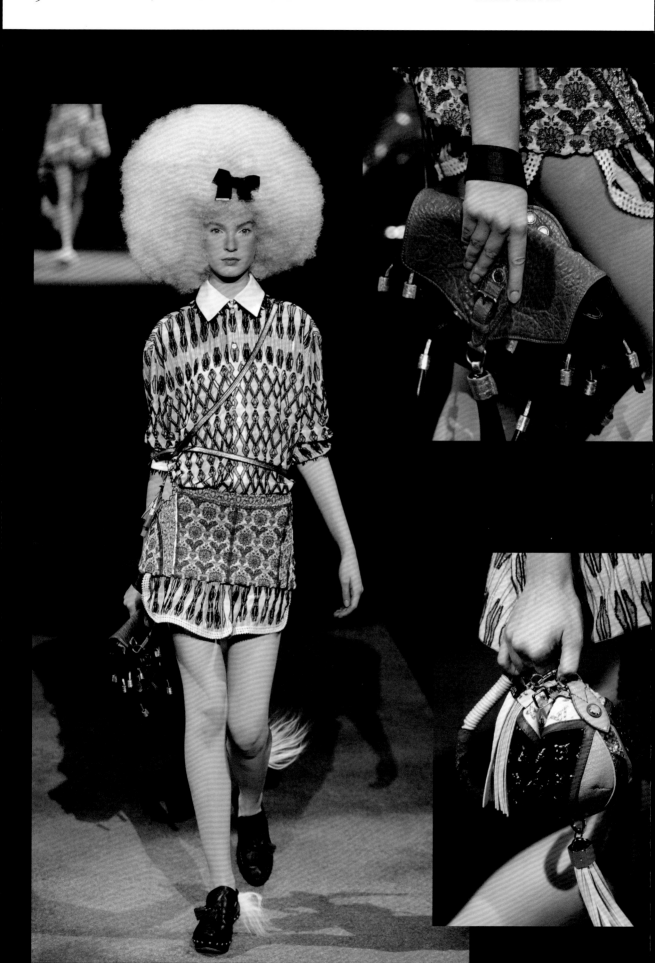

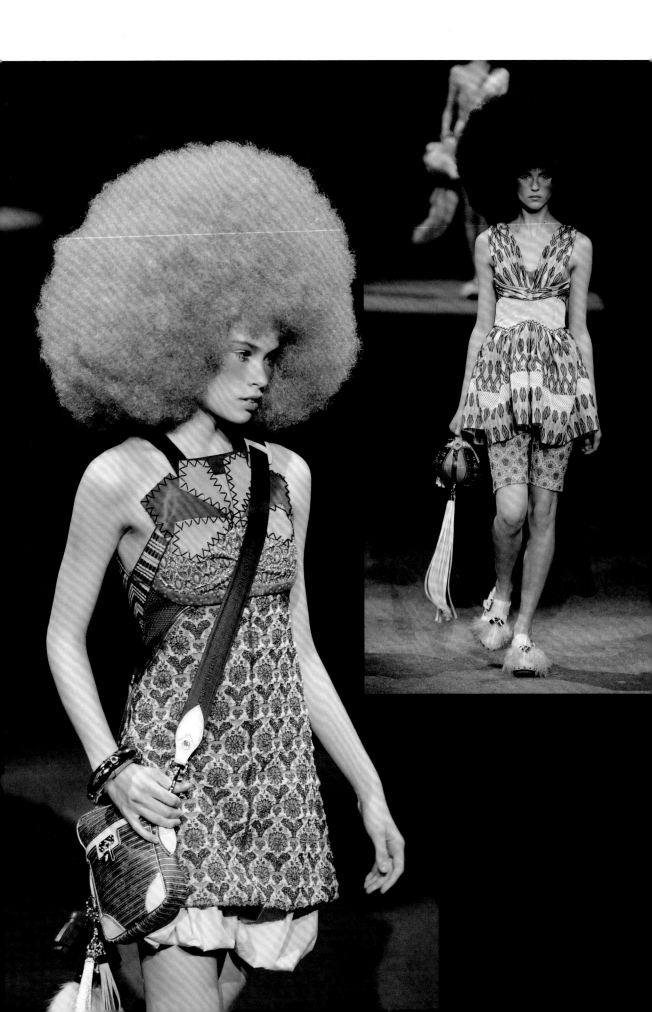

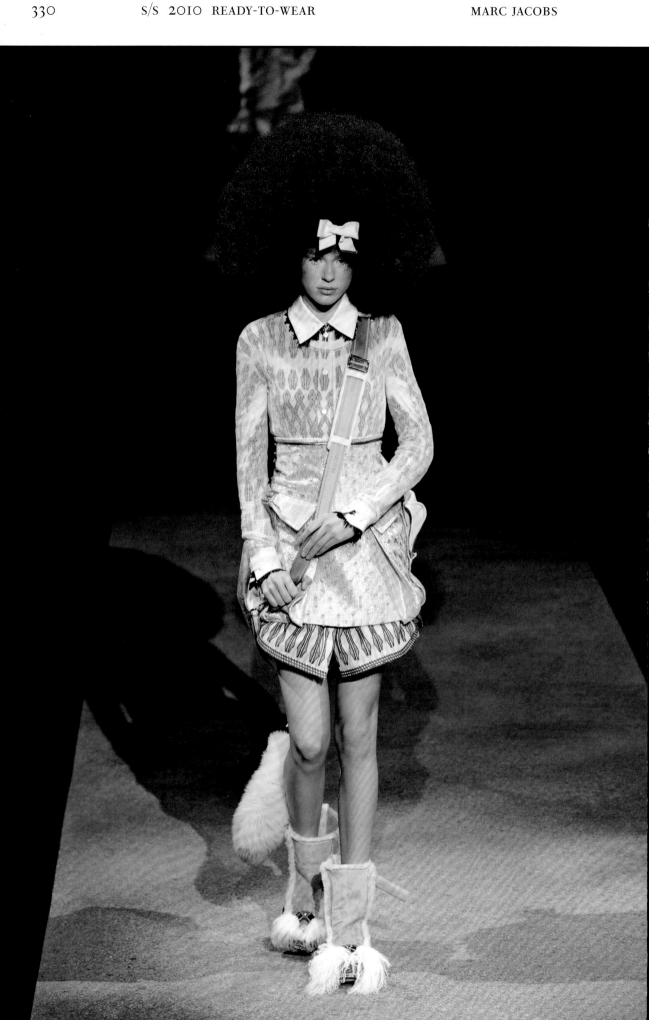

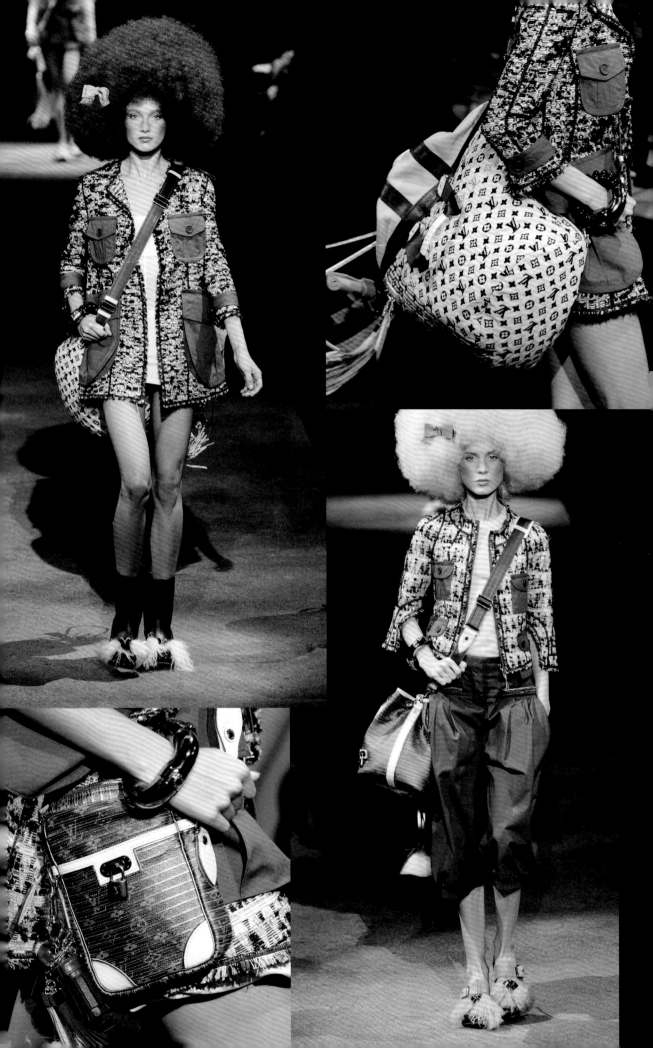

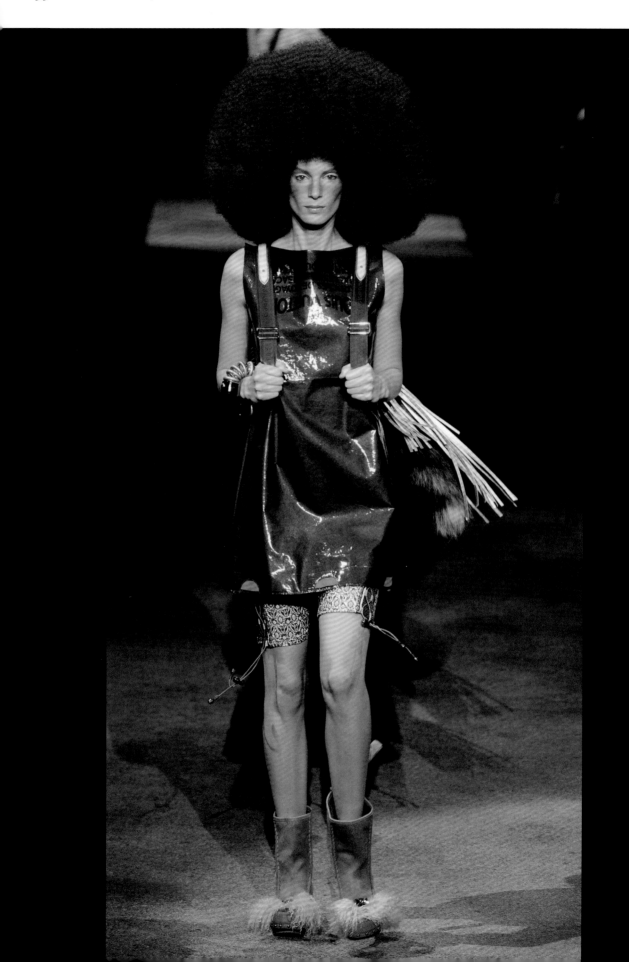

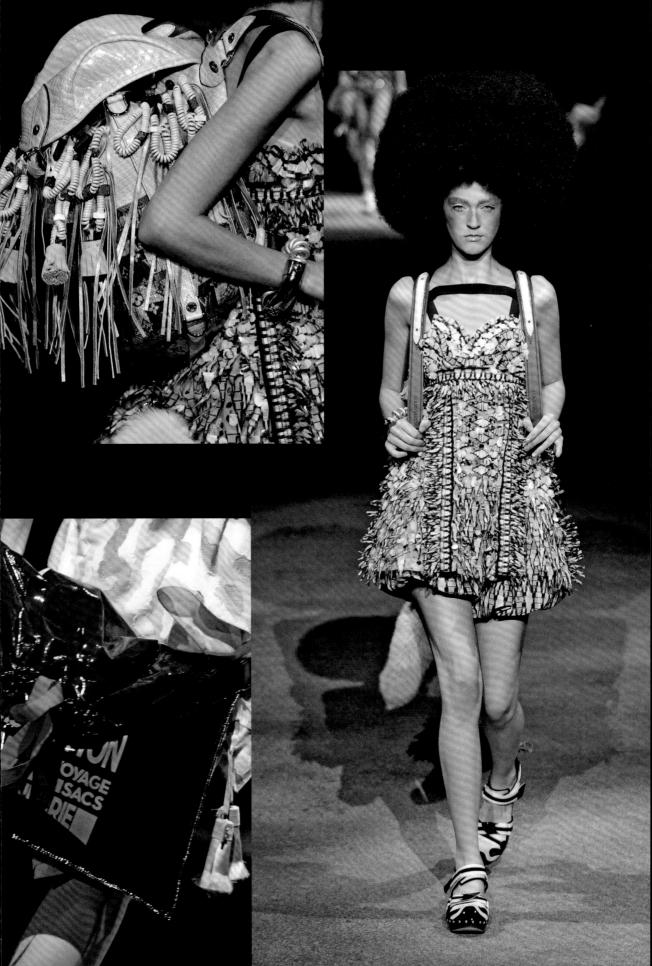

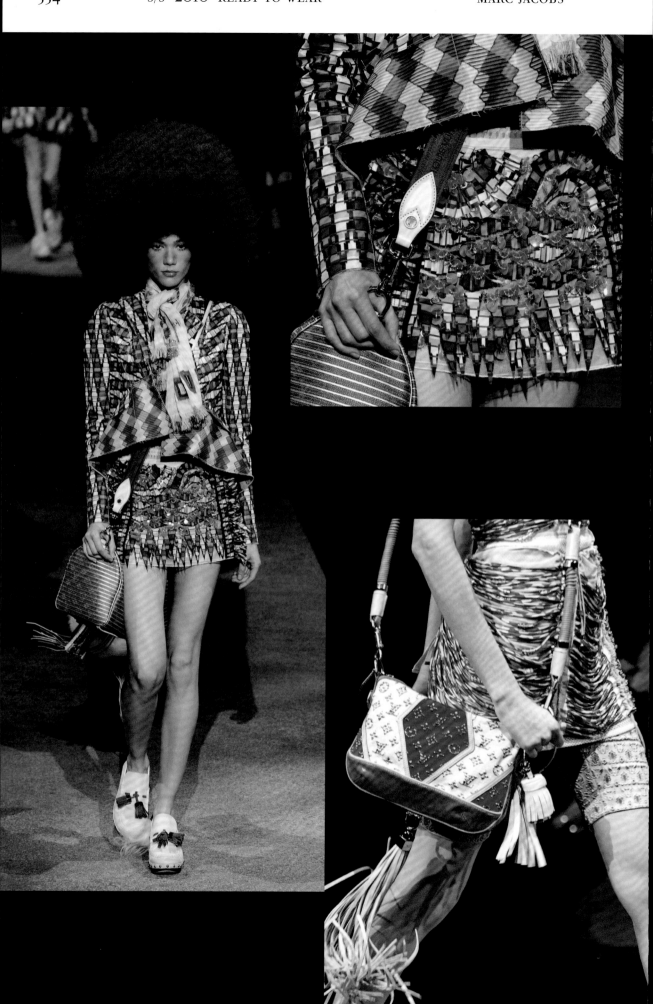

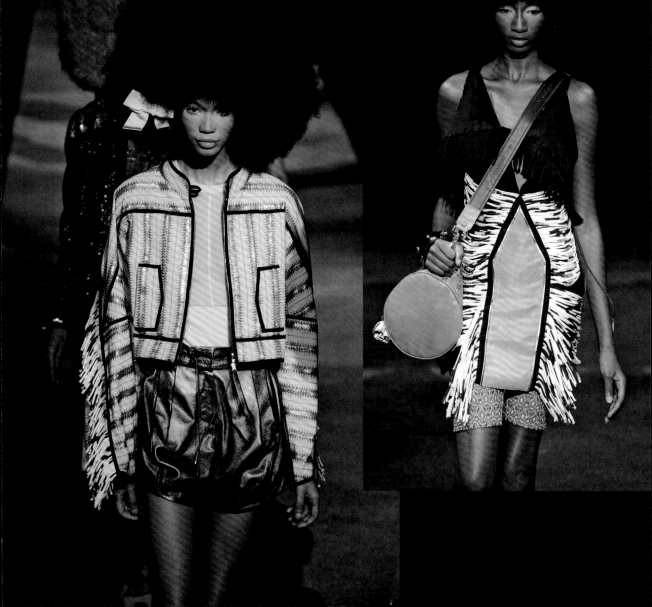

'And God Created Woman'

Titled 'And God Created Woman' after the 1956 movie
starring Brigitte Bardot, the autumn/winter 2010–2011
collection – presented around a spectacular fountain –
was 'a manifesto for beautiful, lady-like clothes'. The
house declared: 'God created woman, and Marc Jacobs
dresses her.' Jacobs chose Laetitia Casta (right) and Elle
Macpherson (p. 348, left) to open and close the show,
embodying the ultra-feminine Louis Vuitton spirit.

Presenting multiple variations on 'a single 1950s-
inspired silhouette – full bust, slim waist, full skirt' –
the collection proposed a series of seductive dresses,
though the formal mood was balanced by knitwear
evoking 'Fifties' sweater girls with their pointy bras'.
Cathy Horyn reported: 'There was an impressive sense
of the physical – corseted breasts, bare arms and legs,
womanly hips under full skirts. In a way, the body
was the main event.'

The vintage spirit was complemented by a very
modern approach to mixing and matching: masculine
fabrics were used to create feminine silhouettes, most
strikingly in pinstriped wool corsets; a sequinned lace
blouse was paired with a grey circle leather skirt (p. 338,
right); and a kalgan sweater was worn with a shearling
'corduroy' skirt (p. 340, left). While the understated
colour palette focused on powdery beige, pink, grey,
brown, marine blue and olive green, the collection
showcased the atelier's extraordinary expertise,
from organza dresses with printed feathers (p. 339) to
bejewelled mink buttons on leather coats and jackets
(p. 344). The five finale looks highlighted what the show
notes called 'gracefully draped volume', including Coco
Rocha's halterneck warp-printed taffeta gown with
enormous black bow (p. 347) and Elle Macpherson's
red flocked taffeta gown with blue duchesse satin lining.

The bow motif was continued on chic pumps of
crocodile, ostrich, satin or velvet, with sparkly block
heels that came in three heights. Other accessories
included long opera gloves, black velvet belts, and chic
round 'Lace' sunglasses. The star of the show was the
iconic Speedy bag, first created in 1930 and now
reinvented in an array of richly worked variations,
from the flocked and sequinned Monogram Fleur de
Jais (p. 340, right) to the pared-back Cuir Cinéma in
smooth waxed calf (p. 338, right). In the limited-edition
'Les Extraordinaires' line, the Damier chequerboard
pattern was hand-painted on crocodile leather alongside
sequinned Monogram motifs (Damier Virtuose;
see p. 343, bottom left) or recreated in fox fur
(Damier Clair-Obscur; p. 341, bottom right).

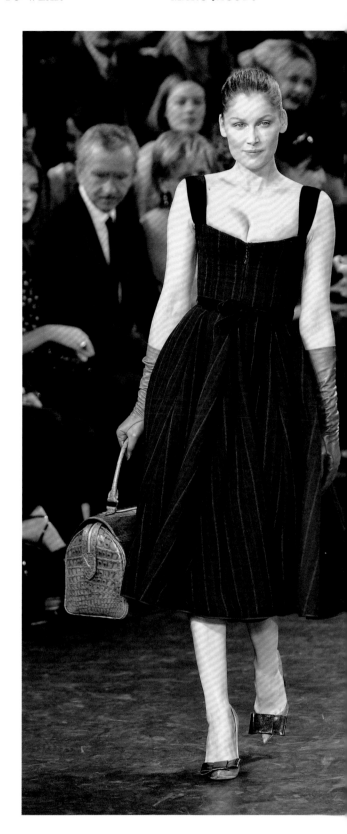

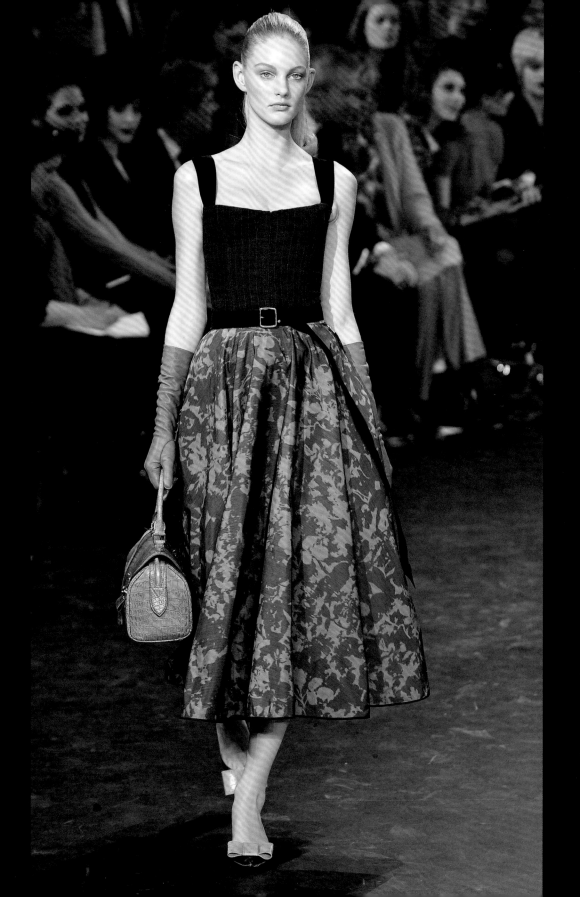

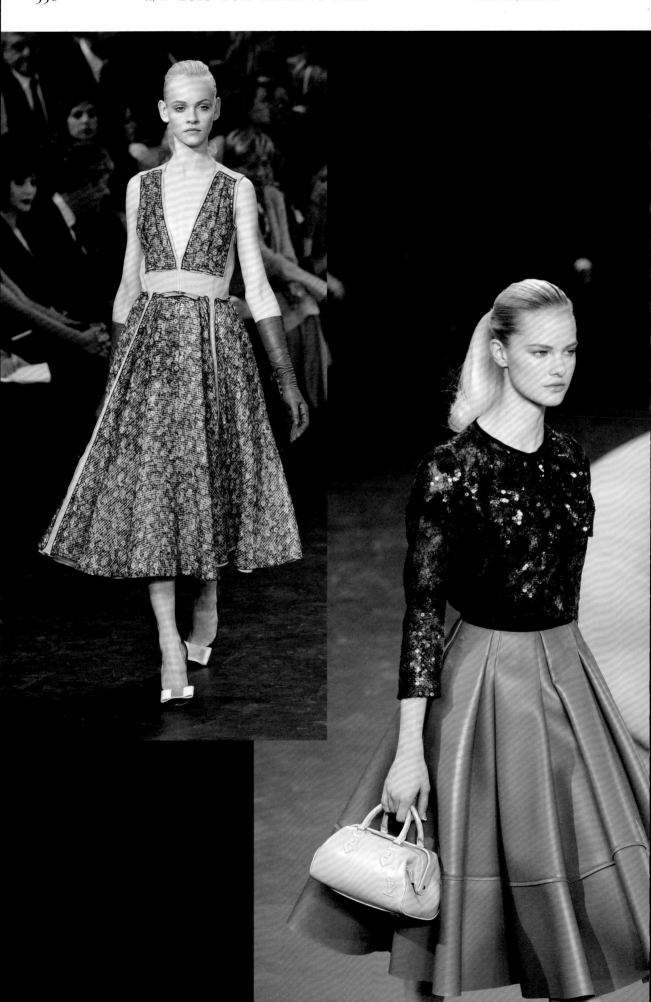

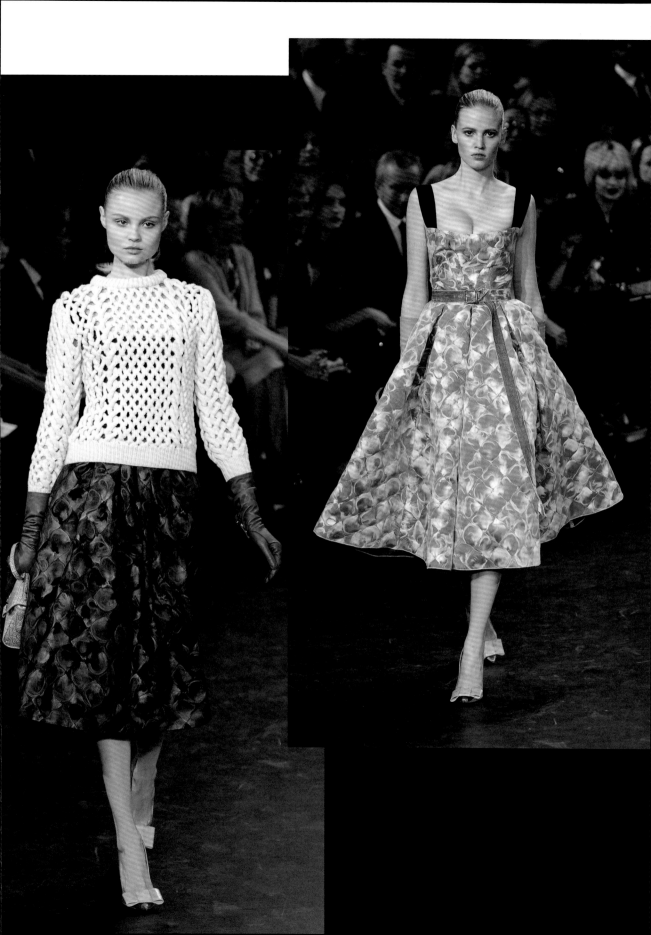

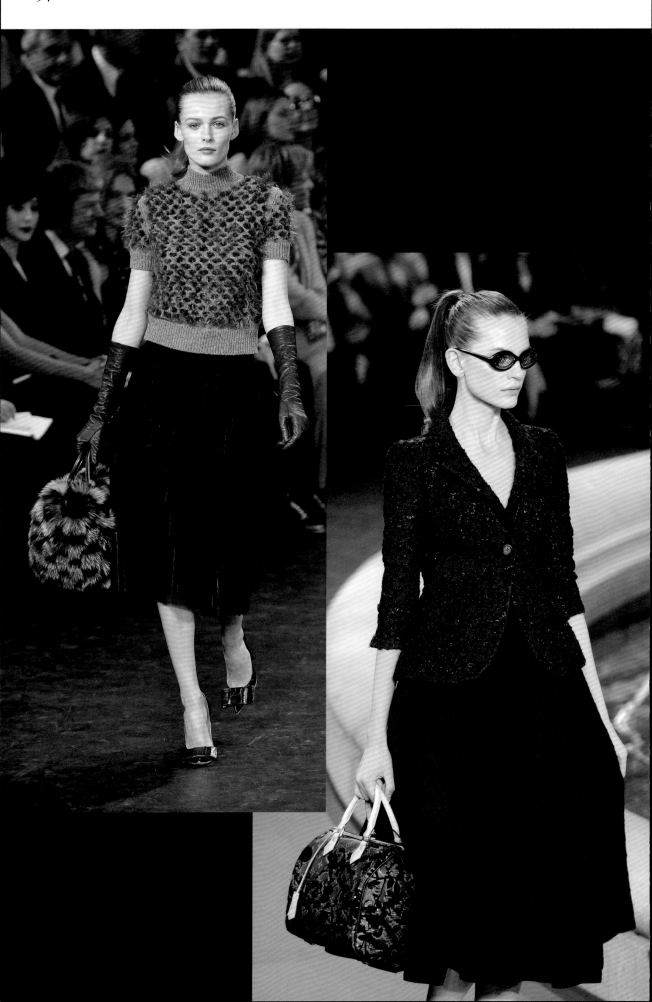

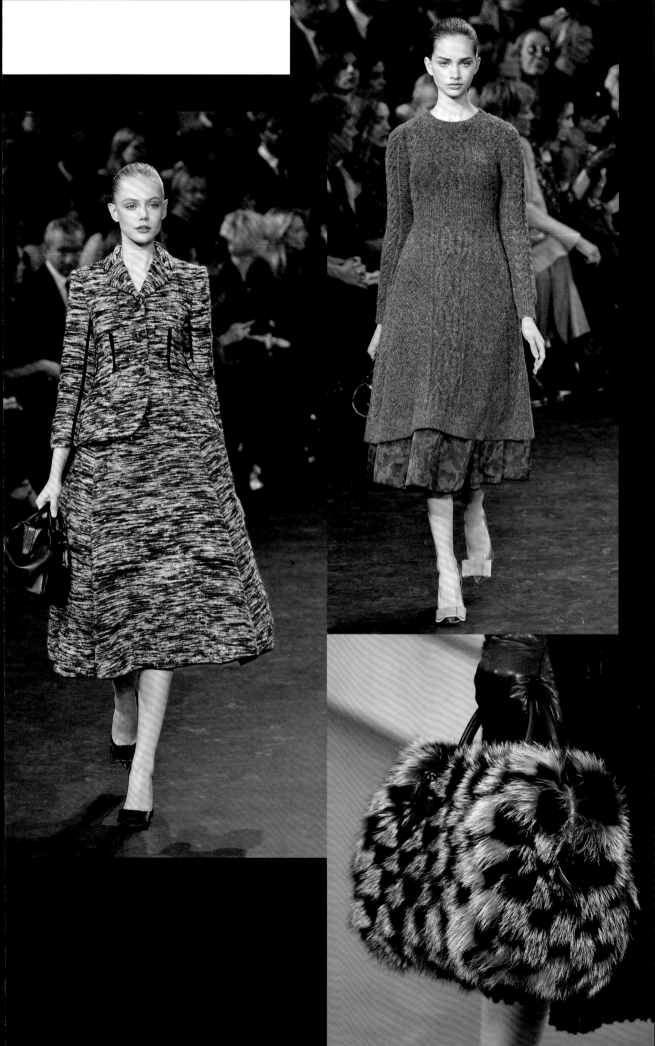

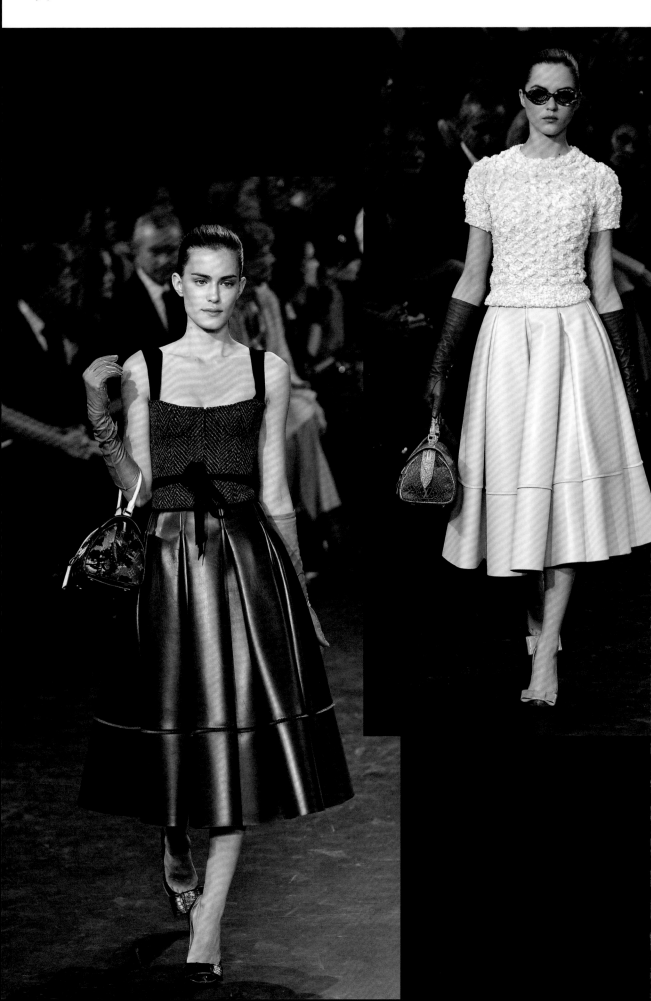

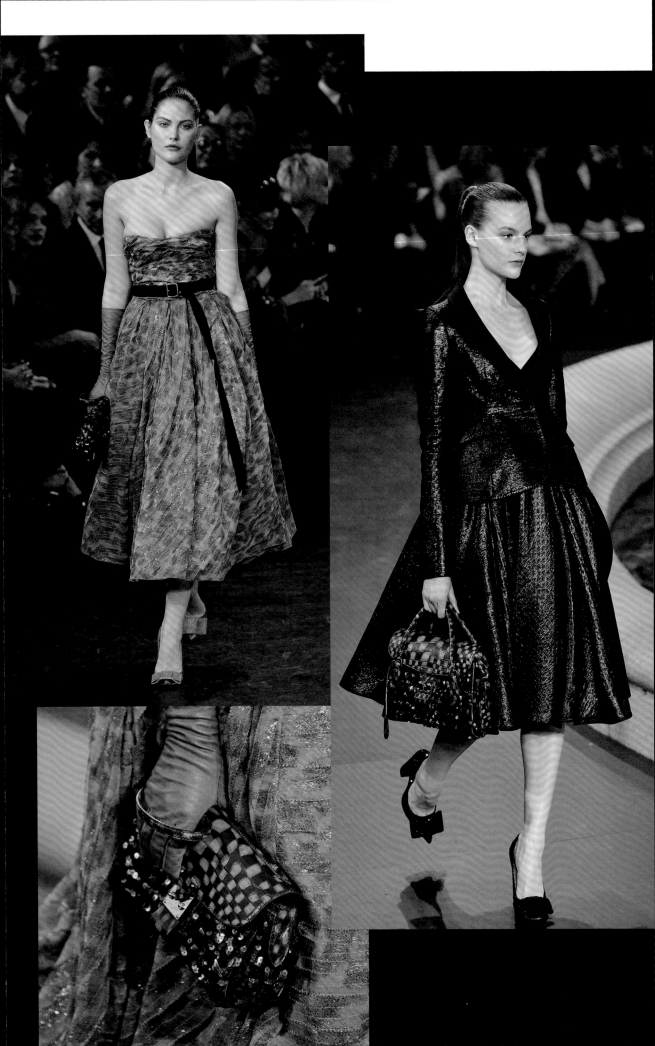

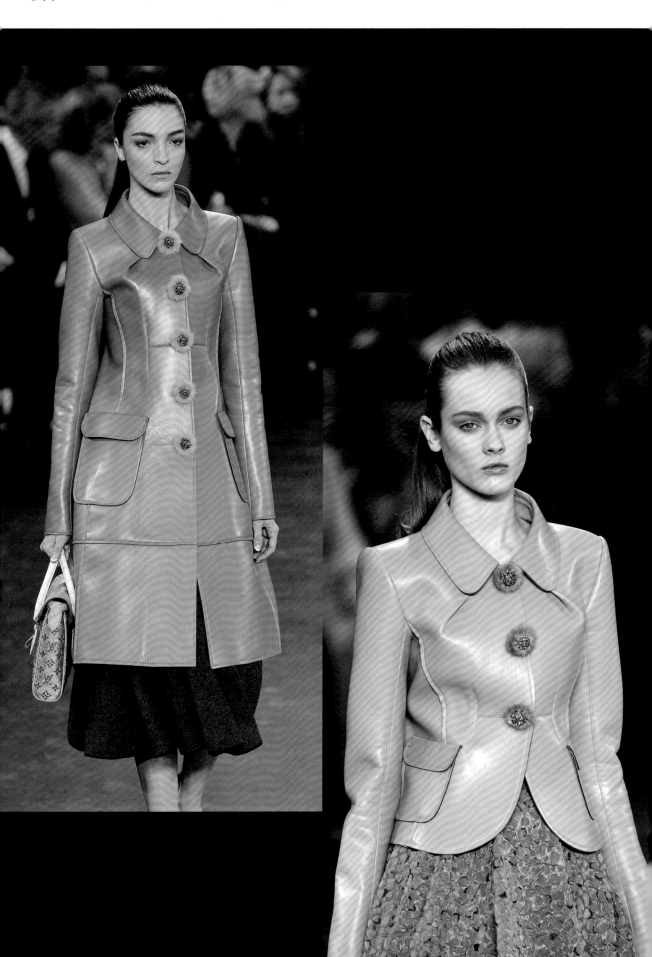

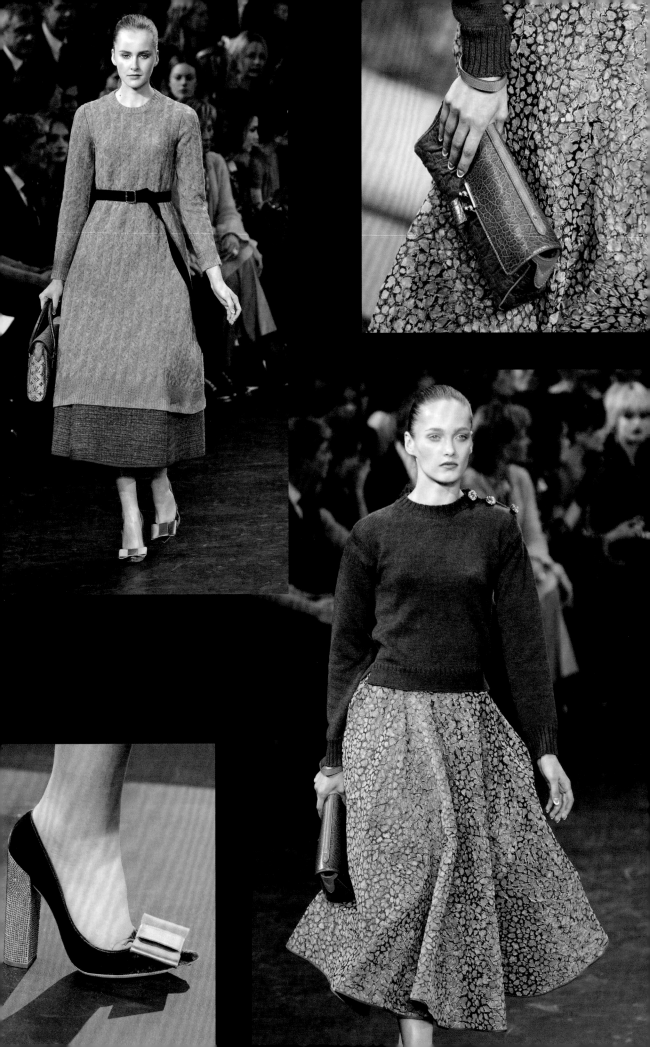

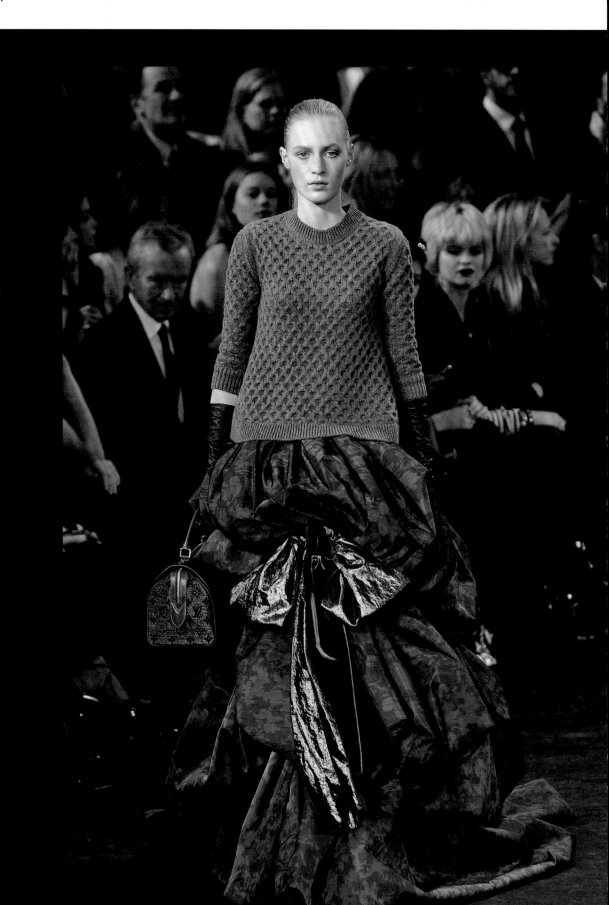

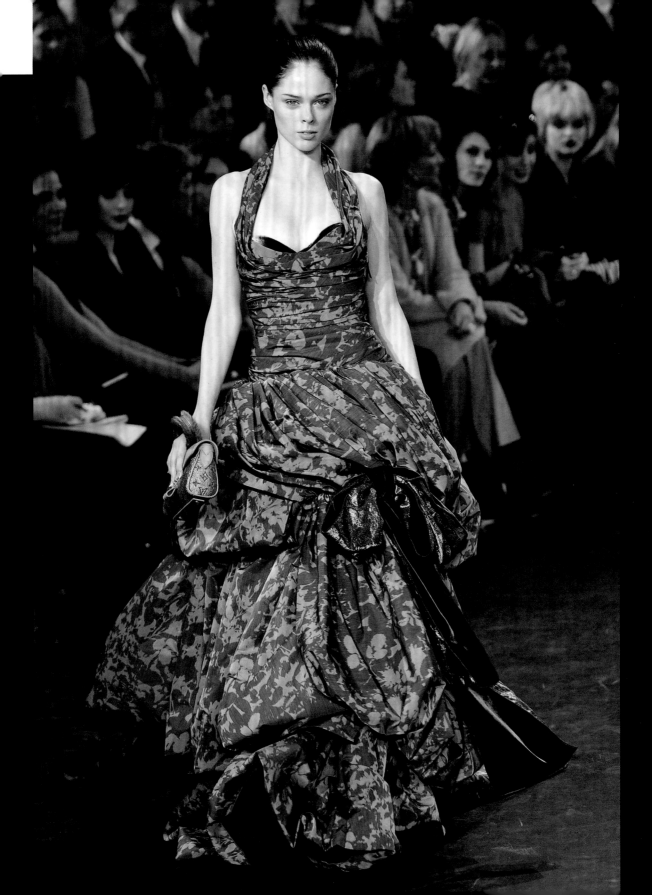

Camp

For his spring/summer 2011 collection, Marc Jacobs chose a quote from Susan Sontag's essay 'Notes on "Camp"' as his main source of inspiration: 'The relationship between boredom and camp taste cannot be overestimated. Camp taste is by nature only possible in affluent societies, in societies or circles capable of experiencing the psychopathology of affluence.' The collection celebrated Jacobs's highly personal definition of camp and 'the glamour and glitter of Paris', through shimmering textures, mesmerizing movement and intricate couture details.

The show opened with a punk Susan Sontag (she also had a white stripe in her hair), wearing a black cheongsam dress embellished with what Jacobs referred to as '$20,000 worth of crystal' (right). 'I didn't want anything natural, I wanted everything overly stylized,' he declared. The house noted that the collection 'elevated decadence to artistry'.

A distinct 1970s influence prevailed (the Venice home of designer Walter Albini, with its black marble, beaded curtains and stuffed animals, inspired the show's décor), as well as a focus on bold colour-blocking (with 'a tropical palette [and] rich jewel-like saturated colours'), Chinoiserie (tweed jackets with mandarin collars, fans fashioned from Monogram lace), lush floral motifs, and animal references. 'I thought of the time when Paris embraced Asian designers such as Kenzo, by Chinoiserie and Japonisme, when I was working in my first job with Kansai Yamamoto,' explained Jacobs. 'At the time Yamamoto was creating designs in Lurex with animals climbing among them and strong, almost vulgar, colour combinations.'

Jacobs's animal kingdom featured crystal-encrusted animal-leg heels (p. 357; 'a reference to the claws that you see on the feet of [Chinese-imported] furniture'), zebra, tiger and giraffe prints, and even the image of a panda created by artist Rob Pruitt embroidered in sequins on a luxe T-shirt (p. 362, right). Pat McGrath created Kristen McMenamy's finale look, which Jacobs described as being 'the ultimate in couture: to have a zebra-inspired, glittering T-shirt painted on your body' (p. 363).

Chic cocktail bags included the Avant-Garde pochette (p. 355, bottom left), Galuchat Maestria clutch (p. 356, bottom right), Art Deco Trapeze (p. 357, bottom right) and spherical Monogram Nova minaudière inlaid with Swarovski crystals (p. 363). Jacobs noted: 'Everyone seems to be trying to address the person who they believe to be the modern woman, what she wants and what she needs. I'd rather be camp, be decadent, shine and be loud.'

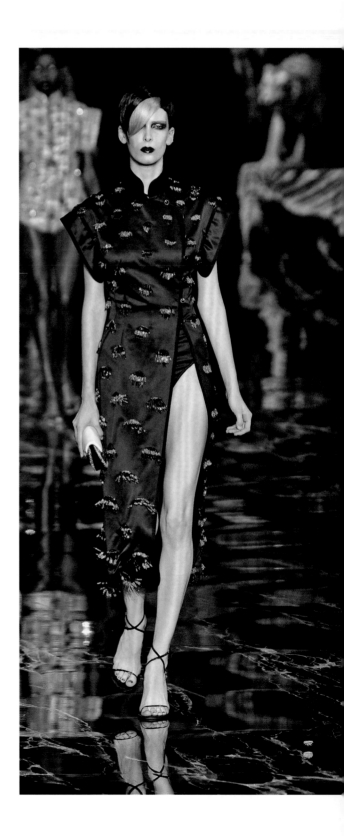

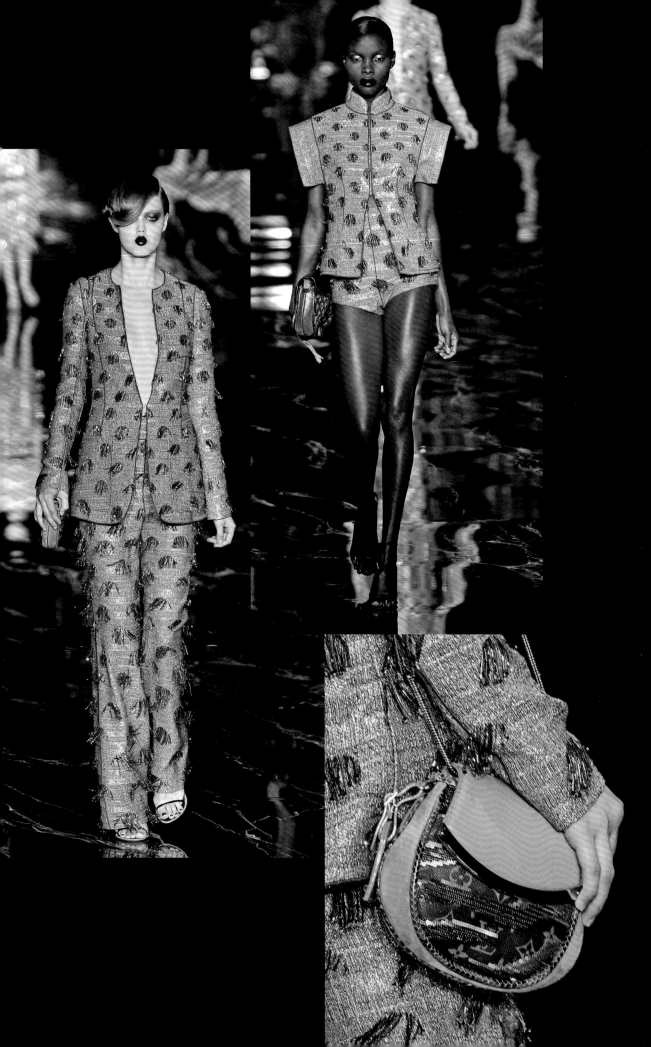

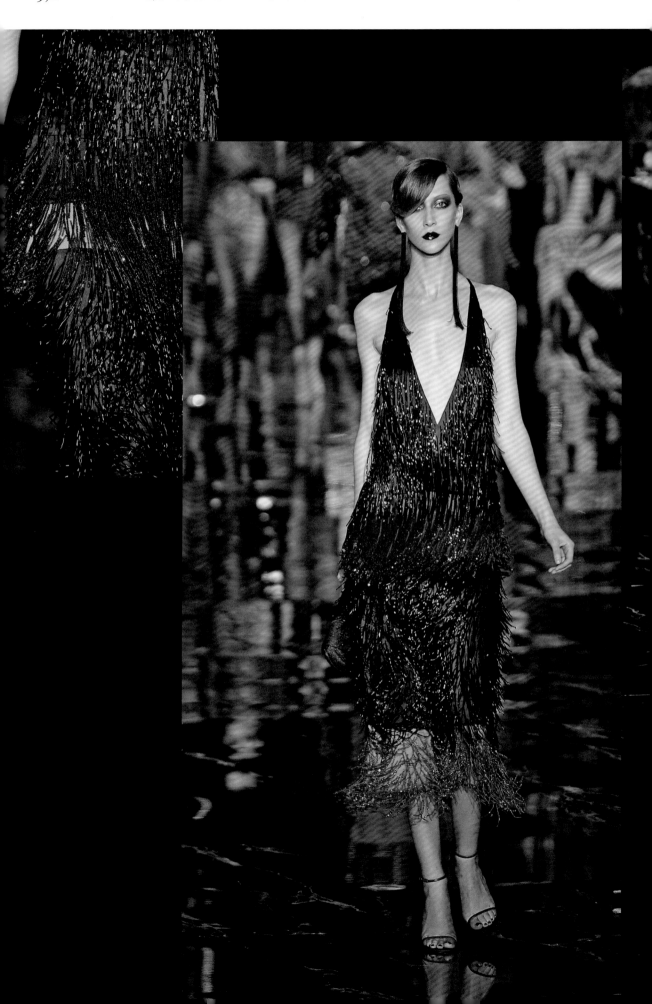

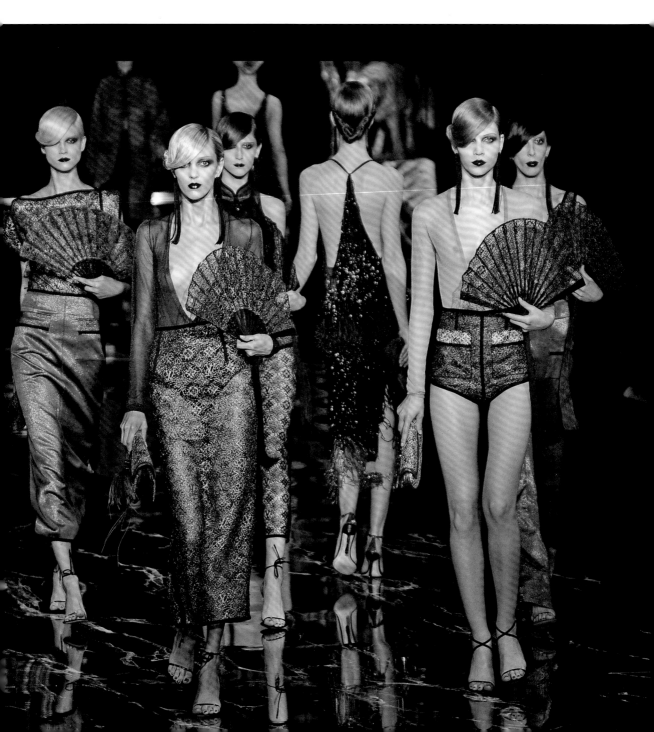

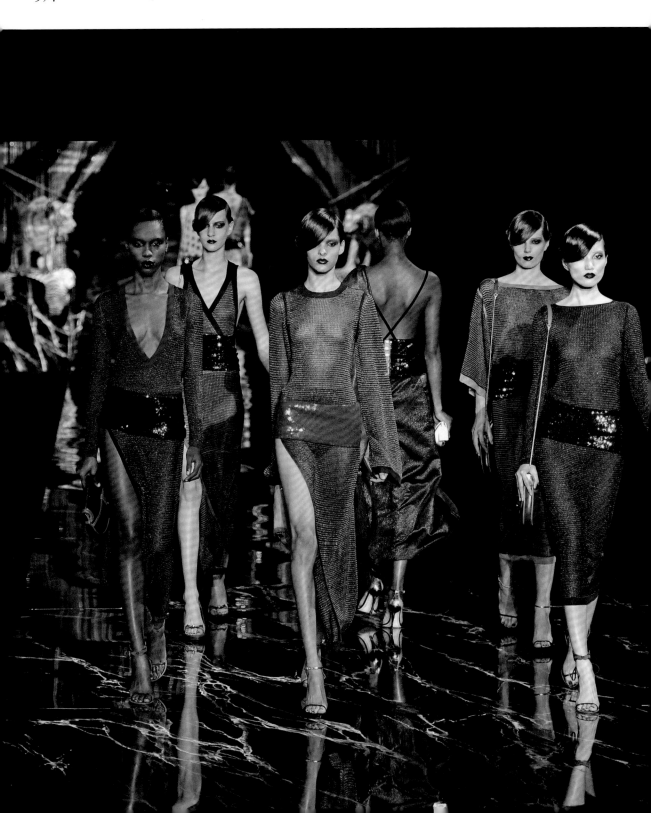

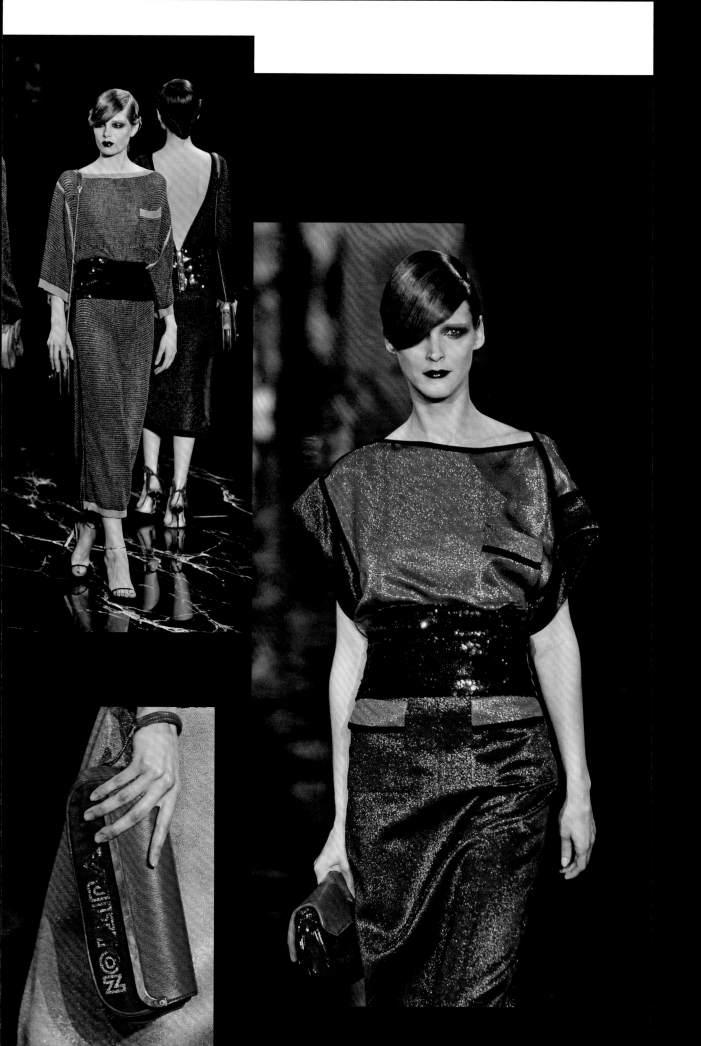

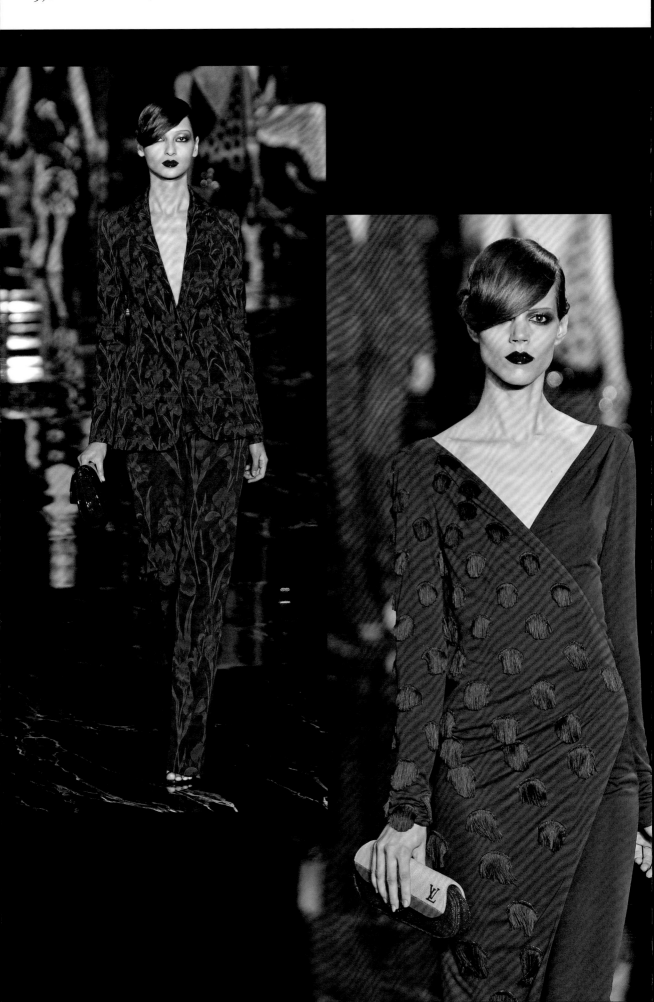

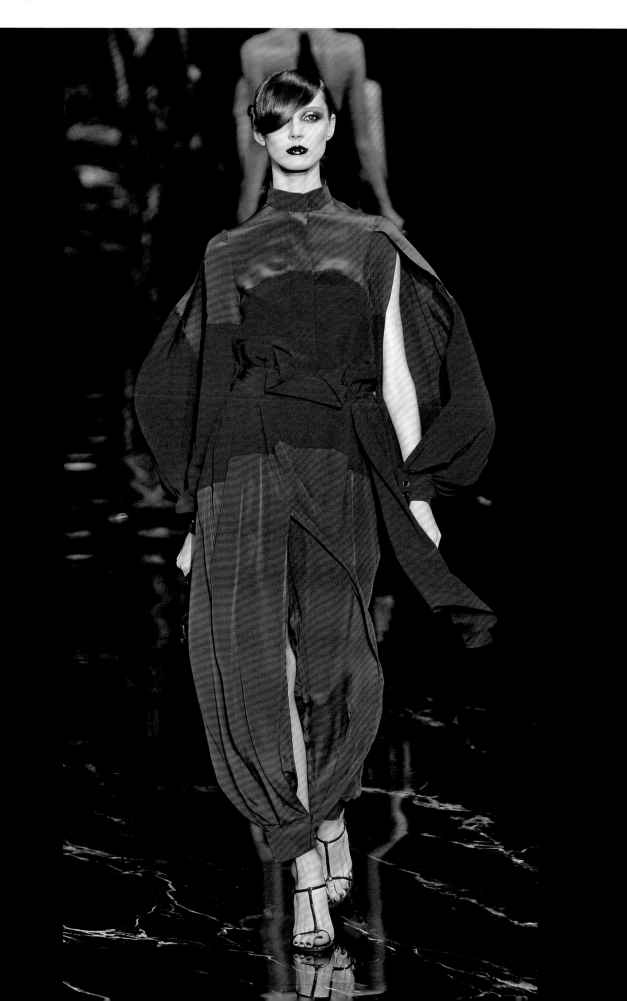

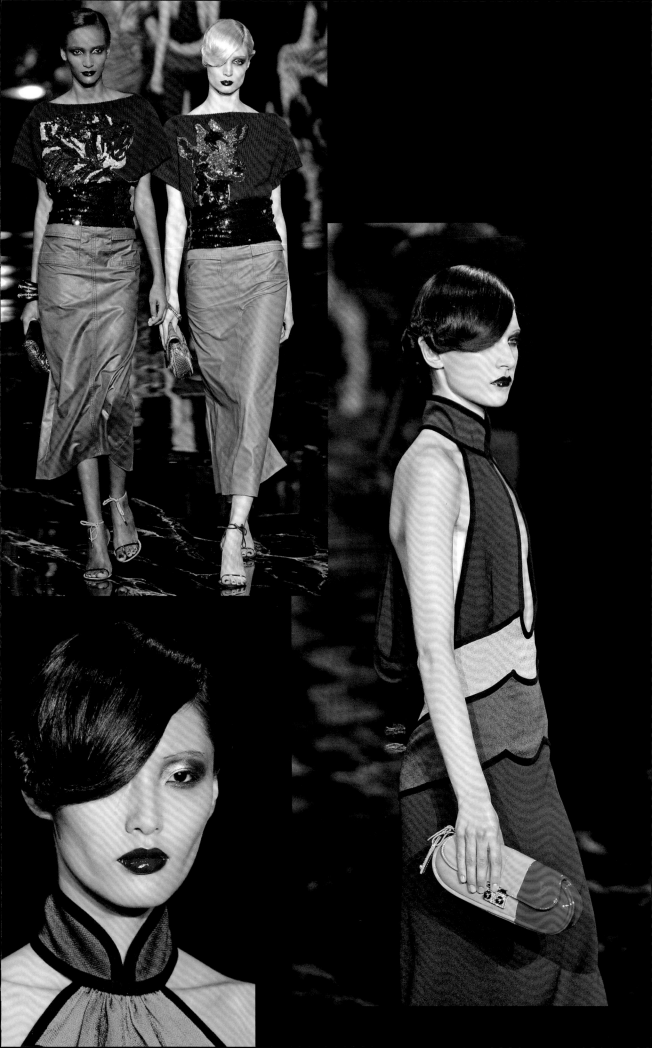

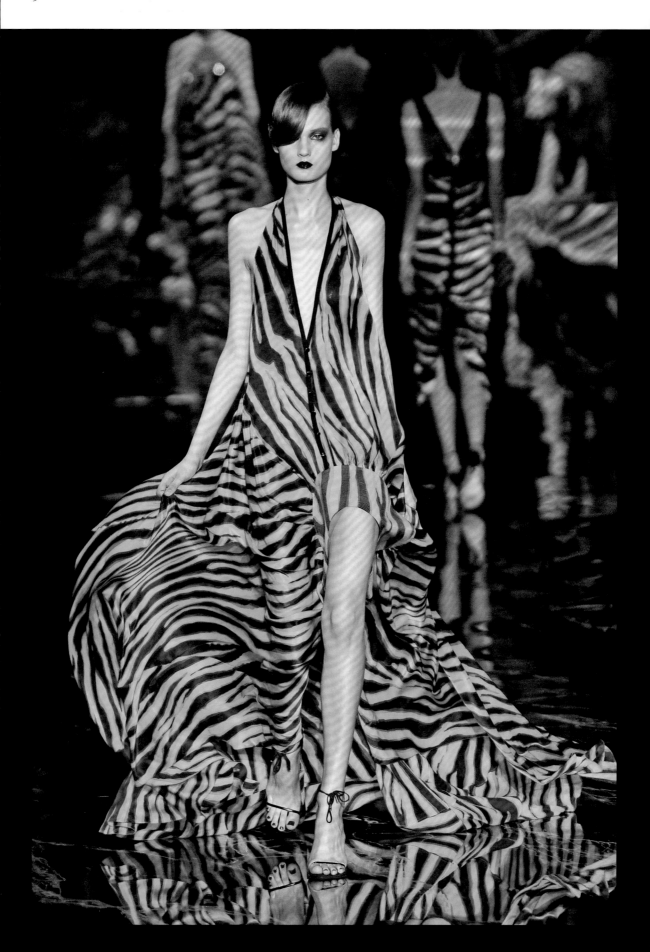

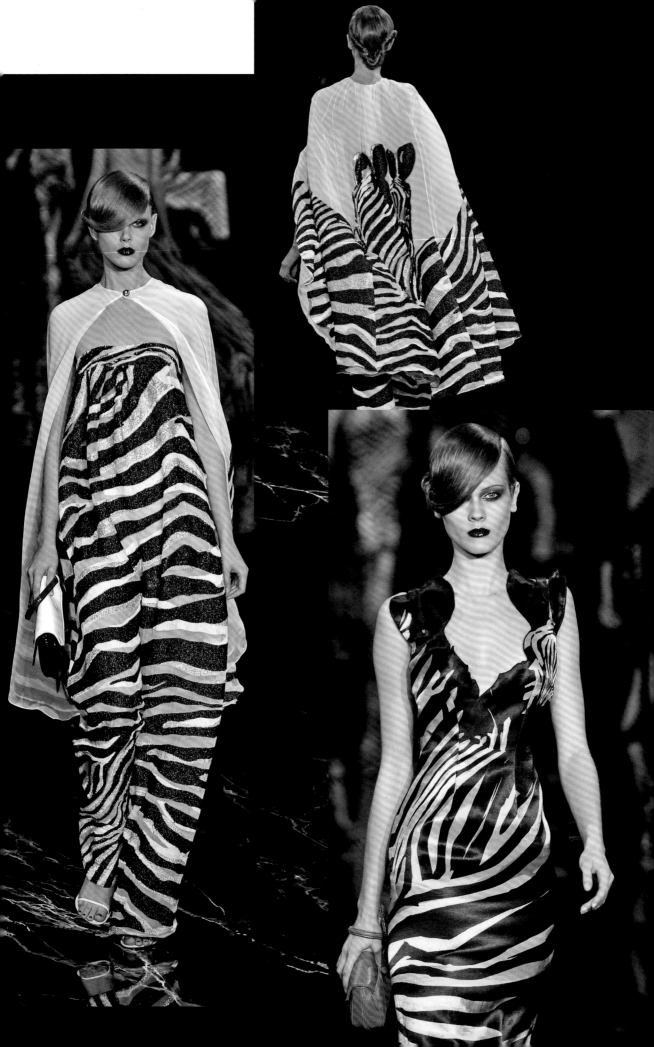

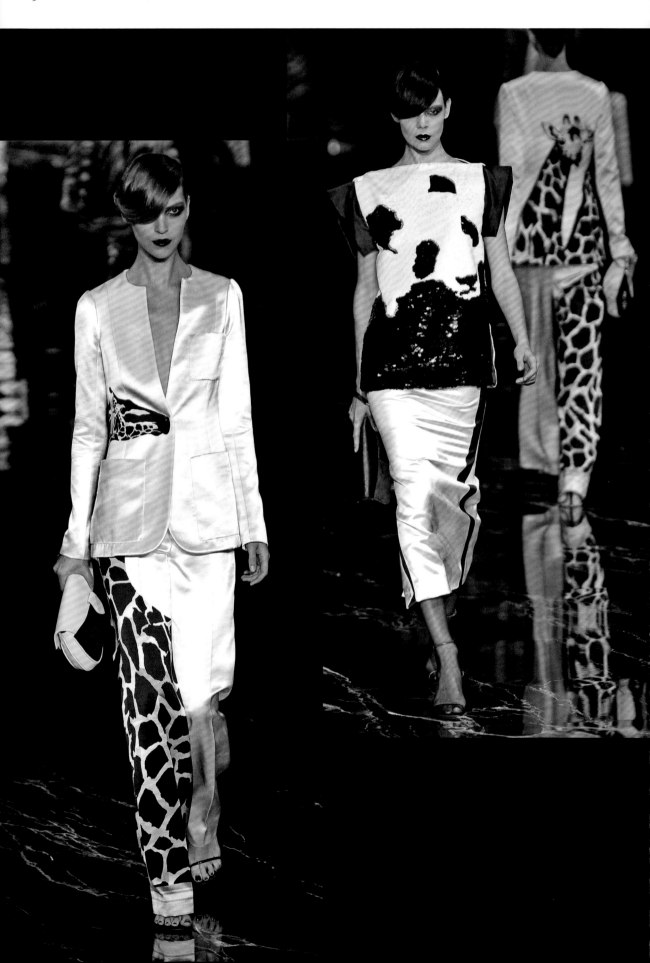

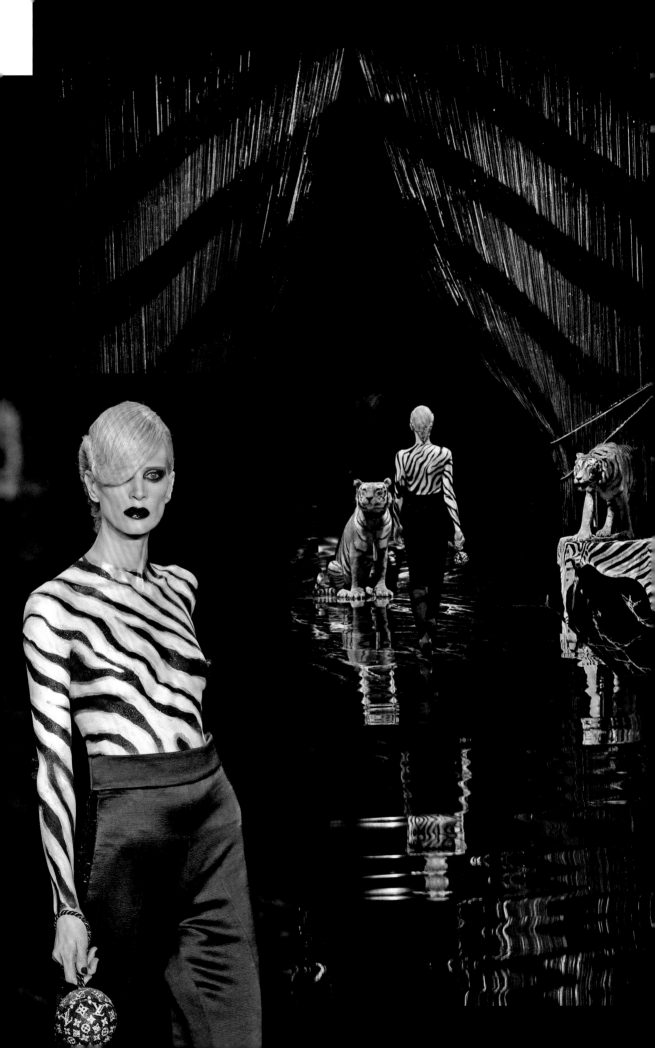

Fetish

For autumn/winter 2011, Marc Jacobs explored the
'fetish', the house providing show notes with definitions:
'an object believed to have a magical power' and
'something to which one is irrationally devoted'. Jacobs
considered this concept in relation to women's obsession
with bags in general, and Louis Vuitton's in particular.
The result was the new must-have: the Lockit.

This bag had originally been launched in 1958, its name
deriving from the padlock that slots through a leather
patch on the side of the bag, allowing its owner to 'lock
it'. The house proclaimed that 'the artisanal devotion
to craft is the apotheosis of fetish', and offered ever
more luxurious versions of the bag to illustrate the
point. These included the 'Mon, Oh! Gram' (p. 366, left
and right) and the rubberized leather Lockit (p. 375, top
right); gold and diamond handcuffs were even added
to limited-edition Lockits (see p. 377, bottom left),
the house quipping that 'a Louis Vuitton handbag,
it appears, is for life'.

The cage elevators out of which the 67 models stepped
onto the Damier-patterned catwalk, and the attendant
doormen and maids, 'came from my experience at
Claridge's', explained Jacobs. 'Hotel living – I love it
when I see these exquisite creatures coming out of the
elevator. Some of them maids, hookers, mistresses...
It's very interesting to see who leaves hotels at what
time, and what they're wearing.'

Fetishist and erotic themes were carried over in the
clothes, from patent leather Claudine collars, corsets
and lace-up boots to doorman caps and headbands
in the shape of eye masks created by Stephen Jones.
Footwear included Mary Jane pumps with lacing
(p. 367, top right) and rubber rain boots (2,000 pairs
sold in their first week). Jacobs's use of materials was
unexpected, mixing heavy vinyl-backed tweed (see
p. 367, left), Mongolian lamb fur (p. 371), re-embroidered
neoprene guipure (p. 375, left), reptilian-scale-like
'paillette python' (p. 376), and even a 'perforated
Monogram' silicone (p. 378, left; raincoat and scarf).

Cathy Horyn reported: 'Now, evoke the eternal 2 a.m.
of *The Night Porter*, fill the room with Philip Glass's
score for *Notes on a Scandal* and finish the scene with
fashion's favorite bad girl, Kate Moss, in black briefs
and boots, ignoring the smoking laws, and you can
understand why people at the Louis Vuitton show
were so giddy at 10 am.'

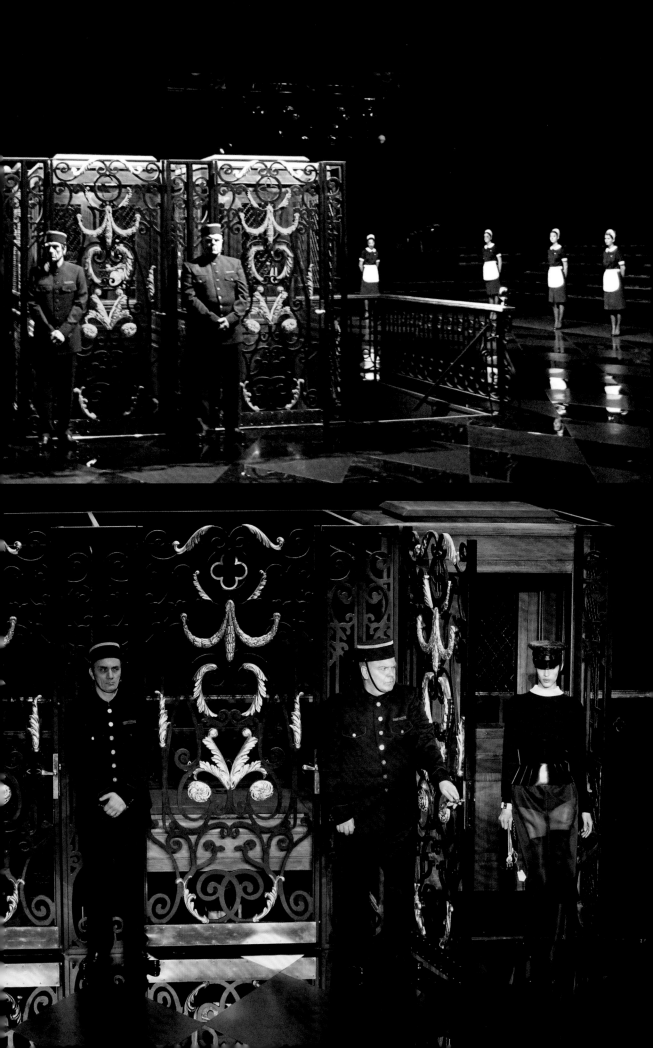

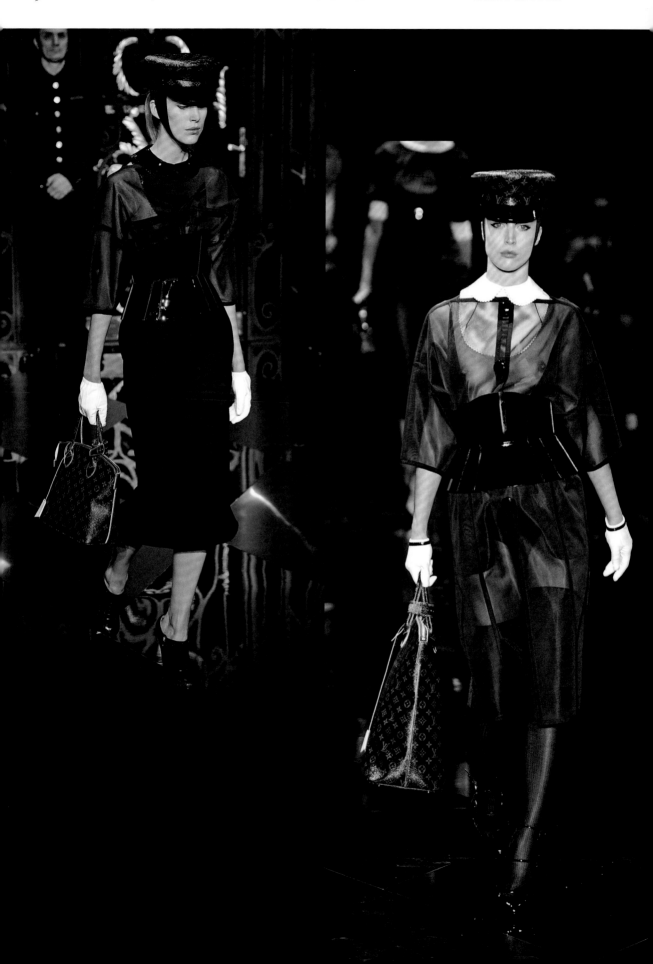

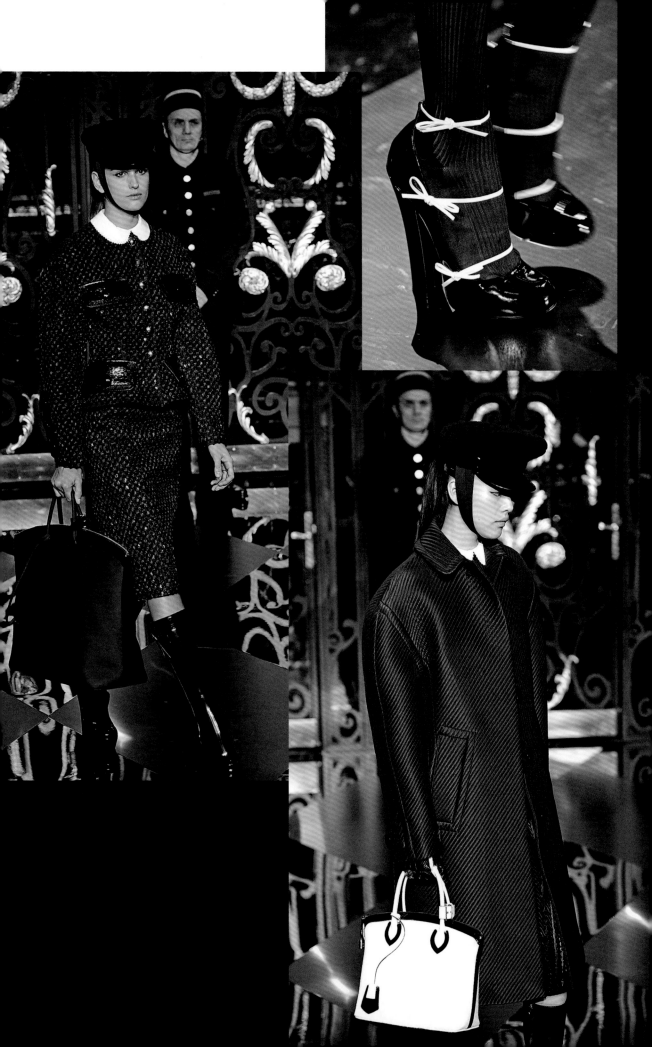

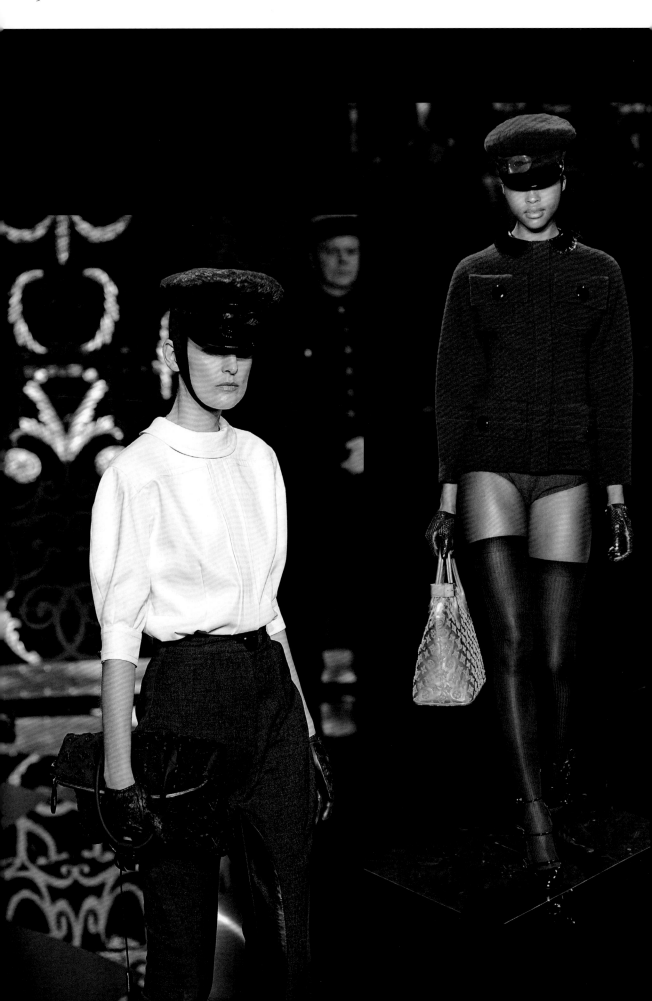

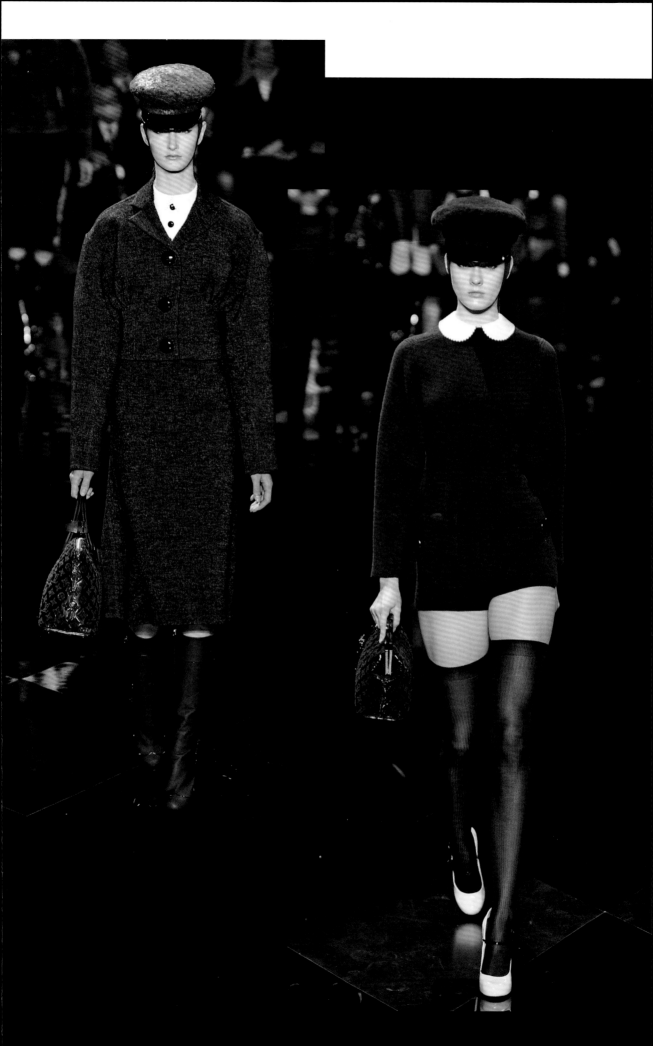

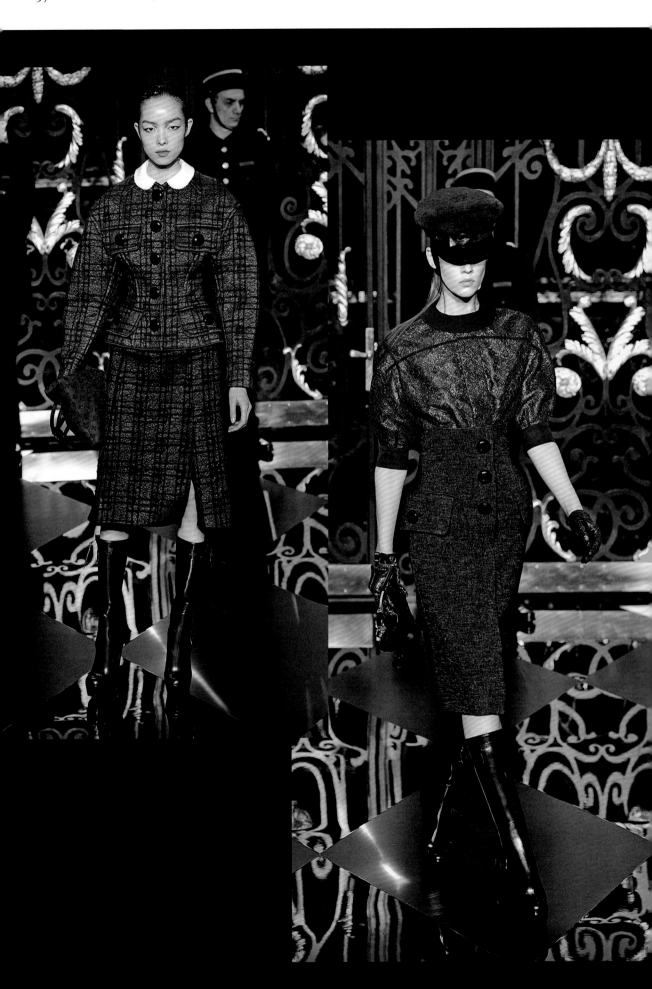

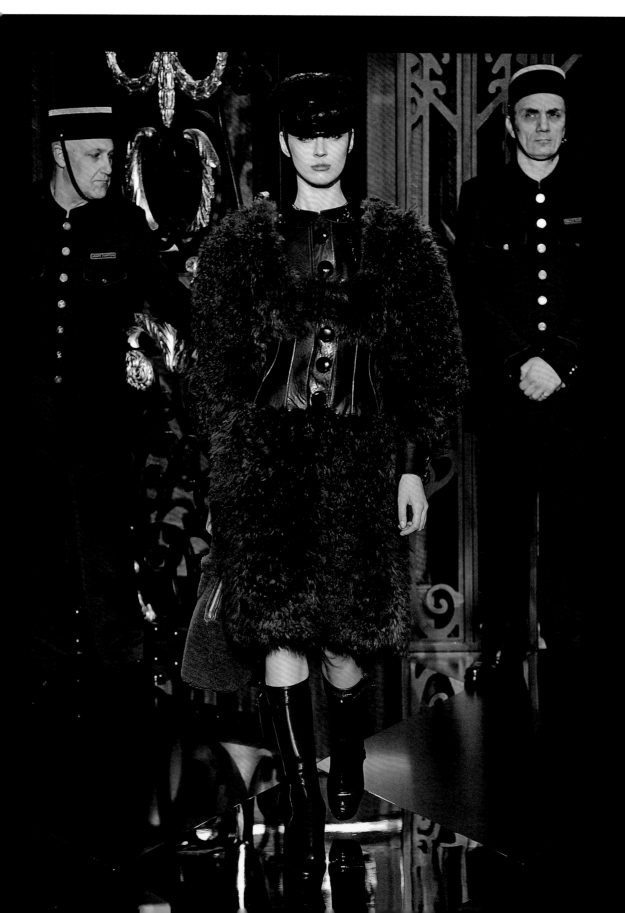

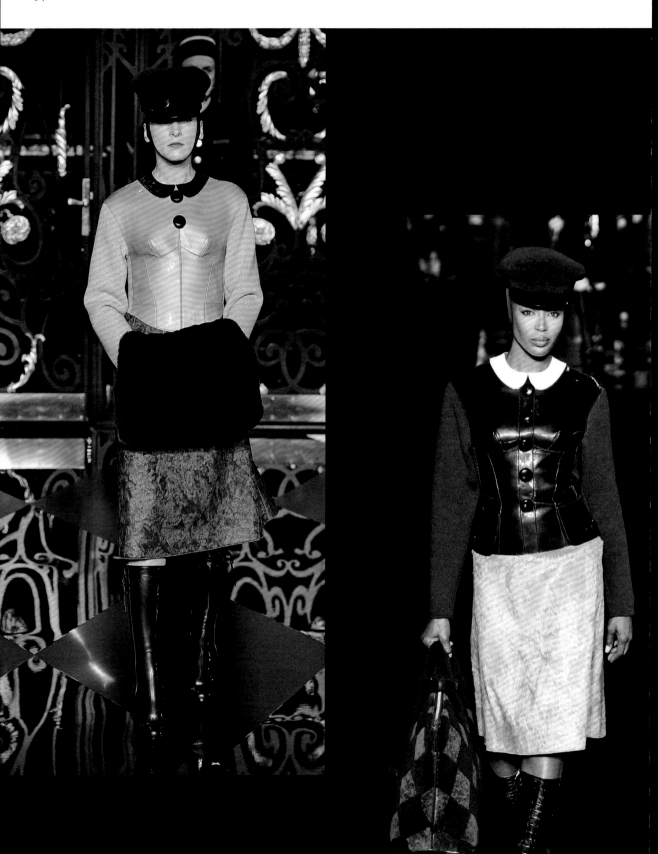

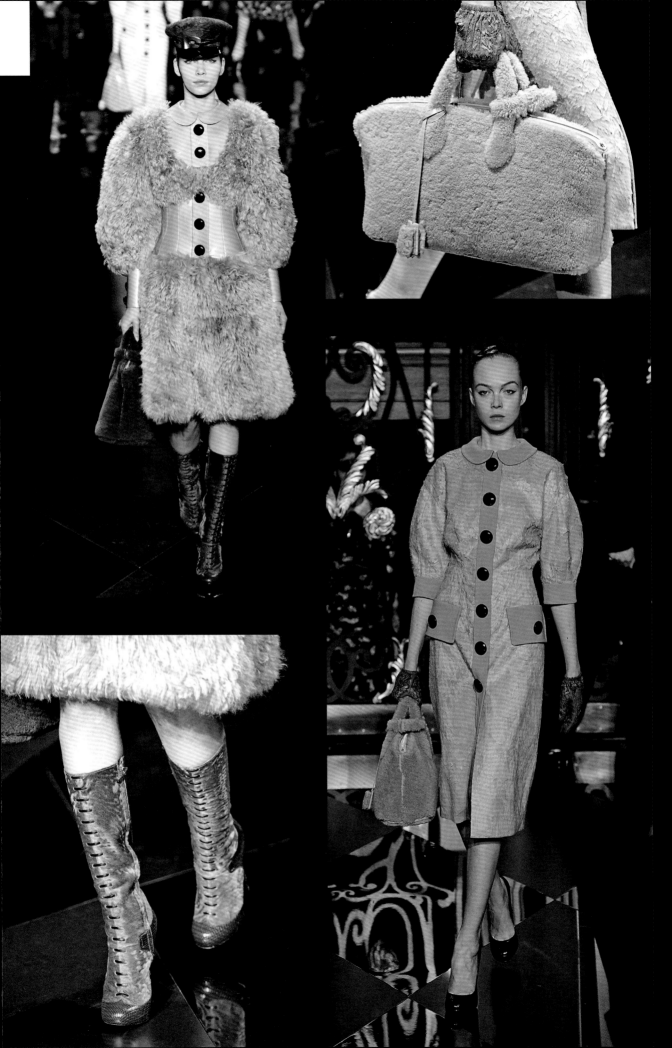

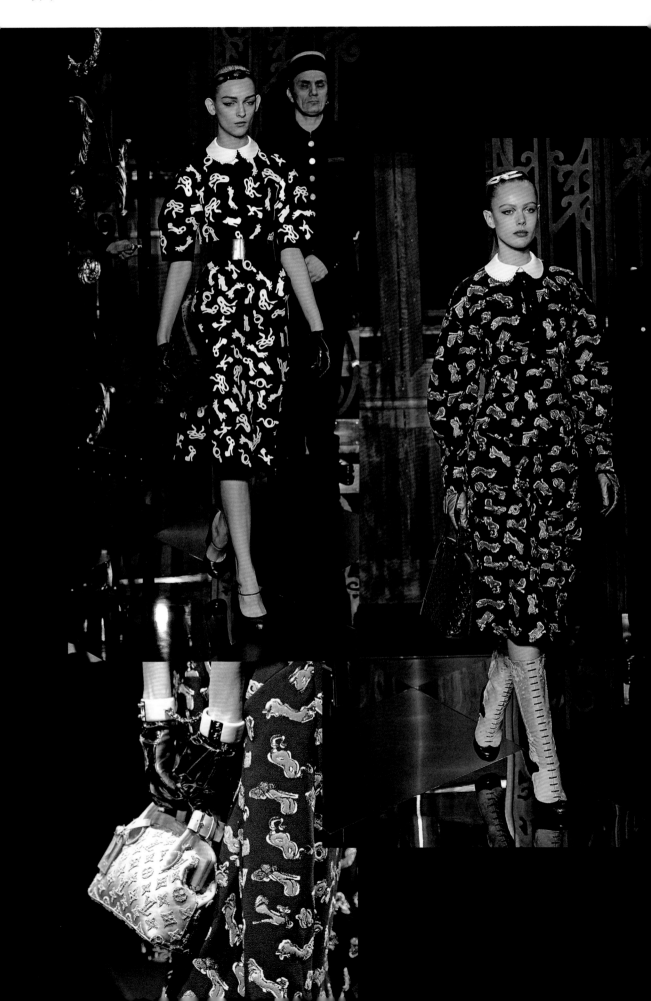

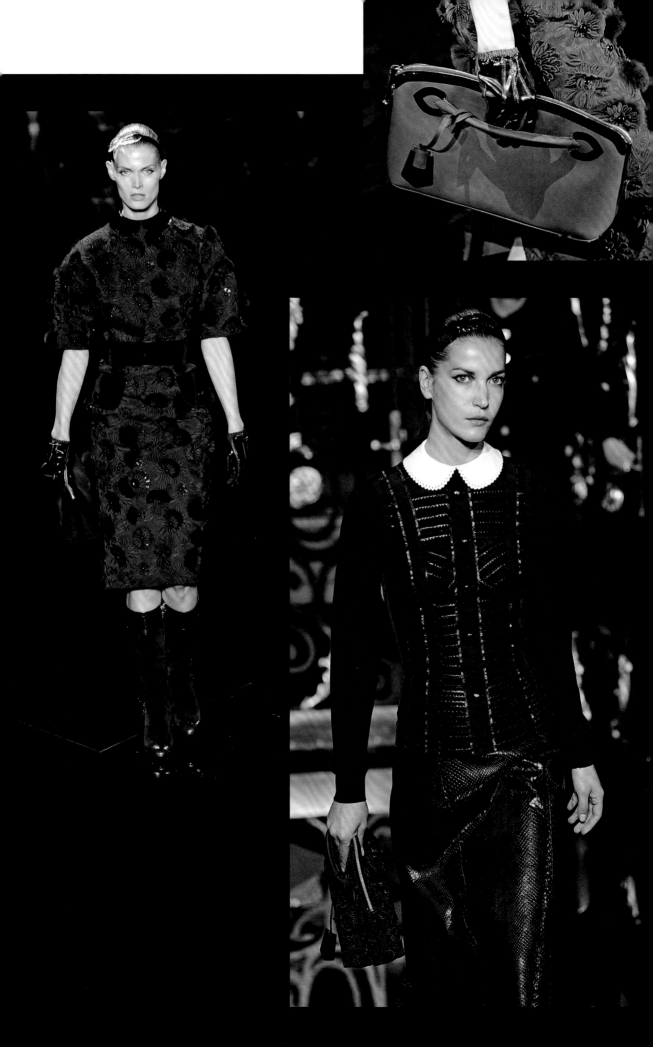

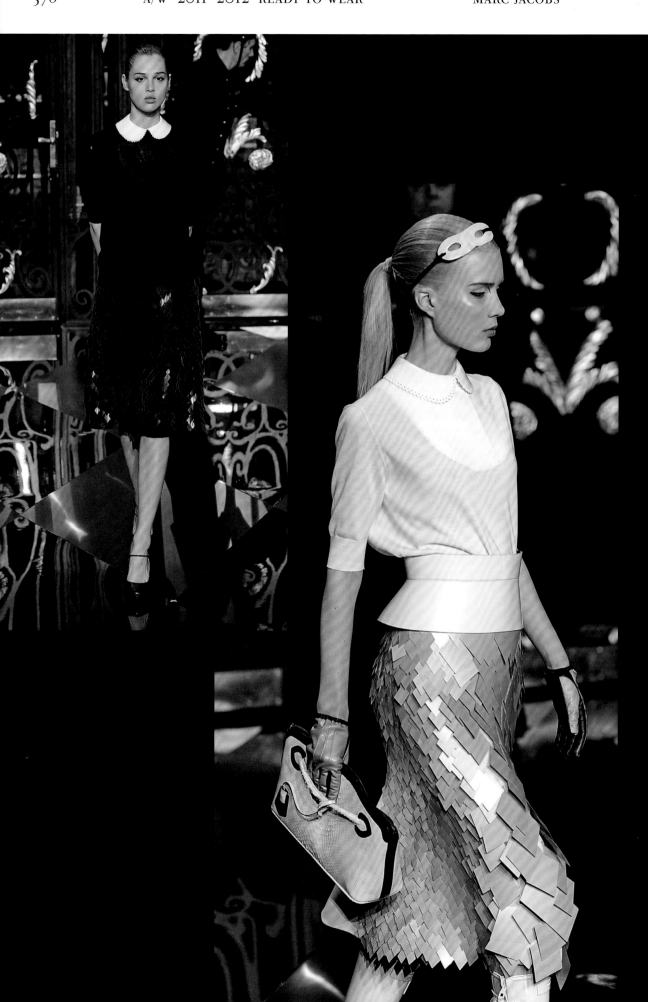

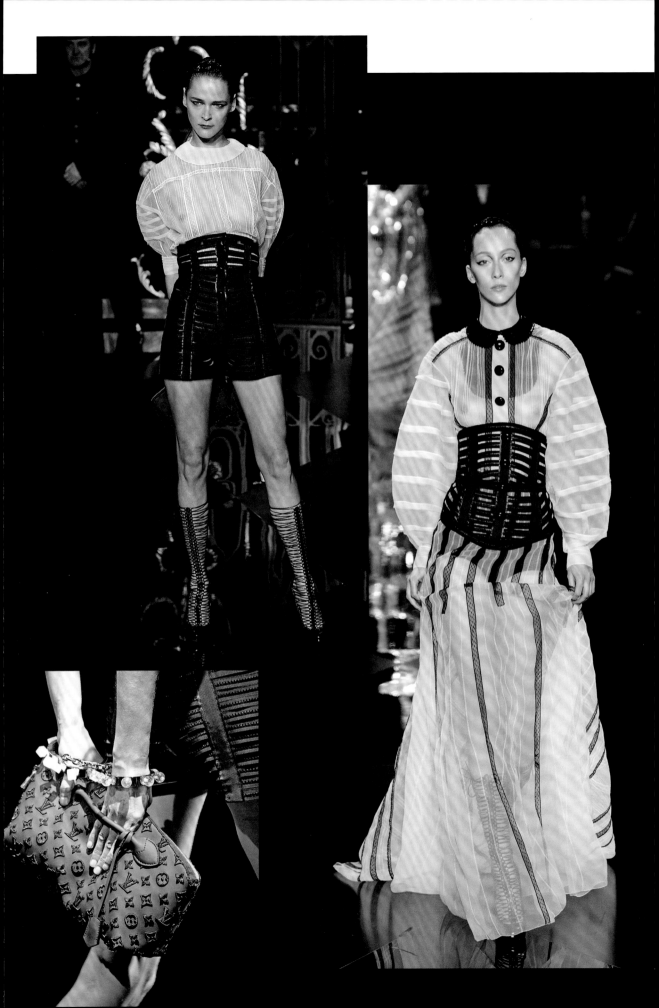

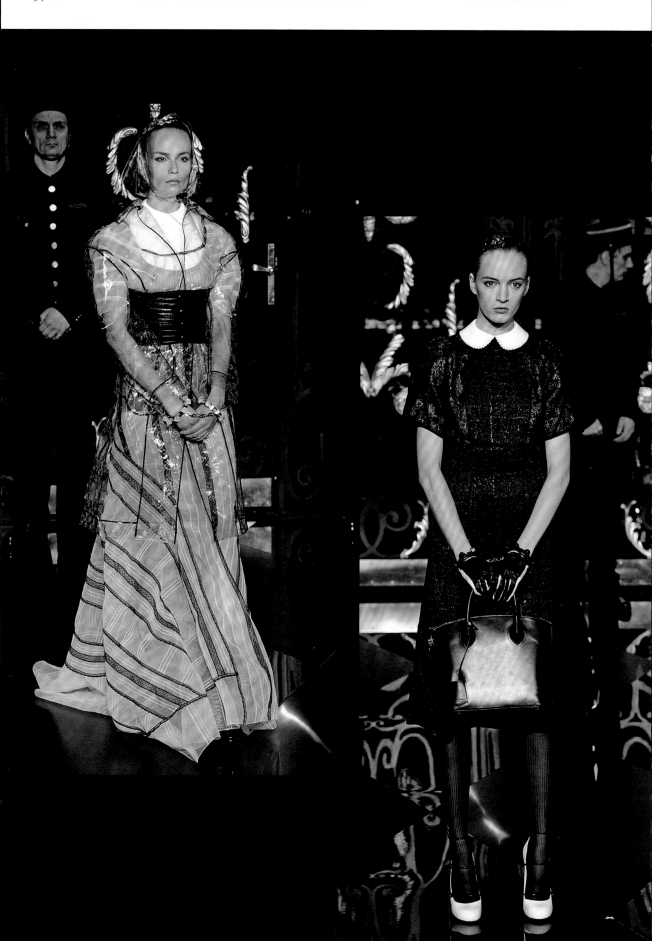

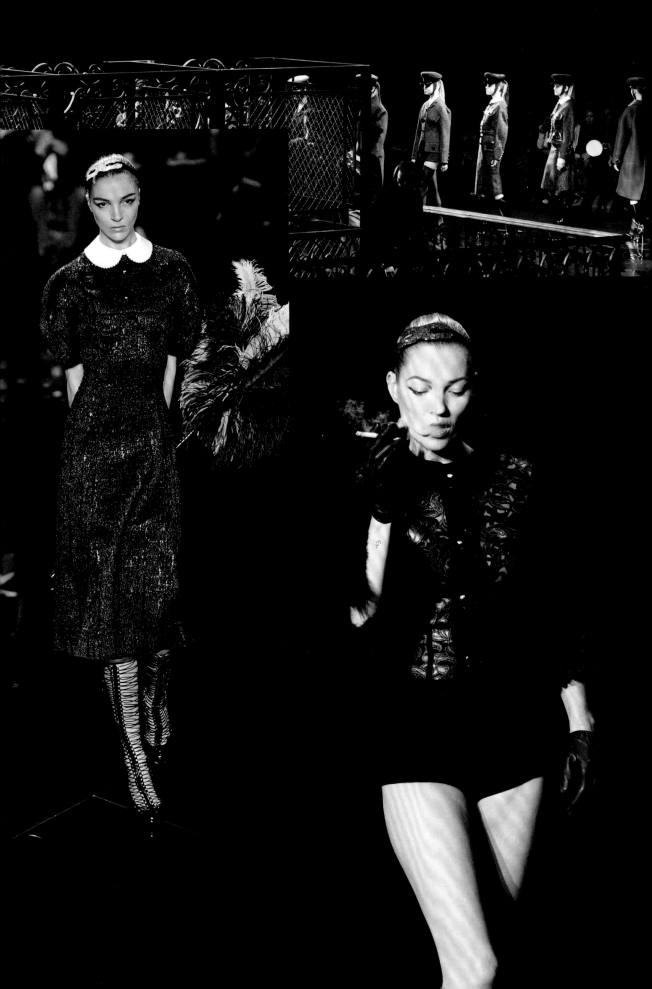

'Le Carrousel'

'We just started out thinking about colours we found pleasant and kind,' Marc Jacobs explained. 'Then we thought about light, air, and things floating and feeling kind of spring-like and magical. And I said, let's put them all on a carousel.' The spectacular mirrored setting for the spring/summer 2012 collection included a hexagon-shaped catwalk, evoking 'the circular dance of fashion'.

The clothes played with both translucence and intricate embellishment. 'The internal workings are as essential as the external ones for each object in the collection,' stated the show notes. 'Construction is exposed through a luminous play of transparency... The silhouette is spun and plumped, lightness refracted, surfaces appliquéd, yet underneath are the strict, firm foundations so necessary to build the fantasy.'

'The romance of Parisian fashion is a joy in the emotional exchange between craftsman and wearer,' the notes explained. 'Fashion is spectacle, but this is an intimate relationship as well; it is not just about the joy of looking but the joy of feeling.' Highlighting the savoir faire of the atelier, the fabric of the season was broderie anglaise, which appeared on oversized Peter Pan collars, dazzling dresses and skirts with 3-D plastic paillettes and crystals (see pp. 390–91), Damier-patterned cashmere bodysuits (p. 387, top left) and a romantic white monogrammed parasol (p. 392).

'With crystal-studded tiaras in their hair and wearing fondant-coloured day suits, swing coats and cocktail dresses and silver Mary-Jane shoes, they looked pretty as a picture – like fairy-tale princesses one and all,' reported Susannah Frankel. If at first the collection seemed to be in stark contrast to the previous season, it in fact included some of the same silhouettes and themes. Stylist Katie Grand explained, 'You had sweetness, with some kind of undercurrent of fetish or wrong-doing.' Charmed objects included rock crystals and miniaturized S-locks, as well as feather (see p. 390, top left) and wishbone jewelry.

Jacobs introduced the 'Coquille D'Oeuf' minaudière (p. 388, right), its exterior 'mosaicked' with 12,500 pieces of egg shell, taking the atelier 300 hours to create. The Monogram Transparence Lockit appeared in translucent voile (see p. 382), and there were cut-out Jelly baskets (p. 389). A wide array of Speedy bags came 'plumped and softened in spongy deer, casually insouciant in bleached denim embroidered with silver thread, playfully basket-like in mirrored metallic leather with an exposed drawstring bag or pristine in powdered and whitewashed crocodile'.

As the house declared: 'The merry-go-round of Parisian fashion might continue to turn, but its love affair with and ultimate commitment to craftsmanship remains timeless...'

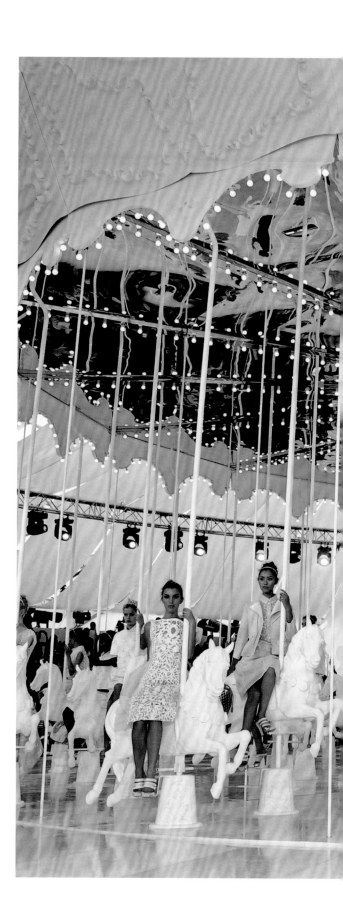

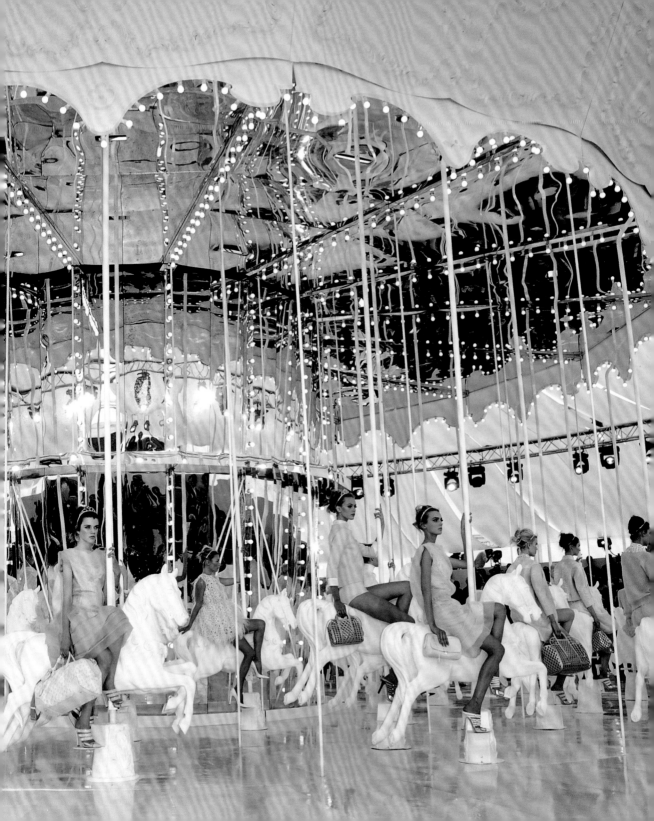

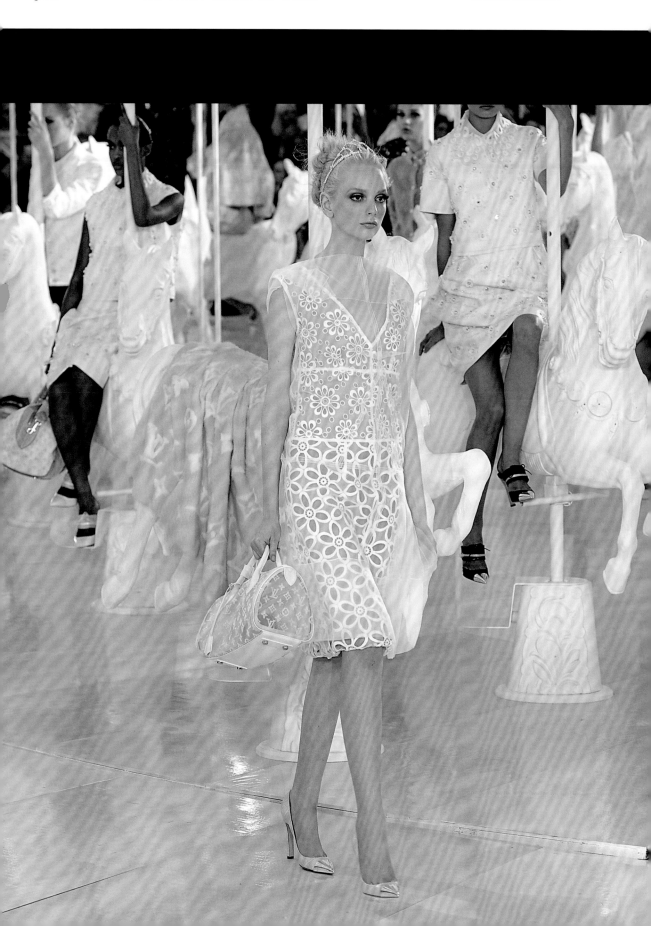

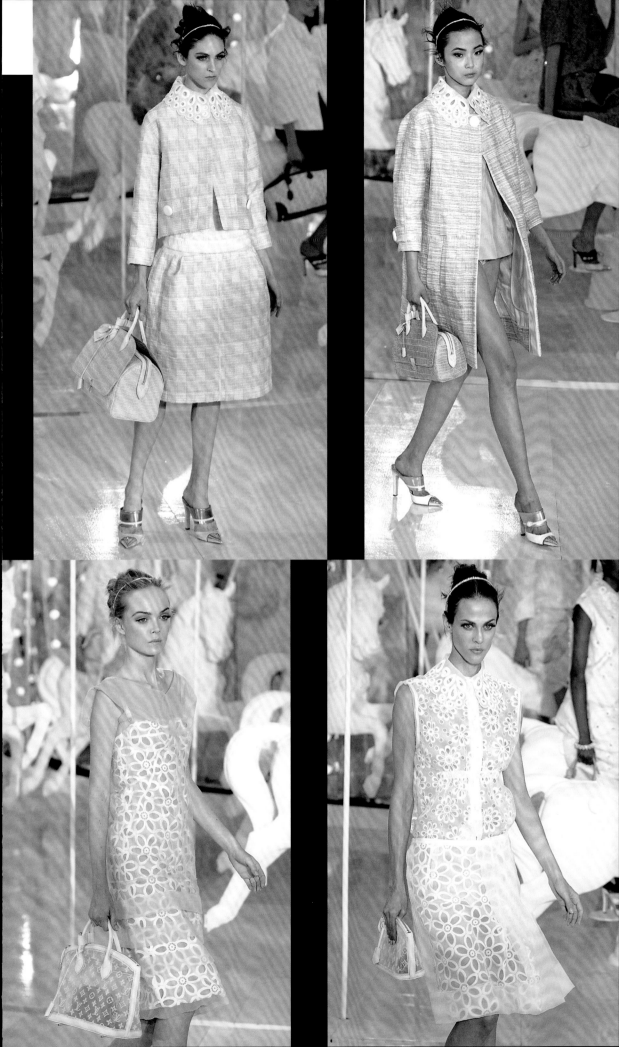

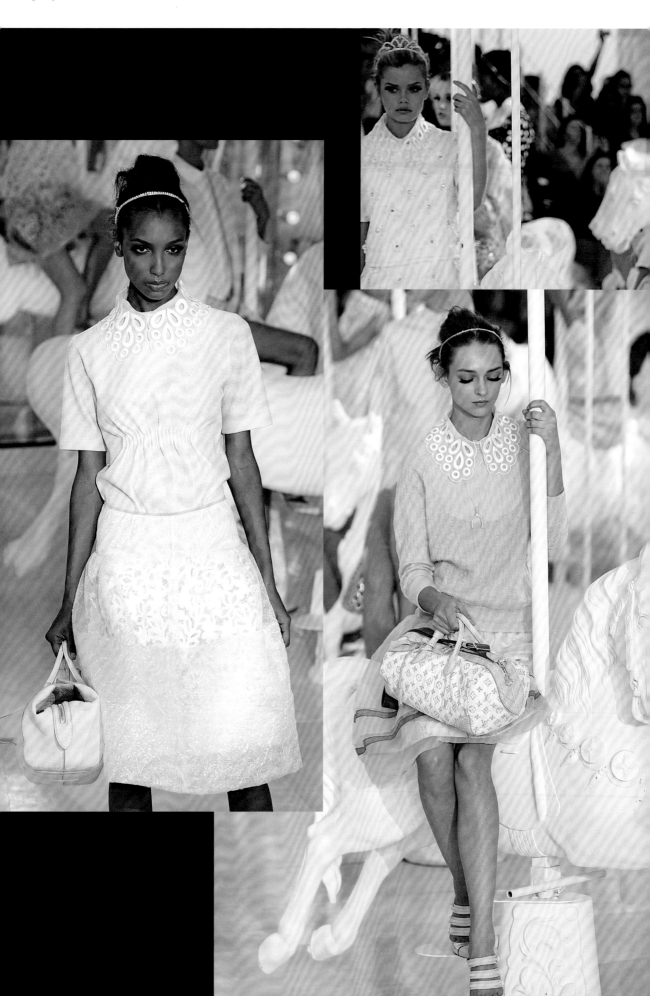

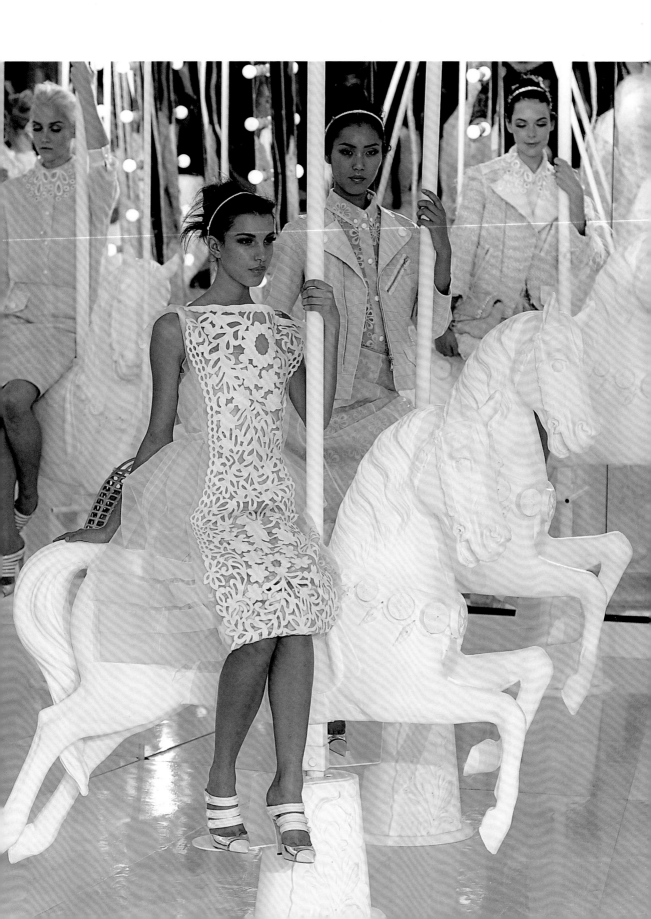

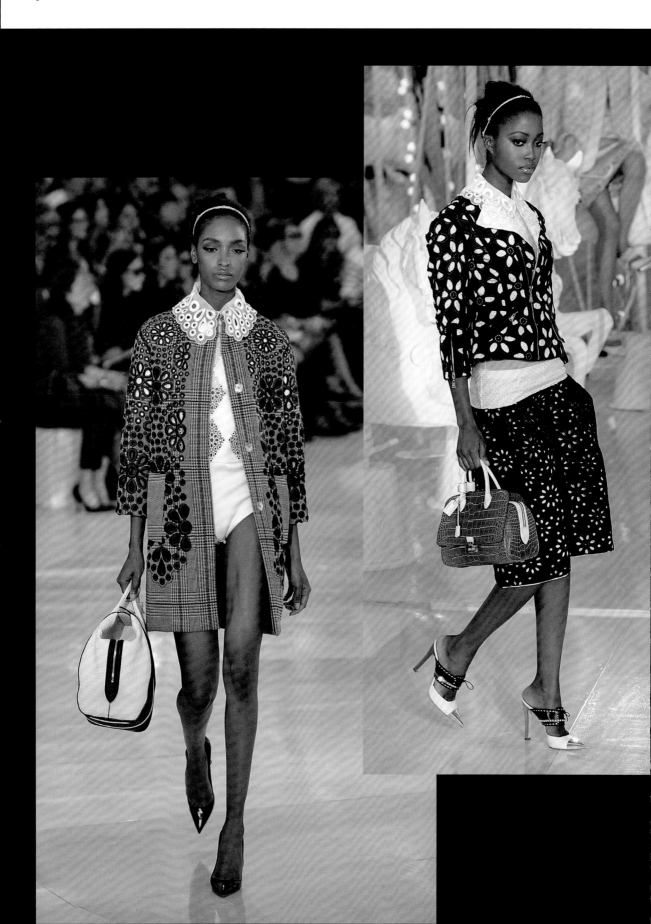

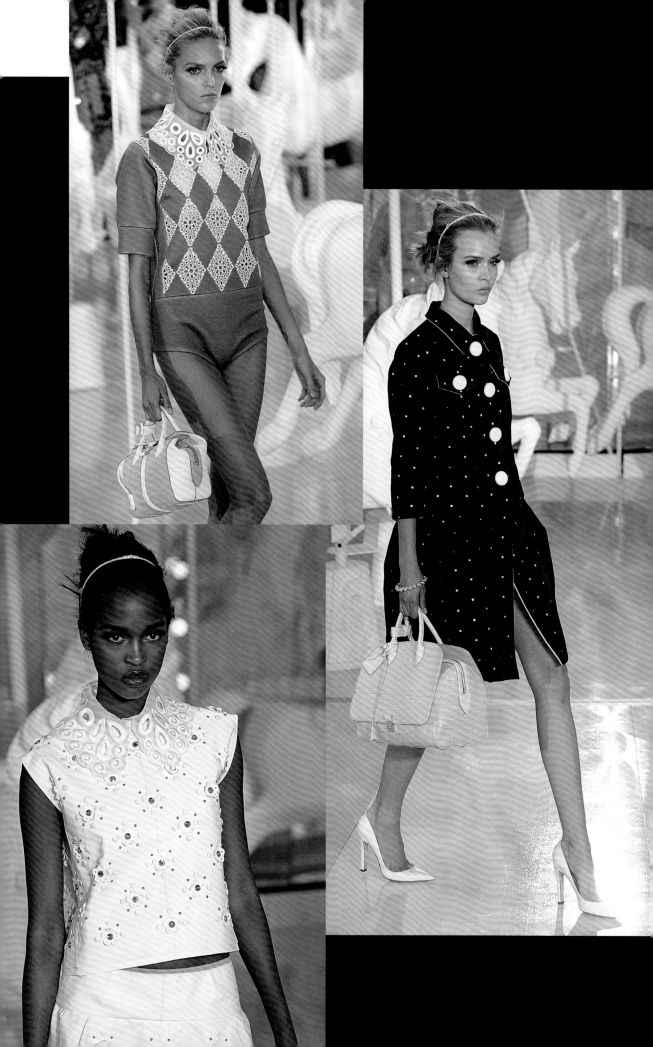

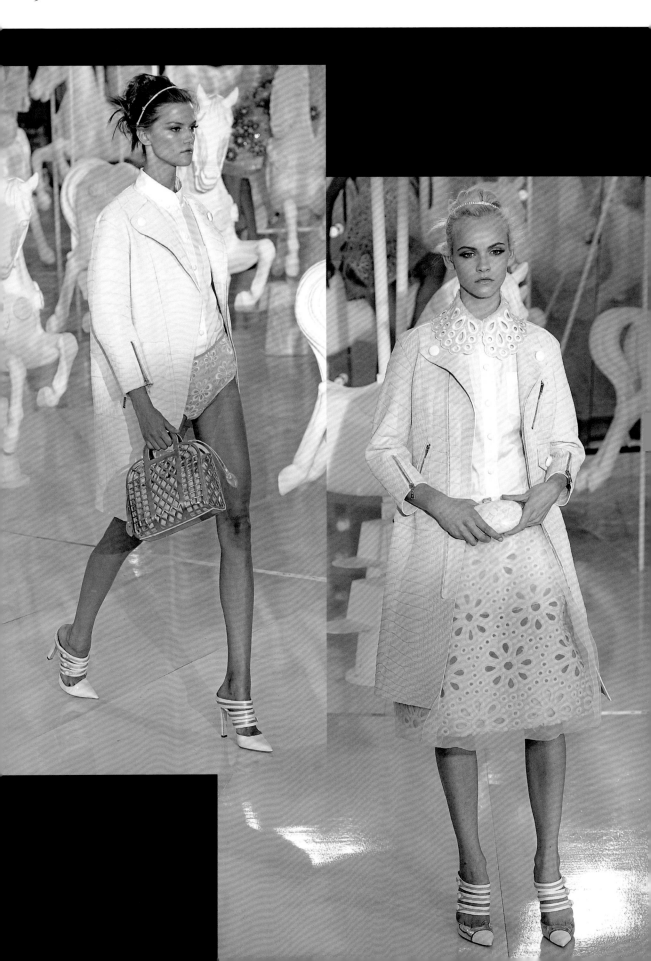

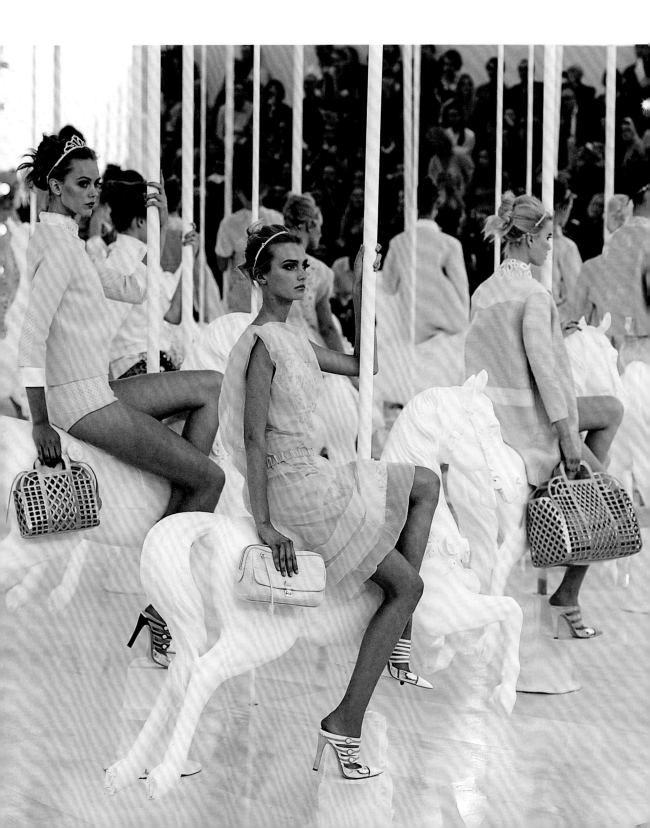

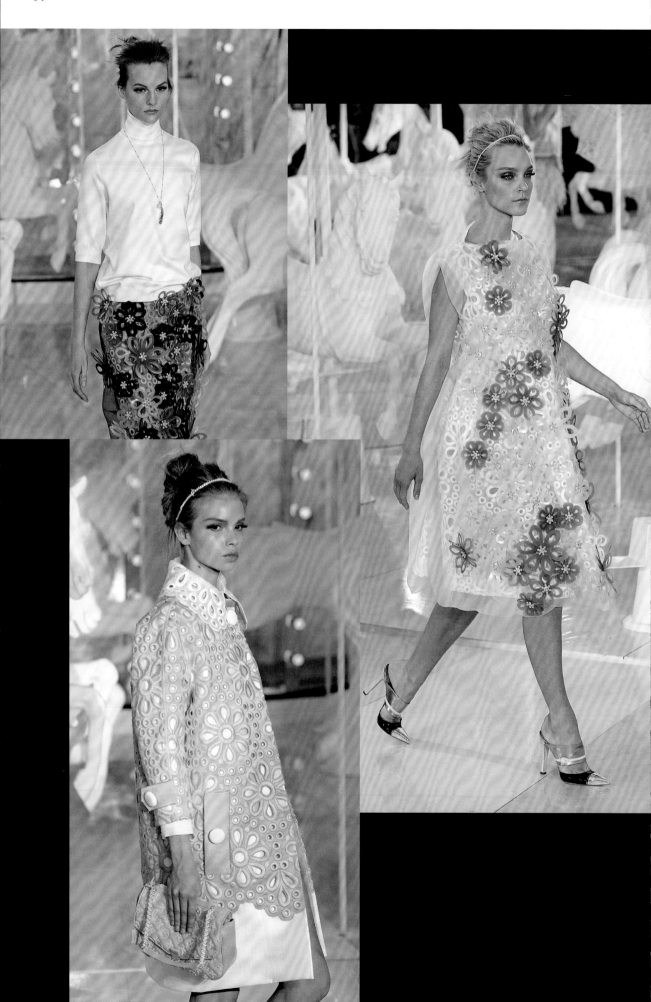

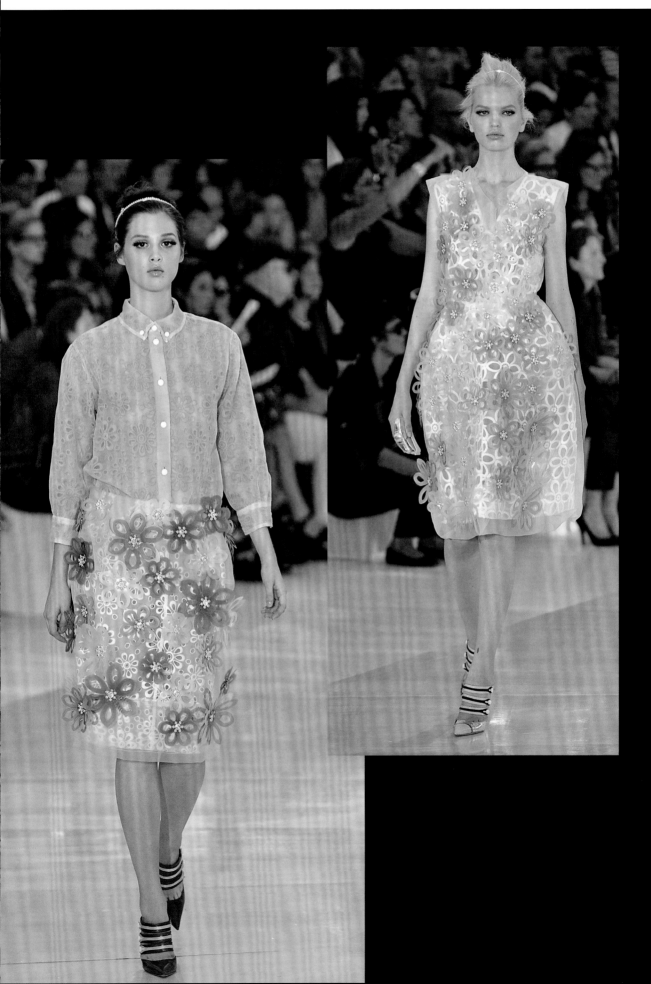

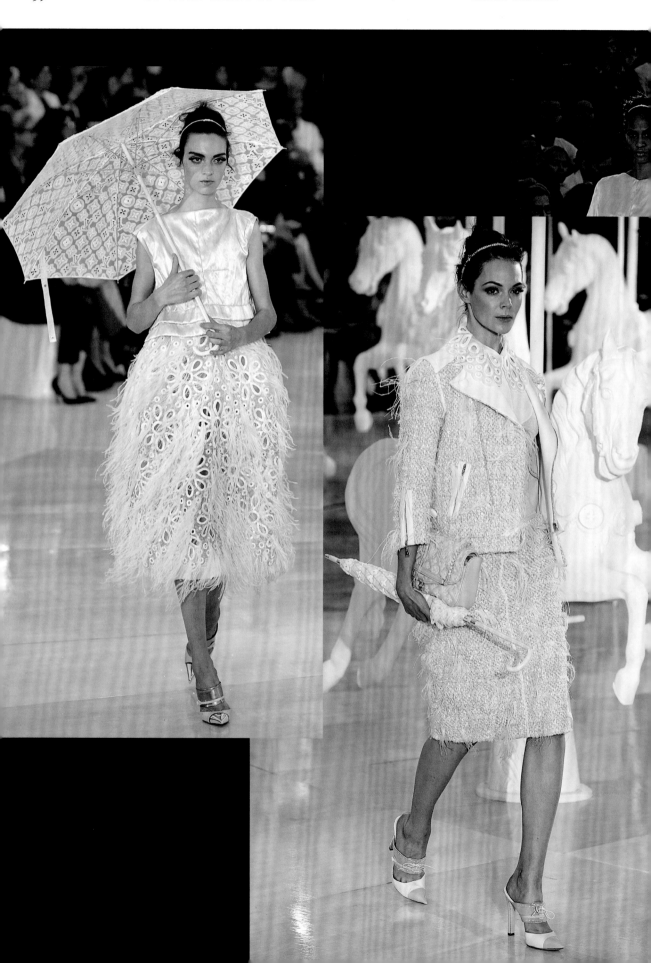

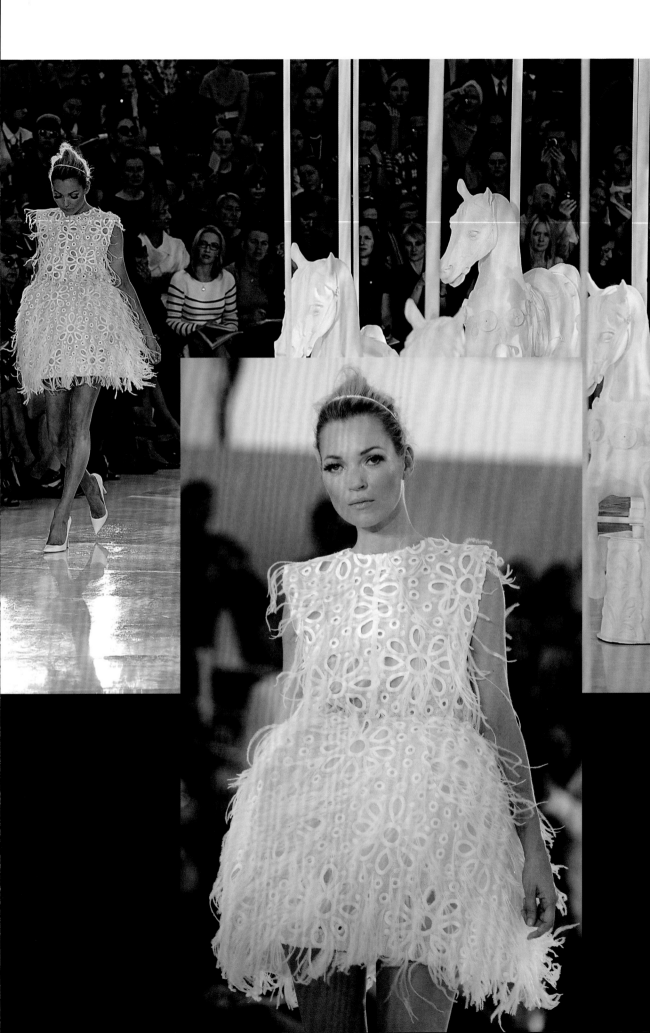

All Aboard the Louis Vuitton Express

'Descending from his fairground carousel, Marc Jacobs boards the train of high fantasy and imagination,' stated the house about the autumn/winter 2012 collection. 'Through clouds of vapor, a gleaming locomotive appears, with luxurious cars displaying the Louis Vuitton initials – and forty-seven passengers with an unparalleled, never-before-seen glamour disembark.' Uniformed porters followed, carrying the models' Monogram- and Damier-printed suitcases (modern versions of the 1901 Steamer trunk), hat boxes and handbags, referencing the heritage of the house and a golden age of exploration.

'The whole collection started with the idea for the train. From there we thought about what bags the woman would have on the train, what she would be wearing, where she would be going,' said Jacobs. Chief executive Yves Carcelle, who had recently reported a yearly revenue of £5.42bn for the house, said, 'There is always an inspiration of travel at Vuitton.' Celebrating 15 years at the house, Jacobs agreed: 'Louis Vuitton is obsessed with the art of packing clothes and knowing how best to look after our most treasured possessions. Recreating this theme of travel and going somewhere seemed very romantic and appropriate.'

Luggage was indeed the main focus of the collection, which was shown the day before the opening of the exhibition 'Louis Vuitton – Marc Jacobs' at the Musée des Arts Décoratifs. Curator Pamela Golbin noted: 'The exhibition was a way to speak about two moments in fashion history which are crucial. With Louis it was about industrialization and with Marc it's about globalization.'

The season's wardrobe had 'a turn of the century feel, but with bits of the 60s and 70s', according to Jacobs. The opening look was a camel-coloured A-line coat with daisy buttons, worn over a matching two-piece skirt and trousers, styled with an oversized cloche hat with feather and horsehair trim (opposite). Linking clothes and luggage, the Damier pattern came in an array of constructions, from patchwork leather dresses (pp. 396, 397) to an abstract marble-printed two-piece suit with flared trousers (p. 400), brocade dress (p. 404, right), and tweed and sequinned dress (p. 406).

The atelier embellished the collection using a complex process of laser-cut holographic swatches bonded onto jacquard and brocade (pp. 402, 403, 404, left). Limited-edition accessories included the Goat Hair Transsiberian bag (p. 398, top right). The elongated silhouette was complemented by a sensual earth-coloured palette of dark brown, green, charcoal, mauve and blue.

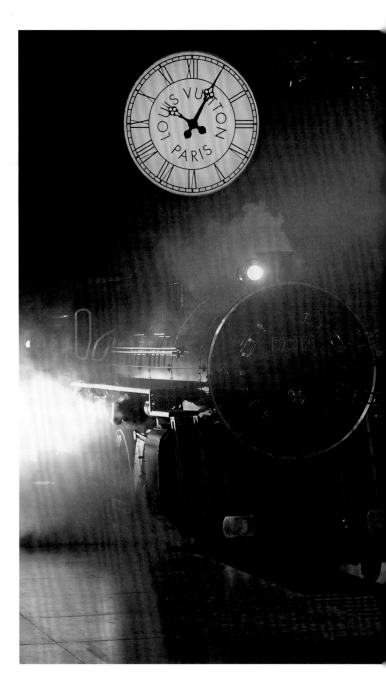

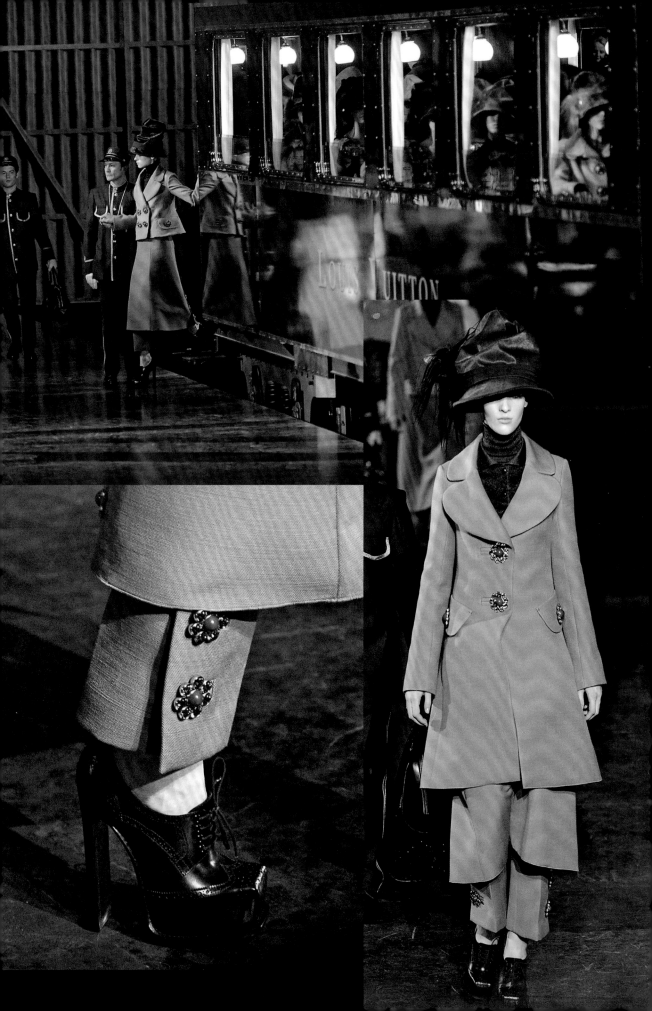

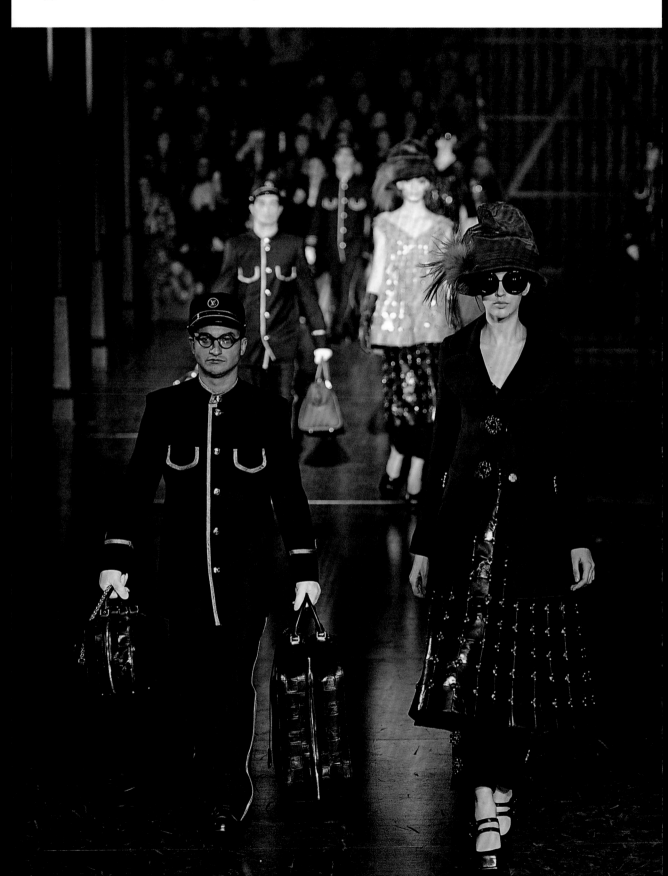

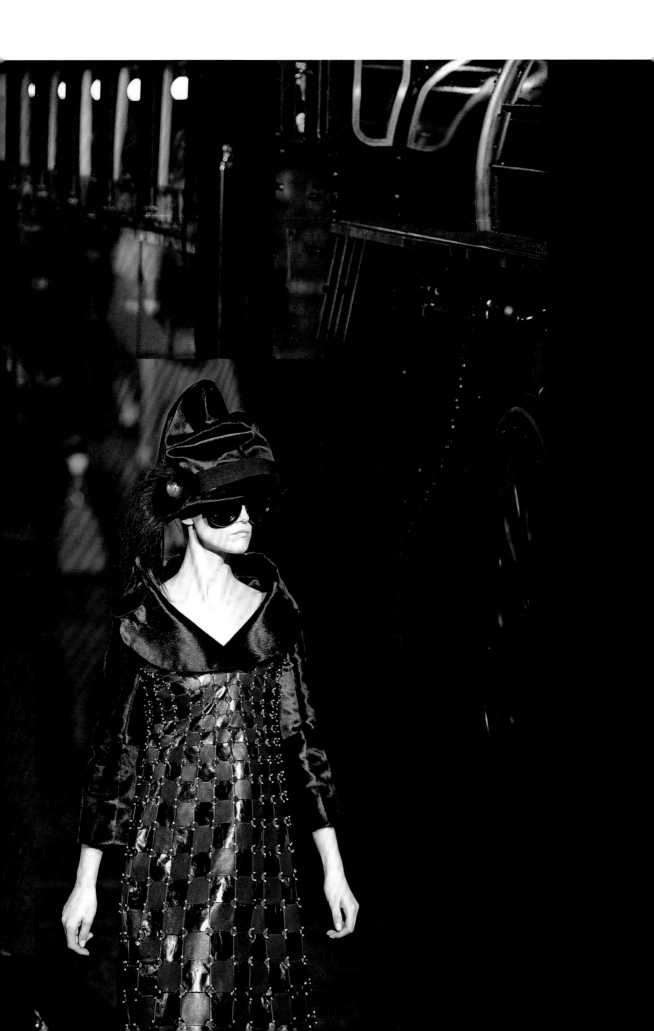

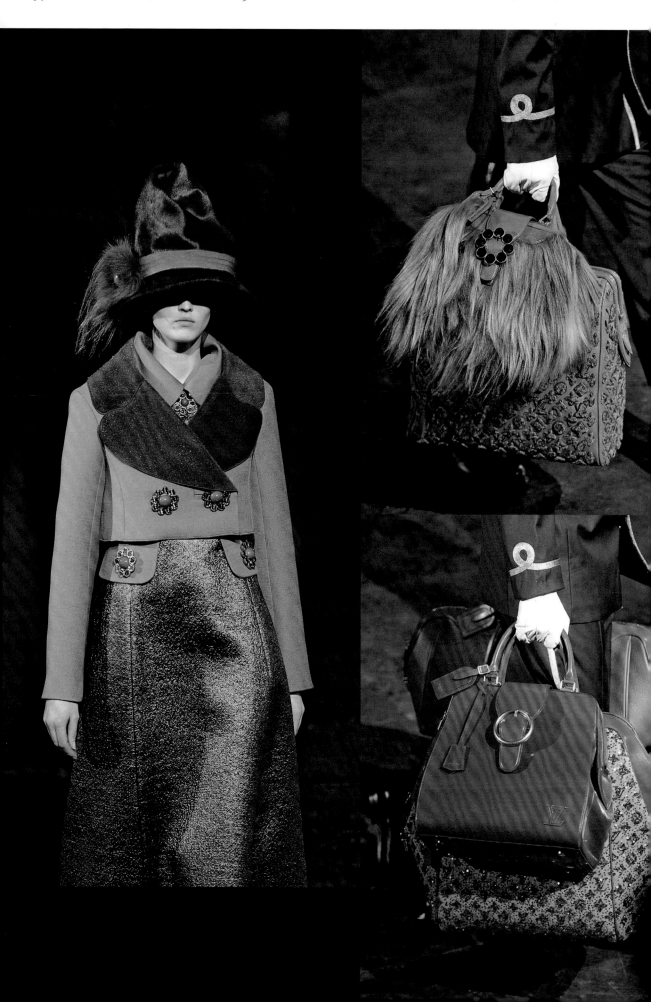

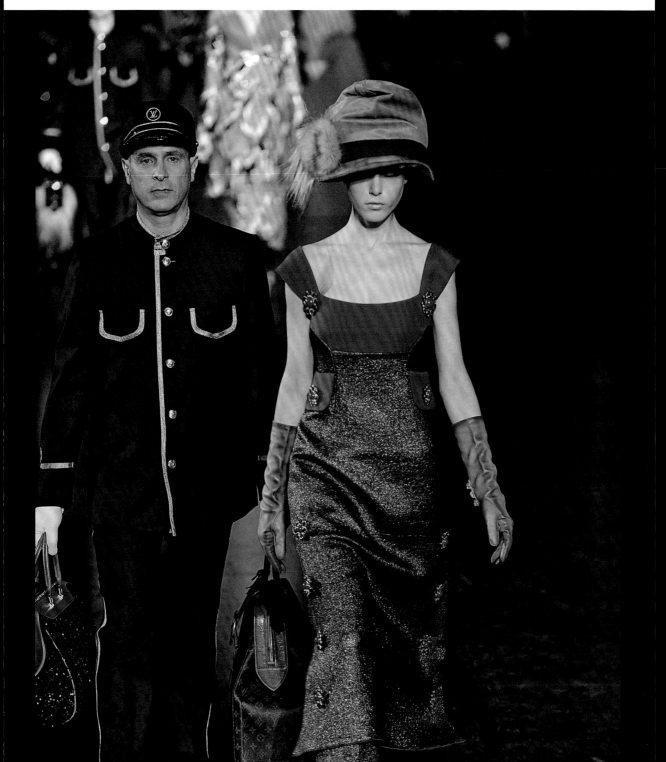

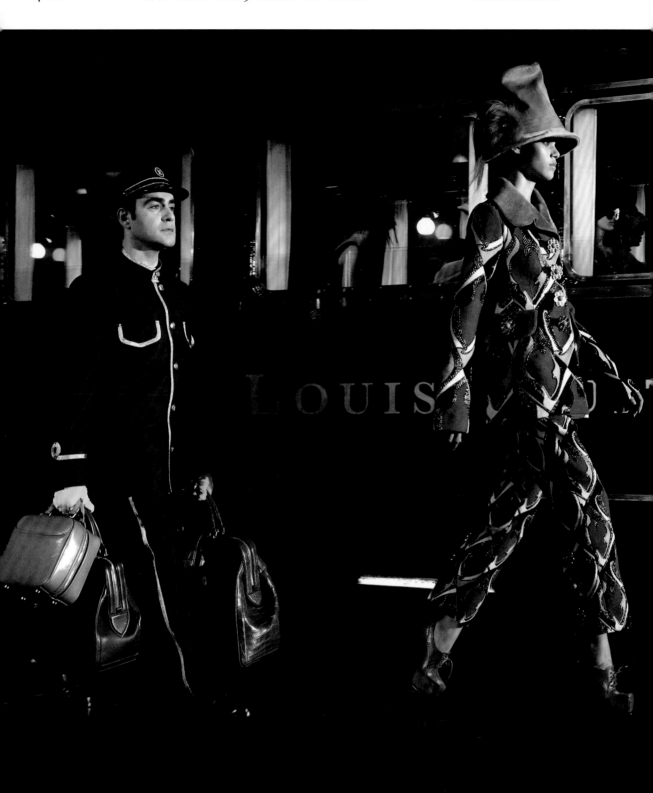

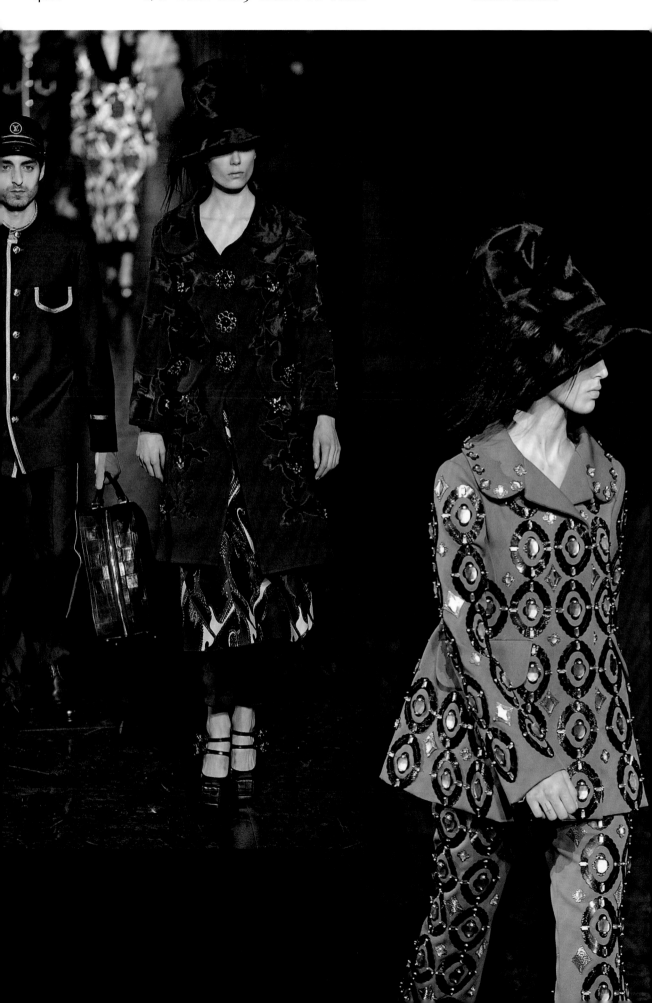

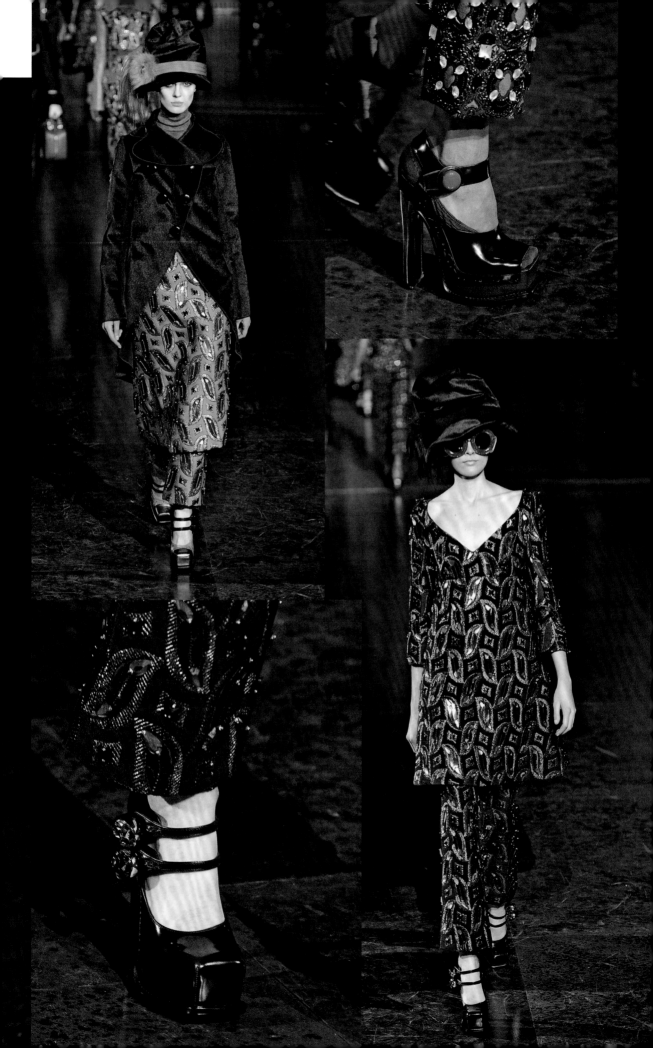

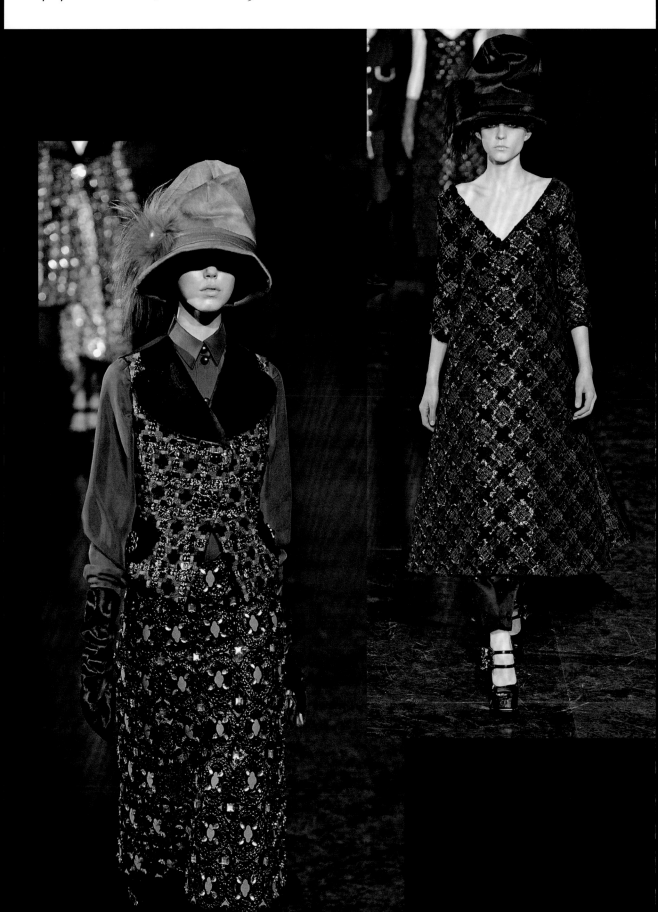

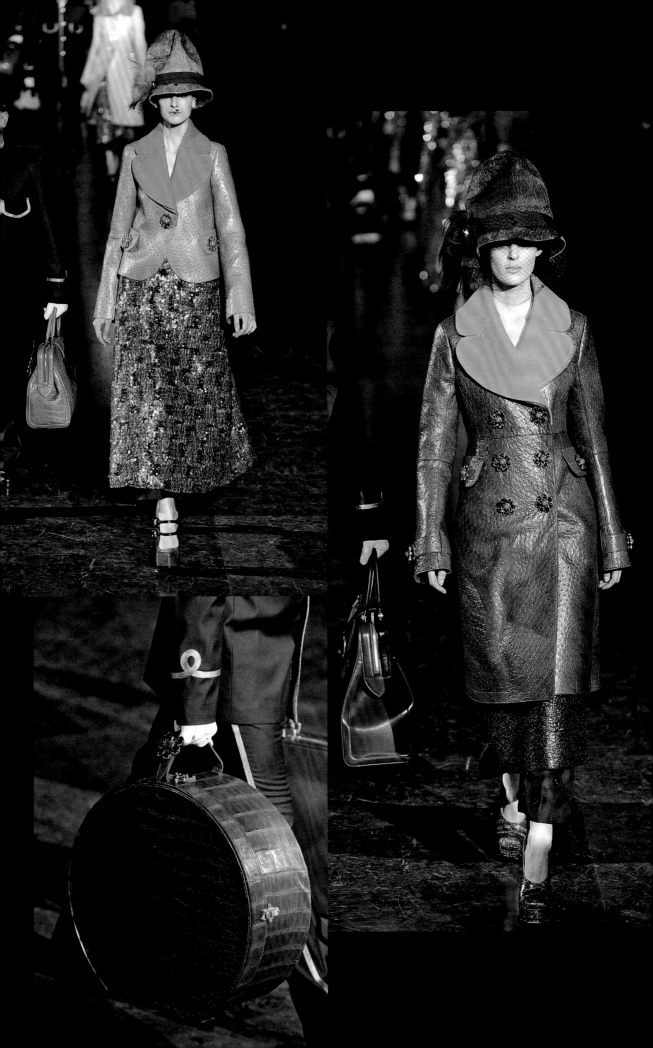

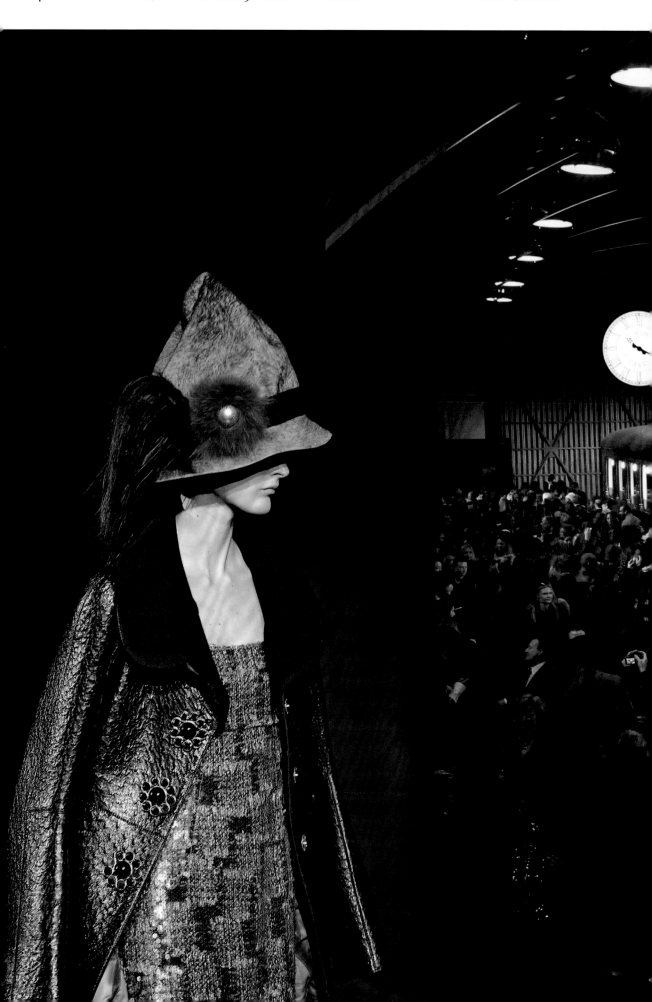

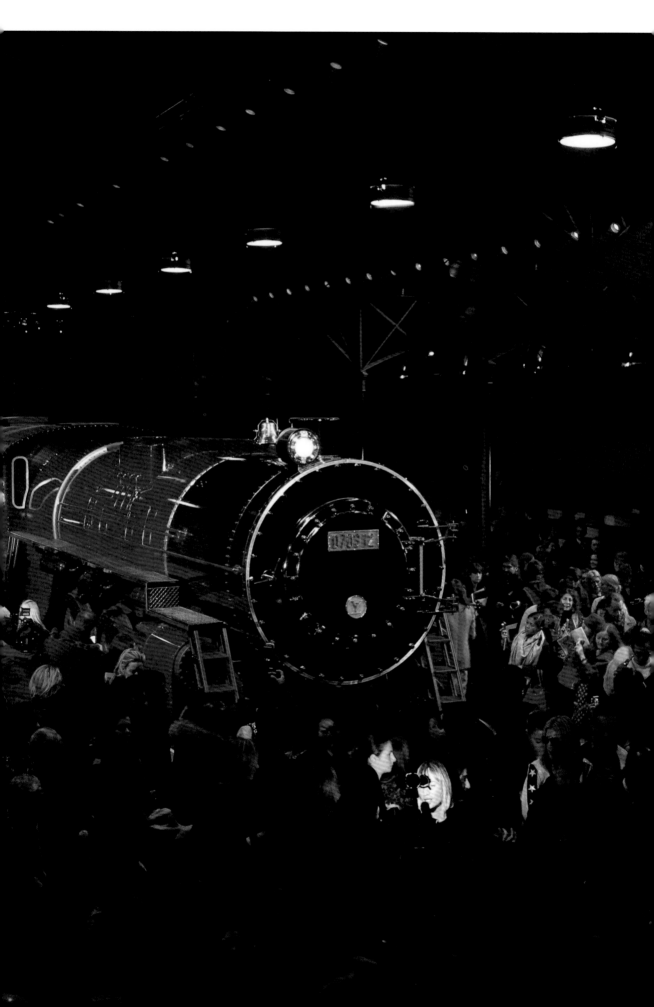

Checkers with Daniel Buren

'After the romance of the train and storytelling ...
I was like, yeah, let's have a grid,' said Marc Jacobs.
'This felt like something very powerful without
telling a story.' His twin inspirations were the house's
124-year-old Damier pattern and the work of French
conceptual artist Daniel Buren with its signature
stripes. As the house stated, this show was all about
'Art Couture'.

To the soundtrack of Philip Glass's opera *Einstein
on the Beach*, the 64 models arrived in pairs, wearing
complementary looks and descending onto the
chequered catwalk from four escalators. 'They're
a moving pattern, a rhythm, it's a mathematical
equation... I just liked graphic patterns, the colour
with light,' explained Jacobs, who collaborated with
Buren on the set. Reflective surfaces emphasized
the 'check overload'.

'[Buren's] work is very graphic with the use of grids,
and so I took inspiration from his sculptures and
installations,' explained Jacobs, citing *Les Deux Plateaux*
– Buren's grid-arranged installation at Paris's Palais
Royal – as his starting point. Made up of 260 columns
of three different heights, this artwork suggested the
collection's three lengths: mini, midi and maxi.

While some narrow floor-length outfits were created
to make the models into a new 'Buren column', other
mini-skirted ensembles were inspired by 1960s icons
such as Françoise Hardy and Jane Birkin. The 'fresh,
chic and hypnotic' look was styled with beehive
hairstyles, bow headbands, square sunglasses,
and slim square high heels with pointed toes.

Damier squares came in different colours, textures
and scales, including scuba and jacquard fabric in
small, medium, large and X-large Damier. Two models
opened the show wearing a boxy jacket over a maxi-
skirt and a maxi-dress in 'Large Damier' double
gabardine (right).

'Embellishments, for which Louis Vuitton is renowned,
are deployed in ways that are not immediately obvious,'
the house added. 'Small sequins are arranged by the
thousand to create fluid metallic surfaces. "Tuffetage",
a technique taken from carpet-making, is embroidered
on leather to create a flock-like effect.' There were
sequinned tufted nappa Damier leather coats
(see p. 417), sequinned nappa Damier leather ensembles
(p. 416), large flower-printed satin twill skirts (p. 414),
a satin silk/organza silk Damier jumpsuit (p. 418, right)
and hand-embroidered sequin dresses (pp. 422, 423).

Matching bags included the Speedy East/West
(see p. 410, bottom left), Speedy Cube Illusion Fleur
(p. 416), 3-D-flocked Damier Cubic (p. 417), and the
exquisite crystal-glass Enveloppe clutch from the
'Les Extraordinaires' line (p. 423, top right).

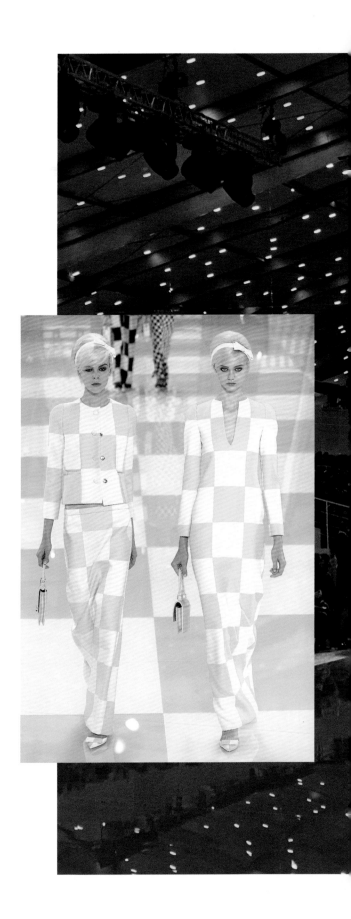

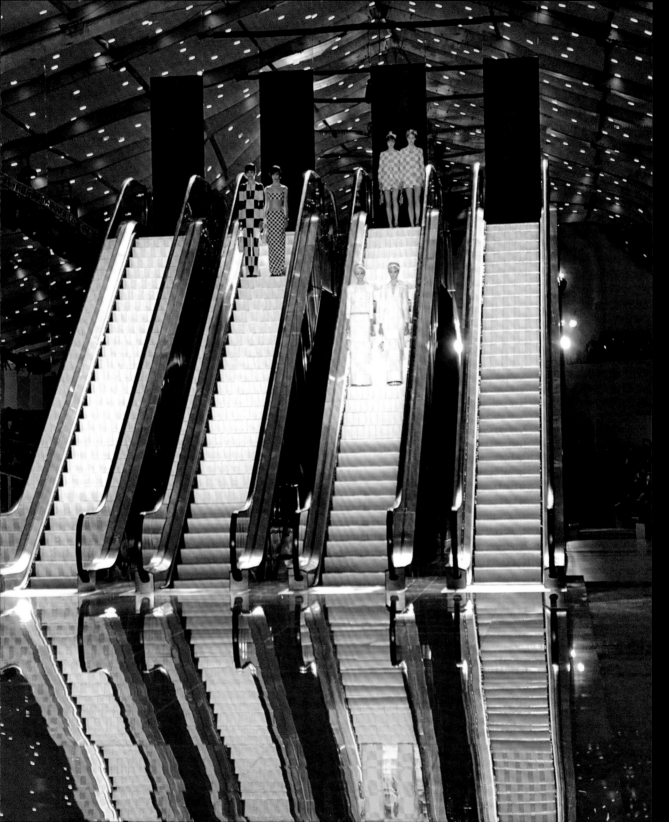

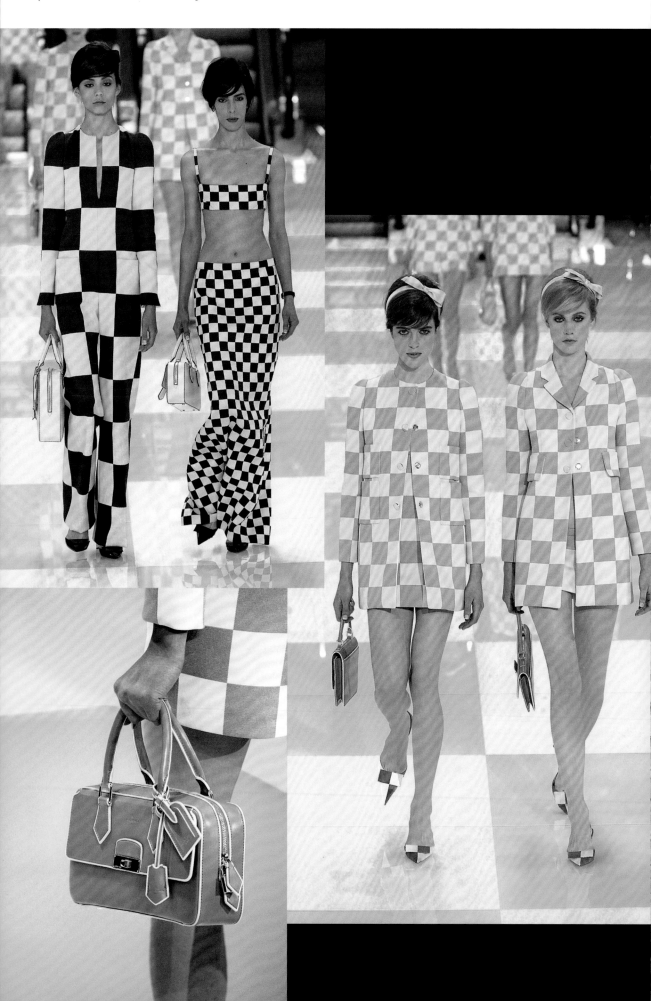

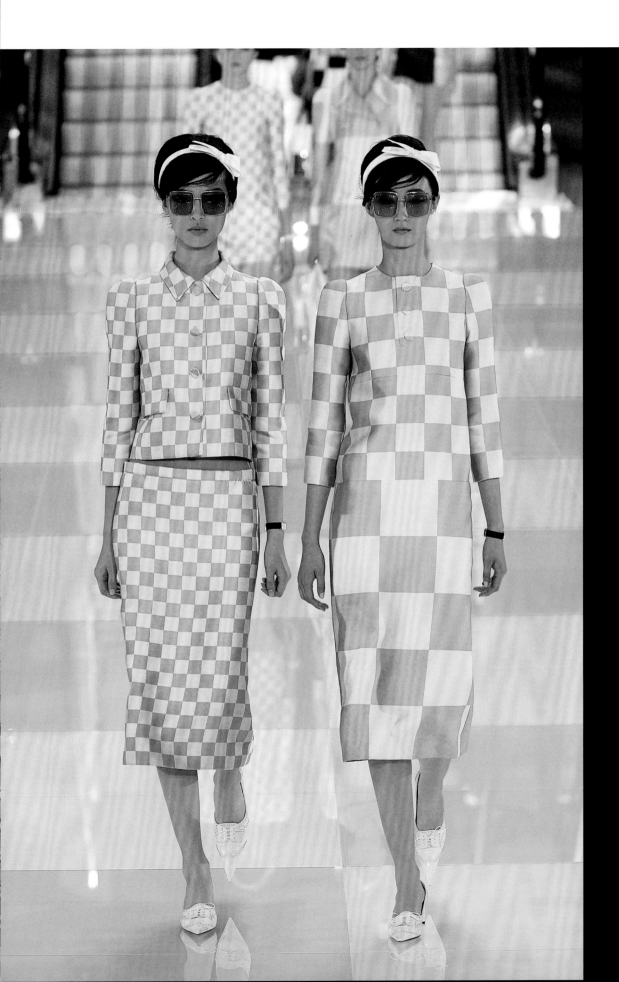

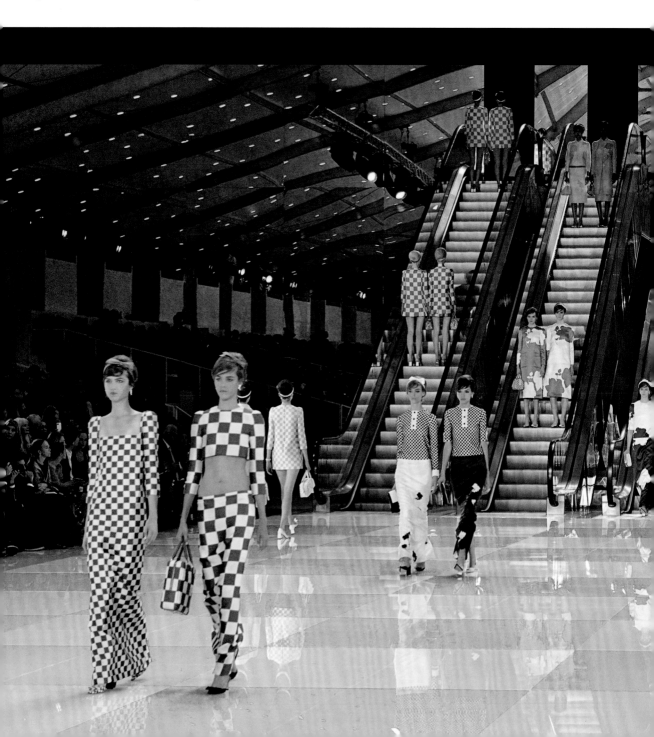

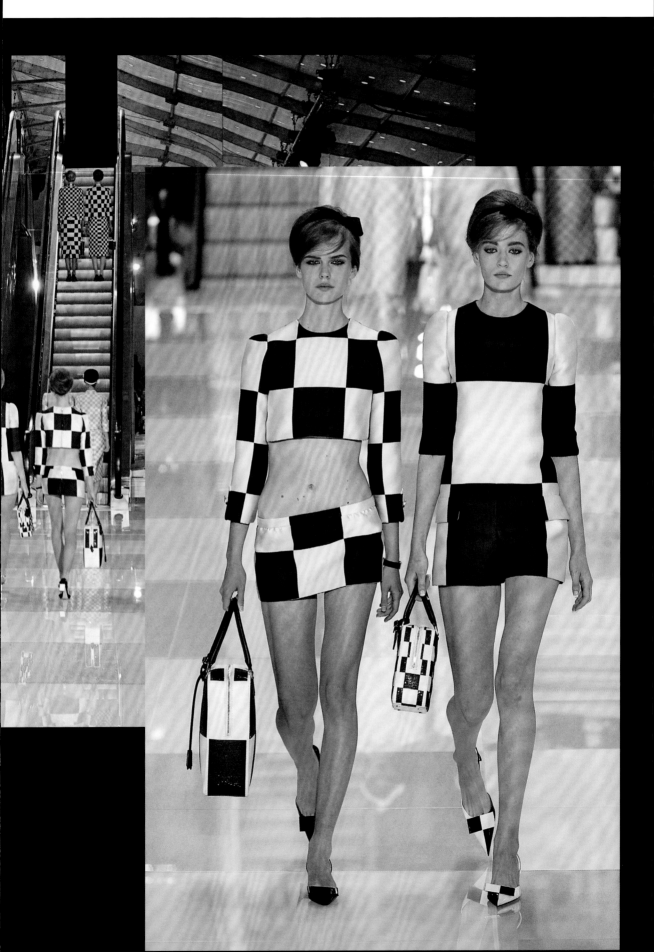

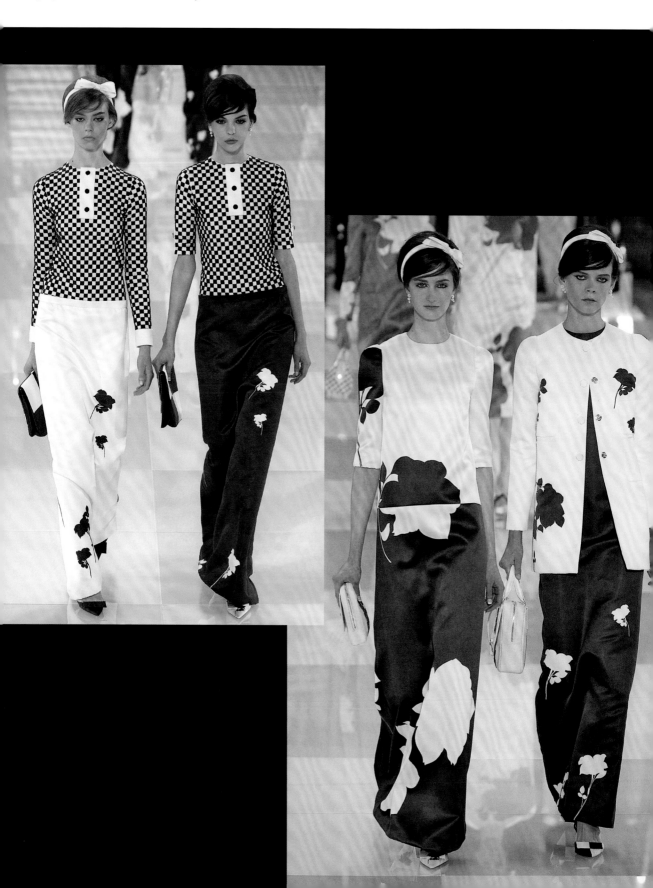

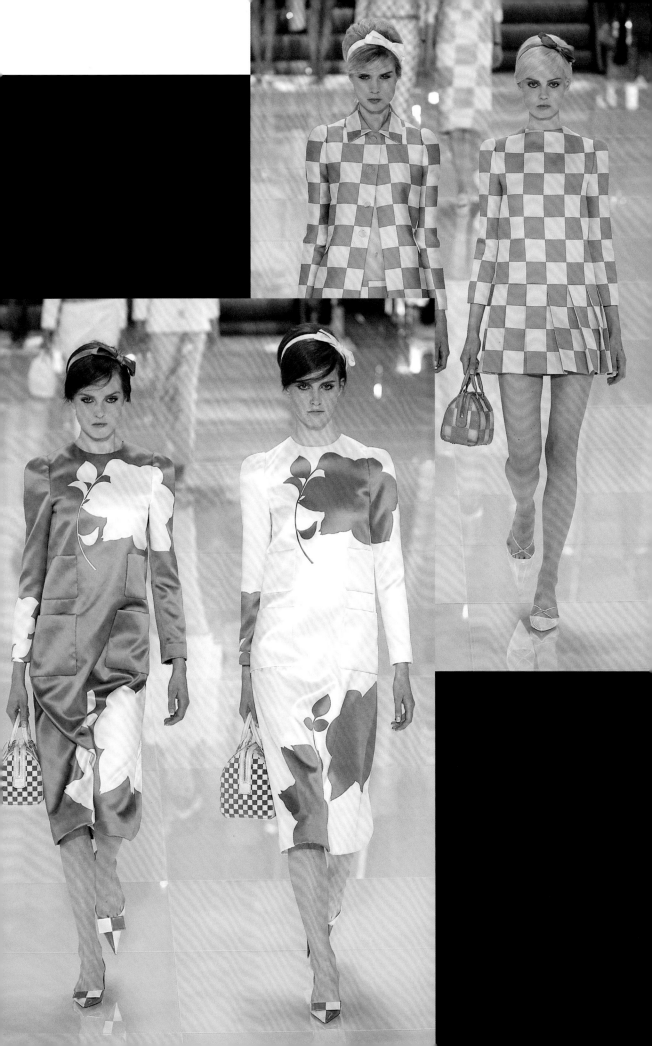

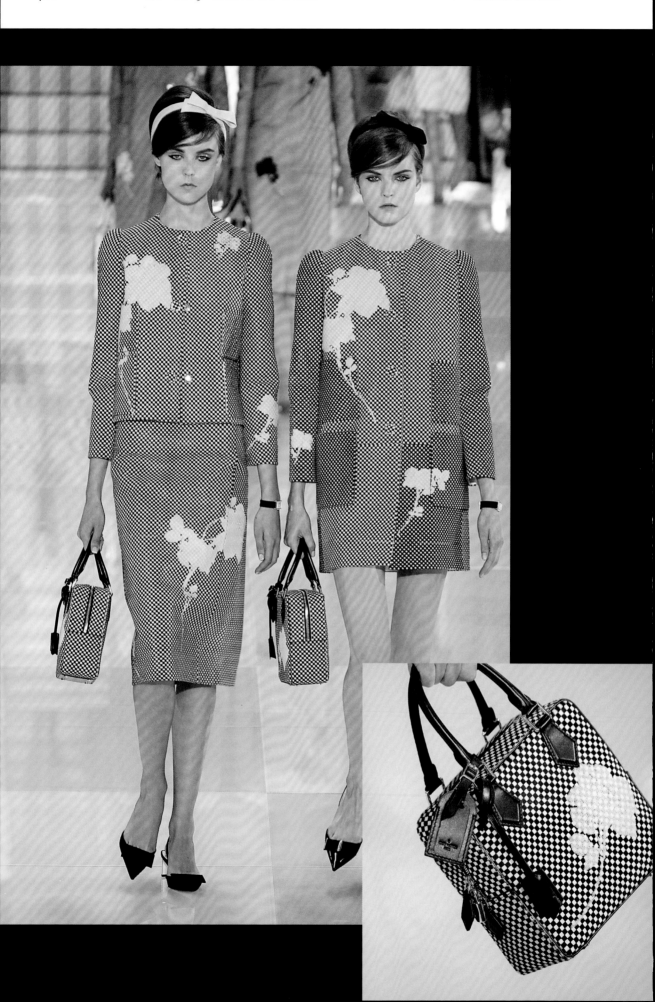

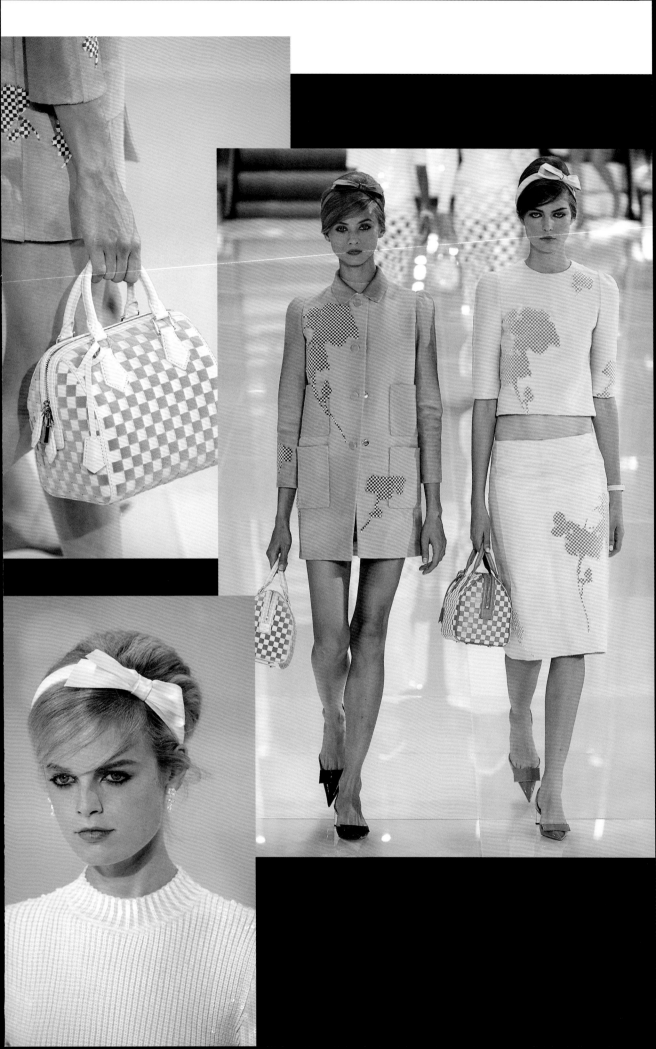

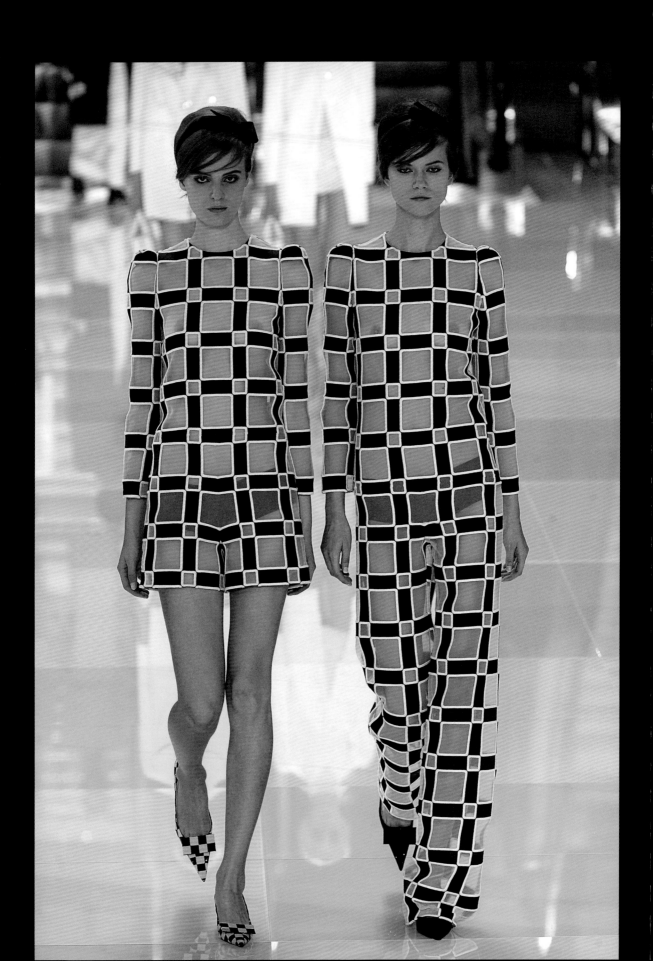

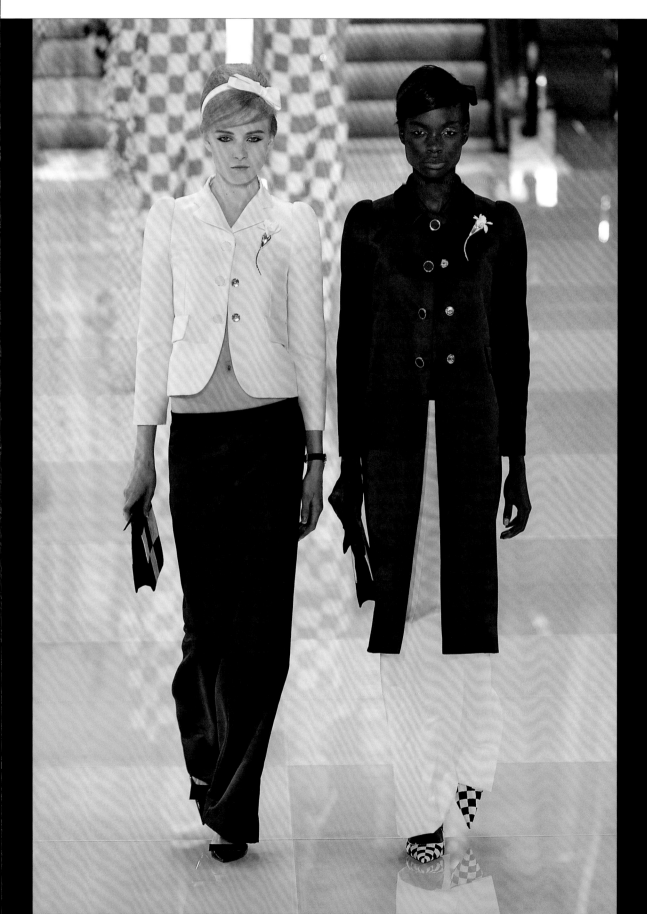

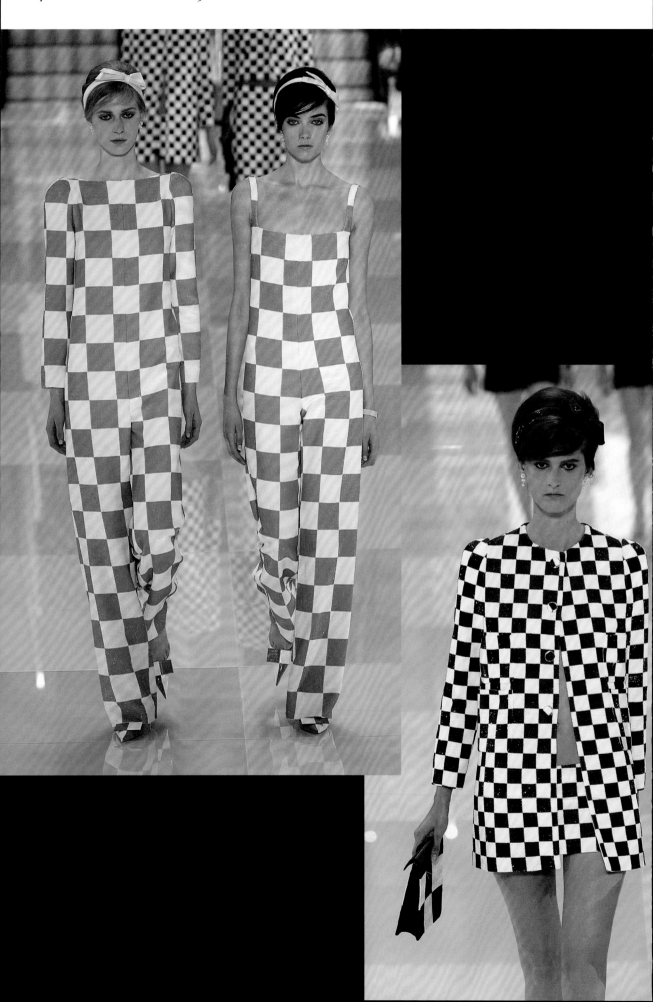

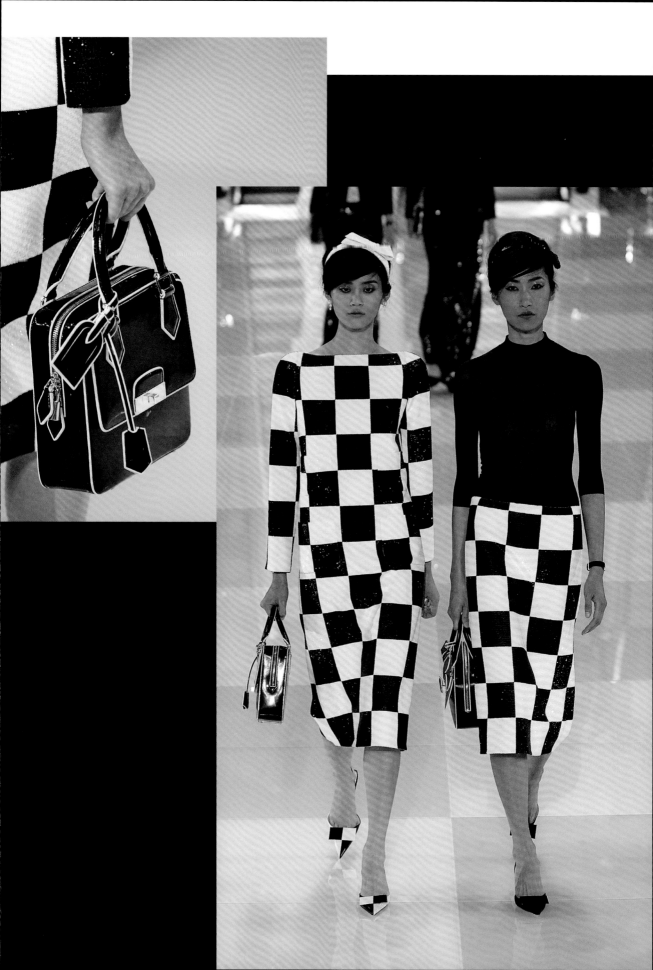

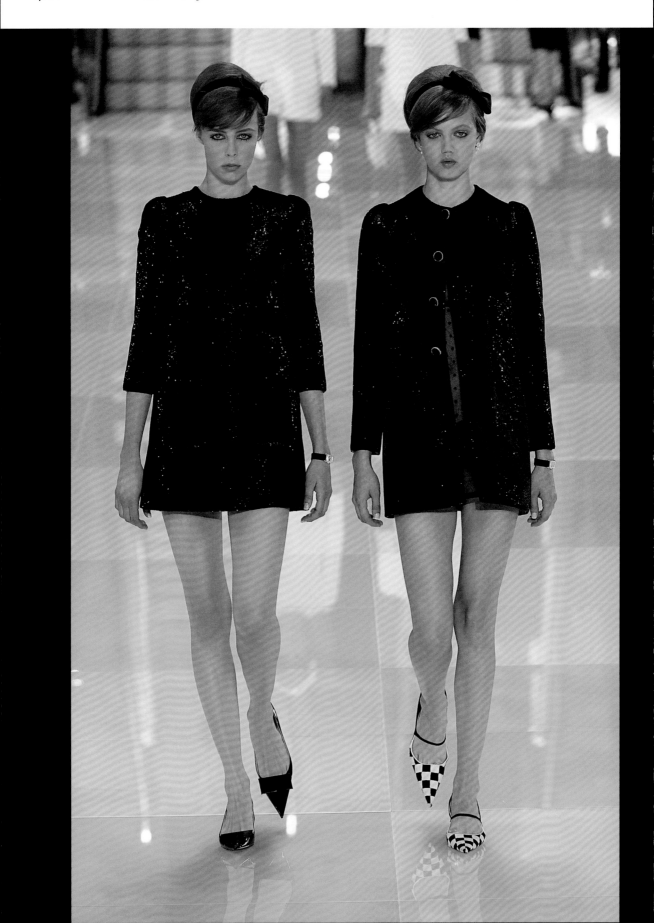

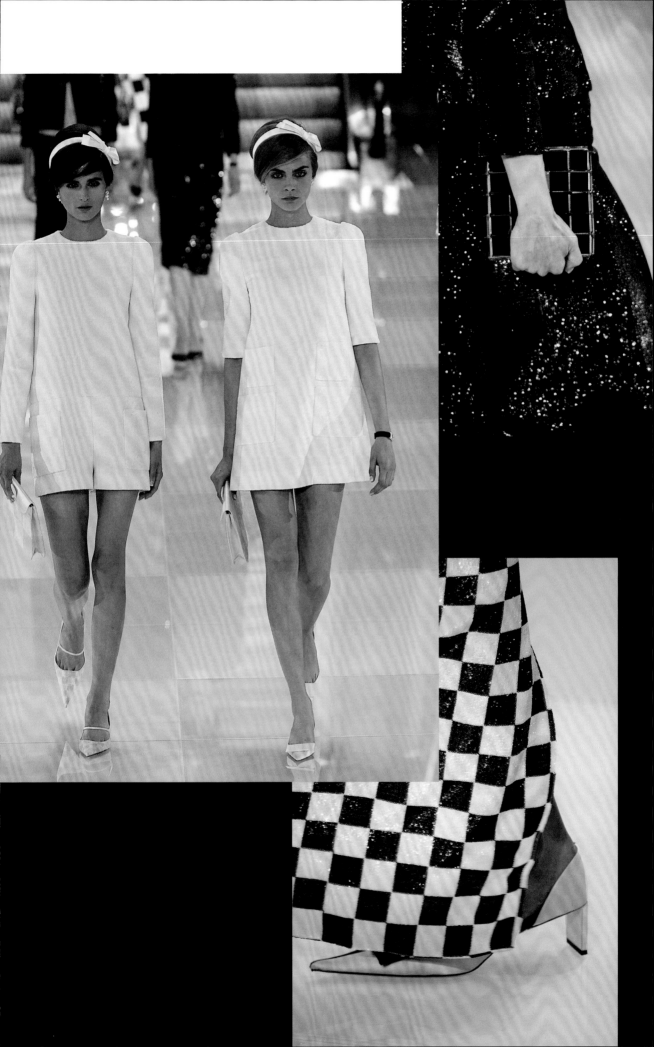

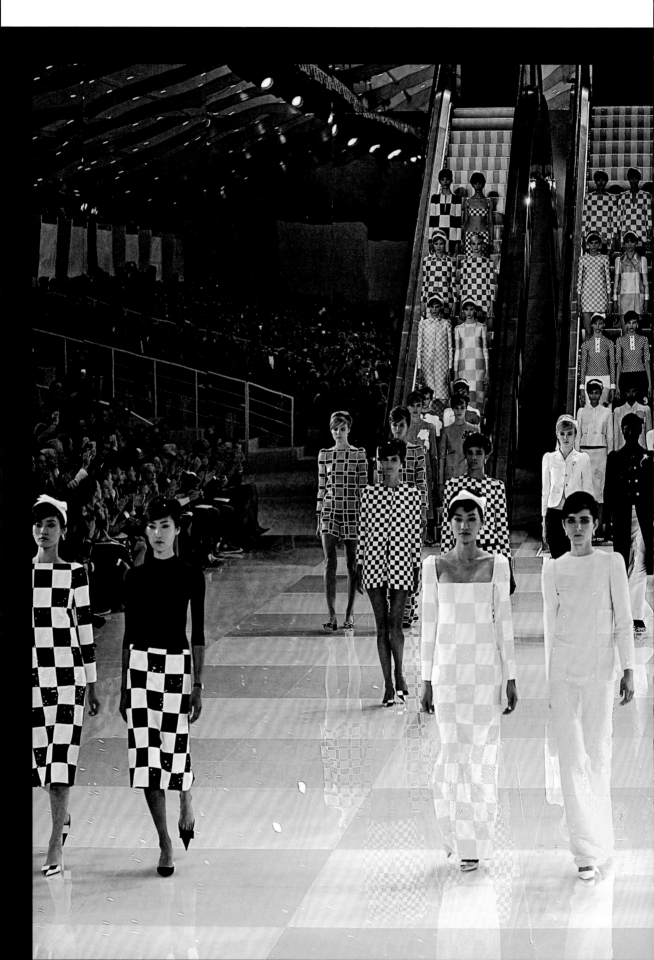

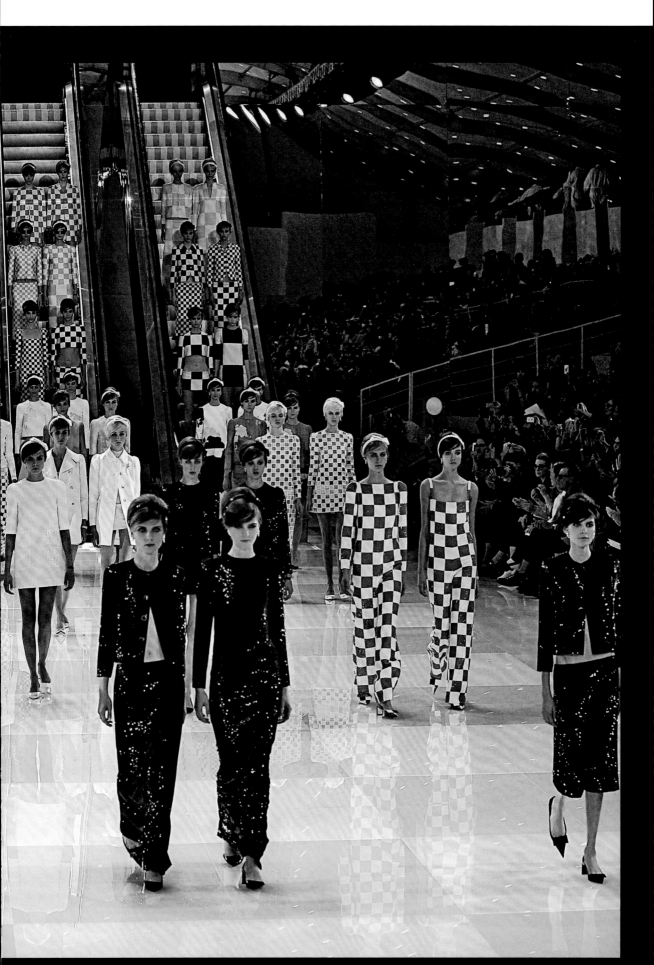

Hotel Room Decadence

This season's travel destination was the corridor of
a grand hotel, reconstructed on a catwalk lined with
50 numbered 'rooms', out of which the black-wigged
models 'emerged in varying states of dress and
undress', *Vogue* reported. Marc Jacobs explained that
the collection was about 'a woman who gets dressed
up, but then decides she'd rather stay in her hotel
room. There's a certain decadence to that. I had in
mind certain friends of mine, who walked in the
show but shall remain nameless, with whom I've
spent many, many nights getting dressed up in
hotel rooms.'

Suzy Menkes called the collection 'an exercise in
the erotic', and compared the unfolding of the show
to a silent movie, noting too that the romantic
sensuality was reminiscent of early Galliano. 'That
particular hard romance lived on in the Louis Vuitton
sheath that went from bra top through tweed body
to lace hem.'

The collection was presented in shades of grey, blue,
maroon, lilac and green. With references including
Gloria Swanson in *Sunset Boulevard*, there was a touch
of the 'robe de chambre'. The show notes stated that
the 'strength of [this collection's] appeal lies not in
a graphic or logo but in the seduction of the surface
treatments. Fabrics and structures derived from
menswear have been rendered more feminine through
their fabrication. From marabou linings to feather
embroidery to dégradé effects, the embellishments
are decadent indulgences redolent of the boudoir.'

There were belted men's blazers and tweed skirt suits
with sequins at the hem, a broadtail dressing gown
over silk floral pyjamas (p. 429, right), belted clutch
silk coats with marabou feathers, and an array of lace,
silk and velvet chemise dresses, some worn under long
coats. 'The feather panels on the dresses took 60 hours
to embroider, while every feather on every shoe was
added individually,' stylist Katie Grand told *The Times*.
Kate Moss closed the show wearing a revealing tulle
dress with exquisite floral embroideries that
mimicked the wallpaper (p. 435).

The Monogram and Damier were nowhere to be
seen. Instead, Pochette, Lockit and Speedy bags
were presented in 'supple fabrications and softer
constructions to emphasize their more sensuous
and feminine aspects'. 'Even the crocodile bags are
lined in sheared mink,' Jacobs remarked. 'Strength
through sensuality.'

He took his bow, wearing Louis Vuitton silk pyjamas
bearing artist duo Jake and Dinos Chapman's print
of Diana Vreeland's 'garden in hell' décor (p. 435),
for what turned out to be his penultimate collection
for the house.

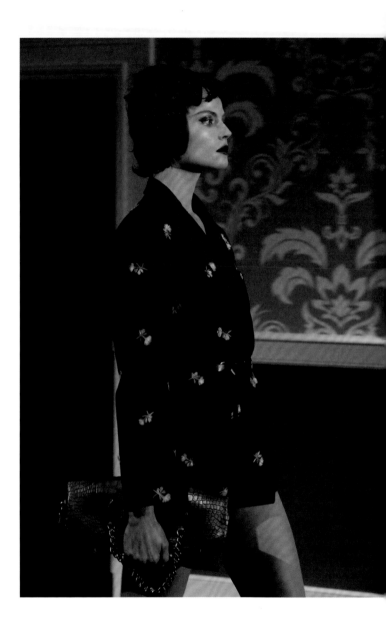

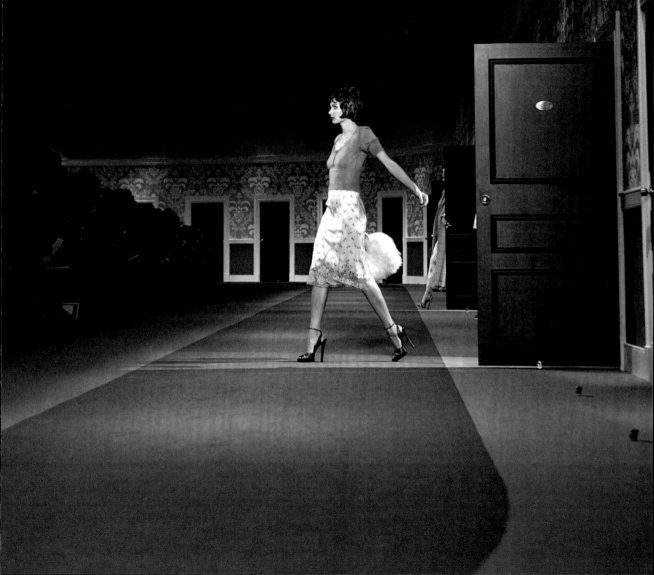

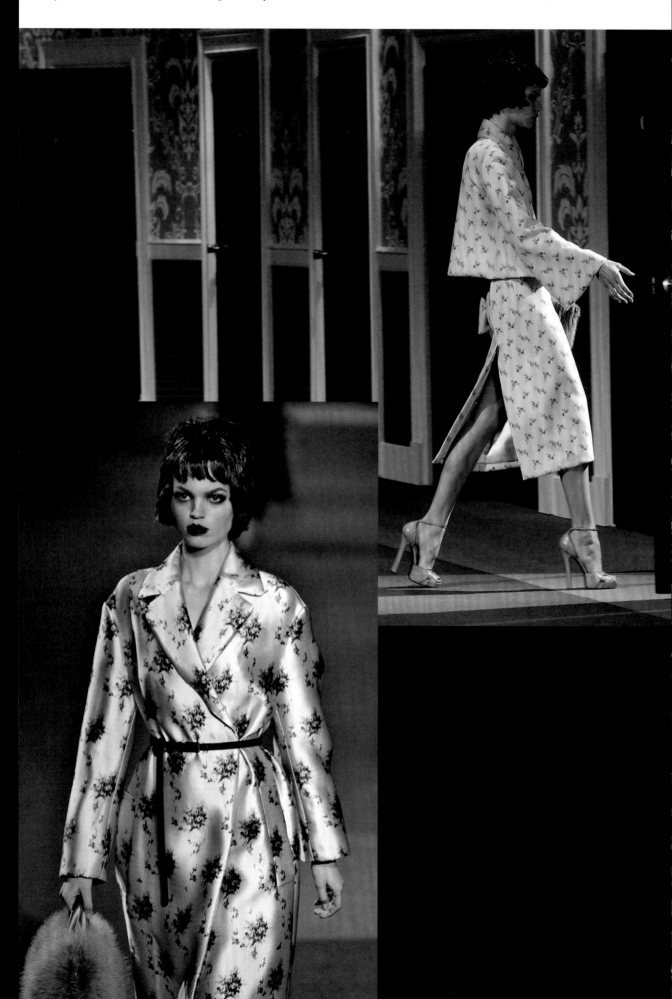

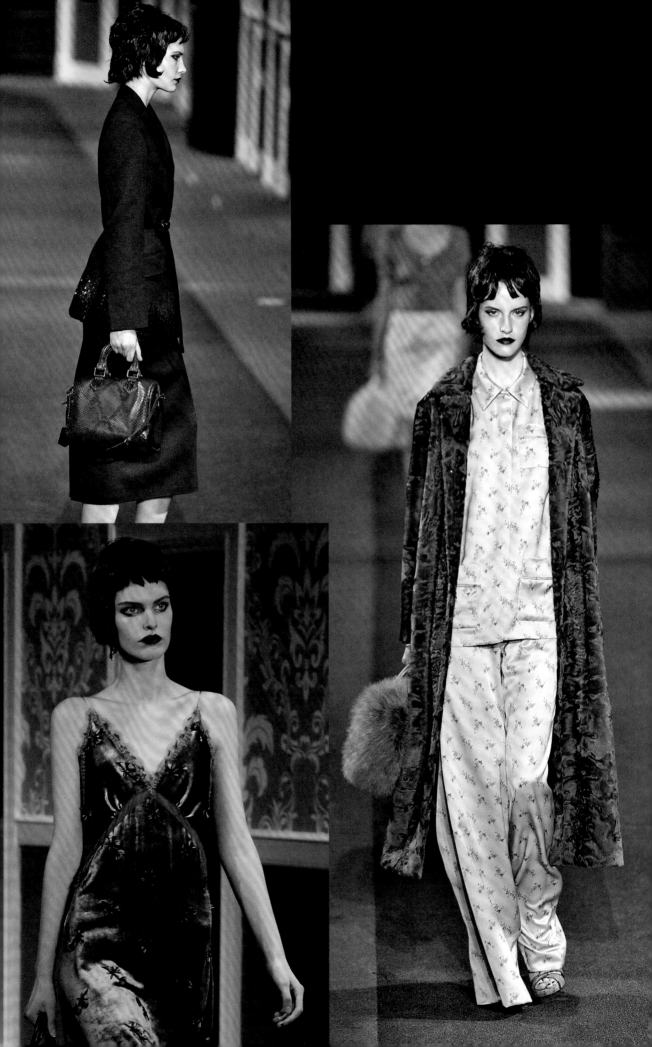

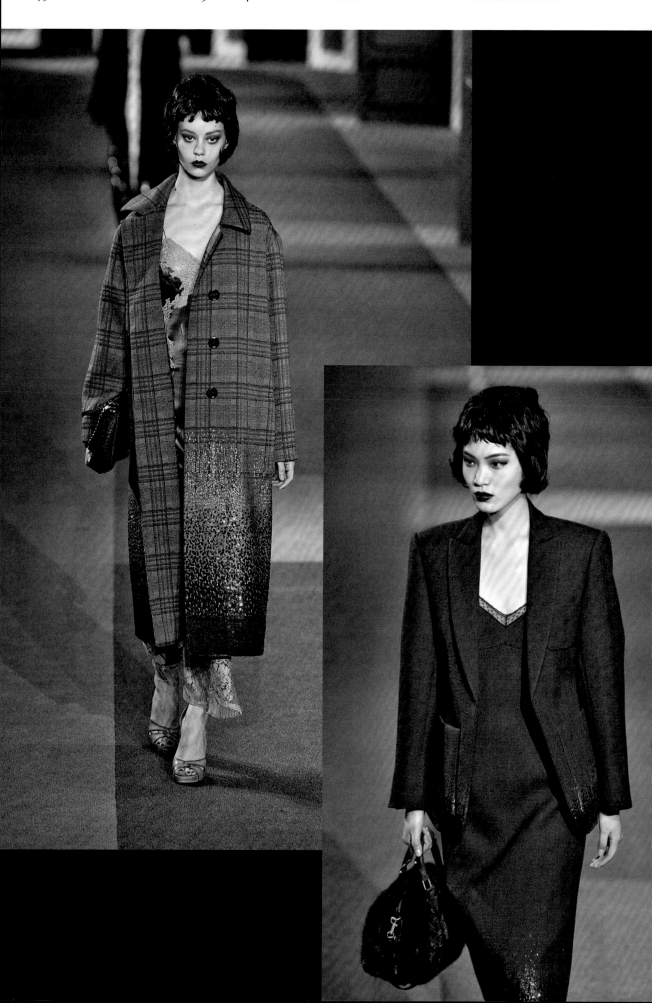

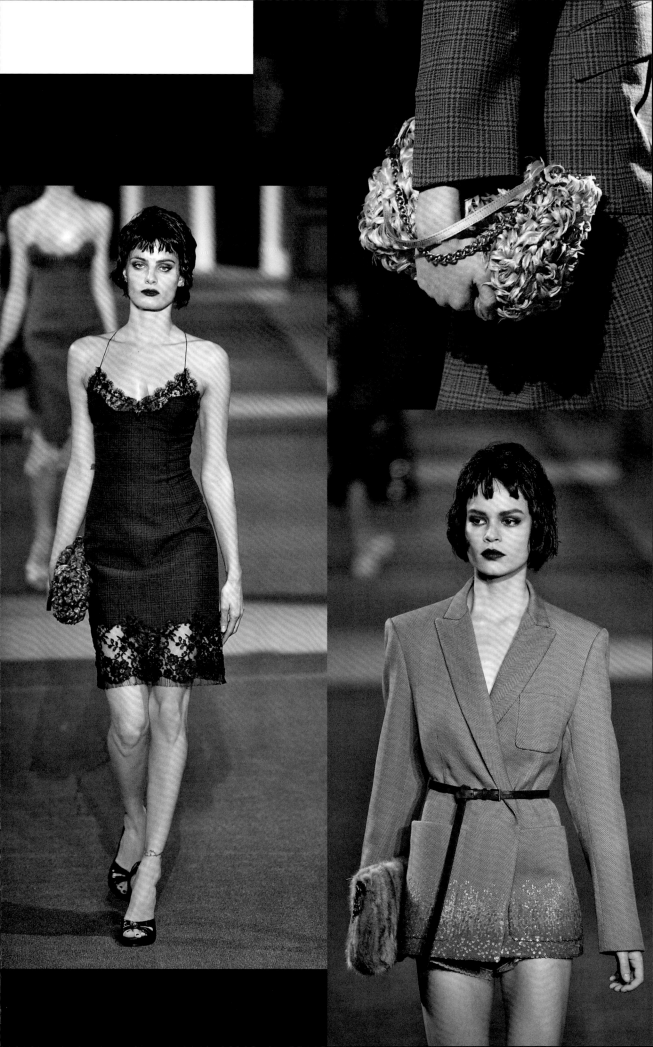

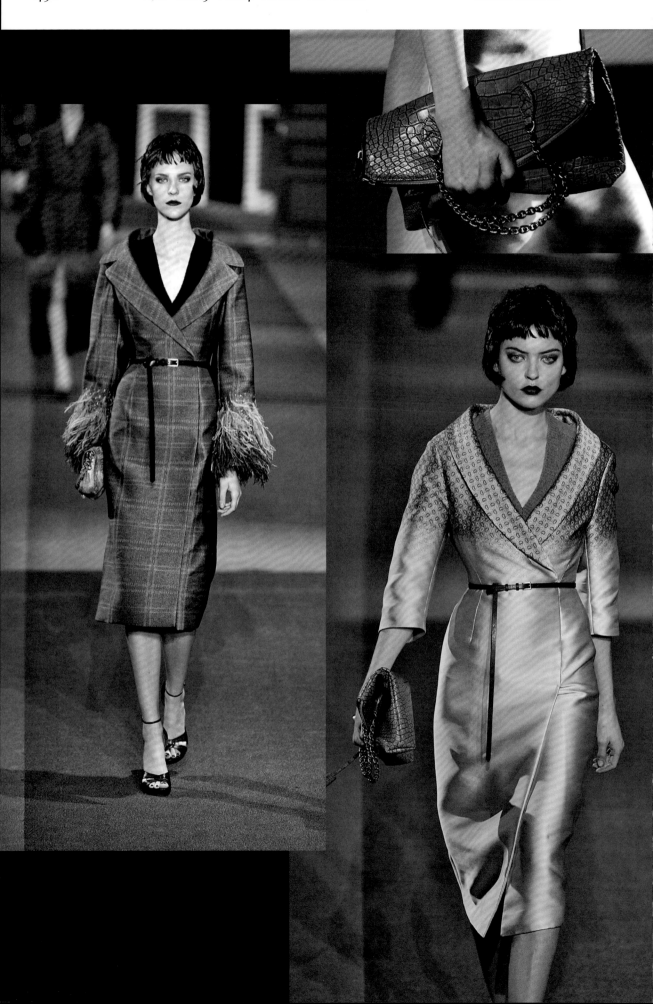

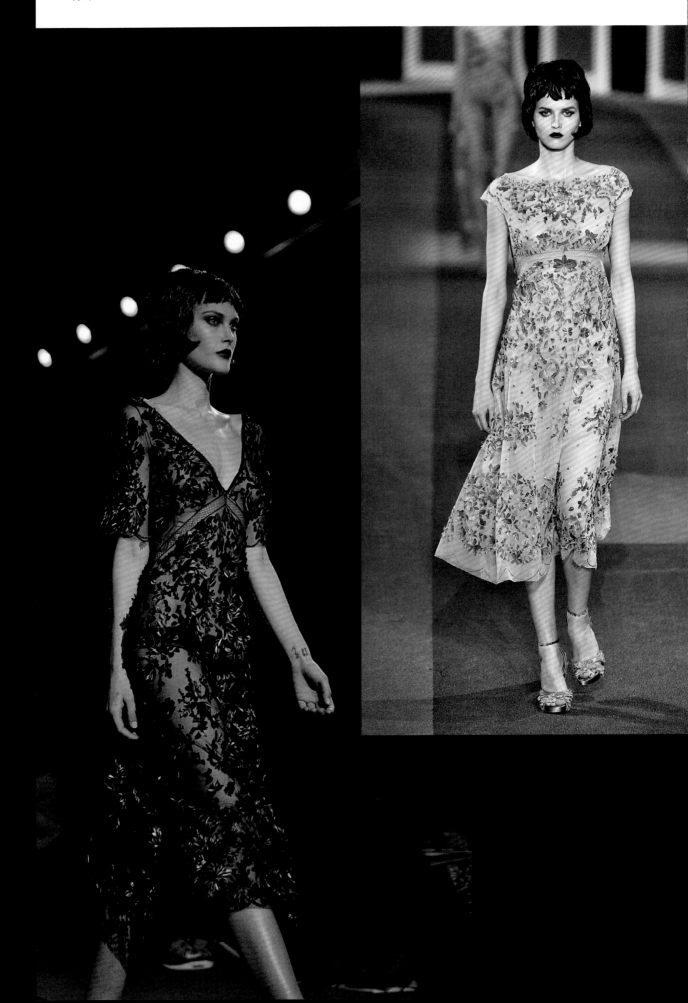

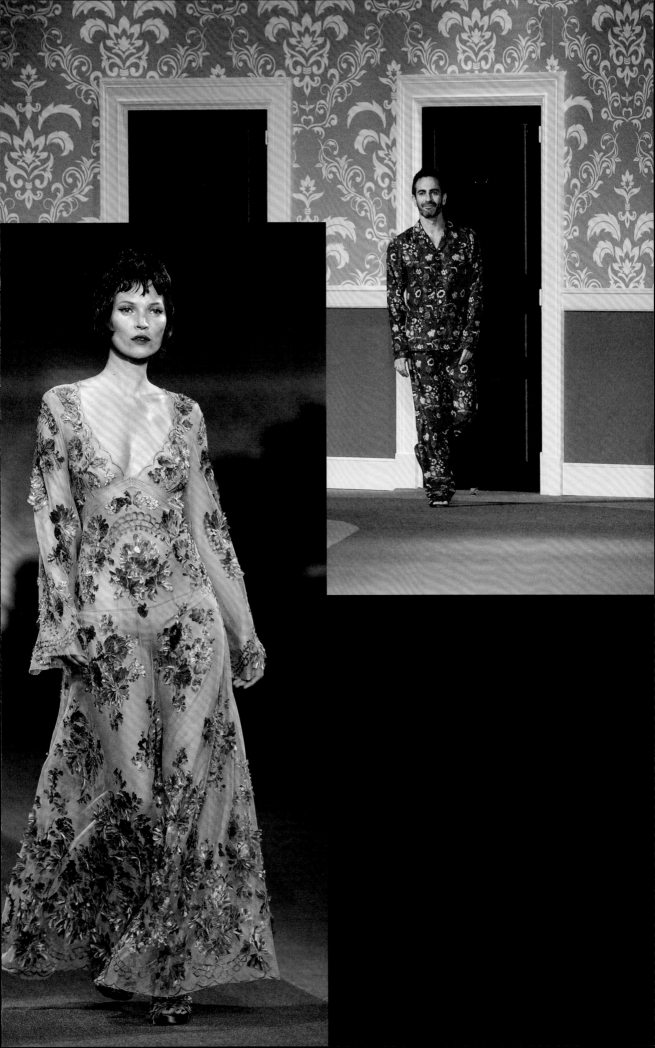

Showgirls

At 10 am on 2 October 2013, Marc Jacobs presented
his final collection for Louis Vuitton after 16
years as creative director. The spring/summer
collection, imbued with dark romance and
spectacular showmanship, cemented his legacy.

Jacobs wrote in the show notes: 'This collection
is dedicated to the women who inspire me and to
the showgirl in every one of them, Emmanuelle Alt,
Jane Birkin, Betty Catroux, Carlyne Cerf de Dudzeele,
Coco Chanel, Cher, Grace Coddington, Sofia Coppola,
Victoire de Castellane, Catherine Deneuve, Claude
Lalanne, Julie de Libran, Lady Gaga, Judy Garland,
Katie Grand, Juliette Gréco, Françoise Hardy, Zizi
Jeanmaire, Rei Kawakubo, Madonna, Liza Minnelli,
Kate Moss, Louise Nevelson, Édith Piaf, Miuccia Prada,
Lee Radziwill, Millicent Rogers, Sonia Rykiel, Carla
Sozzani, Elsa Schiaparelli, Barbra Streisand, Diana
Vreeland, Vivienne Westwood, Anna Wintour.'

The Damier-patterned lambswool carpet and
recycled sets from previous shows – including
a fountain, escalators, a carousel and cage lifts –
were painted black and provided a dramatic catwalk
for the 18-minute performance. As the station clock
on the wall started ticking backwards, a body-painted
Edie Campbell arrived, covered in Stephen Sprouse's
iconic graffiti logo, and wearing crystal-encrusted
chains and a magnificent ostrich feather headdress
created by Stephen Jones (right).

All 41 models wore elaborate showgirl-inspired
headdresses, as well as signature styles of the house,
paired with black eyebrows; 16 carried new versions
of the Noé bag (see p. 440, top right). Originally created
in 1932 to carry five bottles of champagne, the iconic
bag was presented with a short handle, LV lock and
studded drawstring pulls. It came in crocodile and
brushed velvet, and was decorated with feathers
and metallic studs.

'Black to me is the colour of the chicest women
in Paris,' explained Jacobs. 'When I look around Paris ...
it's the decoration and the applied ornamentation that
dazzles... I take pleasure from things for exactly what
they are, revelling in the pure adornment of beauty for
beauty's sake.' His exquisitely embellished collection
included jet beads, crystals, ruffles and passementerie
handsewn onto tulle tank dresses; evening gowns with
feathered trains; American sportswear shirts, leggings
and bomber jackets with 'Paris' and 'Vuitton' on the
back; loose faded or patchwork denim jeans; military
and Victorian-inspired jackets, and biker boots.

Jacobs noted that his collection was for 'the showgirl
in all of us'. By the time he left – to a standing ovation –
annual house sales accounted for 7 billion Euros
(more than half of LVMH's operating profits) and
the brand was valued at £15.1 billion.

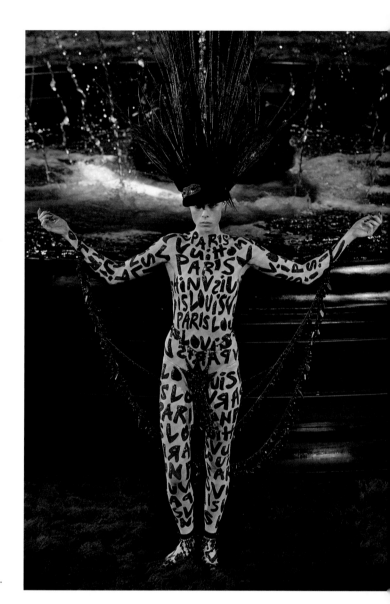

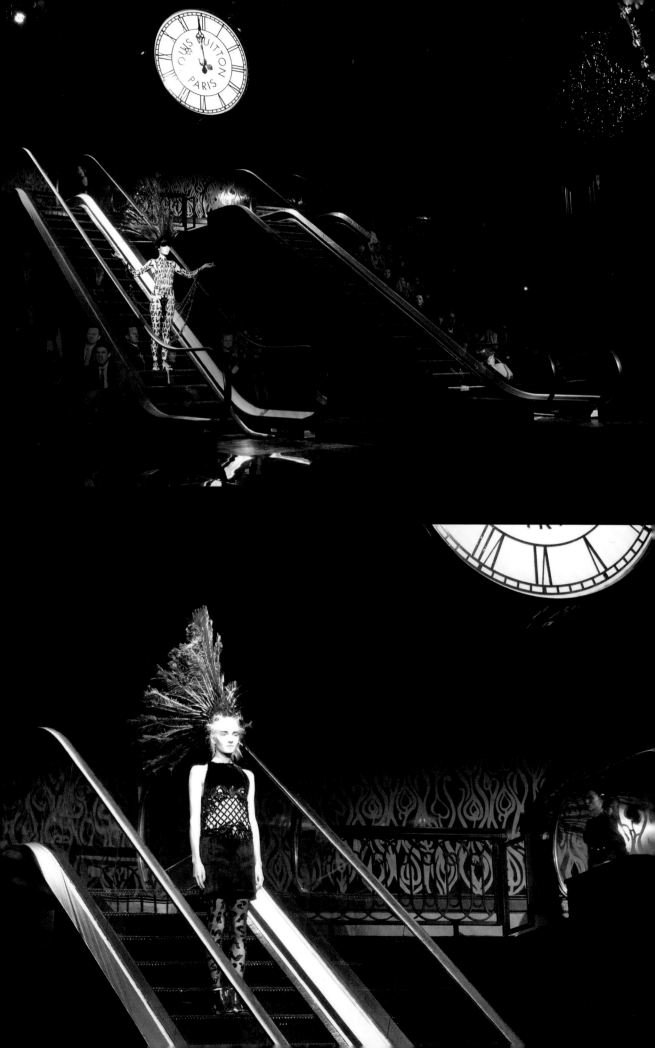

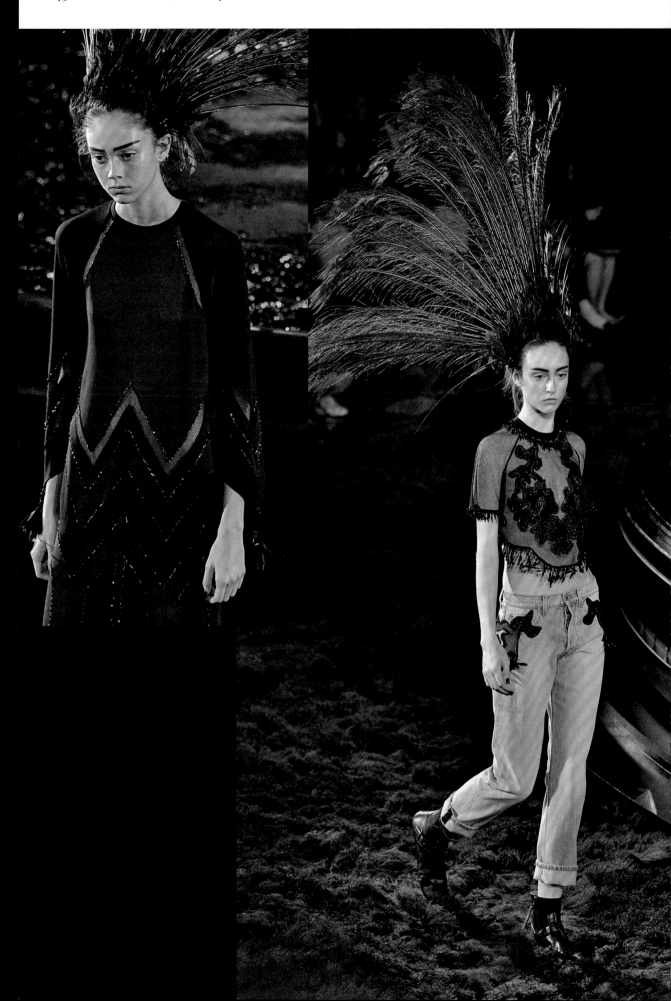

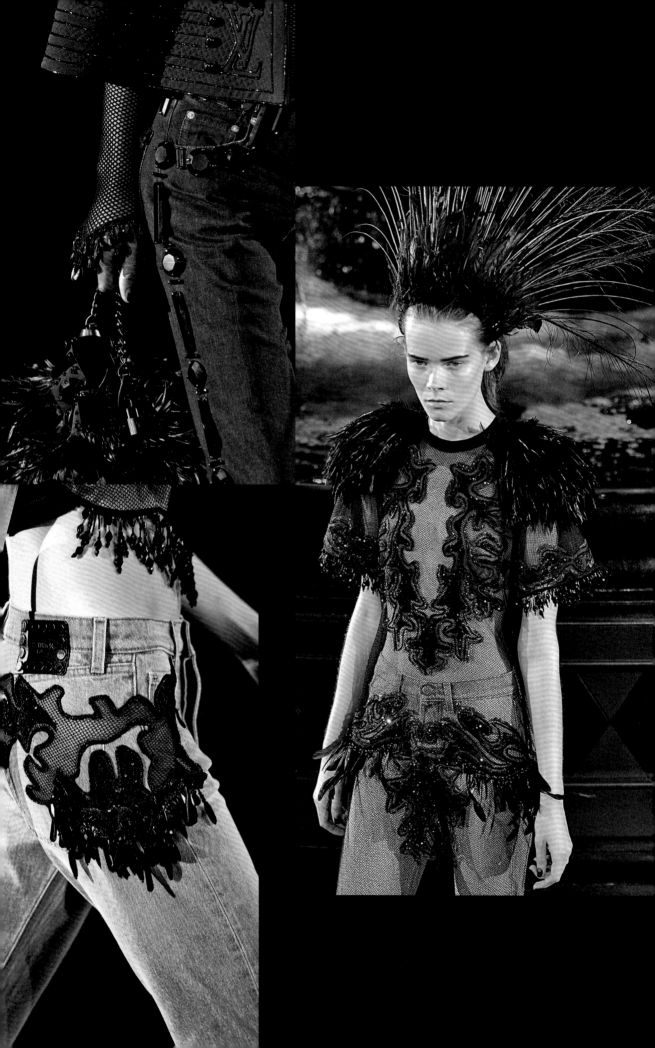

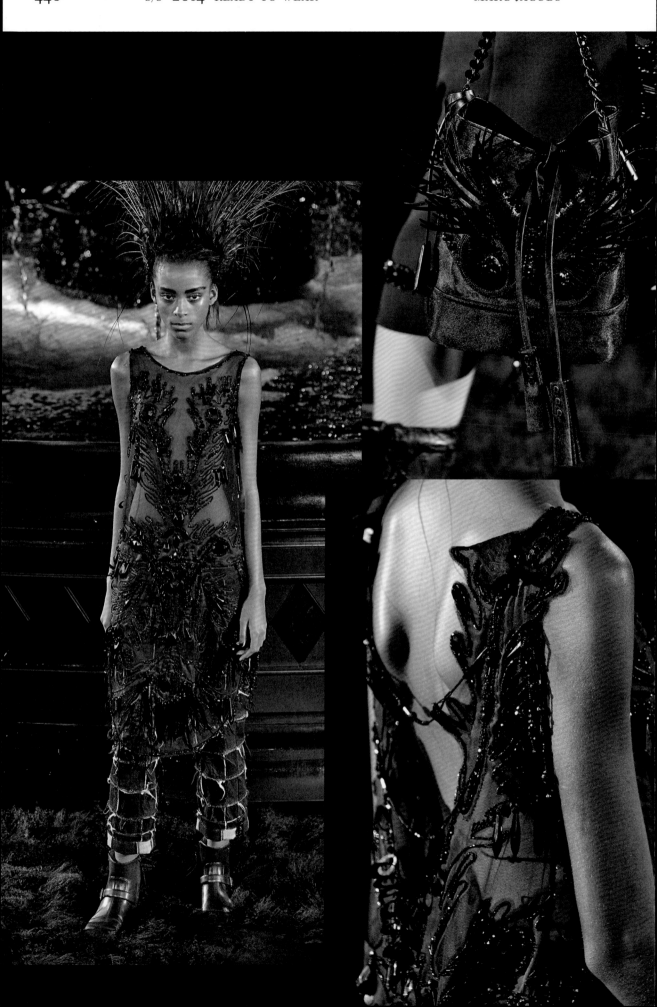

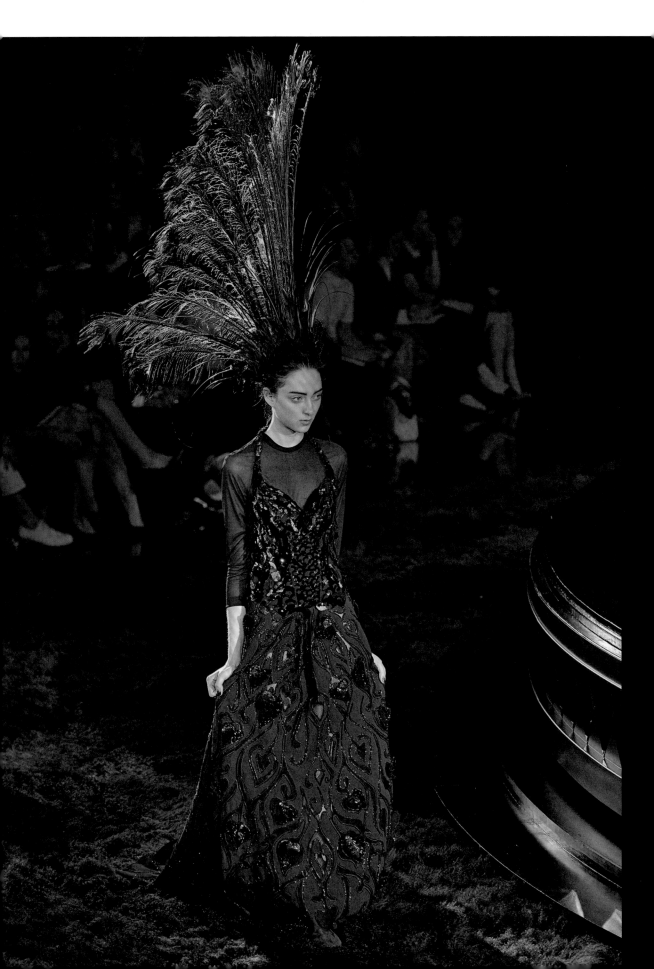

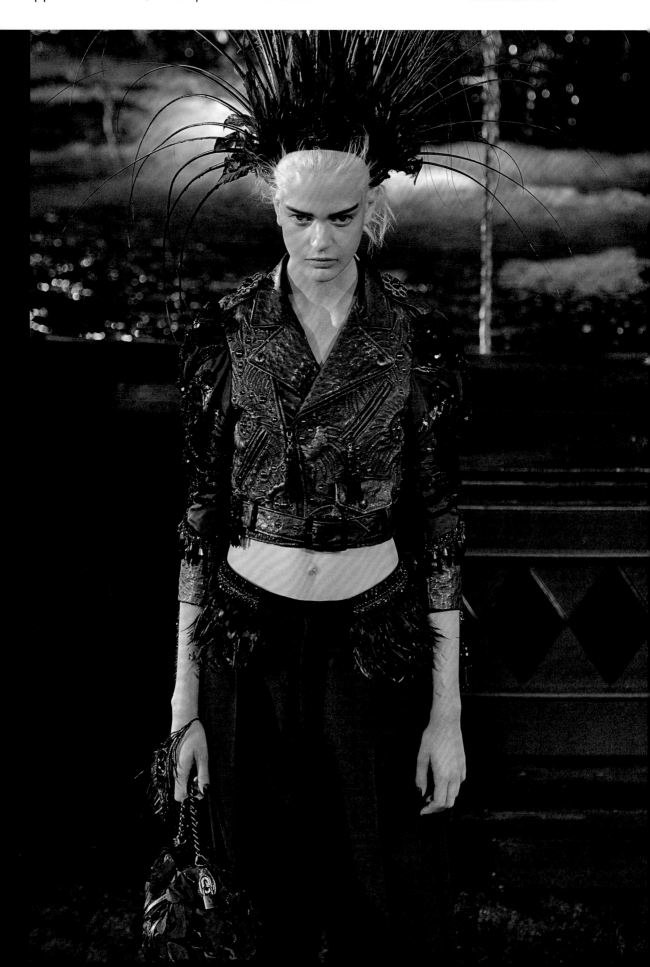

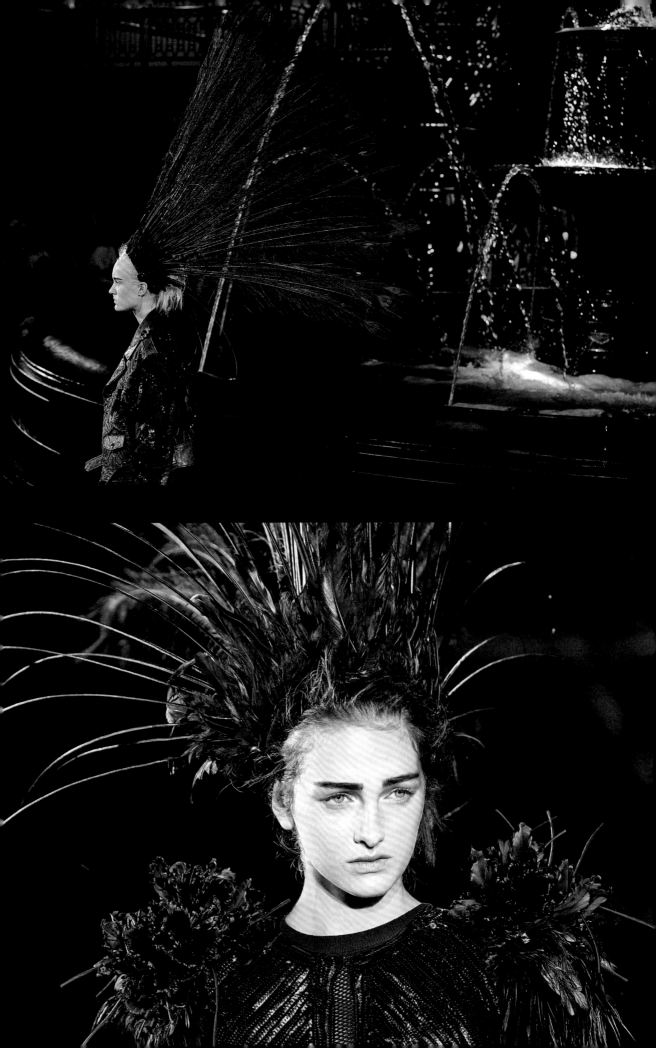

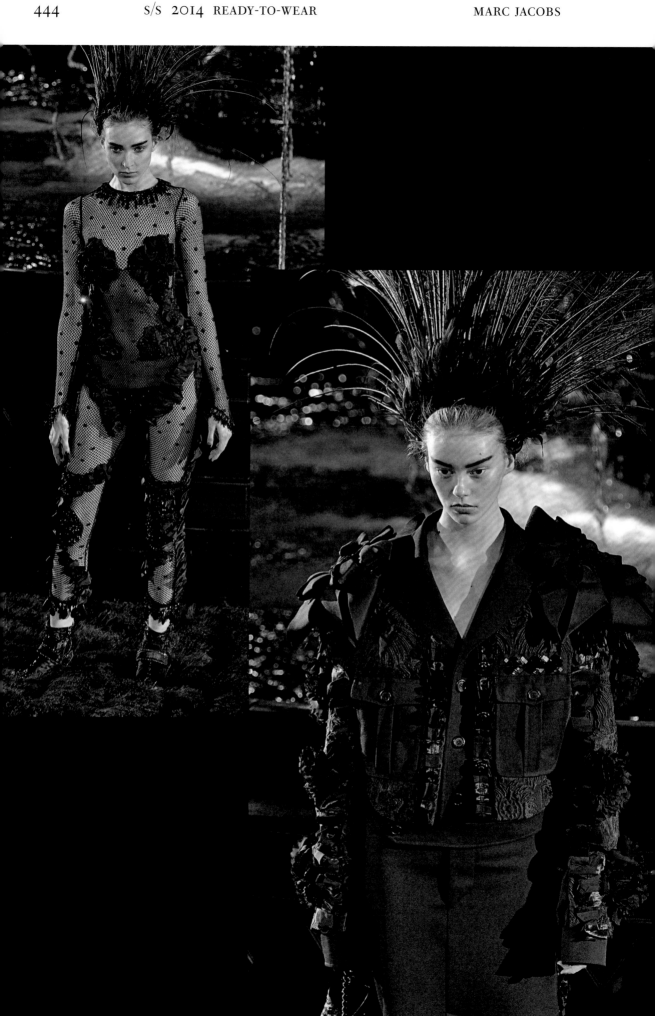

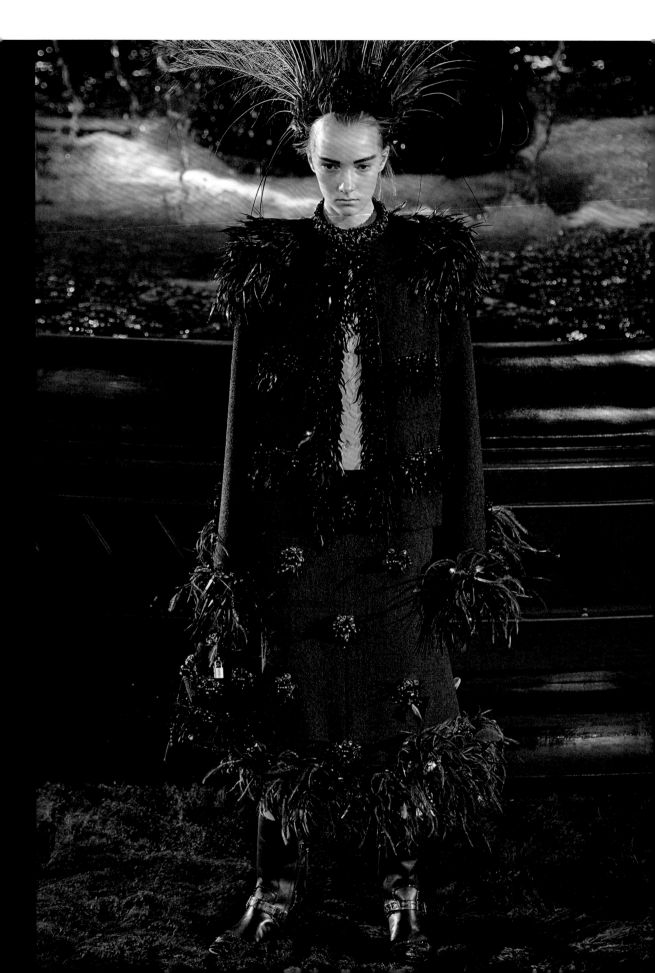

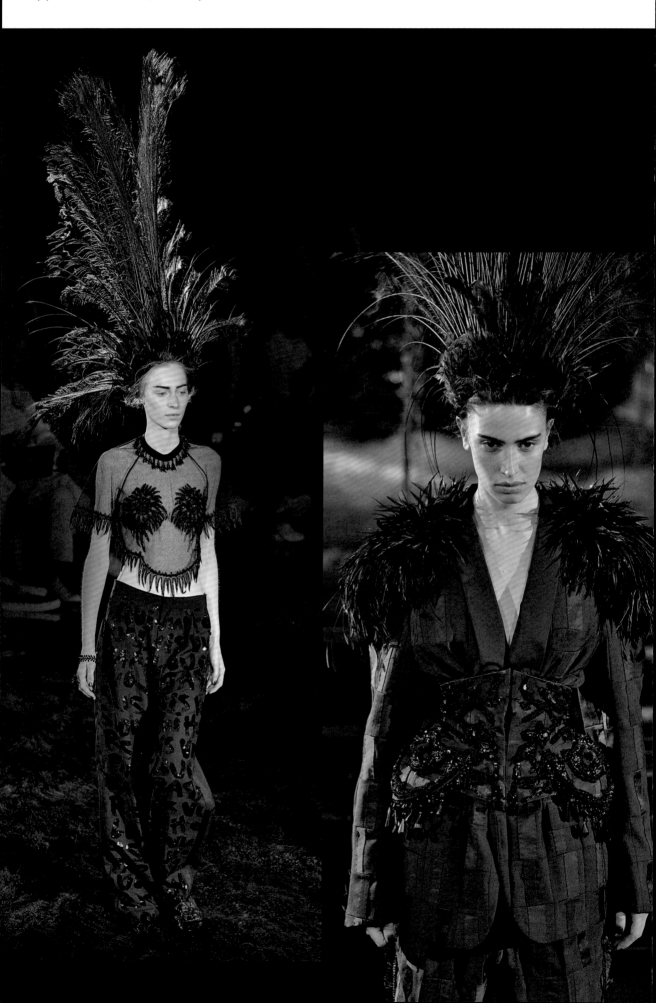

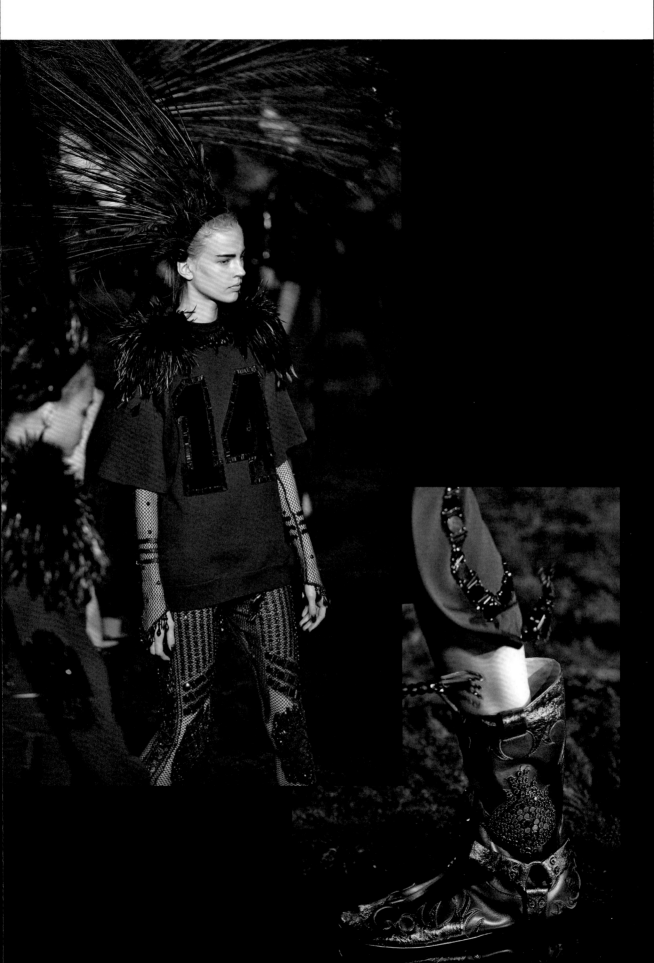

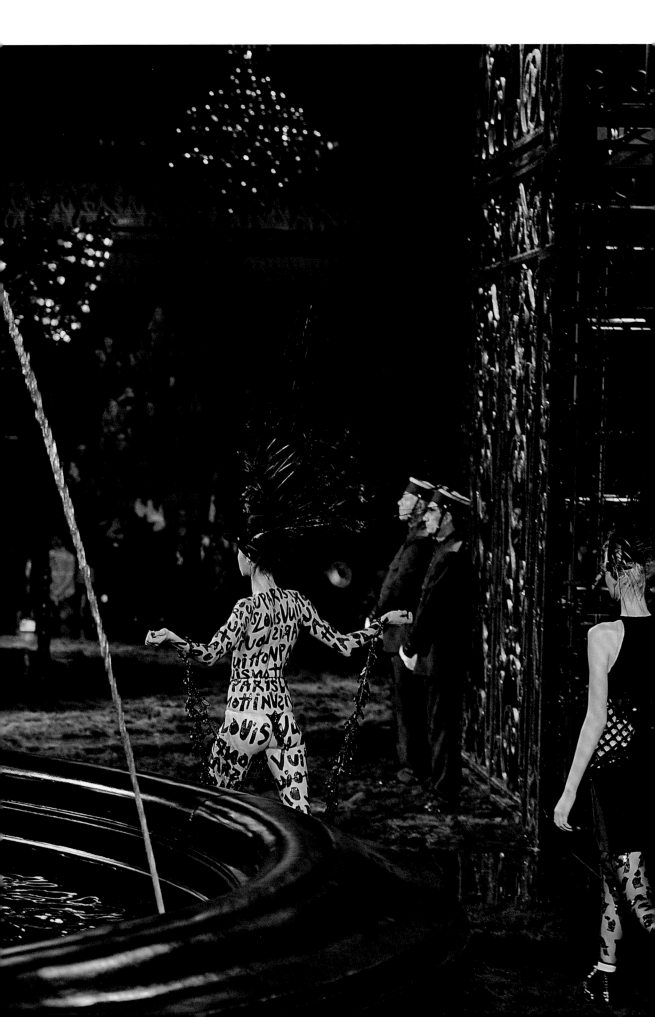

Nicolas Ghesquière

The son of a Belgian golf-course manager and a French mother, Nicolas Ghesquière was born on 9 May 1971 in Comines, in northern France, but grew up in the picturesque medieval town of Loudun in western France. He spent much of his childhood horse riding, fencing and swimming, developing an early appreciation for sportswear. He also covered his school books with fashion illustrations and made dresses from his mother's curtains, declaring at the age of 12 his intention to become a fashion designer.

Determined to learn the trade, he took a summer internship with designer agnès b when he was just 15. 'I watched, I photocopied, I made the coffee,' he explained about his introduction to fashion. He was then offered an internship with Corinne Cobson, with whom he worked at weekends for two years. He moved to Paris after graduating from high school in 1990, selling African statues to galleries on the Left Bank, before landing his first job in fashion with Jean-Paul Gaultier in 1991. Ghesquière assisted Gaultier's right-hand woman, Myriam Schaefer, gaining invaluable experience and developing what he called 'an aesthetic of mixing'. In 1992, he left to focus on his freelance work, designing knitwear and womenswear for brands including Pôles and Callaghan.

In 1995, Ghesquière was appointed head designer of Balenciaga's Japanese licensed product market, creating occasionwear. He explained: 'It was not the most exciting job for me, but it was the most beautiful name in fashion.' In 1986, 18 years after founder Cristóbal Balenciaga had closed the house, it had been acquired by Jacques Bogart S.A.; now, in 1997, recognizing the transformational possibilities of Ghesquière's work, the owners promoted the then-26-year-old to creative director of womenswear, replacing Josephus Thimister. Ghesquière was, in fact, fired after presenting his first collection, but due to the critical acclaim it received he was quickly re-hired. The brand was sold to PPR (now Kering) in 2001, and the acquisition included the Balenciaga archive: access to this allowed Ghesquière's creativity and the business to flourish. At the helm for 15 years, Ghesquière restored and revitalized Cristóbal Balenciaga's legacy, earning himself and the brand a cult following. He became known for incarnating the essence of Parisian chic with his razor-sharp tailoring, innovative use of materials and sculptural silhouettes (he once noted: 'I thought fashion was about embellishment as a kid, [but] when I saw Azzedine [Alaïa]'s work I understood fashion was about construction and architecture, too'). In 2006, an exhibition at the Musée des Arts Décoratifs in Paris paid tribute to the house of Balenciaga, presenting iconic pieces by 'the master' of haute couture, alongside Ghesquière's own work for the house.

Before leaving Balenciaga in 2012, Ghesquière was widely recognized for his achievements. In 2000, he was named Avant-Garde Designer of the Year at the VH1/*Vogue* Fashion Awards. The following year, he was given the International Designer award by the CFDA. In 2006, he was included in *Time* magazine's 'list of the 100 men and women whose power, talent

or moral example is transforming our world'. He was made a Chevalier des Arts et des Lettres in France, in 2007. In 2010, like Marc Jacobs before him, he was crowned 'Superstar' by Fashion Group International.

On 5 November 2013, Ghesquière was named creative director of Louis Vuitton's women's collections and accessories. Merging the DNA of the house with modern craftsmanship and futuristic and architectural inspirations, Ghesquière presided over the creation of a new aesthetic vocabulary for the house. He revamped the visual identity together with the agency M/M (Paris), he introduced a Cruise line, and he sustained the momentum for each collection by elaborating on its concept through social media and campaign series shot by photographers Juergen Teller, Bruce Weber and Annie Leibovitz. Today, the Louis Vuitton Instagram account has over 20 million followers.

In 2014, Ghesquière was named International Designer of the Year at the British Fashion Awards, and was also the winner of the *Wall Street Journal* magazine's Innovator Award in the fashion category. He has been on the jury for the LVMH Prize for young designers since 2015. In 2017, he was presented with the Women's Leadership Award at a gala at the Lincoln Center in New York, honouring him as one of the most innovative designers of his generation.

Louise Rytter

'A New Day'

On 5 March 2014, newly appointed creative director
Nicolas Ghesquière presented his much-anticipated
inaugural collection for Louis Vuitton. It combined
the DNA of the house with a youthful spirit. 'Today
is a new day,' he declared in a personal memo placed
on every seat. Saluting the work of his predecessor,
he noted his own 'immense joy at being here, in the
knowledge that my stylistic expression is at one
with the Louis Vuitton philosophy. The proud legacy.
The inspiring history that looks to the future and to
the world. The quest for authenticity and innovation.
The desire for timelessness.'

As the blinds went up and the sun filled the room in
the Richelieu wing of the Louvre, Freja Beha Erichsen
emerged, to the beat of 'Copycat' by Kelis, swinging
the new It-bag (the monogrammed Petite Malle) and
wearing an A-line leather coat with wide terracotta-
coloured collar (right). 'My vision was of a leather
coat,' said Ghesquière, 'and to narrow it down to
create a wardrobe.'

Styled by Marie-Amélie Sauvé, the 48 looks evoked
influences from 1960s Paris, 1970s sci-fi blockbusters,
and sportswear. As the house noted: 'Hand-crafted
artisanal techniques are updated with a high-tech twist'
and 'glorious, smooth, full-grain leather is contrasted
with hybrid materials'. Ghesquière explained, 'There
is a lot of leather and a lot of metal – which obviously
comes from the bags.' According to Suzy Menkes, the
collection was 'a piece of fashion architecture: Drawn
firmly on straight lines, each sharp top, maybe with
a deep décolletage, or upturned triangle of a skirt,
spelled out the letter V'.

Signature looks included a leather-knitted top worn
over a moleskin skirt with metal eyelets (p. 456, left);
a sportswear-inspired cardigan with Indian floral
patchwork and industrial zip worn with an A-line
leather miniskirt (p. 457, left); high-waisted vinyl
trousers (p. 460); and a black crocodile zipped vest
worn over a feather-embroidered spiral wool skirt
with black patent leather belt, styled with an 18K
gold Petite Malle necklace and patent leather
pumps (p. 461, right).

The Petite Malle bag, evoking the style of Louis
Vuitton trunks, came in Monogram canvas, Damier
Ebène canvas and Epi leather, with magnetic S-lock
and three red x-kisses (the signature of *beau monde*
photography aficionado Albert Kahn; see p. 463,
right); the Silver Epi had a removable cover, like
1960s camera bags (p. 458, bottom right). The Dora
appeared in a graphic print (p. 457, right), and the
Malletage Alma came in lambskin with a diamond
design reminiscent of the house's iconic trunk
linings (p. 460).

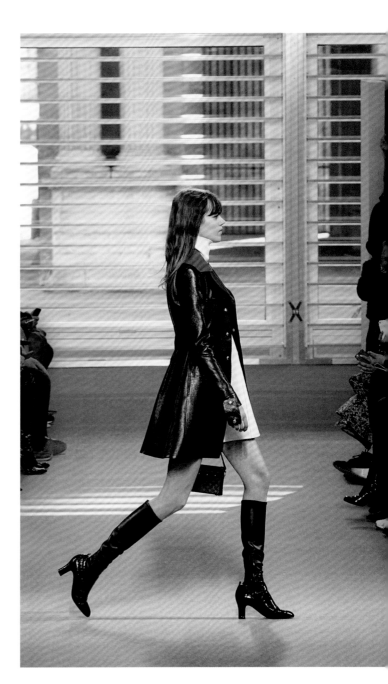

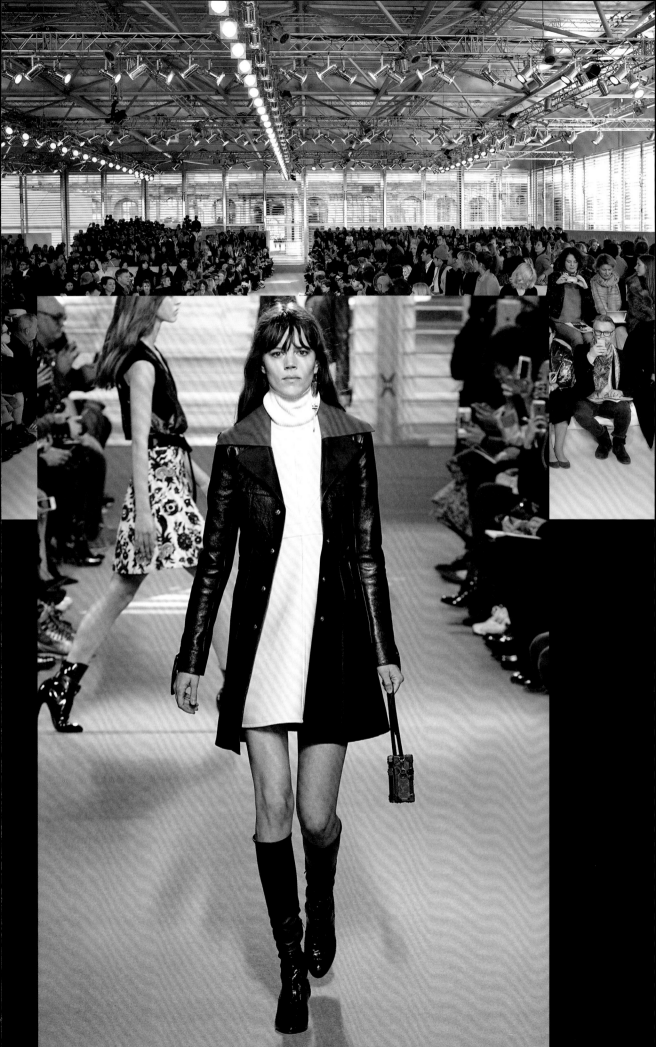

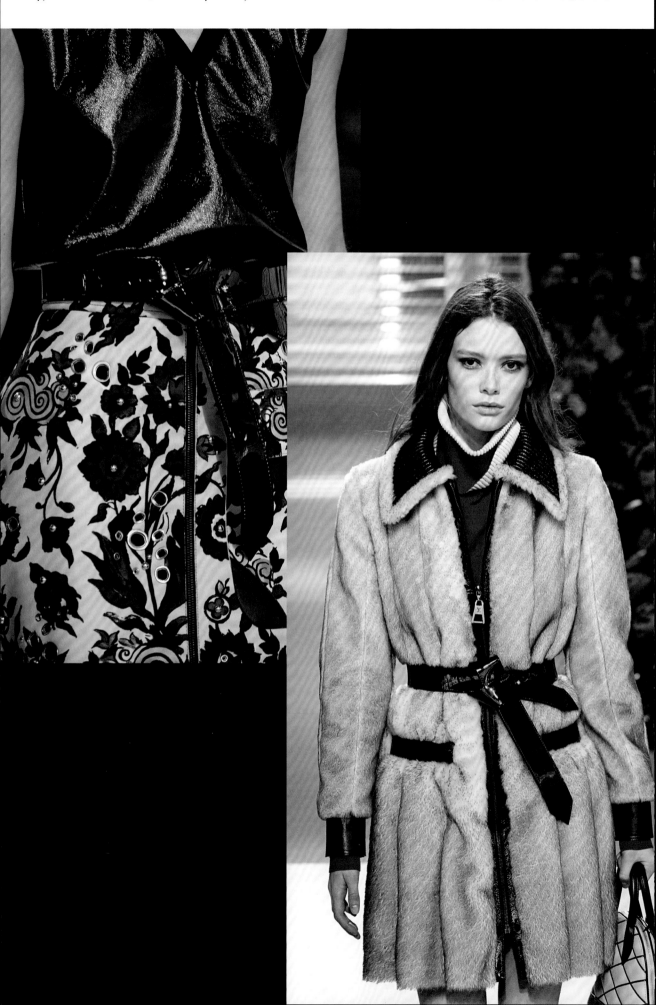

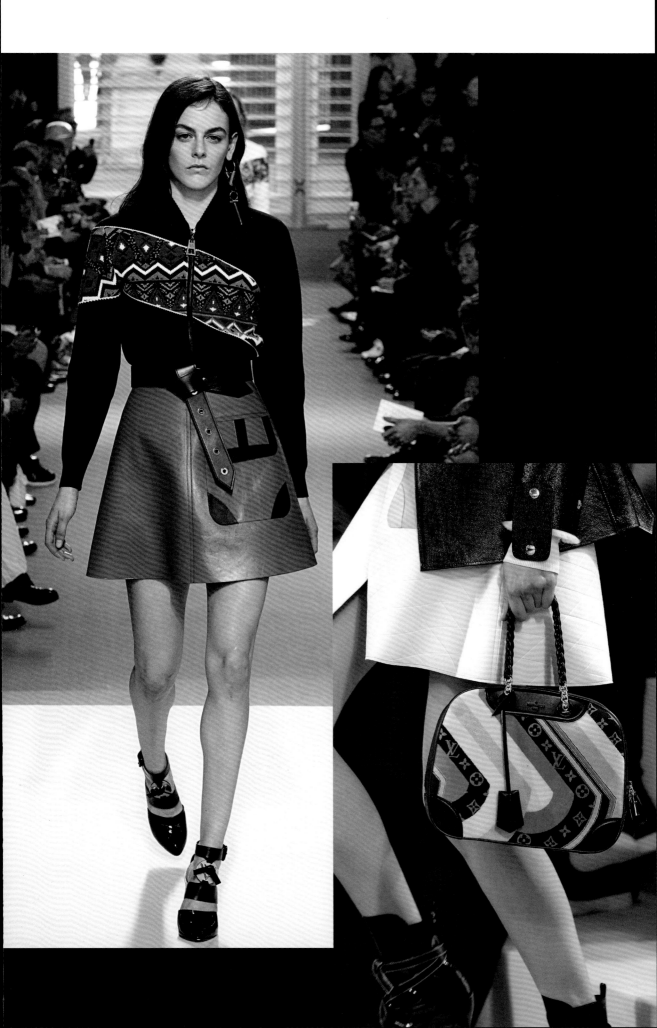

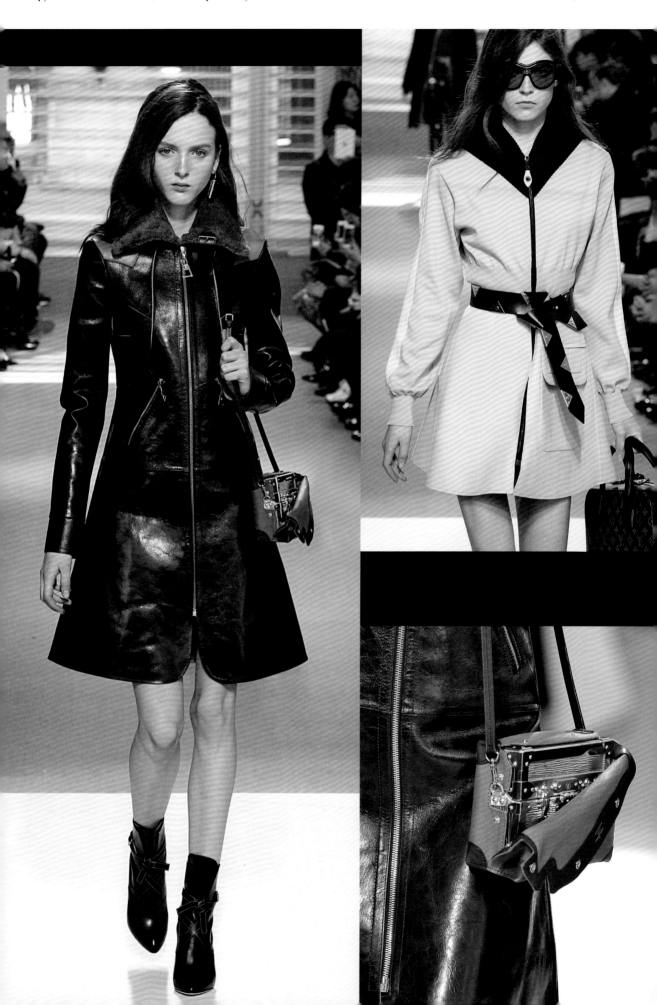

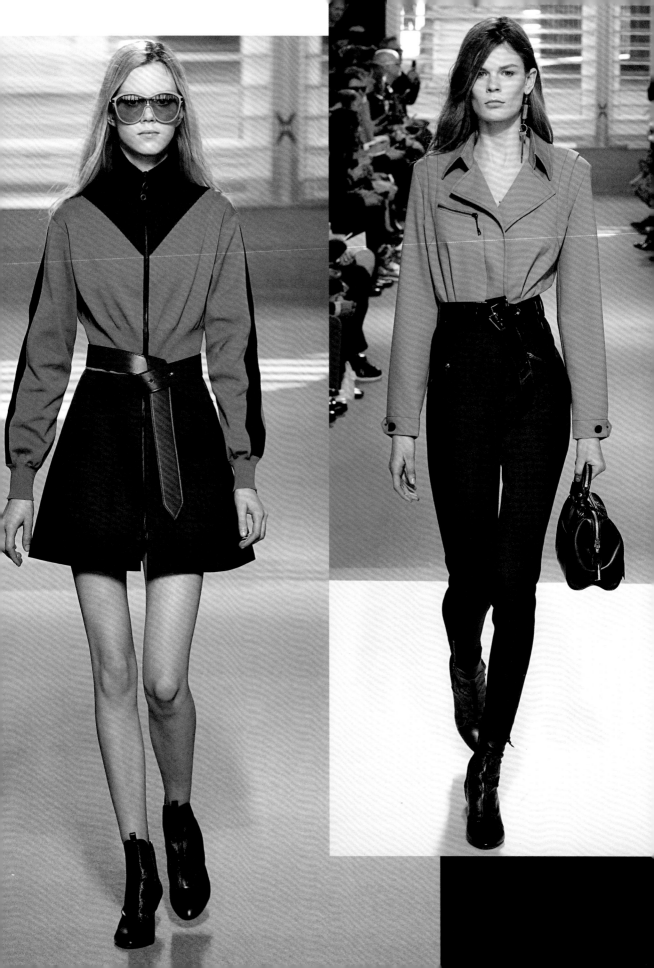

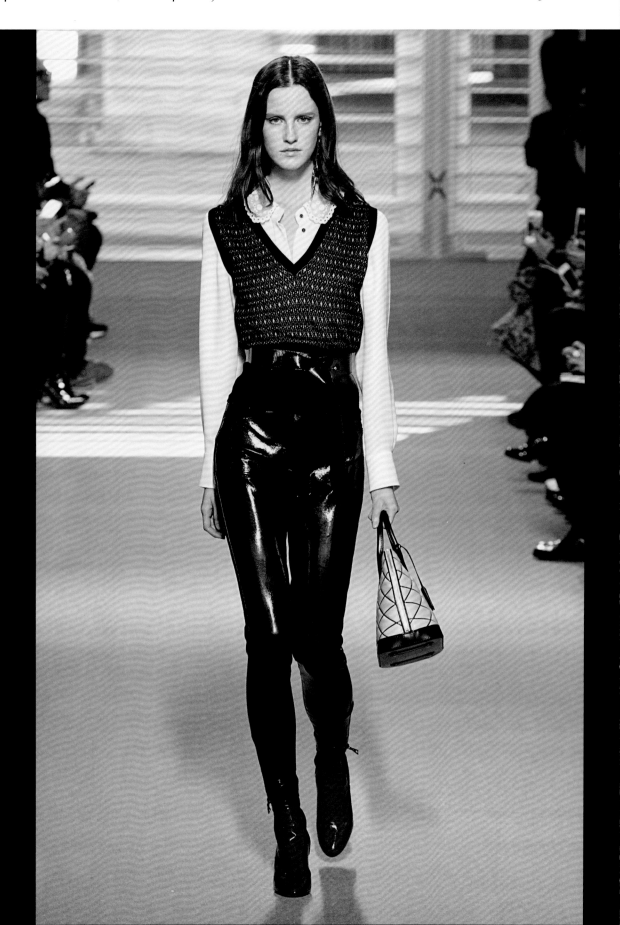

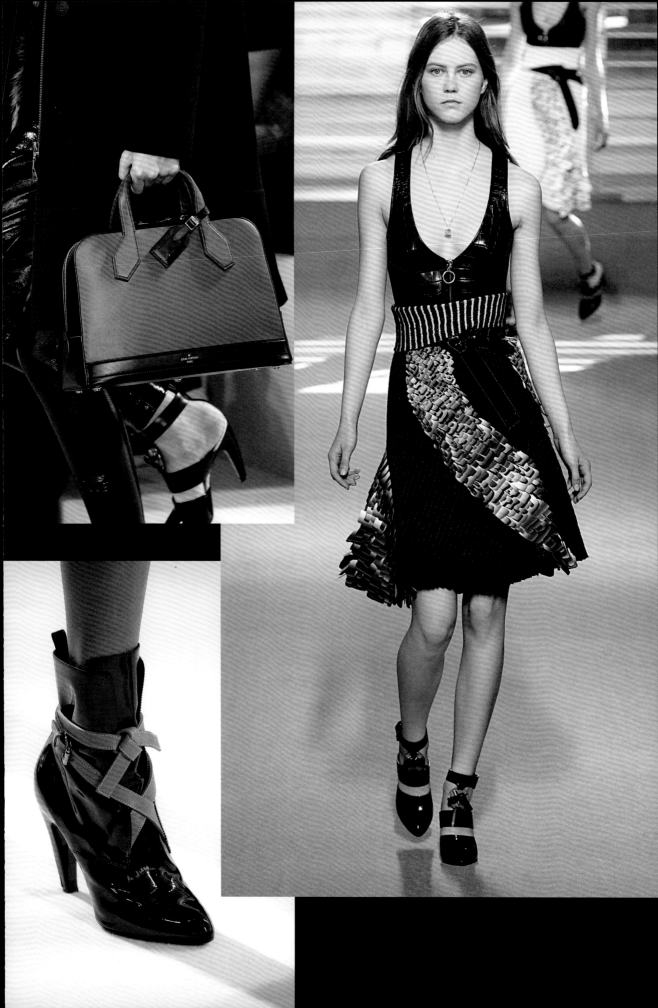

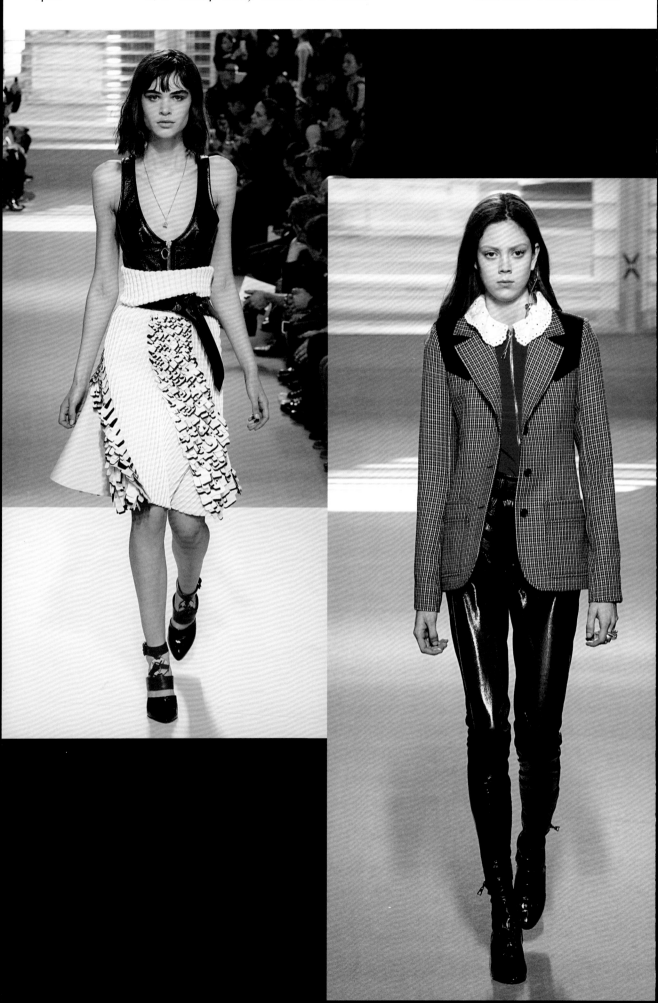

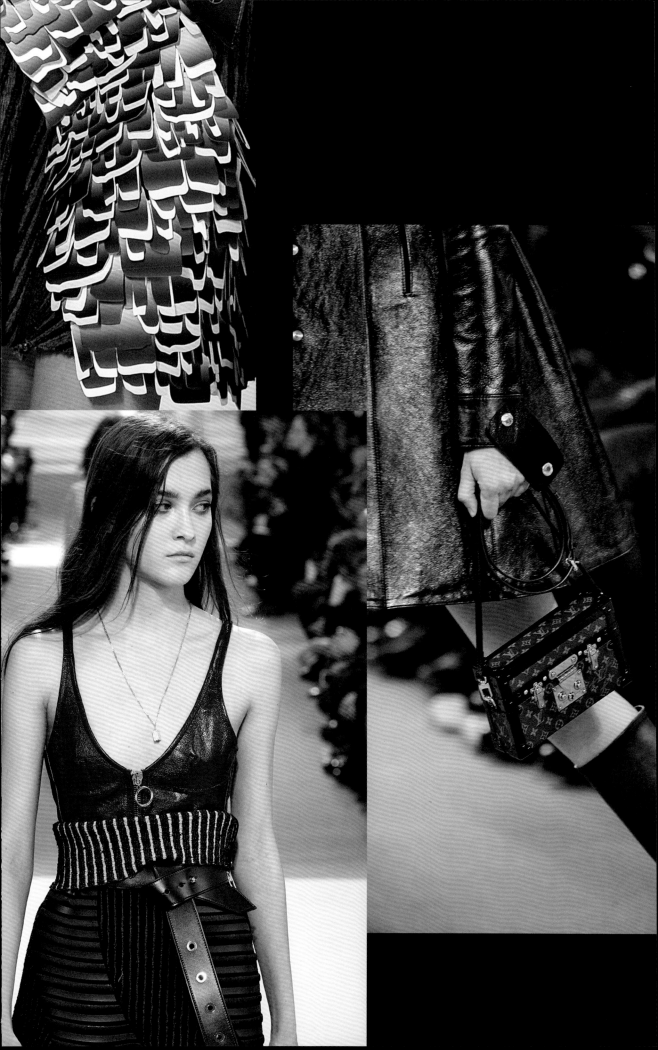

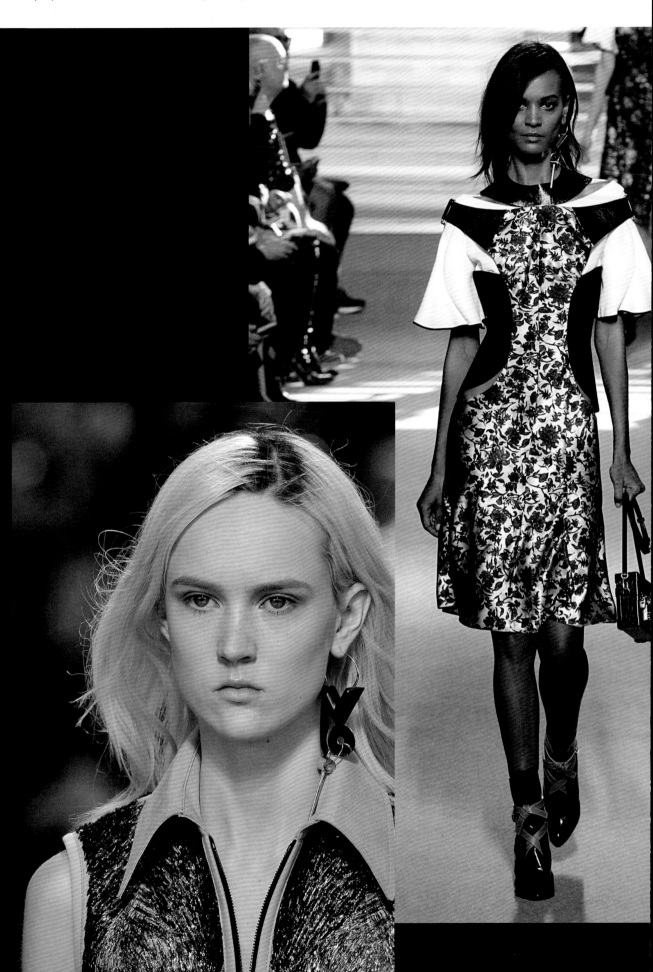

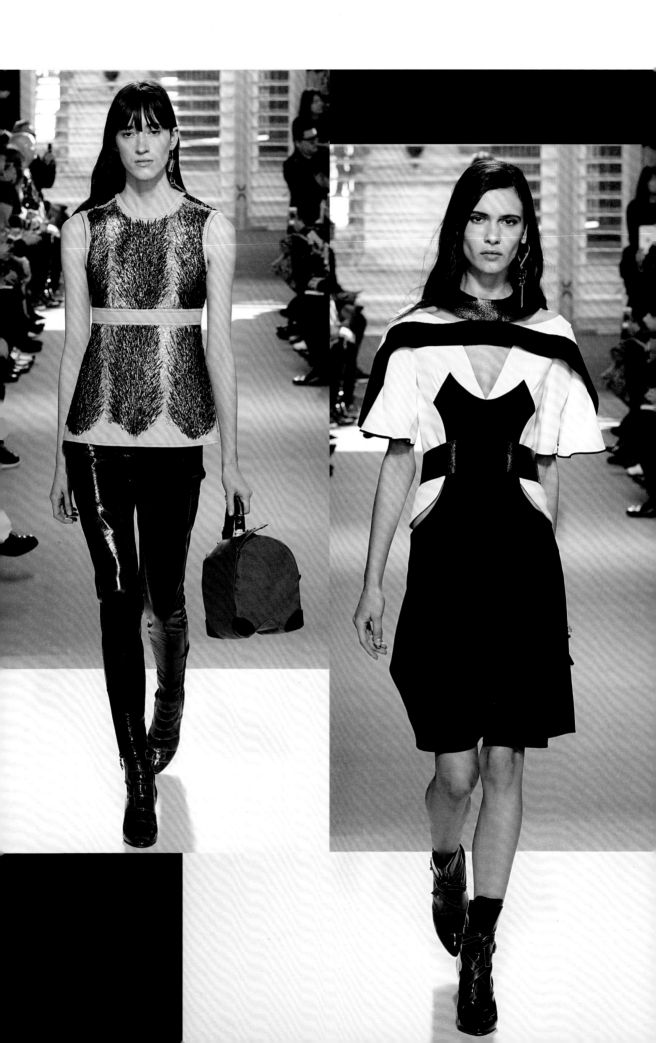

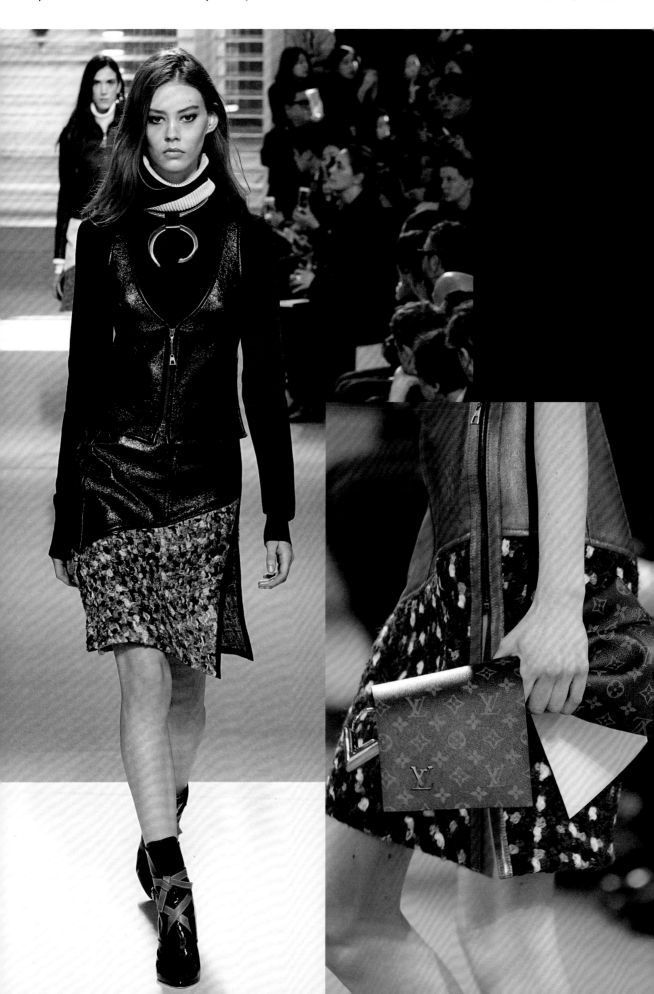

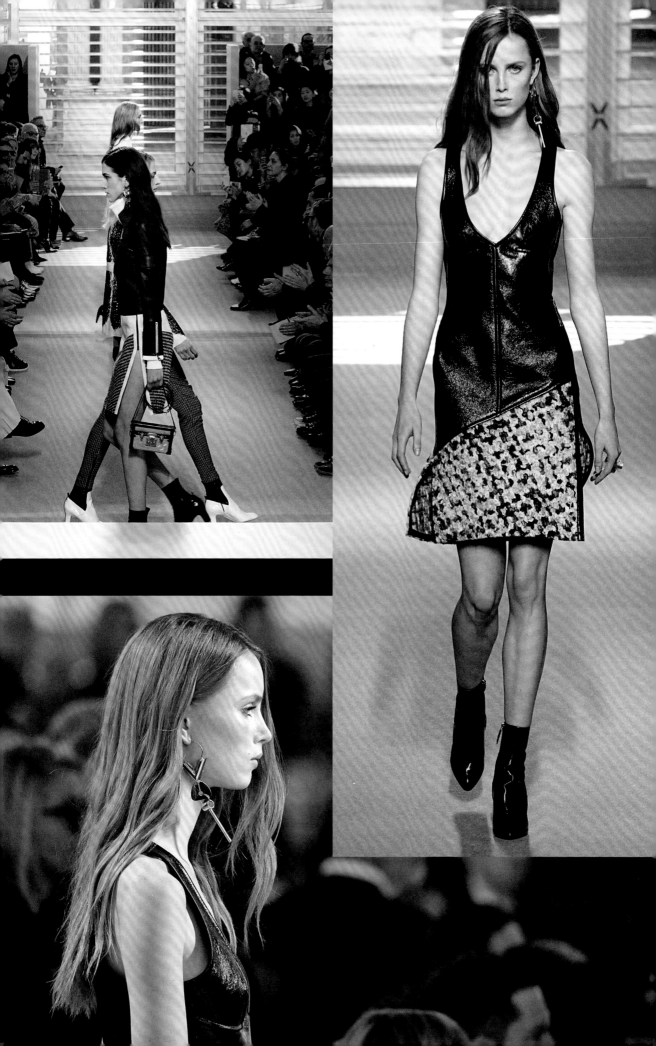

Monaco

Nicolas Ghesquière travelled to Monaco for the presentation of his first Cruise collection for Louis Vuitton. At first glance, the custom-built glass cube installed on the Place du Palais was as light-filled as the set of Ghesquière's first collection, but, as the show started, huge white curtains began blocking the light to reveal a mesmerizing water projection on the catwalk by video artist Ange Leccia. 'I liked the spirit of the girls walking on digital water,' explained Ghesquière.

The aquatic theme was echoed in the collection itself: waves of coral-like motifs (dubbed 'ramages') were embroidered onto jersey tops and skirts, and 'porthole' cutouts and 'ring' prints decorated trouser suits and paisley sweaters, alongside brightly coloured lace, gleaming python coats and jackets, and romantic floral patterns. A nod to Monaco's close link to Formula One (the show took place a week before the annual Grand Prix race), the newly created 'Grand Prix' pattern, inspired by chequered racing flags, animated knitted dresses (p. 472) and an exuberant special-edition Petite Malle bag (p. 471, top right).

Ghesquière set out on a journey 'off the beaten track' to explore 'transformation in clothing', stated the show notes. The idea of the wardrobe, introduced the previous season, was revisited, this time 'shaken up through and through, lending itself to the mixing of genres, peculiar layering, expert dissonance and pseudo-paradoxical juxtapositions. A clash of competing allusions. A cacophony of colours. The illogical striving to become familiar.'

'The overriding impression was of a designer not holding back,' reported *Vogue*'s Nicole Phelps. 'There was an engaging new eclecticism, but it didn't come at the cost of the easiness that he established as one of his key LV codes back in March. The sensational first look – a silk top inset with LV's classic monogram pattern embroideries and a pair of those high-waisted flares – captured that yin-yang best' (opposite, left).

The collection presented a bohemian allure with fluid styles, light fabrics and rich embellishments, set off by striking accessories. The 45 models sported graphic pumps and sandals, 'V' chain gourmettes (right), 'V' bucket bags (opposite, left and right), the new 'Pinch' bag (right), and the playful Monogram Mask bag with S-lock (p. 477, top left).

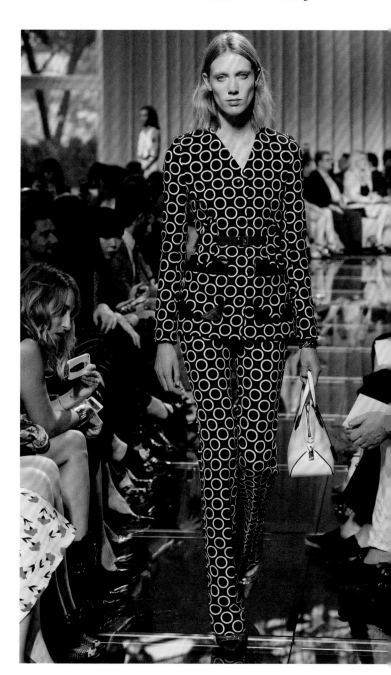

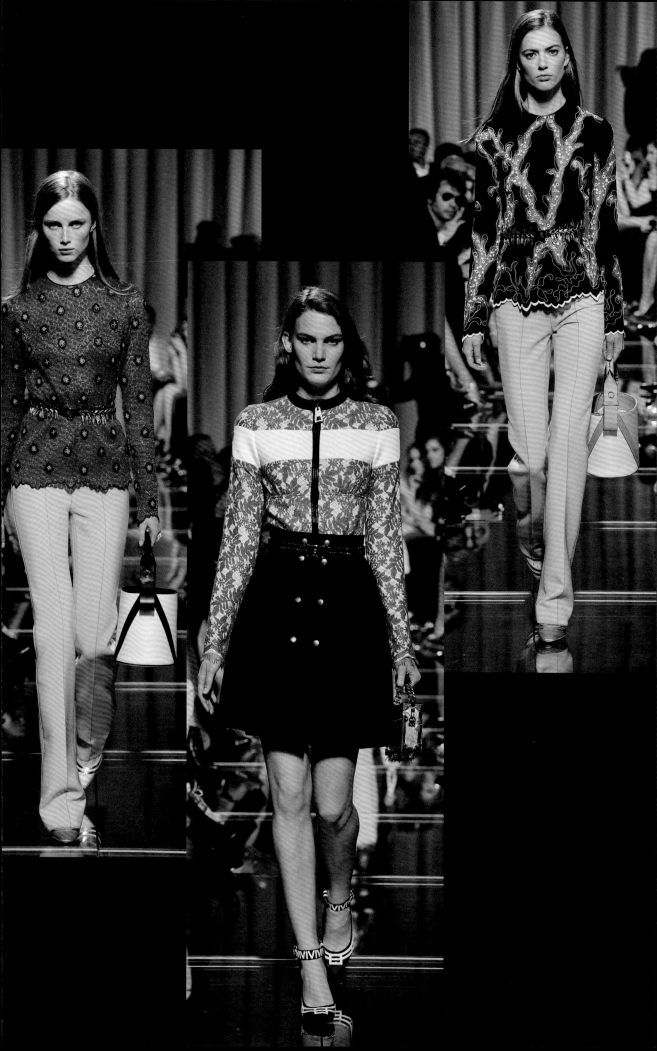

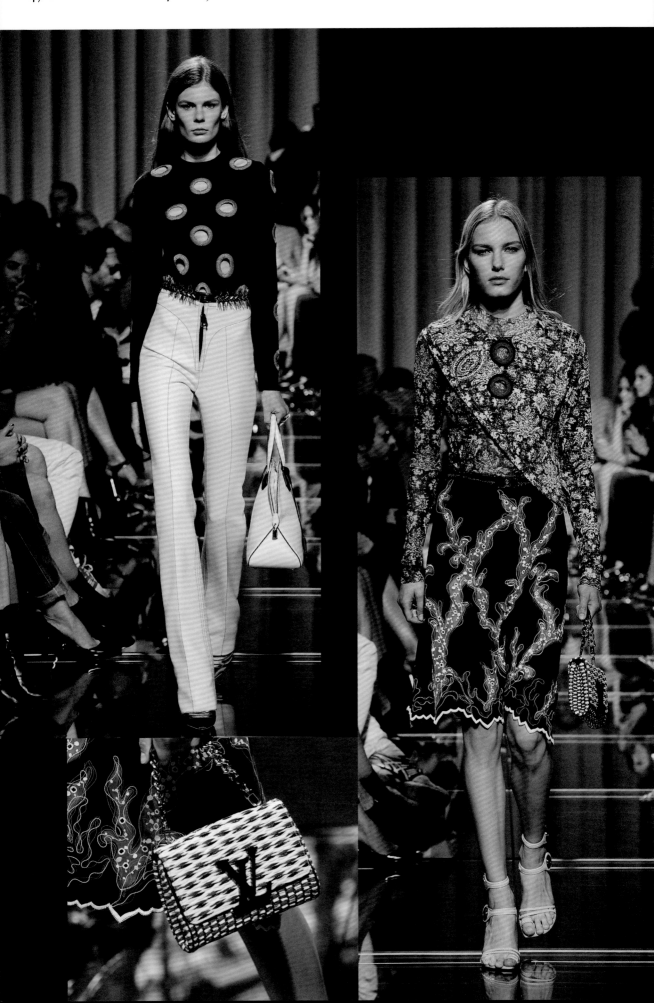

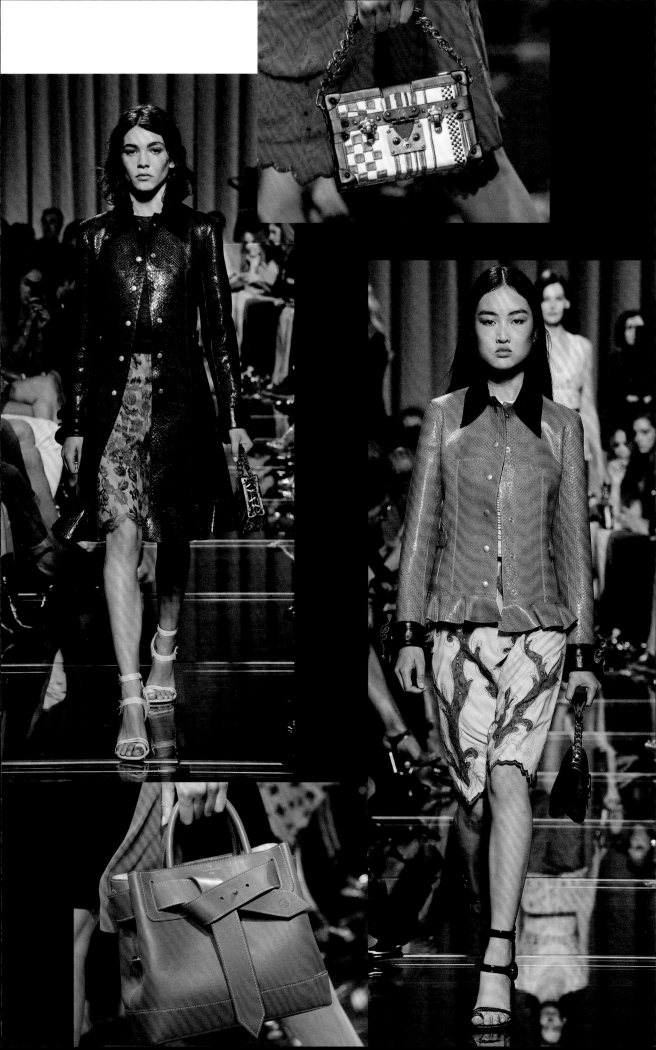

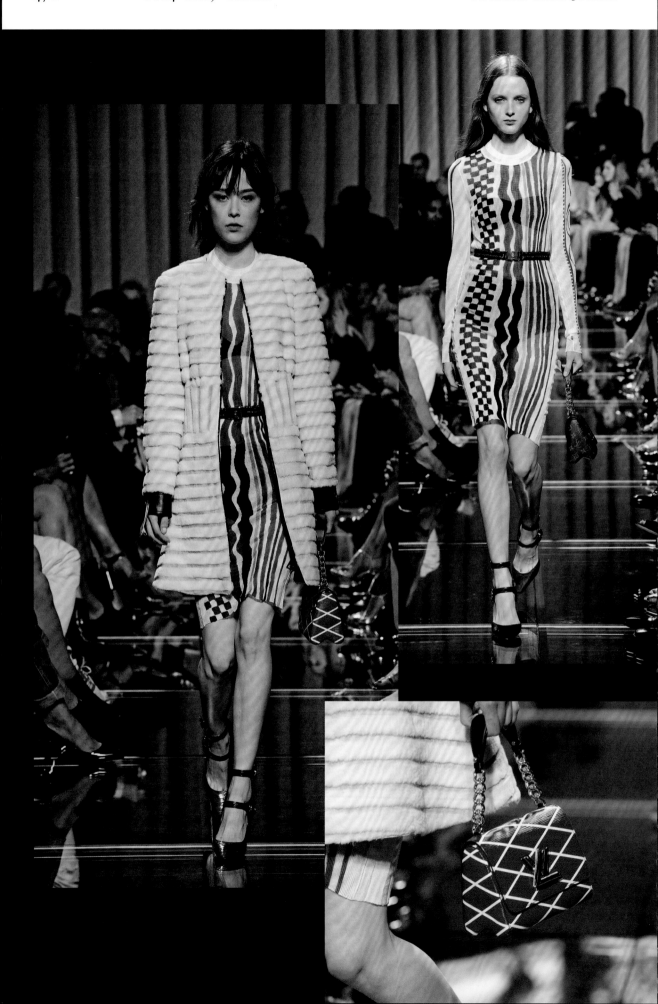

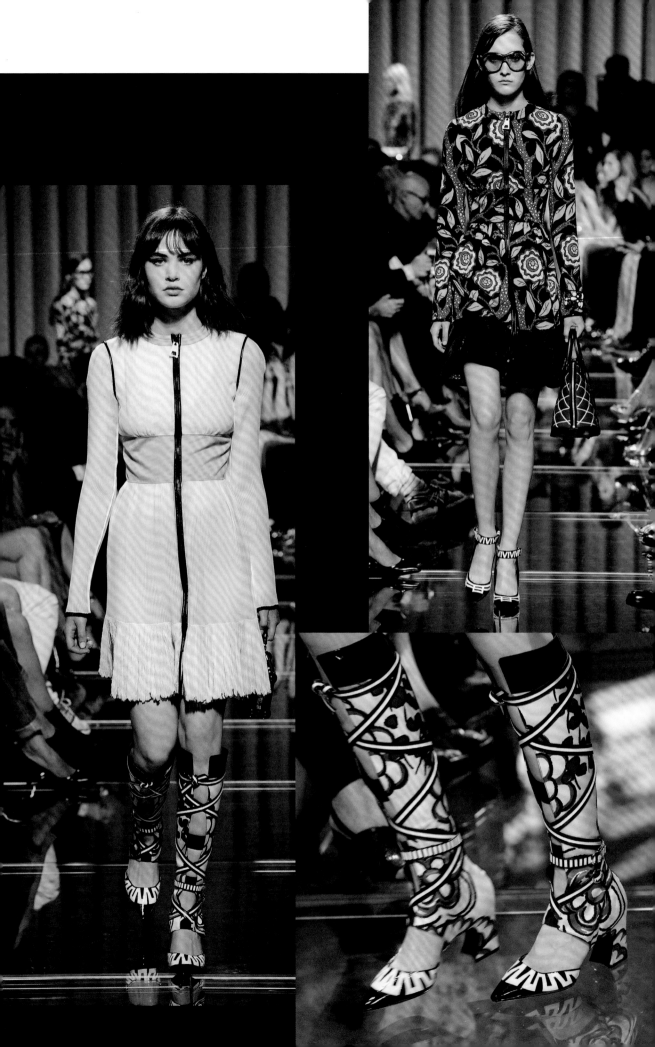

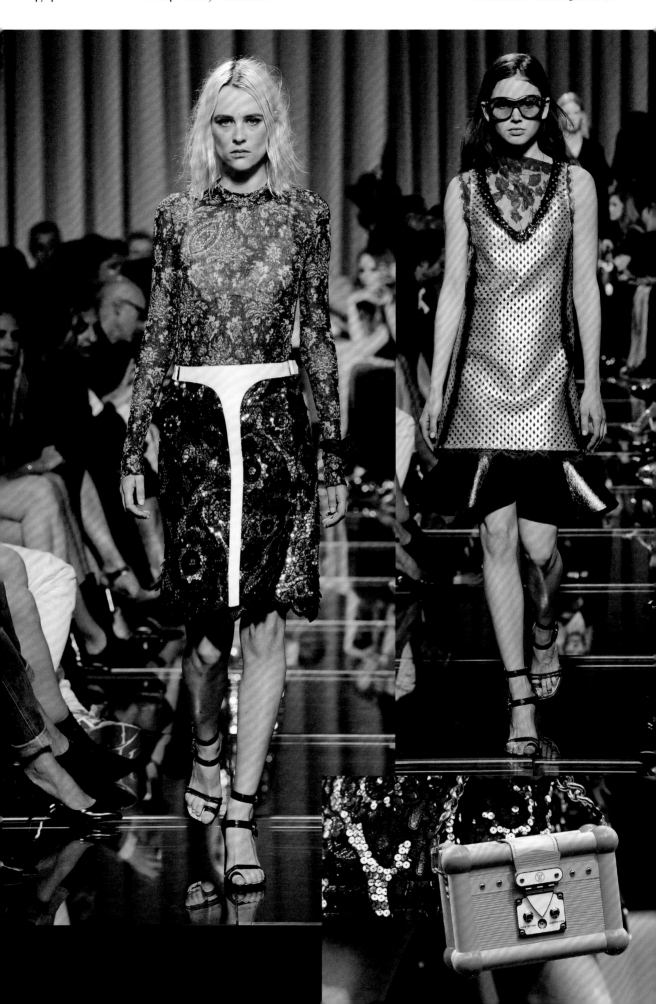

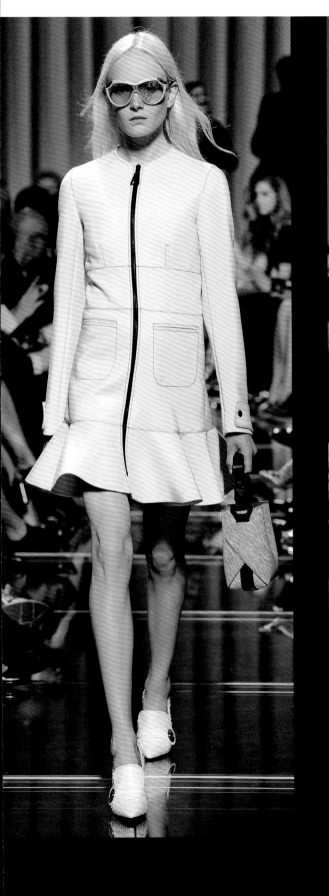
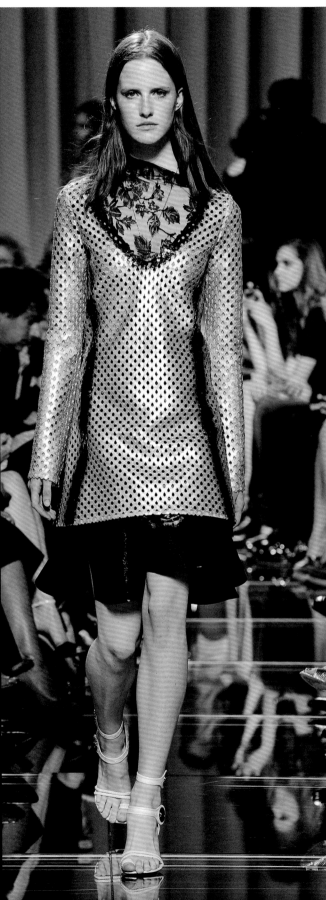

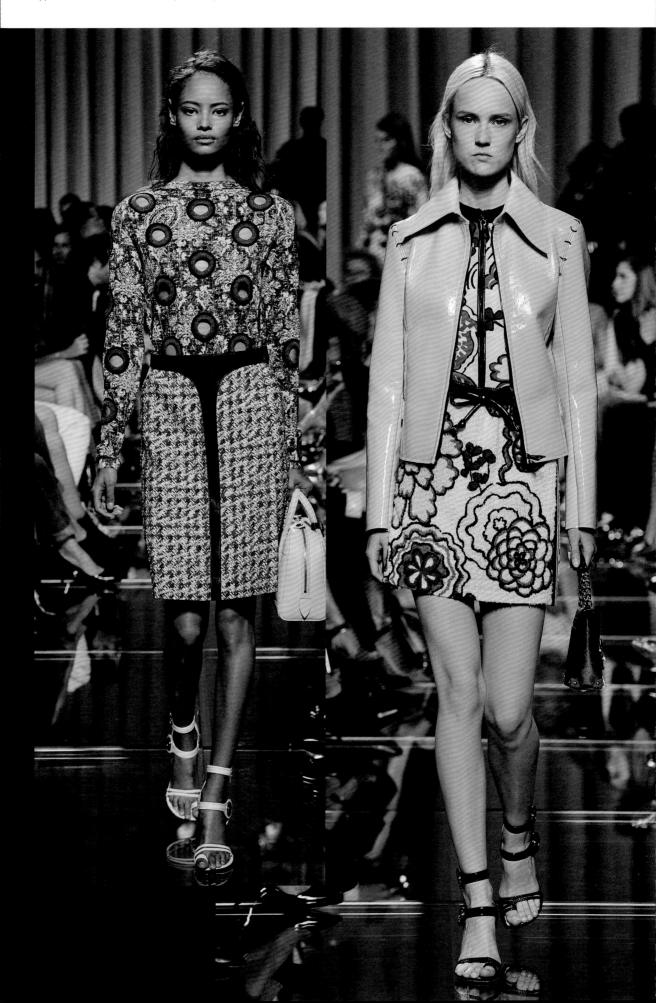

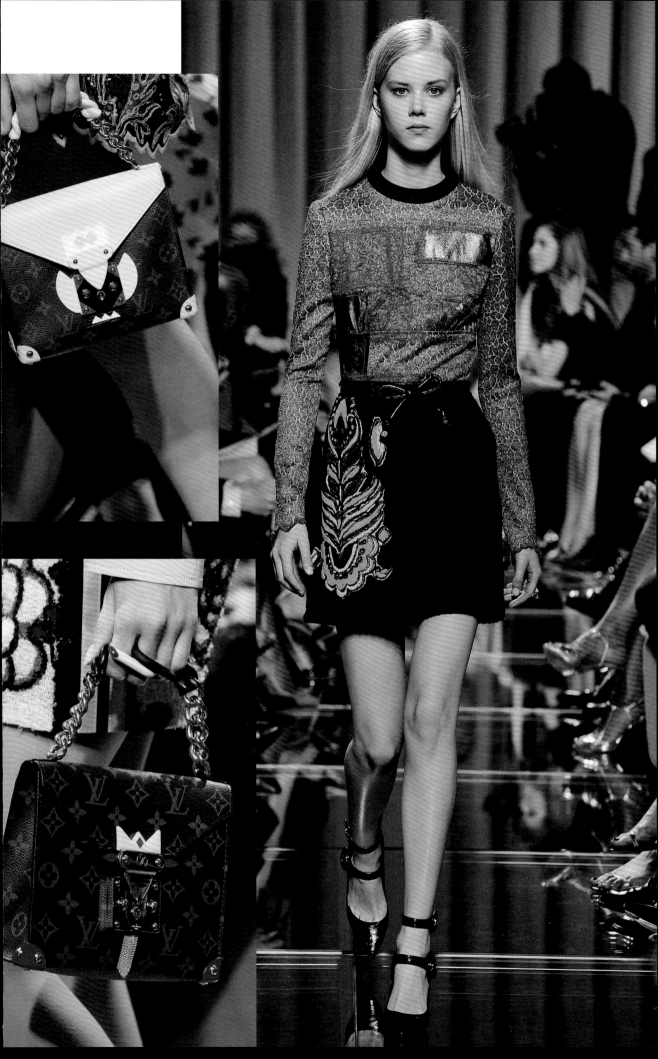

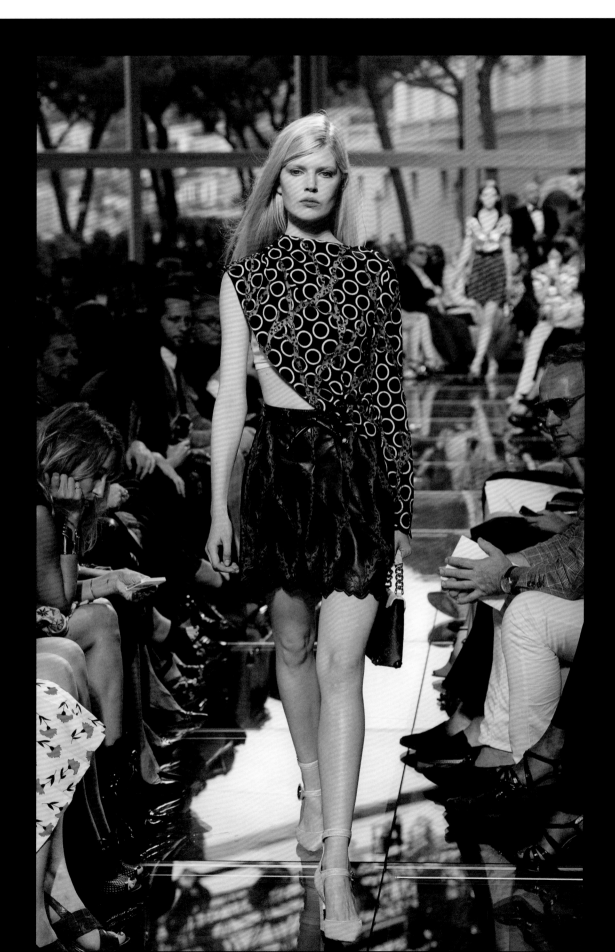

'Code-Named GEHRY014'

'Vuitton is a house that can travel in space and time,'
declared Nicolas Ghesquière after presenting his spring/
summer 2015 collection in the dimly lit basement of
Louis Vuitton's newly constructed space for art and
culture, designed by architect Frank Gehry.

Echoing the opening scene of David Lynch's 1984
sci-fi film *Dune*, Ghesquière introduced the show with
gigantic hologram projections of 15 people lip-synching
in unison: 'A beginning is a very delicate time... Day
zero in the heart of the project, code-named GEHRY014...
The audience is asked to sit in a place that doesn't exist
for now. A ship surrounded by a gigantic woodland,
a ship made up of 3,600 glass panels and 15,000 tons
of steel, a ship that serves as an incubator and ignites
our fellow creative minds... An undisclosed location at
this time. Oh, yes, I forgot to tell you, today, October 1,
the LV house wants to explore the ability to travel to
any part of the universe without moving. The journey
starts here in this place soon named the Fondation
Louis Vuitton.'

Ghesquière's time-travelling muse this season was
Edie Sedgwick, for the way she 'mixed' her clothes:
'She was nostalgic in a way, but projecting the 1980s
already, living fully the 1960s/1970s.' Model Jean
Campbell sported the show's opening look: a knitted
mini-dress, with disc-shaped metal and resin earrings,
black patent-leather ankle boots and the Twist bag
in blue Epi leather (opposite). British *Vogue*'s Sarah
Harris noted: 'This cool retro A-line silhouette
continued, now pieced together in diagonal stripes
of navy and red eel skin. It developed into a tapestry-
printed velvet line up of cropped flares and quilted
biker jackets, button-bibbed white woven dresses
and others covered in black micro sequins.'

Also included were white denim jeans with Pop Art-like
prints showing cars, lipsticks and eyelash curlers (see
p. 483), statue-embroidered dresses (pp. 486–87), and a
velvet dress in a wallpaper-print reminiscent of William
Morris (p. 489, left). Grenadine-coloured outfits (p. 490)
bore reworkings of the coral-like 'ramage' motif of the
previous season.

Architectural heels took the shape of the LV monogram
flower (see p. 482, bottom left), and the models carried
a dazzling array of bags, including the GO-14 (see pp.
482 and 483), Cloud Clutch (p. 485, top left), Monogram
Dora (pp. 486, bottom left, and 487), and Besace
Ronde in calfskin and suede (pp. 488 and 491).

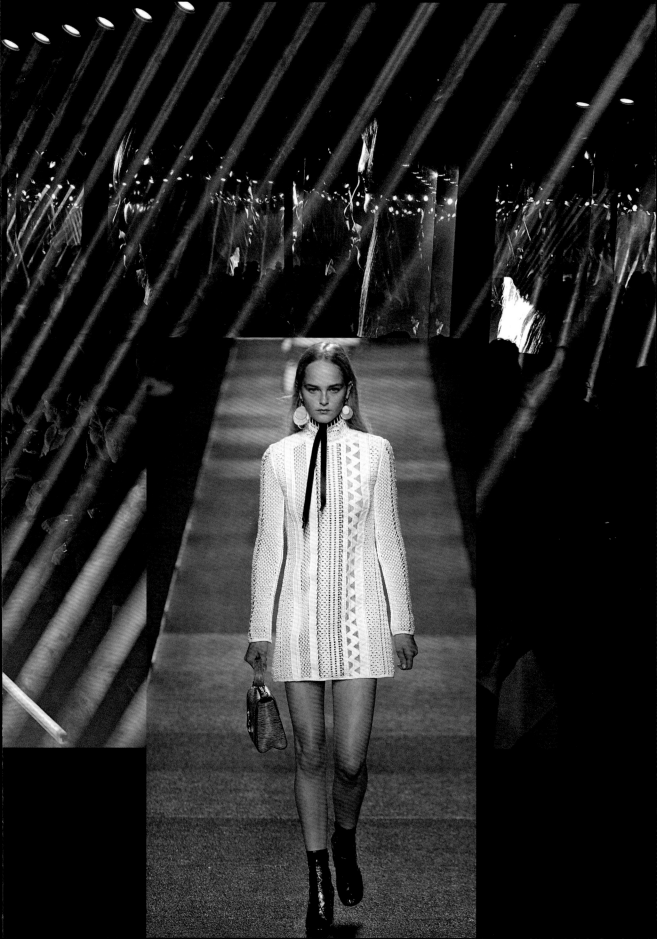

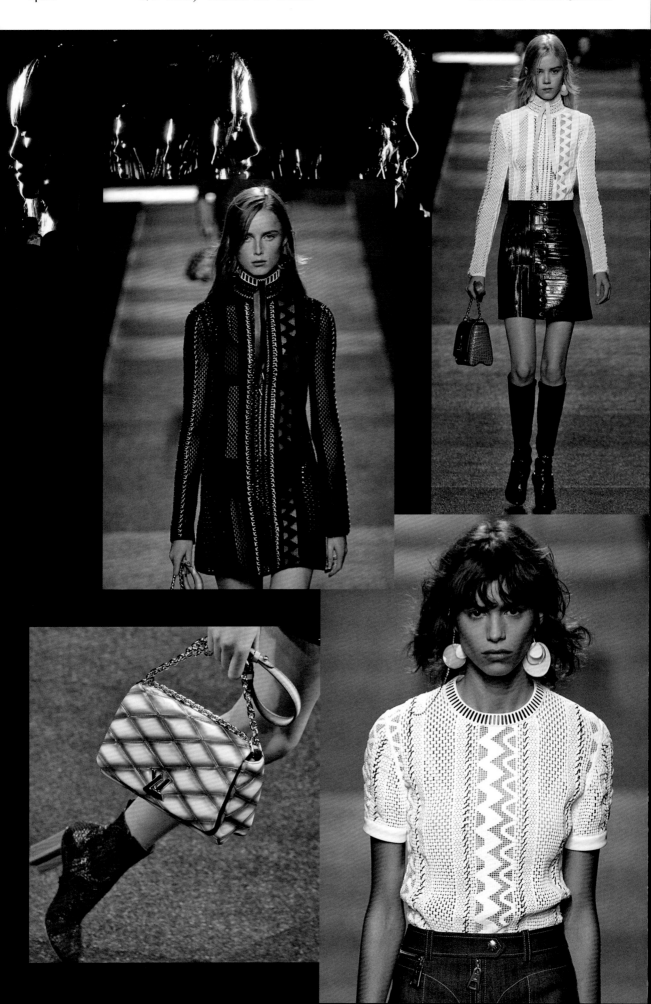

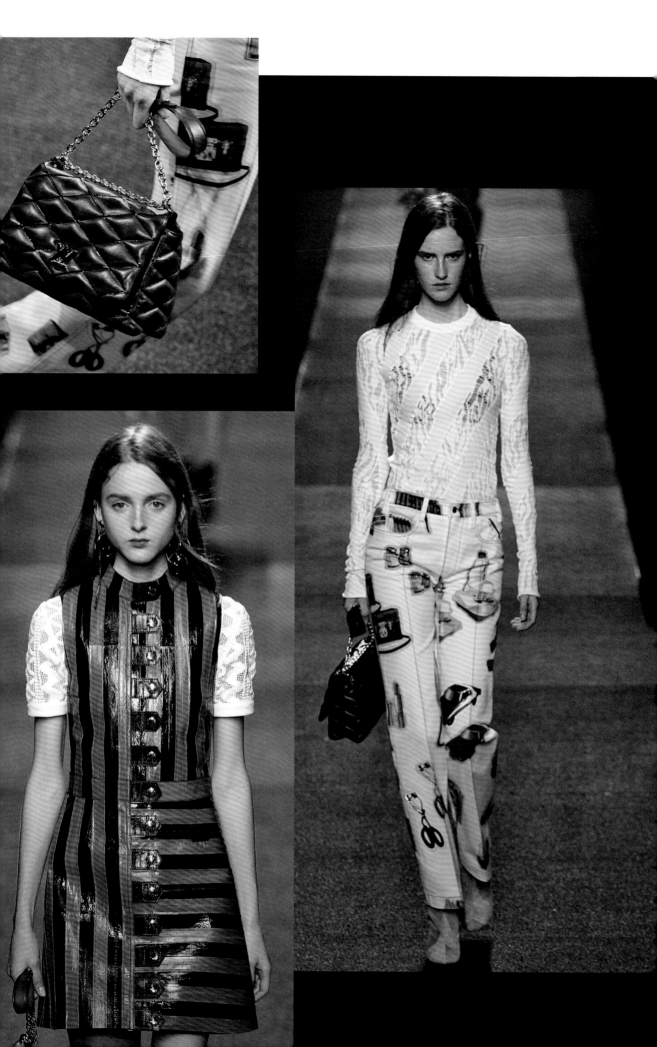

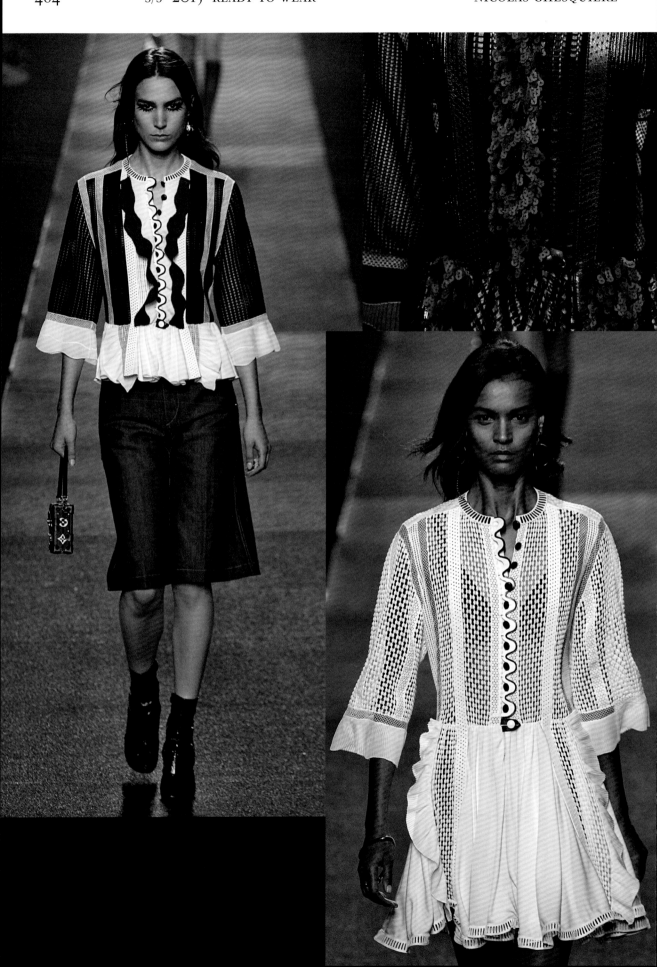

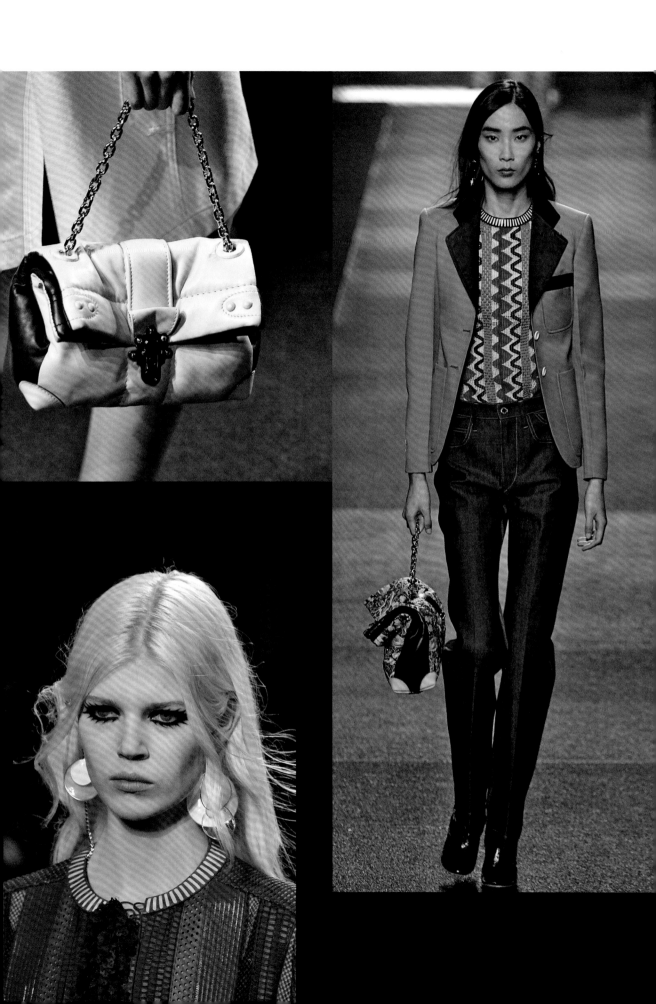

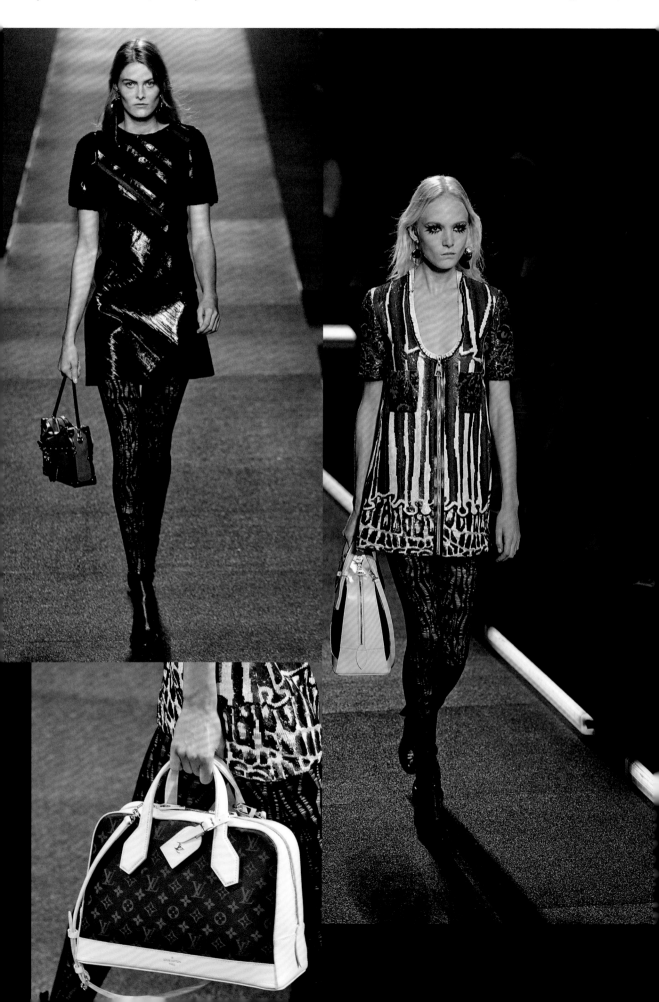

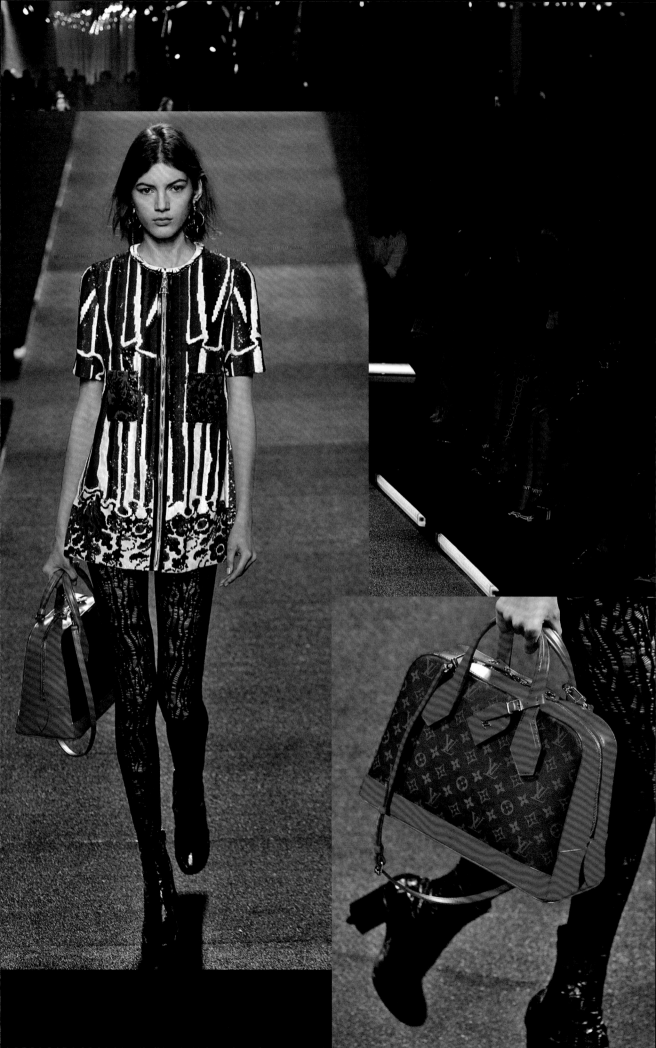

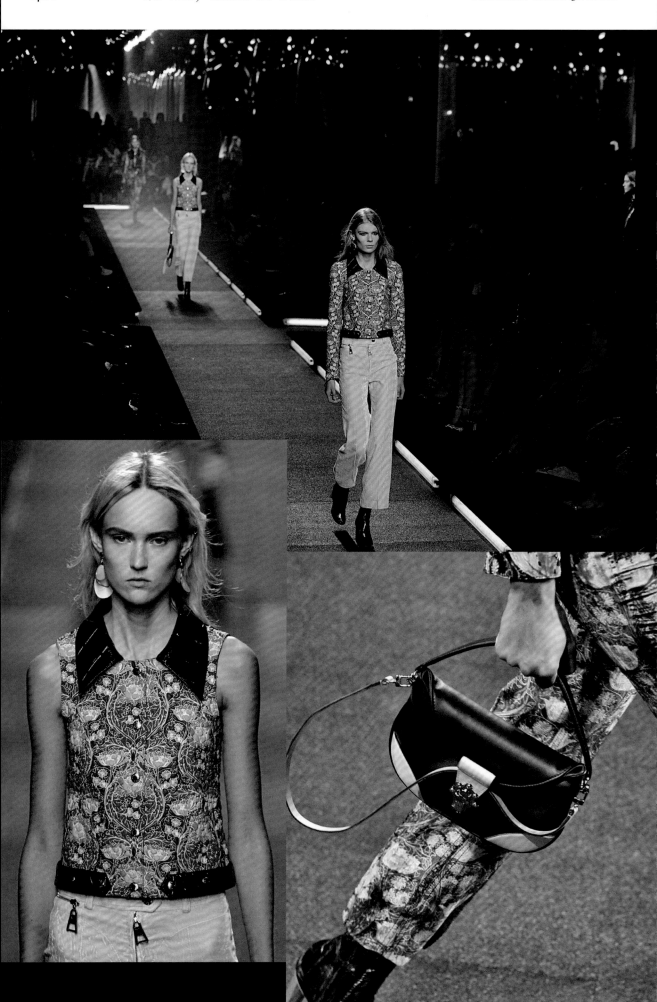

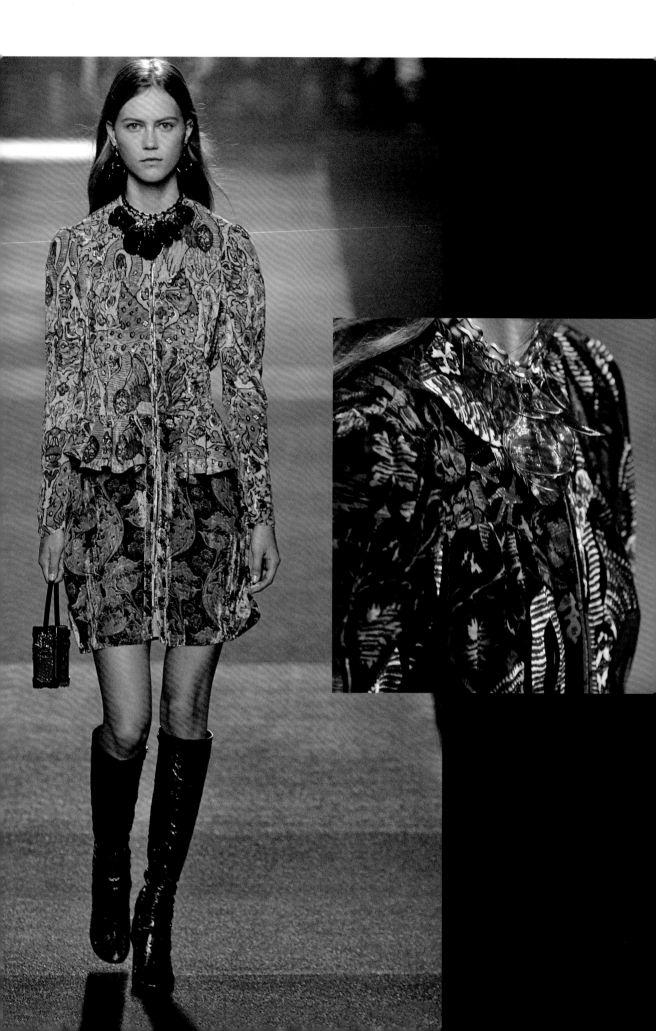

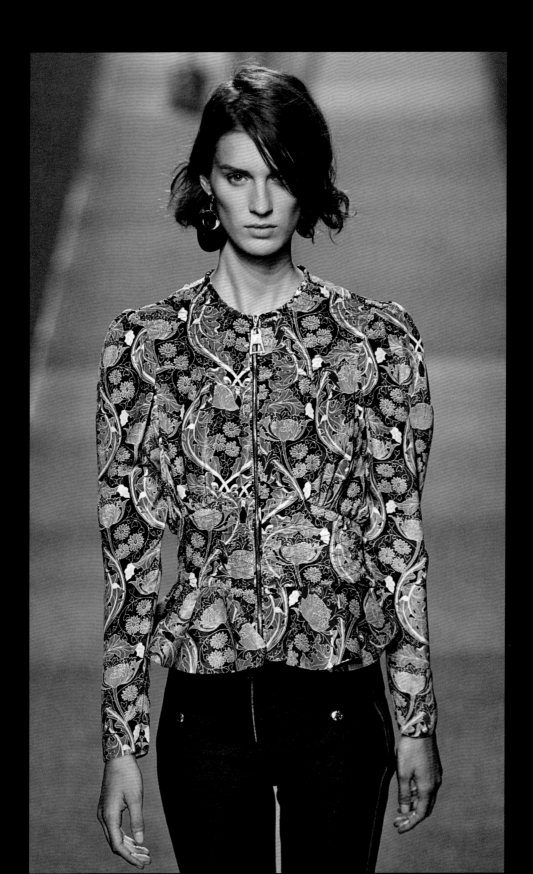

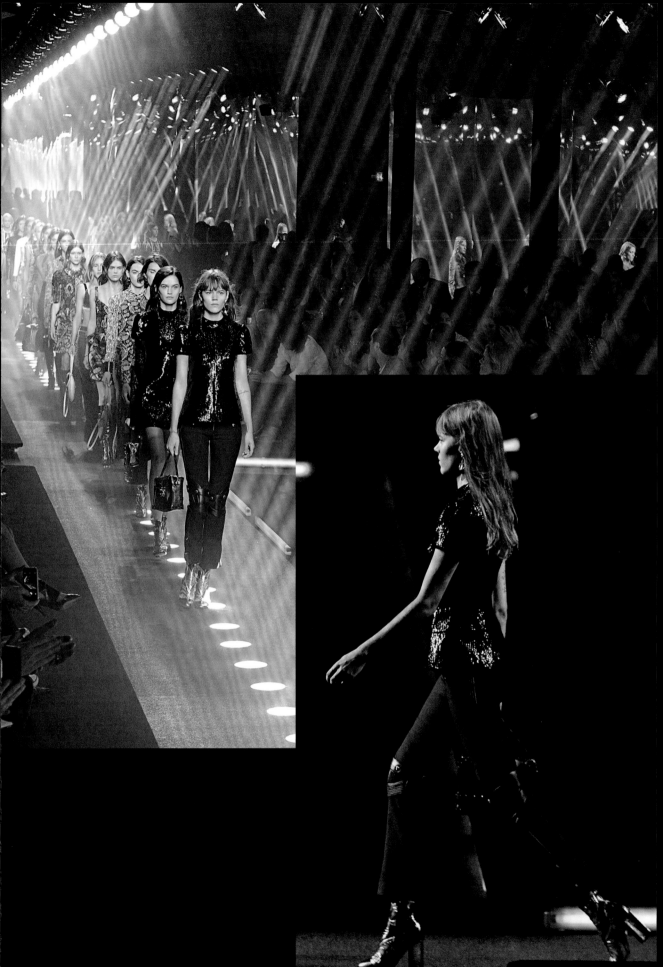

Under the Domes

Presented in three gigantic geodesic domes erected in the grounds of the newly built Fondation Louis Vuitton, Nicolas Ghesquière's fourth collection for the house merged tradition and technology. 'A drone flew over the venue, and twenty-one video screens were arrayed on each of the metal scaffolds propping up the domes' see-through roofing; they played different angles of the show back to the crowd as it was happening,' *Vogue*'s Nicole Phelps reported.

The woman of the season had an 'active, dynamic, athletic and elegant' silhouette, mixing urban rock attitude with historical influences. 'The idea was to build this observatory station,' Ghesquière explained, 'to receive this crowd of women who are themselves a bit of an explorer. This time it was about a lot of individuality. How women today explore in many ways and mix things.'

Freja Beha Erichsen opened the show, sporting an oversized white fur coat and strapped ankle-length booties, and carrying a silvered mini-trunk marked with her initials (right and opposite). Retailing for 15,000 Euros, the Boîte Echappée Belle in silver Epi leather was inspired by the DJ vinyl case created for the house by Helmut Lang in 1996. Several other mini-trunks followed – in Monogram leather, aluminium, copper or ultralight carbon – equipped with storage space for iPads, chargers, and more. The travel theme was timely, with the opening of the Louis Vuitton 'Volez, Voguez, Voyagez' exhibition at the Grand Palais.

'In his third season, the designer has finally struck upon that dream combination of invention and heritage. His clothes had the futuristic edge that has always been his strength. But at the same time there was a pure and perfect modernity,' wrote Suzy Menkes. 'Even the new LV bags – those metal boxes used today for digital-equipment, and historically as car travel trunks – were examples of the designer's witty and smart approach.'

Ghesquière – 'treating classical fabrics in a technical way', as he put it – gave pride of place to fur, leather, metallics, ribbed knits (with curling, unfinished hems), serrure chain belts, cutouts, mutton sleeves, and A-line miniskirts and mini-dresses with zips and buckles. Signature house styles included a Damier patterned skirt suit (p. 500, left), Damier patchwork motorcycle jacket (p. 502, right), and an abstract Monogram patterned mini-dress with Edwardian sleeves (p. 505, right). '[Ghesquière's] Vuitton clothes are luxury sportswear at its liveliest – at once cool and wearable,' Cathy Horyn proclaimed.

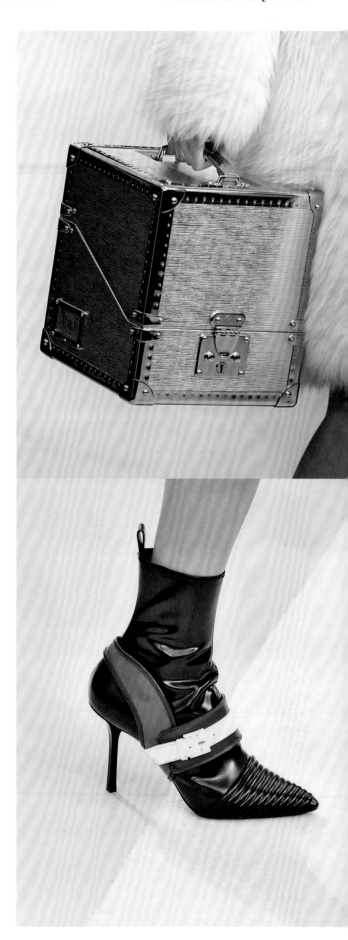

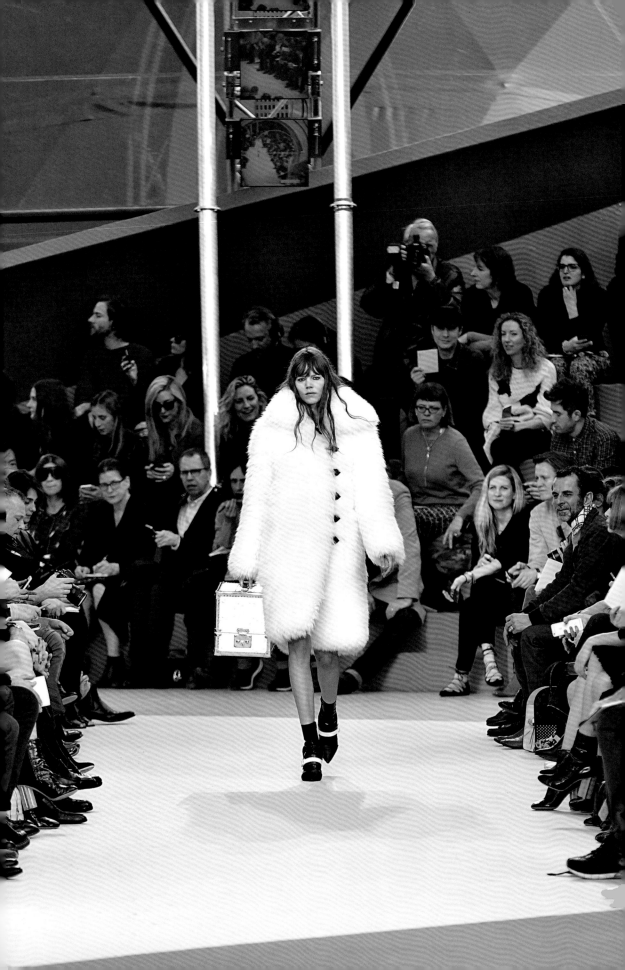

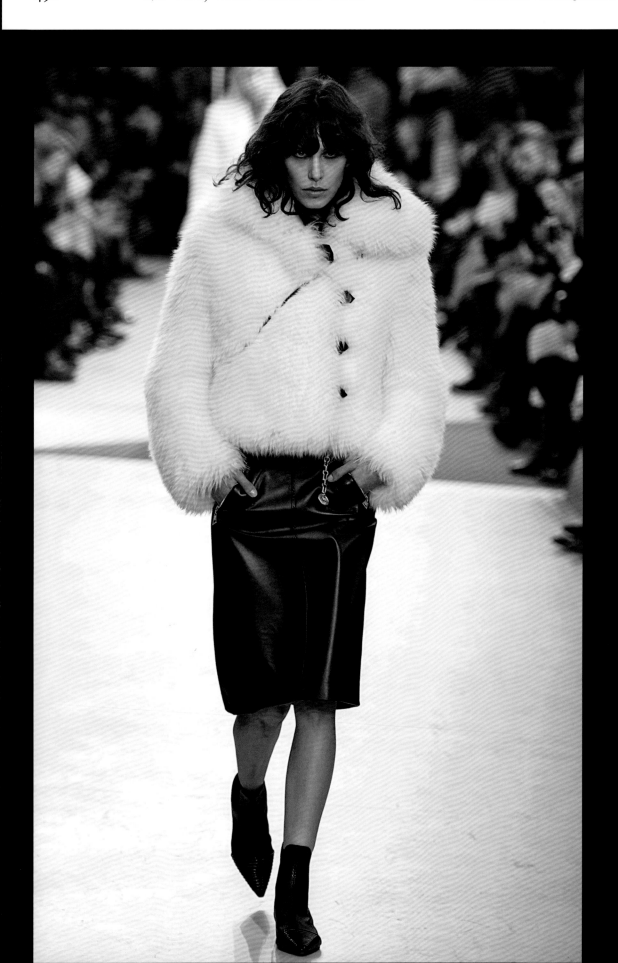

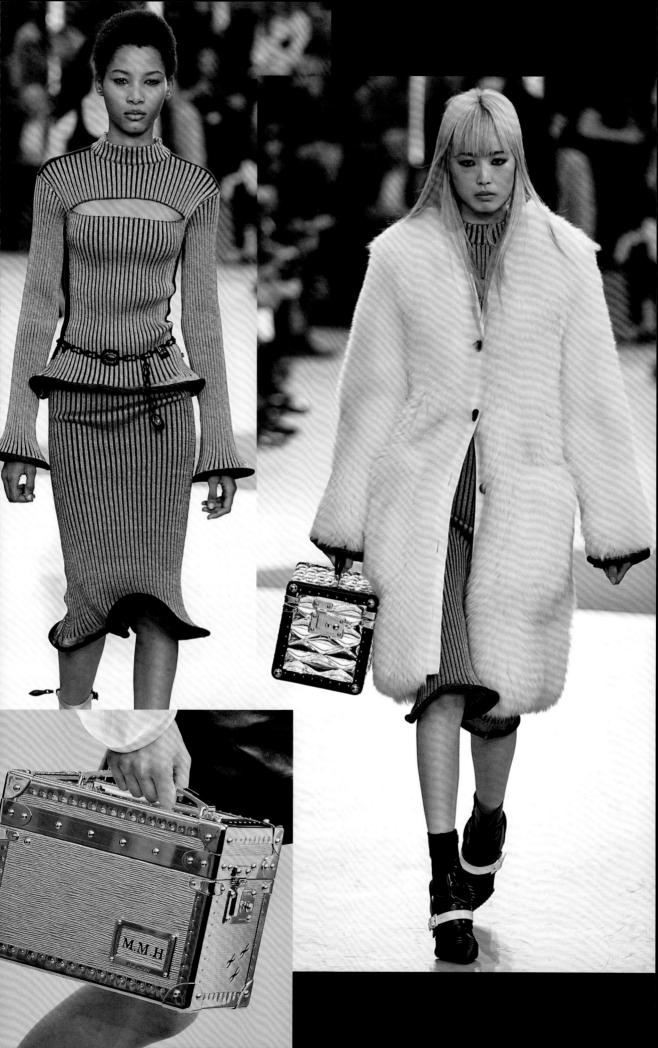

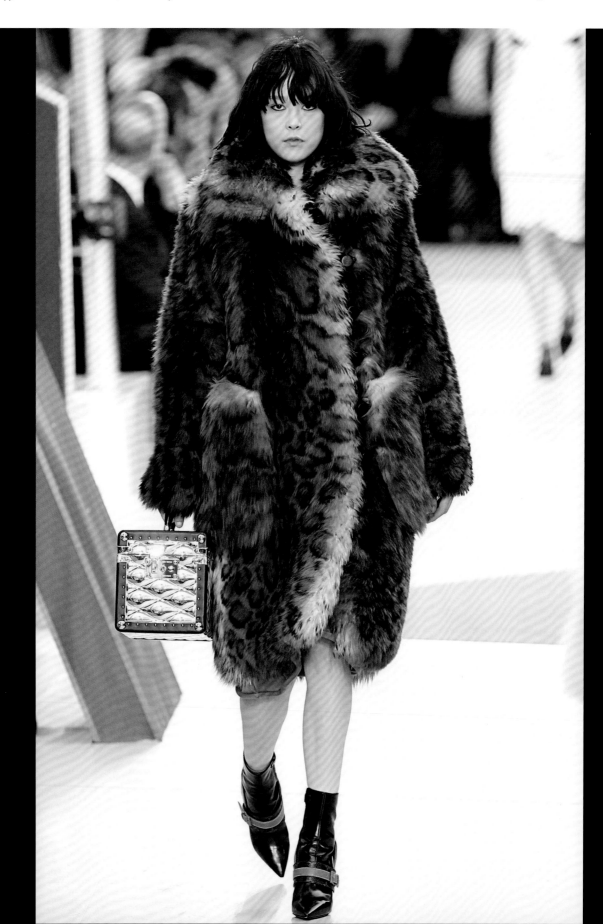

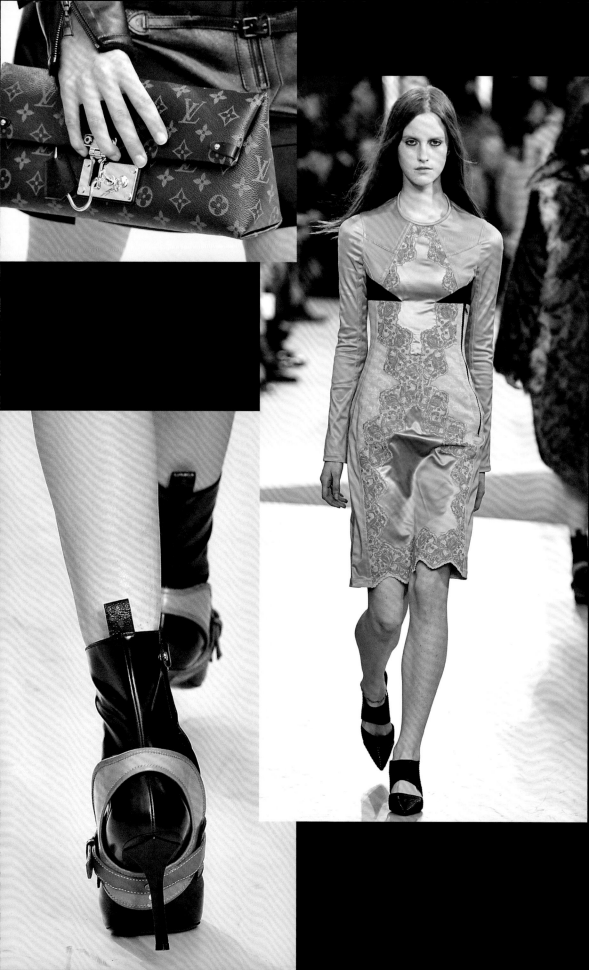

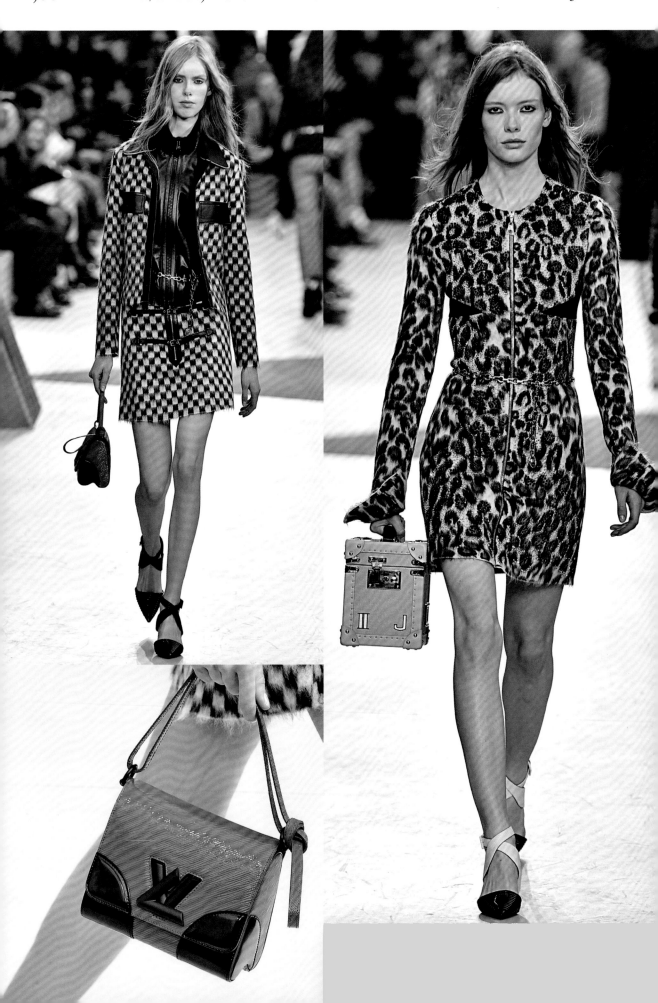

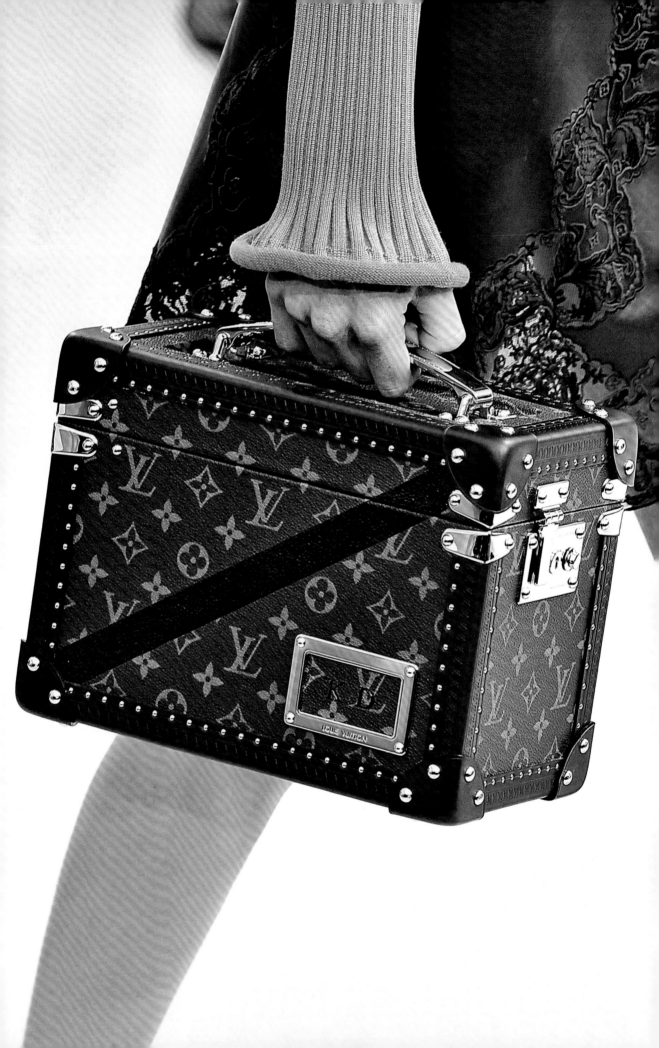

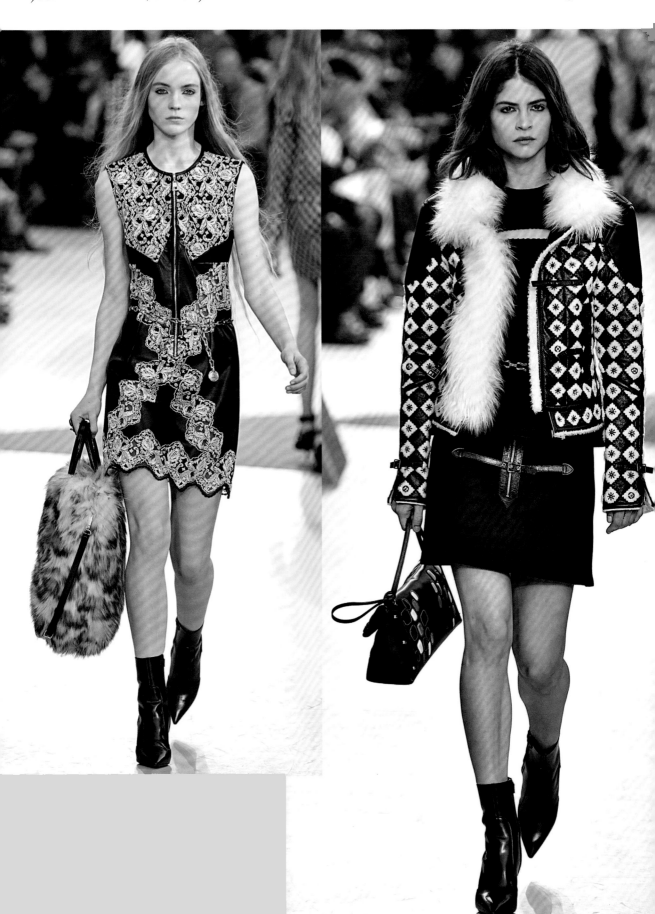

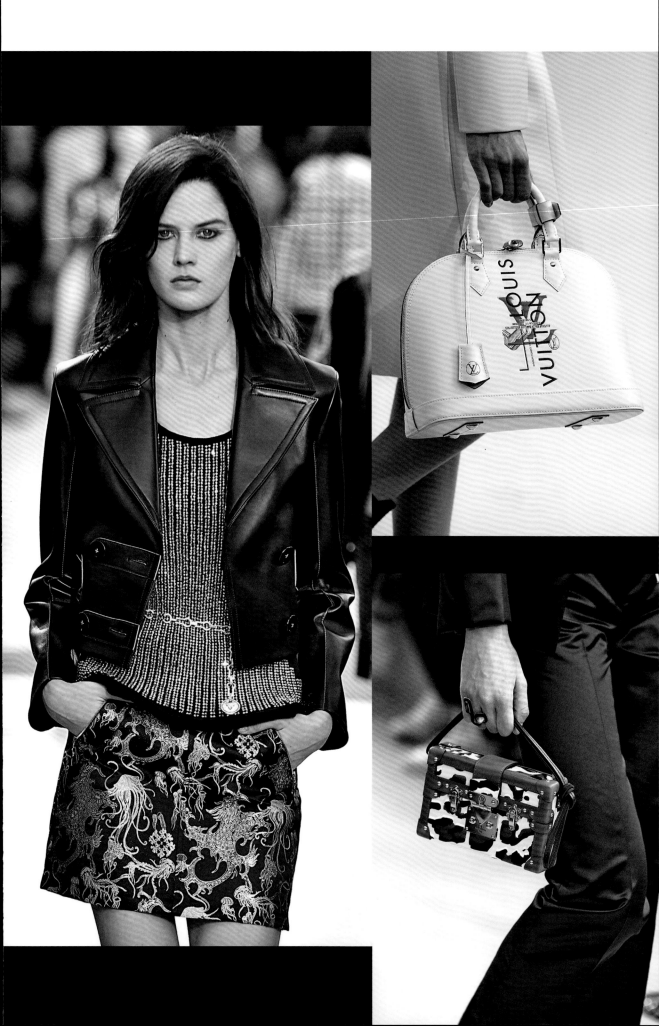

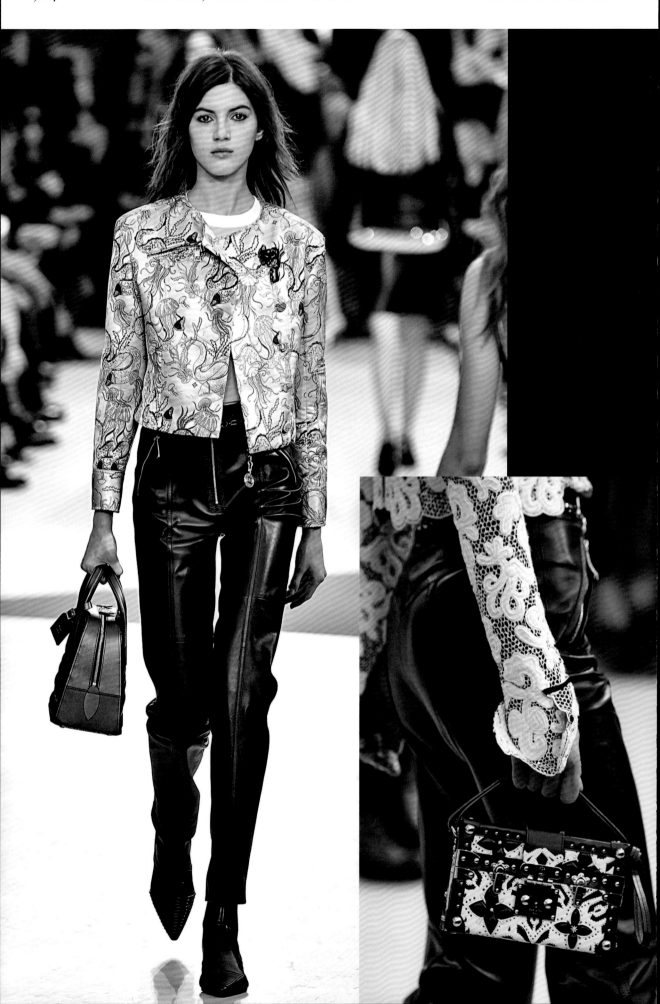

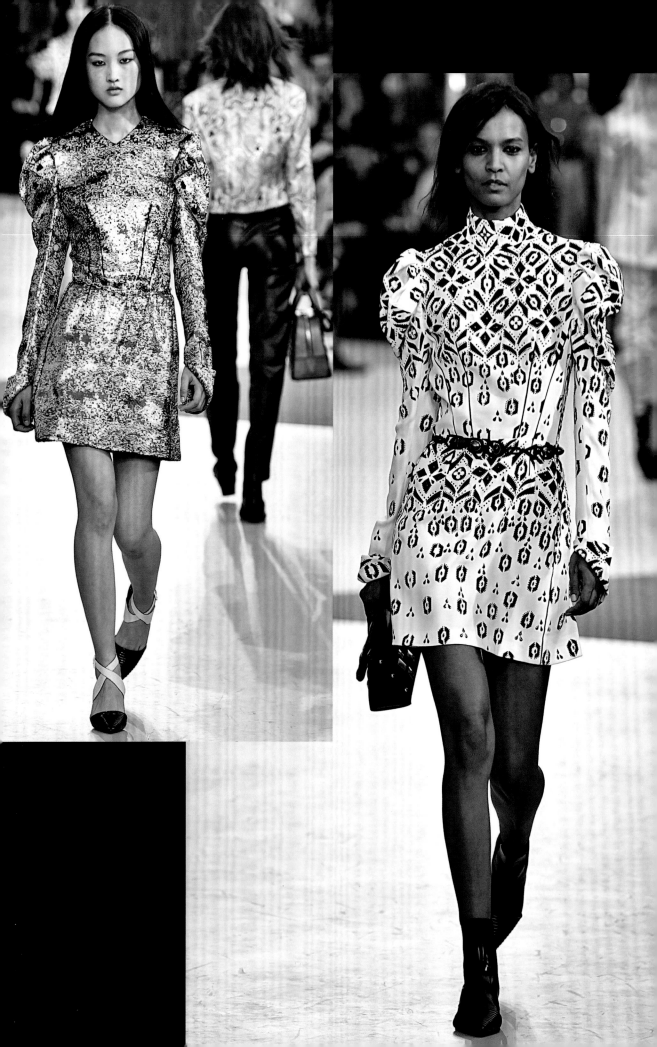

Palm Springs

'When you are here, you think "extraordinary travel",' said LVMH CEO Bernard Arnault about the location of the Louis Vuitton Cruise 2016 collection – the breathtaking Palm Springs estate of the actor Bob Hope and his singer wife Dolores. Nicolas Ghesquière had visited architect John Lautner's 1973 masterpiece 15 years earlier: 'I always dreamed … about the house that was like the city's castle. I was intrigued by its shape. And when I started at Vuitton, I already had the feeling that people are travelling for art and that this could be an architectural journey.'

The show notes stated that Ghesquière presented a wardrobe for a 'community of young women living at the gates of the desert'. Evoking a 'spirit of evasion and exoticism', and inspired by the kind of Californian women who populate Robert Altman movies, Ghesquière combined his American 'desert feeling' with French chic.

Fifty looks emerged, as the sun set and the graphic choreography took the models on a grand tour of the building, juxtaposing the architecture with the clothes. The silhouette, fabrics and accessories were all influenced by the Brutalist lines, modernist materials and colourful interiors. Ghesquière said: 'I was really inspired by the feeling of Brutalism created by Lautner, which is super beautiful, sculptural, sophisticated and technologically daring for its time – and which stands in contrast to the inside of the house, all of the Hopes' choices for the way they lived, surrounded by Hollywood glamour, with the flower wallpaper, the thick carpets, mirrors, water faucets shaped like swans. I adore this contradiction.'

Women's Wear Daily reported: 'The primary silhouette featured a full-ish top cropped short, its stretch banding baring the midriff over a long, fluid low-slung skirt. At times the top was rendered as an abbreviated motorcycle jacket; at others as a sparkly take on a sweatshirt. Brutalist aspects came in accents of leather and hardware: a wide grommeted belt crisscrossing in front; capelet-like sleeves punctuated by multiple rows of grommets. Conversely, a group of long dresses with sober frills drew on gentle notions of Victoriana and looked spectacular in leather lace.'

Models wore flip-flops, sneakers, high-tops and desert boots, and carried an array of iconic handbags including the Dora, Alma, GO-14, and a Monogram rucksack (see p. 513, bottom right). New styles included a larger version of the Petite Malle in an aquatic pattern (p. 509, bottom left) and the Twist handbag adorned with a graphic palm tree-inspired design (p. 511, top left).

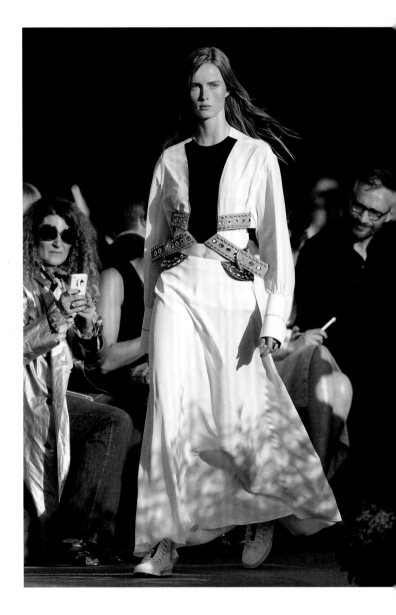

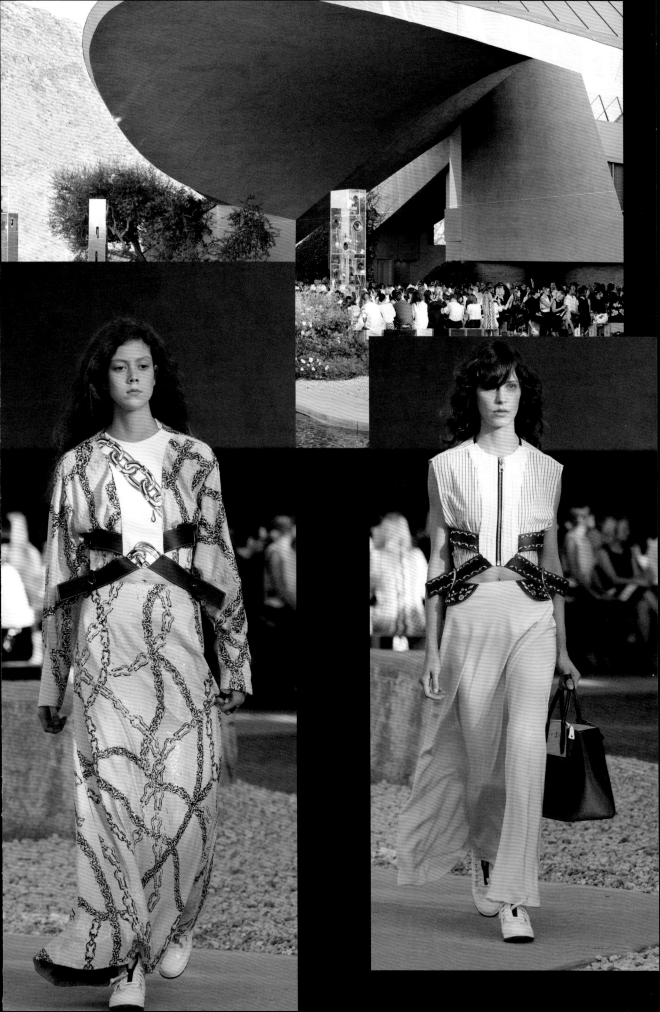

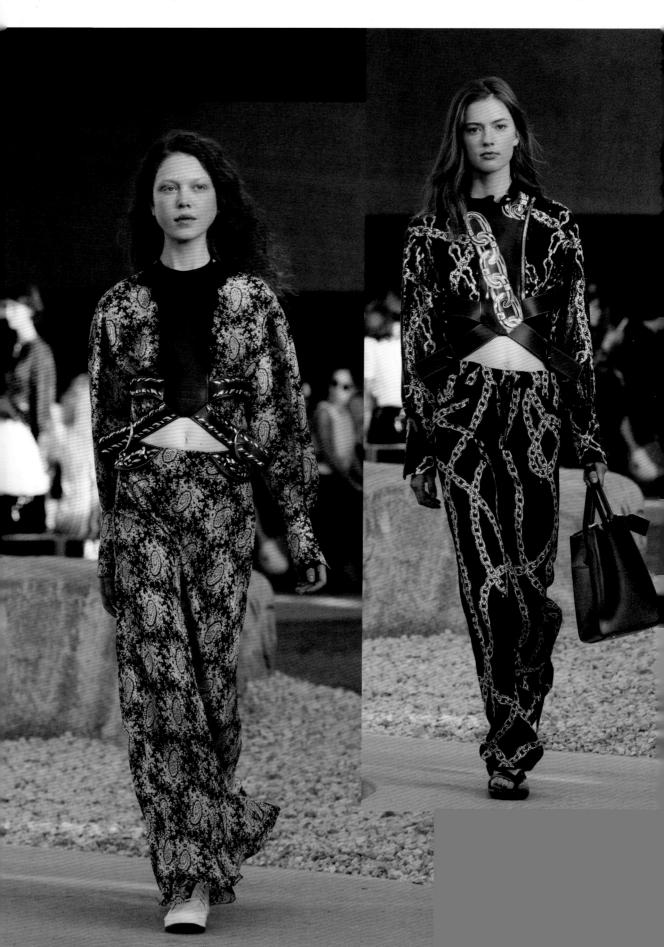

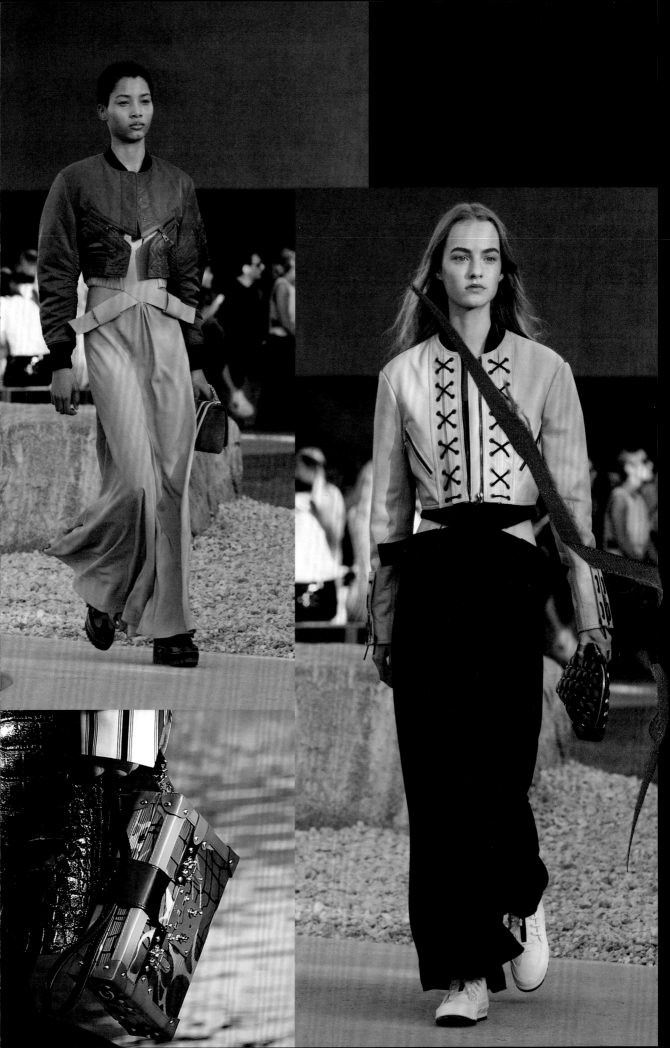

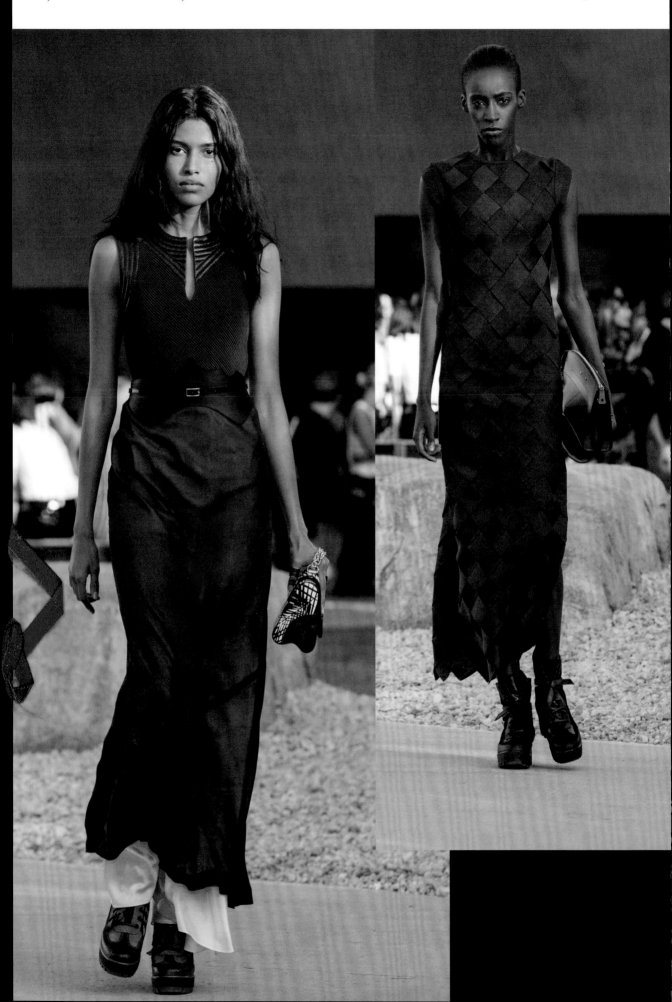

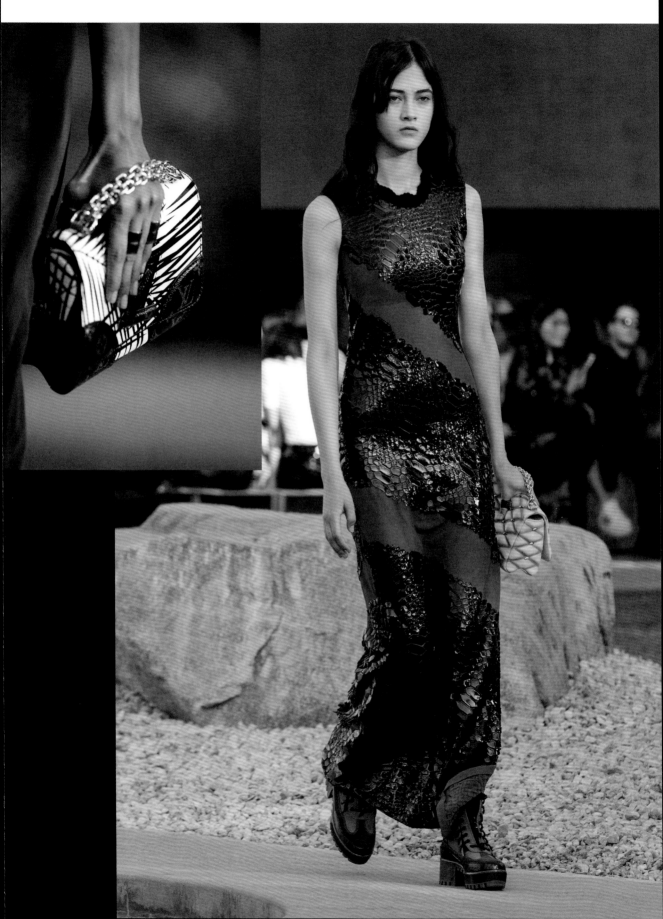

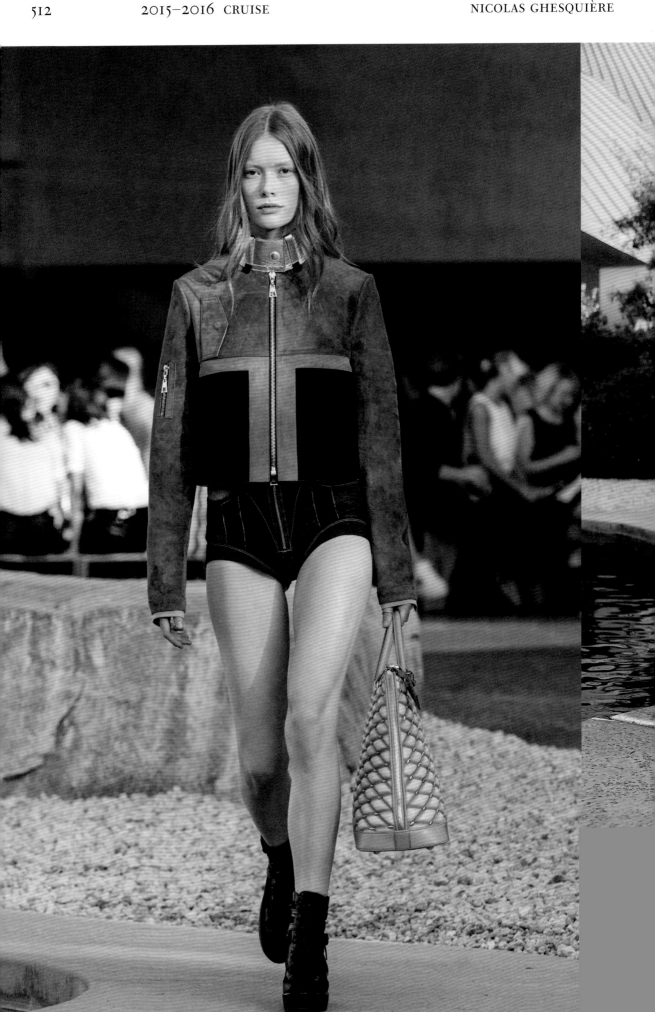

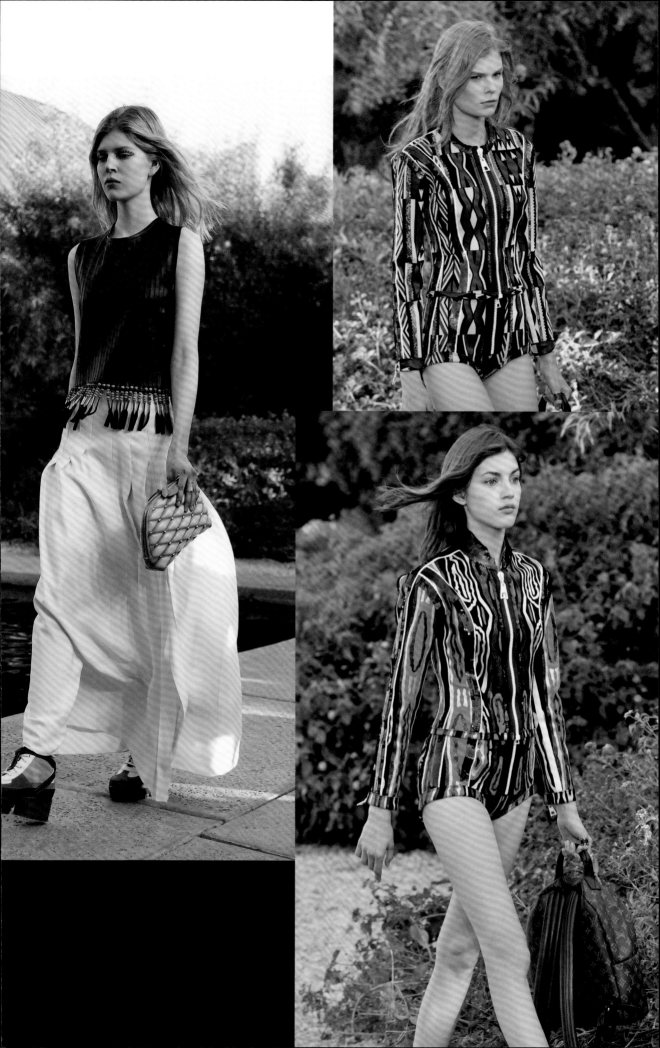

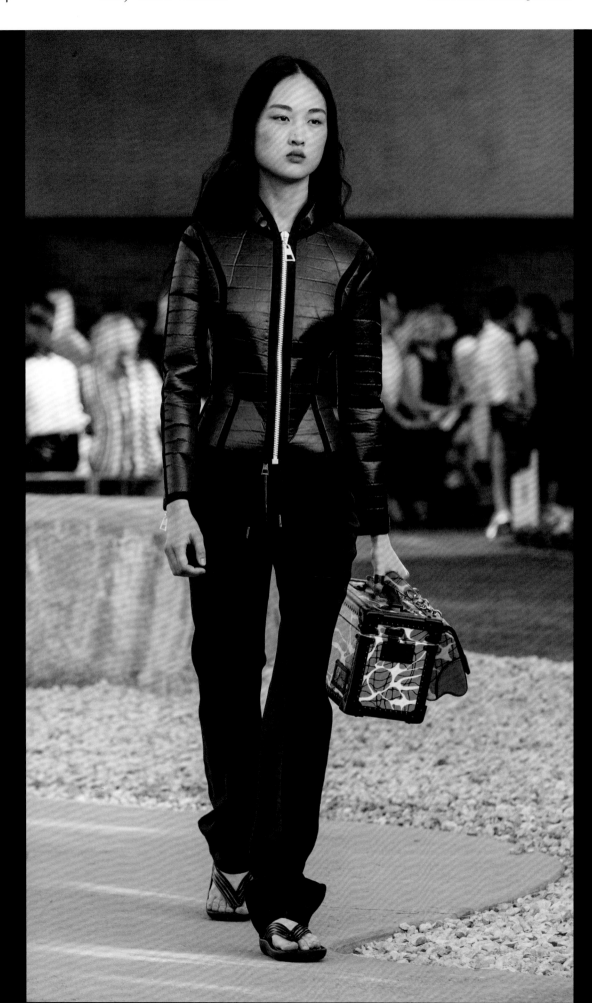

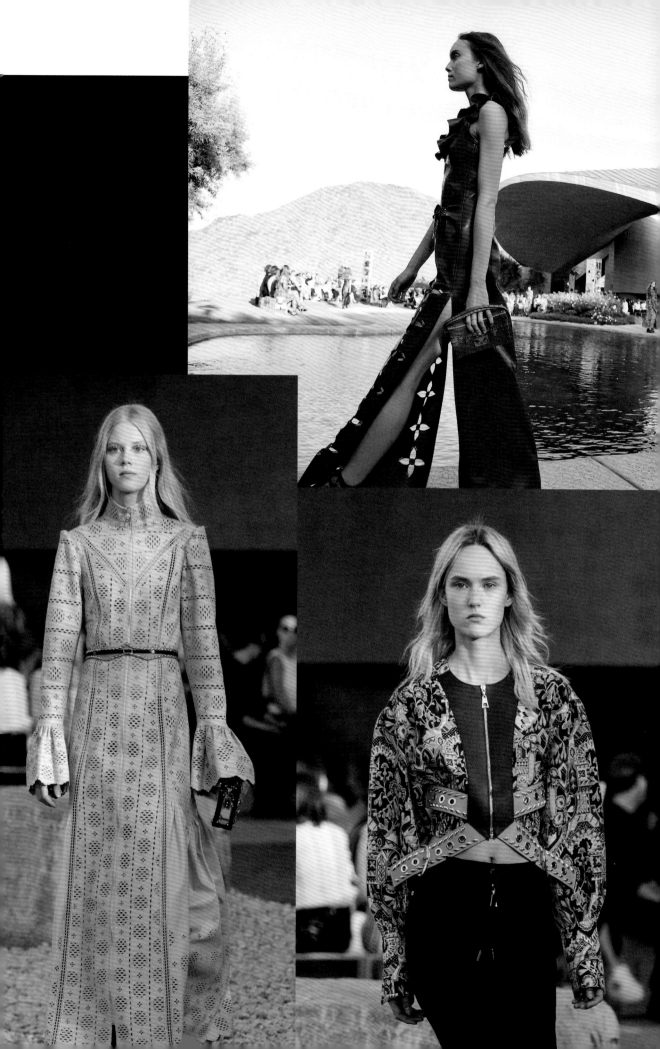

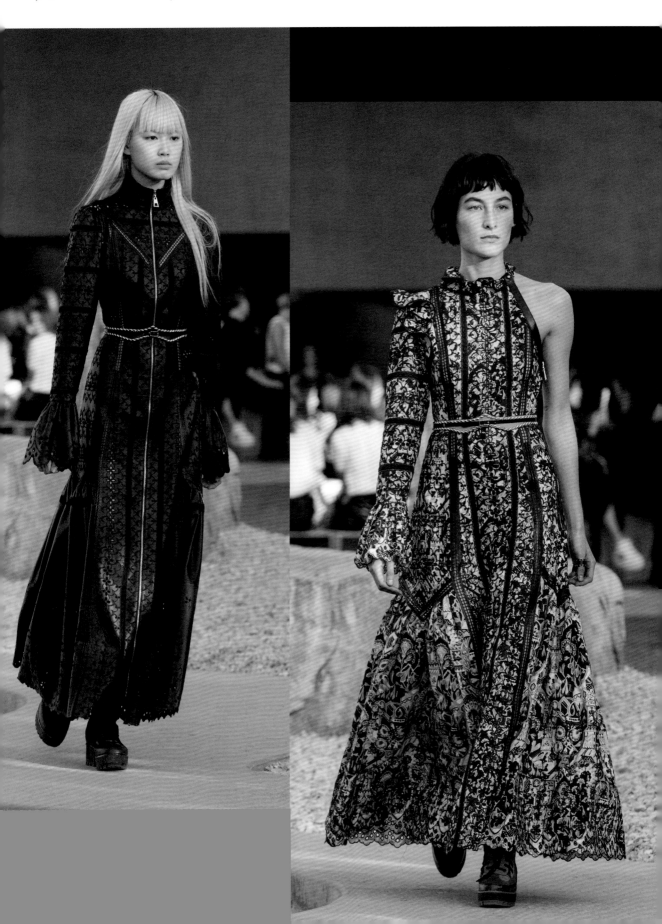

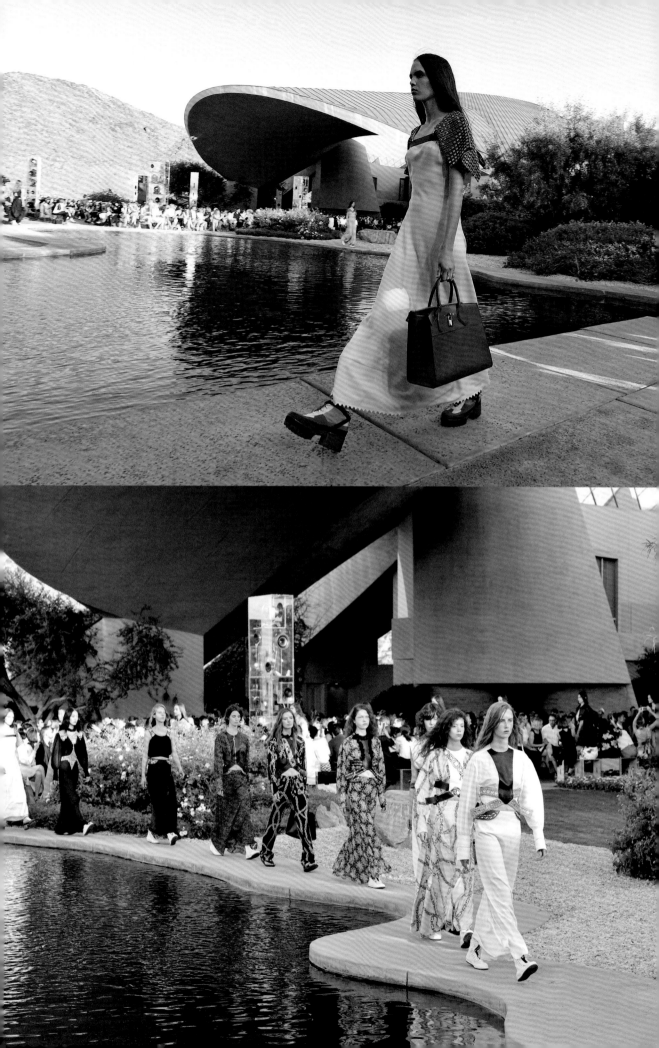

'Heroic Fantasy'

Set in the gardens of the Fondation Louis Vuitton,
the spring/summer 2016 show was presented inside
a custom-built black box encasing a geometric
catwalk landscape of moving metal structures and
giant screens with video projections – what the house
called 'a universe with futuristic accents'. As Nicolas
Ghesquière announced: 'Today, with Louis Vuitton,
I took you to the frontier of the digital world.'

The collection was inspired by travel to cyber spaces,
with multiple nods to video and online role-playing
games (the show's music included themes for Minecraft
and Atari, and Daft Punk's *Tron: Legacy* soundtrack).
'The vocabulary of virtual worlds beckons us to initiate
a quest, a maiden voyage, a heroic journey,' read the
show notes. 'This collection is about stylistic role-
playing, where the heroine passes through various
sartorial levels and explores a universe of multiple
atmospheres.'

As part of this 'Heroic Fantasy' game play, the house
continued, 'the entire evolution of a classic, urban
wardrobe is gradually remastered, rooted in the illusion
of materials that are, in fact, very real': silk jumpsuits
dyed to evoke denim or printed with trompe l'œil mesh
patterns (p. 521), painted leather jackets (p. 525), and,
as Tim Blanks described them, 'spectacularly squirmy
dressed-up looks made of tulle covered with celluloid
sequins, under which the fabric was bubbled and
then hand-painted' (p. 529).

Ghesquière's sources of inspiration ranged wide, 'from
the digital girls that star in the Louis Vuitton window
displays to the work of Wong Kar-wai, and in particular
the film *My Blueberry Nights*, not forgetting the actress
Doona Bae, my great friend and muse, and the Japanese
manga *Evangelion*. What you see on the catwalk is not
the future; it is my vision of the present.'

Candy pink-haired Fernanda Ly opened the show
(right), wearing a matching pink biker jacket with
embellished leather kilt, fingerless half-gloves, platform
sandals, futuristic tiara and GO-14 bag. Other key
accessories were given a tough, adventure-ready look:
chain handles or chain prints (continued from the 2016
Cruise collection) adorned the Papillon (opposite) and
the Alma (p. 520, bottom right), while studs and leather
tassels were added to Mini Lockit (p. 524, top left) and
Twist bags (p. 524, bottom left); the new Petite Malle
Nano Trunk came with rounded corners (see p. 520,
top right).

The designs 'felt like an optimistic take on modernity:
real fabrics ... cut into clothes with a sharp, cyber-edged
functionality infused with humanity,' wrote Tim Blanks.
'As the show notes read, "The only limit is your
imagination"'.

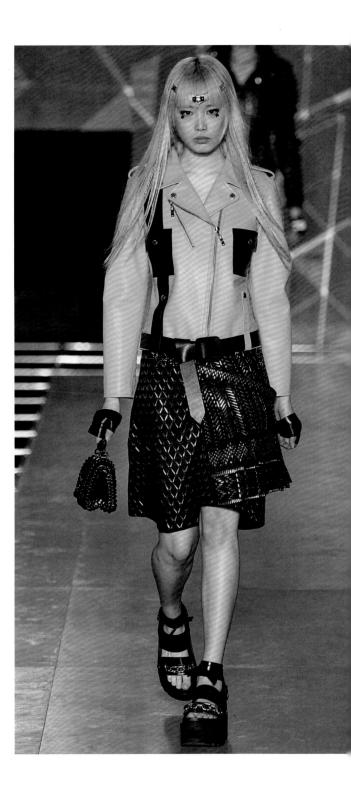

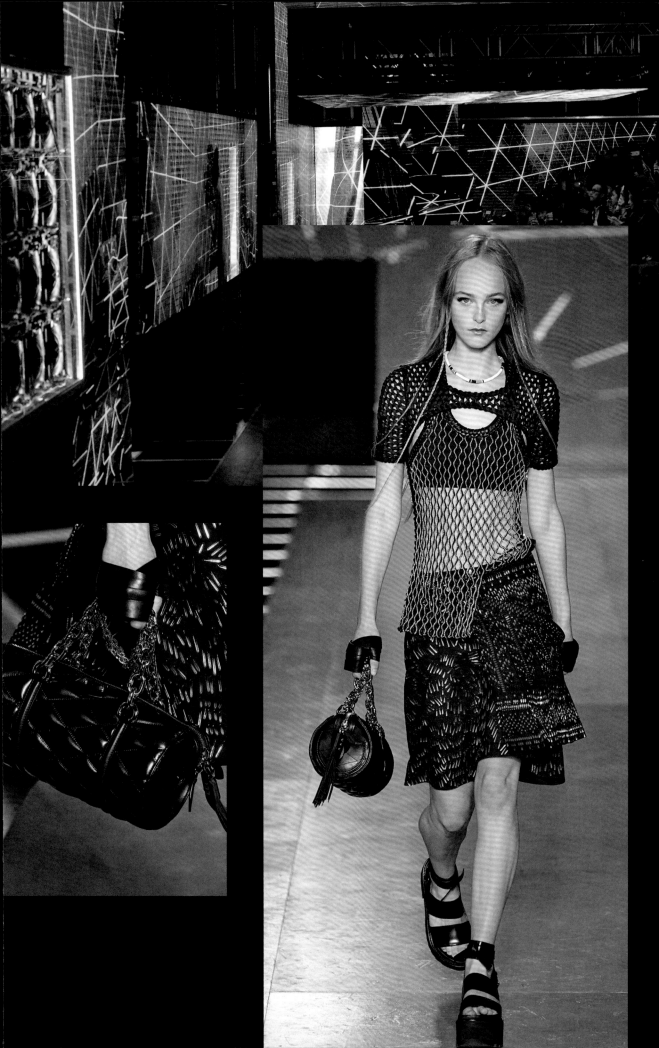

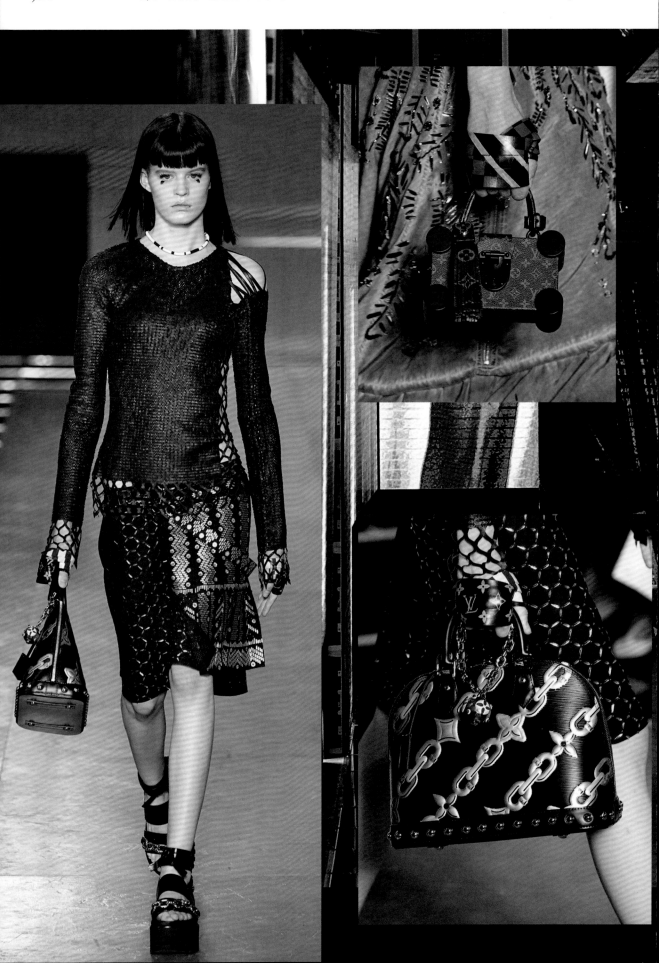

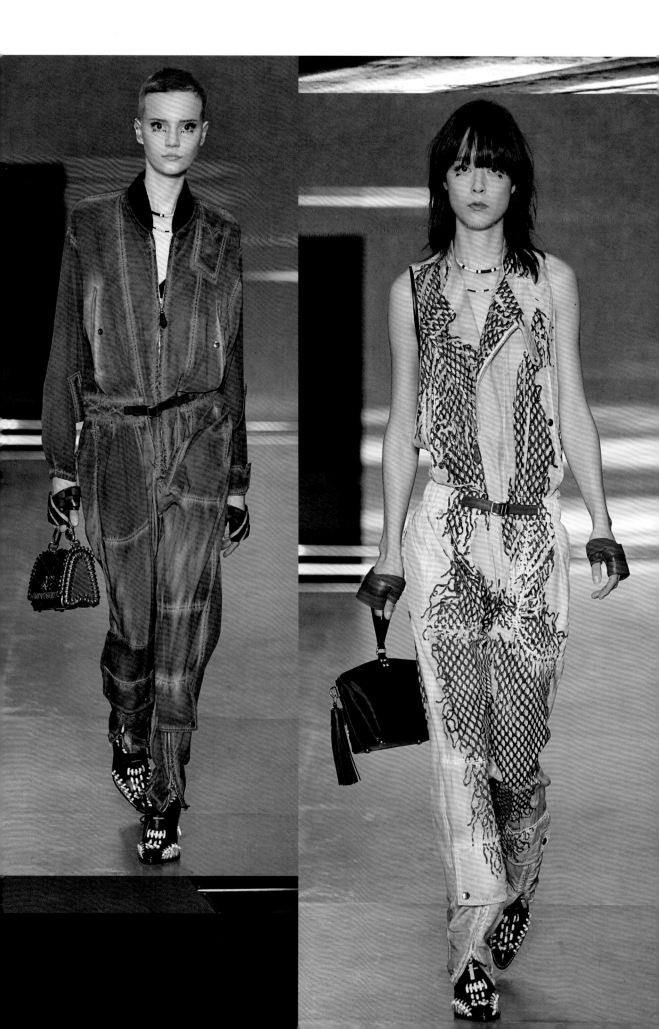

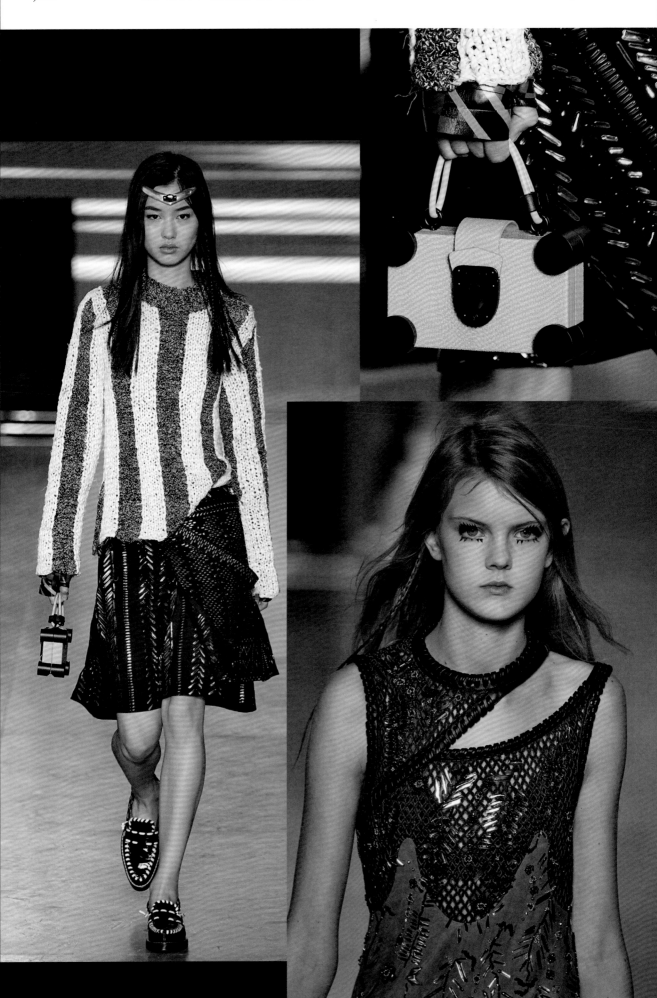

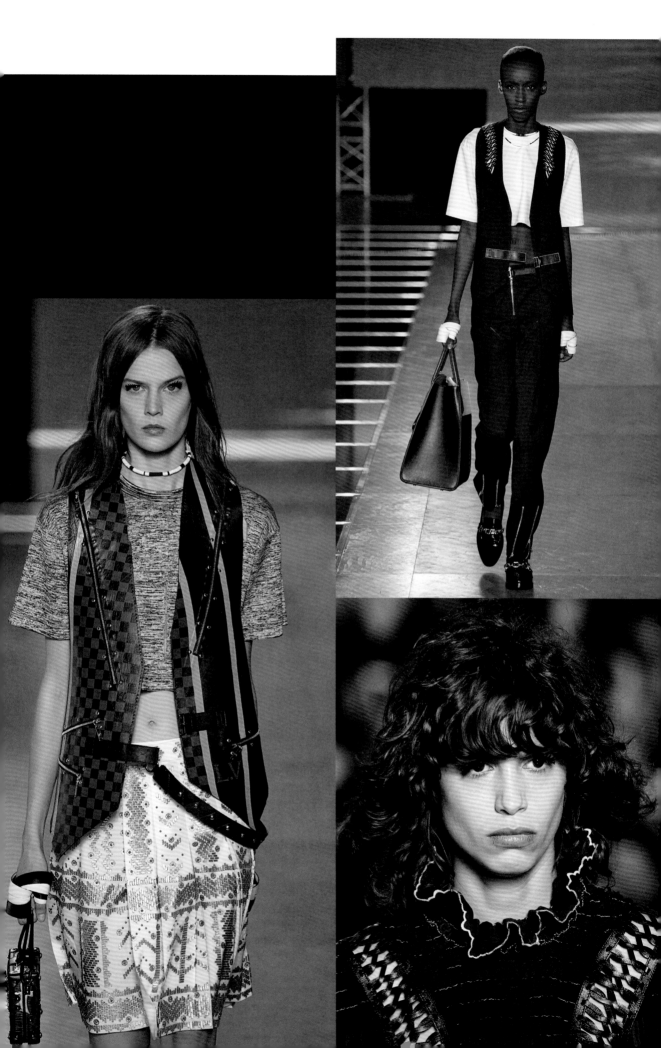

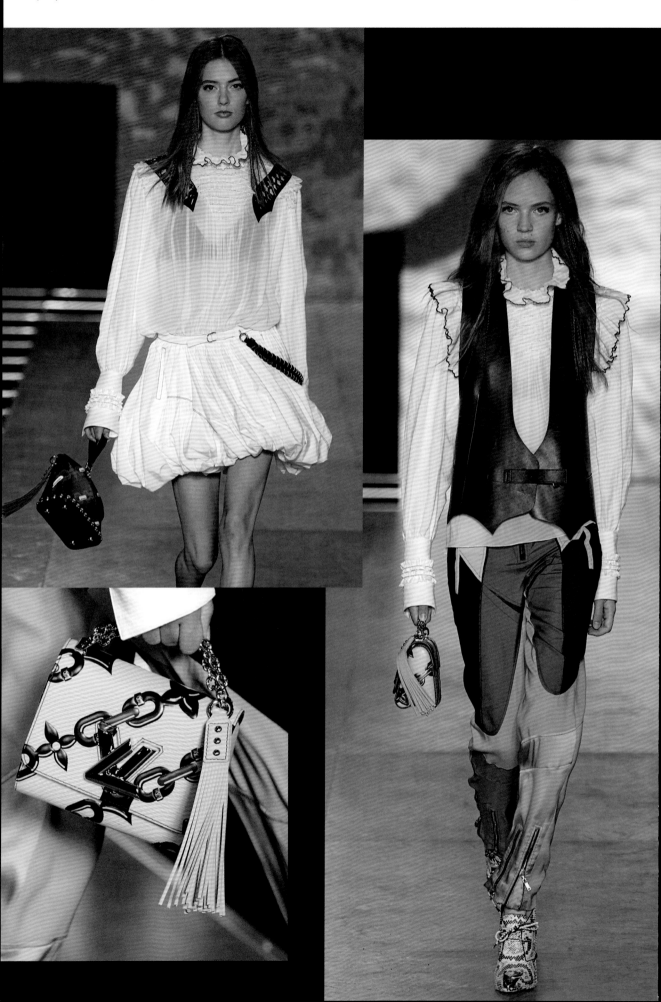

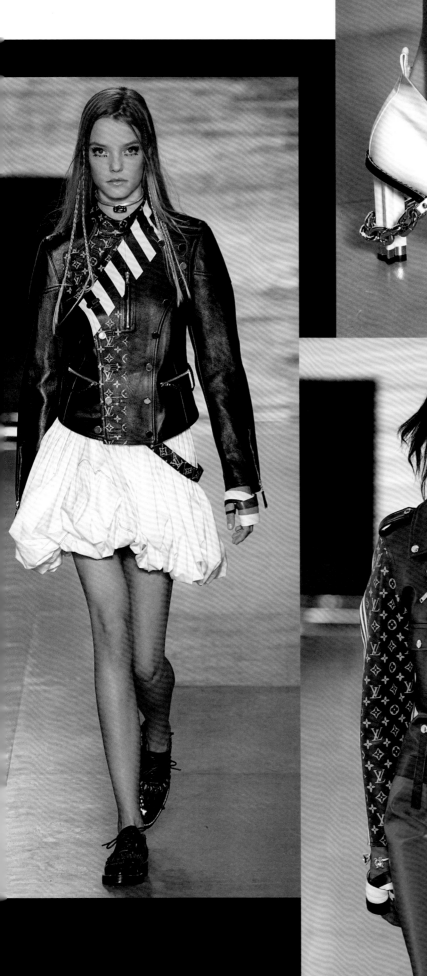

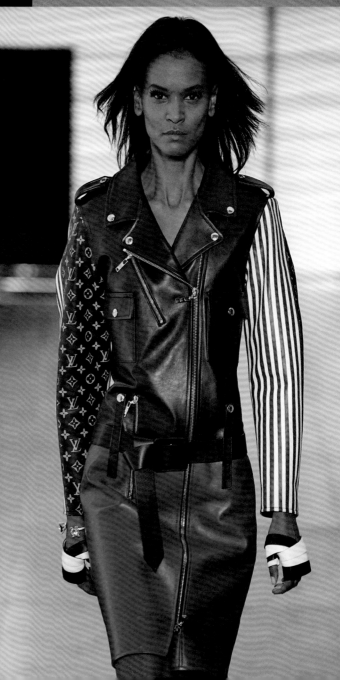

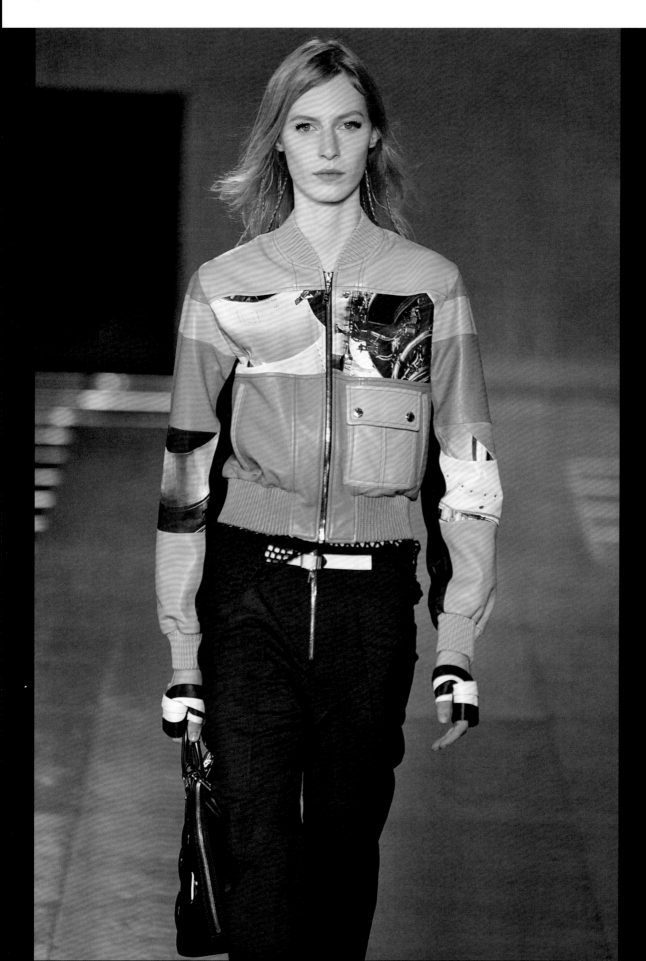

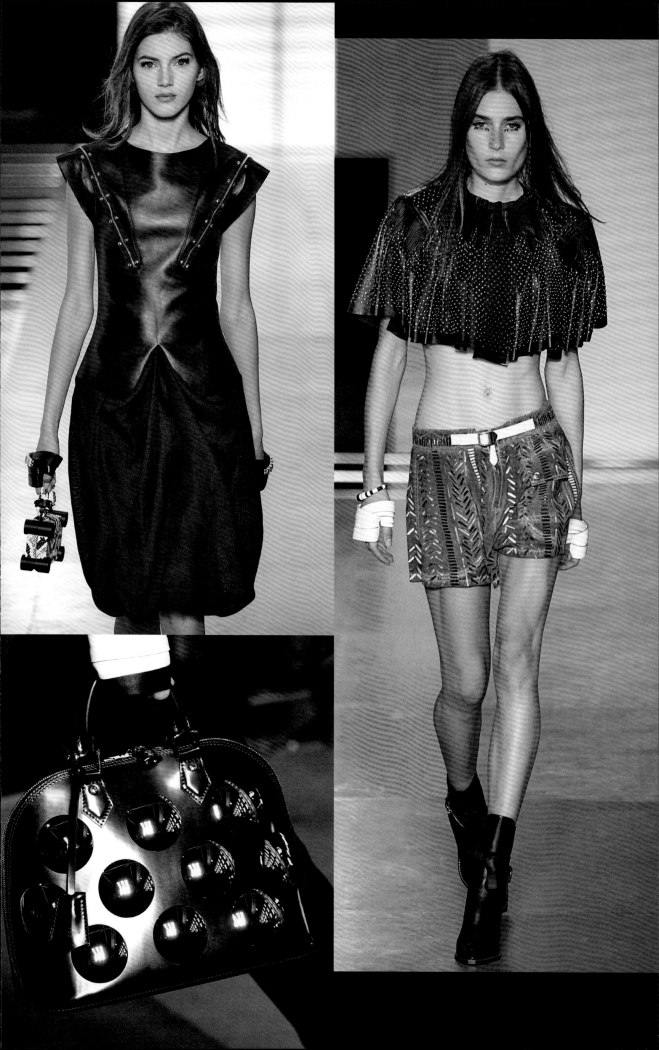

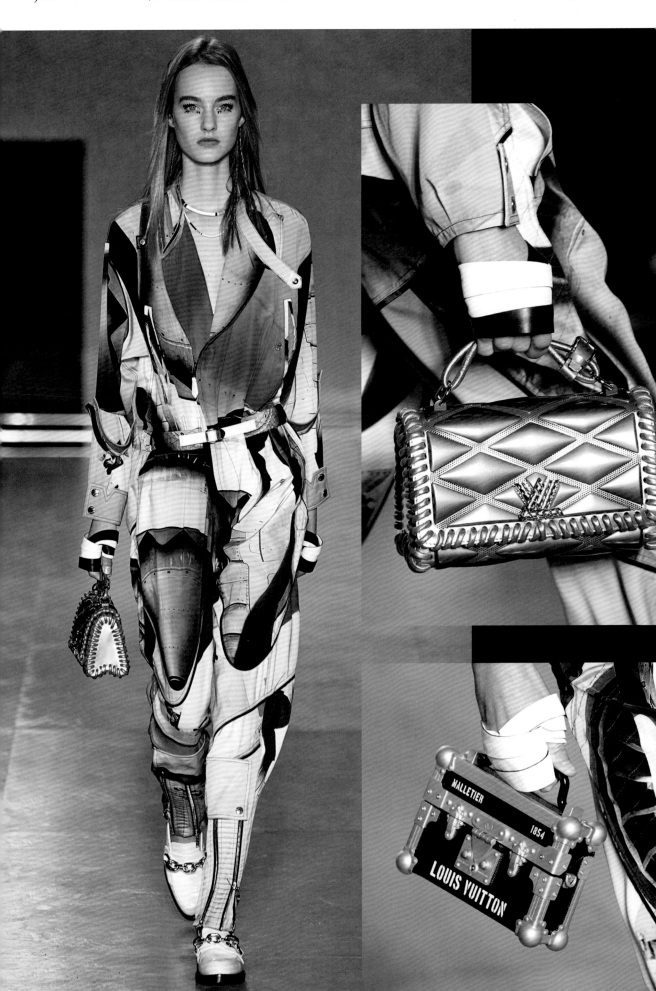

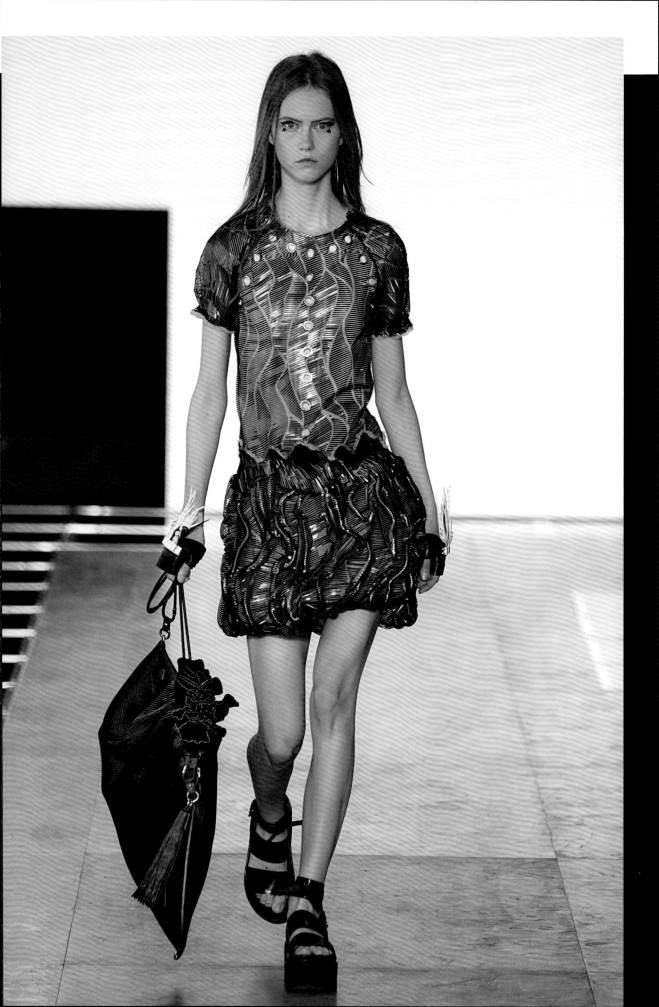

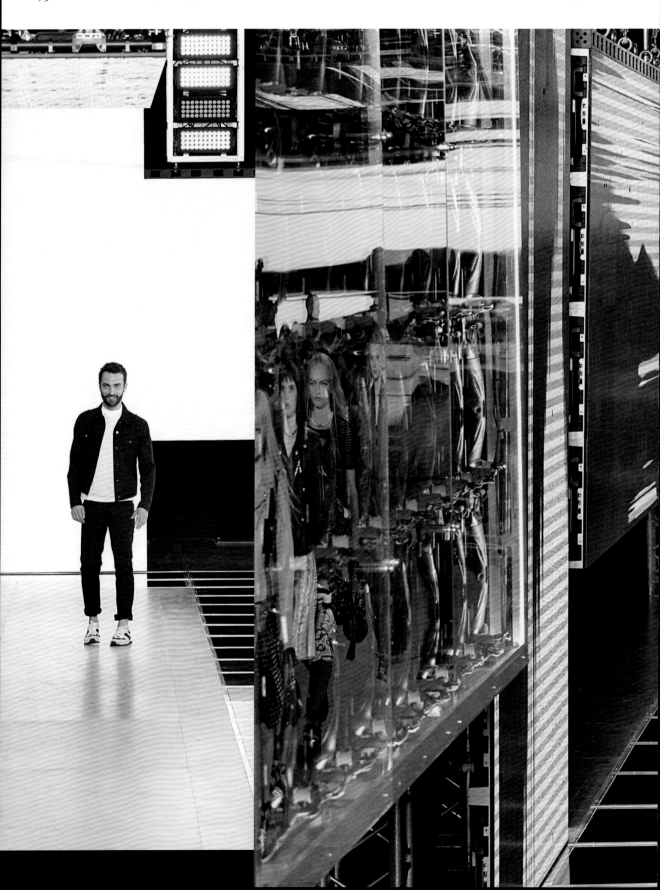

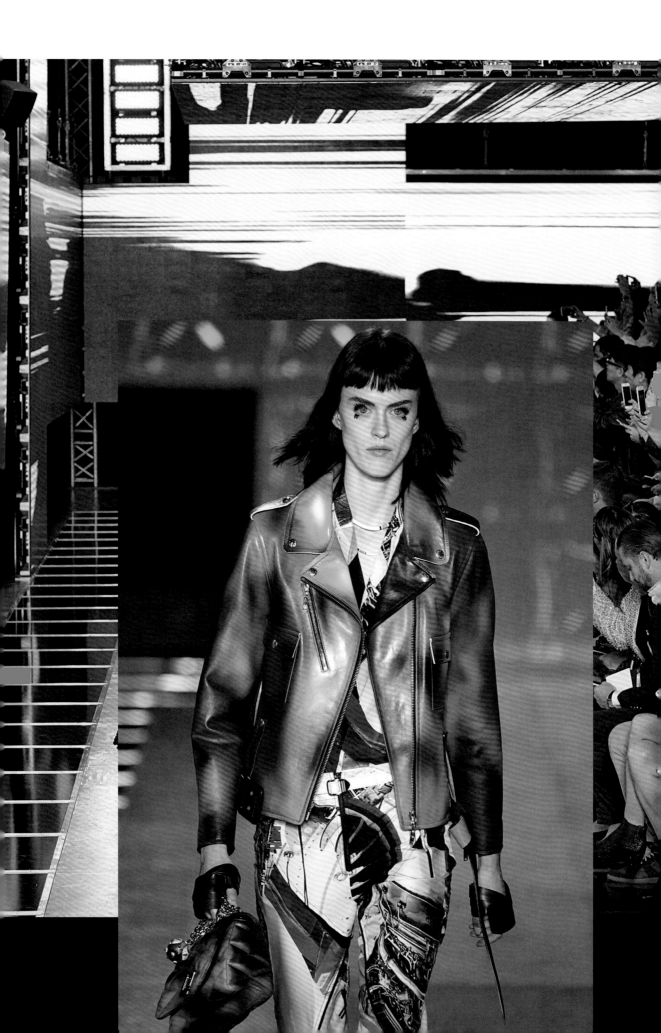

'Future Archaeology'

'We had an idea of this trip, of a woman who could be a digital heroine, like Tomb Raider, when she discovers an archaeological site,' said Nicolas Ghesquière, introducing the follow-up to his cyber-inspired collection of the previous season. The scenography for this new show was intended to represent a 'future archaeology', the house explained. 'An archaeology which unearths the future. An underwater futurist city like the lost city of Atlantis – a city of glass mirrored relics that are unearthed, damaged and partially destroyed.' The 57 columns that comprised the set, made up of 200,000 pieces of hand-fixed shattered mirrors, were a reinterpretation of artist Justin Morin's *Melted Bones* sculpture.

As Vuitton's 'future archaeologist', Ghesquière set out to 'unearth the glorious vestiges of a visionary trunk-maker and recast yesterday's creations for today's tastes', stated the press notes. 'He defines a heroine who is always on the move, whose elegance springs from her dynamism.'

Unfolding to the sound of Lou Reed's 'Street Hassle', the athletic collection presented a feminine wardrobe with a futuristic, punk-like attitude. Ghesquière 'loosened up the silhouette with a series of bias-cut silk skirts in graphic black and red, which were seemingly held together with silver staples,' reported British *Vogue*'s Sarah Harris. 'But if the lower half was loosened, the top half was rigorous and strict. Shrunken patent coats were buttoned only at the waist, tails left to fly; second-skin pannier jackets with ring-pull zips added curve and accentuated wasp waists; while his finale silk dresses were free-flowing except for armoured leather bra-tops that wrapped around torsos and keyed a tougher edge.'

Natalie Westling opened the show (right), wearing a cropped leather jacket with a belted leather bi-dress, red patent leather straight trousers and glazed calfskin lace-up ankle boots, and carrying a small Monogram camera bag. Standout looks included foulard-printed twill stapled T-shirt dresses (accessorized with the Petite Malle in Epi leather with scarf handle; p. 534, left), mohair cardigans and sweaters (p. 536), knitted dresses with leather sleeves worn over silk georgette asymmetric skirts (p. 537, right), as well as an embroidered mohair dress worn with extra-long gloves (p. 543, left).

The Cruiser bag (see p. 538, right) took pride of place in the collection, alongside reinterpretations of the Twist, Petite Malle and City Steamer, which were adorned with a rich animal print or animated by new travel stickers ('the revisited coats of arms of the emblematic cities of the world') – a tribute to Vuitton's spirit of travel.

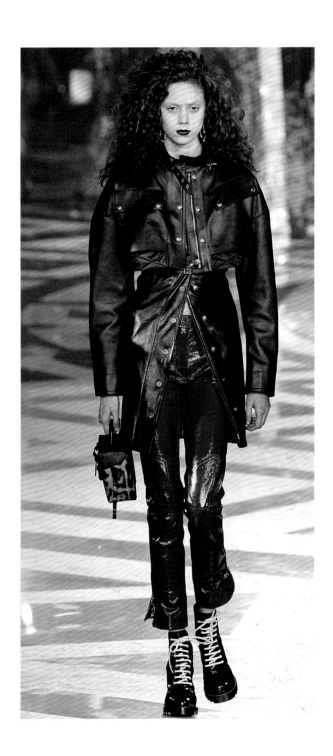

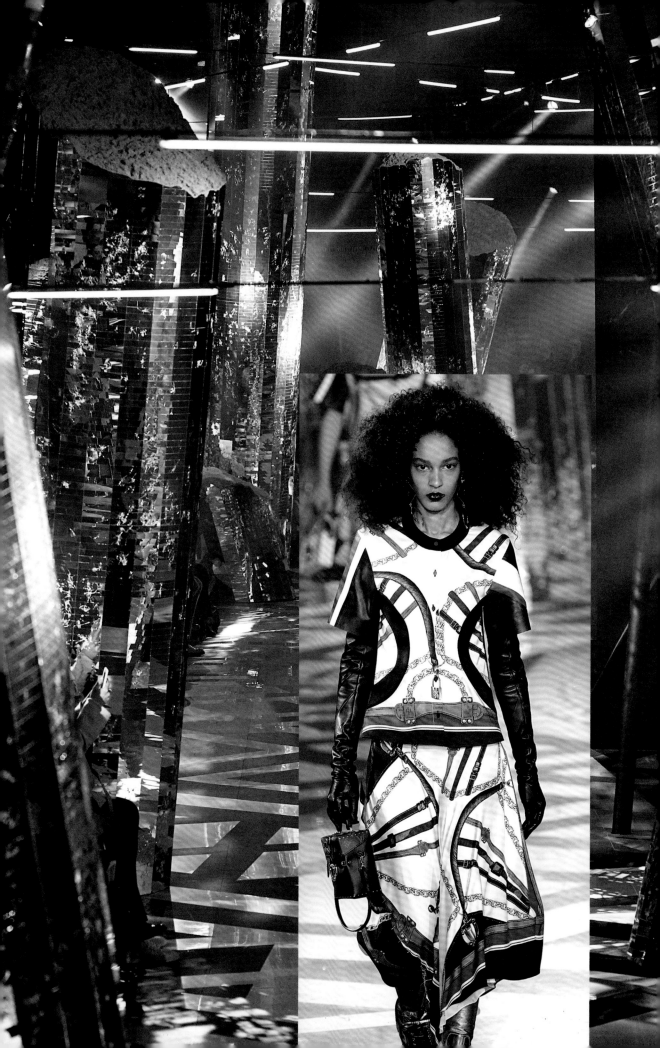

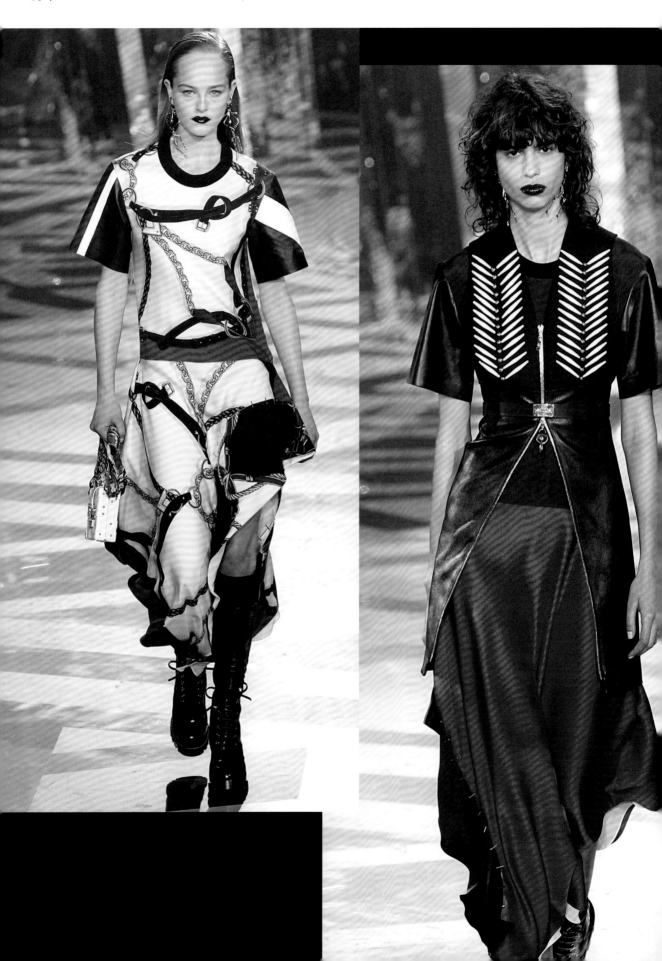

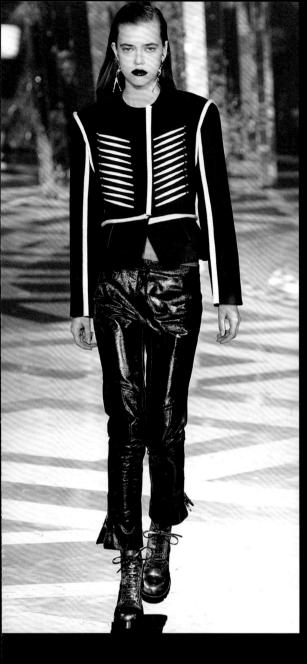

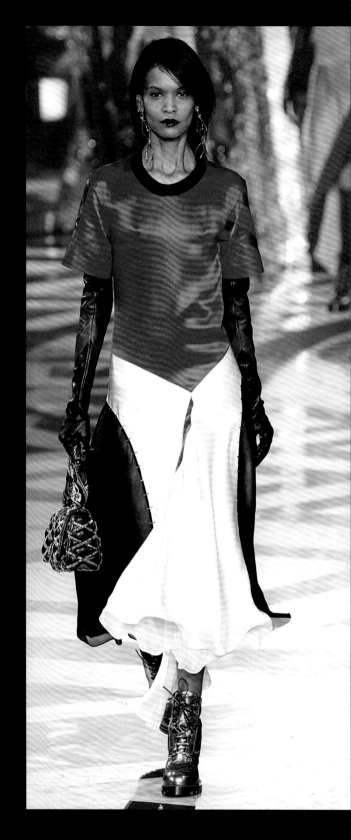

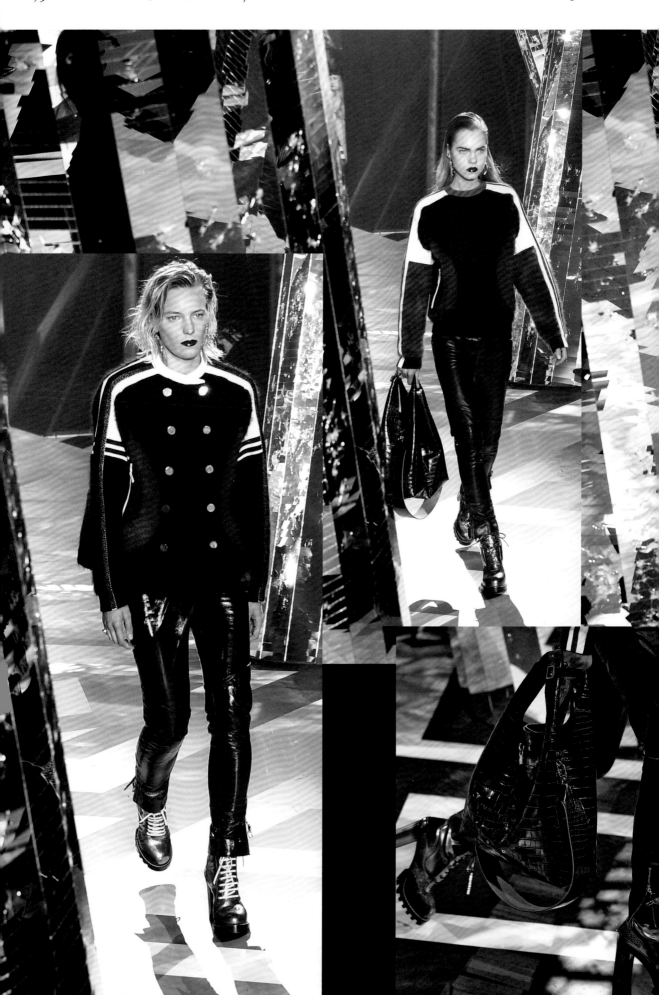

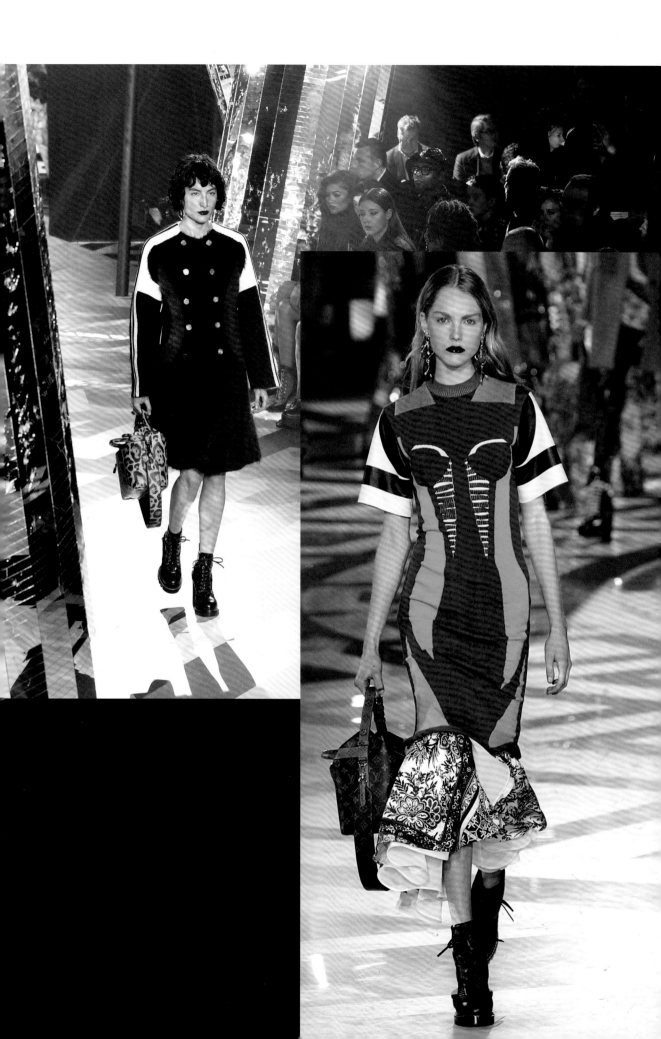

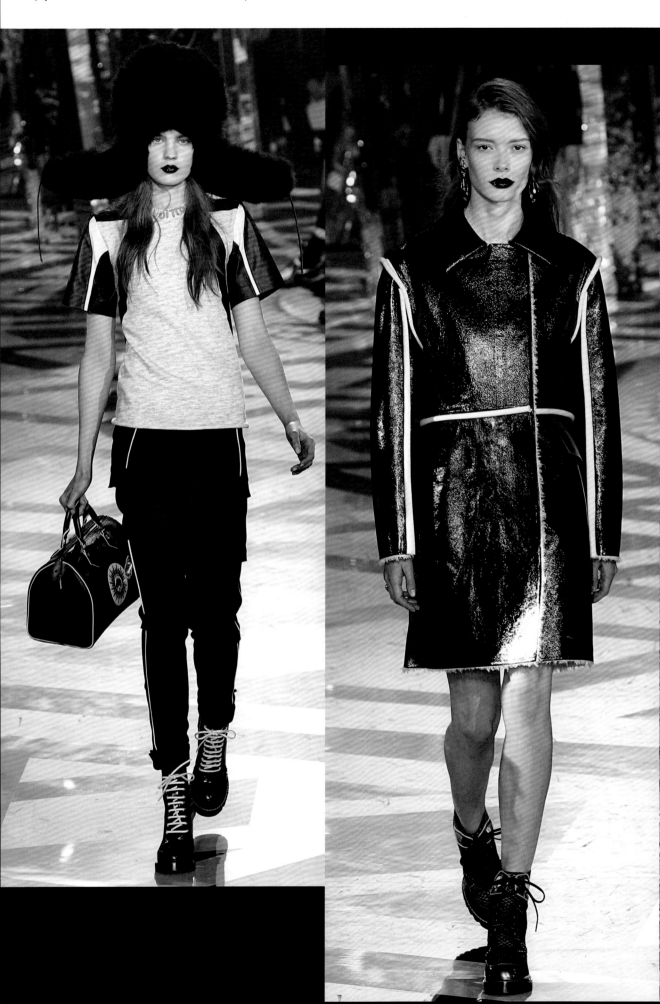

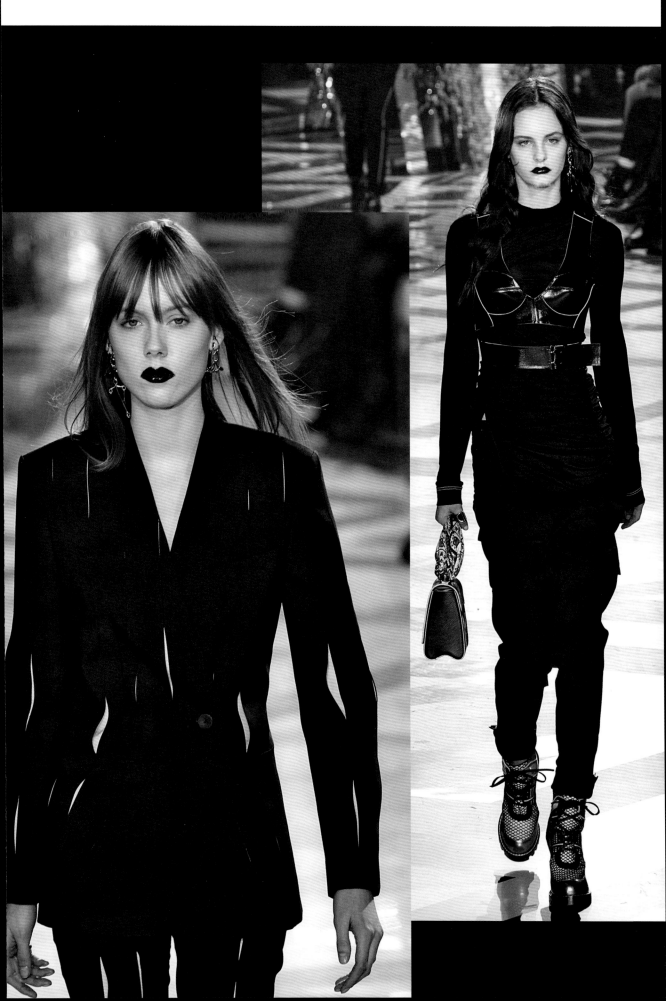

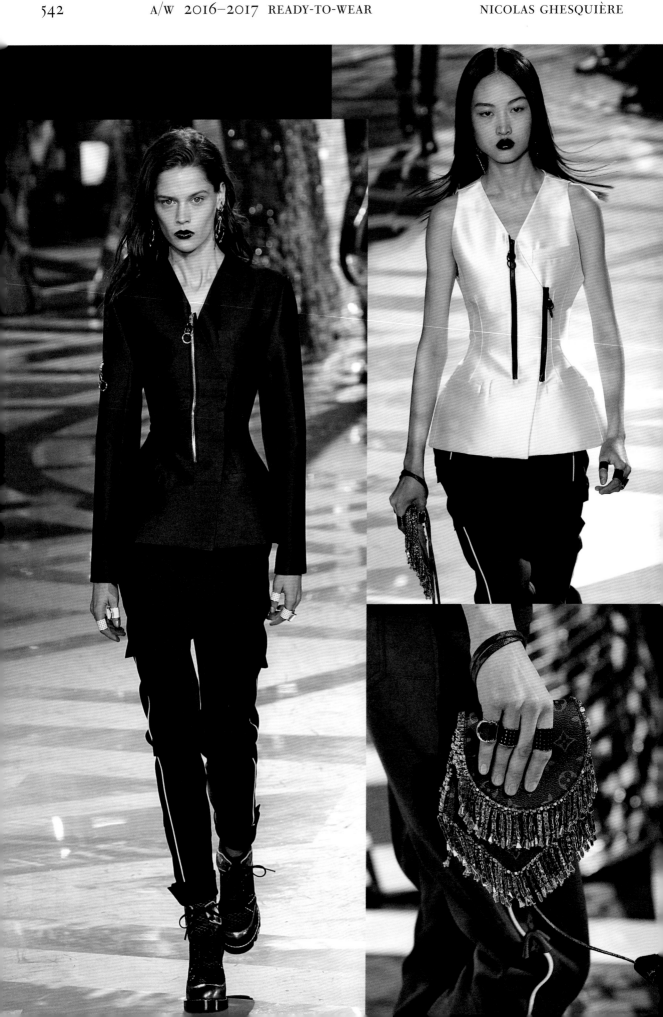

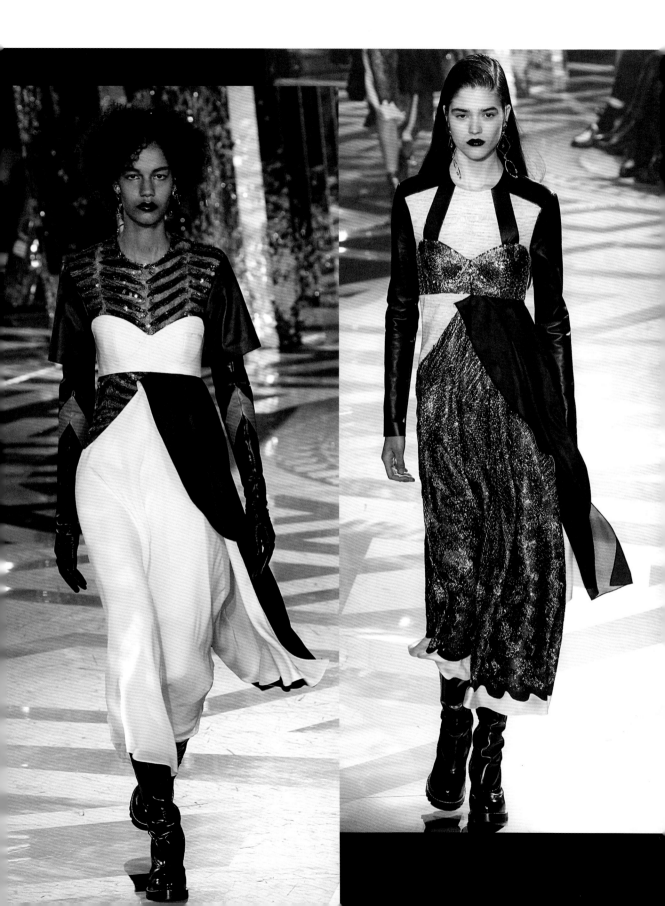

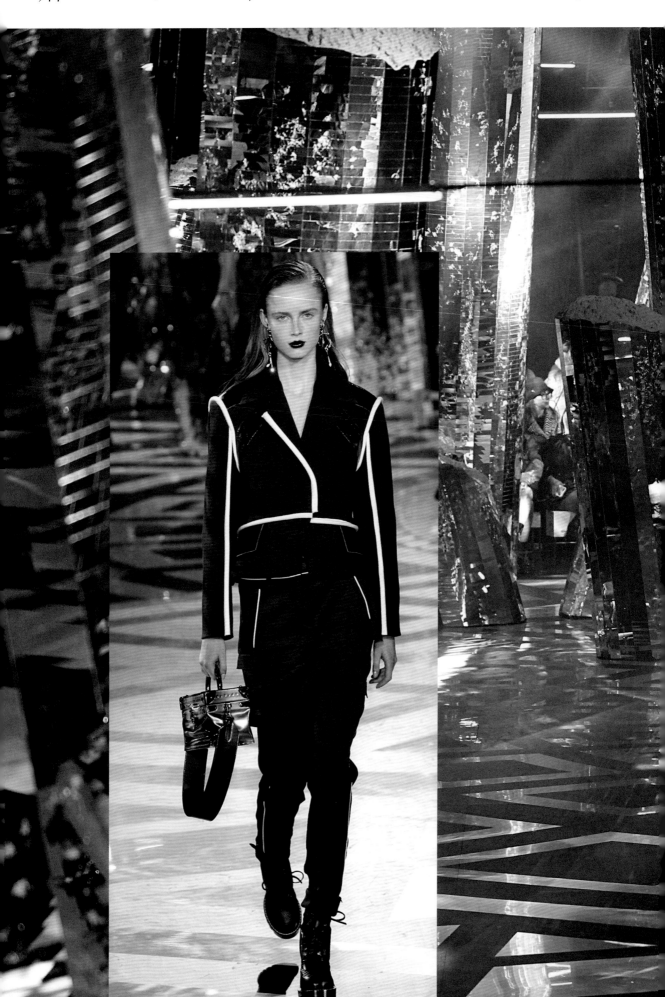

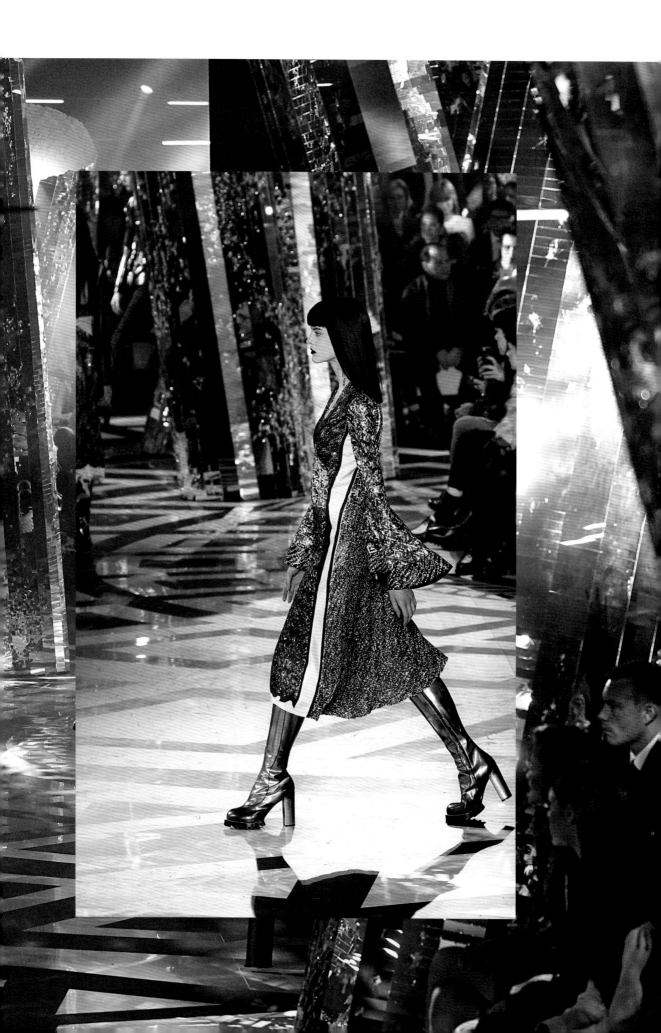

Rio de Janeiro

Nicolas Ghesquière chose the spectacular Niterói
Contemporary Art Museum in Rio de Janeiro as the
location for his 2017 Cruise collection, three months
before the summer Olympic Games were due to take
place in the city. The building, designed by architect
Oscar Niemeyer and inaugurated 20 years previously,
provided a bold backdrop for the collection, which
became one of the most Instagrammed of the season.
'I so admire the power of Oscar Niemeyer's conviction,'
Ghesquière declared. 'His vision, his radicality, his
utopia even. Being able to show a fashion collection
in such an architecturally powerful space is a sensorial
experience.'

Ghesquière revealed his obsession with 'sports clothes,
movement' and what he called 'the new casual' –
a 'fusion of the sophisticated and the sporty'. As he
pointed out: 'What better place than Rio to show
these ideas?' Tropicality and urbanity were the two
major themes. 'I was fascinated by the constant
duality between nature and urbanism and the
pictorial explosion it creates.'

The show notes stated: 'Dresses with a streamlined
spirit illustrate a new aerodynamic silhouette. Slashed
stripes on trousers lengthen the body. Luxuriously
embroidered skirts appear to have been wrapped in
haste, in the manner of a beach towel. Tech-thongs and
neoprene sneakers speak of a heroine who is constantly
on the move.' *The New York Times*'s Vanessa Friedman,
reporting on the 'body-conscious cutaways, ruffles and
leather', judged that 'the rib cage and the upper abs'
were the new erogenous zone.

The audaciously hued collection paid homage to
two Brazilian artists. A series of light-as-air parkas
and taffeta cape-dresses was inspired by Hélio Oiticica's
parangolés (cloaks made from painted fabric and other
materials designed to be worn while dancing the samba,
to become what the artist called 'colour in motion'),
while the work of Aldemir Martins (who made a
famous portrait of Pelé and created several other
football-inspired motifs for clothing that had recently
featured in an exhibition in Brazil) was reinvented and
transposed onto printed dresses (see p. 556, bottom left)
and a special edition of the Twist bag (p. 555, left).

'Ghesquière's show was a synthesis of Brazilian tropes
– "bingo, soccer and colour" – all bound up in sporty
luxe layers and worn with ... a "boombox" trunk bag
[see p. 551, top right], a modern take on the '70s
ghettoblaster reworked with speakers and bluetooth
settings for the millennial age,' reported Jo Ellison
for the *Financial Times*, concluding, '[T]he looks had
the [same] self-assured flamboyance ... as the women
one finds on the beach at Ipanema.'

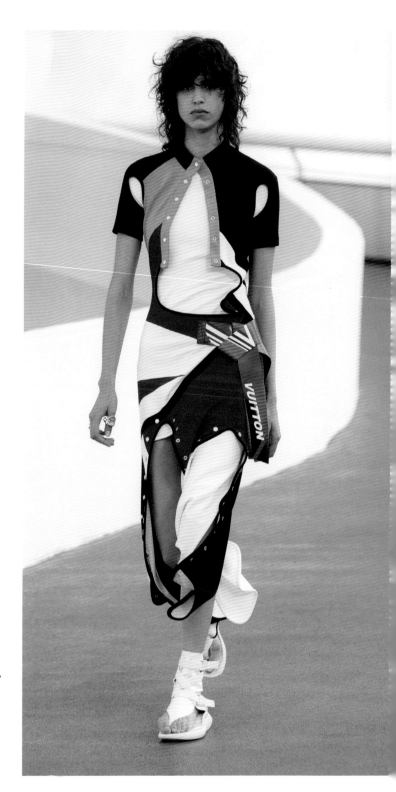

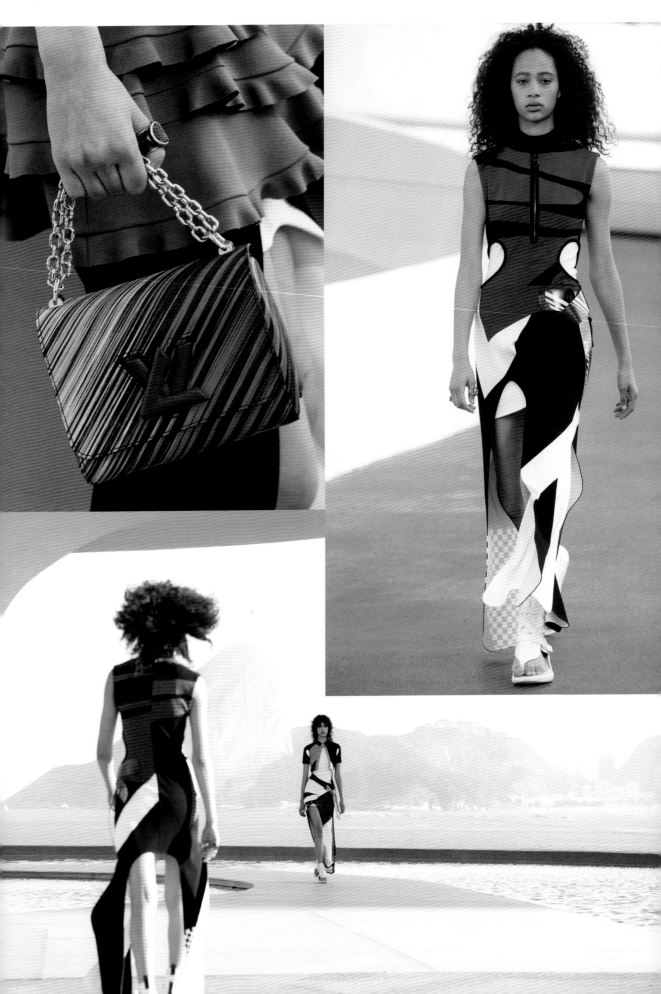

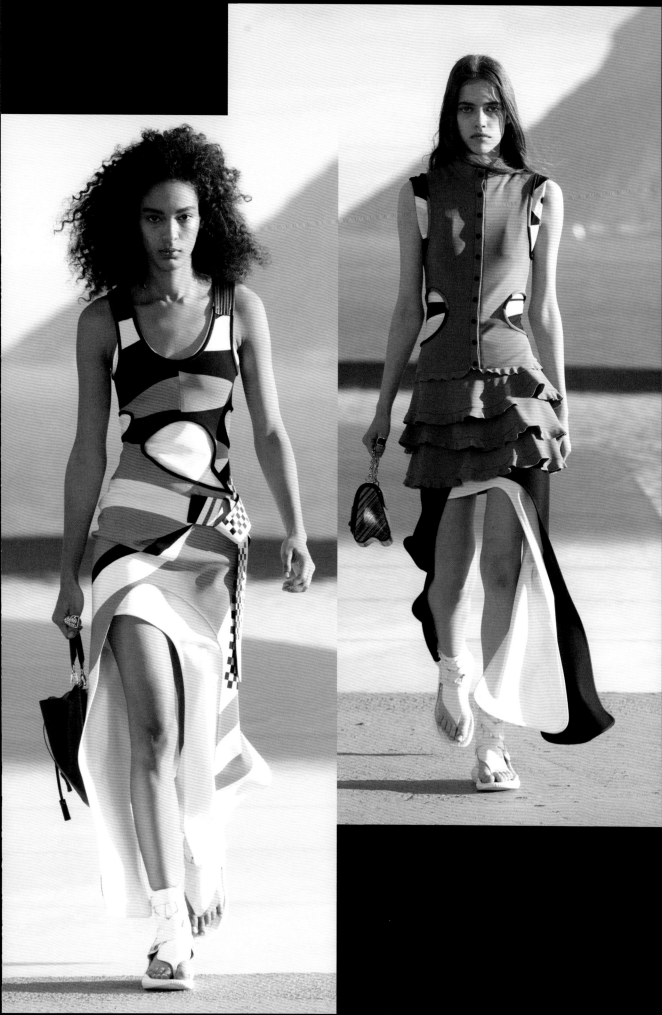

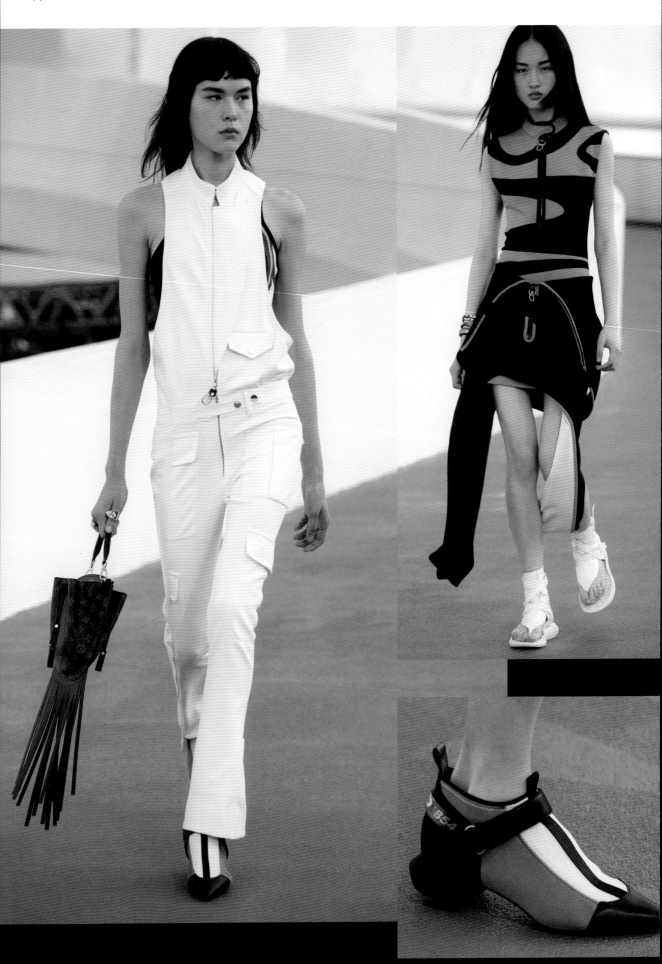

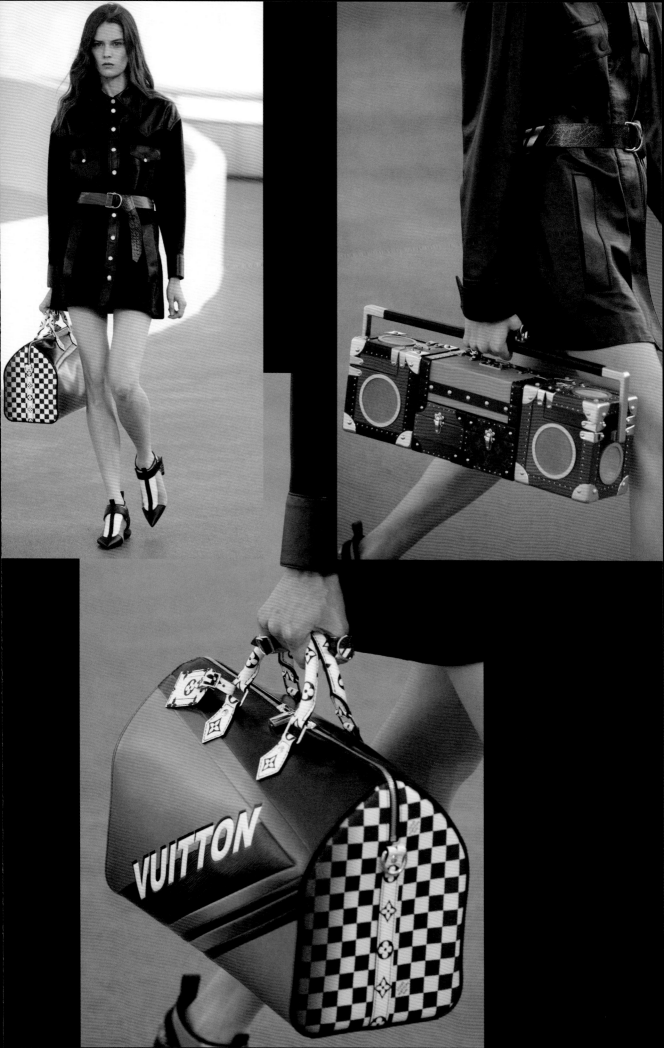

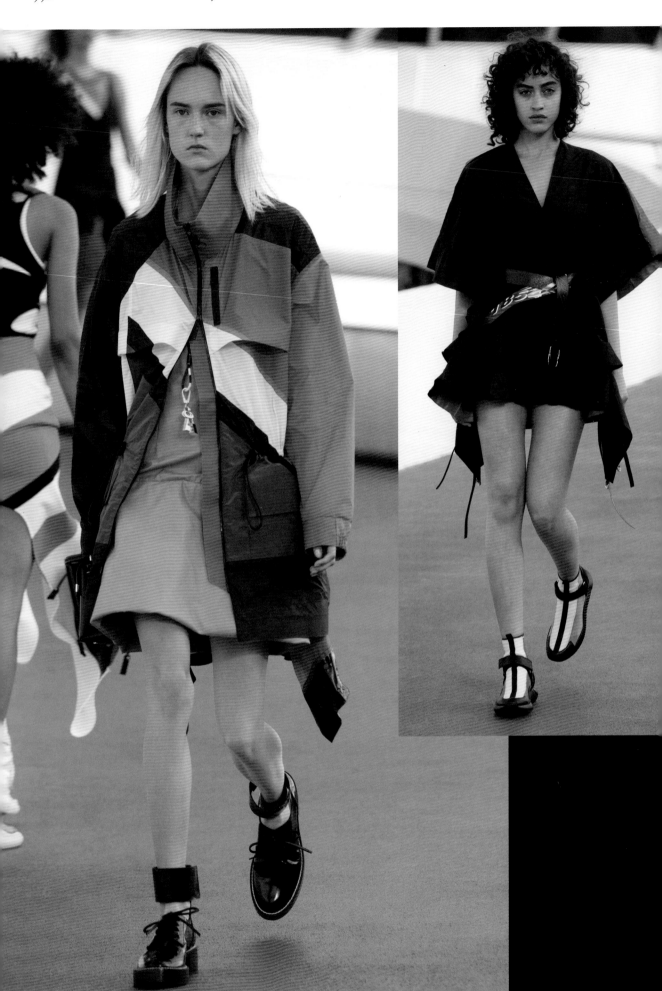

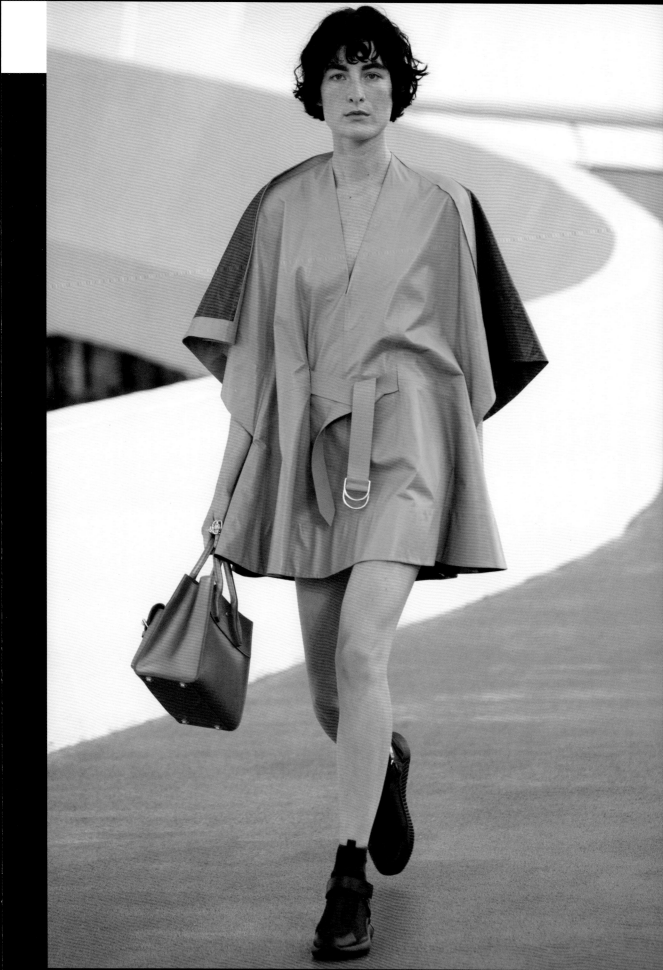

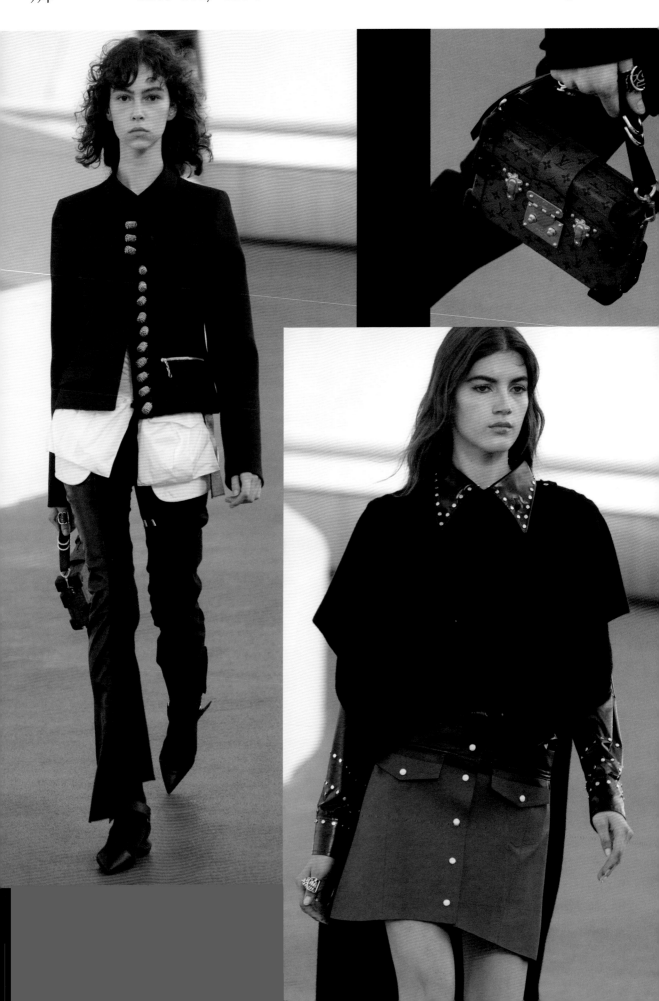

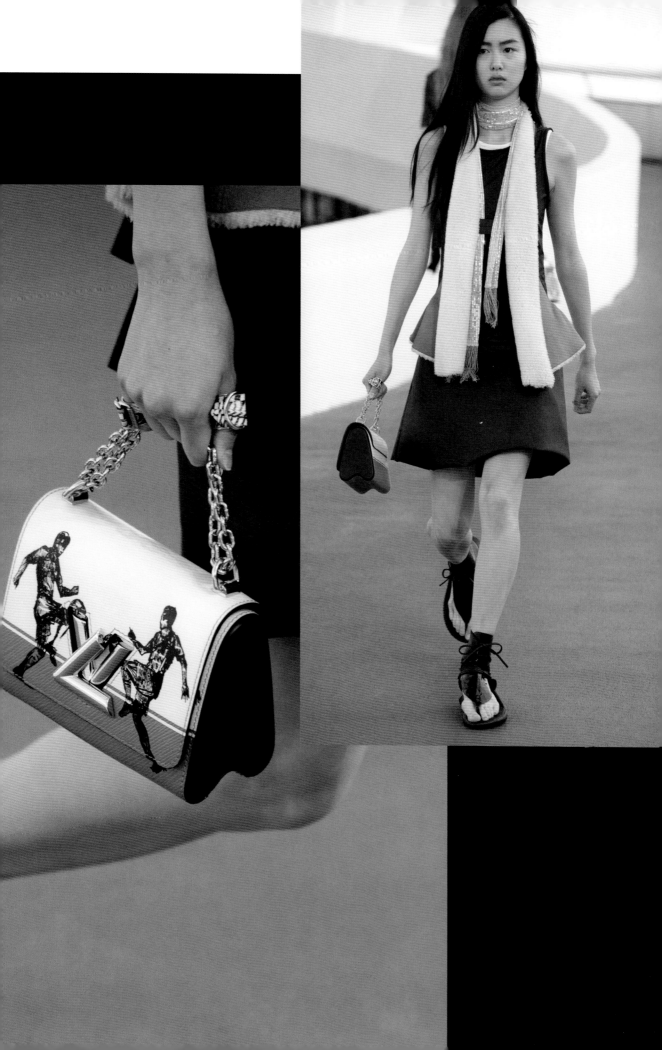

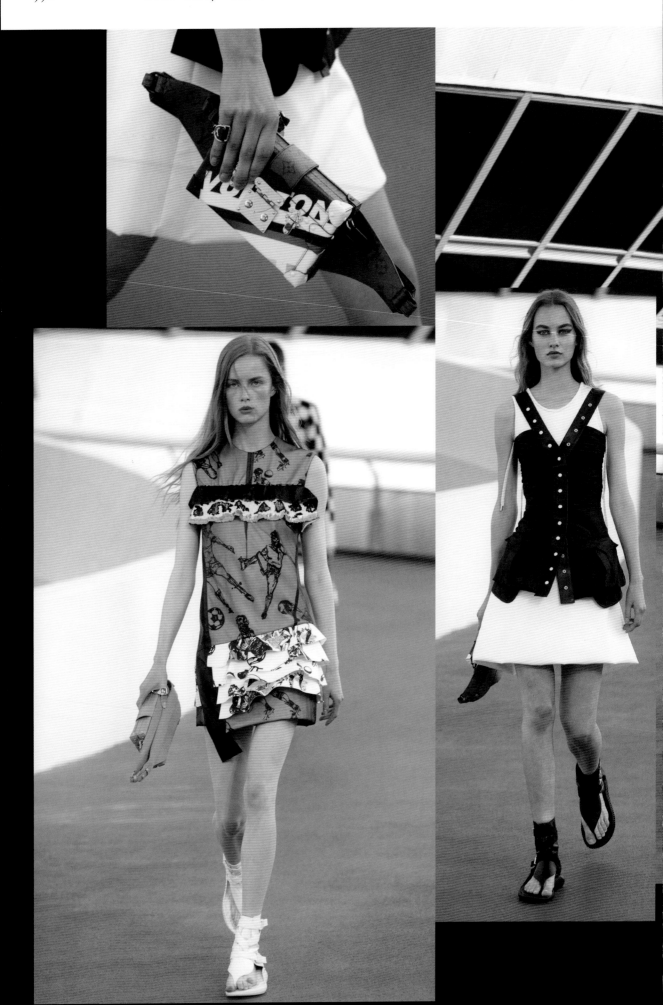

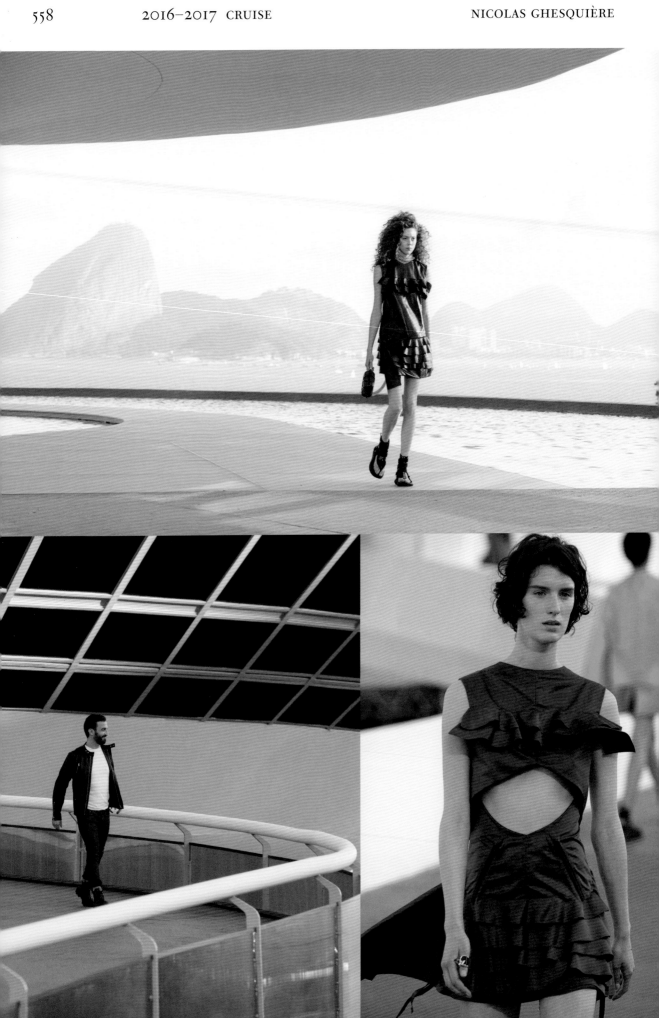

2 Place Vendôme

At 10 am on 5 October 2016, Nicolas Ghesquière presented his spring/summer 2017 collection in the future Louis Vuitton store at 2 Place Vendôme. The house explained that 'this mythical square' – 'the epicenter of French elegance' – 'is at the heart of Louis Vuitton's legend since it's only a few steps away … that Louis opened his first shop'. The brand-new flagship store, designed by architect Peter Marino, was still mid-renovation, with a concrete floor and minimal interior. 'It's interesting to capture this place at its rawest moment, and to seize the purity of its atmosphere,' said Ghesquière. 'An incredible space, laid bare in this magnificent classical building. I very much like this contrast.'

His heroine had departed from last season's bold athleisure collection in Rio, and the show notes described her homecoming: 'Somewhere between theatricality and aesthetism, a witty, wise and savvy Parisienne, a true original for whom dressing is a pleasure, is born out of this enlightened heritage'. These are 'women whose long jersey dresses float as they move' and who 'dream of triumphing in tailored suit, dazzled with seductive rainbow python'.

The collection was an homage to Paris, its women and its architecture. The 18th-century faun heads that decorated the façade of the building were reinvented on tough-looking T-shirts (see p. 566), while the Column Clutch in Monogram leather (p. 568, bottom left) echoed its classical architecture.

'Draping jersey from precisely squared-off … shoulders, [Ghesquière] took an X-Acto knife to the silhouette,' reported Vanessa Friedman for *The New York Times*. 'Dresses had one arm sliced off and scarified with tiny silver staples; jackets were cut away in a curve to expose a crescent moon of clavicle; and trousers were wrapped to flick open at the side. Lace or metallic tunics and leggings were worn with the suggestion of a skirt at the hip to make a new sort of suit, and silver and gold beading traced starburst shots across chiffon left sheer to flash shoulder pads and the plunging bodysuit beneath.'

New accessories included Parure Sangle jewelry, inspired by the woven straps used to secure trunks (p. 567, top right); Parure Coquillage rings (p. 565, bottom right) and bracelets (p. 573); and Parure Pétale necklaces, bracelets (p. 570, right) and rings (p. 572, left). Bags included the Tressage Tote (opposite, bottom left), the Chain-It bag (p. 565, top right) and the on-trend Eye-Trunk for iPhone 7 Plus (see p. 564, bottom left).

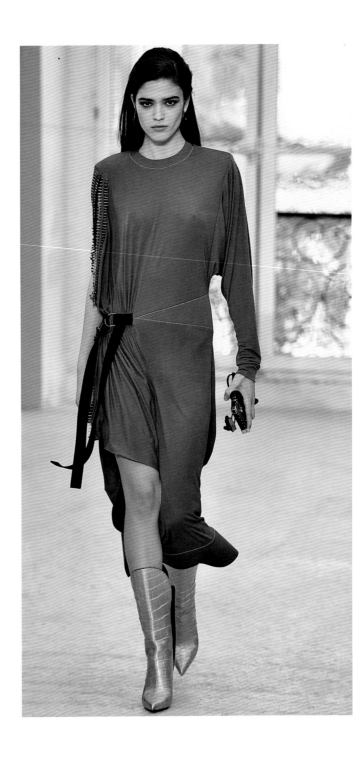

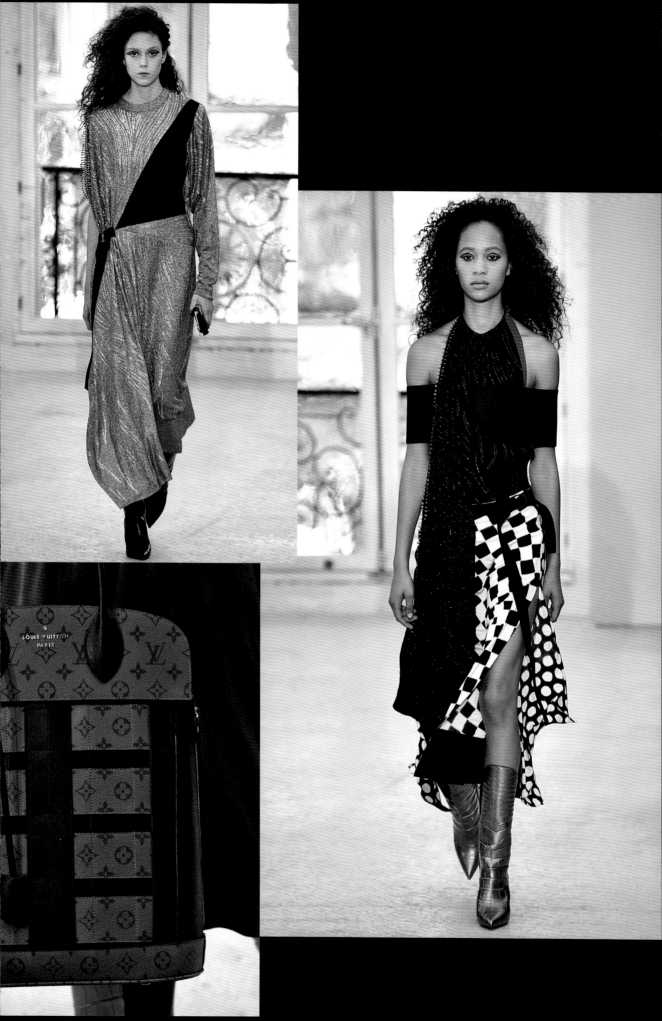

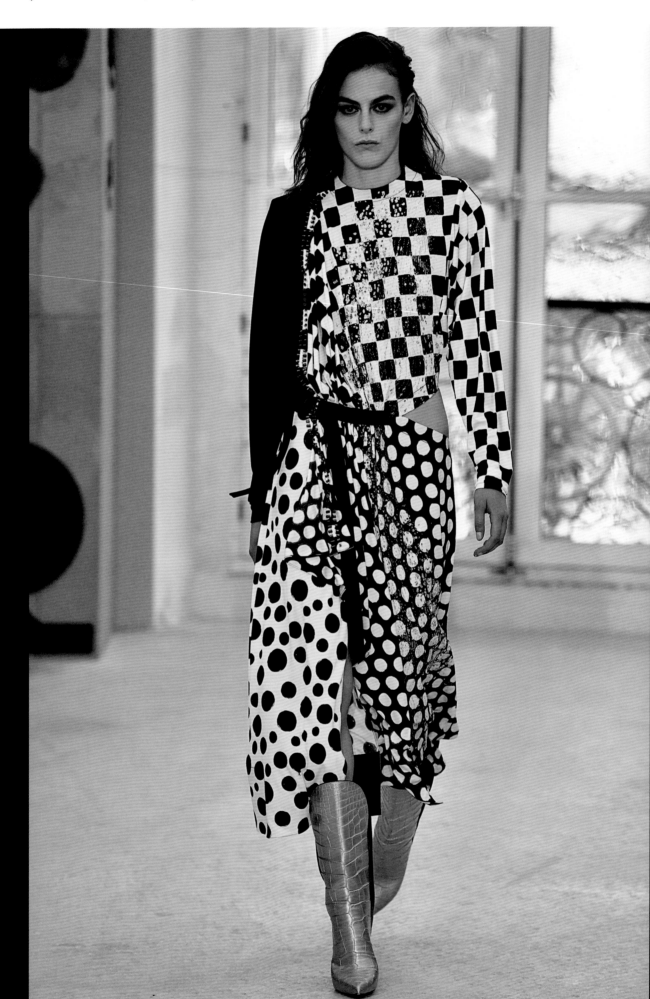

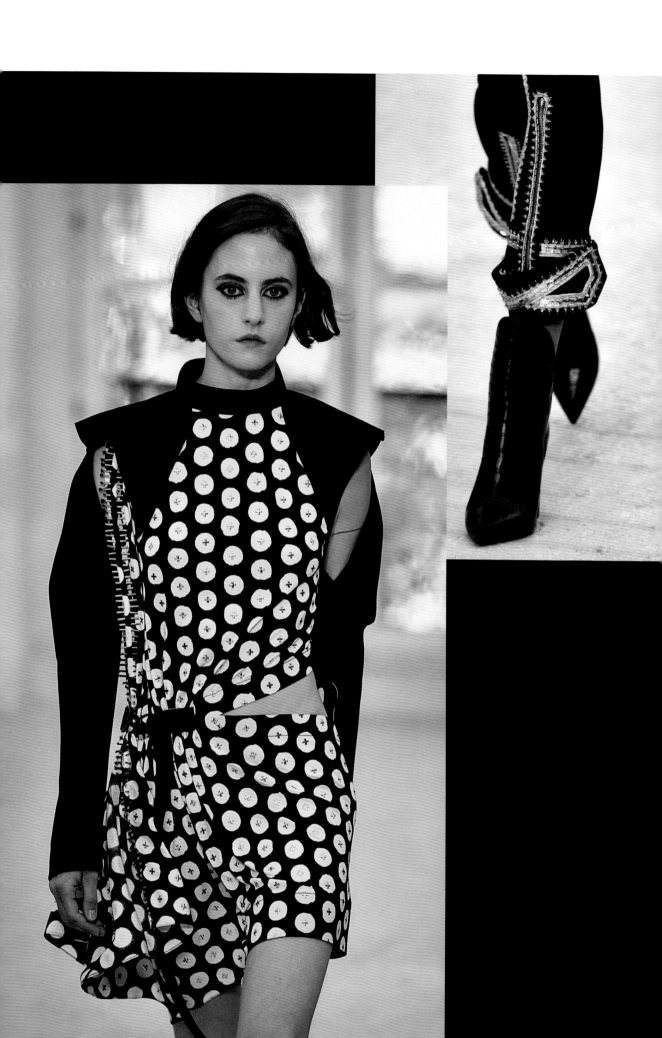

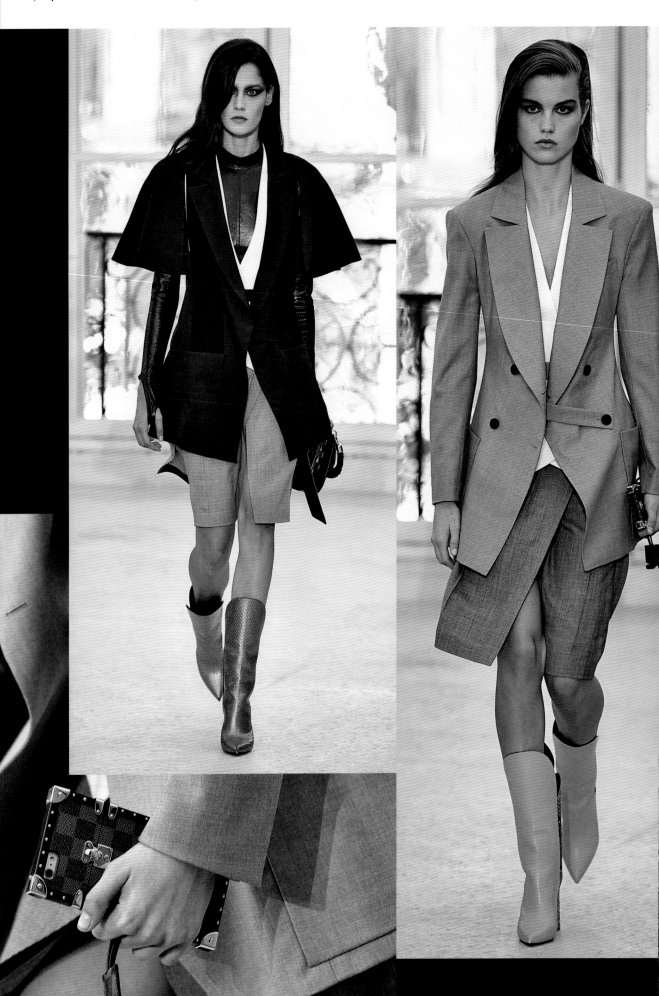

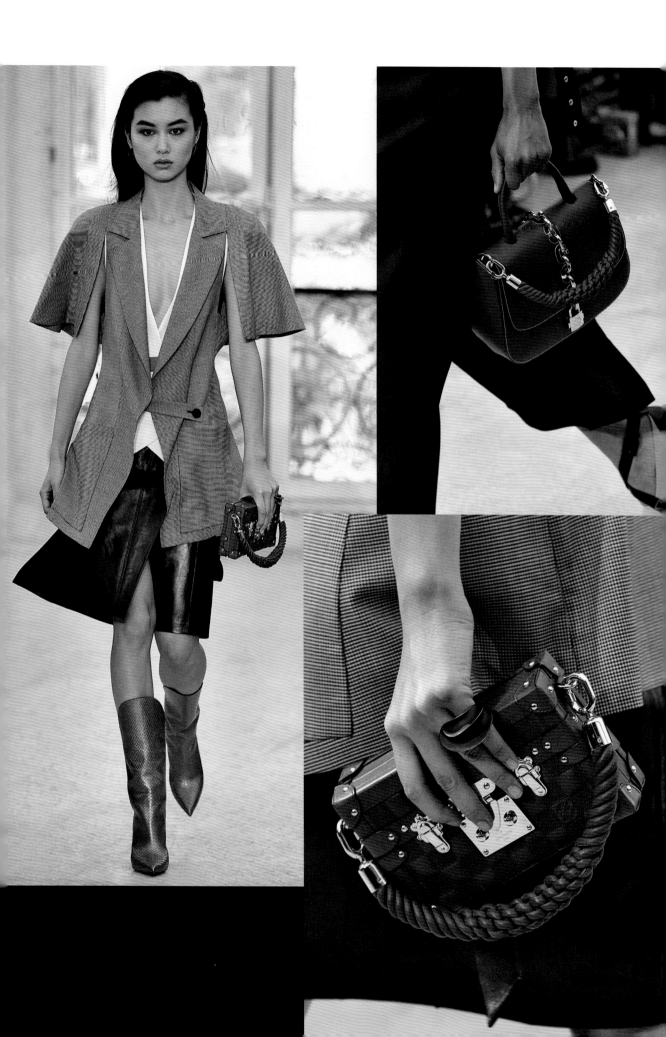

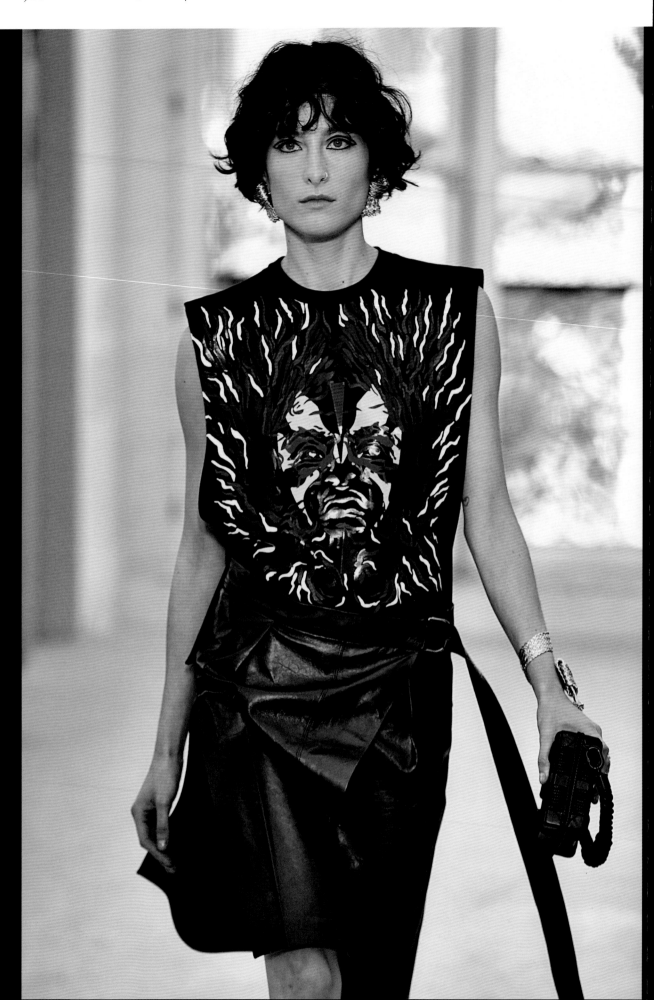

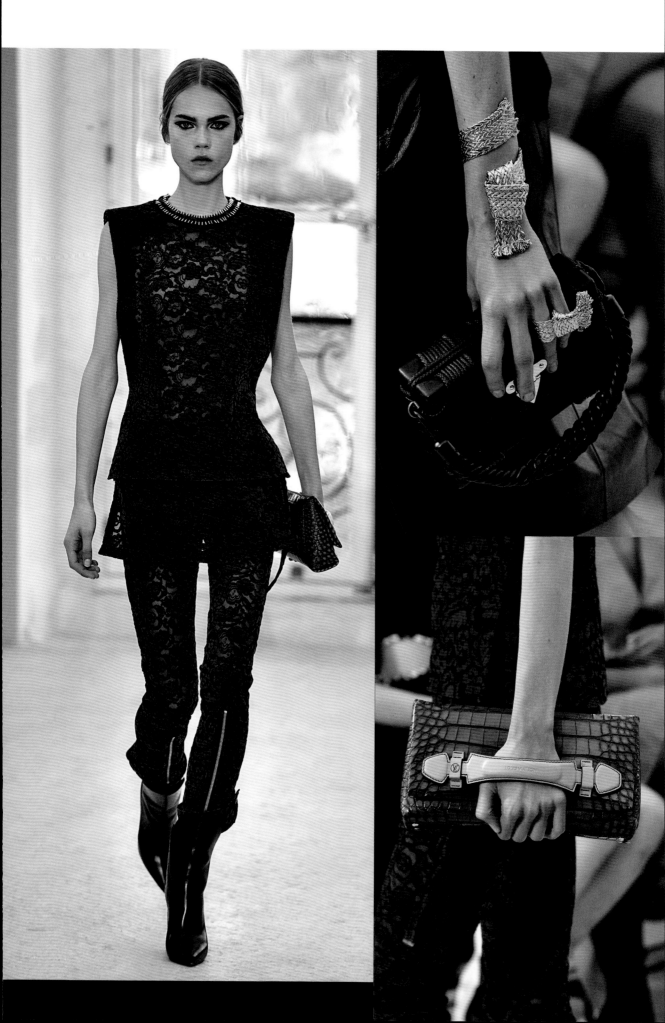

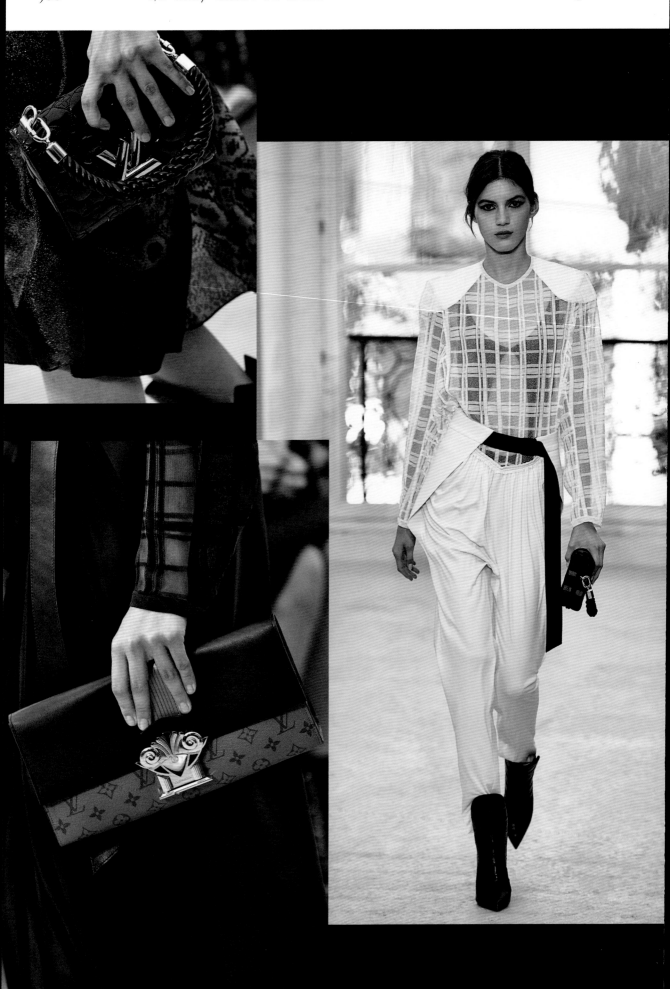

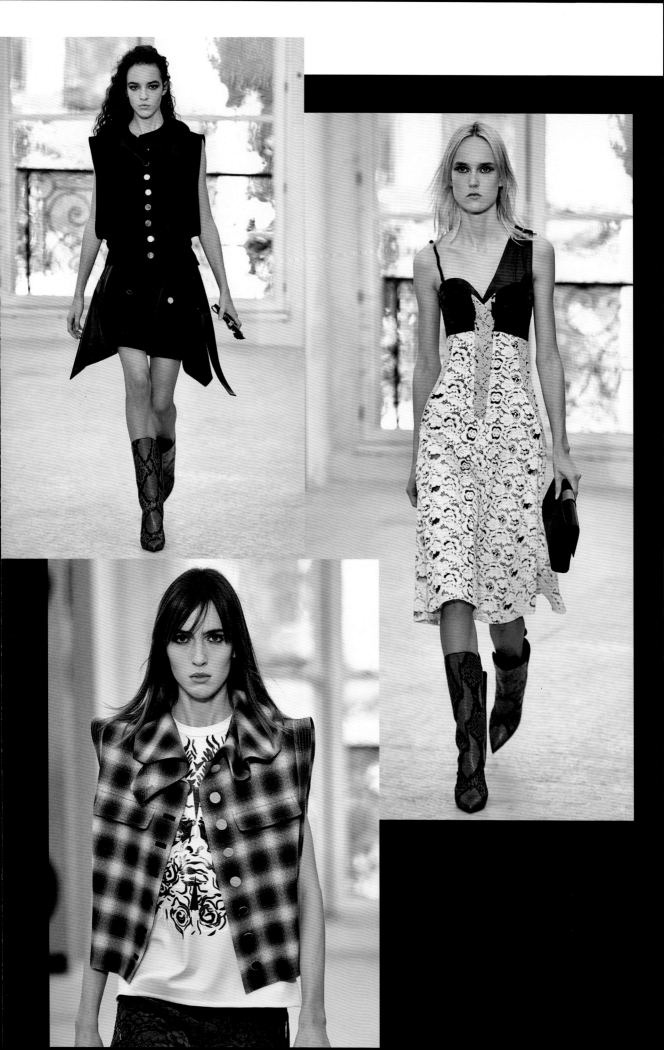

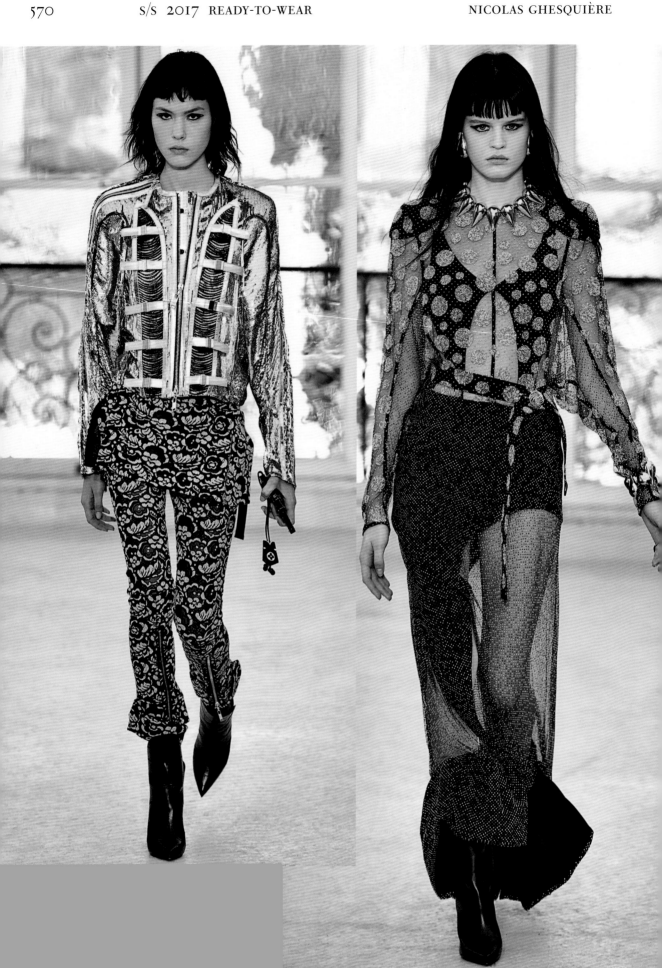

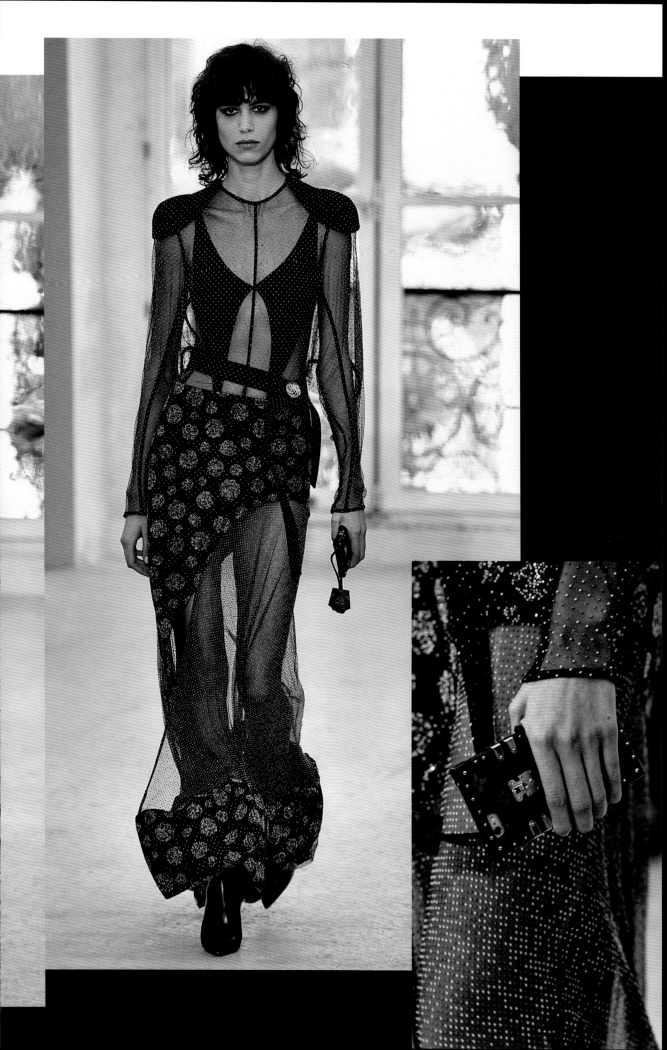

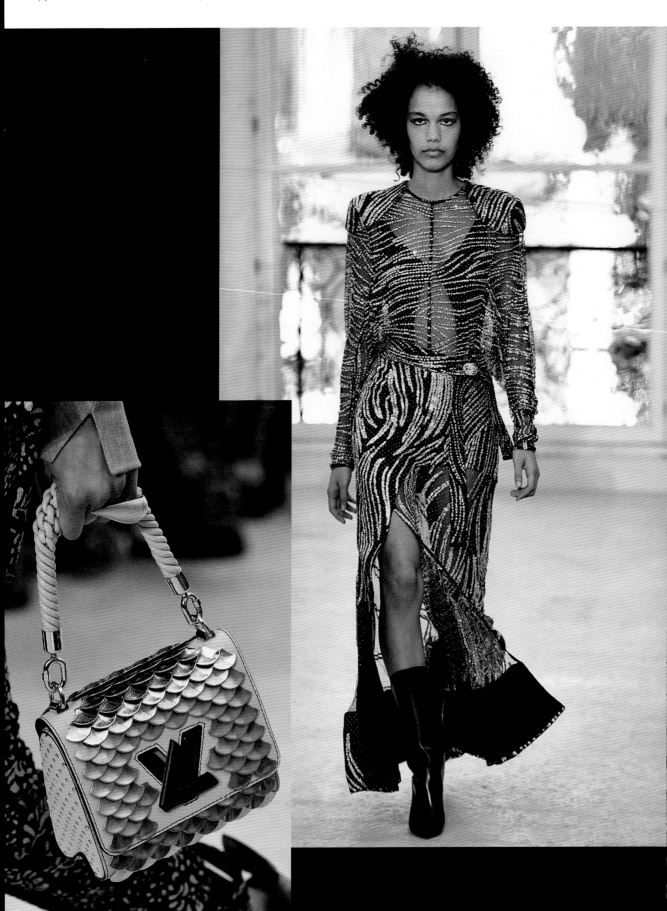

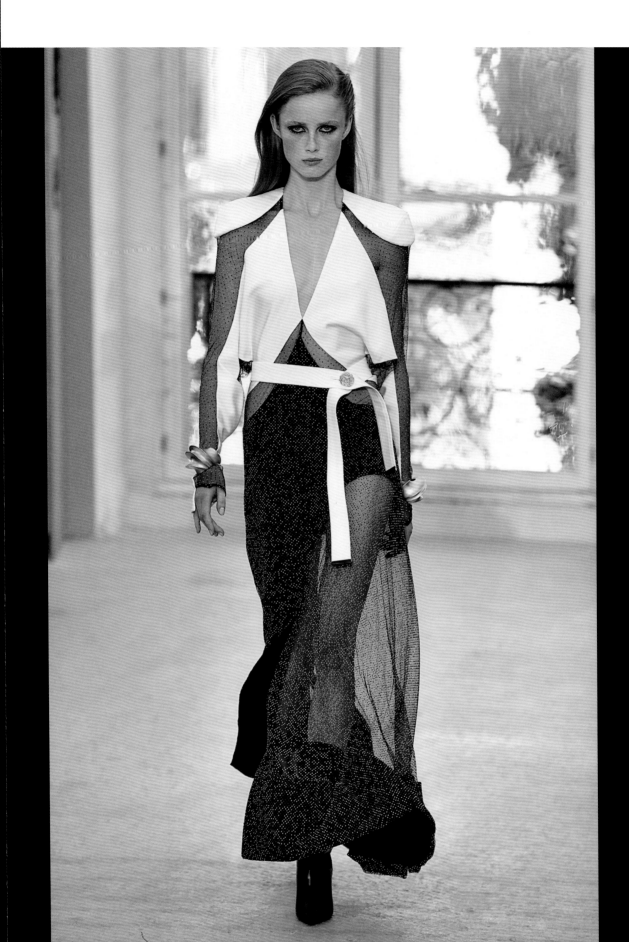

No Frontiers

Unfolding to the haunting sound of Frank Ocean's
'Pyramids', the autumn/winter 2017 collection was
presented in the Louvre's Cour Marly, the courtyard
situated directly under the iconic glass pyramid
designed by I. M. Pei and filled with 17th- and
18th-century French sculptures.

Nicolas Ghesquière had chosen the world's most
visited museum – symbol of 'a borderless space where
culture invites everyone to embark on a journey', the
house stated – as the backdrop to a collection that
aimed 'to do away with frontiers altogether and shift
into an evocation of the nomadic, where the city blends
with distant landscapes, the masculine blurs with the
feminine, the day shades imperceptibly into night'.
The show notes elaborated: 'Frontiers recede, and there
emerges a new play of stylistic lines: great American
sportswear classics and Slavic accents, inspirations from
fashions of the past and translations into the world of
today, urban classics and the magnetic pull of folklore...'

'My intention is purely to show how migration and
multiculturalism have always informed fashion, and
how it's all the better for it,' Ghesquière declared.
His night at the museum opened with silk dresses
cut in multiple panels to create a swirling and sensual
silhouette (p. 576), followed by an American sportswear-
inspired fitted biker jacket worn with matching flared
trousers embellished with stripes, tyre prints in
neo-embroidery and contrasting stitching (p. 578),
and a series of fur capes and jackets, including a
showstopping asymmetrical patchwork coat of fox,
coyote, beaver and silver fox fur (see p. 579). What
appeared to be flared denim jeans were made of wool
(p. 582), accessorized with the designer's signature
Handy LV belt knotted around the waist (designed
to evoke the straps used on Louis Vuitton trunks).
The show closed with an array of floral-printed
evening dresses created in a graphic, textural mix
of silk, lace and fur.

The Cour Marly PM in supple calfskin with a
golden lock, chain and small studs along the bottom
(p. 578, bottom right) was the it-bag of the season,
while the Speedy 25 was revisited in a new futuristic
style (p. 578, bottom left). All the models wore the new
Limitless boot, which was inspired by Chelsea and
biker boots, and was presented in Monogram leather
and glazed calfskin with rubber soles. These were,
according to Vogue's Nicole Phelps, 'highly practical
for forging new frontiers, or simply confronting the
harsh realities of modern life'.

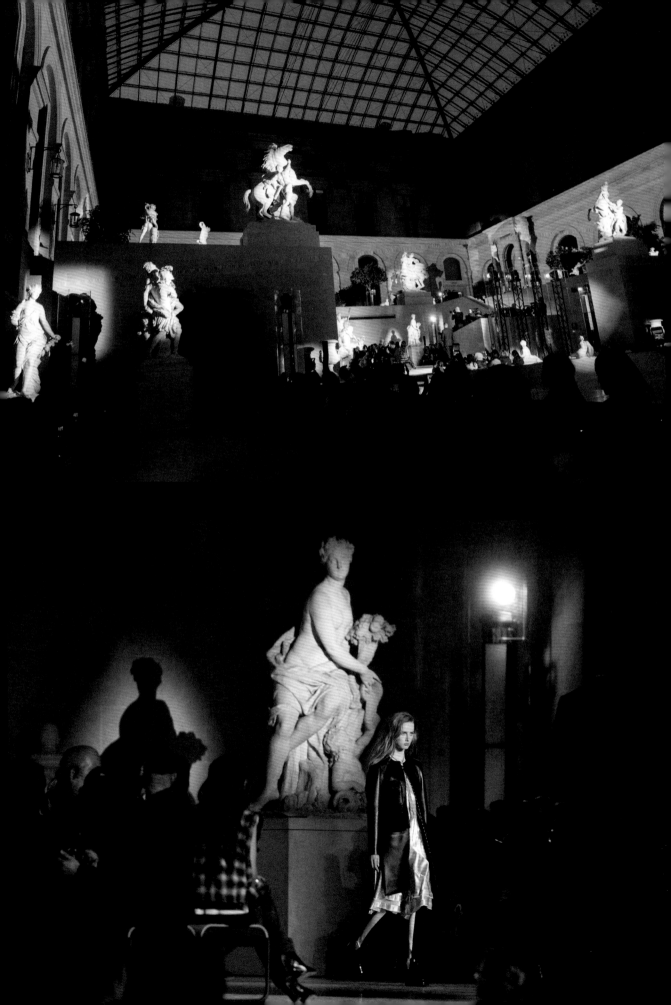

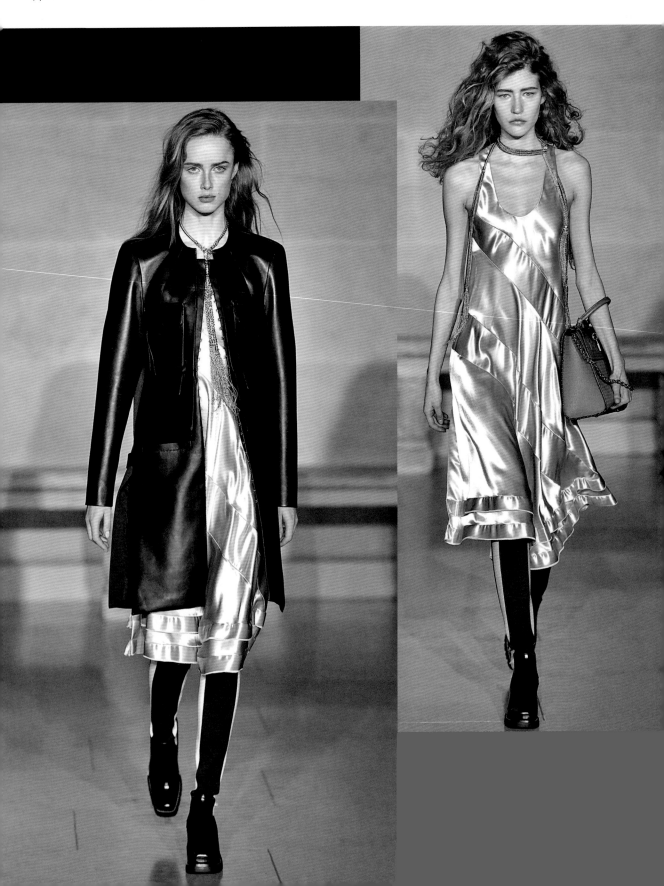

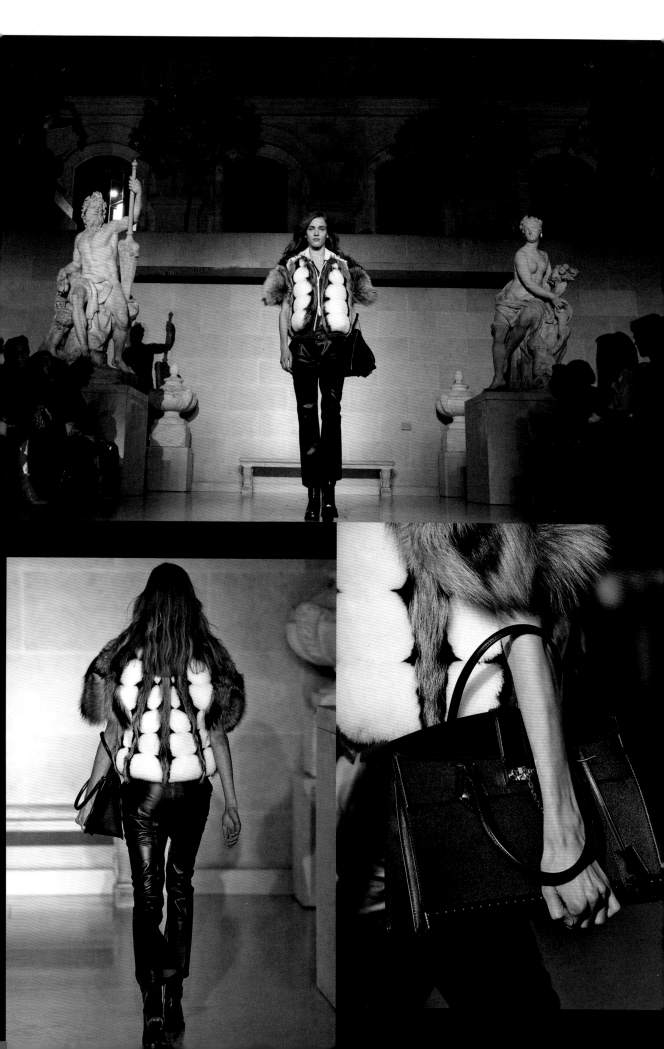

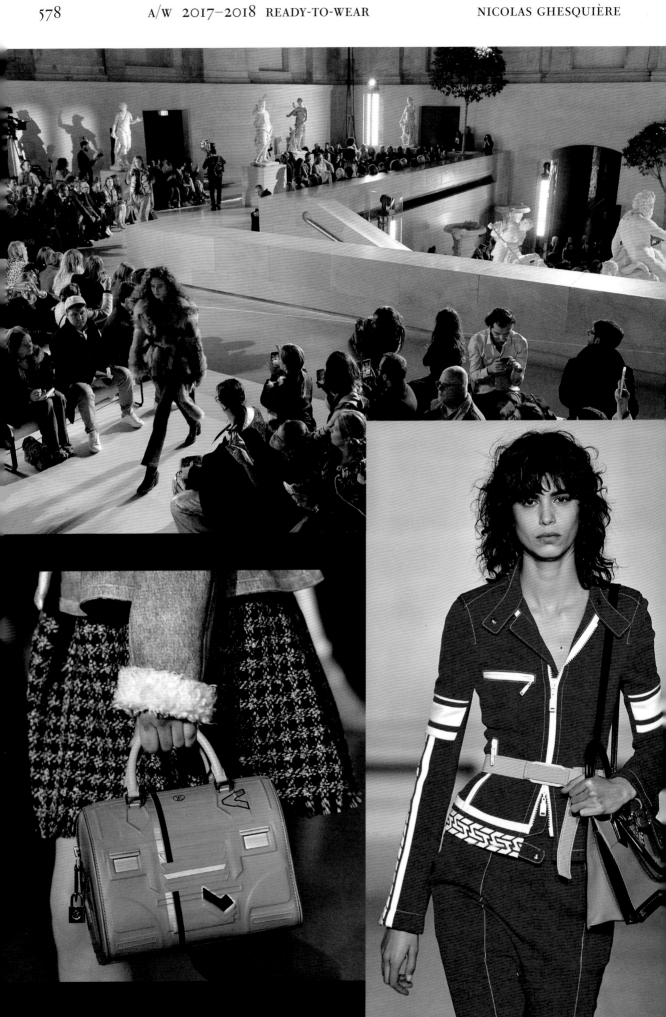

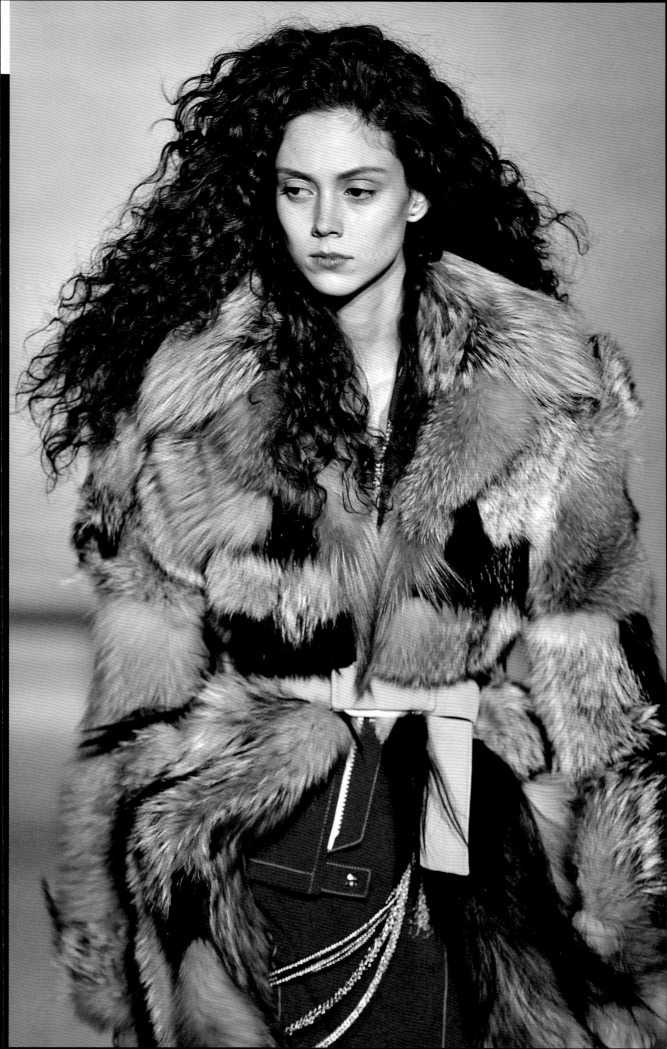

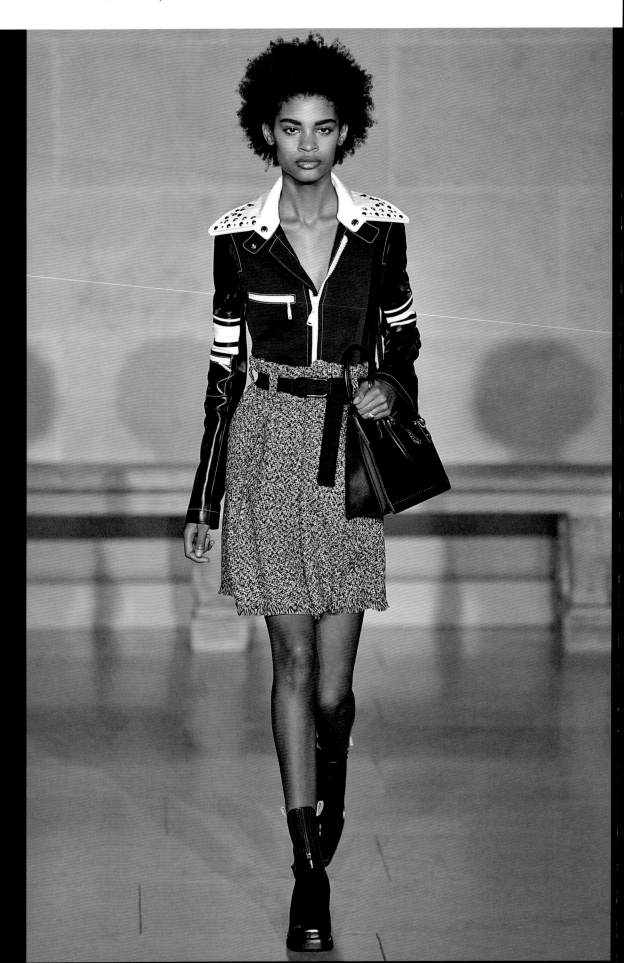

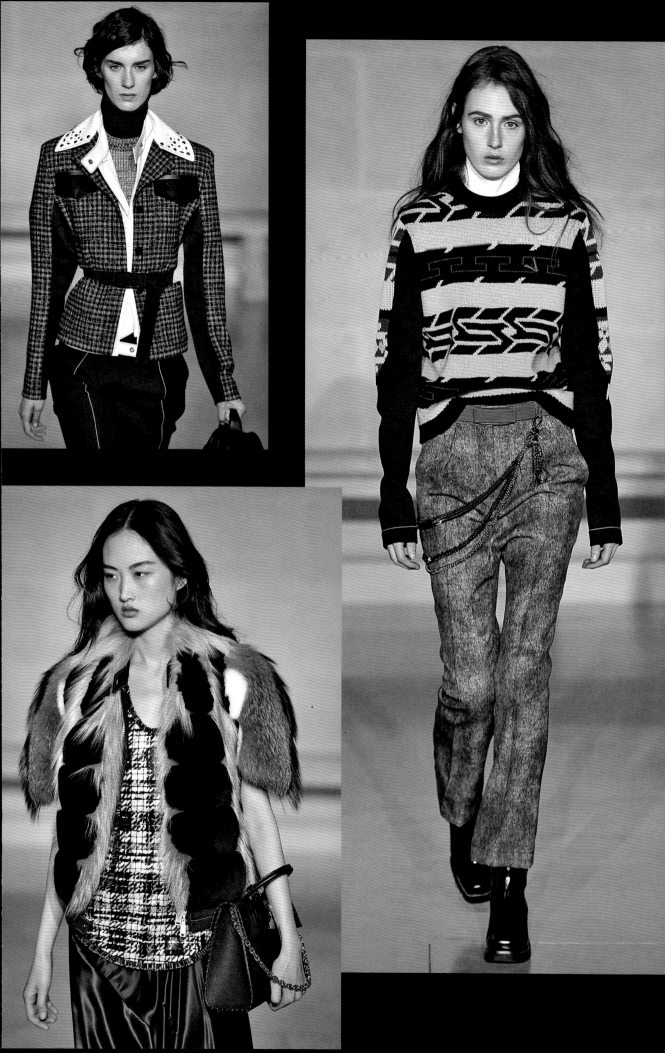

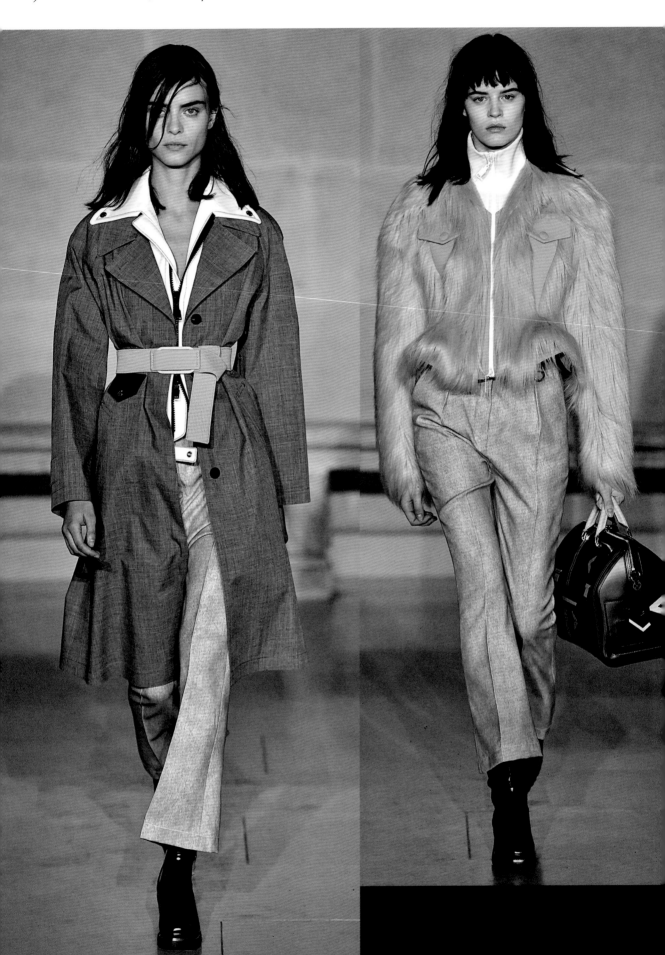

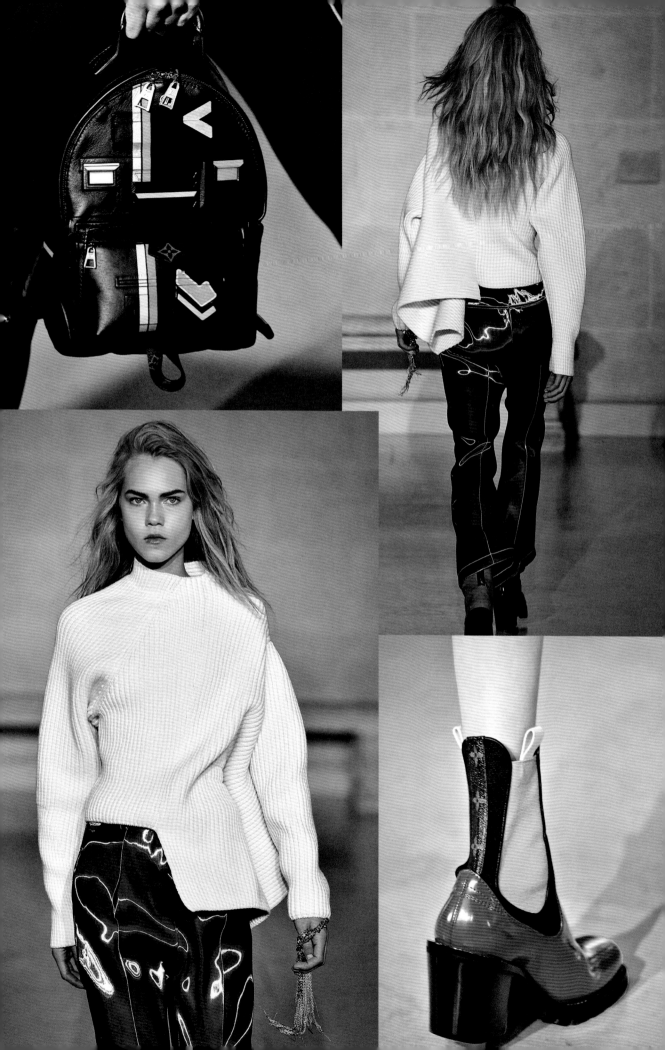

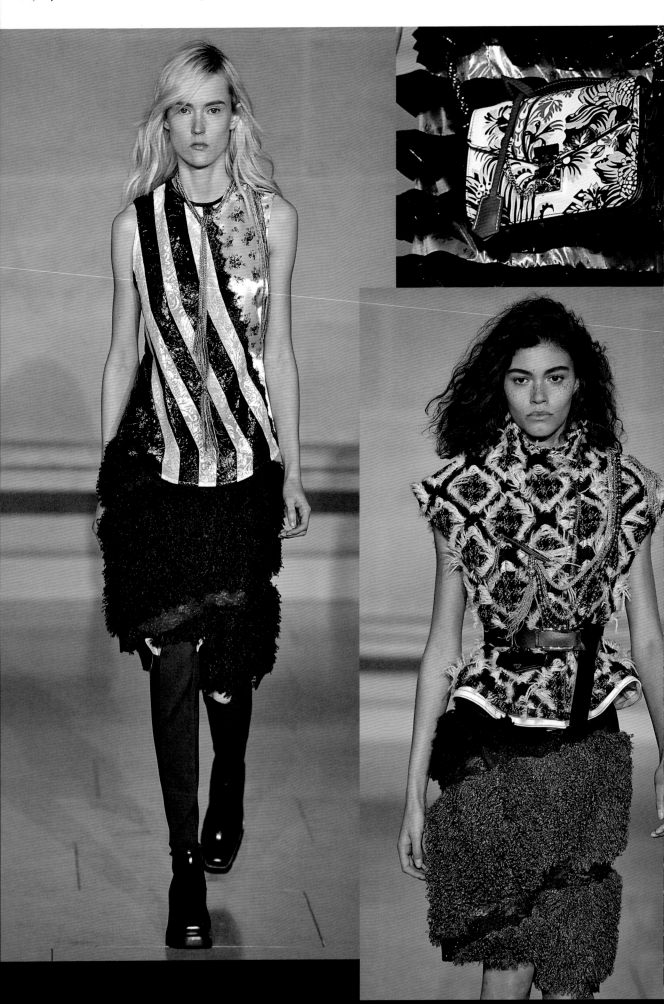

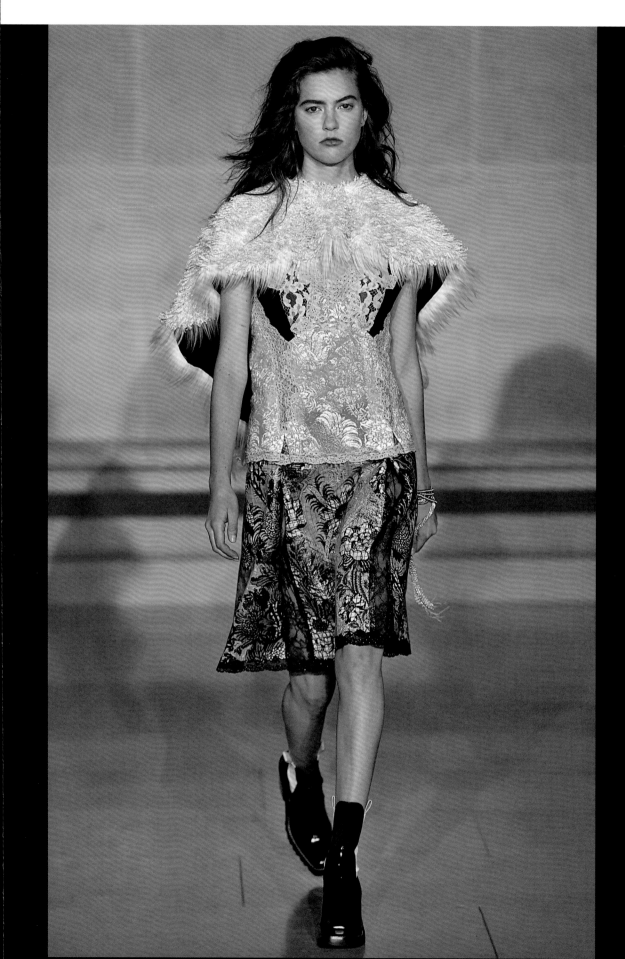

Shiga

Continuing the 'architectural voyage' of Louis Vuitton,
Nicolas Ghesquière chose I. M. Pei's Miho Museum,
in the Japanese prefecture of Shiga, as the location for
his 2018 Cruise collection. The building, inaugurated
in 1997, had been conceived to represent Shangri-La,
the mythical heaven on earth. Against a picturesque
backdrop of thickly wooded mountains, the 50 models
emerged through the museum's long metal tunnel
onto the futuristic suspension bridge, with actresses
Rila Fukushima and Doona Bae opening and
closing the show.

Bringing to mind his own approach to the illustrious
legacy of Vuitton, Ghesquière explained his fascination
with Japan: 'I was always amazed by the contrast
between how they preserve the heritage and the history
and they celebrate it, and at the same time how much
the country is looking forward – it's very technological
and modern.'

'The references are obvious, almost like a sign
of respect,' declared the show notes. 'The garments
recall samurai, figurative engraving, inked landscapes,
ceremonial dress, the keikogi of martial arts, the
Kurosawa cinematic dramaturgy, or the unique
melancholy of Kitano. Urban pantsuits and
architectural tunics are designed in the spirit of
Hokusai. Interwoven jersey and leather sweaters
recall the armor of Japanese warriors [p. 597].
Evening dresses gleam with Noh theater gold [p. 598].'

Ghesquière also referenced more contemporary
and unexpected sources, such as the girl-gang bikers
of the 1970s Japanese 'Stray Cat Rock' films, whose
heroines inspired the makeup look created by
Pat McGrath (bold brows, cat eyes and accentuated
cheekbones), and he presented a special collaboration
with Kansai Yamamoto. 'I wanted to have a joyful
point of view, too, of Japan, and he is it,' said
Ghesquière. 'He did these incredible costumes for
Bowie as we know, but also was the first Japanese
designer to show in Paris, so I thought it was really
interesting to celebrate that and to ask him to
design a few things for the show.'

Yamamoto created graphic designs for loose T-shirt
dresses (p. 595) and a range of accessories, including
special editions of the Speedy and Petite Malle adorned
with Kabuki-influenced stickers and masks (p. 592,
right). Other key accessories included Fireball boots,
caps designed by Kristopher Haigh, and the new
Bento Box bag (p. 590, left).

Ghesquière had created 'hip Vuitton warrior women',
wrote British *Vogue*'s Emily Sheffield. The designer
acknowledged that, having been a regular visitor to
Japan for some 20 years, 'This collection is the
culmination of what Japan has given to me for
a very long time.'

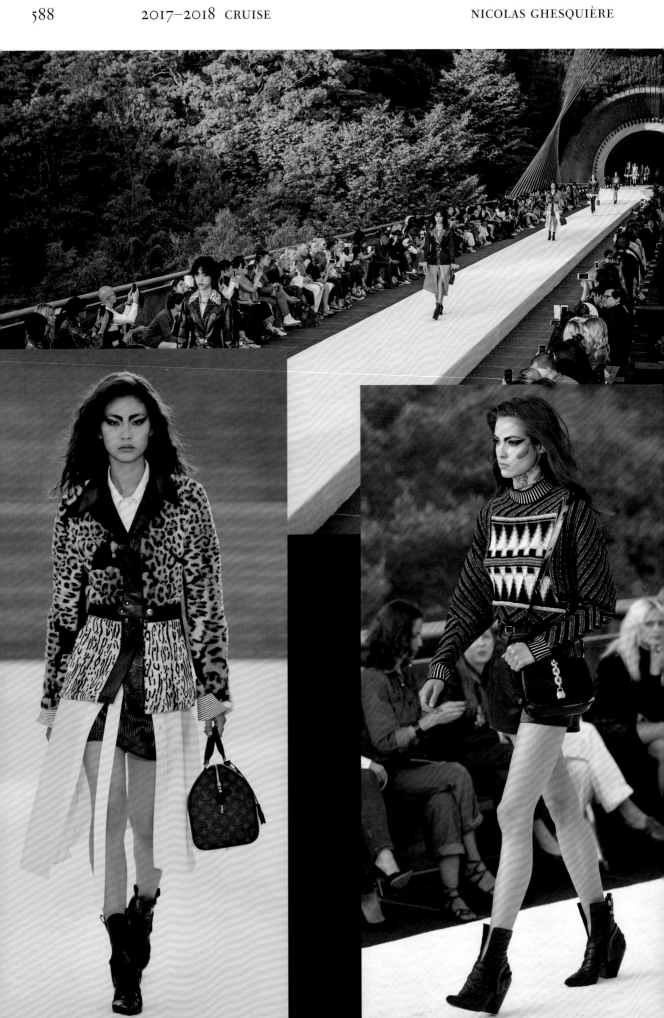

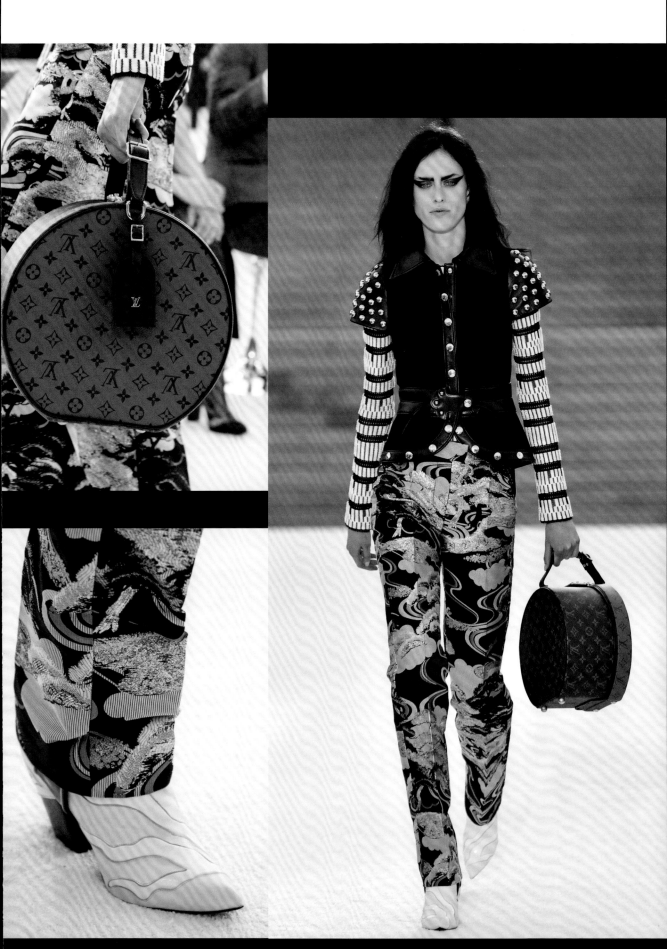

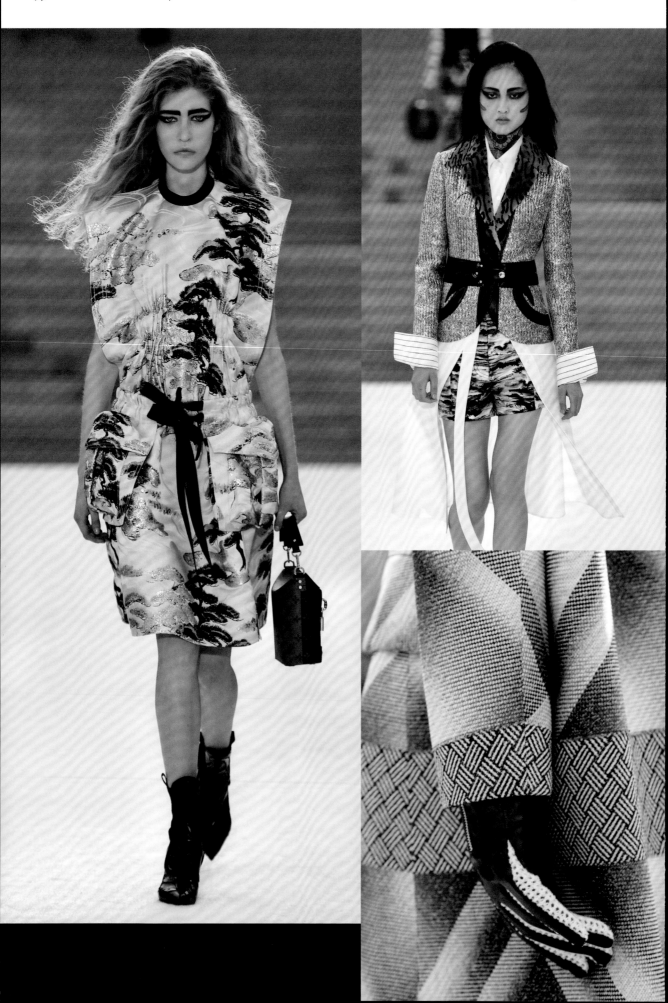

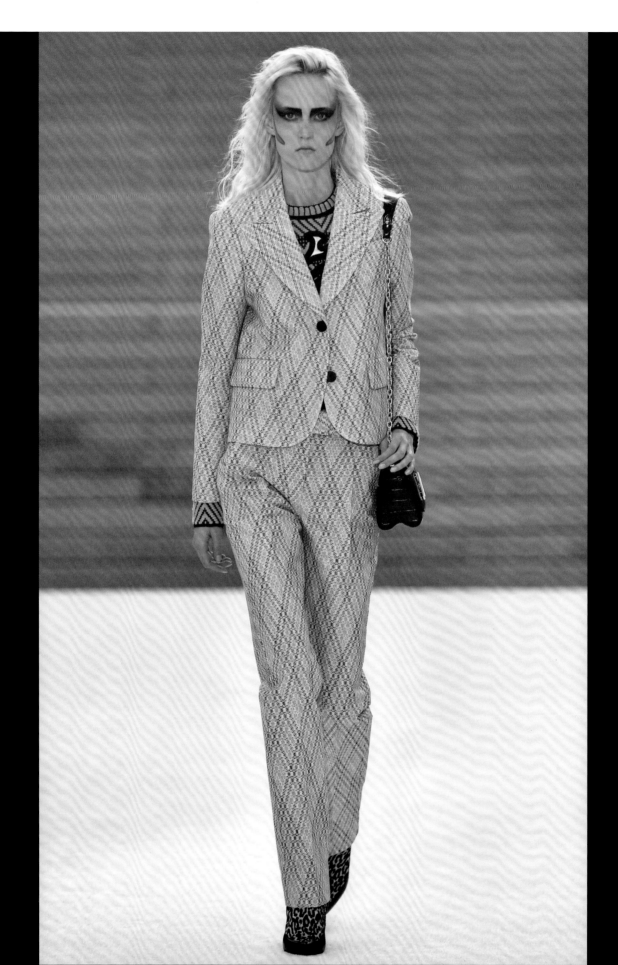

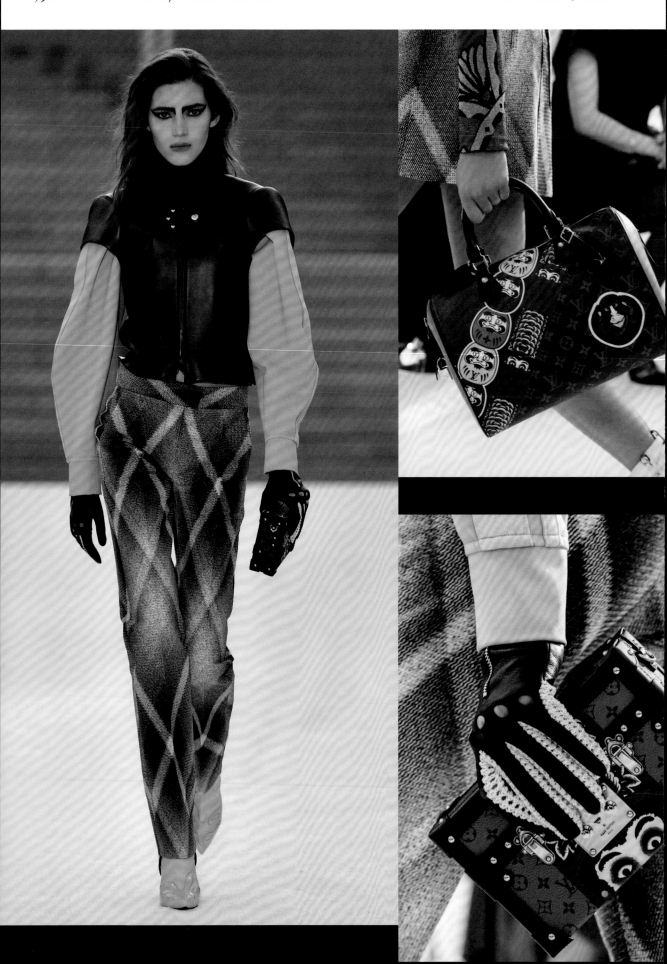

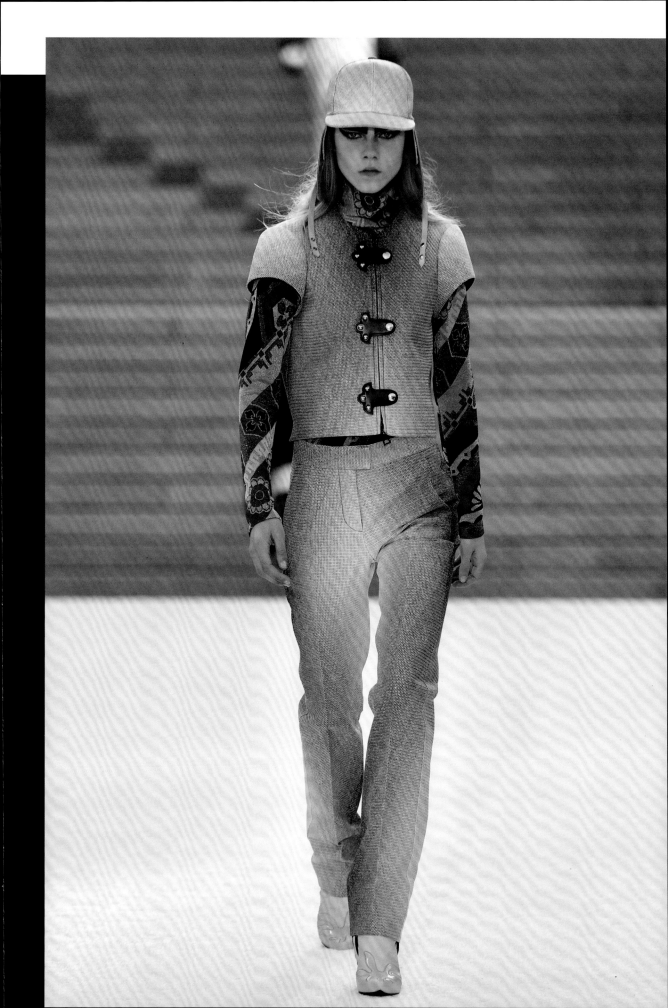

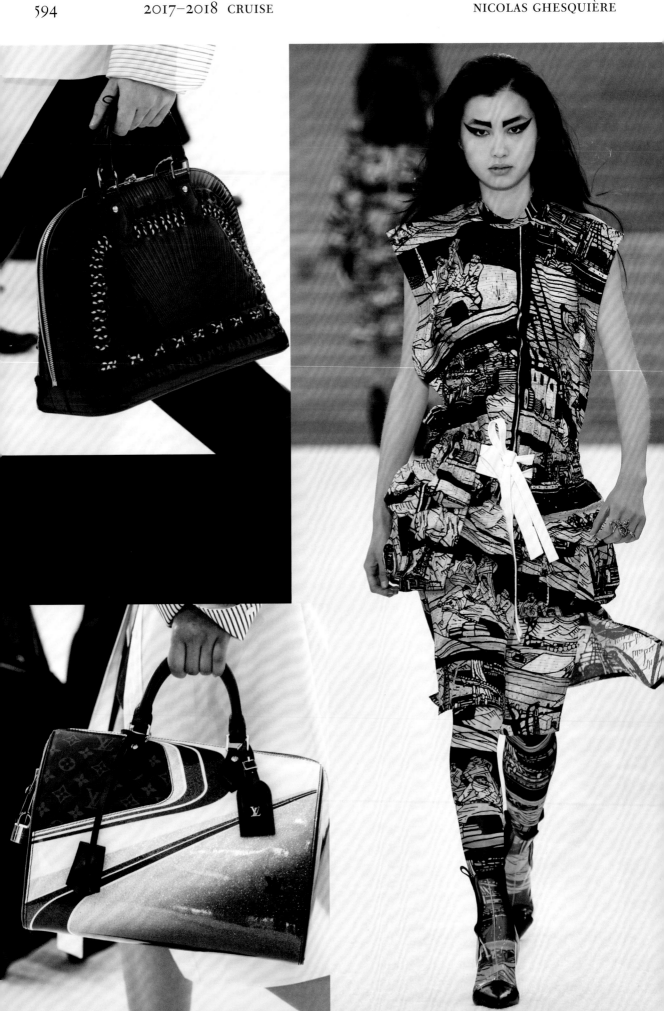

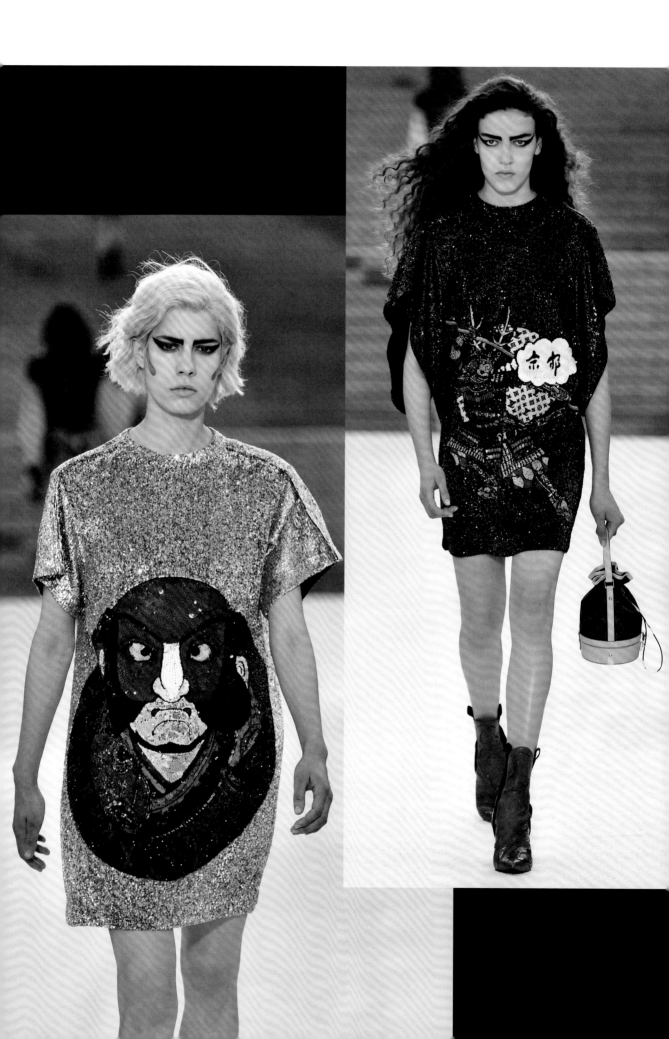

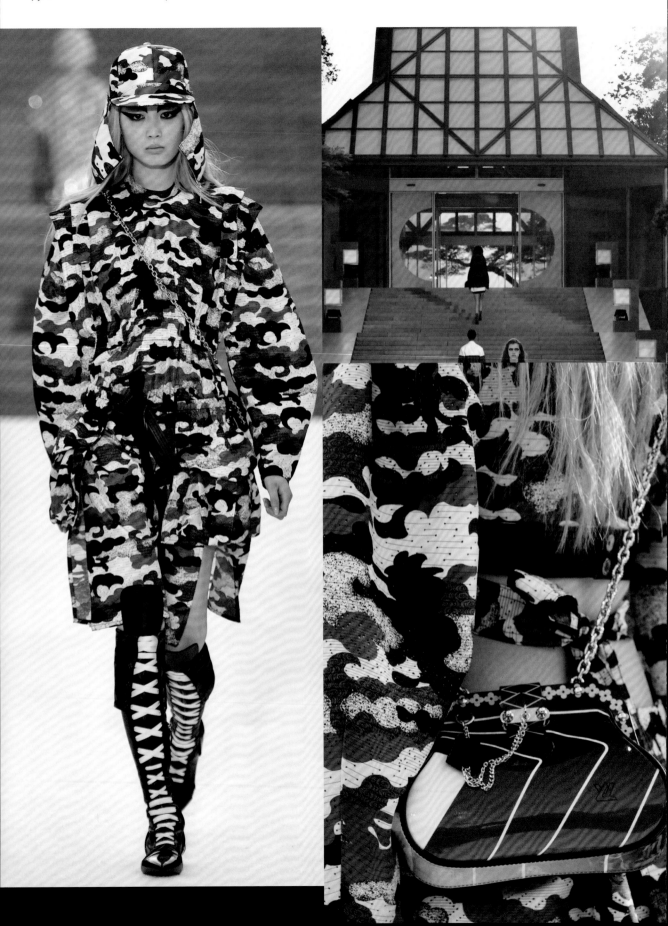

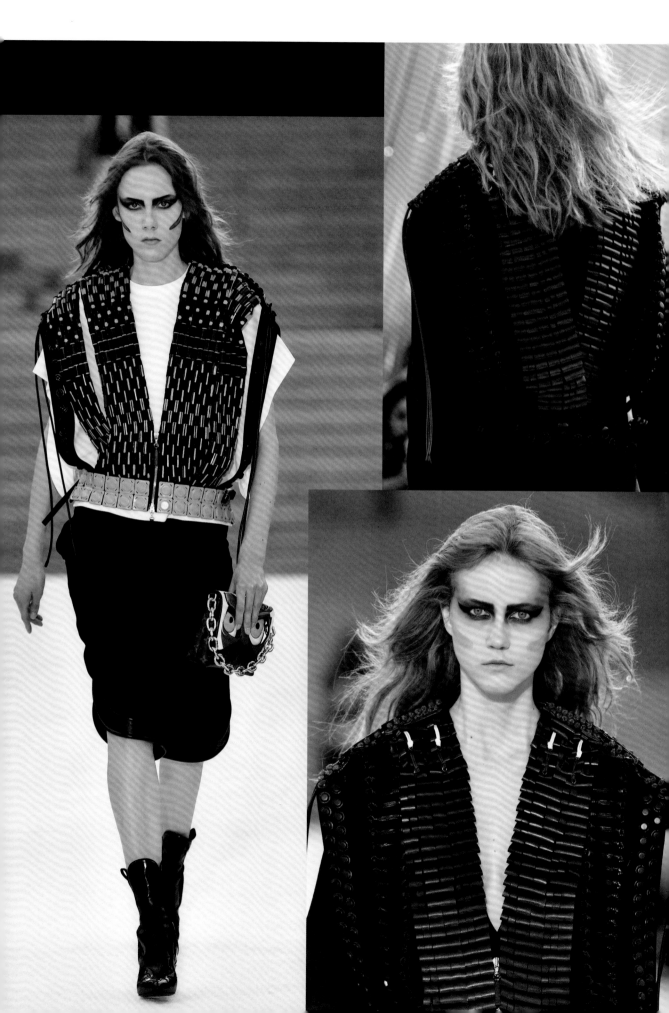

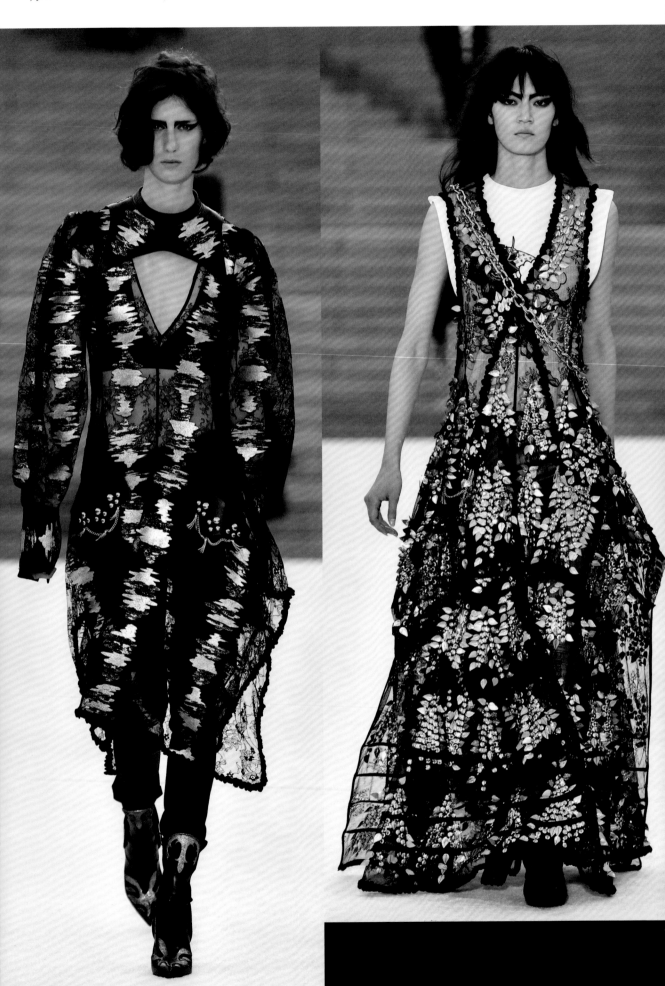

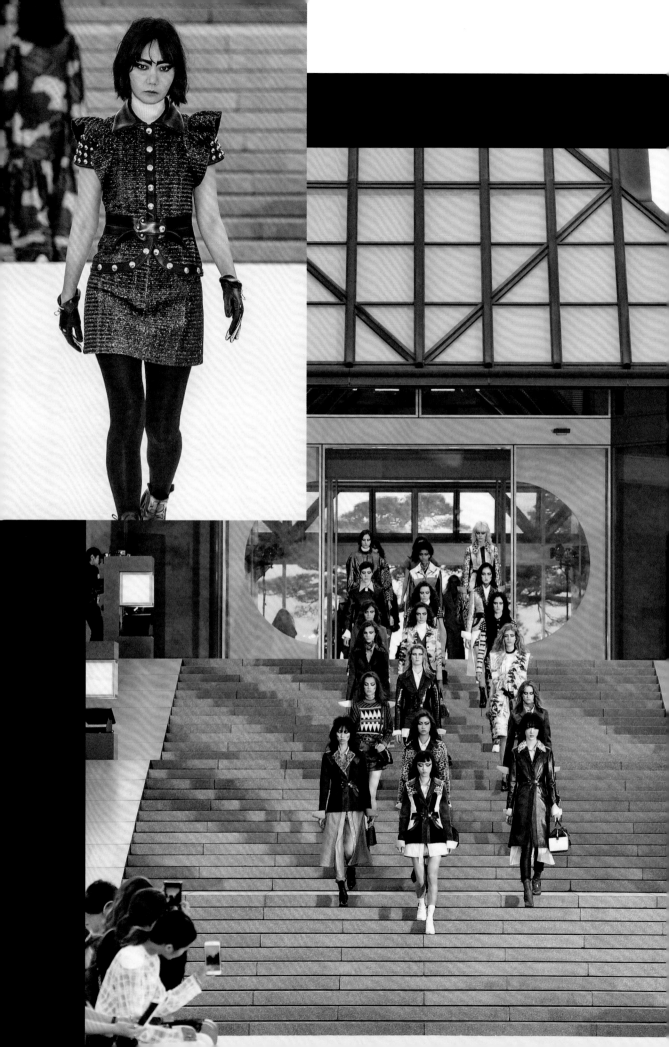

'Transcending Time'

'Might it be possible to awaken the clothes of long-gone eras and infuse them with the spirit of today?' asked Nicolas Ghesquière with his spring/summer 2018 collection. Mixing 18th-century French aristocratic style with urban sportswear, the collection was 'all about anachronisms, a dialogue of wardrobes transcending Time'. The show was presented on the lower-ground floor of the newly renovated Pavillon de l'Horloge at the Louvre, the neon-lit catwalk contrasting with the ancient stone walls. '[I]n the very heart of Paris ... where history is palpable, Louis Vuitton has found its own special significance: travel between the past and the present forever joining together as one,' stated the press notes.

Ghesquière had found inspiration at New York's Metropolitan Museum of Art. 'We saw the most beautiful frocks and I thought, this is so interesting to mix them with sports clothes...' The show notes explained further: 'the refinement of ceremonial dress – the abundant brocade, fine embroidery, and exceeding delicacy of period clothing – blends with the dynamic yet casual modernity of clothes today. An elaborate tail coat can drape harmoniously over tapered trousers, and a melancholic dress can flow beautifully down to sneakers from another world. In this delicate style the House skips across time and dovetails the ages.'

The styling and accessories added to the futuristic aspect of the collection. There were sci-fi-inspired sunglasses (see opposite, top right), a Netflix *Stranger Things* fan T-shirt, and sculptural sneakers with hip, springy soles (see p. 603, top left). Ghesquière said about the accessory of the season: 'It is not incredibly new to put them on the catwalk, it is new to mix them with something very flamboyant...' Jo Ellison reported in the *Financial Times*: 'The line was sophisticated, snug at the waist but then flicking away to the knee. When worn with trousers and the heavy trainer, it created a typically Ghesquière silhouette.'

The Speedy bag was introduced in grey, black and white waxed canvas and, after their unveiling at the Cruise collection in Japan, mini hat boxes were reinterpreted (see p. 606, left and top right). A zipped backpack (p. 604, top left) and a chain-embellished Monogram large tote (p. 605, left) also made an appearance.

Tim Blanks wrote in *The Business of Fashion*: 'It felt like a breakthrough for Nicolas Ghesquière. If the brand's raison d'être is travel, he'd certainly found his own way into the idea: time, not place.' *Vogue* concluded: 'Ghesquière's neat trick here was making the past look like the future.'

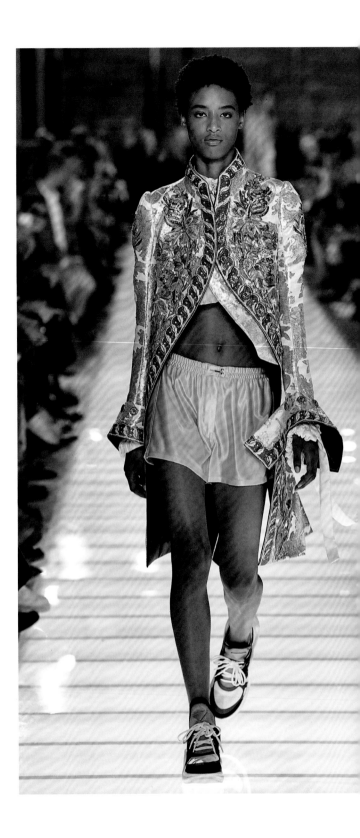

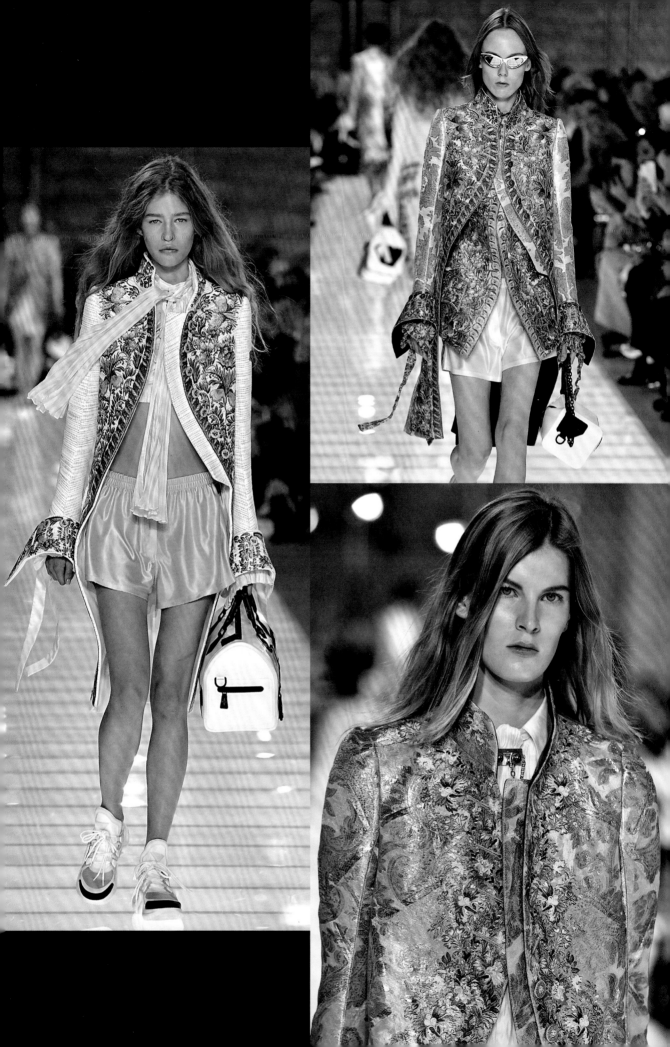

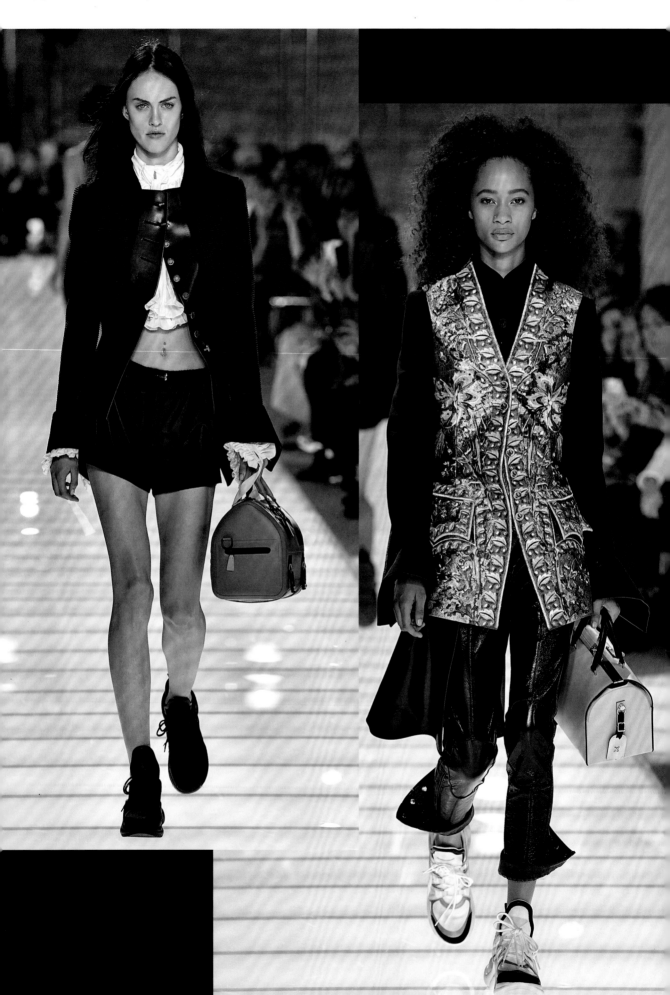

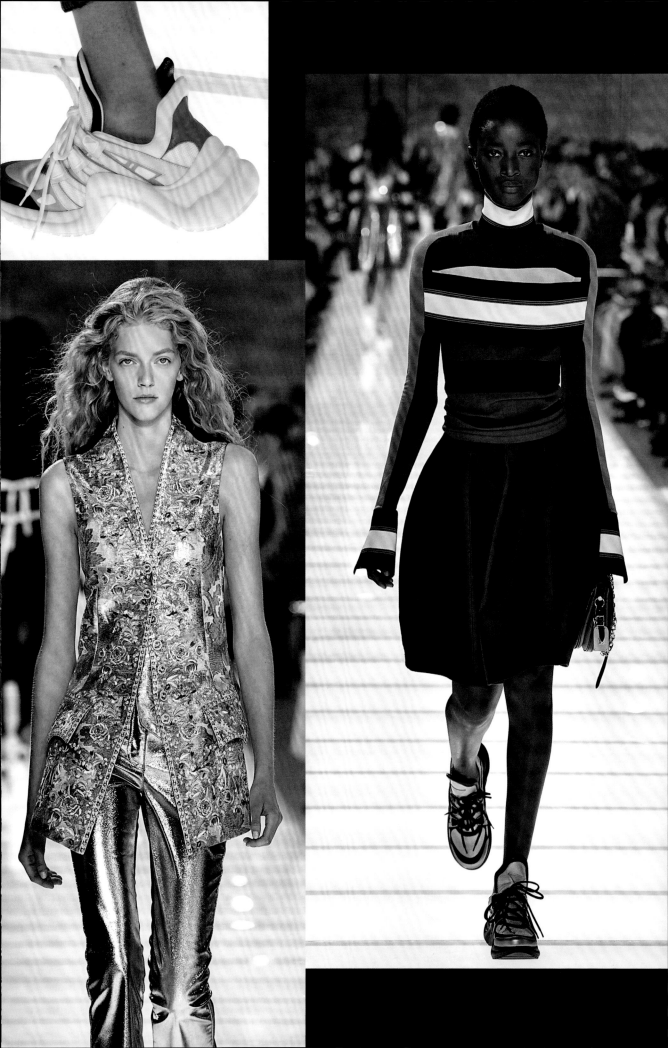

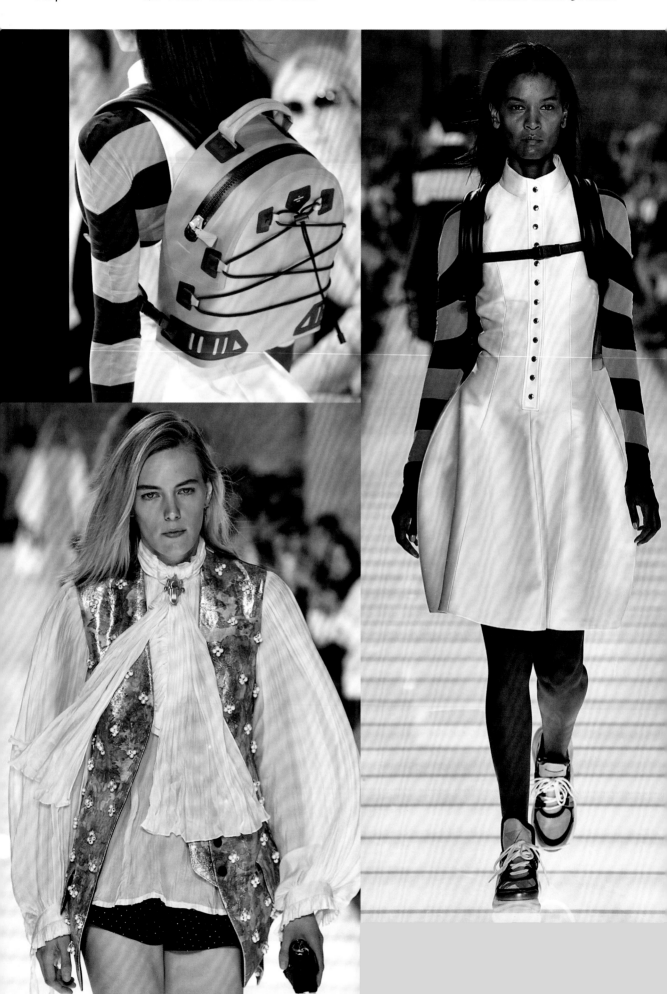

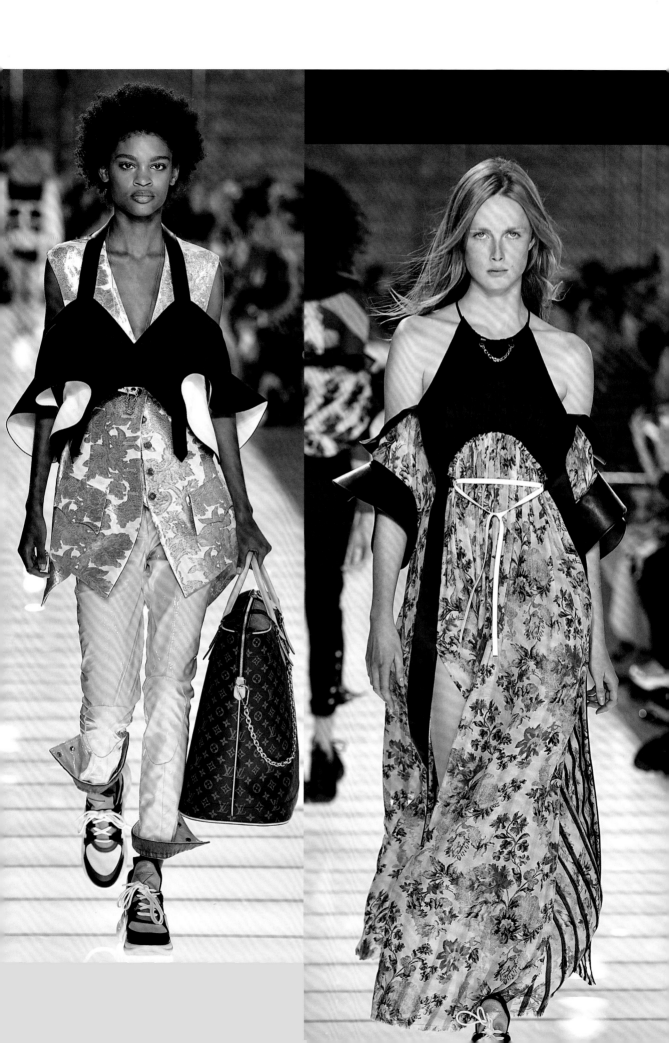

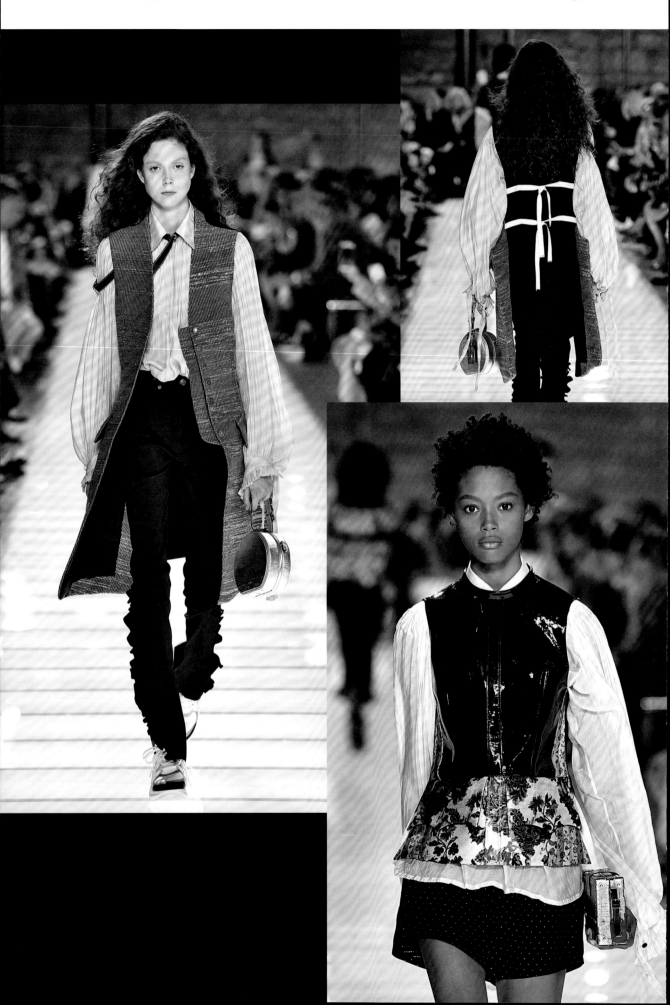

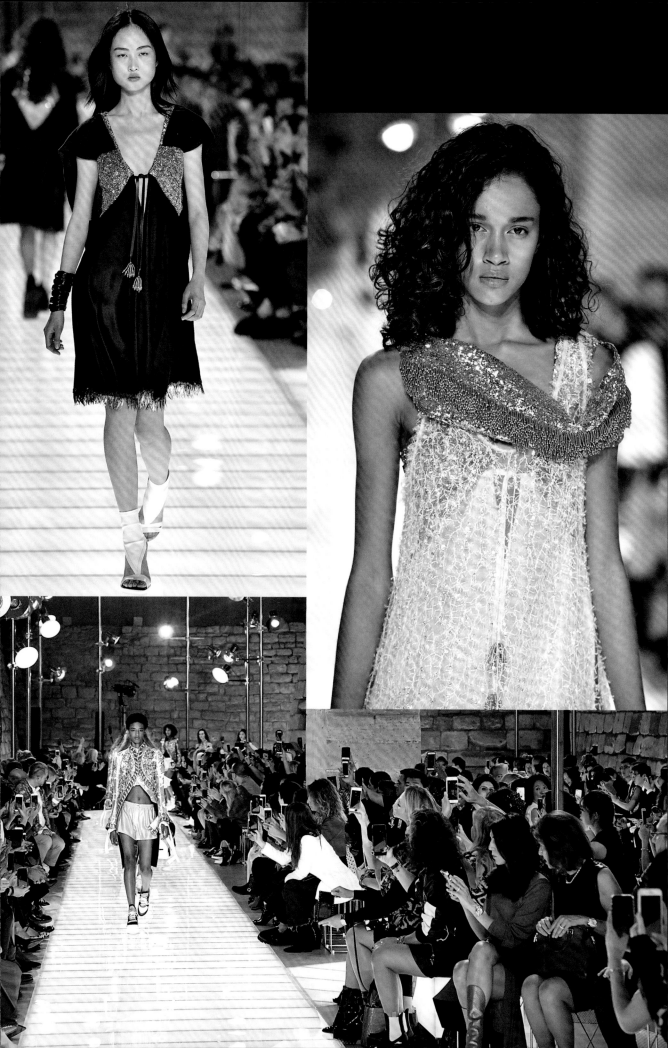

Cour Lefuel

Originally built in the 19th century for Napoleon III
as a gateway for his horses, the Louvre's Cour Lefuel
– normally inaccessible to the public – was the setting
for this season's catwalk show. Designer Es Devlin
covered the horseshoe-shaped stairwell with a colourful
patterned carpet and created a grey spaceship-inspired
platform, which Nicolas Ghesquière described
as being 'sharp and very clean in the middle of the
historical environment of the courtyard'. The show,
live-streamed to millions of people around the world,
represented the ultimate 21st-century travel experience
by merging exclusive access to the hallowed museum
and showcasing a timeless wardrobe imbued in
craftsmanship and technology.

'A parade of Starship Troopers in vestiges of the
outfits of the French female bourgeoisie,' reported
Vanessa Friedman of *The New York Times*. She added:
'Tweed was paired with stargate shirting; the shoulders
big and space-striped, like a pseudo-mantle; skirt suits
layered under cosmic vests. The LV logo had been given
an aerodynamic frame. Jolie madame on the bottom,
sci-fi on top! A little scattershot overall. But haute
Hollywood metallic silk halter-neck tops with athletic
corsets atop black tuxedo trousers captured the best
way to take off: under your own steam.'

'It's the legacy of people who built my taste and
informed my choices, plus the span in time and the
dialogue between East and West,' said Ghesquière.
Capturing the zeitgeist of the #metoo movement, the
forty-six looks – 'quintessentially French, but without
any nostalgia' – were devoted to the inspiring women
in the designer's life. He noted: 'We forget that some
very strong women wore very feminine outfits, and
I love this idea of women, who were changing the
world and did not have to dress like men, or *for*
men. The women I tried to show today are that.'

Ghesquière described the collection as being
'rigorous but in a positive way'. Peplum jackets,
lambswool coats and biker jackets were decorated
with ribbons, buttons, '80s chain-belts and statement
jewelry – bolo ties, necklaces, bracelets, earrings
and brooches. The models wore a single glove
firmly clutching their handbags sideways under the
arm. Ladylike bags came in a striking 'motherboard'
print, and in metallic snakeskin, and one resembled
a tin can.

Cathy Horyn reported that the collection was
'a case for the strength of uncomplicated femininity'.
It also marked a return to the heel. As CEO Michael
Burke commented: 'Last time Nicolas did the 18th
century with trainers [S/S 2018]; this time, he did
the 18th century with shoes.'

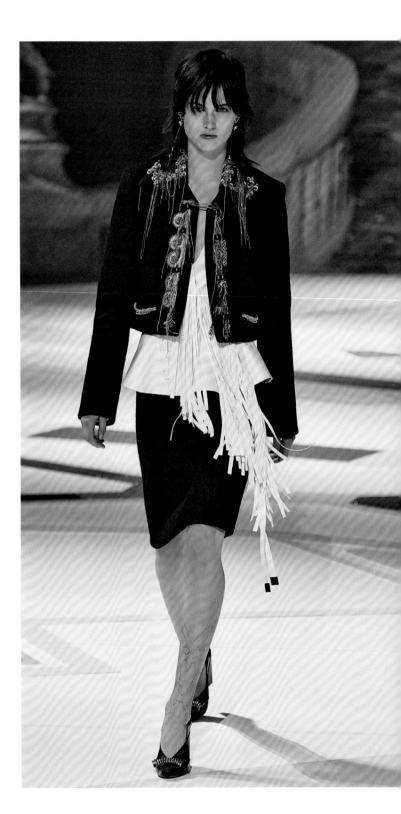

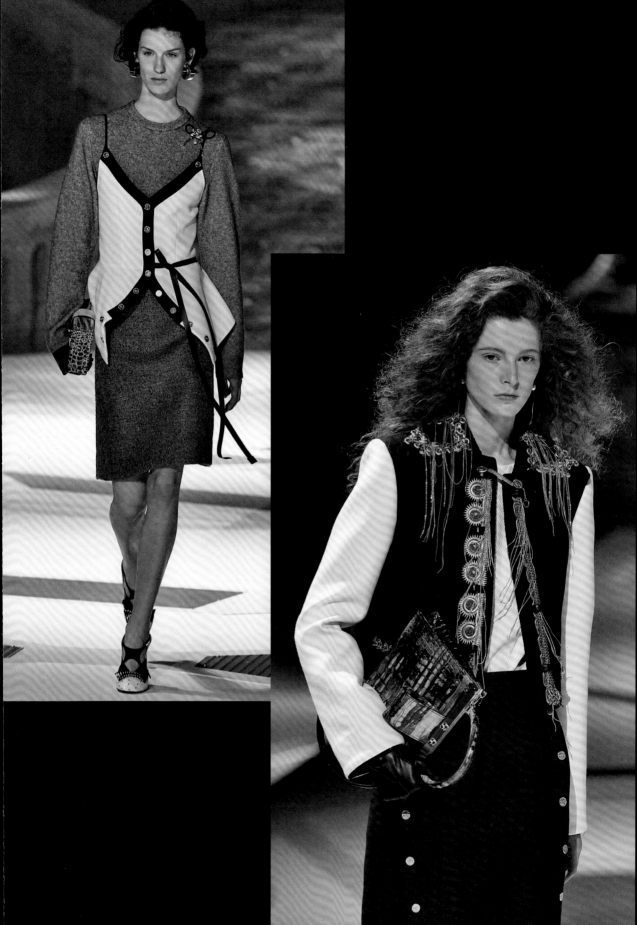

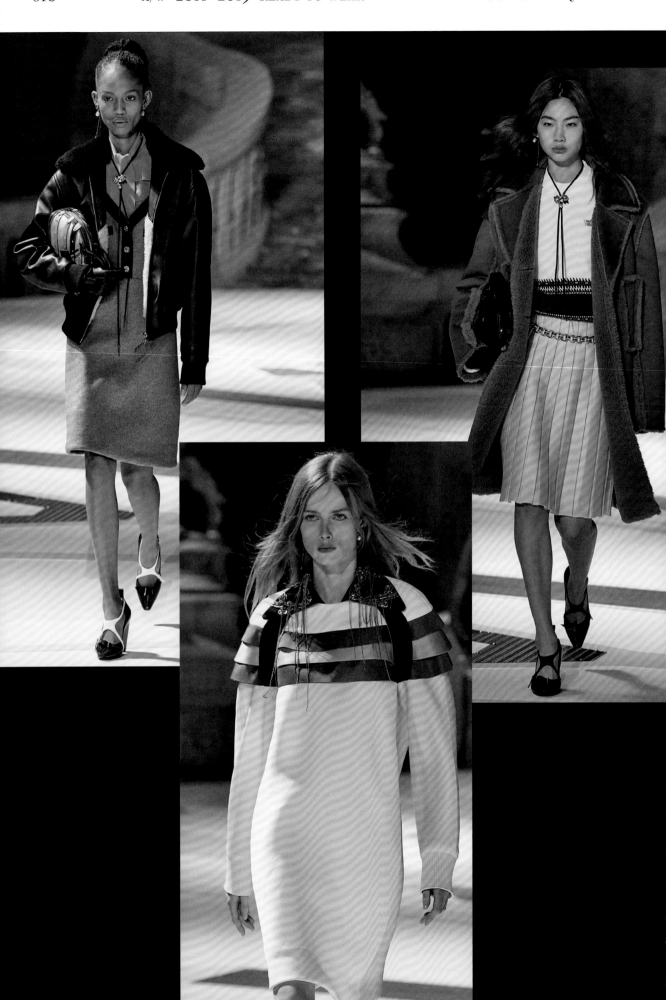

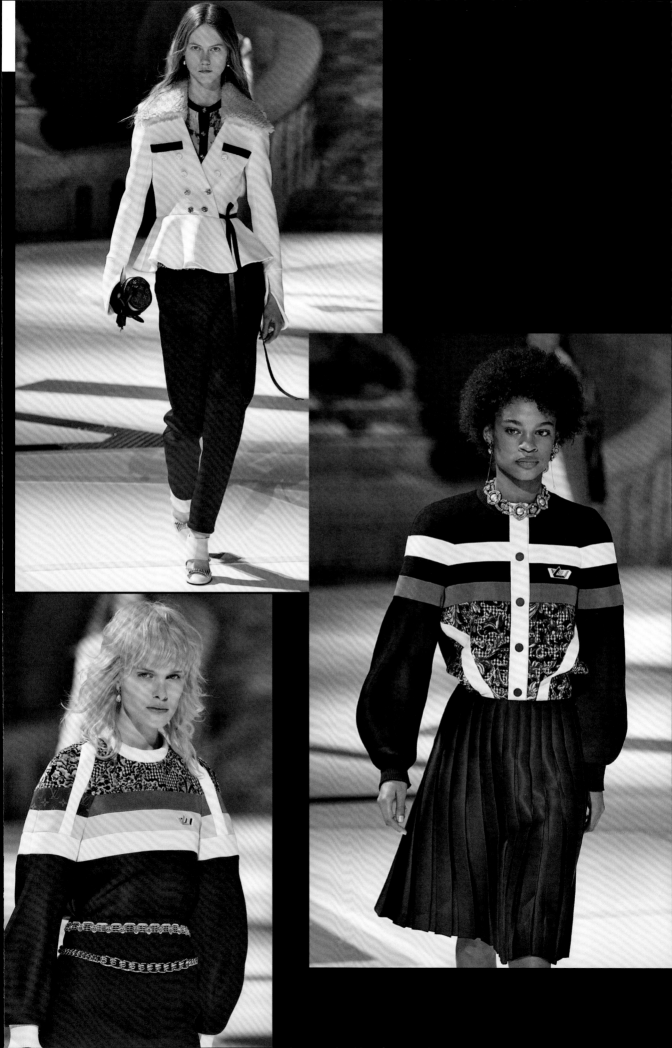

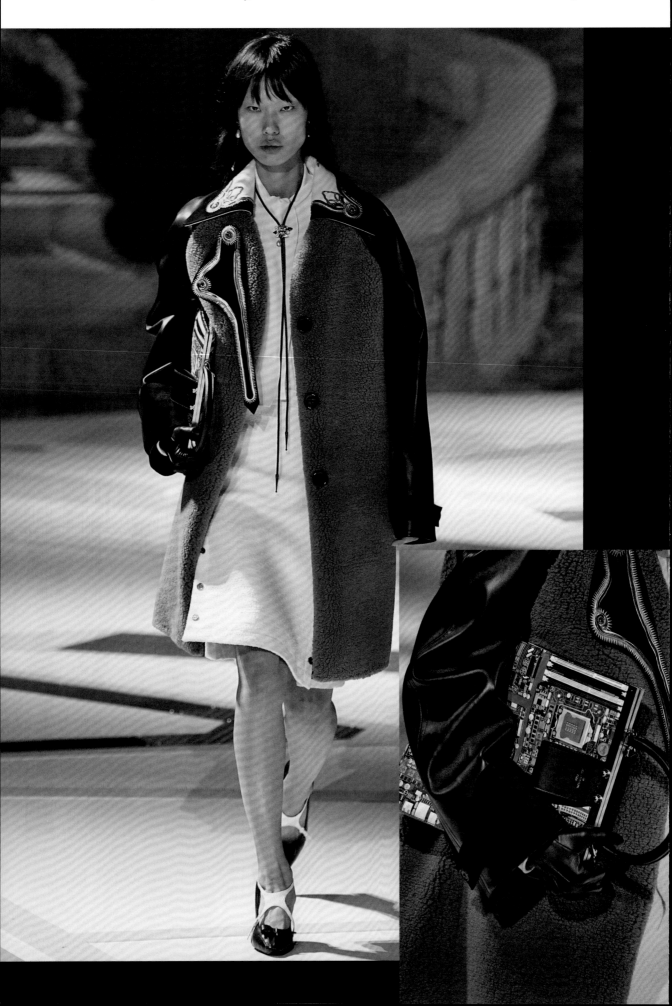

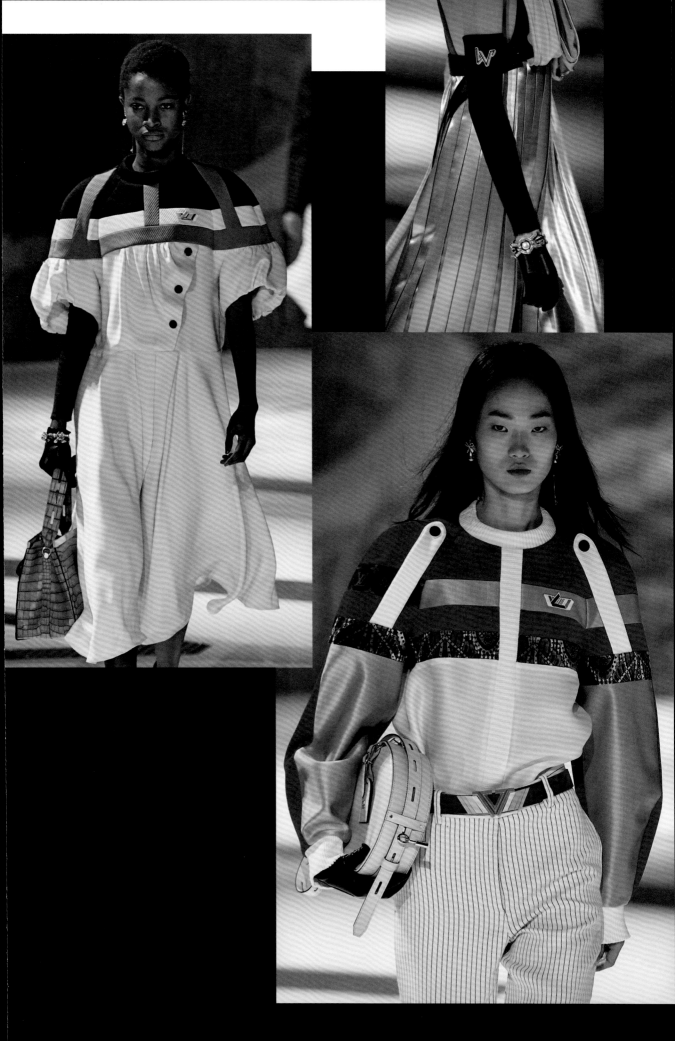

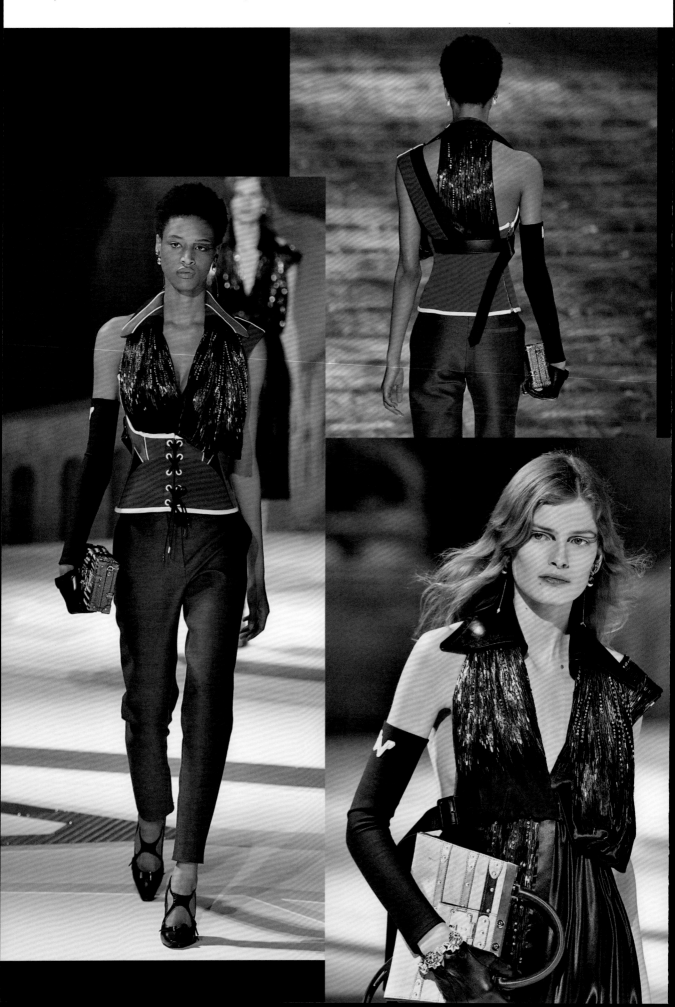

Bibliographic Note

In order not to disrupt the flow of reading, we have decided not to include references or footnotes in the main body of the text.

Sources for the quotations in the designer biographies and collection texts can be found below.

Publications

Pamela Golbin, ed., *Louis Vuitton / Marc Jacobs*, New York: Rizzoli, 2012.

Louis Vuitton: Art, Fashion and Architecture, New York: Rizzoli, 2009/2017.

Brenda Polan and Roger Tredre, *The Great Fashion Designers*, Berg, 2009.

Articles

Hilary Alexander, 'Great expectations for a floral spring', *The Daily Telegraph*, 9 October 2006.

Topaz Amoore, 'It's the Time of the Signs', *The Express*, 2 March 2000.

Lisa Armstrong:
'Jacobs returns Vuitton credit to the black', *The Times*, 13 March 2001.
'McCartney's show lacks a certain something', *The Times*, 12 March 2002.
'Louis Vuitton handbags Paris with style', *The Times*, 7 March 2005.
'Paris Fashion Week: Lisa Armstrong sees the supermodel stride back into controversy', *The Times*, 10 March 2011.

Carolyn Asome, 'The Jacobs look is arriving at Platform Wow', *The Times*, 8 March 2012.

Tim Blanks, 'Past, Present and Future Fuse at Louis Vuitton', *Business of Fashion*, 8 October 2015.

Jess Cartner-Morley:
'At Louis Vuitton the clothes are the accessories', *The Guardian*, 13 October 2001.
'At least we'll always have Paris', *The Guardian*, 11 October 2002.
'Louis Vuitton train pulls in at Paris fashion week', *The Guardian*, 7 March 2012.
'Kate Moss adds glamour and hint of impropriety to Marc Jacobs's Vuitton show', *The Guardian*, 6 March 2013.

Claudia Croft, 'In Paris, vive les nouveaux riches', *The Evening Standard*, 6 March 2000.

Joelle Diderich, 'Louis Vuitton Hosts Cruise 2018 Show in Kyoto, Japan', *Women's Wear Daily*, 14 May 2017.

Jo Ellison:
'Rio grand: Louis Vuitton Cruise 2017 show report', *The Financial Times*, 29 May 2016.
'A night at the museum: Louis Vuitton goes to the Louvre', *The Financial Times*, 8 March 2017.
'The runaway show of the season: Louis Vuitton ss18', *The Financial Times*, 4 October 2017.

Bridget Foley and Marcy Medina, 'Louis Vuitton Cruise 2016', *Women's Wear Daily*, 7 May 2015.

Imogen Fox, 'Marc Jacobs quits Louis Vuitton with emotional Paris fashion week show', *The Guardian*, 2 October 2013.

Susannah Frankel:
'Fashion: Clothes to cut out and keep', *The Independent*, 17 March 1999.
'A rebirth for Paris's bourgeois fashion labels', *The Independent*, 5 October 1999.
'Carousels, movie stars and a kiss from Kate – so has Marc Jacobs signed off in style?', *The Independent*, 6 October 2011.

Vanessa Friedman:
'Louis Vuitton Makes a Statement, Fashion and Political, in Rio', *The New York Times*, 31 May 2016.
'Renovating Fashion's House', *The New York Times*, 5 October 2016.
'Finally, the Fall 2018 Fashion Finale', *The New York Times*, 7 March 2018.

Alexander Fury:
'Nicolas Ghesquière: the man who asked Louis Vuitton's handbag makers to have a go at dresses', *The Independent*, 5 March 2014.
'The full Brazilian: Louis Vuitton comes to Rio, but with economic collapse and pandemics rife, is the girl from Ipanema still luxury's ideal customer?', *The Independent*, 29 May 2016.

Robin Givhan, 'YSL, Last And First; Paris Shows Close With a Collection Open to Possibility', *The Washington Post*, 12 March 2003.

'The Guru of Grunge' [uncredited author], *Women's Wear Daily*, 11 November 1992.

Cathy Horyn:
'Theme of the Spring Season: Anyone Can Join the Club', *The New York Times*, 19 October 1999.
'Critic's Notebook; A Look Back at Spring Shows Reveals a Romantic Streak', *The New York Times*, 15 October 2002.
'Review/Fashion; At Saint Laurent, Intrigue Off the Catwalk', *The New York Times*, 14 October 2003.
'How Nicolas Got His Groove Back', *T Magazine*, *The New York Times*, 28 August 2005.
'Two Schools for Spring: Ruffled and the Reverse', *The New York Times*, 11 October 2005.
'The Last Word, Loud and Clear', *The New York Times*, 4 March 2008.
'A Goodbye Kiss for Paris', *The New York Times*, 7 October 2008.
'A Shift Away From Linear Thinking', *The New York Times*, 12 March 2010.
'Exit Paris, Winking', *The New York Times*, 11 March 2011.
'The Big, Sudden, Unexpected Joy of Encountering Modernity', *The Cut*, 13 March 2015.
'Sometimes It's Okay to Cater to the Bourgeoisie: Nicolas Ghesquière makes a case for the strength of uncomplicated femininity in his new Louis Vuitton collection', *The Cut*, 7 March 2018.

Carola Long, 'Galliano doffs hat to British heritage', *The Independent*, 6 October 2008.

Colin McDowell:
'The big league', *The Sunday Times*, 28 October 2001.
'French Fancy', *The Sunday Times*, 23 March 2003.

Suzy Menkes:
'From brands with a pedigree: Bags vs. clothes;
 The Collections / Paris', *The International Herald
 Tribune*, 7 March 2006.
'All Aboard the LV Express', *The New York Times*,
 7 March 2012.
'Lust, and Not Just for Travel', *The New York Times*,
 6 March 2013.
'I'm ready for my close-up, Mr. Arnault; Special
 Report: Fashion', *The International Herald Tribune*,
 10 March 2010.
'Louis Vuitton: A Debut With Desire', *The New York
 Times*, 5 March 2014.

Lynda Richardson, 'PUBLIC LIVES; It's Graffiti, by
Design, and Flying Cars to Come', *The New York
Times*, 22 August 2001.

Stefano Roncato, 'The interview: Louis Vuitton's
Nicolas Ghesquière', NowFashion, 4 October 2015.

Julia Rubin, 'Marc Jacobs Muses On His Teenage
Years And Early Days In The Industry', *Teen Vogue*,
11 January 2013.

Susie Rushton, 'It's in the bag – Louis Vuitton air
their laundry', *The Independent*, 8 October 2006.

Matt Tyrnauer, 'Palm Springs Modernism,
According to Nicolas Ghesquière', *T Magazine*
(*The New York Times*), 23 September 2015.

Helen Wigham, 'Nicolas Ghesquière' (biography),
Vogue.co.uk, 17 March 2011.

Videos

Loïc Prigent, *Marc Jacobs & Louis Vuitton*, 2007

Style.com, Louis Vuitton:
Spring 2007 Ready-to-Wear.
Fall 2007 Ready-to-Wear.
Fall 2008 Ready-to-Wear.
Spring 2009 Ready-to-Wear.
Fall 2009 Ready-to-Wear.
Spring 2011 Ready-to-Wear.
Fall 2011 Ready-to-Wear.
Spring 2012 Ready-to-Wear.
Fall 2013 Ready-to-Wear.
Spring 2015 Ready-to-Wear.
Fall 2015 Ready-to-Wear.
Spring 2016 Ready-to-Wear.

NB: References to *Vogue* refer to the American
edition of the magazine unless otherwise indicated.

Collection Credits

Louis Vuitton by Marc Jacobs

A/W 1998–1999 Ready-to-Wear

9 March 1998; Grande Halle de la Villette, avenue Jean-Jaurès, 75019 Paris; hair by Guido for Nicky Clarke; makeup by Dick Page for Jed Root, Inc.; styled by Joe McKenna; produced by KCB-WAB

s/s 1999 Ready-to-Wear

12 October 1998; Greenhouse at Parc André-Citroën, rue de la Montagne-de-la-Fage, 75015 Paris; hair by Eugene Souleiman for Toni & Guy; makeup by Pat McGrath; styled by Brana Wolf; produced by KCD–WAB

A/W 1999–2000 Ready-to-Wear

8 March 1999; Greenhouse at Parc André-Citroën, rue de la Montagne-de-la-Fage, 75015 Paris; hair by Eugene Souleiman for Toni & Guy; makeup by Pat McGrath; styled by Brana Wolf; produced by La Mode en Images – KCD

s/s 2000 Ready-to-Wear

4 October 1999; Greenhouse at Parc André-Citroën, rue de la Montagne-de-la-Fage, 75015 Paris; hair by Eugene Souleiman for Toni & Guy; makeup by Pat McGrath; styled by Brana Wolf; produced by La Mode en Images – KCD

A/W 2000–2001 Ready-to-Wear

28 February 2000; Greenhouse at Parc André-Citroën, rue de la Montagne-de-la-Fage, 75015 Paris; hair by Eugene Souleiman for Toni & Guy; makeup by Pat McGrath; styled by Brana Wolf; produced by La Mode en Images – KCD

s/s 2001 Ready-to-Wear

11 October 2000; Greenhouse at Parc André-Citroën, rue de la Montagne-de-la-Fage, 75015 Paris; hair by Eugene Souleiman for Toni & Guy; makeup by Pat McGrath; hats by Philip Treacy; styled by Brana Wolf; produced by La Mode en Images – KCD

A/W 2001–2002 Ready-to-Wear

12 March 2001; Greenhouse at Parc André-Citroën, rue de la Montagne-de-la-Fage, 75015 Paris; hair by Eugene Souleiman for Toni & Guy; makeup by Pat McGrath; hats by Philip Treacy; embroidery by Atelier Montex; styled by Brana Wolf; produced by La Mode en Images – KCD

s/s 2002 Ready-to-Wear

8 October 2001; Greenhouse at Parc André-Citroën, rue de la Montagne-de-la-Fage, 75015 Paris; hair by Eugene Souleiman for Toni & Guy; makeup by Pat McGrath; embroidery by Atelier Montex; styled by Brana Wolf; produced by La Mode en Images – KCD

A/W 2002–2003 Ready-to-Wear

11 March 2002; Greenhouse at Parc André-Citroën, rue de la Montagne-de-la-Fage, 75015 Paris; hair by Eugene Souleiman for Toni & Guy; makeup by Pat McGrath; embroidery by Atelier Montex; furs by Saga Furs of Scandinavia; styled by Katie Grand; produced by La Mode en Images – KCD

s/s 2003 Ready-to-Wear

7 October 2002; Greenhouse at Parc André-Citroën, rue de la Montagne-de-la-Fage, 75015 Paris; hair by Eugene Souleiman for Toni & Guy; makeup by Pat McGrath; embroidery by Atelier Montex; styled by Katie Grand; produced by La Mode en Images – KCD

A/W 2003–2004 Ready-to-Wear

10 March 2003; Greenhouse at Parc André-Citroën, Rue de la Montagne-de-la-Fage, 75015 Paris; hair by Eugene Souleiman for Toni & Guy; makeup by Pat McGrath; embroidery by Atelier Montex; styled by Alex White; produced by La Mode en Images – KCD

s/s 2004 Ready-to-Wear

12 October 2003 ; Greenhouse at Parc André-Citroën, rue de la Montagne-de-la-Fage, 75015 Paris; hair by Eugene Souleiman for Toni & Guy; makeup by Pat McGrath; embroidery by Atelier Montex; styled by Alex White; produced by La Mode en Images – KCD

A/W 2004–2005 Ready-to-Wear

7 March 2004 ; Greenhouse at Parc André-Citroën, rue de la Montagne-de-la-Fage, 75015 Paris; hair by Eugene Souleiman; makeup by Pat McGrath; styled by Alex White; produced by La Mode en Images – KCD

s/s 2005 Ready-to-Wear

10 October 2004 ; Greenhouse at Parc André-Citroën, rue de la Montagne-de-la-Fage, 75015 Paris; hair by Eugene Souleiman; makeup by Pat McGrath; styled by Alex White; produced by La Mode en Images – KCD

A/W 2005–2006 Ready-to-Wear

6 March 2005; Greenhouse at Parc André-Citroën, rue de la Montagne-de-la-Fage, 75015 Paris; hair by Guido for Redken; makeup by Pat McGrath; styled by Katie Grand; produced by La Mode en Images – KCD

s/s 2006 Ready-to-Wear

9 October 2005; Petit Palais, avenue Winston Churchill, 75008 Paris; hair by Guido for Redken; makeup by Pat McGrath; styled by Katie Grand; produced by La Mode en Images – KCD

A/W 2006–2007 Ready-to-Wear

5 March 2006; Petit Palais, avenue Winston Churchill, 75008 Paris; hair by Guido for Redken; makeup by Pat McGrath; styled by Katie Grand; produced by La Mode en Images – KCD

s/s 2007 Ready-to-Wear

8 October 2006; Petit Palais, avenue Winston Churchill, 75008 Paris; hair by Guido for Redken; makeup by Pat McGrath; styled by Katie Grand; produced by La Mode en Images – KCD

A/W 2007–2008 Ready-to-Wear

4 March 2007; Louvre courtyard, Porte Saint-Germain-de-l'Auxerrois, rue de l'Amiral-de-Coligny, 75001 Paris; hair by Guido for Redken; makeup by Pat McGrath; styled by Katie Grand; produced by La Mode en Images – KCD

s/s 2008 Ready-to-Wear

7 October 2007; Louvre courtyard, Porte Marengo, rue de Rivoli, 75001 Paris; hair by Guido for Redken; makeup by Pat McGrath; millinery by Stephen Jones; styled by Katie Grand; produced by La Mode en Images – KCD

A/W 2008–2009 Ready-to-Wear

2 March 2008; Louvre courtyard, Porte Saint-Germain-de-l'Auxerrois, rue de l'Amiral-de-Coligny, 75001 Paris; hair by Guido for Redken; makeup by Pat McGrath; millinery by Stephen Jones; styled by Katie Grand; produced by La Mode en Images – KCD

s/s 2009 Ready-to-Wear

5 October 2008; Louvre courtyard, Porte Marengo, rue de Rivoli, 75001 Paris; hair by Guido for Redken; makeup by Pat McGrath; styled by Katie Grand; produced by La Mode en Images – KCD

A/W 2009–2010 Ready-to-Wear

12 March 2009; Louvre courtyard, Porte Saint-Germain-de-l'Auxerrois, rue de l'Amiral-de-Coligny, 75001 Paris; hair by Guido for Redken; makeup by Pat McGrath; styled by Katie Grand; produced by La Mode en Images – KCD

s/s 2010 Ready-to-Wear

7 October 2009; Louvre courtyard, Porte Marengo, rue de Rivoli, 75001 Paris; hair by Guido for Redken; makeup by Pat McGrath; styled by Katie Grand; produced by La Mode en Images – KCD

A/W 2010–2011 Ready-to-Wear

10 March 2010; Louvre courtyard, Porte Saint-Germain-de-l'Auxerrois, rue de l'Amiral-de-Coligny, 75001 Paris; hair by Guido for Redken; makeup by Pat McGrath; styled by Katie Grand; produced by La Mode en Images – KCD

s/s 2011 Ready-to-Wear

6 October 2010; Louvre courtyard, Porte Marengo, rue de Rivoli, 75001 Paris; hair by Guido for Redken; makeup by Pat McGrath; styled by Katie Grand; produced by La Mode en Images – KCD

A/W 2011–2012 Ready-to-Wear

9 March 2011; Louvre courtyard, Porte Saint-Germain-de-l'Auxerrois, rue de l'Amiral-de-Coligny, 75001 Paris; hair by Guido for Redken; makeup by Pat McGrath; millinery by Stephen Jones; styled by Katie Grand; produced by La Mode en Images – KCD

s/s 2012 Ready-to-Wear

5 October 2011; Louvre courtyard, Porte Marengo, rue de Rivoli, 75001 Paris; hair by Guido for Redken; makeup by Pat McGrath; styled by Katie Grand; produced by La Mode en Images – KCD

A/W 2012–2013 Ready-to-Wear

7 March 2012; Louvre courtyard, Porte Saint-Germain-de-l'Auxerrois, rue de l'Amiral-de-Coligny, 75001 Paris; hair by Guido for Redken; makeup by Pat McGrath; hats by Stephen Jones; styled by Katie Grand; produced by La Mode en Images – KCD

s/s 2013 Ready-to-Wear

3 October 2012; Louvre courtyard, Porte Saint-Germain-de-l'Auxerrois, rue de l'Amiral-de-Coligny, 75001 Paris; hair by Guido; makeup by Pat McGrath; styled by Katie Grand; produced by La Mode en Images – KCD

A/W 2013–2014 Ready-to-Wear

6 March 2013; Louvre courtyard, Porte Saint-Germain-de-l'Auxerrois, rue de l'Amiral-de-Coligny, 75001 Paris; hair by Guido; makeup by Pat McGrath; styled by Katie Grand; produced by La Mode en Images – KCD

s/s 2014 Ready-to-Wear

2 October 2013; Louvre courtyard, Porte Saint-Germain-de-l'Auxerrois, rue de l'Amiral-de-Coligny, 75001 Paris; hair by Guido; makeup by Pat McGrath; millinery by Stephen Jones; body paint by Mario INK Chicago; styled by Katie Grand; produced by La Mode en Images – KCD

Louis Vuitton by Nicolas Ghesquière

A/W 2014–2015 Ready-to-Wear

5 March 2014; Cour carrée du Louvre, rue de Rivoli, 75001 Paris; hair by Paul Hanlon; makeup by Pat McGrath; styled by Marie-Amélie Sauvé; produced by La Mode en Images – KCD

2014–2015 Cruise

17 May 2014; Courtyard, Prince's Palace of Monaco, 98015 Monaco; hair by Paul Hanlon; makeup by Pat McGrath; styled by Marie-Amélie Sauvé; produced by MTEP – KCD

s/s 2015 Ready-to-Wear

1 October 2014; Fondation Louis Vuitton, 8 avenue du Mahatma Gandhi, 75116 Paris; hair by Paul Hanlon; makeup by Pat McGrath; styled by Marie-Amélie Sauvé; set by Es Devlin; produced by La Mode en Images – KCD

A/W 2015–2016 Ready-to-Wear

11 March 2015; Fondation Louis Vuitton, 8 avenue du Mahatma Gandhi, 75116 Paris; hair by Paul Hanlon; makeup by Pat McGrath; styled by Marie-Amélie Sauvé; set by Es Devlin; produced by La Mode en Images – KCD

2015–2016 Cruise

6 May 2015; The Bob & Dolores Hope Estate, 2466 Southridge Drive, Palm Springs, California; hair by Paul Hanlon; makeup by Pat McGrath; styled by Marie-Amélie Sauvé; produced by MTEP – KCD

s/s 2016 Ready-to-Wear

6 October 2015; Fondation Louis Vuitton, 8 avenue du Mahatma Gandhi, 75116 Paris; hair by Paul Hanlon; makeup by Pat McGrath; styled by Marie-Amélie Sauvé; set by Es Devlin; produced by La Mode en Images – KCD

A/W 2016–2017 Ready-to-Wear

8 March 2016; Fondation Louis Vuitton, 8 Avenue du Mahatma Gandhi, 75116 Paris, France; hair by Paul Hanlon; makeup by Pat McGrath; styled by Marie-Amélie Sauvé; set by Es Devlin; produced by La Mode en Images – KCD

2016–2017 Cruise

28 May 2016; Niterói Contemporary Art Museum, Mirante da Boa Viagem, Rio de Janeiro; hair by Paul Hanlon; makeup by Pat McGrath; styled by Marie-Amélie Sauvé; set by Es Devlin; produced by MTEP – KCD

s/s 2017 Ready-to-Wear

5 October 2016; 2 Place Vendôme, 75001 Paris; hair by Paul Hanlon; makeup by Pat McGrath; styled by Marie-Amélie Sauvé; produced by La Mode en Images – KCD

A/W 2017–2018 Ready-to-Wear

7 March 2017; Cour Marly, Louvre Museum, rue de Rivoli, 75001 Paris; hair by Paul Hanlon; makeup by Pat McGrath; styled by Marie-Amélie Sauvé; produced by La Mode en Images – KCD

2017–2018 Cruise

14 May 2017; Miho Museum, Shiga Prefecture; hair by Paul Hanlon; makeup by Pat McGrath; styled by Marie-Amélie Sauvé; produced by MTEP – KCD

s/s 2018 Ready-to-Wear

3 October 2017; Pavillon de l'Horloge, Louvre Museum, rue de Rivoli, 75001 Paris; hair by Paul Hanlon; makeup by Pat McGrath; styled by Marie-Amélie Sauvé; produced by La Mode en Images – KCD

A/W 2018 Ready-to-Wear

6 March 2018; Cour Lefuel, Louvre Museum, rue de Rivoli, 75001 Paris; hair by Paul Hanlon; makeup by Pat McGrath; styled by Marie-Amélie Sauvé; set by Es Devlin; produced by La Mode en Images – KCD

Picture Credits

All images © firstVIEW unless otherwise indicated.

© Catwalking.com: 578 (above)

Pietro D'aprano/Getty Images: 548 (below), 549 (left), 549 (right), 558 (above), 589 (above and below), 590 (below right), 592 (above right and below right), 594 (above left and below left), 596 (below right), 597 (above right)

Tony Barson/Getty Images: 379 (below right)

Robyn Beck/AFP/Getty Images: 506, 509 (below left), 511 (above left), 512, 515 (above), 517 (above)

Fernanda Calfat/Getty Images: 547, 559

Stephanie Cardinale/Corbis via Getty Images: 380–1, 393 (below), 575 (above and below)

Dominique Charriau/WireImage/Getty Images: 468, 470 (below left), 471 (above right and below left), 472 (below right), 473 (below right), 474 (below right), 477 (above left and below left), 478, 479 (below), 519 (above left)

Jean Chung/Getty Images: 588 (above), 599 (above left)

Michel Dufour/WireImage/Getty Images: 400–1

Antonio de Moraes Barros Filho/WireImage/Getty Images: 379 (above)

Francois Guillot/AFP/Getty Images: 406–7

Jean Christophe Magnenet /AFP/Getty Images: 479 (above)

Koki Nagahama/WireImage/Getty Images: 588 (below right)

Petroff/Dufour/Getty Images: 426, 428 (above), 429 (below left), 437 (above and below)

© Annie Powers: 453

Donato Sardella/Getty Images for Louis Vuitton: 507 (above), 513 (above right and below right), 517 (below)

Kristy Sparow/Getty Images: 365 (below)

Venturelli/WireImage/Getty Images: 435 (left)

Victor Virgile/Gamma-Rapho via Getty Images: 455 (above)

Peter White/Getty Images: 536 (above and below left), 537 (above), 574, 577 (above)

Acknowledgments

The Authors and the Publisher would like to thank Marc Jacobs and Nicolas Ghesquière for their support in the making of this book.

Thanks to Kerry Davis and Don Ashby at firstVIEW.

Additional thanks to Alex Duncan at Central Saint Martins Library.

Select Index of Clothes, Accessories & Materials

The page numbers below refer to illustrations.

Embellishments & Materials

Index of Models

Considerable efforts have been made to identify the
 models featured in this book, but in some cases
 we have been unable to do so. We would be
 pleased to insert an appropriate acknowledgment
 in any subsequent reprint.

Index

Published in the U.S. and Canada in 2018 by
Yale University Press
P.O. Box 209040
302 Temple Street
New Haven, CT 06520-9040
yalebooks.com/art

Published by arrangement with
Thames & Hudson Ltd, London

Design by Fraser Muggeridge studio

Library of Congress Control Number: 2018936243

ISBN 978-0-300-23336-0

Printed and bound in China by
C & C Offset Printing Co. Ltd

10 9 8 7 6 5 4